THE AMERICAN DAGUERREOTYPE

THE AMERICAN DAGUERREOTYPE

FLOYD RINHART AND MARION RINHART

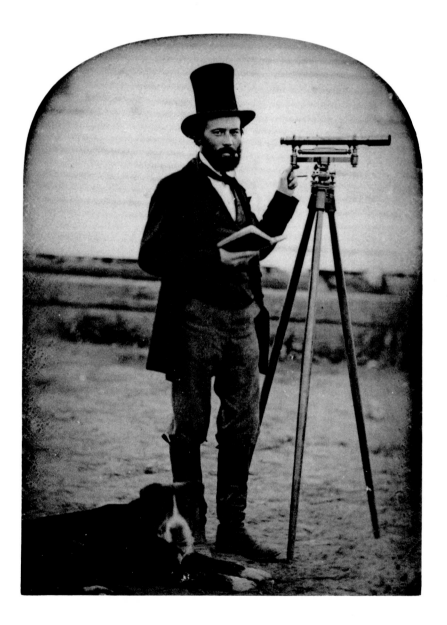

The University of Georgia Press 𝐆 Athens

Set in Korinna and Century Expanded

Design by Richard Hendel

Printed in the United States of America

Library of Congress Cataloging in Publication Data

Rinhart, Floyd.
 The American daguerreotype.

 Bibliography: p.
 Includes index.
 1. Daguerreotype—History. 2. Photography—United States—History.
I. Rinhart, Marion, joint author. II. Title.
TR365.R48 772'.12'0973 80-24743
ISBN 0-8203-0549-9

CONTENTS

Acknowledgments vii

Introduction ix

PART 1. A HISTORICAL SURVEY

Chapter 1. Events Leading to Photography in America 3

Chapter 2. The Pioneer Days, 1839–1840 22

Chapter 3. The Formative Years, 1841–1846 55

Chapter 4. The Years of Expansion, 1847–1850 90

Chapter 5. The Affluent Era, 1851–1860 115

PART 2. THE IMAGES

Chapter 6. Daguerreotype Plates, Apparatus, and Processes 155

Chapter 7. Stereoscopic Daguerreotypes 191

Chapter 8. Color and the Daguerreotype 208

Chapter 9. Art Influences 225

Chapter 10. Art and the Portrait 259

Chapter 11. Miniature Cases 305

Chapter 12. Reflections of an Age 350

BIOGRAPHIES

Key to Abbreviations 379

Professional and Amateur Daguerreotypists 380

Manufacturers and Wholesale Suppliers 417

Case Manufacturers and Engravers 420

Appendix 1. A Tabulation of Hallmarks Found
 on Extant Daguerreotypes 423

Appendix 2. United States Patent Records 426

Notes 429

A Dictionary of Daguerreotype Terms 439

Index 441

ACKNOWLEDGMENTS

We are deeply indebted to W. Robert Nix and Wiley Sanderson of the Department of Art, the University of Georgia, for their encouragement of and help with this volume, after we presented a two-week seminar on early American photographic images to the Art Department in 1977. Dr. Nix has given us valuable aid in editing and improving our manuscript, and he and his wife, Harriet, have been generous in helping with the artwork entailed in the production of this volume. Professor Sanderson has been extremely helpful with technical details and other advice throughout the writing. Both men have allowed daguerreotypes from their collections to be photographed for inclusion in this volume.

Our deepest gratitude is extended to the Department of Photography and Cinema at the Ohio State University for the use of negatives, color transparencies, and other needed items from our former collection, with special thanks to Walter Johnson and Robert W. Wagner.

We are grateful for the generous help given by our son, George R. Rinhart of New York City, who allowed us to use his extensive library on the history of photography and to photograph early images from his extensive collection. We also extend our appreciation to George Moss, Jr., of Rumson, New Jersey, for giving us complete use of his library and allowing us to photograph daguerreotypes from his collection. We would like important recognition to be given to Josephine Cobb, Cape Elizabeth, Maine, our friend of many years, who has always provided us with the encouragement needed to pursue our studies of the daguerreotype. She has sent us research materials which have been invaluable, and she has allowed us to photograph daguerreotypes from her superb collection for use in this volume.

We are very grateful for the generous help given by Arthur T. Gill, photographic historian, Eastbourne, England, who has provided us with research materials and photographs. Our warm thanks go to our friend Mary Sayer Hammond of Athens, Georgia, for helping to locate research materials and for allowing daguerreotypes from her collection to be photographed for this volume. Also, we are grateful to James de T. Abajian of San Francisco, who has kindly sent us information about pioneer photographers.

A very special debt is owed Philip W. Bishop, former chairman of Arts and Manufacturers, Smithsonian Institution, for allowing us to use his extensive notes from the Scovill Manufacturing Company's business correspondence.

Our deep appreciation goes to Beaumont Newhall of Santa Fe, New Mexico, for sending photographs and other data of rare miniature cases for inclusion in this volume. Special thanks should also be given Norman Mintz of New York City for allowing us to photograph many daguerreotypes from his collection.

A very special debt of gratitude must be given to the University of

Georgia Library, and its staff, for valuable aid during our final years of research. We are also deeply grateful to the Rare Books and Manuscripts Department of the library, and its staff, for allowing us to photograph daguerreotypes from their holdings for use in this volume; special warm thanks go to Robert M. Willingham, assistant librarian, Rare Books and Manuscripts. Our deepest appreciation goes to the Department of Art, the University of Georgia, for allowing us to reproduce daguerreotypes and rare daguerreotype cases from its photographic archives.

Other individuals who have generously allowed photographs from their collections to be reproduced in this work are J. Harry Du Bois, Morris Plains, New Jersey; Walt Craig, Columbus, Ohio; Avis Gardiner, Stamford, Connecticut; Henry J. Hulett, Athens, Georgia; Donald Lokuta, Union, New Jersey; Dennis O'Kain, Athens, Georgia; Levon Register, Athens, Georgia; and Robert A. Weinstein, Los Angeles, California.

The following institutions kindly assisted us during our research and/or provided pictorial materials: American Antiquarian Society, Worcester, Massachusetts; Bowdoin College Library, Brunswick, Maine; California Historical Society, San Francisco, California; Franklin Institute, Philadelphia, Pennsylvania; Georgia Historical Society, Savannah, Georgia; Humanities Research Center, University of Texas, Austin, Texas; Library of Congress, Washington, D.C.; Maine Historical Society, Portland, Maine; Metropolitan Museum of Art, New York City; Museum of Fine Arts, Boston, Massachusetts; National Archives, Washington, D.C.; National Maritime Museum, London, England; New York Historical Society, New York City; New York Public Library, New York City; New York State Library, Albany, New York; Northampton Historical Society, Northampton, Massachusetts; Portland Public Library, Portland, Maine; Public Library of Cincinnati and Hamilton County, Cincinnati, Ohio; Rollins College Library, Winter Park, Florida; Royal Photographic Society, London, England; Science Museum, London, England; Smithsonian Institution, Washington, D.C.; Sotheby-Parke-Bernet Galleries, New York City; Western Carolina University, Cullowhee, North Carolina; and York Institute, Saco, Maine.

INTRODUCTION

American daguerreotypes, the first exact images of America and its people, are now being closely evaluated in retrospect for their historical significance both in social history and in art. Every daguerreotype has a place in the history of photography; the daguerreian art and its diversifications can be better understood in a study comprising a wide range of specimens. In this volume the special qualities of a daguerreotype are considered— the image's historical value and its particular process and inconsistencies. Many questions of artistic value are also evaluated—the posing of the subject, lighting techniques, and the total composition as it relates to art.

With the students and custodians of daguerreotype collections in mind, we present a clear, accurate, and detailed history of the progression of the daguerreotype in America, not an abstract doctrine or theory with little or no regard for practicability. On the contrary, we feel that our readers should form their own interpretation from our text and illustrations. Although the aesthetics of the daguerreotype are not presented in an abstract manner, two chapters are devoted to the art techniques and art influences of the era, expounded with research materials not hitherto available in the history of American photography.

Further, the daguerreotypes selected to illustrate this volume have been chosen to show a wide spectrum, from poor to excellent, rather than "prizewinning" specimens. The illustrations are to instruct and not to entertain. We have chosen many examples from our former large collection of early images which are now in a special study room at the Ohio State University, Department of Photography and Cinema. The collection is not regional but represents a cross section of the country and encompasses the entire range of daguerreotyping. The circa dates for daguerreotypes are determined by a method in the appendix.

This volume is a culmination of twenty years of research, study, and travel. Our former collection formed the basic foundation for three major investigations. One was of a physical nature—the study of the daguerreotype plate itself and its characteristics. The second comprised an intensive research of books, manuals, periodicals, newspapers, patent records, and census records, plus the background social history so important to understanding the influences upon the daguerreotype. Our third study was of the miniature cases used by pioneer photographers to protect and contain their images. Throughout the work each segment of the manuscript should provide for the serious student of the history of photography new and controversial avenues for future research.

We have built upon the heritage left by Robert Taft's *Photography and the American Scene* (1938) and Beaumont Newhall's excellent history, *The Daguerreotype in America* (1961). Both men researched

their subject well; without their books the history of American pho-
tography would not have advanced beyond the era of the 1930s, when
little was known about the subject. The information recorded by the
above historians has been subjected to verification, further explora-
tion, and, when necessary, correction—a courtesy we hope will be ex-
tended to this volume by future historians.

One of our most disturbing discoveries was that many publications
tended to compound erroneous information about American photogra-
phy. Generations of photographic historians had written about events
that sometimes had little factual foundation; they habitually and se-
quentially believed in the impeccability of the original researcher
without pursuing further investigation. Thus, by the 1930s, a number
of sophistic details had become accepted facts; unfortunately, this
trend continues into modern accounts, including those presented by
prestigious institutions. For this reason, our use of twentieth-century
material has been limited.

In regard to citations from contemporary source material of the
daguerreian era, we have endeavored to check and recheck them
whenever possible to uncover any errors in dates, spelling, or accura-
cy. Rarely, a later citation will contradict an earlier one, a fact future
historians may ponder. We have, however, been cautious in our choice
of citation material. We have often included citations of our other
books and articles, because many of the notes from these works are
not repeated in this volume. Although quotations from contemporary
newspapers and periodicals often contain misspellings and other er-
rors, we have hesitated to use the obtrusive word *sic* unless a mis-
spelled name is not recognizable; the old-fashioned punctuation has
also not been corrected.

Those in charge of private and institutional collections should be-
come more knowledgeable about the daguerreotype, thus enabling
them to recognize the worth of each item in their collections. Museums
should also reevaluate their daguerreotypes and the miniature cases
that contain them; and the images should be displayed properly, with
appropriate and accurate information. Universities, museums, histor-
ical societies should all expose the daguerreian art to the same recog-
nition that primitive painting finally received in this century.

As the vast amount of important photographic documents and pho-
tographic art accumulates, the understanding of the history of Amer-
ican photography will assume great importance. A more intensive
analysis and a scholarly approach, with practical organization, will be
needed to sort out and to implement the material for future studies
which will integrate the visual power of the photograph with the his-
tory of art and sociology.

PART 1. A HISTORICAL SURVEY

1. EVENTS LEADING TO PHOTOGRAPHY IN AMERICA

Photography in its practical applications began in 1839, but the theories and experiments leading to this go far back into history. Such early philosophers as Euclid, Aristotle, and Leonardo da Vinci had pondered the inverted images of outside objects formed by reflected light passing through small apertures in doors or window shutters. Observations by these learned men led to the use of a darkened chamber, with a small aperture in a window or shutter, to observe eclipses long before Giovanni Battista della Porta popularized the camera obscura in the sixteenth century.

In an account published in 1558, della Porta noted the camera obscura's use in drawing and painting. Just how extensively the camera obscura was employed after it became an aid to artists is unknown, of course, because traces of the instrument would have been obscured by the painter on his canvas. Down through the ages, however, it is certain that many famous artists used the camera obscura to obtain fidelity in landscape and figure painting. After the advent of photography, artists brought realism without idealization to their portraits by reflecting images of daguerreotypes or other photographs on canvas and then finishing the outlines in oil; although the instrument used for reflecting the images was not the camera obscura, it essentially followed the art tradition of previous centuries.

Despite speculation by historians about a possible utilization of the lens in early times,[1] it was not until the sixteenth century that published accounts confirm its use with the camera obscura. Girolamo Cardan cites the use of a round glass speculum in 1550; an ordinary convex lens was employed by Daniello Barbaro in 1568; and a convex lens was mentioned by della Porta in 1589.[2]

During the following centuries, the camera obscura underwent many changes and improvements. The simple darkened chamber gave way to many imaginative innovations in sizes and shapes in the seventeenth century, including portable models of box and lens type, a variation of which later became popular with artists in the eighteenth and nineteenth centuries. The camera obscura, now complete with lens, was a first step toward photography, but light-sensitive materials had to be discovered, understood, and implemented before the elusive images reflected by nature could be fixed upon paper.

The power of the sun to darken certain substances was known from early times, when alchemists searching for the philosophers' stone observed that a combination of silver and chlorine, which they called horn silver, became blackened by light. Unfortunately, they lost interest in the substance when the gold that they sought could not be produced from their findings.[3]

One of the first steps in the evolution of the photographic image came when German professor Johann Heinrich Schulze obtained photosensitive copies of writing as early as 1727—the writing had been placed on a level surface prepared with a mixture of chalk and nitric

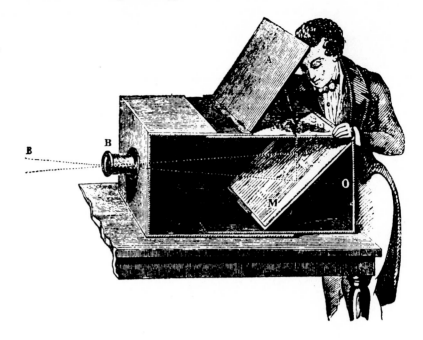

acid and containing some silver. The result: a white copy on a black ground.[4]

Other published accounts later in the century noted the peculiar reactions of silver and light. Swedish chemist Karl Wilhelm Scheele observed in 1777:

> It is well known that the solution of silver in acid of nitre poured on a piece of chalk, and exposed to the beams of the sun grows black. The light of the sun reflected from a white wall has the same effect, but more slowly. Heat without light has no effect on this mixture. . . . Fix a glass prism at the window, and let the refracted sun-beams fall on the floor; in this coloured light put a paper strewed with *luna cornua*, and you will observe that the horn-silver grows sooner black in the violet ray than in any other rays.[5]

After Scheele's experiments, other scientific papers were published by Jean Sénébier in 1782, Benjamin Thompson (Count Rumford) in 1798, and Robert Harrup in 1802, the latter disputing Rumford's experiments. In 1801 Johann Wilhelm Ritter proved that rays existing at a distance beyond the visible spectrum were able to quickly blacken the chloride of silver. Other men of science directed attention toward researching the various rays and their chemical influences. Dr. William Wollaston and Sir Humphry Davy were among the most significant of those who experimented along these lines in the early nineteenth century.[6]

In about 1794, Davy and Thomas Wedgwood had begun experiments which would help lay the foundation for the development of photography. In a paper published in 1802, they outlined a method for copying paintings on glass and for making profiles by the agency of light upon nitrate of silver, but, although their idea for a method of copying images was sound, they failed to fix the images upon glass or paper.

The principle of the camera obscura illustrated. From Harper's Monthly Magazine, *September 1869.*

After the Wedgwood-Davy publication, other European men of art and science must have attempted to fix the images of the camera obscura in the nineteenth century's first decades, but their experiments are clouded or lost to history.[7]

The many European experiments by artists and men of science during this period did not go unnoticed in America, and it is certain that some individuals attempted to fix the elusive images of the camera obscura. However, documentation is lacking—with the exception of two incidents concerning Samuel F. B. Morse before he graduated from Yale in 1810. Robert Habersham, an artist from Savannah, Georgia, recounted the first:

> . . . one day, while in the Rue Surenne, I was studying from my own face reflected in a glass, as is often done by young artists, when I remarked how grand it would be if we could invent a method of fixing the image on the mirror. Professor Morse replied that he had thought of it while a pupil at Yale, and that Professor Silliman (I think) and himself had tried it with a wash of nitrate of silver on a piece of paper, but that, unfortunately, it made the lights *dark* and the shadows *light*, but that if they could be reversed, we should have a facsimile like India-ink drawings. Had they thought of using glass, as is now done, the daguerreotype would have been perhaps anticipated—certainly the photograph.[8]

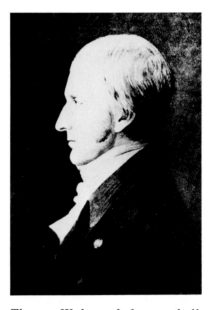

Thomas Wedgwood, from a chalk drawing. Illustrated in R. B. Litchfield's biography, Tom Wedgwood, *1901.*

The second event, from a letter written by Morse himself to his brothers on March 9, 1839, is also concerned with his New Haven experiments with the camera obscura: Morse presumed the production of a "true image" to be impracticable and gave up the attempt.[9]

NIEPCE AND DAGUERRE

The continuing idea that it was of great importance to fix the images of the camera obscura was perhaps the greatest factor leading to the development of photography.

Back across the ocean, the Frenchman Joseph Nicéphore Niepce became interested in lithography about 1813, and by 1816 he was using a camera obscura during his experiments. While trying to permanently fix his pictures on paper, Niepce tried a weak nitric acid solution—which proved at least partially successful because the images, kept in a book, remained visible for fifty years, according to later testimony.[10] In 1825, Niepce gave up paper and turned back to using pewter plates, the material he had worked with earlier in lithography.

In September 1827, Nicéphore visited his ailing brother Claude in England, at Kew. During his stay he became acquainted with Francis Bauer, a fellow of the Royal Society of London, and, as their friendship developed, Niepce discussed his discovery of permanently fixing the image of any object by a "spontaneous action of light." He showed Bauer "several very interesting specimens on polished *pewter* plates, as of impressions on paper, made from such plates after they had been prepared by his chemical process." They were, he said, the first re-

A view from a window, 1826. Pewter plate, 6½ by 8 inches. By Joseph Nicéphore Niepce. His first successful experiment for permanently fixing an image from nature. Gernsheim Collection, Humanities Research Center, the University of Texas at Austin.

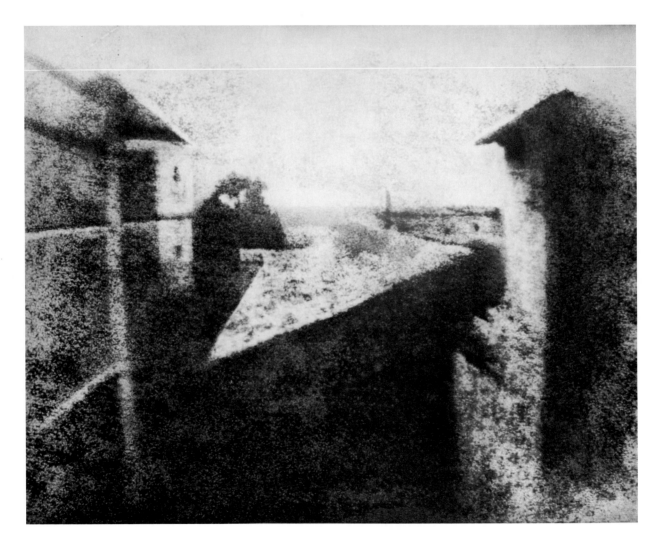

sults of his long research and, further, he wished to be acknowledged by the Royal Society so that he could establish priority of discovery. Subsequently, a memoir was drawn up, dated December 9, 1827, and the document, along with specimens of his work, was presented to the society. Although Niepce was interviewed by society members, the memoir was returned several weeks later because details of the process had not been divulged. Before leaving England in February 1828, he gave Bauer several interesting specimens of his art, including his first successful attempt from nature.[11]

Niepce appears to have been the first of the many experimenters to produce permanent pictures by the influence of the sun's rays. The substance he used on well-polished pewter plates was "asphaltum" or bitumen of Judea. He later used silver plates and a varnish composed of bitumen of Judea, dissolved in animal fat of Dippel. After exposure in the camera obscura, the plate was immersed in a solvent containing oil of lavender and oil of white petroleum, which made the image gradually become visible; the plate was then washed and dried. All the operations during this process required great care. In the camera obscura plates needed an exposure time of from six to eight hours, and from four to six hours were needed to copy an engraving.[12] Niepce called his process heliography.

After Niepce returned to France, he became associated with Louis Jacques Mandé Daguerre, a French artist and coinventor of the diorama who was also investigating the possibility of fixing the images of the camera obscura. Niepce communicated the details of his process to Daguerre on December 5, 1829, and a partnership was arranged which did not end with Niepce's death in 1833 but continued with his son, Isidore; it was mutually understood that future investigations and the profits thereof were to be shared by the partners.[13]

On September 27, 1835, a French publication announced that Daguerre had found a way to record an image of the camera obscura. The story is often told that he discovered the important part of his process quite by chance—that he left an iodized silvered plate, exposed to the camera, overnight in a cupboard containing a number of chemicals, noticed an image on the plate in the morning, and deduced that one of the chemicals had brought out the image.

A more likely story, however, is one related to Charles R. Meade, a daguerreotypist from Albany, New York, who visited Daguerre in Paris in 1848. Daguerre told Meade that he had iodized his plate, exposed it in the camera, and held it over mercury heated in an iron crucible by means of a furnace to the boiling point (this is much too high a temperature for the art). One day, however, after exposing a plate to mercury, he found a dim shadow on the outer edge of the plate, where the heat of the mercury was not so great—and thus he reduced the temperature and at last obtained a picture.[14] Although an image was brought out on the plate, the problem of fixing the iodized silvered plates still remained, but Daguerre finally found that by immersing his plates in a hot saline bath he could fix his images. Success came in May of 1837 and, by the fall of 1838, his process was ready for promotion.

Daguerre hoped to attract investors by subscription: a printed notice went out and a daguerreotype exhibit was promised for January 15, 1839.[15] This showing apparently did not take place, although from printed accounts it is known that the daguerreotypes were seen by Parisians as early as the fall of 1838. Fortunately for Daguerre, his

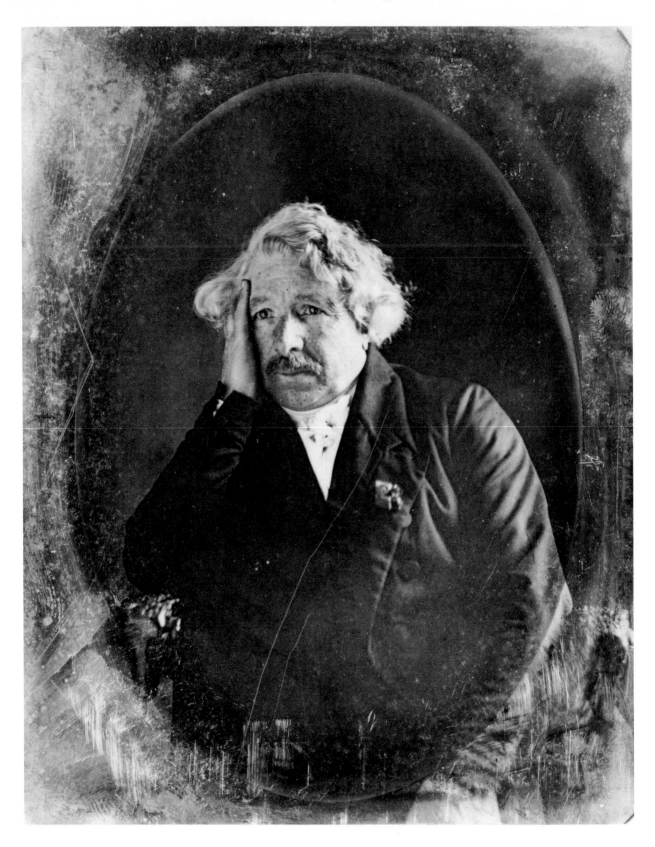

Louis Jacques Mandé Daguerre, By Charles R. Meade.
1848. Whole-plate daguerreotype. Smithsonian Institution.

process caught the attention of several eminent scientists in Paris. Dominique François Jean Arago, secretary of the French Academy of Science, was deeply interested in the new invention and became Daguerre's spokesman before the academy on January 7. Arago pleaded for the government to award pensions to both Daguerre and Niepce and to place the invention before the world. Although the discovery was described, the secrets of the process were not disclosed.

Meanwhile, the day before Arago's lecture, an item appeared in the *Gazette de France*, dated January 6, 1839, and written by H. Gaucheraud, which tells of Daguerre's discovery:

> We have much pleasure in announcing an important discovery made by M. Daguerre, the celebrated painter. . . . This discovery seems like a prodigy. It disconcerts all the theories of science in light and optics, and, if borne out, promises to make a revolution in the arts of design.
>
> M. Daguerre has discovered a method to fix the images which are represented at the back of the camera obscura; so that these images are not the temporary reflection of object, but their fixed and durable impress, which may be removed from the presence of those objects like a picture or an engraving.
>
> Let our readers fancy the fidelity of the image of nature figured by the camera obscura; and add to it an action of the solar rays which fixes this image, with all its gradations of lights, shadows, and middle tints, and they will have an idea of the beautiful designs, with a sight of which M. Daguerre has gratified our curiosity. M. Daguerre cannot act on paper; he requires a plate of polished metal. It was on copper that we saw several points of the Boulevards, Pont Marie, and the environs, and many other spots, given with a truth which Nature alone can give her works. M. Daguerre shews you the plain plate of copper: he places it, in your presence, in his apparatus, and, in three minutes, if there is a bright summer sun, and a few more, if autumn or winter weaken the power of its beams, he takes out the metal and shews it to you, covered with a charming design representing the object towards which the apparatus was turned. Nothing remains but a short mechanical operation—of washing, I believe—and the design, which has been obtained in so few moments, remains unalterably fixed, so that the hottest sun cannot destroy it.
>
> Messrs. Arago, Biot, and Von Humboldt, have ascertained the reality of this discovery, which excited their admiration; and M. Arago will, in a few days, make it known to the Academy of Sciences.
>
> I add some further particulars. Nature in motion cannot be represented, or at least not without great difficulty, by the process in question. In one of the views of the Boulevards, of which I have spoken, all that was walking or moving does not appear in the design; of two horses in a hackney coach on the stand, one unluckily moved its head during the short operation; the animal is without a head in the design. Trees are very well represented; but their colour, as it seems, hinders the solar rays from producing their image as quickly as that of houses, and other objects of a different colour. This causes a difficulty for landscape, because

Dominique François Jean Arago. From an engraving in the London Illustrated News, *March 4, 1848. The French scientist Arago was the sponsor and spokesman for Daguerre and his photographic process in 1839.*

Friedrich Heinrich Alexander von Humboldt. From an engraving in the London Illustrated News, *September 22, 1849.*

there is a certain fixed point of perfection for trees, and another for all objects the colours of which are not green. The consequence is, that when the houses are finished, the trees are not, and when the trees are finished, the houses are too much so.

Inanimate nature, architecture, are the triumph of the apparatus which M. Daguerre means to call after his own name—Daguerotype. A dead spider, seen in the solar microscope, is finished with such detail in the design, that you may study its anatomy, with or without a magnifying glass, as if it were nature itself; not a fibre, not a nerve, but you may trace and examine. For a few hundred francs travelers may, perhaps, be soon able to procure M. Daguerre's apparatus, and bring back views of the finest monuments, and of the most delightful scenery of the whole world. They will see how far their pencils and brushes are from the truth of the Daguerotype. Let not the draughtsman and the painter, however, despair—the results obtained by M. Daguerre are very different from their works, and in many cases, cannot be a substitute for them. The effects of this new process have some resemblance to line engravings and mezzotints, but are much nearer to the latter: as for truth, they surpass every thing.

I have spoken of the discovery only as it regards art. If what I have heard is correct, M. Daguerre's discovery tends to nothing less than a new theory on an important branch of science. M. D. generously owns that the first idea of his process was given him, fifteen years ago, by M. Nieps, of Chalons-sur-Saone; but in so imperfect a state, that it has cost him long and persevering labour to attain the object.[16]

Gaucheraud clearly points out that Parisians were well aware of Daguerre's work and that he had freely demonstrated his process to the public before Arago's formal announcement.

BAYARD, TALBOT, HERSCHEL

While Daguerre had been improving his process on silvered copper plates, a fellow Frenchman, Hippolyte Bayard, had been experimenting with a paper process since 1837; in February of 1839, he displayed some negative images on paper. After the announcement of Daguerre's process, Bayard was determined to produce direct positives on paper—on March 20, he succeeded in the attempt with a long exposure of about an hour, and before June some thirty of his photographs were exhibited. Meanwhile Arago, not wishing to jeopardize his negotiations with the French government on behalf of Daguerre and Niepce, persuaded Bayard to postpone revealing his process. If he had not succumbed to Arago's demands and accepted the small sum of six hundred francs, he might have later received more acclaim as an independent inventor of photography, but it was not until February 24, 1840, that he presented his findings to the academy.[17]

The disclosure of Daguerre's new photographic process created a considerable stir in England. At the time of the announcement, William Henry Fox Talbot of Lacock Abbey, landowner, author, and scientist, was preparing an account of his discoveries and experiments for

forming pictures by means of solar light for presentation before the
Royal Society.

When Talbot had traveled to Italy in 1833, he made use of the cam-
era lucida, a reflective aid, to sketch the picturesque Italian country-
side. But the frustration of trying to sketch the details thrown by the
lens onto his drawing paper led him—perhaps to recall the earlier the-
ories of Scheele, Davy, and Wedgwood—to dwell on the theories of
light and shadow and the interaction of chemicals and light needed to
permanently fix the reflected scene.

After his return to England, Talbot began experimenting with the
process of photogenic drawing—photography on paper—with and

William Henry Fox Talbot,
ca. 1846. Daguerreotype.
By Antoine Claudet.
Royal Photographic Society
Collection.

without the use of the camera obscura. His first attempts—copying flowers and leaves selected from his herbarium—were accomplished with great fidelity. In the summer of 1835, he had a number of tiny cameras made, having found that a shorter focus and a smaller box produced more perfect pictures; the one-inch-square images, actually negatives, had to be viewed with a lens to make out the minute details. During the summer Talbot carried his miniature cameras outdoors and placed them in various locations about his country home. Each camera had its proper focus for the particular scene to be recorded; after a half-hour exposure, the cameras were brought in and opened, and in each a miniature picture had been formed.[18]

Talbot's process and images were later described with simplicity in an article published in *Chambers' Edinburgh Journal*:

> Without following him through the various steps by which he finally arrived at the present stage of the invention, we may mention he prepares his paper in the following manner. Having selected it of a firm quality and smooth surface, he dips it in a weak solution of common salt, dries it, and then spreads its surface with nitrate of silver, which he dries at a fire. Afterwards, he washes it alternately for a considerable number of times with saline water, and a solution of silver, by which process the sensibility of the paper is increased. The paper is presented to the object by means of a camera obscura, and the time usually required for producing the effect is about a quarter of an hour. When finished, he washes the picture with a weak solution of *iodide of potassium*, which, transforming the former preparation into an *iodide of silver*, renders it thenceforth 'absolutely unalterable by sunshine.' The same effect may be produced in a simpler way by giving the picture one more washing in dissolved salt; for, strange to say, the same solution which formerly increased the sensibility of the paper now destroys it.

Cameras constructed for Talbot by Joseph Foden for the 1835 photogenic-drawing experiments at Talbot's country home. Royal Photographic Society Collection.

SOME ACCOUNT

OF

THE ART OF

PHOTOGENIC DRAWING,

OR THE PROCESS BY WHICH

NATURAL OBJECTS MAY BE MADE TO DELINEATE THEMSELVES

WITHOUT THE AID OF THE ARTIST'S PENCIL.

BY

HENRY FOX TALBOT, Esq. F.R.S.

(*Read before the Royal Society, January 31, 1839.*)

LONDON:

PRINTED BY R. AND J. E. TAYLOR, RED LION COURT, FLEET STREET.

1839.

Title page of Talbot's brochure, published February 1839. The first publication devoted exclusively to photography. Gernsheim Collection, Humanities Research Center, the University of Texas at Austin.

The images obtained are white, but the ground on which they display themselves is variously and pleasingly coloured. . . . The various *grounds* producible are sky-blue, yellow, rose-tint, brown, and black: green contrary to what might have been expected, has not been obtained.[19]

In a speech before the Royal Society on January 31, 1839, Talbot outlined the many uses for his photogenic drawing.[20] Losing no time, he again read a paper before the society on February 21, giving the full details of his process.[21] By his openness, Talbot gained the admiration of his fellow countrymen; also, it quickly became evident that his process differed rather sharply from that of Daguerre. However, it was Daguerre's process which would appeal to the inventive Americans (although an improved paper process would rival the much publicized daguerreotype by the end of the 1850s).

Meanwhile Sir John Herschel, the noted astronomer, had been de-

Feathers and lace, 1839.
Photogenic drawing.
By W. H. Fox Talbot.
Gernsheim Collection,
Humanities Research Center,
the University of Texas at
Austin.

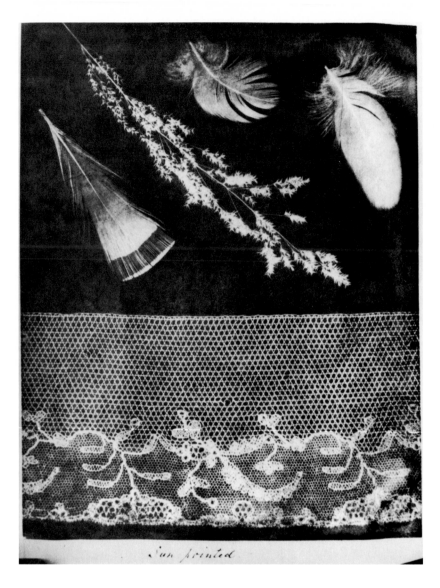

voting attention to the subject of photogenic drawing after hearing of
Daguerre's process. In 1819 Herschel, highly accomplished as a chem-
ist, had discovered the solvent power of hyposulfite of soda on the oth-
erwise insoluble salts of silver—a forerunner of its fixing agent in later
photography—and the *Literary Gazette* of February 23, 1839, noted
that Herschel had obtained pictures from the light of "Daniell's great
galvanic battery." In a letter to Talbot dated February 28, Herschel
explained his process for washing out his photogenic pictures with
"Hyposulfite of Soda"; he also enclosed a few specimens of his work—
one washed with the solution on February 19.[22] Herschel made a report
to the Royal Society of London on March 14, 1839, titled "Note on the
Art of Photography, or the application of the Chemical Rays of Light
to the purposes of Pictorial Representation." In his account he used
the term "photography," and he also stated that copies made from the
original pictures reversed the light and shadows and gave them back
in the same order as that of the original, a fact which would have con-
tinuing importance in photography.[23]

Not wishing to overshadow Talbot in any way, Herschel did little to

publicize his independent research. Although other men both in England and on the Continent were experimenting with photogenic drawing at this time,[24] Talbot overshadowed them all, possibly because his writings appeared in the learned journals of the day.

THE AMERICANS

As far as is known, only two written records exist of later photogenic experiments in America, although rumors occasionally mentioned other American experimenters, including Robert Hare of the University of Pennsylvania and James J. Mapes, a New York chemist and inventor. These men received attention in fields somewhat related to photography in the predaguerreotype days. The *New York Journal of Commerce* stated in July 1839 that "some artists and connoisseurs were experimenting in an effort to discover Daguerre's process." Other accounts also hinted about the quest without being explicit.

John W. Draper, a scientist and professor of chemistry at the City of New York University, recalled in 1843 that his first experiments with photography began in 1834; the results, published in the *Journal of the Franklin Institute* in 1837, gave an account of experiments with the effect of the sun's rays on sensitized paper and a summation of his conclusions.[25]

The second man to have his experiments documented was John Locke, a native of New England, a scientist, inventor, and physician. In 1815, while at Yale, he attended Benjamin Silliman's lectures on chemistry and for a while was also an assistant in the professor's laboratory. Notice of Locke's experiments appeared in a Cincinnati newspaper in the spring of 1839:

> A process similar to that of M. Daguerre of France and Mr. Fox Talbot of England, has been tried successfully by a gentleman of Cincinnati. . . . Some experiments on photogenic drawing have been made by professor Locke of the Medical College of Ohio, and with entire success. He prepared paper chemically for this purpose, and placed it under some astronomical diagrams, which were then exposed to the sun rays. The new picture was in a few minutes formed and removed and a process used, by which the figures were permanently fixed. The specimens thus produced are in every respect satisfactory. They look as though they had been most carefully engraven.[26]

At first glance, it might be assumed that Locke had merely used photogenic paper, which was enjoying a measure of popularity at this time.[27] But he had a formidable record of experiments and a wide diversification of interests. Just how broadly his experiments embraced photography is unknown, but he did lecture on the daguerreotype in May of 1840. His experiments with the daguerreotype would have to have taken place very early, because he was traveling with a geological survey from September 1839 until January 1840.[28]

Most important, though, was Samuel F. B. Morse, often called the father of American photography. There is certainly no doubt that his direction and his farsighted political acumen gave the new art its first impetus in America.

Morse traveled abroad to promote his telegraph in May of 1838, and

Advertisement for Locke's lectures. From the Cincinnati Daily Gazette, *May 13, 1840. Professor John Locke, of Cincinnati, had been one of the first Americans to experiment with the photographic process in early 1839.*

An editorial comment on public apathy concerning Locke's lectures on the daguerreotype. From the Cincinnati Daily Gazette, *May 16, 1840.*

it was fortunate for the history of American photography that a man of his talents—distinguished as both artist and inventor—should be in Europe when the first announcement of Daguerre's invention was made the following year. In England Morse hoped to secure a patent for his invention, but his petition was refused—the English claimed that the theory of the telegraph had already been published. Failing in England, Morse traveled to Paris to seek a French patent. He appeared before the French Academy in September, Arago presiding, and an exhibition of his telegraphic apparatus attracted many of the most eminent members of the Continent's scientific fraternity. Included among the group was the great scientist Alexander von Humboldt, an old friend dating back to the days when Morse had been an artist in Paris. The display gained Morse a French patent for his telegraph, valid for two years, but because the French government had a monopoly on communications the patent was of little value. After his Paris triumph, Morse exhibited his telegraph in various countries, even in far-off Russia.[29]

Not long after Arago's announcement of Daguerre's discovery in early 1839, Morse returned to Paris, thoroughly disheartened by his lack of success in promoting the telegraph. He found that Paris had become a world center for speculation about the new photographic discovery and a mecca for the curious. News coverage of Daguerre's invention was widespread, and men from a number of nations had gathered to seek out Daguerre for more details of the new process. Also, in England, Talbot appeared before the Royal Society in London, making public details of his paper process. Even so Paris, not London, was the center of activity—the astounding beauties of the daguerreotype were topics of conversation.

Morse, always interested in new discoveries, contacted Daguerre, and an exchange of visits was arranged—Morse was to examine Daguerre's invention on Thursday, March 7; Daguerre was to view the telegraph the following day. Morse had come to Daguerre well recommended by Arago and von Humboldt, two of the three men who had attested to the validity of Daguerre's process. Morse and Daguerre had much in common; both were artists and inventors, and both were successful in their respective discoveries and achievements.

Morse was impressed with and enthusiastic about the daguerreotype specimens he saw: no painting, he felt, could ever approach the daguerreotype for detail. He viewed under magnification the image of a spider's head no larger than the head of a pin, and on another daguerreotype he saw minute lettering on street signs. Here was a great invention and a broad field to explore!

Friday would be a tragic day for Daguerre: while he visited Morse, his diorama establishment went up in flames, and four of the huge paintings were lost. However, it was said that "a part of his movables were, however, saved from the ruins."[30] Whether any of his daguerreotypes and his apparatus were rescued from the fire remains a mystery.

Before leaving for home, Morse wrote an enthusiastic and detailed letter to his brothers in New York about his visit to Daguerre. The letter, reprinted in newspapers throughout the country, gave readers the first account of the new art by an American eyewitness who called the daguerreotype "Rembrandt perfected."[31] By coincidence the letter arrived at the same time as Morse's arrival home on April 15, aboard the steamship *Great Western*.

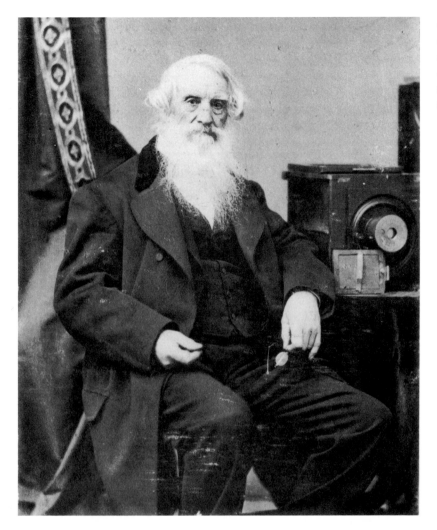

Samuel F. B. Morse, 1871.
Paper print.
By Abraham Bogardus.
Morse with one of his early da-
guerreotype cameras.
Smithsonian Institution.

Samuel Morse was an American from his birth to his death. Nowhere in the world was he ever recognized as anything but an American. In his younger days, he had spent some years abroad, studying in England and France, but he did not adopt or imitate in dress or manner the English or the French. Like so many Americans, Morse had a deep concern for his country's future, as his subsequent movements conclude. He is often portrayed in later history as a dreamer, but he was also a practical man. The effects of political movement did not escape him. He was alert to the causes and effects of historical situations.

In the era of Daguerre's invention, a keen three-way rivalry existed between France, England, and the United States. France and England, as the leading countries of Europe, were rivals of historic standing in war and peace, with each country watching the achievements of the other incessantly. The United States was the newcomer, and its competitiveness was directed mainly toward the English. Simply stated, this was the historical situation when Morse returned to New York in mid April.

The patriotic, practical Morse was certainly well aware of the greatness of Daguerre's discovery and its far-reaching possibilities in both art and science. Acting quickly and decisively, he moved to assure

American participation in the new art by placing Daguerre's name before the National Academy of Design for honorary membership. The academy was devoted to the arts—painting, sculpture, architecture, engraving—and Morse now proposed photography, although Daguerre was already recognized as an artist of merit. Morse had been the academy's only president since its founding in 1826, and his influence was naturally great—so great that Daguerre was elected with "wild enthusiasm and no dissenting vote."

On May 20, Morse wrote to notify Daguerre of his election to the academy and express his sympathy regarding his late losses by fire. But, of more strategic importance, he wrote: "Notwithstanding the efforts made in England to give another credit which is your due, I think I may with confidence assure you that throughout the United States your name alone will be associated with the brilliant discovery which justly bears your name."[32] In closing Morse presented Daguerre with a suggestion: "If when the proper remuneration shall be secured to you in France, you should think it may be for your advantage to make an arrangement with the government to hold back the secret for six months or a year, and would consent to an exhibition of your *results* in this country for a short time, the exhibition might be managed, I think, to your pecuniary advantage. If you think favorably of the plan, I offer you my services gratuitously."[33]

On that same day, Morse also wrote his old friend, the politically powerful Arago, a letter, delivered by an American attaché to Paris, repeating his desire to help Daguerre. He also emphasized: "His discovery has excited great attention throughout the United States . . . that we in the United States might in some way contribute our portion of the reward due to M. Daguerre." Again he urged: "An exhibition (which is the mode in this country best adapted for the purpose desired) of a few of his admirable results in several of our cities, I am persuaded, would yield a sum which may not be unimportant in the present state of M. Daguerre's affairs." In closing Morse stated: "If, by any gratuitous services of mine in this country in favor of M. Daguerre, I can in any degree return the kindness and liberality I received in France, I hope M. Daguerre and his friends will not hesitate to command me."[34]

In the month following his return to America, Morse had succeeded in having Daguerre publicly honored in America, thus bringing his discovery to the immediate notice of the intellectual community. After inferring that America and he stood with France and Daguerre, and after disclaiming the English attempts to publicize Talbot's discovery, the astute Morse had reinforced this support with an offer of a countrywide tour to exhibit examples of Daguerre's important process. While his vision of such a display failed, his offer must have impressed the French favorably.

Daguerre answered Morse's letter in July, thanking him and the academy for the honor bestowed upon him. He stated that his transactions with the French government were nearly at an end and that his process would soon be made public; he also declined Morse's offer of an exhibition.[35] This letter ended Morse's negotiations with the French. However, his continuing activity—published letters and ensuing newspaper coverage—persuaded the American public that the daguerreotype was the most desirable process for image making.

MORE FORMAL ANNOUNCEMENTS

By the spring of 1839, news of Daguerre's invention had reached far beyond the eastern seaboard. The letter recounting Morse's visit to Daguerre was estimated to have been reprinted in more than two hundred newspapers and periodicals. Also, innumerable accounts describing the great discovery were reprinted from foreign newspapers and periodicals. The news often captured the imagination of editors—for example, the *Cincinnati Republican* proclaimed on March 18:

> Farewell to Ink, Types, Clocks! M. Daguerre, at Paris, has effected all that painting or printing can achieve, by means of the camera obscura. . . . The drawing finished, and it is done in a few minutes, a light preserving varnish is passed over it, and the image remains inattachable by the action of air or light . . . the same objects, drawn at eight o'clock, present such differences, that it may be judged at what time of the day the operation took place.

The staid Franklin Institute was not above speculation when it reprinted an article from the *London Mechanic* in April 1839:

> What is the secret of the invention? . . . In good sooth we know nothing about it. Figure to yourself . . . a mirror, which, after having received your image, gives back your portrait, indelible as a picture and a much more exact resemblance. Such is the miracle invented by M. Daguerre.[36]

The talbotype was also publicized in scholarly journals, but newspaper coverage was meager. In July, the *American Journal of Science and Arts* reprinted the latest account of photographic processes on paper, which Talbot had read before the Society of Arts, Edinburgh, in April.[37] Because of its completeness, the article could have interested American experimenters, but no evidence exists to further this theory. The daguerreotype's mirrored image somehow seemed more exciting, and it is not surprising that it captured the imagination of the Americans in photography's first decade.

Meanwhile, in early July, Arago presented an official report to the French Chamber of Deputies which described the daguerreotype as highly superior to all other forms of photography. This at once aroused controversy in England. The *Literary Gazette* of July 20, in reporting Arago's speech, stated: "He also alluded to the importance of the discovery which he contended was proved by the avidity with which the subject has been taken up by other nations, and the *trifling* pretext they had seized to establish their priority of invention." The British editor, fully aroused, also answered Arago's contention with a footnote: "M. Arago is always sufficiently national, and partial to the claims of his own country and countrymen. In this instance he is evidently unjust to the claims of others; and even more French than usual."[38]

The mystery and excitement surrounding Daguerre's discovery had reached a high crescendo of interest. The Daguerre bill finally became law on August 1, 1839, and two weeks later Arago announced that Monday, August 19, would be the day of revelation, the day when the details of the daguerreotype process would be given to the world.[39]

Daguerreotype camera with Daguerre's signature, 1839. Manufactured by Alphonse Giroux and Company, Paris. British Crown copyright. Science Museum, London.

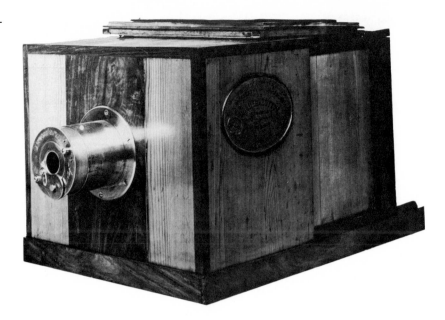

The meeting place would be the French Academy of Science, the time three o'clock in the afternoon.

On the appointed day, all seats allotted to the public were filled at an early hour, and an overflow crowd of some two hundred people had to stand in a courtyard of the academy, forming an almost separate scientific uproar—"Everybody was anxious to hear *the* secret, everybody to catch the *mot*; all were desirous of learning whether their own scientific conjectures would be confirmed or not."[40]

Arago's speech began with a long and detailed history of the development of the daguerreotype. Step by step, he traced its progress from 1814 to 1839, but detailed the process without giving a practical demonstration. It was announced, however, that a booklet to be issued within a few days would reveal the complete process. Alphonse Giroux, a curio and stamp dealer, had been appointed as the manufacturer of Daguerre's apparatus and equipment.[41] Daguerre displayed three of his recent specimens, and the minute detail of the images was a source of amazement to the viewers. As the historic meeting closed, "the most enthusiastic cheers responded from the grave benches even of the Academy, on the termination of Arago's description; and the President M. Chevreul complimented M. Daguerre in the warmest terms."[42]

Although the rest of the world was laudatory, not so the English press. One editor, while giving an account of Monday's announcement, called the word "daguerreotype" a "barbarous term."[43] Another announced in a footnote: "The images produced by M. Daguerre are exquisitely correct, but gloomy-looking. They resemble moonlight pictures done in ink."[44]

While the dispute between English and French editors continued, neither suspected that the Americans would be the first to improve and excel in the art of daguerreotyping. American experimenters would begin their search for an improved daguerreotype in September of 1839, after the details of Daguerre's process arrived in New York

City: they would overcome the difficulties of the new invention with the same ingenuity that typified American expansion during that era.

In September, as Americans began experimenting with the new process, Daguerre presented a series of three practical demonstrations to the public, by the order of the minister of the interior, to show that the Chamber of Deputies was justified in giving him a pension for his discovery. Newspaper correspondents were invited to attend free of charge.

In the first demonstration, at the Grand Hotel on the Quai d' Orsay, a camera was placed in a window of the hotel so that a view of the Tuileries, the Quai, and the Seine could be taken. Every step of the process was followed, from the initial polishing of the silvered copper plate to the final washing and fixing of the image. The day was dull, and exposure time for the view was about fifteen minutes. According to a correspondent from the *New York Evening Star*, the entire time occupied in the demonstration was seventy-two minutes, much longer than he had expected; but the resulting daguerreotype was impressive: "The difference of grain in the separate flags on the trottoir was visible, and the *texture* of everything, if I may use the phrase, was easily distinguishable."[45]

2. THE PIONEER DAYS, 1839–1840

By the time Daguerre's process reached America in the fall of 1839, the country had nearly recovered from a severe economic depression. President Martin Van Buren's term was half over, and the stormy era of Jackson's influence would soon be only a memory. America stood on the edge of change. Henceforth, inventors and inventions would become almost a national mania—at times it would appear that nearly every American had some kind of idea to explore.

Basically, the population was Anglo-American and the people still looked back to the time of the American Revolution for their national heroes. George Washington, now firmly entrenched as the father of his country, and his compatriots were uniformly eulogized in the stories of the day. The arts and literature were also establishing their unique place on the American scene, with Thomas Cole recognized as one of the foremost artists of the day and James Fenimore Cooper and Washington Irving popular leaders in the literary world. Many other talented men of this era would soon have the status of being familiar names in the American household.

The age was one of unprecedented oratory—speech making was a highly regarded art, one in which young men could gain recognition, especially in the field of politics or religion. Among the prominent models were the politicians Henry Clay, Daniel Webster, and John Calhoun and the theologians William Ellery Channing and Lyman Beecher, each unique and distinctive in his own way.

Beyond Cincinnati, still known as the Queen City of the West in 1839, was only a vast, sparsely settled region reaching all the way to the Pacific Ocean. Boston, New York, and Philadelphia were the centers for new ideas and inventions; experimenters often drifted there in search of financial backing and recognition. Speculation about Daguerre's invention from far-off Paris occupied only a tiny segment of the huge realm of intellectual interests, especially for those of a scientific mind.

In the spring and summer of 1839, newspapers were filled with rumors about Americans experimenting with the daguerreotype process, but if any were successful it did not become public knowledge. Therefore, America's role in the art must begin in Paris on August 19, 1839, when Arago revealed enough details of Daguerre's process for an experimenter to produce an image on a silvered copper plate. The necessary chemicals used in the process were also described by Arago, and only the smallest details remained unexplained.

A number of notable Americans were in Paris when Arago spoke, but how many were interested enough to attend the meeting at the French Academy of Science is a matter for conjecture. Francis Hall, editor and owner of the *New York Commercial-Advertiser*, one of the city's leading newspapers, was in France on August 19, but it is not known whether he was present at the meeting.[1] However, correspondents from the *New York Evening Star* were there.

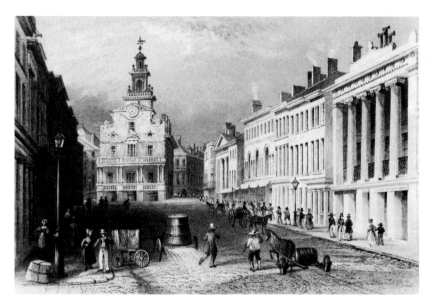

View of Boston, America's cultural center, as it appeared in 1838 to artist William Henry Bartlett. From an engraving in Nathaniel P. Willis, American Scenery, *ca. 1840.*

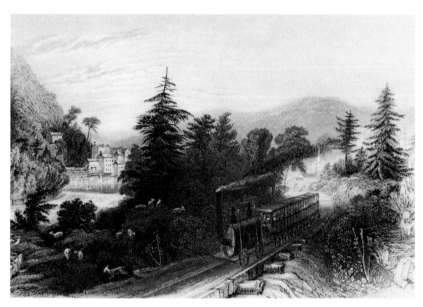

The rural town of Little Falls, New York. Railroads were emerging as America's communication link when William Henry Bartlett painted this scene in 1838. From an engraving in Nathaniel P. Willis, American Scenery, *ca. 1840.*

The well-attended meeting was highly publicized, of course. The next morning the *Journal des Débats*, a leading Paris newspaper, printed a complete account on page one—an account more detailed than those appearing in London newspapers a few days later.[2] On that same day *Le Moniteur*, another Paris newspaper, carried an advertisement—headed *Le Daguerréotype* in bold type—announcing that Alphonse Giroux and Company were agents for Daguerre's apparatus and for booklets explaining and illustrating his process; therefore, information revealing the complete process was available on August 20.[3]

Several correspondents from London newspapers had also attended the famous meeting at the academy. Usually Paris news items, being sent by ordinary express, were printed two days later in London, but the *London Globe* waited until August 23 before publishing its journalist's account of Daguerre's process.

Reprints from the *Globe* were a standard source of information for

Great Western *crossing the At-*
lantic. An 1837 engraving. The
Great Western, *fastest of the*
transatlantic steamers, sailed
from Bristol, England, on Au-
gust 24 (7 P.M.) and arrived in
New York on September 10 (7
A.M.), 1839. Aboard were En-
glish and French newspapers,
the first to reach America with
accounts containing the details
of the daguerreotype process
made public by Arago, on Au-
gust 19, in Paris. The passenger
list included the Reverend Ed-
ward Kirk, of Paris, a close
friend of Samuel Morse's.
National Maritime Museum,
London.

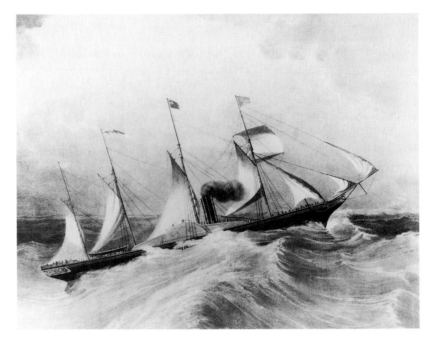

American newspapers, and, when the *Great Western* sailed from Bris-
tol at 7 P.M. on August 24, it carried copies of the *Globe*, printed on the
twenty-third, and possibly some Paris newspapers up through the
twenty-first.[4] On September 10, when the steamship arrived in New
York harbor, at 7 A.M., the *New York Evening Post* noted that Francis
Hall had returned with "provincial and other English papers" through
the twenty-fourth of August, plus the Paris newspaper *La France* of
August 21.[5]

This latest news from Europe brought by the *Great Western* was
distributed, depending on travel time, to various cities and towns
across the country. Bostonians read the news from the *Great Western*
on September 12, it reached Richmond readers on the thirteenth,
Charleston on the sixteenth, Lexington on the nineteenth, and New
Orleans on the twentieth. The editors selected from the wide variety
of European news in their dispatches only those political and commer-
cial reports which they deemed important. Oddly enough, despite the
great publicity given the meeting between Morse and Daguerre six
months earlier, none of the big city newspapers mentioned Arago's
revelations of August 19. The respective editors had apparently
thought other news more significant, and, except for the *New York
Evening Post*, which printed part of the account through an odd
chance of fate, the story was not reported for some time—which ul-
timately added to the confusion concerning when Americans learned
about Arago's announcement and the hitherto secret details of Da-
guerre's process.

Because of a rivalry between newspapers, the Daguerre story, re-
printed from the *London Globe* of August 23, was finally published
just a few hours before the *British Queen* arrived on September 20.
On that day the *New York Evening Post* proclaimed: "One of the morn-
ing prints announces very formally the secret of Mr. Daguerre's late
discovery is known in this city and will be revealed on the arrival of
the *British Queen*. An article published in another column will inform

such as are desirous of knowledge on the subject without waiting the motions of the steamer . . ."[6]

But anyone interested in Daguerre's process could have easily obtained a copy of the *London Globe* of August 23 or the *Journal des Débats* of August 20. Apparently D. W. Seager, of New York City, obtained information about the process from the dispatches coming in on the *Great Western*;[7] he later claimed to have produced his first results with the daguerreotype process on September 16.[8] Whether others also read the papers describing the process is unknown, although the *American Journal of Science and Arts* stated in its October issue that "a professional gentleman in New York informs us before the late arrival of the *British Queen*, that he was in possession of the secret, and in connection with an eminent chemist in New York had already obtained beautiful results, but is not able to fully arrest them."[9]

The "professional gentleman" was undoubtedly Samuel Morse, because the Reverend Edward N. Kirk, a close friend of Morse's, was aboard the *Great Western* when it arrived on September 10. Morse had stayed at Kirk's Paris apartments in the winter of 1839, and the rooms had been the scene of Daguerre's historic visit to examine the telegraph on March 8. It is possible that the well-educated Kirk accompanied Morse, as a translator, when Morse inspected Daguerre's invention the day before. It is also possible that Kirk heard Arago's disclosures on August 19; certainly he had read the *Journal des Débats* of August 20 by the time he boarded the *Great Western* on the twenty-fourth. Apparently Kirk had not bought Daguerre's booklet from Giroux and Company, because many years later Morse said that he obtained the first booklet from a bookseller.

After the *British Queen* arrived on September 20, newsmen belatedly awoke to the fact that they had missed the Daguerre story. On September 21, *Niles' National Register*, of Baltimore, printed a small account about the daguerreotype—a subject which would become increasingly popular over the next two weeks: "We have reason to believe that the secret of M. Daguerre's wonderful invention or discovery . . . will be known here on the arrival of the *British Queen*. In fact, we may say, the secret is already known to one or more individuals in this city, but they are restricted from promulgating it, we understand until the *British Queen* arrives."[10] The *British Queen* carried many additional accounts about the daguerreotype. The *Literary Gazette* of August 24, for example, echoed the *Globe*'s story, and it is also likely that the official booklets sold by Giroux and Company were aboard.[11] The booklets contained drawings of the various types of apparatus employed by Daguerre, which were not illustrated in the *Globe* account.

THE FIRST TRIALS

On September 28, the *New York Journal of Commerce* announced: "Professor Morse showed us yesterday the first fruits of Daguerre's invention. . . . It was a perfect view, on a small scale, of the new Unitarian Church, and the buildings in the vicinity . . ."[12] The claim to the first daguerreotype was refuted by Morse in a letter printed by the same paper on September 30, when he stated that the "merit I believe belongs to Mr. D. W. Seager of this city." On that same Monday, Seager's activities were published in the *Morning Herald*: "The New

Art.—We saw the other day, in Chilton's in Broadway, a very curious specimen of the new mode, recently invented by Daguerre in Paris of taking on copper the exact resemblance of scenes and living objects through the medium of the sun's rays reflected in a camera obscura." The scene described showed a part of Saint Paul's Episcopal Chapel and a corner of the Astor House. While the average citizen passing James Chilton's shop might wonder why the small plate on display should cause such excitement, others would stop for a closer look and would leave with the urge to pursue this intriguing art.

This display in Chilton's window plus the newspaper accounts of his work at once made Seager the central figure in the new art.[13] Advertising a lecture on Daguerre's process—to be held at the Stuyvesant Institute on Saturday, October 5, the price of admission being fifty cents—he said that he would exhibit specimens which would amaze spectators and also added, "The process, cannot be carried to ultimate completion by candlelight, but every stage of the operation will be exhibited to familiarise others with the mode."[14]

Seager gave a second lecture at Clinton Hall on Thursday the tenth —the admission price for ladies being reduced to twenty-five cents. On the same day, editor Francis Hall finally published an item about the new art: "The Daguerreotype—This is the new art of solar delineations, and is the commencement of a new era in science and the arts."[15]

Americans now had a new word to pronounce. The *Journal of Commerce* suggested "Dar-ger-row-type." Others said "Daguerr-o-type," while Edgar Allan Poe said it as though it were accented on the second e. Since newspapers all over the country featured the arrival of the process in late September and early October, any American who did not recognize the word "daguerreotype" either could not read or was simply not a good listener!

From the day that the *Great Western* docked in New York harbor, the development of photography in America assumed a sharply contrasting direction from that taken in Europe: it would be the career seekers, the entrepreneurs, those hoping for financial gain, who would explore and improve the daguerreotype in America, while in Europe the academics would pioneer in its development. In the first decade, inquiring and enterprising Americans from all walks of life were attracted to the broad opportunities offered by the new art—the potential for financial gain seemed immeasurably great. This would be the mold of men who made the American daguerreotype the best in the world. The American academic community, with the exception of Frederick A. P. Barnard, Samuel Morse, and John W. Draper, trailed far behind the entrepreneurs in the practical development of the art in these early years. Scientific reports in American journals were often meager accounts echoing advancements which were common knowledge among working daguerreotypists six months to a year before. The mark of the professional daguerreotypist was practical achievement, not written accounts in notebooks or scientific journals. For this reason the patent records of the working daguerreotypists stand as their public monument, because a self-imposed secrecy surrounded most of their significant improvements in the art.

A number of American experimenters were quick to realize that the daguerreotype had great commercial value if it could be adapted to

portraiture. A portrait painter himself, Morse had asked Daguerre back in March about the possibility of taking portraits by the process and had received a negative reply. Following Arago's disclosure of August 19, many French experimenters had attempted the portrait—but with indifferent success. To pose a human subject for fifteen minutes seemed an almost impossible feat.

Needless to say, the first successful American portrait soon made its appearance: two New York businessmen, partners in the manufacture of instruments and dental supplies, devised a solution to the problem on October 6.[16] That morning, John Johnson went to Alexander S. Wolcott's home with a copy of the complete Daguerre process. By afternoon, Wolcott had constructed a small camera box (without a lens) with a speculum to reflect the image onto the tiny plate. Johnson polished the miniature plates and prepared the chemicals. Their first two trials brought strange and exciting results—one a negative, the other a positive. Unexplainable! In 1846, Johnson wrote about their third and last attempt of the afternoon:

John Johnson, 1813–1871.
From a portrait, ca. 1867.
York Institute, Saco, Maine.

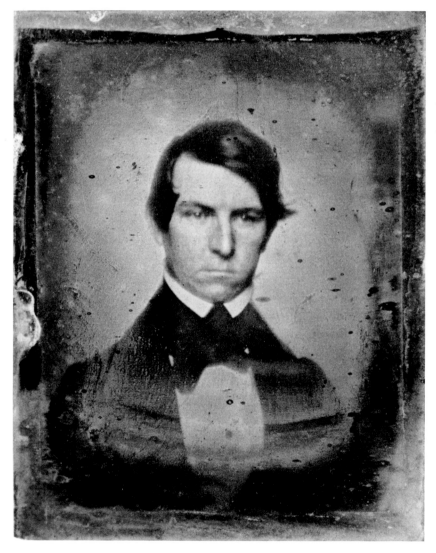

Seated man, ca. 1839 or early 1840. Sixth-size daguerreotype. Artist unknown. Plate hand-die-stamped "Corduan & Co., N.Y." One of the earliest extant examples of an American daguerreotype.
Rinhart Collection, the Ohio State University, Columbus.

Having duly arranged the camera, I sat for five minutes and the result was a profile miniature (a miniature in reality) on a plate not quite three-eighths of an inch square. Thus, with much deliberation and study, passed the *first* day in *Daguerreotype*—little dreaming or knowing into what a labyrinth such a beginning was hastening us.[17]

Writing to Professor James J. Mapes on March 13, 1840, Wolcott recalled:

Not having an achromatic glass in my possession larger than an object glass of a microscope, I proceeded to experiment with a single concave reflector, as the most simple of all optical instruments, and the one which, if of large dimensions and truly elliptical, would probably best answer . . . distinctness and brilliancy combined. My first experiment was, I think, in October, with a reflector of 1¼ inches aperture and 2 inches focus. With this I took the profile of a person standing opposite a window; and here having but three principle facts relating to M. Daguerre's process, Viz: The exposing the plates to vapor of iodine, afterwards to that of mercury, and washing in hyposulphate of soda, or in common salt, I fell into the same error as probably many others, which was, that I supposed it necessary to keep the plate in the camera until the image was visible. This error prevented my making a larger instrument immediately.[18]

The result: the first successful portrait taken in America less than a month after the arrival of the *Great Western*. But the immediate problem for Americans, if portraiture were to become a reality, involved reducing the exposure time then needed to take a daguerreotype—about fifteen minutes, depending on light conditions.

Radical improvements were necessary. These came in early 1840, when information that Dr. Paul Beck Goddard of Philadelphia—educator and editor of numerous medical textbooks—had used bromine to quicken exposure time circulated to a number of daguerreotypists.[19] Chemists and medical men in particular were familiar with its uses, and Wolcott, either from his own knowledge of chemistry or, perhaps, because he knew about Goddard's application, asked Dr. James Chilton to make up a small quantity of the chemical in the winter of 1839–40. His experiments proved a failure—he had used too much bromine in combination with iodine. Johnson, also experimenting along similar lines, would develop a "peculiar chloride of iodine" later in the year.[20] In March, Dr. Mapes' journal published Seager's list of the exposure time necessary for exterior views.[21] By the time the information was published, it was hopelessly outdated—American experimenters had reduced exposure times far beyond those given in the table.

Many other Philadelphians were also experimenting with the daguerreotype. On October 16, 1839, a successful daguerreotype was made of the old arsenal and part of the old Philadelphia High School. Joseph Saxton, curator of the United States Mint and an inventor of international repute, had taken the view from the window of the mint, following an English translation of Daguerre's process prepared by Dr. Alexander Bache, a fellow member of the prestigious Franklin Institute.

Members of the Franklin Institute must be given credit for their contributions to the advancement of the daguerreotype in the fall of 1839. Many members of the American scientific community, some internationally recognized, belonged to the Franklin Institute, and the new art definitely whetted their scientific curiosity. The backgrounds of individual members varied—some were foremost educators in the sciences, others were inventors who had gained recognition at home and abroad. And not to be neglected were the many successful merchants whose inquiring minds qualified them for membership in the institute. The *Journal of the Franklin Institute* for September and October 1839 had given the daguerreotype only a passing mention, but its indifference had obviously disappeared by November, when it published J. F. Fraser's translation of the complete Daguerre process, including illustrations. Thereafter, the journal became almost a logbook for photography's progress.

Sometime in November, Robert Cornelius, a highly regarded merchant of Philadelphia, also succeeded in taking a daguerreotype portrait; one of his portraits was shown on December 6 at the regular meeting of the American Philosophical Society, eliciting favorable comment.[22] Cornelius had studied chemistry at Nashville University under the famous Dr. Gerard Troost, and he had also studied drawing under James Cox, which gave him the advantage of an artist's knowledge of portraiture in his daguerreotyping. At the time he began daguerreotyping he had joined his father's firm, which manufactured silver-plated ware, lamps, and chandeliers. Working along with Cornelius in his experiments was Dr. Goddard.

Meanwhile, the *London Globe*'s account of Daguerre's process was gradually being reprinted in various newspapers about the country,

Studio Outfit of Dr. Paul Beck Goddard, Philadelphia, 1840. Lens and shutter. Camera with body extended, showing mirror set for focusing. From the Journal of the Franklin Institute, *1893.*

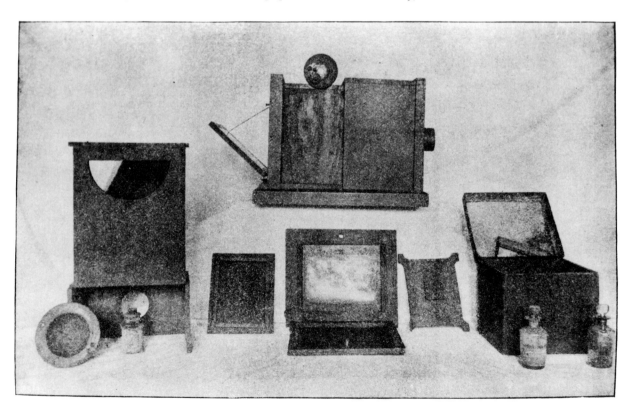

and this seemed to have the immediate effect of bringing new experimenters to the process. The news quickly spread over the East to the South and Midwest. The names of most of Boston's early experimenters are lost, although one account cites a Mr. Davis and a Professor Grant as being successful three days after the daguerreotype process had been published.[23]

Early experimenters in the South were Dr. James M. Bush and Dr. Robert Peter, of the Medical Department of Transylvania University in Lexington, who had returned to America aboard the *British Queen* on September 20.[24] Their summer months had been spent in attending lectures in London and Paris and in buying "Books, Chemical Apparatus, Surgical Instruments . . . for the Medical Department of Transylvania University . . ."[25] Bush, professor of anatomy and surgery, and Peter, professor of chemistry and pharmacy, made daguerreotypes during the fall of 1839. They had apparently purchased daguerreotype apparatus in Paris, but whether the materials were aboard the *British Queen* or whether they had been shipped aboard the *Gibraltar* or the *Poland* (both ships had reached the country before the *British Queen*) remains a mystery.[26] Also, it is not known whether the professors illustrated their lectures at the university with daguerreotypes.

Back in New York, during October and November 1839, Wolcott and Johnson had improved their camera: the box was made larger and they experimented "to grind down or increase the curve for focal distance." In this specialized work, and to obtain a professional polish on the speculum, they were aided by Henry Fitz, the noted telescope maker.[27] In his March 1840 letter to Professor Mapes, Wolcott mentioned his work with the speculum: "From experiments which I have made, I find that a speculum of 7 inches aperture and 12 inches focus will form a picture in about the same time as a single lens of 3⅔ inches aperture and 12 inches focus."[28] Unfortunately, operations were suspended for the month of December, when Johnson became ill, but they resumed in January.

Morse had also continued his efforts with the daguerreotype, and on November 16, 1839, he wrote Daguerre: "I have been experimenting, but with indifferent success, mostly, I believe for the want of a proper lens."[29] He asked Daguerre to select and send two lenses—a request which was never answered. For his experiments of September and October Morse had enlisted the help of Dr. John Draper, professor of chemistry at the City of New York University. Many years later Morse could not recall whether it was he or Draper who had captured the first portrait, although he later claimed to have photographed his daughter and a group of her friends by the end of November. Morse did not mention his success with the portrait of his daughter in his letter to Daguerre, nor does Draper specify exactly when he first succeeded in taking portraits from life, although December is usually conceded to have been the date.[30]

FRANÇOIS GOURAUD

Despite some successes in taking portraits, the results were far from satisfactory and, by early December, experimenters in New York and Philadelphia were still few in number. The art needed a messiah, a

strong personality to attract the press, a flamboyant and vocal leader whose magnetism would captivate the public.

"Charming, dark, and sly," his detractors later called him, but they failed to mention that the new promoter of daguerreotyping was also competent, knowledgeable, and experienced in the art when he appeared in New York at the end of November. François Gouraud's mission: to bring the daguerreotype to America as the agent for Giroux and Company of Paris, who held the exclusive franchise in France for Daguerre's apparatus and materials and now hoped to expand their enterprise in America.

Announcements of Gouraud's arrival in New York came quickly, with a small item appearing on November 30 in the *New York Observer*, a paper owned by Morse's two brothers.[31] Gouraud, a pupil and friend of Daguerre's, brought a number of daguerreotypes taken by Daguerre, along with plates, apparatus, manuals, and other equipment, but, most significant, he brought a personal working knowledge of the process. His arrival in America is important to the history of photography because wherever he traveled he displayed Daguerre's work, showing the American public the visual excitement and the vast potential of the new art.

Gouraud was well received in New York. Morse immediately offered him a rent-free exhibition hall, which he politely refused. On December 4, he arranged a semiprivate preview exhibition of daguerreotypes, including some taken by Daguerre. Notable New Yorkers were invited, as well as officers of the National Academy of Design. This promotion of the daguerreotype came at an auspicious time—the first exhibition caught the public fancy, and news coverage was enthusiastic.

On December 10, moving quickly after an appraisal of American society, Gouraud opened an exhibition and lecture room at 57 Broadway —the public was cordially invited, and thus many people rather than a few prominent citizens were attracted. The publicity Gouraud sought came quickly through widespread news coverage. The prestigious *New Yorker*, for example, discussed the exhibition on December 14:

> *The Daguerreotype.*—The specimens of this wonderful art now
> exhibited by Mr. Gouraud at 57 Broadway are of a character to
> afford the most unmingled delight to those who take an interest
> in the fine arts. . . . The most beautiful and accurately painted
> miniatures if placed beside many of Mr. Daguerre's representa-
> tions, would appear very much like a miserable daub. . . . It is
> not in landscape views that the Daguerreotype impresses us
> most with its beauties; but in interiors, copies of oil paintings
> and statuary, where delicate shades and minute objects are to be
> preserved. In these it is most accurate and astonishing. The best
> specimens of the art in Mr. Gouraud's collection is no. 21—an
> interior, in which is represented several statues, bas reliefs,
> drapery, and a portrait of Mr. Daguerre himself. This is certainly
> a very beautiful picture in its execution—nothing could be more
> *perfect*—and the price of it is $500. The price of others vary
> from $40 to $300.00. These specimens must be seen to be appre-
> ciated—no description can do justice to their beauties . . .[32]

The editor of *The Knickerbocker*, one of the city's leading publications, was also enthusiastic:

The Daguerreotype.—We have seen views taken in Paris by the
Daguerreotype, and have no hesitation in avowing, that they are
the most remarkable objects of curiosity and admiration, in the
arts, that we ever beheld. Their exquisite perfection almost
transcends the bounds of sober belief. Let us endeavor to convey
to the reader an impression of their character. Let him suppose
himself standing in the middle of Broadway, with a looking glass
held perpendicularly in his hand, in which is reflected the street,
with all therein is, for two or three miles, taking in the haziest
distance. . . . This is the Daguerreotype! The views themselves
are from the most interesting points of the French metropo-
lis. . . . Take, first the Vue du Pont Notre Dame, and the Palais
du Justice. Mark the minute light and shade; the perfect clear-
ness of every object; the extreme softness of the distance.
Observe the dim, hazy aspect of the picture representing the
towers of Notre Dame. . . . Look, again, at the view of the
Statue of Henry the Fourth and the Tuilleries, and Pont des
Arts, Pont du Carousel, Pont Royal, and the Heights of Challot
in the distance. There is not a shadow in the whole, that is not
nature itself; there is not an object, even the most minute, em-
braced in that wide scope, which was not in the original. . . .
Think of that! So, too, of the Tuilleries, the Champs Elysees, the
Quay de la Morgue—in short, all of every view in the whole su-
perb collection. . . . Look where you will, Paris itself is before
you. Here, by the silent statue of the great Henry, how often has
Despair come at midnight, to plunge into eternity! By the Quay
de la Morgue, remark the array of washing-boats, and the
'Ladies of the Suds' hanging out their clothes, which *almost*
wave in the breeze. . . . There is a view, now, which Mr. Irving
helped to render famous. . . . It needs no Victor Hugo to tell us
this is the time-honored *Notre Dame de Paris*. Take the view
into the strongest sunlight, by the window, and survey with a
glass its minutest beauties. There is not a stone traced there,
that has not its archetype in the edifice. Those square towers,
those Gothic arches and buttresses; the rich tracery, and that
enterprising tourist looking down upon Paris—there they were,
and here they are! Look sharp, and far within, you may see the
very bells. What an association! . . . We have little room to
speak of interior views. We can only say, in passing, that they
are perfect. . . . Indeed the Daguerreotype will never do for
portrait painting. Its pictures are *too* natural, to please any
other than very beautiful sitters . . . but illness, with sea-voyage
cures, must decline now; for who would throw up their business
and their dinners, on a voyage to see Paris or London, when one
can sit in an apartment in New York, and look at the streets, the
architectural wonders, and the busy life of each crowded metrop-
olis? . . . We close by saying to all our metropolitan readers, Go
and see the views taken by the Daguerreotype; and when
M. Gouraud commences his lectures upon the art, fail not to hear
him.[33]

Gouraud's exhibition had proved a huge success. To exploit this, he
advertised that lectures and lessons would be given on the process if
one applied to Gouraud, the master of the art. Morse and Draper,

among other New Yorkers, enrolled for instruction, because it was quickly evident to all the pioneer experimenters, after seeing the exhibition, that they had much to learn!

Apparently the remaining days of December and the first days of the new year were quiet ones for daguerreotypists—but this ominous silence preceded an eruption in late January which would reveal that Gouraud had taken advantage of American improvements in the art which were being used by the American experimenters, who were also retaining the best of the French process and equipment. Meanwhile, Morse had become seriously committed to the daguerreotype, even though he had repeatedly failed to get help from Daguerre, dating from his March visit, in Paris, but all efforts and letters came to naught. Daguerre's seeming indifference must have hurt Morse, especially after viewing the quality of Daguerre's work at Gouraud's exhibition.

In January 1840, he began a notebook to record his progress. The entry for Monday, January 13, indicated that he and Gouraud had produced a daguerreotype, using Daguerre's original process, with an exposure time calculated at twenty-four minutes.[34] Thursday's notation recorded the fact that "Mr. Seager quarreled with M. Gouraud." On Friday, January 17, he wrote that Dr. Chilton was present at Gouraud's lesson, and to record the day's experiments he included a sketch showing a brick church to be photographed, the sun, and the location of the camera; the time of day was two minutes before three o'clock, the exposure time was sixteen minutes, and the proof was fairly satisfactory.[35]

When Morse wrote that Seager and Gouraud had quarreled, he had no idea that within a few weeks he would become involved in what the newspapers called "The Photogenic War." On the following Saturday, January 18, Seager placed a lengthy vituperative letter in the *New York Evening Star* condemning the Frenchman as a swindler and an imposter. The next Wednesday, in a letter addressed to the *New York Journal of Commerce*, Gouraud published an even longer letter, equally abusive, wherein Seager was portrayed as an idiot, a fool, and a buffoon, whose meager skills in daguerreotyping were so small that he ought to withdraw from the art completely. Unquestionably, Gouraud's command of the English language made him the victor in this exchange of public letters. One point which bothered him greatly was the accusation that he was a foreigner and a purveyor of imported goods. He said that, although he had lived in France since childhood, he was born in the New World; whereas if anyone should be called a foreigner, it should be Seager, who had come to these shores from "Northampton in England."

On Tuesday, the day before Gouraud's letter was published, a curious advertisement appeared in the *Journal of Commerce*, signed by J. G. Wolf, which announced that Seager was now taking views from the balcony and ballroom of Tammany Hall each morning from eight to eleven and that the public was invited to see the operation gratuitously. The new apparatus was simple, cheap, and easy to construct, it was stated, and outmoded the cumbersome equipment hitherto used, and Seager could teach a child of eight to make better views than those Gouraud could produce with his apparatus.[36] Whether Seager continued the free exhibitions, if indeed any took place at all, remains

unknown. But the advertisement is important in that it publicly announced for the first time that the Americans had produced superior daguerreotype equipment, a fact which would become more and more apparent in the weeks ahead.

As January drew to a close, Gouraud became quite aware that George W. Prosch, a New York City philosophical-instrument maker, was advertising American-made cameras and apparatus now highly superior to those of the French; Prosch had developed a light-proof camera, which Morse began using in December.[37] The optician J. G. Wolf had designed a new lens which reduced exposure time. Also, Corduan and Perkins were now producing daguerreotype plates of fair quality, a prime desideratum of the art. However, Gouraud had no intention of relinquishing his position of oracle, at least in New York City. He had advertised early in January that he would tour other cities but did not keep to this plan, although he did go to Philadelphia for a few days, returning to New York City on January 4. On January 31, for one day only, Gouraud did acknowledge American equipment to be a potent factor in the art:

Daguerreotype Apparatus—
Mr. F. Gouraud's central depot, for all that concerns the Daguerreotype in the new world, will soon be open at 281 Broadway. Mr. G. is now ready to receive any order concerning the Daguerreotype Apparatus. To satisfy every taste, he will afford, imported (from Paris) as well as *genuine apparatus constructed in this country* under his immediate instructions by some of the most able and intelligent artists in New York. The same it will be for all the other numerous articles of the Daguerreotype. Prices of the apparatus, properly so called, $30 made of mahogany, maple and white holly. The same, with the greatest instrument of all that must necessarily be added to it. $41. The lens or *achromatic* and *periscopique* glass of the camera, 39 lignes of diameter, $10. The superfine planished plates, 8½ inches by 6½ inches plated with the 20th of silver upon the 19th of copper. $1. Every article examined and *warranted* perfect, will bear the Signature and seal of Mr. Gouraud.

N. B. A Daguerreotype Apparatus (equal to that of Mr. Daguerre) must be composed of 62 of the following objects, viz:— one camera obscura 12½ inches by 15; one iodine box 1 foot by 9 inches and 9½; one mechanical camera sash; one mercury box; one chemical substance box; one plate box for 25 plates; the traveling apparatus case; one spatula for the spirit lamp; one iron tripod; one mechanical iron furnace; three rinsing pans; one long glass funnel for the mercury; one chemical match box; one special funnel for the iodine; one gi't comparing metalic plate; one glass filtering funnel; twelve mahogany levelers; ten silver clamps; one spirit lamp; one pummice box; eight ground stoppered bottles; one paste board box for the cotton; one special glass funnel for purifying the mercury; one bottle of alcohol; one do. of mercury; one do. of nitric acid; one do. of purified oil; one do. of polishing substance; one pair of scissors; one pair of warming tongs; one lens made of purest crown and flint glass, fully *periscopique* and perfectly *achromatique*; the Instruction Book, and the general packing box.

NOTICE—This description is given by Mr. G. in order that those who should rely upon other advertisements, may know what they have to *claim* for their money.

All orders will be postpaid.[38]

Sometime during the month of January, or possibly in late December, Gouraud opened an exhibition room in the Granite Building, a rendezvous for artists on the corner of Broadway and Chambers Street, and it was from here that he directed all his publicity. Along with his supply depot advertisement of January 31, he placed an equally large notice that, beginning February 1, he would give two one-hour lectures each day, one at 11:30 in the morning and another at 2:00 in the afternoon. The 2:00 lecture on Tuesday and Friday would be given in French, and on Thursday at the same hour the lecture would be delivered in Spanish. On the same day, another, smaller advertisement stated that, except during the lecture hours, the exhibition room would continue to be open to the general public for the reduced price of twenty-five cents, and all proceeds from the tickets would be donated to "THE CHARITABLE INSTITUTIONS OF THIS CITY."[39]

During the month of January, Gouraud had instructed a relatively small group of devotees, including Morse, and had received only a small amount of publicity, but now he launched a new campaign to revive public interest and to recapture his prestige.[40] A description of his first lecture, apparently delayed until February 5, was printed by the *New York Commercial-Advertiser* the next day:

> The Daguerreotype—Mr. Gouraud's first lecture, yesterday, was given to a small but highly respectable audience of perhaps a hundred and twenty persons—just enough to fill the room comfortably. Among them we recognized the Rev. Dr. Milnor, Commander Levy of the navy, Mr. Chilton the chemist, the editor of the Albion and several others. A number of ladies also were present—some of them very beautiful, and all had faces beaming with intelligence. The lecture was eminently practical, the entire process being performed, from the polishing of the plate to the ultimate washing which fixes the drawing. The view taken was of the building occupied by the American Institute—formerly by Scudder's Museum—the Park, etc. The process took up somewhat more than two hours. The drawing was perfect, and Mr. Gouraud announced his intention of presenting it to the President of the United States, as the first perfect specimen of the Daguerreotype produced in this country. The lecture was in English, which Mr. Gouraud speaks with great fluency, though with a very slight foreign accent.[41]

In February, Morse and Gouraud had a sharp clash of personalities —probably brought on by the pupil exceeding his teacher! The apparatus and process Morse had used for his mid January experiments had rapidly become obsolete, a factor which caused him to change over to the latest of American cameras by the end of the month. In early February, he produced a beautiful daguerreotype of the city hall on a Corduan, Perkins and Company plate, and a number of newspapers lauded the superb quality he was now achieving. Ostensibly, "The Photogenic War" had been caused by Gouraud's arrogant refusal to sell Seager French daguerreotype plates, and Morse had now proved American

Advertisement from the New York Evening Post, *February 21, 1840. An identical advertisement ran in the* New York Commercial-Advertiser *from January 27 through February 28.*

plates to be of equal quality. Siding with Seager, by the end of January Morse was a central figure in an anti-Gouraud clique. The city hall view seemed an almost retaliatory rebuttal to Gouraud's insulting letter of February 1, when he called Morse an amateur. Morse's answer appeared in the *New York Evening Star* three days later—he declared that the Frenchman had nothing more to teach him and that it was Drs. Draper and Chilton to whom he was indebted for his success.[42] Another matter which bothered Morse greatly was the sale of toilet articles at Gouraud's lectures, a purely commercial exploitation totally unrelated to photography.[43] The rift widened further—Morse wrote that Gouraud had degraded the name of Daguerre and of France.

Gouraud had earlier given notice through newspaper advertisements that he intended to leave New York by the end of February, and on February 26 he left for Boston, where he anticipated a warm welcome. Boston would present a new challenge, and he would find a fertile field for his lectures and apparatus. His first letter to the Boston newspapers, notifying the public of his impending arrival, was published on February 19, followed by an apology for postponement on the twenty-second and another notice on the twenty-sixth. Shortly after his arrival, he set up his daguerreotype display and proceeded with the same promotional activities he had used in New York.[44]

THE EARLY SUPPLY HOUSES

Meanwhile, as the art became more popular, experimenters in New York, Philadelphia, and elsewhere were clamoring for daguerreotype materials and supplies. Leaders in mechanical apparatus improvements were emerging—men who would make and furnish supplies so that daguerreotyping could become a business. At least three or four supply houses, in addition to Gouraud's offerings, had appeared by the early part of 1840, and all these concerns manufactured daguerreotype apparatus, usually supplemented by other materials necessary for daguerreotyping, including instructions.

Among the New York supply houses was that of William and William Henry Lewis (father and son), who later said they had opened for business in the fall of 1839. John Roach, a philosophical-instrument maker, also claimed that his business began in the fall of 1839. Another, often overlooked source of daguerreotype supplies was the chemist James Chilton's shop, where Seager's daguerreotype had been displayed in September 1839. Chilton's store carried a general assortment of philosophical and chemical apparatus, including such items as air pumps, electromagnets, blowpipes, and, in 1840 and 1841, complete daguerreotype apparatus. However, it was undoubtedly George Prosch who built the first American lens camera, because by early 1840 he had not only emerged as a camera maker but had established the largest depot to date for apparatus and supplies. J. G. Wolf was also in the supply trade, although in a limited way; he probably had an exchange agreement—lenses for camera boxes—with Prosch.

Wolf occupies a prominent position in pioneer American photography. In the field of optics, indications are that he had developed a special lens for portraiture by the end of 1839 or by early January 1840. His lens system, used in combination with the quasi-secret knowledge

Advertisement from the New York Evening Post, *February 24, 1840. J. G. Wolf, a former student of the internationally renowned Fraunhofer, imported his lenses from Fraunhofer and Company, Munich. His expertise in grinding and polishing lenses was instrumental in the rapid progress made by the Americans in the fall of 1839 and early 1840.*

that bromine could act as a quickener (it is likely that, when the inquisitive Gouraud went to Philadelphia in early January, he learned of Goddard's experiments with bromine), serves to explain why the exposure time for a daguerreotype was sharply reduced in the first few weeks of February. Wolf was the first American optician to realize the inadequacy of the lens used by the Daguerre camera. As a former student of the internationally famous Joseph von Fraunhofer of Bavaria, Wolf had a knowledge of optics probably equal to that of J. J. von Prechtl and S. Stampfer, well known in the Vienna school of optics. Like Wolf, they experimented with lens improvements after Arago's report of August 19—experiments which a short time later led to their association with Peter Friedrich Voigtländer and Josef Petzval and the successful Petzval lens.

Wolf imported his lenses directly from Fraunhofer and Company in Munich, one of the best sources in Europe for optical supplies. Apparently Wolf's reputation for grinding and polishing lenses was exceptional in New York. In June 1840, for example, the editor of *The Knickerbocker* praised him for his achievements:

> The Daguerreotype: Periscopic lens. . . . This beautiful instrument . . . is manufactured in its perfection by J. G. Wolf, number 40 Chatham St. . . . He has recently made improvements in the Daguerreotype, by means of which accurate miniature-likenesses of living subjects may be taken, which has not been so successfully accomplished before. We had the pleasure to see, a few days since, some beautiful specimens of photogenic engraving, from life, by this wonderful instrument. Mr. Wolf has also introduced into this country the meniscus or periscopic lens of the new-moon shape, for remedying the defects of vision in near sighted persons.

In the fall of 1839 and during the early years of daguerreotyping in New York, much of the activity related to the art centered around the city hall, where Chatham Street met lower Broadway—a convenient area, close both to the daguerreotypists and, of great importance, to the intercoastal shipping wharves and to the New York, Harlem, and Albany Railroad terminal, adjacent to the city hall.

The convenience of shipping materials to other areas of the country obviously added to the rapid expansion of the art. George Prosch possibly realized this when he advertised his daguerreotype apparatus outside the limits of New York City. His advertisements came at an auspicious time, when Morse and Gouraud were producing high-quality scenes and Johnson and Wolcott were preparing to open the first commercial portrait gallery in the world. On February 20, 1840, a Prosch advertisement appeared in the *Charleston Courier*:

> The Daguerreotype.—The Daguerreotype apparatus, made from the designs of the distinguished discoverer of the process, is manufactured and for sale at 140 Nassau-street. The subscriber is the first, it is believed, who made this apparatus in this country. It has been used, with successful results by gentlemen well known to the public, who are ready at any time to attest to its excellence. Several simplifications also of the apparatus, by scientific men have been adopted, making it preferable to the French apparatus. Its cost will also be less by about 30 dollars.

Advertisement from the New York Observer, *March 14, 1840. An identical advertisement appeared in the* New York Evening Post *from February 21 through May 10, 1840.*

N.B.—Orders received for Plates manufactured
by CORDUAN, PERKINS & CO.

The above articles are all warranted or no sale. Proper directions will be given for all articles, which can be procured of Chemists with directions for using the Daguerreotype apparatus.[45]

From mid February onward, Prosch embarked on an extensive campaign in many New York newspapers. His New York advertisements were much more detailed than the one he had placed in Charleston: he offered daguerreotyping outfits, costing from fifteen to sixty dollars, which included a camera, iodine and mercury boxes, a box containing chemical preparations, a plate box, a spirit lamp, and a device for washing and finishing the plate, "put up in a neat chest suitable for traveling, and fitted up in such manner that the traveler may stop by the way and take views without being put to the inconvenience of first providing a dark chamber for that part of the process which requires to be done in the dark."[46]

Apparently he had invented a light-proof holder for the sensitized daguerreotype plates which could be fitted into a camera when needed, while one was away from the darkroom—a remarkable achievement for early 1840.

The art had also spread westward. By spring other philosophical-instrument makers had entered the field—Wells and Foster, 2 Baker Street, Cincinnati, advertised on May 12 that they were selling daguerreotype apparatus;[47] by June another philosophical-instrument maker, Ari Davis of Boston, advertised daguerreotype apparatus for the low price of twenty-five dollars. Hamilton L. Smith of Cleveland, later famous as the inventor of the melainotype or tintype, experimented with improving the use of mercury vapor for bringing out images on the daguerreotype plate. Theodatus Garlick, a medical doctor and sculptor in the same city, published a method of plating brass or copper which would solve many of the difficulties in producing good daguerreotype plates.[48]

The entire complexion of daguerreotyping had changed by the end of February—the art was ready for its first commercial venture.

THE FIRST COMMERCIAL STUDIO

The distinction of opening the first commercial portrait studio would be awarded to John Johnson and Alexander Wolcott, who had worked tirelessly to improve the daguerreotype process. When Johnson recovered from his illness in January, the partners began once again to make improvements, realizing that the commercial aspects for taking portraits lay in perfecting their speculum camera. All previous experiments had been inexpensive, but now no cost was spared in developing a "studio camera." Wolcott applied for a patent on the camera, which was granted on May 8, 1840—this would be the first United States patent for photography.

Other details inherent in taking portraits were considered. For example, in the matter of light and shade, the two men came up with the idea of placing blue glass in front of the sitter, the objective being to shield the sitter's eyes from the glare of direct sunlight. Another way

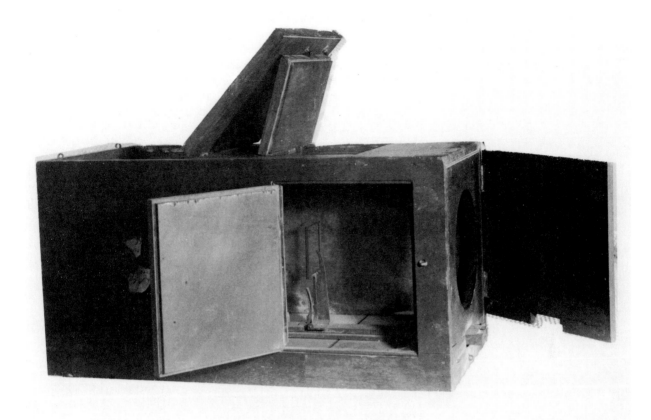

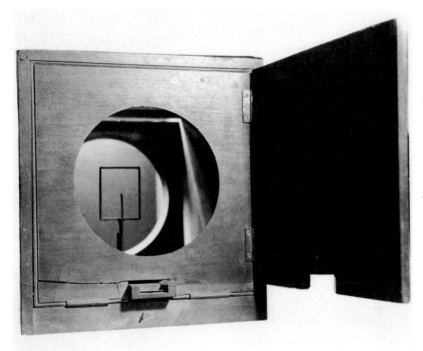

The Wolcott-Johnson twenty-inch speculum camera, side view with doors open. A 2 x 2½ inch daguerreotype plate was held in a vertical position by a positive finger-type bar (inside center) which could be focally adjusted on a brass and wooden track. York Institute, Saco, Maine.

The Wolcott-Johnson camera, front view. Light (that is, the image) entered the 5½-inch opening and was returned to a sensitized daguerreotype by a concave metal reflector (not shown) fastened to the rear compartment divider. A small mirror was used to obtain a correct focus before the daguerreotype was placed in the plate holder. York Institute, Saco, Maine.

to produce a softening effect on the shaded portions of the portrait, without solarizing the picture, was to use a looking glass, mounted on top of the camera, directed almost horizontally at the sitter. Background colors and materials, also taken into consideration, were so arranged that the lighter parts of the sitter would be contrasted by black velvet, the darker parts by a light material.

The partners were so confident that their camera and lighting system would succeed commercially that they sent Johnson's father, William Johnson, to England in early February with the idea of establishing a studio there. The elder Johnson carried both a sampling of portrait daguerreotypes and a knowledge of the partners' method of operation. Shortly after his arrival in England, he contracted with Richard Beard to set up a London gallery, using the Wolcott-Johnson method of taking portraits. Thus, less than six months after Daguerre's process had come to America, the Americans had extended their daguerreotype operations overseas, and, although it would be some time before the London studio would open, it would be England's first working gallery. Other Americans would soon become important photographers in both London and Paris.

Back in New York, Wolcott and Johnson had received some unexpected publicity. At a February meeting of the Mechanic's Institute, a friend of Wolcott's drew some diagrams on a blackboard to illustrate the partners' unique lighting methods. Johnson later recounted: "Shortly after, Professor Mapes, Dr. Chilton, and many others sat for their portraits, and were highly gratified. Professor Morse also came and proposed to Mr. Wolcott to join him in the working of the invention, etc."[49]

Improvements and changes in the new art were an almost daily occurrence. Citizens were responding by having their portraits taken, and those who had learned the art were instructing others. During the first two months of 1840, the basic foundation for the American daguerreotype process had been laid, and the art was well on its way to becoming an integral part of the American scene.

Throughout this period of activity, Wolcott's residence had been used as a portrait studio, but the public demand for both portraits and instructions proved far greater than the partners had originally anticipated. Probably because of the considerable interest in New York in daguerreotyping, a news item about the first studio in America appeared in the *New York Sun* for Wednesday, March 4:

> Sun Drawn Miniatures—
> Mr. A. S. Wolcott, no. 52 First street, has introduced an improvement on the daguerreotype, by which he is enabled to execute miniatures, with an accuracy as perfect as nature itself, in the short space of from three to five minutes. We have seen one, taken on Monday, when the state of the atmosphere was far from favorable, the fidelity of which is truly astonishing. The miniatures are taken on silver plate, and enclosed in bronze in cases, for the low price of three dollars for single ones. They really deserve the attention of the scientific, and are valuable acquisition to art, and to society in every respect.

Since the time seemed right to expand operations, space was hired in the new Granite Building, where Gouraud had lectured and where

many famous artists had studios: in this atmosphere, mutual interests between artists and daguerreotypists must have developed. Auspiciously, on Friday, March 13, the *New York Sun* announced: "Daguerreotype Portraits—Mr. Wolcott, the portrait taker of whom we spoke a few days since, has taken rooms nos. 21 and 22 in the granite building corner of Broadway and Chambers streets."[50]

The rooms in the Granite Building were small, causing the partners to make further adjustments in their lighting arrangements. The window sashes were removed, and two large, adjustable, nearly horizontal mirrors were substituted. One immediate problem was to find satisfactory blue glass for filtering the sunlight; Professor Mapes helped with this by suggesting a trough of glass—twenty-eight inches square, three to four inches thick—filled with ammonia sulfate of copper. However, the solution's power to filter was short-lived, and finally, by suspending a large piece of blue glass from chains, kept in motion while the camera's aperture was opened, the problem of lighting was solved.

Other improvements in lighting techniques and equipment design followed. Years later Henry J. Lewis, son of the pioneer daguerreotype apparatus manufacturer, recounted some of the advancements made by Wolcott and Johnson in those early days:

> William Lewis and William H. Lewis (his son) made the first camera used for taking likenesses as a business by the Daguerre process; also coating box, mercury bath and head rest. These were first used by Walcot and Johnson on the corner of Broadway and Chambers street. . . . These gentlemen charged for a picture on a plate 2 x 2½ inches, in a plain case, five dollars, and at this price the wonderful pictures were in great demand; but owing to the difficulty attending an untried business, many times they were not successful in producing a shadow a day. Iodide of silver, though forming the basis of the picture, required some other agent to quicken the action of the light. The new beginners in what as yet was only an experiment were not deterred at difficulties. Having at times produced tolerable pictures, they resolved to find some agent to quicken and at the same time produce a more pleasing tone. To accomplish this they consulted with Dr. Chilton, a noted chemist in the times, and by his advice were induced to experiment with chloride of iodine, which he prepared for their special purpose. With this, in combination with the vapor of iodine, they finally succeeded in making pictures in much less time and with greater certainty of success. They next tried to improve their work by producing more harmonious effects of light and shadow. Hence they cut a circular opening through the roof, and built a circular room revolving on a railway at the pleasure of the operator. With these improvements they made their business a success. In the height of their prosperity, however, they sold out (to good advantage) to a Mr. Van Loan, whose son continued in the business for many years.[51]

This circular room and revolving railway, new in the spring or summer of 1840, became part of the Wolcott-Johnson system in England.[52] Americans, however, generally preferred rectangular rooms with movable light reflectors.[53]

Richard Beard's studio, London. From a woodcut by George Cruikshank, 1842. After Wolcott and Johnson opened their studio in March of 1840, in the Granite Building, New York City, a circular room and revolving railway, similar to that illustrated, were introduced by the partners to coordinate their cameras and lighting.
Gernsheim Collection, Humanities Research Center, the University of Texas at Austin.

Samuel Sheppard Gilbert, 1840.
Sixth-size daguerreotype.
Artist unknown.
The portrait was probably taken
with a Wolcott camera. Note the
outline of a perimeter band on
the image area and the abrupt
termination of the subject's right
elbow. The normal reversal of the
daguerreotype image is absent.
Documentation was sealed with
the case.
Anonymous collection.

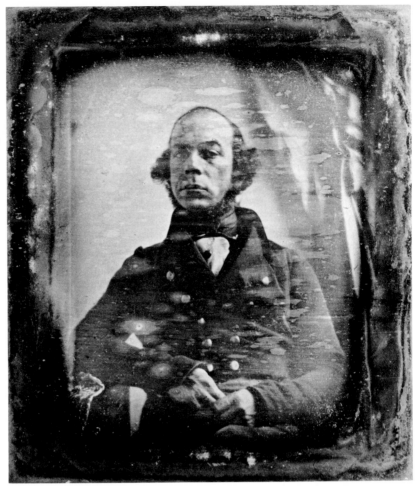

GOURAUD IN BOSTON

Gouraud's stay in Boston followed the pattern of his New York visit.
The private exhibition of his daguerreotype collection, on March 6 at
the Tremont House, elicited praise from the editor of the *Evening
Transcript* who was of the opinion that Boston would appreciate the
best qualities of the daguerreotype more than had the New Yorkers.[54]
Gouraud's first public exhibition opened on March 11 at the Horticul-
tural Rooms, Tremont Street, with hours from 10:00 A.M. to 9:00
P.M.—admission fifty cents. The hall was thronged all day with "a
crowd of ladies and gentlemen in attendance."[55]

Before his lecture series, to be given at the Masonic Temple on
March 27 and April 3, 4, and 6, Gouraud took some excellent daguerre-
otype views of Faneuil Hall, Quincy Market, and Park Street. The day
before his first lecture, the *Boston Daily Advertiser and Patriot* pub-
lished an interview with him which gave a clear insight into his opera-
tions and his mode of taking daguerreotype portraits—how to pose,
what the subject should wear, the correct lighting and its arrange-
ment, and other pertinent details. Gouraud stated that his exposure
time was about twenty seconds.[56] He again mentioned that he used a

meniscus lens, the same type he was using at the end of January. Also, it must be remembered that, by the time Gouraud reached Boston, it is entirely possible that he had experimented with bromine as an accelerator. Whether, indeed, he learned more from American practitioners than they learned from him remains debatable.

Gouraud's first lecture was well attended, as evidenced by a news item in the *Evening Transcript* on March 28:

> The Daguerreotype. Mr. Gouraud's lecture at the Temple, yesterday, in explanation of the process of producing the Daguerreotype pictures, gave the utmost possible satisfaction to an audience of five hundred ladies and gentlemen, the number of whom would have been twice or thrice increased if the lecturer had not judiciously limited the issue of tickets, to prevent confusion and give every auditor a full opportunity to hear and see. During the lecture Mr. Gouraud prepared a plate, describing the mode of operation as he proceeded, which, when finished, was placed in the camera obscura, and the whole apparatus being then set on a window of the hall commanding a view of Park street from the Church to Beacon street, including a portion of the Common—a most beautiful and perfect picture was produced in *ten minutes*, to the delight and astonishment of the spectators.

An item in the *Evening Transcript* on April 4 also noted that the lectures were very well attended and that the "delight manifested at the first lecture, seemed not, in the slightest degree, to have abated." Further, the article stated that after the fourth lecture Gouraud's attention would be given to private classes before he left the city.

The lectures and exhibition attracted not only Bostonians but men from other parts of New England. Young George Fuller, later a famous artist, was lured to the new art of daguerreotyping. He wrote home on April 11:

> Dear Father . . . you have heard much (through the papers) of the daguerreotype, or drawings produced by rays of light upon a plate chemically prepared. Augustus and I went to see the specimens, and to one of the lectures, but we were too late, as they had ceased delivering them. Now this can be applied to taking miniatures or portraits on the same principles that it takes landscapes. M. Gouraud is now fitting up an apparatus for the purpose. . . . The plate (metallic) costs about $1.50, and it is easily prepared, but 2 minutes time is required to leave a complete impression on a man's countenance, perfect as nature can make it. He will give me instructions for $10.00, and the apparatus will cost $51.00 making in all $61.00 only, for the whole concern. . . . This is a new invention, and consequently a great novelty, of which everyone had heard, and has a curiosity to see. It is just what the people in this country like, namely, something new. I think anyone would give $7.00 for their perfect likeness. We could clear ourselves of all expense in two weeks.[57]

On April 16, a small advertisement appeared in the *Evening Transcript*: "Daguerreotype Portraits. Mr. Gouraud is fitting up an apparatus for taking portraits of any person who may desire to have them

delineated by the Daguerreotype process. For further information apply at Mr. Simpkins bookstore. 21 Tremont Row." Thus Gouraud did not leave Boston when he had originally intended but stayed on during May and June. On May 30, the *Evening Transcript* announced that he had just received from Paris some two hundred daguerreotype views taken in Paris and in Rome. Of great interest to the history of photography is the following statement: "The value of the collection is enhanced by two of the largest specimens of the art—on a scale of nearly three feet. They will be exhibited to the public early in the next week. In the meantime, Mr. Gouraud is preparing his apparatus for taking portraits."[58]

On June 2, an advertisement in the *Evening Transcript* not only gave notice of Gouraud's second exhibition but documented the fact that he was taking portraits commercially:

> Daguerreotype Portraits, and Second Exhibition of the Daguerreotype Drawings. Mr. Gouraud has the pleasure of informing his friends and the public that his apparatus for taking portraits now ready, he will begin to take them, at the Hall of

"T. M. Cahill age 40, 1840."
Sixth-size daguerreotype.
Artist unknown.
The United States census of 1840,
Boston, recorded a Thomas M.
Cahill, age 30–40. Additional
documentation written on the
silk pad opposite the image noted
that the daguerreotype was
"Taken J. 1840."
Rinhart Collection,
the Ohio State University,
Columbus.

the Historical Society in Tremont street, on Monday next, and that he will continue to take them every fair day, from 10 A.M. to 5 P.M. Price of a portrait of the ordinary size, $5. New specimens of portraits can be seen at the bookstore of Mr. Simpkins, no. 21 Tremont Row.

At the same time will be opened, at the Hall of the Horticultural Society, a new Exhibition of more than 100 beautiful Views, and various other interesting Pictures, taken by the Daguerreotype in Rome, Paris, Athens, etc., and just received from France. Some of these views are of extraordinary size and great beauty, and one of them (that of the Hotel des Invalides) contains 450 square inches.

The Exhibition will be open every day, except Saturday and Sunday, from 9 A.M. to 7 P.M.

Admission to the Exhibition 25 cents.

Meanwhile, "The Photogenic War" continued—with Gouraud in Boston and Morse in New York. Gouraud had written to his Paris benefactor, Abel Rendu, accusing Morse of having had Daguerre elected to the National Academy of Design as part of a scheme to use the new process for his own gain. Daguerre disavowed Gouraud upon reading the letter. A number of letters were exchanged and reprinted in American newspapers; some slanted their stories toward Morse, others toward Gouraud. Rendu came to America to inquire into the state of affairs and, after an investigation, disclaimed further responsibility for or connection with Gouraud.[59] In a letter to Morse, the disappointed Rendu wrote that "he had raised Gouraud from the lowest conditions of life . . . he had furnished him with the means to live in France and America."[60]

When Gouraud left Boston remains uncertain, and his subsequent whereabouts also remain rather obscure, but in the summer of 1840 he traveled on to Providence, Rhode Island. During the summer of 1842, after Morse found Gouraud daguerreotyping at Niagara Falls, he wrote to his brother, describing this chance meeting:

And now who do you think was my pilot through all the interesting parts of this region? You never would guess. No less a person than *Francis Gouraud.* . . . He is doing well here; has established himself quite on a large scale, is taking views of the Falls, has made some important improvements in the apparatus, for which he intends to procure a patent, which in his zeal to make ammends for what has passed, he has freely confided to me. In short, from all I have seen and heard of him, there has been a great deal of misconception in regard to him. He has doubtless been imprudent, and must blame himself for much of his trouble, but he is not the character which circumstances led us to believe he was. Much allowance must be made for habits of education and temperament, and I would make them for him. Those reports which affected his moral character, I have reason to believe are false; his wife and child are with him here; he assures me that in this he was grossly slandered by Rendu, and I fear that Rendu is not what I had supposed him to be, an honorable, and correct man. How cautious it is necessary to be with these foreigners![61]

The man who had given the daguerreotype process its impetus in America seemed to have lost his drive and ambition after Rendu's denouncement. After the summer of 1842, Gouraud apparently gave up daguerreotyping, and his subsequent life is shrouded in mystery.[62] The whereabouts and ultimate fate of his large collection of daguerreotypes is also a mystery. Because of a January 1843 announcement in a New Orleans newspaper that "Daguerre's Chemical Pictures" had been lost by fire, some historians assumed that the loss involved Gouraud's collection of daguerreotypes, but the four pictures destroyed by fire were original dioramas painted by Daguerre.[63]

PROGRESS IN THE ART

In the spring of 1840, Philadelphia was keeping pace with the progress and improvements elsewhere. Robert Cornelius opened a portrait studio, the second American gallery, sometime between February and March.[64] Alexander Beckers, a pioneer daguerreotypist, later recalled how he had encountered the new art: "The first daguerreotype I saw was made by Robert Cornelius, in Philadelphia. His laboratory was conspicuous. On the outside could be seen a large mirror, swung on a bracket, for illuminating his sitters with reflected sunlight."[65]

The meeting of the Franklin Institute on April 23, 1840, included a display of portrait daguerreotypes. A report of the meeting gave details of the exhibit:

> J. J. Mapes, Esq., of New York, editor of the American Repertory, showed several specimens of Photographic portraits, executed by Mr. Walcott [*sic*] of that city, which were much admired for strength of light. Several beautiful portraits by the same process, executed by Mr. Robert Cornelius and Dr. Goddard, were exhibited by the latter gentleman. Mr. Joseph Saxton, produced a galvanic copy of a Photographic landscape, which, although manifestly imperfect, as the result of a first attempt, gives promise that these two novelties of science may be advantageously united.[66]

Just how far the Americans had progressed in their quest for reduced exposure time was made clear by an item in the May *Philadelphia Chronicle*:

> Daguerreotype Miniatures . . . Mr. Robert Cornelius, of this city, is now engaged, most successfully in making miniature likenesses by means of the process discovered by Mons. Daguerre. Nothing could possibly be more true than these representations of the human face divine for they transfer to the plate the exact images of the sitters, 'living as they rise.' The mode, too, is as simple as the results are accurate. All you have to do is to place yourself in an easy well-cushioned chair, assume the position in which you desire to be perpetuated and look steadfastly at a given object for the matter of a half minute . . .

Another feature besides the reduced exposure time of thirty seconds, which Cornelius provided his sitter, would become standard equipment in the daguerreian studio—the well-cushioned chair![67]

From Philadelphia in July came the even more startling news that "Justus E. Moore of this city . . . has succeeded in discovering a method by which a portrait of the human face may be taken in a single instant of time." This news item was reprinted on August 1 by the *New York Journal of Commerce* without comment.

By the early spring of 1840, the basic nuclei for the nationwide expansion of daguerreotyping had formed. Gouraud was conducting his lectures and courses in Boston; in New York, Wolcott and Johnson, as well as Morse and Draper, were giving instructions; and in Philadelphia Robert Cornelius had opened a studio and was also giving instructions in the art. Most important in the growth of the art was the fact that every daguerreotypist in turn instructed others. Indeed, the new daguerreotypists found a profitable sideline by advertising in newspapers—"Instructions given in the Art"—a practice which quickly widened the circle of daguerreotypists. Many enthusiastic pupils, after receiving instructions, toured the smaller cities and towns of America, following the tradition of limners by staying in each place for a few weeks or months, depending on the local response to their advertisements or handbills.

How fast knowledge of the art was spreading may be judged by an advertisement in the *Daily National Intelligencer* of Washington,

Seated couple, ca. 1840.
Half-size daguerreotype.
By Robert Cornelius
(attributed).
Cornelius used a distinctive
heavy framing mat (not shown)
for his daguerreotypes.
Anonymous collection.

D.C., on March 9, 1840, announcing that an exhibition of daguerreotypes could be seen at the Hall of the Medical College and that a series of lectures would commence soon thereafter. The next word came on March 14, stating that the editor had examined the beautiful specimens executed by a Mr. Seixas and that the exhibition had been moved to the American Hotel. On March 17, in a letter to the newspaper from "A Friend of the Arts," it was noted that the writer had seen the exhibition "and was astonished both with the drawings and explanations as given by Mr. Seixas." The next announcement came in an advertisement dated March 23: "Sun Painting—On Tuesday 24th inst. at 11 o'clock precisely, in the parlor of the American Hotel, Pennsylvania Avenue, will be shown and explained, with complete apparatus, the process of Mr. Daguerre of making permanent pictures on silver . . . Tickets $1, to admit a lady and gentleman . . . N. B. Should the Weather interfere on Tuesday, the lecture and demonstration will take place on the first suitable day afterwards, at same hour and place."

Meanwhile, the tedious process of improving the daguerreotype continued. At some time, Morse and Draper conducted joint experiments: for this purpose, a building with a glass top was constructed on the roof of the City of New York University. Lighting remained a problem and—like Wolcott, Johnson, and Cornelius—the two men employed a set of mirrors. However, Draper did not continue as a partner for long, and Morse later moved to a specially constructed glass studio on top of his brothers' building on the corner of Nassau and Beekman streets. Financially this period was a low point in Morse's life, as his professorship of art at the university paid very little and prospects that Congress would finance his telegraph were dim; thus he turned to daguerreotyping for his livelihood. A number of students, many of whom later became famous daguerreotypists, came to study the art under Morse; the charge for instruction was twenty-five to fifty dollars.[68]

When Draper's association with Morse came to an end in the summer of 1840, he was organizing a medical department for the City of New York University, which left him little time for daguerreotyping. However, he continued his experiments when time permitted and, in July of 1840, his paper on taking portraits from life was published. The article was actually a progress report on the American daguerreotype, incorporating his knowledge of the subject. Although mainly writing of his own experiments, he also drew heavily from the trials and errors of Wolcott and Johnson, Gouraud, Morse, and others without specifically naming them. He mentioned from twenty to ninety seconds of exposure time for a portrait in direct sunlight and from five to seven minutes in diffused daylight. In the matter of sensitizing chemicals, Draper had made little progress: he still used only iodine. Perhaps he felt his line of inquiry, through optics, to be superior.[69] Also in July, he succeeded in taking a portrait in sixty-five seconds; the sensitizing agent—iodine.

The spring of 1840 also saw the appearance of the traveling daguerreotypist, a trend which was of great importance in the early days of photography, bringing rural folk the opportunity to have their portraits taken and thus beginning a documentation of exact images of Americans for social history. How many itinerants were on the road or where they traveled remains unknown, although Draper in his July article mentions that the occupation was routine.[70]

Mr. Larrabee of Boston, an itinerant daguerreotypist, visited Saint Albans, Vermont, probably in early April 1840. According to one broadside: "Having taken rooms at —— will remain at —— for a few days only. . . . *Likenesses* . . . are also taken in so short a space of time, (from thirty seconds to three minutes, according to the strength of light,) . . . Family Groups, and Companies of Twelve or more, taken at discount from usual prices. *Portraits* and *Views* copied in Miniature."[71] The exposure time mentioned in the broadside was about comparable to that of other daguerreotypists at this time. The way Larrabee operated—giving advance notice and hiring rooms for a few days—formed a pattern which later daguerreotypists would follow as their wagons traveled from town to town throughout the countryside.

Thus two trends of daguerreotypists were now in evidence—the traveling itinerant and the professional in his city gallery. Wolcott and Johnson's studio in New York was a financial success by mid spring. Although their distinctive camera was rapidly becoming obsolete in America, the lighting techniques developed by the partners were still widely copied by other daguerreotypists. In June, Wolcott left Johnson to operate the New York studio while he made a trip to Wash-

This broadside was posted before April 25, 1840. National Archives.

ington to help John G. Stevenson, a daguerreotypist who seemed to have had more patrons than he could handle. In a letter of June 25, Wolcott wrote of the many details he was trying to correct in the Washington operation:

> Friend John—I forgot in my last to mention how you should di-rect your letters—you must send them by Harnden's Express Line to Baltimore, directed to *John G. Stevenson, care of William Hawkins, Baltimore*, and send the receipt you get for the package to Wm. Hawkins at Harrison & Co., requesting him to get the package and forward it to John G. Stevenson at Wash-ington. Send me a lot of the gilt frames; Mr. Stevenson has only about five dozen of the cases so if you have any to spare *send*; no glasses on hand but those I brought with me. If you have bought another lot of thermometers send two or three, we have none at present, but will have to buy at a high price; send a few sheets of filtering paper to manufacture distilled water with. How shall I direct my letters to you? I am busy *busy* busy, don't think I can be ready before Monday. How many customers has your adver-tisement brought to your rooms, and how many V's have they left with you? When Mr. Kells finishes the two lens he has on hand, he may, if you think proper, make two more of the same curves and of as large diameter as ⅜ glass will allow. Mr. Ste-venson intends when he leaves here to go to Baltimore, where he cannot use the reflector.[72]

Progress was slow in the Wolcott-Johnson enterprise in England; by midsummer a studio was in operation, but it was not yet open to the public. Because of the many difficulties encountered, it was necessary for John Johnson to go to London in October to lend a helping hand; Wolcott joined him in July of 1841, to insure the success of the English venture. The American operation was bought out by Matthew Van Loan sometime in late 1841, and his advertisements in New York news-papers began appearing as early as March 24, 1842.[73]

The summer of 1840 passed quietly, as the number of daguerreo-typists in America continued to grow. George Prosch, in a July 21 ad-vertisement in the *New York Journal of Commerce*, broadened the daguerreotype's appeal by soliciting the general public to examine the new art. The advertisement mentioned facets of the art unthinkable in the fumbling days of January, six months before: "Daguerreotype Ap-paratus . . . Each set will be proved and instructions in the art free of charge. Pictures for sale, and views taken of residences, public build-ings and other views to order, at very moderate charge. Ladies or Gentlemen residing in this city or Brooklyn, wishing to purchase can be instructed in the art at their residences."

Meanwhile, Morse must have made progress during the summer months, because a November 18 letter from Eben N. Horsford, an early pupil of his and a professor of mathematics and natural sciences at the Albany Female Academy, revealed: "I learn, with equal aston-ishment and gratification that you have succeeded in taking likenesses in ten seconds with diffused light. Pray reveal to me the wondrous dis-covery. So capricious has our sunlight been, that we have done very little since I last saw you."[74] Insight into the ten-second exposure time came with a detailed summary of the art's progress by William Henry

DAGUERREOTYPE LIKENESSES.—The perfection to which the Daguerreotype art in taking likenesses has been carried, must be a matter of surprise and gratification to both the scientific world and to those who only look at things in their practical results. I have lately visited the rooms of Mr. Van Loan, in the Granite Buildings, corner of Broadway and Chambers-street, where quite a number of beautiful impressions, in the Daguerreotype art, are to be seen. Mr. Van Loan, by a happy combination of chemicals with the iodine, on which the results in these impressions are dependent seems to have succeeded beyond most others, if not having surpassed all others, in the accuracy of his likenesses. He has a room arranged in the attic of these high buildings, which can be turned on a railway in such a manner as to secure, at all times of the day, the most favorable light; and some of his likenesses which I have seen, are so beautifully shaded as to relieve them entirely from the usual ghost-like appearances, which render the Daguerreotype impressions of the human countenance so objectionable. The art is certainly an astonishing and beautiful one; and the rapidity with which the likeness is taken must make it a matter of interest to almost every one to secure a Daguerreotype resemblance of himself and friends. No where will one secure these miniatures in greater perfection, and perhaps not equally perfect, as at Mr. Van Loan's rooms.

Editorial comment from the New York Tribune, *March 24, 1842. The original Wolcott-Johnson studio was bought by Matthew Van Loan sometime in 1841, and he continued advertising "Photographic Likenesses" throughout 1842.*

Goode, assistant professor of chemistry at the City of New York University. Dated December 17, 1840, the report was probably six months behind the commercial aspect of the art; it was based fundamentally on improvements contributed by Morse and Draper after September 1839 and, with minor exceptions, did not include progress made by other practicing daguerreotypists in New York or elsewhere. However, the Morse and Draper accomplishments were impressive. The original French cameras had been imperfect in shielding light from the sensitized daguerreotype plate. This was corrected:

> The clean plate is placed and secured in a frame fitted to the back of the camera; this frame is grooved so as to allow a piece of tin to slide . . . in front of the silver surface . . . another frame, similar to that just described carried the ground glass. These frames should be so constructed that the ground glass and the plate shall occupy the same position when one replaces the other. Instead of the deep . . . French . . . iodine box . . . one two inches deep, but much larger in every direction, is now commonly used. Iodization, however, can be effected with greater uniformity by placing the frame containing the plate on a board impregnated with iodine, than by any other arrangement.[75]

Much of Goode's article commended Morse and Draper's improvements on the smaller manipulations of the daguerreotype process. Of exposure time, he wrote: "The camera operation is usually completed in from 1 *m.* to 2½ *m.*; portraits however, have been obtained in 10 *s.*"

The welcome scene, ca. 1841.
Sixth-size daguerreotype.
Itinerant artist unknown.
An allegorical scene—the open
gate, hats in hand, and the open
doorway with children silhouet-
ted beyond. For an example of
an early difficulty in daguerreo-
typing, note the aberration of the
lens in the center of the scene.
Rinhart Collection,
the Ohio State University,
Columbus.

About the function of Wolcott's camera, he stated: "The time required for the camera operation varies from ½ *m.* to 2 *m.*; if the sun's light and the mirror are employed; 3 *m.* are necessary to its completion in diffused light."[76]

Morse and Wolcott, at the close of 1840, were still using reflective mirrors for lighting; they had, however, gained a wealth of knowledge during the year regarding the size and placement of their mirrors. Another significant 1840 improvement, important in making the image more permanent, was used by many of the pioneer daguerreotypists and was universally adopted as a final step in finishing a daguerreotype. The Frenchman Hippolyte Louis Fizeau had perfected the use of neutral chloride of gold in a mixture of hyposulfite of soda and water for sealing, thus brightening the daguerreotype image and giving it great durability—no longer could the *Literary Gazette* complain about the silver image being drab and gray.[77] Fizeau's discovery of the gold toning process was immeasurably better than the varnish Daguerre had used or the dextrin and water proposed by a Mr. Dumas.[78]

One event that had passed unnoticed was an attempt to capture an image on a daguerreotype plate by artificial light. This successful experiment had been conducted by Goode and Benjamin Silliman, Jr., in November of 1840 but remained unrecorded until July of 1842, because another scientist had been working on the project but had abandoned

it. Silliman and Goode obtained a photographic impression by galvanic light, reflected from the surface of a medallion to the iodized surface of a daguerreotype plate. The large battery in the Yale laboratory, consisting of nine hundred pairs of plates, four inches by ten inches, was charged with a weak solution of sulfuric acid; its poles were adjusted with charcoal points, when an intensive light was to be produced by this instrument. Two pictures were obtained—the image of the retort stand on which the medallion of white plaster rested and the image of the medallion. The camera was about six feet from the charcoal points; the medallion was a little on one side and to the rear of the points. The plate was exposed to the light about twenty seconds, and the only lens employed was a French achromatic, three inches in diameter with about sixteen inches of focal length.[79]

By the end of 1840, daguerreotyping was no longer a novelty: a profession had been formed. A number of artists of the brush had entered the new field, a trend which continued throughout the daguerreian era. Daguerreotype galleries had opened in various cities, back roads and small towns were served by traveling daguerreotypists, and now any citizen with about five dollars in his pocket could have his image recorded for posterity. In New York City a patron could go to the studios of Wolcott and Johnson, Morse, Jeremiah Gurney, Henry Insley, George Prosch, and probably others.[80] In Philadelphia the Cornelius studio was in operation, and possibly others were in existence. During the October exhibition of the Franklin Institute, John F. Watson and Company (also lithographers), Paul Goddard, Joseph E. Parker, G. W. Henry, and Eliza Henry all displayed "views and minature likenesses and portraits." It is possible that Watson had opened his studio by this date; he may have been Cornelius' first competitor. Eliza Henry would have the honor of being the first female daguerreotypist in the United States.[81] In Boston, John Plumbe, Jr., was practicing the art in late 1840, although it was January 1841 before he advertised. John Stevenson was in business in Washington in the spring of 1840 and, probably, in Baltimore later in the summer, or perhaps he divided his time between the two cities. In Tuscaloosa, Alabama, William H. Harrington and Frederick A. P. Barnard were taking portraits, and in Cabotsville (Chicopee), Massachusetts, Albert S. Southworth and Joseph Pennell had been taking daguerreotypes.

Typical, perhaps, of the 1840 daguerreotypist was the story told by Jeremiah Gurney of his experiences in the pioneering days of the art. A jeweler by trade, Gurney took up daguerreotyping in March of 1840 and had been an early pupil of Morse's. After procuring the necessary plates and apparatus from John Roach, he began his first venture into the art:

> I commenced experimenting at my private residence and thus soon convinced myself that I had so far mastered the art as to justify renting a room on the second story of the building, 189 Broadway. My sign at the doorway was a frame of four small daguerreotypes, and the first, I believe ever exposed for this purpose on Broadway. It was perfectly astonishing to see the multitudes who stopped to look at these pictures, and one perhaps in a thousand would rush upstairs to know something more about this new art. But it usually resulted in the knowledge, simply, that they went away with five dollars less in their

Advertisement from the Savannah Republican, *February 19, 1841. Part of the evidence of the amazing growth of daguerreotyping for the year 1840.*

pockets in exchange for a shadow *so thin* that it often required the most favorable light to detect that it was anything more than a metallic looking-glass. In fact, people had to be taught how to look at the picture or ten chances to one they could never see it. And it often happened that the operator himself failed to find a light in which it was visible. He might, perhaps, discover a shirt-bosom, but nothing more. This was a period in the art when it might be called interesting. Interesting, I mean, when the fever of excitement and disappointment had passed away and some new dodge had been contrived that might possibly obviate former difficulties. Here was a wide field for inventive genius—a school in which to learn patience, to exercise both the reason and the imagination, and to cultivate the organs of combativeness and secretiveness to their fullest extent.[82]

In America by the close of 1840, any friendly exchange of ideas and improvements in daguerreotyping had almost disappeared. Advancements in the process were to become trade secrets. Portrait taking had become an American specialty, and native technical improvements had now placed them ahead of Europe.

Meanwhile, the English had not yet opened a commercial studio for taking daguerreotype portraits. However, they had not been idle. John F. Goddard, a lecturer on optics and an associate of Johnson's in the London enterprise, had experimented with bromine and other chemicals in November 1840, and a notice of his success was published in the December *Literary Gazette*: "So delicately sensitive are the plates, when properly prepared, that the faintest lights act upon them; even on the dull, cloudy days of November, with a London atmosphere, if not too foggy, and there is sufficient light to produce a picture, it will by a few minutes exposure, be delineated. . . . I have no doubt that with a clear summer sun in London the effects will be almost instantaneous."[83]

Toward the end of 1840, Daguerre had inaugurated a series of experiments to reduce exposure time through a method of electrifying sensitized plates. Although the news of this discovery of making instantaneous photographs came in January of 1841, it was not until June 7 that Arago satisfied the curious by revealing that daguerreotype plates had indeed been submitted to electricity. However, the report came too soon. As the eminent Robert Hunt stated: "Some great obstacle appears to have interfered with the successful use of this new and important discovery." In fact, it could not be done, at least by anyone but Daguerre, and the matter was soon forgotten.[84]

3. THE FORMATIVE YEARS, 1841–1846

By 1841 photography was emerging from its experimental and embryonic stage—such early experimenters as Morse and Draper were no longer leaders of daguerreotyping in America. The art was fast becoming a business enterprise, and successful portrait taking was no longer a matter for conjecture or a shadow on a plate: the new profession had become part of the American scene. Always eager, inventive, and enterprising, Americans were ready to embark on any new venture which promised financial gain. For those seeking an occupation on a relatively high plane, daguerreotyping—with its standing as a new art, combined with the hope of monetary gain—attracted men from a wide sphere of society. With few exceptions, Europe had no counterpart to this group of restless, inquisitive Americans.

Although some historical material reveals the many advancements made in the art of daguerreotyping in 1840, few written records exist concerning these improvements, especially in the field of optics or in the development of American cameras and lenses. A number of men in the larger cities on the eastern seaboard were in the business of optics and optical equipment, and these were often called upon to incorporate their ideas for camera improvements.

CAMERA IMPROVEMENTS

In his December 1840 article, Professor Goode had given but passing notice to the French achromatic lens and had not mentioned the construction details of American cameras or the type of lenses used.[1] The American cameras of 1840 were customarily sold by such philosophical-instrument makers as George Prosch and John Roach in New York, J. S. F. Huddleston and Ari Davis in Boston, and Wells and Foster in Cincinnati. The names of other instrument makers who made cameras in the early days of photography remain unknown. Again secrecy surrounded the camera as it surrounded other improvements in the daguerreotype process. However, if America lacked historians of photography in 1840, the Europeans were quick to report the latest improvements in the camera lens, and several were cited during 1840 and 1841.

The early single lenses were found to be too slow for portraiture, and opticians directed their efforts toward obtaining as much light as possible as well as good definition. In about 1840, both Andrew Ross and Charles Chevalier devised compound lenses which consisted of "two achromatic compounds, one at each end of a tube"; the Ross lens photographically corrected the visual and chemical focuses.[2] The famous Petzval "portrait lens" was not long in coming: in the fall of 1840, Professor Josef Petzval of Vienna perfected an excellent lens, suited for portraiture. By January 1841 Peter Friedrich Voigtländer was mar-

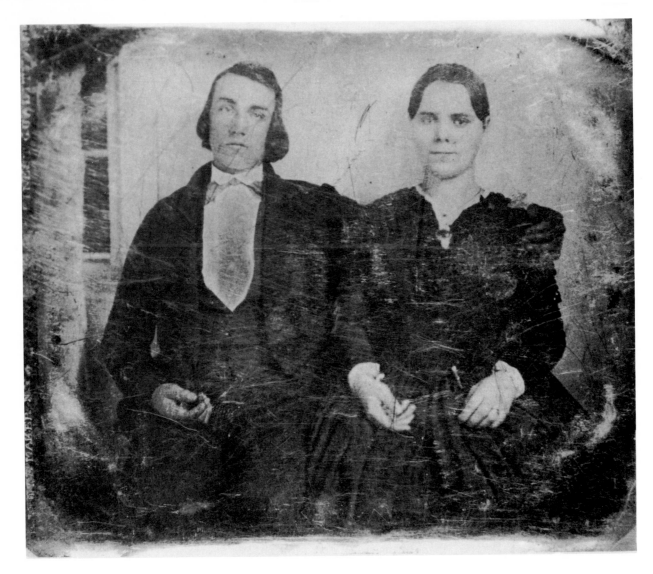

Seated couple, ca. 1841.
Sixth-size daguerreotype.
Itinerant artist unknown. Dur-
ing the first two years, many da-
guerreotypists took their
portraits outside in the sunlight
to reduce exposure time.
Rinhart Collection,
the Ohio State University,
Columbus.

keting Europe's first camera, using the Petzval lens, now designed especially for taking portraits.

The shape of the Voigtländer camera was different from that of the rectangular wooden ones then in use. The brass instrument was round and conical, somewhat like a small cannon. The exposure time was reduced sharply over that of the European cameras currently in use; when the new camera was tested on a clear day, using iodized plates, with the sitter in the shade, exposure time was never more than two minutes.[3]

While the new Voigtländer camera created considerable interest in Europe, it seems to have been mostly ignored by Americans.[4] However, after the Langenheim brothers, William and Frederick, opened their Philadelphia studio in the summer of 1842, they used a Voigtländer camera—sent to them from Germany as a gift from their brother-in-law, Johann Schneider—which took a daguerreotype four inches in diameter, with an exposure time of twenty-five seconds; by December, the Langenheims were taking daguerreotypes eight inches in diameter with a larger camera of the same style.[5] Neither camera

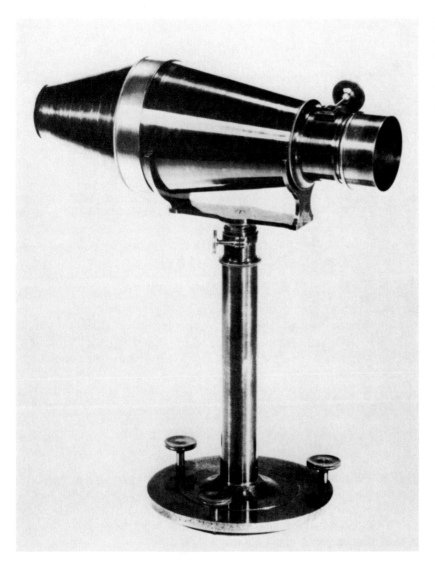

The Voigtländer-Petzval camera, ca. 1841. Gernsheim Collection. Humanities Research Center, the University of Texas at Austin.

competed successfully with the rectangular style used by American daguerreotypists in 1842, a fact possibly recognized by the German camera maker because, in 1843, the firm began producing a rectangular-shaped camera mounted on a high tripod.[6]

The advent of the cone-shaped Voigtländer camera did not seem to have impressed John Johnson, who was working in London during the winter of 1841, preparing Richard Beard's studio for its March opening at the Polytechnic Institute—England's first photographic gallery. The *Literary Gazette* wrote glowingly about the operation of his and Wolcott's camera, and, if the article was accurate, the camera seemed to be superior to those then in use in Europe: "We . . . have been both delighted and astonished by its ingenuity and accuracy. It is truly magical, the performance of a few moments, most simple, and most scientific . . . executed for about a sovereign or a guinea, it is worth that sum to see it done."[7] But Voigtländer continued to improve his instrument, and by 1850 it was considered by many Americans to be the best available, although others preferred the American instrument. American manufacturers found it difficult to compete effectively

with Voigtländer's precision lens and apparatus until Charles C. Harrison's camera became popular in the early 1850s, when once again Americans regained a considerable share of the market.[8]

ACCELERATORS

Meanwhile, in 1841, exposure time was usually less than half a minute but seldom less than ten seconds for an indoor studio portrait—considerably shorter than it was in Europe.

Almost all of those working to reduce exposure time during this period in America were professional daguerreotypists. Experiments were conducted on an individual basis, and discoveries were usually kept secret. Only newspaper or other advertisements reflected improvements. Throughout the first half of 1841, daguerreotypists experimenting with various chemicals were hoping for a superior light-sensitive compound—the optimum being a near instantaneous photograph. The many compounds marketed as a result of these 1841 experiments became known as quicks or patent accelerators.

One of the first quicks to appear on the open market, in early 1842, was "Wolcott's American Mixture"—Alexander Wolcott and John Johnson's formula. While its exact chemical mixture remained a secret, it was a compound of bromine, chlorine, and iodine, neatly packaged in hermetically sealed glass bulbs.[9] Within a short time, every supply house carried a number of brands of quicks, each being advertised as better than the others.

The long search for a satisfactory accelerator was nearly over in the spring of 1841, when the *New York Journal of Commerce* reported:

> By a peculiar preparation of the plate, discovered by George Prosch of this city, daguerreotype likenesses are taken at the studio of Professor Morse with the most perfect correctness, in a second of time—as quick, indeed, as the aparture [*sic*] of the lens can be opened and shut again.[10]

An exposure time of one second or less—incredible! Only a little over a year before, Morse's time had been eight to fifteen minutes, Wolcott's time five minutes for a portrait.

Others were also experimenting independently of Morse and Prosch. Some insight into the search for a shorter exposure time appeared when Frederick A. P. Barnard's article on his 1840 and 1841 researches was published. Barnard, professor of mathematics and natural philosophy at the University of Alabama, had been interested in Daguerre's process from its first announcement in 1839 and had applied to Morse for instruction either in the winter or the spring of 1840, although whether he had actually received instruction from Morse remains uncertain.[11] In any event, from the early summer of 1840, although far from the busy centers of Boston, New York, and Philadelphia, Barnard probably kept in touch with the art's progress through correspondence. Apparently he had a number of friends among the professional daguerreotypists and, also, was well qualified to exchange any pertinent information on the subject in the academic field.

In October of 1841, the *American Journal of Science and Arts* pub-

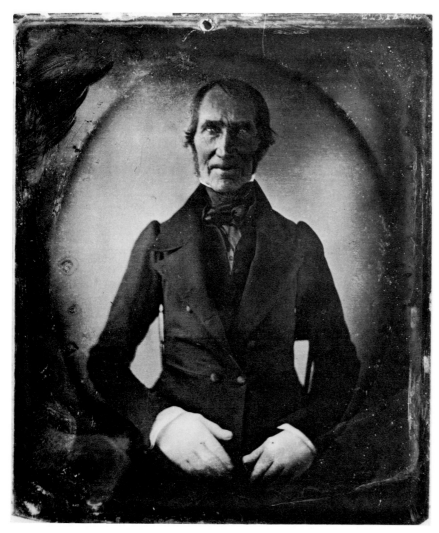

*Seated man, ca. 1841 (or before).
Sixth-size daguerreotype.
Artist unknown.
An example of a lens aberra-
tion—out-of-proportion elbows
and hands were often a problem
in early daguerreotyping. This
image was undoubtedly used in
a doorway or studio by a da-
guerreotypist as a specimen of
his work (note the nail hole, up-
per center edge). Also of interest,
the plate has been die-stamped
by hand, a manufacturing pro-
cedure rarely found on Scovills
plates.
Rinhart Collection,
the Ohio State University,
Columbus.*

lished Barnard's monumental article, a milestone in American pho-
tographic history, and those practicing or interested in the art could
now review the phenomenal progress accomplished since the intro-
duction of the daguerreotype in America. Written on July 1, 1841,
the paper was titled "Improvement in the Daguerreotype process of
Photography":

> Messrs. Editors,—I commenced, about a year since, in connec-
> tion with Dr. Wm. H. Harrington of this place, a series of exper-
> iments in photography, according to the methods of Mr. Fox
> Talbot and M. Daguerre. Our attention was directed principally
> to the Daguerreotype process. From the analogies known to ex-
> ist between iodine and chlorine, we were strongly impressed
> with the belief that the latter substance might in some manner
> be employed to render the surface of silver more sensitive to the
> action of light than it had yet been made. To determine the cor-
> rectness of this opinion we instituted a variety of experiments,
> which, as they proved for the most part unsuccessful, it is un-
> necessary to detail. . . . We were led, therefore, to seek whether
> by the decomposition of some compound of the metal, a sensitive

chloride could not be produced. Mr. Talbot had already done this in the preparation of his photogenic paper; but as it was our desire to avail ourselves of the beautiful lights formed by the vapor of mercury, and as the prepared paper, at least so far as our experiments go, is not susceptible of receiving them, we endeavored to produce the decomposition upon the surface of the solid metal. It occurred to us as a possibility that the iodide formed in the usual manner, by exposing a plate over the vapor of iodine, might perhaps give up its silver to chlorine and thus produce the desired coating. This impression was not verified in our first experiments, owing to a cause which will presently be noticed. Perseverance, however, at length brought its reward. By varying in every possible manner, the circumstances of the experiment, we succeeded in producing a surface so exquisitely sensitive to the action of light, that the image of an illuminated object was formed upon it in the camera in a space of time almost inappreciable.

The following is the process by which the result is obtained. Let the plate be prepared in every respect as if an impression were to be taken according to the method of M. Daguerre. Let it be then exposed for the space of half a minute to the action of chlorine gas, diluted with common air to such a degree that it may be inhaled without any particularly unpleasant sensation. It will then be found so extremely sensitive, that on being placed in a camera, with an aperture such as is commonly employed in taking miniature portraits, an impression will be produced upon it in the smallest time in which it is possible to remove and replace the screen. The completion of the picture over mercury is effected in the usual way.

A plate thus chlorized, on exposure to light almost immediately assumes a very deep violet color, nearly approaching black. The mercury is not directly tarnished, and in this state the picture is even more beautiful than after being washed with the hyposulphite of soda. But without this washing it cannot be preserved.

M. Daguerre has announced that he is able to take images of objects in an instant of time. I have not seen any statement of his method. Some of the artists in the Atlantic cities have been equally successful. Their process is not that which I have described. I suppose that I am acquainted with the mode of preparation which they employ; but as it was communicated to me under an injunction of secrecy, before I had discovered it myself, although I had actually employed it unskilfully, and therefore without complete success before, I can say nothing of it here. It will, without doubt, soon be made public, if it is not already known. I believe, at any rate, that the chloride coating is more sensitive than any other which has yet been used.

This discovery has opened a new field of experiment, in which we are now actively engaged. The results may be communicated hereafter.

It appears to us that the lights produced by this process of preparation are much finer and smoother than those of the original process of M. Daguerre. Some idea of the quickness of the

camera operation may be formed from the statement of the fact, "that a man walking may be represented with his foot lifted as about to take a step . . ."[12]

Of significant interest is the notation: ". . . a man walking may be represented with his foot lifted as about to take a step." This was a great first in photography—the instantaneous photograph was a reality and the urgent probe for reduced exposure time was achieved! Barnard also awarded others credit for their almost parallel achievements when he wrote that "some of the artists in the Atlantic cities have been equally successful." He explained that they had also eliminated the time exposure problem through the use of a different arrangement of chemicals (probably bromine) and had thus produced results equal to his.[13] Barnard did not imply that all daguerreotypists had successfully solved the time problem, but apparently a great many practitioners had because, after the end of 1841, a new line was added to many advertisements—"Portraits taken in but a few seconds."[14]

While the length of time that a patron had to remain immobile was an important factor in persuading the public to visit a daguerreian studio in 1842 and 1843, its importance declined after 1845. By then time was rarely noted in advertisements and, depending on conditions, the sitting was only one to five seconds long, although some daguerreotypists still preferred a much longer exposure.

Daguerreotypists now began examining other ways to improve their art, and from 1841 on they sought to create more brilliant and lifelike images. Also, with competition continuing to grow, they endeavored to make the studio as pleasant as possible for their patrons.

Seated young man, ca. 1842. Sixth-size daguerreotype. Artist unknown. The use of studio appointments was an early innovation—a small table covered with a brightly patterned cloth and leather books titled in gold were especially popular. A favorite pose was an arm or elbow resting on the table. Anonymous collection.

Sisters holding daffodils, ca. 1842. Sixth-size daguerreotype. Artist unknown. Many early daguerreotypists used flowers, fans, and beaded bags to provide an artistic and decorative touch to their portraits. Rinhart Collection, the Ohio State University, Columbus.

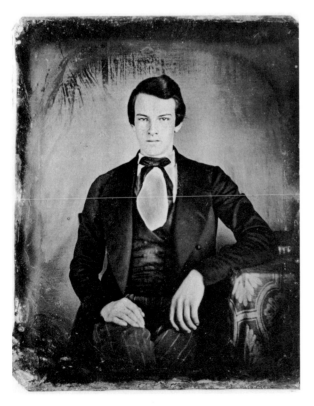

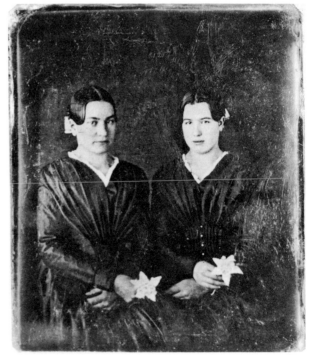

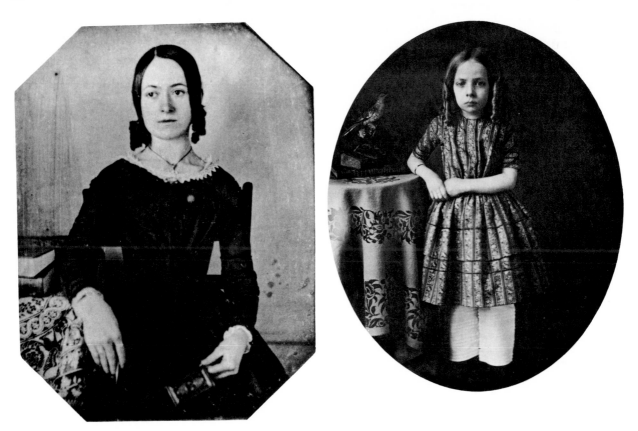

THE EXPANSION OF THE ART

The number of daguerreotypists steadily increased throughout 1841. Among the newcomers were men who would later distinguish themselves as America's foremost photographers, men who would be called the founding fathers of American photography, men who would help shape the art of daguerreotyping into the best in the world.

As 1841 drew to a close, daguerreotyping had some excellent practitioners, and the art was spreading rapidly southward and westward. In Boston, John Plumbe, Jr., was well entrenched as a professor of the art, and his assistant, William Shew, later became a famous California photographer; the firm of Southworth and Pennell was firmly established; and John Whipple was probably beginning his career in photography. New York galleries were steadily being opened by new daguerreotypists, many of whom would also become famous. In Philadelphia, many pupils of both Robert Cornelius and Paul Beck Goddard would become well known in photography. For example, John Mayall, who learned the art in 1840, became a noted daguerreotypist, and in 1846 he went overseas to become the leading daguerreotypist in London. John H. Fitzgibbon, later of Saint Louis fame, probably learned the art from Cornelius while living in Philadelphia; by about 1841, he was using a daguerreotype camera in Lynchburgh, Virginia. In Baltimore, Henry Fitz, the telescope maker who had aided Wolcott with his camera, was a daguerreotypist from 1840 to 1842. From the Midwest, Thomas Faris, a portrait painter, began daguerreotyping in Cin-

cinnati in 1841, and Theodatus Garlick, a medical doctor and sculptor, became a daguerreotypist in Cleveland in 1841. In the South, John Houston Mifflin, a portrait and miniature painter, was taking studio likenesses in Athens, Georgia, in 1841.[15] In Charleston, B. A. and W. W. Chilton opened a gallery, after coming south from New York City. Another New York partnership, that of Thomas N. Starr and Jonas M. Edwards, who advertised as pupils of Morse, opened rooms in Richmond.[16]

Meanwhile, a new school in the art had been formed in Tuscaloosa, Alabama. Sometime in late 1840, Dr. William H. Harrington had formed a partnership with Barnard, and the studio of Barnard and Harrington became the first southern gallery on record. In early 1842, Harrington moved to New Orleans; on February 8, he opened a temporary studio at the house of Madame Page. One of Barnard and Harrington's distinguished pupils, James Maguire, had also moved to New Orleans and opened a gallery on the same date.[17] Both men called their studios "Photographic Apartments," and theirs were possibly the first advertisements to use the word "photographic" in connection with daguerreotyping in the South. They each advertised along the same lines—to quote Harrington: ". . . pictures are remarkable for their brilliancy and distinctness, and free from the ordinary defect of being seen only in one particular light."[18] Both men also gave much credit to Barnard and his improvements in daguerreotyping.

By the end of 1841, Boston had become a center for high-quality daguerreotype likenesses; in residence were several men who were exceptional students of the art. Albert Southworth and Joseph Pennell had opened a rooftop studio in the spring; at first, Southworth later recalled, their income was so small that they often lived on seventy-five cents a week. Before moving to Boston, the partners had operated in Cabotsville (Chicopee), Massachusetts, in 1840. For their first venture they had less than fifty dollars, but despite their meager means they experimented with the Wolcott-Johnson system of operation.

Advertisement from the Savannah Republican, *April 28, 1843.*

Advertisement from the Charleston Courier, *December 13, 1841.*

PHOTOGRAPHIC APARTMENTS,
No. 93 Canal street.

DR. WM. H. HARRINGTON, (of the firm of
Barnard & Harrington, Tuscaloosa, Alabama,)
will open his rooms for the reception of visiters, at
the house of Madame Page, on Tuesday, 8th inst.

The ladies and gentlemen of New Orleans are in-
vited to call and examine his specimens of miniature
portraits taken from the life.

Dr Harrington and his associate, F. A. P. Barnard,
Professor of Mathematics in the University of Ala-
bama, have made some valuable improvements in the
DAGUERREOTYPE process, by which their pic-
tures are remarkable for their brilliancy and distinct-
ness, and free from the ordinary defect of being seen
only in one particular light.

Being provided with instruments of the best pos-
sible construction, Dr. H. is prepared to execute
miniatures to order, warranted to be faithful trans-
cripts of the features and characteristic expression
original, and unexceptionable as works of art.
fy7 tf

They constructed by hand a very large Wolcott-type camera, weighing
fifty-five pounds. The polished reflector had a diameter of thirteen
inches and a focus of thirty inches—an apparatus much larger than
anything Wolcott had attempted. Southworth later recalled his brief
sojourn in Cabotsville as a financial disaster—too many experiments
and not enough portrait taking.

After the two men arrived in Boston, they apparently gave up the
Wolcott camera in favor of the lens type, which had greatly improved
by then. Southworth later recalled his hardships of 1841: "We had our
discouragements and we had our successes. In the fall of 1841, we sent
a case of our daguerreotypes for exhibition to the fair of the American
Institute and received first premium for the best daguerreotypes. This
encouraged us . . . and led us to hope to be able to keep up with, if not
to lead, our competition."[19]

Also in 1841, permanent studios were being established in small
towns where once only traveling daguerreotypists had visited. The
Worcester Spy advertised on December 1, 1841: "G. Evans manufac-
turer and dealer in Daguerreotype apparatus, 6 Stone block, corner of
Main and Central Streets, Photographic Miniatures taken in a few sec-
onds."[20] Evans' advertisement showed a curious aspect of daguerreo-
typing which would increasingly pervade the art in both large and
small towns: a dual practice of being a daguerreotypist and a dealer in
photographic apparatus.

Unquestionably, the need for supply houses in rural areas existed
before dealers sold only photographic materials; most necessary sup-
plies came from diversified sources, not from a central depot. For
example, in early 1841, cameras were obtained from one source, chemi-
cals from another, and daguerreotype plates were bought directly

from Scovill, Corduan, or other early platemakers. An exception to this trend was M. A. Gallet of Philadelphia. Gallet was probably an agent sent from Paris by Giroux and Company who, in the spring of 1841 and spring and summer of 1842, sold Alphonse Giroux's apparatus, lenses, and chemicals.

John Plumbe and Southworth and Company opened supply depots in 1841 to serve the rapidly expanding profession. Both concerns began manufacturing cameras under their own names and carried plates, apparatus, and chemical supplies. The Scovill Company, probably in a mutual exchange of materials, was appointed distributor for the Southworth camera.[21] By 1842, both Plumbe and Southworth and Company owned active supply depots, although the taking of images was still their main source of income.

John Plumbe, one of America's first great promoters of photography, had a forceful, magnetic personality, not one easily dismissed. His career began in Boston in late 1840, and by early 1841 he was known in the city as a professor of photography. Earlier in 1840, he had again tried but had failed to interest Congress in a transcontinental railroad

Aged woman holding a book, ca. 1841. Sixth-size daguerreotype. By John Plumbe, Jr. It is difficult to determine whether this is an outdoor portrait or an early use of a scenic background. Rinhart Collection, the Ohio State University, Columbus.

route to the Pacific Ocean; in this venture he had depleted his own funds and, like Samuel Morse, turned to daguerreotyping for a source of income. Plumbe never disclosed where he had learned the art, but it is possible that he took instruction from John G. Stevenson in Washington.

Insight into Plumbe's character and his progress in the art was revealed in an advertisement placed in a Boston newspaper in March of 1841:

> Mr. Plumbe, Professor of Photography, having at length succeeded in so far improving his apparatus, as to be enabled to produce a perfect photographic miniature in any weather, and consequently, without using direct rays of the sun, proposes to instruct a limited number of gentlemen in the beautiful art, who will be furnished with complete sets of improved apparatus, by means of which any one may be enabled to take a likeness in an ordinary room, *without opening a window* or requiring any peculiar adjustment of light. Hitherto it has been generally supposed that sunshine and an open window were indispensable to the production of Daguerreo Miniatures, but an important improve-

ment just perfected proves this a mistake. The new apparatus costs only one-half the price of the other and furnishes the ability of the possessor the security of independence in a profession as honorable, interesting and agreeable as any other, by the expenditure of a mere trifle and a few days application. Can any other pursuit in life present the same advantage in furnishing the means of gentlemanly support, not to say fortune. Miniatures taken in beautiful style—terms $3.00—Daguerreo Rooms, Harrington Museum, 75 Court St.[22]

A month later, with the eye of a promoter, Plumbe changed the studio's name to the United States Photographic Institute.

Plumbe's advertisement became a classic model—"Daguerreotypes taken in all kinds of weather" would be used by professionals all over the country. Of interest in mechanical progress was the notation that likenesses could be taken in a room *without opening a window* or requiring any peculiar adjustment of light." Plumbe did not specify his type of lighting, but it could be assumed that he was one of the first to use a skylight for light balance.

Skylights later became commonplace in the daguerreian studio. Easy to install because many of the commercial buildings of this time

Seated woman, 1842.
Sixth-size daguerreotype.
By John Plumbe, Jr.
Note the contrast of lighting on the shawl.
Rinhart Collection,
the Ohio State University,
Columbus.

had flat roofs, they were usually constructed in the style of a gable roof—the pitch being about forty-five degrees. In size the dimensions ranged from about ten feet square upward. The usual skylight was composed of a number of small panes of glass; for daguerreotyping, frosted glass was used for diffused light. As the 1840s progressed, daguerreotypists added sidelights, shutters, and pulldown shades to further control the light in their studios.

Plumbe's first step in the creation of his photographic empire came in 1841, when he established himself as a wholesale distributor of daguerreotype materials. Cameras were made by a local instrument maker, J. S. F. Huddleston, and in July an account was opened with the Scovill Company for daguerreotype plates.[23] Also, Plumbe may have begun making miniature cases in 1841. His second gallery opened at 173 Chestnut Street, Philadelphia, in late 1841. From there, expansion was rapid—by the first half of 1843, he also had galleries in New York City, Baltimore, Albany, and Saratoga Springs. The famous watering place could hardly be compared to other cities in size, but as a measure of American social prestige, as the gathering place of the country's elite and wealthy citizens, it had no equal as a summer resort.[24]

Aged man with cane, ca. 1842 (or earlier). Sixth-size daguerreotype. By John Plumbe, Jr. One of Plumbe's innovations in the development of the daguerreotype was to make the background as pleasing as possible. It is probable that this image, with its primitive background, was taken in one of Plumbe's new galleries or perhaps earlier at his rooms in the Harrington Museum, Boston. The birthdate of this aged man predates the American Revolution by some years—a portrait of interest to the social historian.
Rinhart Collection,
the Ohio State University,
Columbus.

Interior of a miniature case, ca. 1844. Americans preferred their daguerreotypes enclosed in an attractive and durable case resembling a jewel box, and such cases were an important cost factor in the purchase of an image. Rinhart Collection, the Ohio State University, Columbus.

One of the problems which beset the northern daguerreotypists was what to do in the winter months when business was slow. Plumbe must have encountered this difficulty, particularly in his Saratoga Springs operation. In this era before Florida became a winter resort, many of the wealthy and the invalids sought the milder weather of the South—South Carolina and Georgia being especially popular. During the 1840s, many daguerreotypists also traveled south, usually opening their rooms in early December in time for Christmas portrait taking. Some of the visiting daguerreotypists moved from small town to small town, visiting each briefly. Those who settled in the larger towns or cities, like Savannah or Charleston, usually remained in one location throughout the season. This custom was no more than a continuation of the traditions followed by many artists of the brush for years.

Advertisement from the Savan-
nah Republican, *December 9,
1843.*

One of the artists who went south for the winter before taking up
daguerreotyping was Samuel Broadbent, who later became one of the
great daguerreian artists of the era. Broadbent advertised on May 15,
1840, as a miniature painter in Athens, Georgia, and just a short time
later he studied the new art under his friend Samuel Morse.[25] Appar-
ently Broadbent was busy as Morse's assistant in 1841, and, as far as is
known, it was not until the winter of 1843–44 that he again journeyed
south. He spent the entire season in Savannah after late November,
leaving there about the end of March.[26] The following winter he re-
turned to his old practice of traveling from town to town. In early De-
cember of 1844, he advertised that he had taken rooms in Macon,
Georgia, but would remain only a short time.[27] He closed the winter
season in Athens, where he advertised his usual color daguerreotype
portraits on May 15, 1845.[28]

In the winter of 1845, two of Plumbe's operators appeared in Savan-
nah—Mitchel from Saratoga Springs and Parsons from the Boston gal-
lery—the two featured "Plumbe's Patent Color Photographs." Reuben
F. Lovering, Plumbe's superintendent in Boston, made his appearance
in Columbus, Georgia, in December 1846.[29] And not very far away, in
Macon, William A. Perry, another Plumbe operator, opened a studio

*Seated woman holding book, ca.
1841. Sixth-size daguerreotype.
By Samuel Broadbent. An ex-
ample of the use of a black cloth
behind the head to bring out the
subject's face and matron's cap.
Wolcott and Johnson, during
their early experiments with
studio lighting, recommended a
dark material to bring out the
lighter parts of an image.
Georgia Historical Society at
Savannah.*

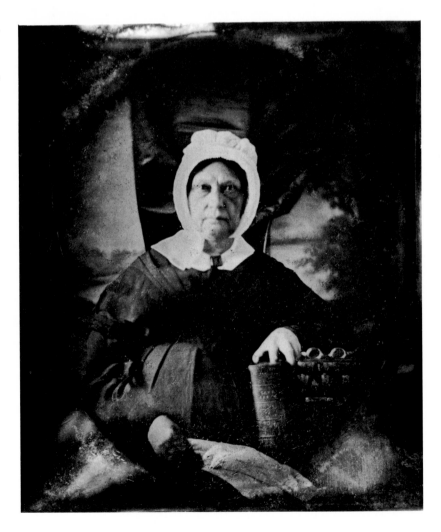

for the same 1846–47 season.[30] This seasonal influx of northern daguerreotypists was probably beneficial for daguerreotyping in general. Whatever progress had been made in the art by northern or southern practitioners would no doubt have been exchanged during these wintertime excursions.

By 1842, daguerreotypists began turning their talents toward producing portraits with lifelike colors. Early in the spring, a method of hand-coloring daguerreotypes was patented.[31] As news about the availability of colored daguerreotypes spread, those who could afford it preferred to have their portraits tinted.

John Plumbe became the leader of this new trend. In the fall of 1842, he bought the rights for a unique patent from Daniel Davis, Jr., of Boston; unlike other processes, this put color onto a daguerreotype by electrolysis. Plumbe instituted a large-scale newspaper campaign in early 1843 to bring his colored daguerreotypes to the public's notice. In his prodigious advertising, he claimed that he could produce beautifully colored portraits at half the price of others—three dollars, whereas his competitors charged five to ten dollars.

Plumbe's widespread studios became centers for instruction in the art, and he selected only his most talented students to become his op-

Sarah A. Dunwody (1827–1849), Jane Adaline Dunwody Jones (1820–1884, m. 1841), Mary Elizabeth Dunwody (1818–1884), Cobb County, Georgia, ca. 1846. Quarter-size daguerreotype. By Samuel Broadbent. Broadbent probably painted this scenic background and used it selectively for a certain class of patrons for its rich effect. He continued to use this backdrop well into the 1860s.
Jones Collection,
University of Georgia Libraries,
Athens.

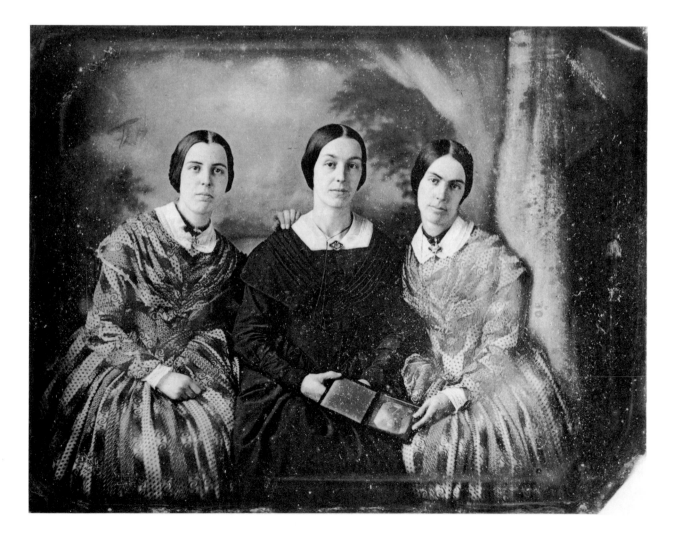

William J. Dunwody, Cobb County, Georgia, ca. 1846. Half-size daguerreotype. By Samuel Broadbent. Broadbent, of New York and Philadelphia, was one of the great masters of the daguerreian art. Georgians were fortunate in having him among them each winter during the 1840s. His itinerary usually included Macon, Athens, and Savannah.
Jones Collection,
University of Georgia Libraries, Athens.

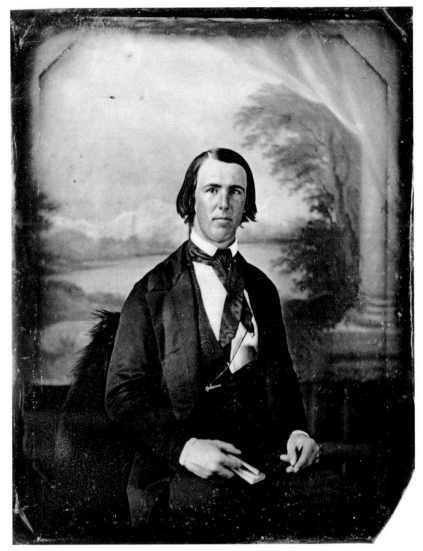

Advertisement from the Columbus Times, *December 15, 1846.*

erators. Many would later become famous photographers in their own right, long after Plumbe left the scene in 1847. Another of his contributions was the premise that daguerreotype studios should be both ornate and comfortable. He installed the theme of an "open arms" gallery—the public always welcome. As he advertised his New York gallery: "The gallery and lounge is free, frequented by the elite of the city who find it an agreeable resting place."

Awards and honors given at fairs and mechanical institutes enhanced a daguerreotypist's reputation and gave him needed prestige in an area of intense competition. Plumbe did not neglect to remind the public of the important awards he had received: "Awarded the Gold and Silver Medals, Four First Premiums and Two Highest Honors, at the National, the Massachusetts, and the Pennsylvania Exhibitions, respectively, for the most Splendid Coloured Daguerreotypes and best Apparatus."[32] The awards mentioned were from the American Institute, the Mechanic's Institute, and the Franklin Institute. Plumbe was the only daguerreotypist mentioned in the Franklin Institute cita-

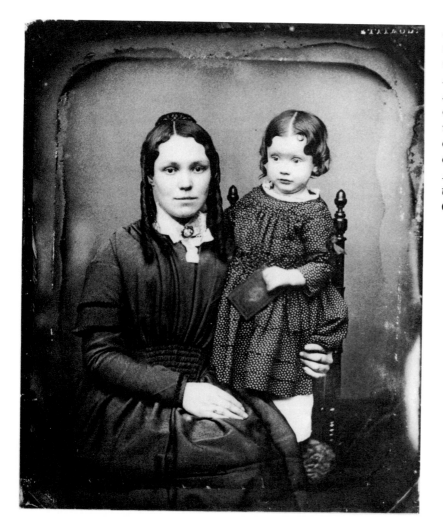

*Mrs. Ballard and Nina,
ca. 1848.
Quarter-size daguerreotype.
By William A. Perry.
Perry's success with mother-and-
child themes brought him recog-
nition in the 1850s—his fellow
daguerreotypists called him one
of the best in the country.
Rinhart Collection,
the Ohio State University,
Columbus.*

tion for 1843: "The committee notice with commendation the collection Daguerreotype Miniatures #1317, by J. Plumb, Jr."[33] The Franklin Institute awards for 1844 gave him a share in the second honors—". . . no. 2004, Daguerreotypes by Plumb; no. 1014 ditto by Langenheim, and no. 2029 by Root and Collins, all possess a very high degree of merit, and we award to each a certificate of Honorable Mention. To Van Loan of Philadelphia, for some very perfect Daguerreotype pictures, decidedly the best ever exhibited here, we award a silver medal."[34] In the 1845 exhibition, Plumbe was not mentioned; the first premiums went to Simons and Collins (very worthy) and the Langenheim brothers (very superior). Van Loan and Mayall (superior) were awarded third premiums.[35]

At the highest point of his career, Plumbe advertised that he had been awarded eight medals, including one from Ohio. Sometimes his boasting was rather homespun and picturesque: "Mr. P., not wishing to puff himself into notice, would merely mention that he has been awarded the medal, four first premiums and two 'Highest Honors' at the exhibitions . . ."[36]

By 1846 Plumbe had at least sixteen studios, spanning the country westward from New York and Boston to Dubuque, Iowa, and

The eleventh annual exhibition at the Franklin Institute, 1842. Daguerreotype. By Dr. Paul Beck Goddard. Franklin Institute.

southward to New Orleans. In addition, he owned two galleries over-seas—one in Liverpool, the other in Paris. To supply his chain with the necessary apparatus and materials, he located at least one large subsidiary in New York City—an operation called the Plumbe National Daguerrian Depot which employed an estimated five hundred people at its peak. Plumbe continued to advertise widely in city and small-town newspapers, making his name a household word.[37]

Plumbe ventured into fields only partially related to daguerreotyping in 1846, when he purchased a publishing house. Perhaps he thought he could gain more publicity by publishing a newspaper devoted primarily to his chain of galleries. In any event, the only known issue of *The Plumbeian* was printed in 1846.[38] During the same year, he also published *The National Plumbeotype Gallery*, a pictorial magazine with lithographic reproductions of daguerreotypes which he had taken over the years of prominent members of American society—government officials, statesmen, the military, the clergy, the literary, the wealthy.

During 1846 and 1847, Plumbe's preoccupation as publisher and author caused his chain of galleries to suffer from a lack of personal supervision; toward the latter part of 1847, he began selling his galleries, one by one, to meet his debts. Marcus Root later said: "His agents had stole him blind." There was possibly an element of truth in Root's statement, but among Plumbe's operators were those who were honest, reputable, and competent. Probably an examination of why Plumbe's "National Galleries" had fallen into bankruptcy would reveal that expansion had been too rapid for sound financial footing; also, competition had become intense, and a lack of direction hastened failure.

Plumbe had accomplished much before his withdrawal in 1847. Setting a high standard for the art, he had contributed vitality and innovative ideas. He had given instruction to a number of top-ranking artists, such as William Perry and Gabriel Harrison, both of whom later worked for the famous Jeremiah Gurney in New York. Perry was considered by many to have been the best operator in the art, and Harrison was known for his work with mammoth-size daguerreotypes. His influence on pioneer photography had been tremendous, and the direction he had given the art continued long after he withdrew in 1847.

The patent office, Washington, D.C., ca. 1846. Half-size daguerreotype. By John Plumbe, Jr. (attributed). This view was apparently taken from the upper floor of the general post office. Plumbe's views of Washington were said to have been displayed in his gallery in that city; possibly this view and the daguerreotype of the capitol were displayed there.
Library of Congress.

The east front of the United States Capitol, ca. 1846. Half-size daguerreotype. By John Plumbe, Jr. (attributed). The curved dome of the Capitol was designed by Charles Bulfinch and erected shortly after the War of 1812. This masterpiece of architectural daguerreotyping was believed to have been used as a model for a "Plumbeotype" which appeared in The National Plumbeotype Gallery *in 1846. Library of Congress.*

COPYING DAGUERREOTYPES

Americans liked to have keepsakes of their heroes and politicians, and many preferred having an actual daguerreotype rather than the easier-to-obtain engravings and lithographs. However, the daguerreotype was a one-of-a-kind positive photograph with no negative available to make copies—a duplicate could be made only by rephotographing the original daguerreotype. Copying daguerreotypes must have been one of the first progressions of the art—but where or when it began remains unknown. Mr. Larrabee, the itinerant daguerreotypist, had printed in his broadside of April 1840: "*Portraits* and *Views* copied in miniature." Unfortunately, he did not specifically state that he could copy daguerreotypes.[39]

Daguerreotypists were not only asked to produce copies of the prominent, but the average citizen often required duplicates for members of the family. Also, copy daguerreotypes of valuable paintings and statuary were a form of insurance to the owners. When a da-

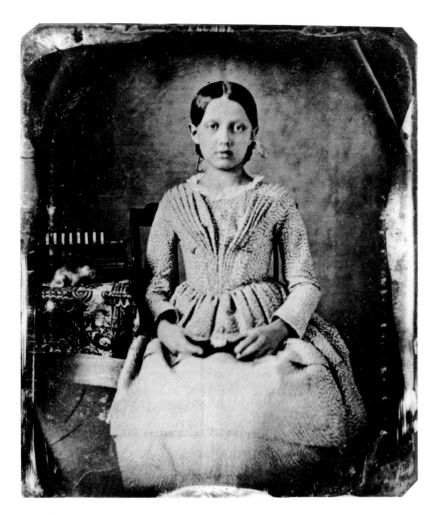

Seated girl holding miniature doll, ca. 1845. Sixth-size daguerreotype. By John Plumbe, Jr. The plate is die-stamped Plumbe (top center), indicating that Plumbe may have manufactured daguerreotype plates. Courtesy of Mary Sayer Hammond.

J. PLUMBE, Jr.
GALVANIC BATTERY.

No. 2,984. Patented Mar. 4, 1843.

guerreotypist took a portrait of a well-known man or of an unusual event, he usually reserved a duplicate copy for himself; thus he could build an image library of famous personages. Many daguerreotypists, including John Plumbe, Mathew Brady, Edward Anthony, Jesse H. Whitehurst, Albert Southworth, and Josiah Hawes, followed this practice.

A universal method for copying daguerreotypes did not seem to exist—each operator devised his own mode and apparatus for the relatively simple process. Most daguerreotypists copied the plate bare, without its protective glass or mat. To hold the image in a horizontal position and to keep it steady, carpet tacks or spring clips were often used to fasten the plate to a slab of wood. One interesting point of the operation was that, no matter how carefully the original daguerreotype was focused, and daguerreotypists as a rule were extremely careful to have a sharp focus, the resulting copy was always minutely less exact than the original. However, a copy did reverse the image back to the subject's original appearance.[40]

Since the highly reflective daguerreotype plate caused lighting problems when it was rephotographed, the individual daguerreotypist had to develop his own method for overcoming light reflections on copy pictures. The only apparatus on record designed for copying daguerre-

Plumbe patented this galvanic battery and used it as a sideline in his Albany gallery in 1843. He advertised an "Electro-Gilding and Silvering Establishment" which renewed "Surgical and Dental Instruments, Knives and Forks, Door plates, Knobs, Lamps, Candlesticks, all articles of polished brass which are so difficult to be kept bright, may be now coated with Gold or Silver for a trifle."

Advertisement from the Boston city directory, 1846.

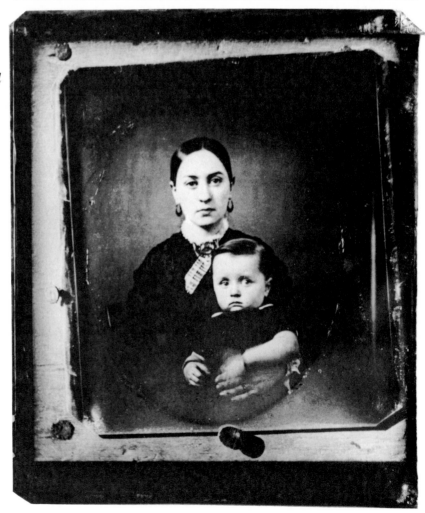

TWO SILVER MEDALS FOR THE BEST PICTURES & PLATES.

MESSRS. SOUTHWORTH & HAWES,

THE ONLY FIRST PREMIUM

Daguerreotype

ROOMS,

ARE AT 5½ TREMONT ROW,
BOSTON.

The attention of all persons interested
in procuring

DAGUERREOTYPE LIKENESSES

Of themselves or friends, or copies
from Portraits, Miniatures, Paintings,
Engravings, or Statuary, is particular-
ly invited to our specimens.

For seven years we have taken
copies of every description, *without
reversing* them ; also from Life when
desired.

We have in attendance two Ladies, and Females can have assistance in arranging their dress and drapery, and con-
sult them as to colors most appropriate and harmonious for the Daguerreotype process.

Our arrangements are such that we take miniatures of children and adults instantly, and of DECEASED persons,
either at our rooms or at private residences. We take great pains to have Miniatures of deceased persons agreeable and
satisfactory, and they are often so natural as to seem, even to Artists, in a quiet sleep.

In style of execution and picturesque effect — in boldness of character and beauty of expression — in variety of size
and delicacy of lights and shadows, we shall aim at the highest perfection possible.

Photographs painted in the very best manner if required. Cameras which will not reverse pictures, and every variety
of Apparatus, Chemicals, and Materials, furnished and warranted.

Assisted by MRS. & MISS SOUTHWORTH, they will sustain their well-earned reputation. No CHEAP work done.
Plates PERFECTLY polished. They neither use steam, humbug by false pretences, nor wear laurels won by competitors.

Mother and child, copy, ca. 1850.
Sixth-size daguerreotype.
Artist unknown.
A specimen of a daguerreotype
readied for copy work, positioned
by carpet tacks. When the copy
portrait was matted and cased,
only the image was visible.
Rinhart Collection,
the Ohio State University,
Columbus.

otypes, one which considered the lighting factor, was patented in England on March 18, 1843, by the Americans Wolcott and Johnson.[41] At the time the patent was issued, the partners were still in England— Johnson had a studio in Manchester, and Wolcott was working in London. After the customary preamble which extolled the amiability that existed between Queen Victoria and Wolcott and Johnson, the apparatus was described as "a camera in which photographic pictures on polished plates may be copied by the scattered light from the surface of the plate." While the apparatus was specifically designed for copying daguerreotypes, it was also, more important, photography's first enlarger.

The Wolcott-Johnson apparatus was a rectangular wooden box with a slanted aperture on one end of the top, directly above the daguerreotype plate to be copied. The oblique vent effectively dampered the rays of light entering the box, thus minimizing the reflective qualities of the daguerreotype image. Inside the box, at the vented end, grooves held the image plate in place; a groove for each size of plate was provided. The other, dark end of the box had a similar arrangement for holding the plate to be copied. Uniquely, the grooves could be slightly tilted on a vertical plane to help correct any distortion on the original plate. A system of lenses was placed inside the box, about

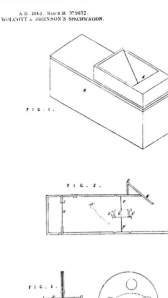

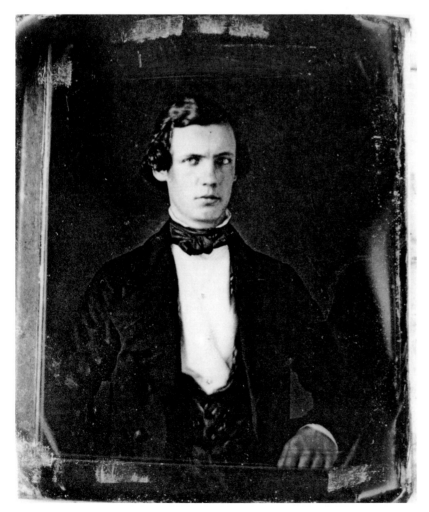

A sketch of Wolcott and Johnson's daguerreotype-copying apparatus. From the English patent. The Wolcott-Johnson invention illustrates how rapidly photography advanced in its early years. Their apparatus had a dual purpose. One, it was a copy box having diffused lighting and a unique system of lenses, especially designed for a specific photographic function; two, it was the first enlarger to be patented, a photographic manipulation which would become increasingly important during the art's formative years. Courtesy of Arthur T. Gill.

Seated young man, copy, ca. 1846.
Sixth-size daguerreotype.
Artist unknown.
An example of a daguerreotype originally taken around 1842, secured and positioned by a protector before being rephotographed. Anonymous collection.

*Portrait of a naval officer,
ca. 1820–1830, copy, ca. 1848.
Sixth-size daguerreotype.
Artist unknown.
A daguerreotype reproduction of
a painting.
Courtesy of Josephine Cobb.*

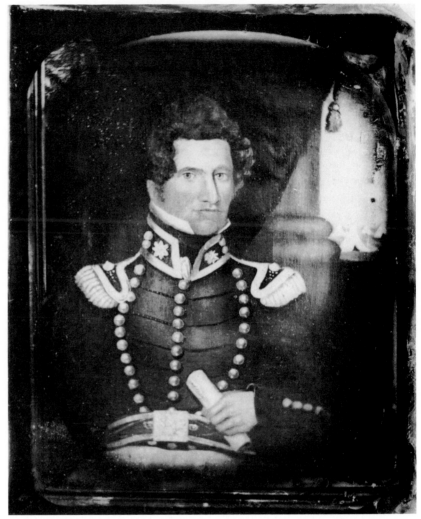

halfway between the two plates.[42] A wheel diaphragm, with four different-size apertures, was inserted between the two pairs of lenses.[43] All in all, the complex copy box was startling in contrast to the usual American method of copying daguerreotypes with an ordinary camera. Whether the apparatus was used to any extent in America is unknown.

By the close of the 1840s, copying "old" daguerreotypes had become a routine part of the profession. Public demand for portraits of deceased relatives or for copies of earlier images and, also, a persistent rumor that earlier daguerreotypes would fade and disappear helped make copy work a profitable part of the business.[44] In the 1850s, new lines were added to daguerreotype advertisements—"Daguerreotypes copied to look as well as original," or "Old pictures cleaned, free of charge, and new ones made at moderate prices."[45]

Closely allied to copying daguerreotypes was the practice, in the 1840s, of taking a number of portraits at the same time with a battery of cameras, a service only the larger studios could afford. Marcus Root, a successful daguerreotypist in Philadelphia, later related how he had captured multiple likenesses of Henry Clay on March 7, 1848:

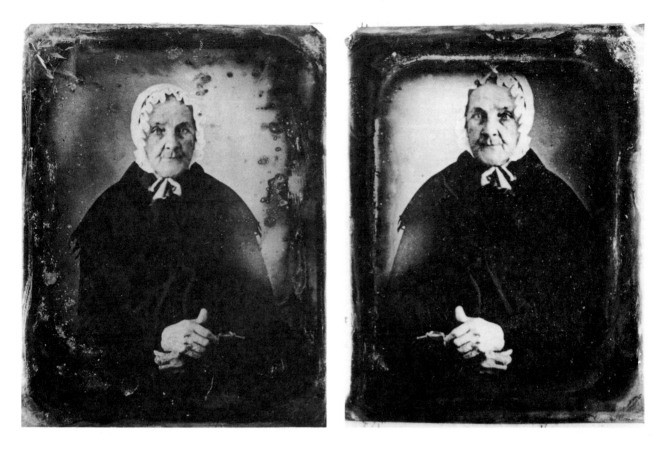

An appointment being made for my taking the daguerreotype of Henry Clay, I requested the Mayor of our city together with several other of Mr. Clay's friends who were present to keep the statesman in brisk conversation until I was ready to expose the plates to the image, and in twenty-three seconds three good portraits were taken at once. In a few seconds more his likeness again was daguerreotyped by four cameras at once, all representing him as we then saw him engaged in conversation, mentally aroused and wearing a cheerful intellectual and noble expression, of countenance. Thus seven portraits were taken in but thirteen minutes with such success that Mr. Clay remarked after inspecting them: 'Mr. Root, I consider these as decidedly the best and most satisfactory likenesses that I have ever had taken and I have had many.' These words he left in my register with his autograph.[46]

Seated aged woman, copy, ca. 1855.
Ninth-size daguerreotype.
Artist unknown.
An example of an original daguerreotype and its copy. The copy image, on the right, is less sharp in detail.
Anonymous collection.

PHOTOLITHOGRAPHY

Meanwhile, in November of 1846, John Plumbe had said that his issue of *The National Plumbeotype Gallery* would have reproductions transferred directly from daguerreotypes to print, made possible through his new invention in photolithography. The issue was scheduled for January 1, 1847, under the revised title *Pictorial Works of the National Plumbeotype Gallery, New Series*. To promote the magazine,

Plumbe sought to organize literary clubs across the country. Pre-
miums were offered to club founders as well as reduced rates for multi-
ple subscriptions. Upon payment of dues, club members could expect
to receive, over the year, 313 portraits plus a portfolio. The promotion
proved a failure, however; whether even one issue was printed re-
mains questionable.

The first knowledge about this interesting branch of photography
came when Doctor Berres, of Vienna, published his findings of May
1840 in an article titled "Method of Permanently fixing, Engraving,
and Printing from Daguerreotype Pictures." Berres fully revealed his
process, but it was clear that the innovation was far from perfected.
As the editor of the *American Journal of Science and Arts* concluded,
"We do not see how a film of metallic silver, however thin, can be
transparent."[47] However, Berres' experiments proved a catalyst for
other members of the scientific community: the prospect of photo-
duplicating the daguerreotype image by mechanical printing caused
further research, and the daguerreotype with its silvered copper made
an ideal medium for the transferal of an image and converted into a
printing block with a minimum of trouble.

Photoengraving again became a subject of intense interest in the

summer of 1841, when Professor W. R. Grove, an expert in electricity, presented a paper to the London Electric Society titled "On a Voltaic Process for Etching Daguerreotype Plates."[48] A few months later, when Grove's process appeared in print, he had added a postscript to his original paper, stating that he had encountered difficulties in transferring to paper the minute details etched on the printing plate.

Meanwhile, in America, John Draper had been pursuing his theory of photoengraving. In September 1841, he announced in the *London and Edinburgh Philosophical Magazine* that he had achieved a limited success—using isinglass dried upon the surface of a daguerreotype picture—and had made multiple copies from the isinglass block. Draper's experiments were put aside in 1842—the year he became involved with Sir John Herschel in a dispute concerning "Latent Light and a curious class of Spectral Appearance connected with Photography." Herschel had publicly given credit to Dr. Möser of Konïgsberg, Germany, for discoveries in the field, and Draper indignantly pointed out that he had made similar discoveries in 1840 (Joseph Saxton had also made like discoveries in 1839). During most of 1842, Draper was occupied in an often heated exchange of letters and articles with Herschel on the subject of light.

Advertisement from the Gem business directory, New York, 1844. The first comprehensive list of photographic portraits of the prominent.

In 1843, however, Draper was ready to reveal his process of photoengraving in an article titled "On the Tithonotype, or Art of Multiplying Daguerreotypes." The name tithonotype indicated his process of photoengraving, which was relatively easy—by pouring liquid isinglass onto a daguerreotype and performing other manipulations, he could obtain a printing block.[49] Whether his process was an improvement over the one announced in 1841 remains unrecorded. He did claim satisfactory impressions, but as far as is known the technique was not widely used.

Photoengraving experiments were also announced by Wolcott and Johnson, who had made a successful printing block in 1843. And Hippolyte Fizeau developed a process of etching daguerreotype plates in 1845. Although not much is known about the practical application of photoengraving in the formative years of photography, the professionals undoubtedly believed John Plumbe in 1846, when he asserted that he could reproduce daguerreotypes with photographic realism.

PUBLIC ACCEPTANCE

The daguerreotype became part of American life in its first seven years. The photographic studio, like the local dry goods store, had its familiar place in the American scene, and the new art was accepted just as the railroads had been accepted a few years before.

By 1846 American daguerreotypists had captured many images of the rich, the poor, the farmer, the city dweller, the young, and the old—some said every man, woman, and child in the country! Daguerreotyping had been made easy, pleasant, and painless, and any religious objections or superstitions had all but disappeared. Because

Advertisement from the Mobile city directory, 1844.

Seated man with sideburns, ca. 1844. Sixth-size daguerreotype. Artist unknown. An example of how rapidly lighting techniques had advanced by 1844. Anonymous collection.

the daguerreotypist had consistently appealed to a cross section of the population, the art had become a popular diversion. The numbers of daguerreotypes produced were enormous when compared to those of Europe; there were more working daguerreotypists in New York City than in all of England!

A summation of the daguerreotype's progress and its popularity was reflected in an 1846 article in *Littell's Living Age*. The writer began his dissertation with an appropriate quotation from *Hamlet*: "God hath given you one face, and you make yourself another." He then eulogized the great Lord Bacon as a philosopher and a seer who had, nevertheless, failed to predict photography:

> But we do not believe that he ever dreamed of daguerreotypes; nor do we think ourselves guilty of any reflections on the wisdom and sagacity of that illustrious sage, in asserting this incredulity. . . . And this leads us to observe that daguerreotypes are not now what they once were. They have emerged from the rude into the polished state. . . . We can very well recollect the first specimens that we ever saw. We then supposed that they were finely, admirably done. But this was a delusion; they were merely rude, unfinished experiments. The lily white hand of a

Seated man wearing black stock, ca. 1845. Sixth-size daguerreotype. Artist unknown. A number of daguerreotypists, particularly those of the early 1840s, followed the art tradition of writing names or other data, often with India ink, along the border on the image side of the plate. The long-term reaction resulting from the original daguerreotype process and the accumulation of tarnish on the silver plate compounds the problem of bringing out latent writings on extant daguerreotypes. The light reproduction print on the right brings out the hidden writing not easily discernible on the darker print. Anonymous collection.

fair lady, in the old style daguerreotype, had exchanged its lily whiteness for a gloomy tinge of pale green, or an intense sky-blue. Shirt bosoms that we positively know to have been of extraordinary whiteness, by the daguerrian process were villanously bronzed and smutched as by the over-heated iron of an unthrifty housewife. . . . Daguerreotypes now-a-days, though still *light*, are by no means so trifling affairs. A pale blooming cheek, a gentle or flashing eye, a smooth or wrinkled brow, are each fairly and faithfully imprinted. By enlarging the dimensions of the plate, great accuracy and beauty have been conferred. In a three by four inch likeness the projecting features are ridiculously out of proportion; thus a very modest, retiring nose, assumes the gigantic dimensions of the nasal organ of the Duke of Wellington, or of ex-president Tyler; and a chin, the fartherest possible from double, astonishes you with its more than alderman obesity. All these errors have been corrected; and now, so perfect is the 'counterfeit presentiment,' that you recognize your friends at a glance, and find yourself stretching out your hand to their daguerreotypes.

For our own part we are unable to conceive any limits to the progress of this art. On the contrary it tasks the imagination to conjecture what it will *not* accomplish. Already the daguerreotypes of the most important public characters adorn the saloons of noted artists. You have only to enter and you will find yourself in a miniature President's levee.—We anticipate the establishment of a society for obtaining daguerreotypes. Said society will employ a number of experienced professors, every art now has its *professors*, who shall visit foreign parts, the courts of Eu-

rope, the places of pashaws, the Red Sea and Holy Land, and the pyramids of Geza, and bring home exact representations of all the sublime and ridiculous objects which it now costs so much to see. . . . Apparatus so extensive will doubtless be constructed that a whole assembly may be taken at once. By this improvement the tax-paying millions of this free and enlightened republic, may be furnished with an accurate picture of the appearance and occupation of their worthy official organs in the halls of the house and senate. (This anticipation, however, is rather fanciful, than real as we are persuaded that such a project would be unanimously voted down at the first reading.) On the same plate may be represented the preacher and his hearers; and thus a curious spectator will obtain a bird's-eye-view of a whole congregation as they appear in various stages of listening, half-gone, sound asleep, and waking up. Indeed, it will be impossible for a tree to bud and blossom, a flower to go to seed, or a vegetable to sprout and come up without executing at the same time an exact photograph of the wonderful process on the skilfully prepared plates of some agricultural, botanical, or horticultural photographic society. A man cannot make a proposal, or a lady decline one—a steam boiler cannot explode, or an ambitious river overflow its banks—a gardener cannot elope with an heiress, or a reverend bishop commit an indiscretion, but straightway, an officious daguerreotype will proclaim the whole affair to the world. There can be no safety for rogues. Every apple-orchard, store-house, and coat-pocket, will contain a self-regulating photographic machine faithfully performing *its* functions, while the depredator is executing *his*.[50]

Seated man, 1845.
Sixth-size daguerreotype.
Artist unknown.
Unfortunately, very few daguerreotypists used this authentic method of dating their portraits. Later, the month was also included in this type of documentation.
Courtesy of Josephine Cobb.

Country children, ca. 1845.
Sixth-size daguerreotype.
Artist unknown.
Often it was difficult to distinguish small boys from girls, because they wore dresses over pantaloons. The young girl wears a necklace which was believed to ward off disease.
Rinhart Collection,
the Ohio State University,
Columbus.

By 1846 the art of daguerreotyping had matured enough to indicate the trend that photography would follow in the years to come. The art was slowly approaching the grandiose era of the 1850s, an era of affluent and ornate galleries and superb daguerreotypes.

Advertisement from Doggett's New York City business directory, 1844.

UNITED STATES DAGUERREIAN GALLERY,
175 BROADWAY, Up Stairs.

E. WHITE

Would respectfully call the attention of Citizens, and Strangers visiting the city, to his splendid collection of Daguerreotype Portraits, single, or in groups, from two to fourteen persons on the same plate, which, for beauty and accuracy of delineation, cannot be surpassed. Portraits taken in all kinds of weather, either with or without the colours.

The American Institute, at its late exhibition, awarded Mr. White the First Premium for the best Daguerreotype Likenesses, (for grouping and general effect,) which is but another proof of the superiority of his Portraits.

Mr. White is the sole agent in New-York for the very superior imported German Cameras and at no other establishment in the city or state can they be obtained.

N.B.—Imported German Cameras, also French and American Instruments of the very best quality, with Plates, Cases, Chemicals, Polishing Materials, &c. always on hand, for sale, at the very lowest prices.

Young people of Athens, Georgia, ca. 1846. Quarter-size daguerreotype. Artist unknown. This rather primitive background (see crease to right of curtain) was probably used by an itinerant daguerreotypist passing through Athens. The drapery so close to the young woman's head interferes with the illusion of space in the background.
Courtesy of Mary Sayer Hammond.

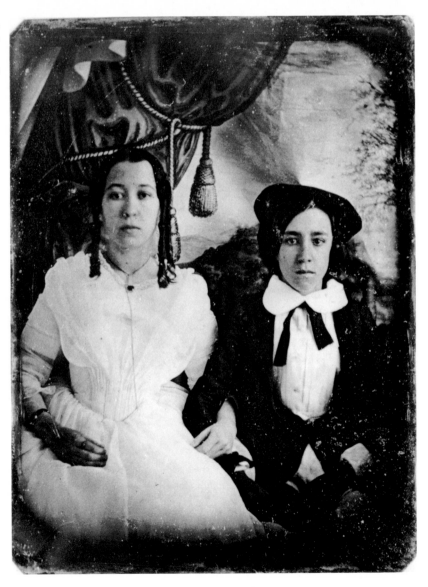

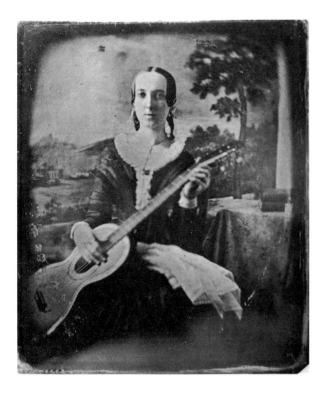

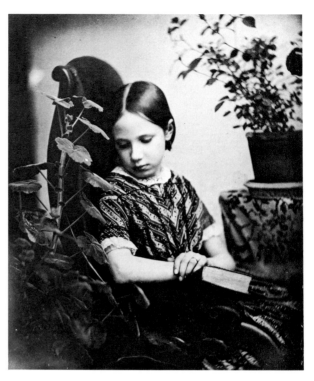

Young musician, ca. 1845. Sixth-size daguerreotype. Artist unknown.
An early use of the scenic background. Music was encouraged for young women in the daguerreian era; social gatherings were enhanced by young musicians singing ballads with the guitar as accompaniment. Courtesy of Norman Mintz.

Sleeping girl, ca. 1845. Sixth-size daguerreotype. Artist unknown.
A superb daguerreotype displaying the ultimate in artistic composition—the lighting, posing, and the use of plant arrangement, book, and drapery provide a flowing and ethereal effect. Courtesy of Norman Mintz.

Advertisement from the Gem business directory, New York, 1845. Typical of daguerreotype advertisements in the mid 1840s.

4. THE YEARS OF EXPANSION, 1847–1850

The style set by John Plumbe, with his picturesque advertisements, had not gone unnoticed by the growing number of daguerreotypists during the intense competition from 1845 to 1850. Advertising, it was found, increased profits; and full-page announcements in business and city directories and four- to six-inch columns in newspapers, some with engravings and woodcuts showing cameras and studios with people posing for portraits, enticed new patrons into daguerreotype studios. Outlets for advertising also expanded to include many periodicals and fraternal publications.

The volume of advertising reflected the ever widening circle of daguerreotypists. In 1845, for example, six professional daguerreotypists were listed in the Boston city directory; by 1856, the number had

Mr. Morgan and baby, ca. 1847.
Sixth-size daguerreotype.
By Fuller and Co.
One of the interesting portraits from the famous Morgan family daguerreotypes of Hartford, Connecticut. The daguerreotypist has shaded Morgan's face, thus focusing attention on the baby.
Rinhart Collection, the Ohio State University, Columbus.

increased to thirty-nine.[1] Philadelphia listed ten studios in 1845, which forecasted its emergence as a photographic center by 1850, and in New York the growth of the art was enormous, from sixteen galleries in 1844 to fifty-nine in 1850.[2] The same pattern of growth was reflected elsewhere—Richmond, Charleston, New Orleans, Cincinnati, and Saint Louis all experienced considerable professional expansion. Rural areas were also receiving an influx of newly established daguerreotypers.

The cost of operating a city gallery rose sharply between 1844 and 1847, due to the public's preference for an ornate studio. No longer could the new daguerreotypist expend a modest amount of money for a room, the basic apparatus, and a small stock of plates, call himself professor, and have an overflow of patrons. Gone also was the pioneer studio, where the operator hung a few small daguerreotypes in the street entrance, which led to an upstairs studio equipped with a minimum of furnishings—a carpet, a small table, and five chairs, including one with a clamp headrest. Gone, too, was a bare minimum of working apparatus, including a camera on a three-legged stand, a side-reflecting screen, chemicals, and a small closet that doubled as a darkroom.

While small towns still supported the one-room studios reminiscent of the earlier years, by 1847 the larger city practitioners had adopted the three-room gallery, which consisted of a reception room with pleasing carpeting and comfortable chairs, an operating room, and a processing room or darkroom. The operating room, where the portrait was taken, now had cameras of different sizes for specialized work, backdrops on the wall, and a standard skylight for good lighting. For the balance of the decade, the patron was catered to—his every comfort was anticipated. Perhaps the atmosphere which the daguerreian artists sought for their customers paralleled in quality and tone that of the fabulous Stewart's Department Store in New York City or the later Grand Union Hotel in Saratoga Springs. The name of a prestigious gallery became a byword that a patron could use when displaying his daguerreotype portrait to his friends!

Perhaps the Meade brothers best typify the successful rise from a humble beginning to a magnificent Broadway gallery. Charles and Henry Meade began daguerreotyping in Albany in 1842; by 1843, they had opened branch studios in Buffalo and Saratoga Springs.[3] As a sideline, they sold photographic materials and manufactured miniature cases.

Throughout the 1840s the brothers carefully cultivated a respected name among their patrons and won the respect of their fellow daguerreotypists. During the last half of the decade, they also created a favorable image internationally. In 1846 they took scenes of Niagara Falls, a favorite subject with Europeans, and sent views to the French king and to the emperor of Russia. In return they received presents and complimentary letters from these monarchs.[4]

In 1847 and 1848, Henry Meade traveled abroad to observe photographic improvements, and after he returned home his brother left for Europe; while in France, he obtained some of the most valuable photographic prizes of the decade—portraits of Daguerre. Charles Meade visited Daguerre at his home, the Château Brie sur Marne, and persuaded him to have some daguerreotypes taken, a difficult task because the master was always reluctant to be photographed.

The Meade brothers opened their New York City gallery in 1850.

Seated young man, ca. 1842.
Sixth-size daguerreotype.
By the Meade brothers.
The coat worn by this young
man slightly predates the era of
photography.
Rinhart Collection,
the Ohio State University,
Columbus.

The Meade brothers' gallery,
New York City. The reception
room. From The Photographic
Art Journal, *1853.*

Probably the most ornate gallery of its kind in the world, it had a palatial atmosphere designed to appeal to the wealthy carriage trade. The interior walls, lined with some of America's finest daguerreotypes, also displayed awards and testimonials received by the two over the years.[5]

While the Meade brothers' accomplishments were outstanding, other ambitious daguerreotypists had also become superb promoters of the art during the 1840s, whereas Europe had little to offer, with the exceptions of Antoine Claudet and John Mayall of London, to rival the productive skills of the Americans. England and the Continent lacked the great promoters of photography—men like John Plumbe, the Meade brothers, Mathew Brady, and Jesse Whitehurst. Also during this period, the genius of American invention was at its peak, and science was greatly encouraged in the education of young men both in the academies and in colleges.

Mathew B. Brady, the best known among the promoters of photography, began daguerreotyping in New York City in late 1843 or early 1844 at 207 Broadway. Circumstances surrounding his instruction in the art remain obscure.[6] However, within a year or two after he established a gallery, his reputation as a portrait photographer was unexcelled, and like his competitors he publicized his awards widely. A branch studio was opened in Washington, D.C., in 1849, and Brady sought to capture the visages of the politically prominent to add to his

Advertisement from The Daguerreian Journal, *1851.*

Advertisement from The East, New York, *1846.*

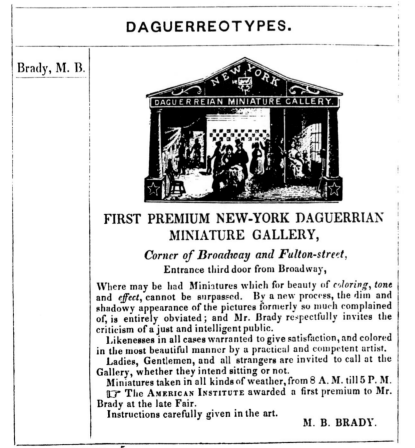

Mathew B. Brady (attributed), 1847.
Quarter-size daguerreotype.
By the Brady gallery.
At the time this portrait was taken, Brady was about twenty-four years old and already established as one of New York's leading daguerreotypists. Under magnification, the hair shows evidence of grease to flatten it; Brady's later portraits show him with beard, mustache, and spectacles. The daguerreotype was double-signed and dated by Brady himself (signature verified) with an engraving tool: "M B Brady, N. Y. 1847."
Anonymous collection.

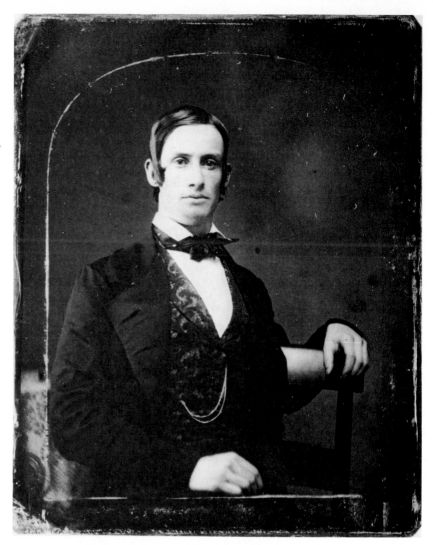

already formidable collection of famous people. However, his first venture in Washington failed and the gallery closed—competition from Plumbe's old National Daguerrian Gallery (Blanchard P. Paige, operator) had proved too intense.[7] Nevertheless, Brady's reputation as a daguerreian artist continued to grow in New York, and by 1850 he was recognized as a leader in the art.

Another organizer-promoter who opened a number of galleries in the late 1840s was Jesse H. Whitehurst of Richmond, Virginia. In 1842, Whitehurst was instructed in the art by an unidentified friend in Norfolk; his teacher was said to have been "one of the first in the country to learn the art."[8] In 1847, Whitehurst opened a studio in Richmond, followed shortly by others in Petersburg and in Lynchburg. By 1850, he had opened galleries in Washington, D.C., Baltimore, Norfolk, and New York City—seven studios in all.

Whitehurst's volume and range of publicity excelled all others, and as a flamboyant personality he was second to none. When Jenny Lind, the famous Swedish singer, came to America in 1850, Whitehurst in a munificent gesture paid the unheard-of price of 750 dollars for seats for

himself and a lady to see her perform. The ensuing publicity was well worth the price!

In exploring new money-making possibilities, Whitehurst offered daguerreotypes of theater personalities—Ole Bull, Jenny Lind, Madam Bishop, Grace Greenwood, Julia Dean, and the notorious Lola Montez.[9] The introduction of theater personalities to the public was a forerunner of the popular *carte de visite* photographs (calling card size), when the demand for portraits of actors and actresses was unprecedented. Besides his daguerreotypes of theater personalities, Whitehurst also had a sizable list of other distinguished Americans to offer the public. A partial list for 1853 included Generals Franklin Pierce and Winfield Scott, and from the politically prominent were offered Henry Clay, Daniel Webster, Millard Fillmore, John Crittenden, Lewis Cass, and Stephen A. Douglas.[10]

SUPPLY HOUSES

Meanwhile, with increasing demand from daguerreotypists and jobbers for photographic materials, many new concerns had entered the field by the mid 1840s. New York City had become a national clearinghouse for photographic supplies and pioneer supply houses like those of John Roach and William and William Henry Lewis had turned to manufacturing instruments and apparatus. George Prosch, meanwhile, probably moved to Newark, New Jersey, in about 1847, as a daguerreotypist, leaving his brother Andrew to operate his philosophical-instrument business. Another relative, Charlotte Prosch, operated a daguerreotype gallery at a new address on Broadway in 1845 and 1846. The name Perkins had been dropped from Corduan and Perkins, daguerreotype platemakers, sometime in 1840, and in about 1844 Corduan and Company ceased making plates.

In contrast to that of the Corduan business operation, the Scovill Company's record had been one of success. They had not only captured the daguerreotype plate market, but they had opened a store in New York City in 1846 which carried a full line of photographic materials.[11]

During the period from 1844 until about 1847, one of the leading national supply depots was owned by Edward White and Company of 175 Broadway, New York City. Classification of the concern was difficult because White was not only a distributor of materials, a manufacturer of high-quality daguerreotype plates, and a maker of miniature cases, but he also operated daguerreian galleries in New York, New Orleans, and possibly elsewhere.[12] His business, while supplying American daguerreotypists, also, through widespread advertising, welcomed orders from Canada, the West Indies, and South America in 1845. Despite his extensive advertising campaign, it is doubtful that White's volume of sales exceeded that of the Plumbe Supply Depot, although in 1844 he advertised his "case manufactory [as] being the largest and most extensive in the United States."[13]

New York City had four other dealers in photographic supplies in 1844, and all also offered goods and services in fields not related to photography.[14] The most interesting of this group was François A. Artault, who ran the Lafayette Bazaar on the corner of Broadway and Liberty Street. His stock ranged from perfumery to candy and sugar-

PHILOSOPHICAL INSTRUMENTS.

G. W. PROSCH,

140 NASSAU-STREET,

NEW YORK,

Manufactures all *Instruments used in Colleges*, Academies, and Schools for illustration. All instruments warranted perfect, or they may be returned.

N. B. Daguerreotype apparatus for portraits or views constantly on hand; also lenses *of every description* made to order.

Advertisement from the New York business directory, 1841.

Advertisement from The East, *New York, 1846.*

Advertisement from Sheldon and Company New York business directory, 1845.

W. H. SMITH & CO.,
(LATE YOUNG & SMITH,)
No. 4 Maiden Lane, NEW-YORK,
IMPORTERS AND WHOLESALE DEALERS IN
MILITARY EQUIPMENTS AND ARMS,
of every description.
Revolving Pistols, Rifles, Fowling Guns and Sporting apparatus, Table and Pocket Cutlery, Razors and Scissors, Fancy Hardware, in great variety, Plated, German Silver and Britannia Ware, Daguerreotype Plates and Cases, Ever-pointed Gold Pens, Jewelry, Coral Beads, Bracelets, Necklaces, &c., &c.

Advertisement from The East, *New York, 1846.*

NATIONAL MINIATURE GALLERY,
No. 247 Broadway,
NEW-YORK.

Likenesses by the Improved Daguerreotype, various sizes, and of the most delicate execution, may be obtained at the above Rooms during the day.
This Gallery contains, as its name imports, several hundred perfect Likenesses of eminent American Statesmen, and other distinguished characters, and is constantly receiving additions.
Chemicals, Plates, Cases, Cameras, and other Apparatus and Materials connected with the Art, constantly on hand and for sale. The above articles are selected with great care, and warranted in all respects. Orders promptly attended to.
ANTHONY, CLARK & CO.

Advertisement from The East, *New York, 1846.*

plums; the emporium also had an "ICE CREAM saloon and OYSTER SALOONS," as well as two daguerreotype galleries where, in 1846, a Mrs. H. Shankland took a "PERFECT LIKENESS FOR ONE DOLLAR."[15] Another New York dealer whose range of merchandise had little affinity to daguerreotyping was Louis B. Binsse, who had an upstairs store at the corner of William Street and Maiden Lane. Along with daguerreotype plates, apparatus, and chemicals, Binsse specialized in imported French cloth and fancy goods—hairbrushes, pins, and buttons.[16]

The classification of daguerreotype supply houses as such was peculiar in the mid 1840s. Daguerreotypists all over the country had from the beginning of the art advertised supplies as a sideline. The Lewis family, while making daguerreotype apparatus, also operated a hat factory and as another sideline owned a daguerreian gallery. The Scovill Company, even after opening a New York outlet, still primarily manufactured metal products, such as military brassware and buttons.

But the era was almost over for small dealers like Louis L. Bishop of New York City, who in 1845 advertised his plates, chemicals, apparatus, and galvano-pasty while not relinquishing his title as daguerreotype artist, with yet another sideline as gilder and silverer on all metals.[17] The widespread public acceptance of image making in the latter half of the decade caused an increased demand for daguerreotype materials and apparatus. Competition would make the small part-time supplier obsolete, and by about 1846 there arose an obvious need for central supply houses which would carry a complete stock of daguerreotype supplies. The pattern followed that of the traditional American standard of merchandising—selling finished materials from the manufacturer through the wholesaler and on to the retailer. The quantity of a single item sold by a manufacturer was large, too large for a retail outlet of limited finances to stock—hence the need for a wholesale distributor, often called a jobber, to dispense smaller quantities to retailers. An immense amount of capital was necessary to establish such a large central depot, but the demand by 1847 suggested that such a wholesale establishment would prosper.

By the time the well-financed Scovills opened their New York branch, another firm was established, one which would become the largest supply dealer in America by 1850—that of Edward Anthony and Company. Edward Anthony was an astute entrepreneur, well versed in all branches of daguerreotyping by the time he founded Anthony, Clark and Company in 1845—he had been one of America's pioneer daguerreotypists. Apparently, he and his brother Henry had opened a small supply house in 1842, an establishment separate from his daguerreotype gallery, a venture the art could hardly support in that year.[18]

However, in 1845, probably sensing that the time was auspicious, Anthony opened the first supply depot to exclusively serve daguerreotypists. Where he and J. R. Clark secured the necessary financial backing for their enterprise is unknown. Sometime in late 1847, Clark withdrew from the firm, and Anthony changed its name to E. Anthony and Company—a name quickly destined to become famous all over the country as a source of high-quality daguerreotype materials. The failure of the Plumbe supply depot must have helped boost Anthony's sales, and in early 1848 an aggressive sales program was designed to

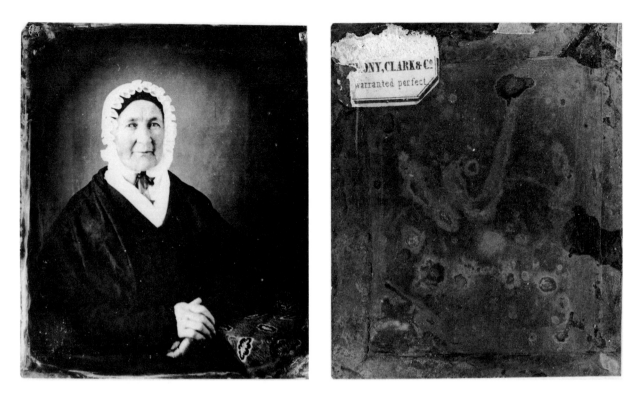

make his company's name a byword among daguerreotypists.[19] Large quantities of French daguerreotype plates were imported and stamped with his name near the French hallmarks, thus providing the Scovill plates with formidable competition. Anthony advertised in out-of-town newspapers, and he hired Henry Hunt Snelling as sales manager, which proved to be an astute choice.

As the major American port, New York City would continue as America's center for daguerreotype supplies throughout the 1840s and 1850s; however, in the last half of the 1840s, a number of wholesale houses in other cities were also founded. In Cincinnati Peter Smith, who sold a general line of imported merchandise, began stocking daguerreotype materials in 1846.[20] His new line proved so profitable that

Aged woman wearing matron's cap, 1846. Sixth-size daguerreotype. Artist unknown. A specimen of an Anthony star brand plate. The rear of the plate (right) has an Anthony, Clark & Company label.
Anonymous collection.

A sales receipt from Edward Anthony to L. L. Hill for the purchase of eight dozen daguerreotype cases in 1849. Courtesy of Walt Craig.

Advertisement from The Daguerreian Journal, *1851.*

he started dealing exclusively in daguerreotype supplies, and he became the largest dealer in the West in the 1850s. In Baltimore F. W. and Richard King opened a supply house in 1848, stocking it with a full line of materials for daguerreotyping.[21] In the 1850s they began manufacturing instruments, cameras, plates, cases, and chemicals. In Boston Benjamin French, a daguerreotypist since 1844, decided to open a supply house in 1848 and thereafter devoted all his efforts toward building a prosperous business; at one time French was reported to have had the exclusive agency for the distribution of Voightländer cameras in the United States.[22]

By 1849 the photographic complex had assumed a definite shape. The central supply depot was a reality—a clearinghouse which advised daguerreotypists of the latest innovations in apparatus, materials, and chemicals. Apparatus manufacturers and casemakers found favorable outlets for their products from the wholesale supply houses, although there did exist a tendency for the very large galleries to buy directly from the manufacturer whenever possible.

INSTRUCTION IN PHOTOGRAPHY

During the first years of photography, instruction in the art was generally a personal affair: newly instructed pupils taught others for a modest fee. Secrets of the process were either shared among friends or bought from a gallery owner. A few hints on advancements in the photographic process could be gleaned from academic journals in other fields published at home and abroad, but the information in their articles was usually outdated by the time it reached the reader. To keep abreast of new ideas and developments, the professionals needed a journal of their own.

In 1849 Henry Hunt Snelling, sales manager for Anthony, wrote the first comprehensive survey of the American daguerreotype—*The History and Practice of the Art of Photography*. The book appeared just a few months before Samuel Humphrey, a daguerreotypist from upstate New York, published the first periodical devoted to photography—*The Daguerreian Journal*, which would be known as *Humphrey's Journal* after 1852. The new journal, its first issue being published in November 1850, explored both foreign and domestic improvements in the art and, of great interest to daguerreotypists, newsy items about fellow practitioners were recounted.

Another 1850 publication was Levi L. Hill's *A Treatise on Daguerreotype*, a work in four parts which contained a wealth of easy-to-understand information about the art by an experienced operator. The publication was so instructive that Hill used it as a textbook for his daguerreian school, founded in 1850. Abandoning the traditional informal teaching of the art, Hill patterned his school after the private academy with boarding facilities; he provided equipment, textbooks, and diplomas. The school was advertised in the *Kingston Journal* throughout the year of 1850:

HILL'S
DAGUERRIAN SCHOOL
THE WHOLE ART OF DAGUERREOTYPING TAUGHT
IN FROM TWO TO FOUR WEEKS

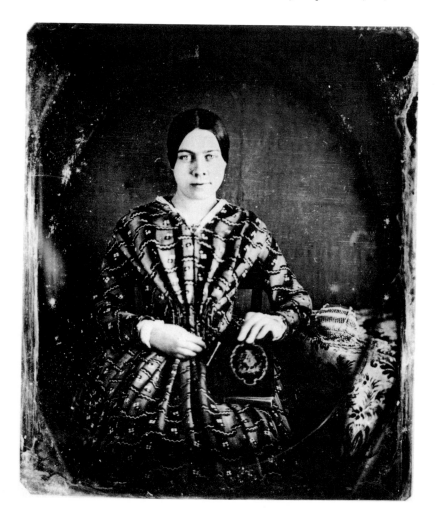

Elizabeth Patterson, April 1847.
Sixth-size daguerreotype.
Artist unknown.
The date is given in a note in the
rear compartment of the case.
Rinhart Collection,
the Ohio State University,
Columbus.

The subscriber, a practical Daguerrian Artist of long experience, and author of "The American Treatise on Daguerreotype," . . . the most perfect modes of manipulation with all the late improvements taught in a manner so simple, that any person of common taste and judgement may become within the time specified, a first class operator. At the close of term each pupil is furnished gratis with a diploma, and a copy of the "Treatise" which contains a full expose of all the secrets and mysteries of the art . . . a large edition of this book, at $5.50 per copy has been sold, and it is universally approved by artists throughout the U.S. . . . The average profits of a first class Artist who devotes his time to the business are from $100–$200 per month.

TERMS

Price for Tuition $25.00—Board in subscribers or other families $2.00 per week. Cost of an outfit—camera and other apparatus, chemicals and a small amount of stock from $50.00–$75.00—according to size and quality apparatus. Price charged in New York and other large cities—$50.00–$100.00 (tuition). Address all communications to Westkill, Greene Co., N.Y.

References:
W. & W. H. Lewis—142 Chatham St., N.Y.
M. A. Root—143 Chestnut St., Phila.
Meade & Bros.—Exchange Bldg., Albany, N.Y.
James Ketchum, Esq.—Dover, Dutchess Co., N.Y.
Rev. H. L. Gros
Gen. Hommell—Editor of Ulster Telegraph, Saugerties, N.Y.
R. H. Hill, artist, Kingston, N.Y. brother of Hill
Lexington, Green Co., N.Y. Nov. 1, 1849.

THE INNOVATORS

During the first decade of photography, a few practitioners directed
their own ideas and special talents toward giving individual studios
distinction, and in so doing they also made new contributions to the
art. In naming new or improved processes, a tradition was followed by

*Mr. Morgan of Hartford, ca.
1847.
Quarter-size daguerreotype.
Artist unknown.
A nonstudio portrait. Very often
daguerreotypes made outside of
the gallery were of the infirm or
the deceased. However, an excep-
tion was made if the patron were
wealthy and the fee commensur-
ate with the travel expenses. The
above subject was a member of
the prominent John Pierpont
Morgan family of Hartford.
Rinhart Collection,
the Ohio State University,
Columbus.*

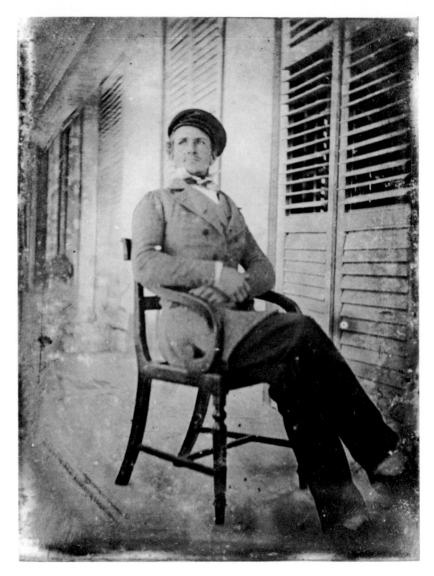

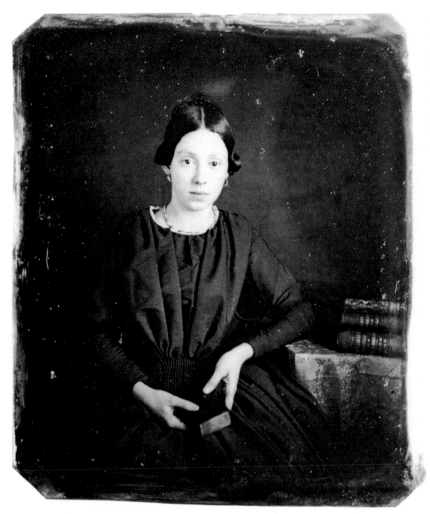

adding "otype" to the name of the inventor or to a word meaningful to
the inventor. For example, William A. Pratt of Richmond introduced
the celerotype in 1848, a process now unidentified, but the name was
distinctive to the Pratt gallery.[23] After Levi Hill announced his color
process in 1850, Samuel Humphrey called the color specimens hill-
otypes, although Hill preferred to call them heliochromes. Most of the
"otypes" were not patented; some, like Hill's discovery, could not be
patented.

John Whipple's great invention, the crystallotype, served as a cata-
lyst to the art of paper photography in the United States. Among his
fellow pioneer daguerreotypists, Whipple was considered a genius—
and perhaps he was. He applied photography successfully to fields of
scientific research and, through his achievements, was recognized
both at home and abroad. He created a number of outstanding innova-
tions and, more than any other pioneer daguerreotypist, he would in-
fluence the direction of American photography.

Whipple's interest in daguerreotyping began in 1840, when he set-
tled in Boston; by chance he met a daguerreotypist who was searching
for chemicals to use in the new process. After this meeting Whipple,
using his knowledge of chemistry, drifted into the manufacturing of

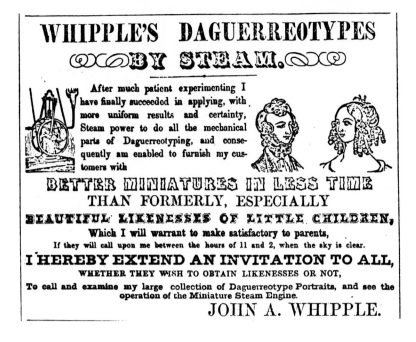

chemicals for the new art; for a while, as far as is known, he was the only supplier in Boston. Restless, and finding his contact with chemicals harmful to his health, he then began his long career in photography.[24]

In 1844 and 1845, Whipple was in partnership with Albert Litch, another pioneer who later became an operator for Jeremiah Gurney in New York. Litch withdrew and, in 1846, Whipple was operating his own gallery, where he soon put some of his radical ideas to work.[25] For example, he installed a miniature steam engine in his gallery—it served the dual purpose of attracting patrons and making them comfortable. The engine turned an immense fan which, Whipple advertised, kept his "sitters cool in the hot sultry days of summer." He also used the steam engine to turn "the cleaning and buffing wheels."[26]

Also in 1846, Whipple began his often discouraging experiments to produce a negative on glass through the use of milk as the bonding agent for the sensitized material. Toward the end of the decade, he discovered that albumen, or the white of an egg, would best serve the purpose—and his process was patented on June 25, 1850. The paper prints made from the glass negatives were called crystallotypes, an invention which was probably Whipple's greatest contribution to photography. However, although winning distinguished awards, the prints could hardly compete with the beauties of the daguerreotype in 1850.

After Whipple's glass negative was patented, he was widely acclaimed as an important contributor to scientific research. One of his projects, an effort to daguerreotype the moon, had begun in 1848 at the Harvard College Observatory, which had the largest telescope then in use.[27] After innumerable failures, Whipple—with his assistant, William B. Jones—finally succeeded in clearly delineating a star on a daguerreotype plate in 1850. This was followed in March 1851 by an excellent daguerreotype of the moon—a three-inch image was taken

Daguerreotype of the moon, August 6, 1851. Quarter-size daguerreotype. By John A. Whipple. The date of the image is documented on the rear side of the plate, and the date also appears in the telescope log of the Cambridge Observatory. Whipple won a medal at the Crystal Palace exhibition in London in 1851 for one of his daguerreotypes of the moon.
Courtesy of Donald Lokuta.

with an exposure time of thirteen seconds. Other successful images were made shortly afterward.[28]

Members of the American Philosophical Society were, of course, extremely interested in Whipple's images of the moon. At a monthly meeting of the society later in 1851, two daguerreotypes of the moon were placed on a table for examination—one showed the moon in its first quarter, the other when it was nearly full. The society's enthusiasm was reflected in its report:

> Hitherto any attempt to portray the scenery of the moon by drawings, has been entirely unsatisfactory in conveying a true impression of its diversified appearance through a telescope; but he now hoped, from the constant improvement in the art of daguerreotyping, that an enlarged picture of the moon's disc may be obtained from which engraved maps might be made, so that

selenography of our satellite may be studied in our schools, in conjunction with the geography of our planet.[29]

Whipple continued his efforts to combine photography and astronomy, and at a later date he took "Magnitudes of the Stars" and a magnificent daguerreotype of the sun and its spots. His efforts to adapt photography to the sciences also included experiments with photomicrography on daguerreotypes and the use of artificial light as a means to take images. For these achievements, he received the acclaim of Europeans, possibly more than did any other American photographer in the era of the daguerreotype.

Many scientific men lost interest in the art after the first few years of daguerreotyping, and subsequent improvements were mostly made by the daguerreotypists themselves. However, a few academics continued to be interested in certain facets of the process. Back in 1840, Benjamin Silliman and William Goode had conducted preliminary experiments to record images with artificial light.[30] In 1850 Silliman, while at the University of Louisville, again experimented with artificial light—this time he was highly successful, using better lighting equipment and improved daguerreotype procedures. In the 1850 trials he used fifty pairs of Bunsen's carbon batteries, which gave him a consistent light not possible in his earlier experiments. He brought in J. W. Stancliff, an excellent Louisville daguerreotypist, to operate the camera and to tend to the processing of the daguerreotypes. Through trial and error Silliman discovered that the best results were obtained when the lights were placed twelve feet from the object to be photographed, the camera placed slightly closer; good images could be recorded in about forty seconds, although they had a tendency to be a little "solarized" (if that term could be applied to galvanic light). His experiments included portraits of his friends, and he cautioned: "In the use of this light, care is required to avoid the deep shadows which are not relieved as in the sunlight by natural reflection, and unless attention is paid to this circumstance, the impression appears disfigured by shadows of almost inky darkness."[31] His prediction for photography through artificial light fell far short of later reality: ". . . in the United States, where fine sunlight may be obtained almost any day . . . these trials may be considered of minor importance. . . . But in the dark and murky atmosphere of London, it may become an important auxiliary in the art."[32] The Silliman experiments had proved that special lighting equipment was still far too cumbersome for practical use but that, with a proper lighting vehicle, photography by artificial light could be performed without difficulty.

AWARDS

As the daguerreotype continued to reflect the American way of life on its silvered plates, learned societies were somewhat puzzled regarding the classification of daguerreotypes for exhibition. The Franklin Institute in 1847, for example, was uncertain as to their placement: "Although the judges do not consider this department as strictly belonging to the *Fine Arts*, still good collections are attractive and add to the interest of our exhibitions."[33]

In many ways the report of the institute's 1847 exhibit reflected the general level of daguerreotyping and its progress nationwide:

> Daguerreotypes—In this department there are some very excellent specimens in the exhibition, and the judges think they see a progressive improvement in this branch of art. They have not recommended an award in favor of any of the competitors, but are disposed to rank first in order, the collections of McClees and Germon as containing the largest number of superior specimens. Next to these they place those by M. P. Simons—which however, are closely followed in excellence by those of M. A. Root. The collection of Langenheim is much smaller than at former exhibitions; but shows pieces of great merit.

Some of the reluctance to classify daguerreotypes as a fine art must have come about because of the rapid expansion of related fields—items related to photography were classified as philosophical apparatus and were placed in a separate display area. For example, magic lantern slides and a portable darkroom fell into this category. The committee wrote that the magic lanterns made by Henry S. Nolan of Philadelphia were "Believed to surpass the European paintings of the same kind, in accuracy of design and in clearness and delicacy of execution. A Second Premium." The display of a portable darkroom must have excited the amateur daguerreotypist, particularly in the Phila-

Youth and age, ca. 1847.
Quarter-size daguerreotype.
By Montgomery P. Simons.
Simons was a master of ivory-typing—an artistic treatment which brought out beautiful flesh tints in his portraits.
Rinhart Collection,
the Ohio State University,
Columbus.

City of Cincinnati, waterfront, 1848.
Whole-plate daguerreotype.
By Charles H. Fontayne and William S. Porter. The two scenes are from the magnificent set of eight whole-plate daguerreotypes which comprise a panoramic view of the Ohio River and Cincinnati from Fulton Street to the end of Vine Street. This remarkable panorama, first exhibited at the Franklin Institute in 1848, was later displayed at the Maryland Institute and at the Crystal Palace exhibition in 1851.
Cincinnati Public Library.

delphia area, where a number are recorded in the history of photography. The darkroom was described in the institute's report as "portable Daguerreotype apparatus, invented by A. C. Harrison, and deposited by Elliot and Gunn of Philadelphia. An ingenious and compact arrangement, exceedingly convenient for travelers, obviating the necessity of making a darkroom at every place of operation. Deemed worthy of a Second Premium."[34]

While the exhibit at the Franklin Institute reflected the high quality of the daguerreotypes being produced, it could not in any way show the activity and the extreme degree of competition which had developed during the decade. However, the institute, although favoring Philadelphians, was still a national barometer for daguerreotyping in 1848. The journal for that year read:

No. 1338. Daguerreotype portraits, by M. A. Root, Philadelphia. A First Premium; No. 1399. Daguerreotype portraits, by M. P. Simons. A First Premium; No. 1240. Daguerreotype views of Cincinnati, by Fontayne & Porter. A First Premium; No. 1292. Daguerreotype portraits, by England & Gunn, Philadelphia. A Second Premium; No. 1209. Daguerreotype portraits, by McClees & Germon, Philadelphia. A Third Premium.[35]

A first premium certainly did justice to entry 1240—a magnificent eight-plate panorama of Cincinnati's waterfront, covering a vista of two miles. The eight plates assembled the scenic view with exact precision. The panorama was a measure of the remarkable progress made

by American daguerreotypers in the taking of outdoor scenes since 1839—this masterpiece ushered in an era which produced many fine daguerreotype panoramas. The taking of a panorama required an utmost degree of skill to turn or adjust the camera to eliminate any part of the previous plate; the scenes on the plates had to mesh perfectly to form an uninterrupted scene.

The Franklin Institute's exhibition of 1849, in fine arts, was disappointing—for the single daguerreotype, Marcus Root received a first premium for "unrivaled excellence." However, something new was added to the display that year when William and Frederick Langenheim exhibited their talbotypes and hyalotypes. The Langenheims had acquired Talbot's patent for paper photographs for the United States on June 26, 1847, but it was not formalized until May 11, 1849. In 1850 they patented their glass photographs with a frosted background or hyalotypes. The judges commented favorably on this display: "A new feature in the exhibitions; creditable to the ingenuity, skill, and enterprise of the producers—A First Premium."[36] The appearance of paper photographs at the institute's exhibit marked a trend which would be commonplace within a few years; however, in 1849, the daguerreotype was still the highly superior photograph in America.

In the early years, the only arenas for judging daguerreotypes had been the prestigious American Institute in New York City, the Franklin Institute in Philadelphia, and the Massachusetts Charitable Mechanic Association in Boston. During the last half of the 1840s, however, competitive daguerreotype exhibitions were held in other lo-

*Patent drawing for an improve-
ment in the daguerreotype appa-
ratus for panoramic views. Van
Bunschoten, Woodbridge, and
Mann, April 17, 1849.*

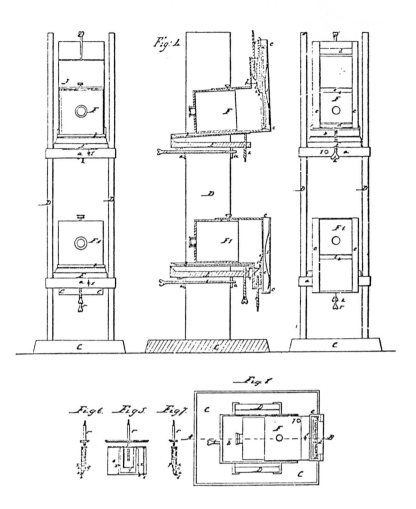

cations. While awards from the major institutions continued to be
highly valued nationally, displays of daguerreotypes assumed a more
local flavor, particularly in rural areas. The annual small city or county
fair had long been part of American life, a place where local business-
men, farmers, and homemakers demonstrated their talents and prod-
ucts to their neighbors.

The regional daguerreotypist generally had little trouble with local
competition, but a display at the county fair provided a chance to so-
licit patronage. Exceptions to this occurred in the larger cities of the
South, where the seasonal daguerreotypists sought to escape the
rigors of the northern winters—an influx often resented by local pho-
tographers. In November 1849, for example, Montgomery Simons, a
pioneer daguerreotypist from Philadelphia, arrived in Charleston and
opened a gallery at 208 King Street. He advertised lavishly in the
Charleston Courier, which included such critical praise from Phila-
delphia newspapers as "Mr. Simon's pictures are more like delicate
ivory paintings than ordinary daguerreotypes," and "The perfection of
the eyes is wonderful."[37]

Seated young man, ca. 1849.
Sixth-size daguerreotype.
By Marcus A. Root.
The Franklin Institute's da-
guerreotype display was disap-
pointingly small in the 1849
exhibition. Marcus Root was the
only entry and won a first pre-
mium award for "unrivaled
excellence."
Courtesy of Wiley Sanderson.

Seated man, ca. 1849.
Sixth-size daguerreotype.
By the Langenheim brothers.
The slightly turned subject, with
arms crossed, was a pose favored
by the Langenheim gallery. Their
annual photographic displays at
the Franklin Institute seldom
failed to win an award or honor-
able mention.
Rinhart Collection,
the Ohio State University,
Columbus.

At the time of Simons' arrival, Charleston already had a surplus of permanent daguerreotypists—George Cook, Charles L'Homdieu, and others, all masters of the art. At an early date the city had become a mecca for visiting daguerreotypists who combined business with the pleasure of wintering in the South. Samuel Broadbent and the Perry brothers had already been formidable seasonal competitors, so Simons' arrival created no undue approbation among the local practitioners. However, unlike the others, Simons was aggressive—in late November, he entered his finest daguerreotypes (he specialized in the ivory-hue daguerreotype) in the fair of the South Carolina Institute and was awarded a silver medal, much to the chagrin of local photographers, one of whom protested vehemently. It was now Simons' turn to feel aggrieved, and he advertised in the *Courier* on December 13:

> We have understood that a brother artist has, upon several occasions, expressed dissatisfaction regarding the award made us at the late fair held in this city. . . . Is it because we have by our own industry, perseverance and indefatigable researches in the profession, always been successful . . . Or is it because our pic-

Man with violin, ca. 1849.
Quarter-size daguerreotype.
By S. S. Miller.
America was becoming musical in the daguerreian era, and native musicians played to large receptive audiences, stimulating an interest in music in many towns and villages throughout the land. A valuable documentation of a nineteenth-century violin.
Courtesy of Wiley Sanderson.

tures "were not all made in this state?" As an American citizen we claim the privilege of submitting our specimens before the scientific bodies of each and every state in the Union. . . . Notwithstanding this, we are willing to meet the objection by placing three daguerreotype pictures which were executed by us in this city . . . along side any three our neighbor may select . . . the respective merits of each to be decided by a committee of artists. . . . This we conceive to be the fairest way of settling the question. . . . We hope our disappointed friend will be willing to have it honorably settled.[38]

Simons' reply apparently ended the controversy, but the affair serves to illustrate the amount of resentment caused when out-of-town daguerreotypists exhibited at local fairs, and it gives a measure of the intense competition pervading the art by 1849.

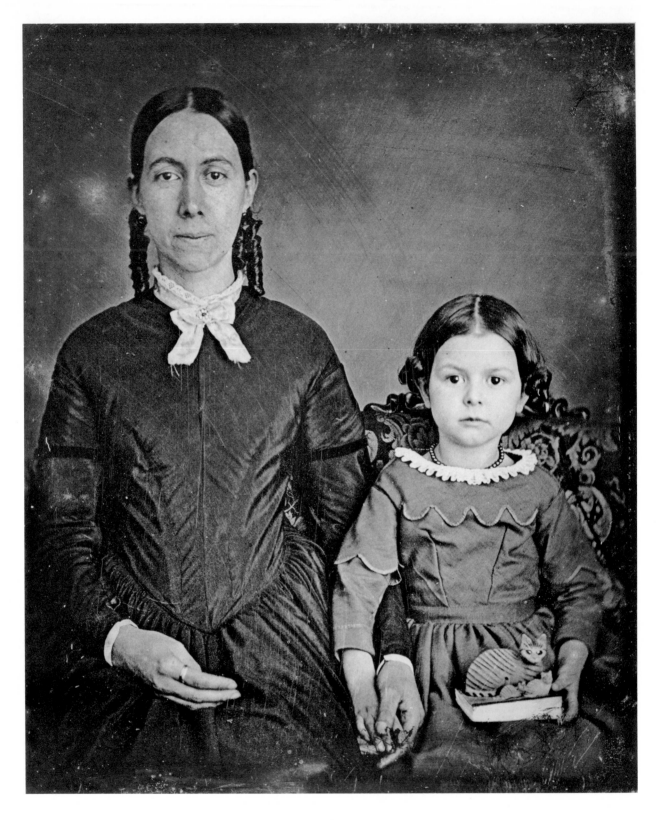

Mother and daughter with calico Rinhart Collection,
cats, ca. 1849. Quarter-size da- the Ohio State University,
guerreotype. Artist unknown. Columbus.

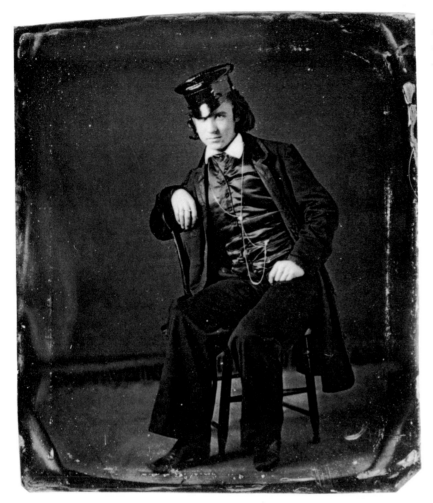

Seated young man, ca. 1850.
Sixth-size daguerreotype.
By Montgomery P. Simons.
Courtesy of Wiley Sanderson.

"THE DAGUERREOTYPIST"

The writers of 1846 had noted that the daguerreotype had become part of the American way of life, but the writers of 1849 called it an integral part of the American character. T. S. Arthur, who would begin publishing *Arthur's Home Magazine* just a few years later, wrote a series of articles for *Godey's Lady's Book* in 1849 titled "American Characteristics." His fifth article, "The Daguerreotypist," discussed the effects that the daguerreotype had had on American thought and conduct:

> If our children and children's to the third and fourth generation are not in possession of portraits of their ancestors, it will be no fault of the Daguerreotypists of the present day; for, verily, they are limning faces at a rate that promises soon to make every man's house a Daguerrean Gallery. From little Bess, the baby, up to great great-grandpa, all must now have their likenesses; even if the sober Friend, who heretofore rejected all the vanities of portrait-taking, is tempted to sit in the operator's chair, and quick as thought, his features are caught and fixed by a sun-

Advertisement from the Savannah Republican, *February 27, 1850.*

Advertisement from William's Cincinnati directory, 1850. By 1850 daguerreotypists were becoming more sophisticated in their advertising, and a variety of photographic trade emblems or logotypes were appearing. A general style employing cherubic figures similar to this Faris prototype became popular after the carte de visite *became the photographic fashion in the 1860s.*

beam. In our great cities, a Daguerreotypist is to be found in almost every square; and there is scarcely a county in any state that has not one or more of these industrious individuals busy at work catching 'the shadow' ere the 'substance fade'. A few years ago it was not every man who could afford a likeness of himself, his wife, or his children; these were luxuries known to those only who had money to spare; now it is hard to find a man who has not gone through the 'operator's' hands from once to a half-a-dozen times, or who has not the shadowy faces of his wife and children done up in purple morocco and velvet, together or singly, among his household treasures. Truly the sunbeam art is a most wonderful one, and the public feel it is a great benefit![39]

The number of American daguerreotypists had increased in a near arithmetic progression year by year. Many men had practiced the art for only a brief period and had drifted on to other occupations; others had stayed on to build careers. The 1850 census revealed a total of 938 daguerreotypists in the United States, a statistic which did not include the broad spectrum of allied trades and industries.[40] There was probably a minimum of 5,000 persons employed part- or full-time to help service the daguerreotyping profession, including those working to produce photographic supplies, apparatus, and miniature cases. Other supportive trades would also be indirectly involved.

In many ways this era of intense competition was a very profitable one for the daguerreotypist—the cut-rate operator had not yet appeared to any appreciable extent. The average price for an image in its miniature case ranged from three dollars to ten dollars, depending on the size of the image and on the quality of the case; materials usually cost the operator about fifty cents, seldom more than one dollar; and thus a very good gross profit remained for expansion—expansion that was steadily reflected throughout the decade by larger and more comfortable galleries. Unquestionably, photography was on a sound financial basis by the beginning of the 1850s.

5. THE AFFLUENT ERA, 1851–1860

By 1850 America had become a formidable power. The population of the United States now nearly equaled that of England, and Americans stood ready to challenge England's industrial might and its inventive achievements. Current innovations and speed in transportation had made America an industrial nation—its railroads were fast becoming the best in the world, although the English had been the pioneers. It was America that the czar of Russia had turned to, in 1847, when he built his railroad from Moscow to Saint Petersburg.[1] In agriculture, America was ahead of Europe: in 1850 more than 118 million acres of improved farmland were being cultivated; Cyrus McCormick had perfected his reaper by 1845; and by 1850 factory production of the reaper had reached one thousand six hundred machines, with five hundred to be exported to England! Also, the American farmer had developed new strains of fruits and vegetables.[2] On the seas, fast-sailing clipper ships challenged Britain's supremacy, and the United States Navy had equipped its vessels with shell-firing cannons and had introduced the screw-driven warship.[3]

Americans were also revolutionizing industrial output with innumerable inventions, especially those involving improvements in woodworking machines. In science, Joseph Henry had discovered an electrical radio wave impulse, and Samuel Morse had successfully marketed his telegraph. Moses G. Farmer was experimenting with electricity and had constructed the first electric train—a two-car miniature.[4]

When gold was discovered in 1848, the eyes of the nation turned westward to California. Gold fever seized the population, and the lure of quick riches changed many formerly placid workers into men with sifting pans and a purpose.[5] The gold rush would also bring daguerreotypists into the goldfields of the Far West, since it provided them with their first opportunity to record a great historical movement.

The year 1851 was an exciting one for photography. In November 1850, Levi L. Hill of Westkill, New York, had announced in his technical manual *The Magic Buff* that he had reproduced the colors of nature on daguerreotype plates. The announcement would begin years of controversy among professionals: was the process valid or was it a hoax (see chapter 8)? Also during the 1850s innumerable patents were issued for various improvements in photographic equipment and, often, these concerned ingenious processes. For example, thirteen plate-holding devices were patented between 1850 and 1855.

Another event of importance was the publication of *The Photographic Art Journal*, which had its beginning in January 1851; edited by Henry Snelling, the publication followed the first issue of *The Daguerreian Journal* by only two months. After volume 6, the title became *The Photographic and Fine Art Journal* until 1860. These photographic journals probably did more than any other single factor to knit the professional daguerreotypists into a homogeneous group.

Also, instruction in the art continued its more formal path. In the

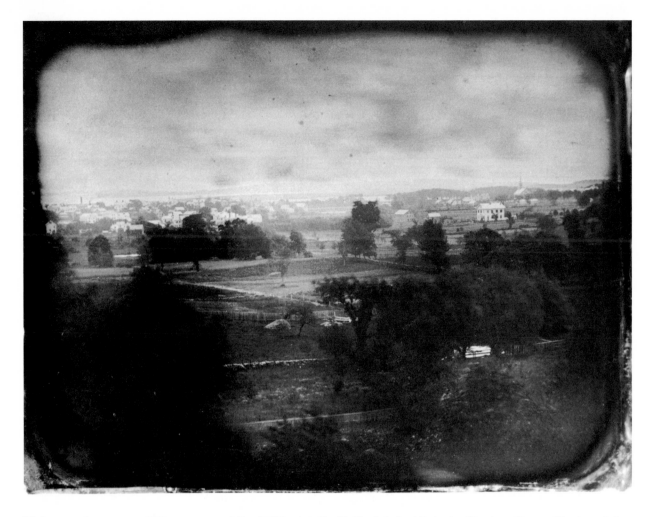

Unknown town, ca. 1853.
Half-size daguerreotype.
Artist unknown.
This scene probably depicts a
typical American industrial
town of the 1850s. The clouds
have been hand-painted for real-
istic effect. Most daguerreotype
scenes did not record cloud for-
mations except under peculiar
atmospheric conditions.
Courtesy of Norman Mintz.

fall of 1851, Austin T. Earle's institute in Cincinnati was "designed for instruction in all branches of the art." Ezekiel C. Hawkins, a pioneer daguerreotypist in Cincinnati after 1843, demonstrated the practical aspects of the process, and Professor J. Mellon Sanders of the Eclectic Medical College propounded theory and chemistry.[6] Whether this school, or Hill's 1850 school, met with success is unknown. Later on in the decade Samuel Humphrey and Mathew Brady each began schools of photography in New York City, but the success of and the details of these ventures are unknown.

THE WORLD FAIRS

Much of America's attention and activity were still centered on the gold rush in 1851, when the English opened their mammoth world's fair—the first international exhibition ever held. The fair was located in London, where the English had constructed the Crystal Palace, a huge building of iron and glass, an engineering feat that some called the eighth wonder of the world, a place where people of all nations could display their skills and products.

Queen Victoria opened the exhibition on May 1, standing amid the glories of the empire with the unspoken acknowledgment that En-

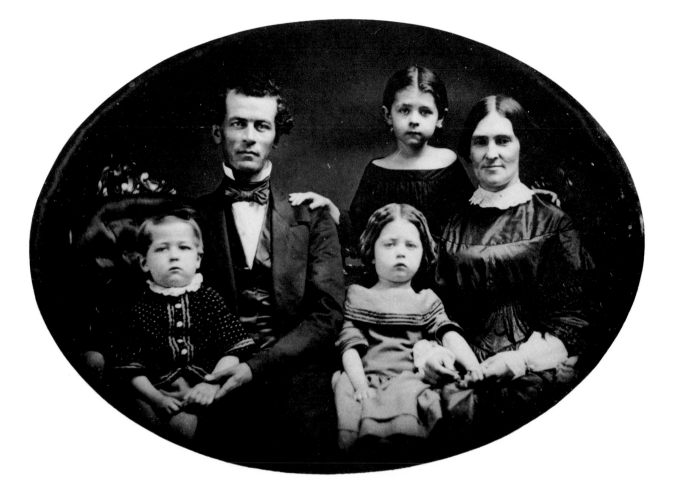

gland was the center of western civilization. Of the nearly 14,000 exhibitors, more than half were from Great Britain and its colonies, compared with 650 from the United States.

William Drew, a tourist-visitor to the fair, predicted with patriotic fervor that, when the awards were announced, "the United States will take more Premiums than any other nation according to the number of articles exhibited."[7] With an eye to the American talent for practical inventions, Drew also pointed out that "those who came to the Fair expecting to see great America emptying microscopic works upon the floors and tables of the palace, with a view to outdo Italy and Germany and France, or even England, in bizarre trinkets, and in some fine arts, must be disappointed."[8]

Drew's appraisal was correct—the American exhibitors had come prepared with displays of machinery, agricultural implements, food products, and photography. Except for photography, the displays of art were small but creditable—Hiram Powers exhibited his *Greek Slave* and *Fisher Boy*, Jonas Chickering his piano, Robert Cornelius of Cornelius and Company two elegant examples of gas chandeliers (Cornelius had given up daguerreotyping in about 1843 and was now head of his father's manufacturing firm).

However, there was criticism of the relatively small size of the American display. In answer, Albert G. Riddle, the American commis-

Family portrait, ca. 1853.
Half-size daguerreotype.
Artist unknown.
Family portraiture had improved remarkably by the 1850s: it was not unusual for an experienced and skilled practitioner of the art to take a relaxed family portrait without the aid of restraining belts or headrests.
Rinhart Collection,
the Ohio State University,
Columbus.

*Miners panning for gold, ca.
1851 (or before). Half-size da-
guerreotype. Artist unknown.
The California gold rush was a
social upheaval of unrivaled pro-
portions in America. It provided
for the first time an opportunity
to record a great moment in his-
tory with the undeniable realism
of the camera's eye. Many da-
guerreotypists, abandoning their
eastern portrait studios, came to
California. They roamed the
gold fields and in their travels
photographed the miners at
work.
Courtesy of Robert A. Weinstein.*

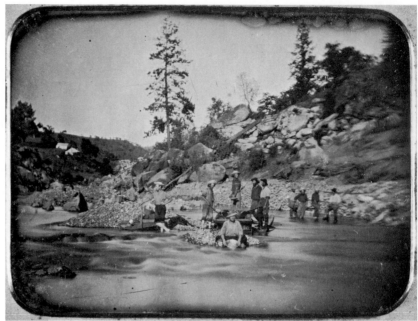

*Interior view, United States
exhibition, Crystal Palace,
London, 1851. From* The Master
Pieces of the International Ex-
hibition 1851.

sioner at the Crystal Palace, wrote: "Notwithstanding the sneers of
the English press . . . in every respect save that of number these con-
tributions are worthy of the country."[9] In retrospect, it does seem
likely that the Americans had been more interested in California and
the gold rush than in a world's fair and had sent but a partial represen-
tation of goods, considering the amount of space originally requested;
it had been supposed that the number of American exhibitors would
exceed that of all foreign nations except France and Great Britain.
However, although many American products were not fully repre-
sented, the exhibit of daguerreotypes displayed America's unprece-
dented skill and knowledge.

In fact, the American display of daguerreotypes caused Drew to re-
act with enthusiasm and, perhaps, a touch of homesickness:

DAGUERREOTYPE and TALBOTYPE
PORTRAITS. — Royal Adelaide Gallery. — Mr.
CLAUDET begs to recommend persons desirous of
having their PORTRAITS taken, to avail themselves of
the present favourable season, before the prevalence of
fogs, during which photographic operations are less suc-
cessful. Sunshine is not, however, necessary, for portraits
are always taken in the shade, where persons can better
preserve a natural and pleasing expression; nevertheless
the operation is almost instantaneous. The important
improvements Mr. Claudet has introduced in the process
are fully exemplified in his extensive collection of Da-
guerreotype and Talbotype Portraits, plain and coloured,
of various sizes, produced by his patented improved
apparatus, with which he has taken so successfully the
likenesses of H. M. King Louis Philippe, H. M. Queen
Dowager, H. G. the Duke of Wellington, and many
eminent persons. The Exhibition contains also the
splendid specimens which have been lately submitted to
Queen Victoria, and which have received her Majesty's
gracious approbation. Visitors are admitted free to the
photographic department of the Adelaide Gallery by the
house corner of Adelaide-street and King William-street,
Strand; open from half-past 9 until dusk: the early
hours of the day are generally more favourable for the
operation.

Advertisement from The London Illustrated News, *1845.*

Daguerreotype miniatures are here in great numbers and perfec-
tion. The truth is, American daguerreotypes are much better
than those of England—probably because our air and light are
clearer. The first likenesses I saw were a few from Vermont,
representing some of the handsomest daughters and mothers in
the Green Mountain State; and I could but feel proud of such an
exhibition of the beauty of our country. Among other daguerrian
likenesses, we noticed very large ones of President Fillmore, Mr.
Webster, Mr. Clay, Col. Benton, Mr. Calhoun, Gen. Jackson,
Gov. Cass, Gen. Scott, Gen. Taylor, etc.[10]

Others felt the same way. The London reporter for the Washington,
D.C., *National Intelligencer* wrote: "The American daguerreotypes
are pronounced the best which are exhibited."[11]

The English jury which passed judgment on the photographic dis-
plays had no trouble making their selections on a national basis.[12]
Awards went to the Englishmen Antoine Claudet (council medal, i.e.,
gold) and to William Edward Kilburn (prize medal, i.e., bronze). How-
ever, it was the American display which caused the most comment:

On examining the daguerreotypes contributed by the United
States, every observer must be struck with their beauty of ex-
ecution, the broad and well toned masses of light and shade, and
the total absence of all glare, which renders them so superior to
many works of this class. Were we to particularize the individual
excellencies of the pictures exhibited, we should far exceed the
limits of the space to which we are necessarily confined.[13]

While the jury had little difficulty choosing America's display of da-
guerreotypes over the best from France, Germany, and England, they
had far more trouble selecting which Americans should receive the
three bronze medals. Their dilemma was reflected in the official cata-

log report: "The Americans . . . The success with which the art is practiced, and the degree of perfection to which it has been brought, may be estimated by the specimens exhibited by various artists. The brilliancy and sharpness of some of these are highly remarkable."[14]

John Whipple was awarded a medal for his daguerreotype of the moon. Martin M. Lawrence, a pioneer New York daguerreotypist, received a medal for his "Past, Present, and Future," which showed three ladies facing left, front, and right. The third medal was given to Mathew Brady for his impressive display of forty-eight daguerreotypes portraying "likenesses of Illustrious Americans."

Facing the bewildering array of excellent daguerreotypes, the judges had followed a conventional pattern. One award had been given because of Whipple's contribution to science; Lawrence's allegorical daguerreotype had won because of its relation to art; and the Brady award was presented in homage to distinguished Americans. Later, critics asked why only three medals were issued when so many entries had equal merit. Whitehurst's twelve views of Niagara Falls, Fontayne and Porter's Cincinnati panorama, and the Meade Brothers'

Seated man, ca. 1854.
Quarter-size daguerreotype.
By Martin M. Lawrence.
Lawrence's ability to bring out a sitter's character made him one of the truly great daguerreian artists.
Rinhart Collection,
the Ohio State University,
Columbus.

allegorical depiction of the four continents were only a few of the magnificent daguerreotypes which also qualified for bronze medals.

The colossal success of the Crystal Palace exhibition, both in scope and as a moneymaker, caused a group of energetic Americans to try to duplicate it but, as it turned out, they had neither enough expertise nor the backing of their government, which had been one of the factors for success in the London fair—the drama created by the panoply and patronage of royalty had given dignity and prestige to the proceedings. The American fair of 1853 would be dull by comparison.

The American International Exhibition, as it was officially called, was organized by a few New Yorkers in 1852 as a joint stock company, operated under the authority of the New York state legislature. Almost immediately, protests arose from all parts of the country that the fair, under its guise of a broad patriotic movement, was nothing more than a scheme to benefit the city of New York and a few of its citizens.

The location which the committee selected for the fair was ill-suited to the New York of 1853, and the building, also called the Crystal Palace, was too large for the property.[15] Made of glass and iron, octagonal

Family portrait, ca. 1852.
Half-size daguerreotype.
By Mathew B. Brady.
An example of the beautiful and skillful interplay of light and shadow which brought fame to Brady's New York City gallery.
Courtesy of Josephine Cobb.

Young ladies with dog, ca. 1849.
Half-size daguerreotype.
By Jesse H. Whitehurst.
An example of the fine portrai-
ture produced by the Whitehurst
galleries. Whitehurst's entries at
the London Crystal Palace ex-
hibition, 1851, failed to win
recognition by the award com-
mittee, although many disputed
the decision, citing his scenes of
Niagara Falls as equal to any-
thing exhibited.
Courtesy of Josephine Cobb.

in shape and smaller than the London Crystal Palace, the New York Crystal Palace was scheduled to open its doors in June, but the event was delayed until the middle of July. With a disappointing lack of the pomp and ceremony attending the London exhibition, President Pierce and an array of his secretaries, six commissioners from Great Britain, and a number of other foreign dignitaries were present when the exhibition opened on July 14—an occasion almost ignored by the rest of the country.

The number of registered exhibitors was small—a total of 4,685, including 2,083 American entries. The photographic section was almost totally American—the only foreign exhibitor being Henry Plant, of France, who won a bronze medal for his photographic apparatus. The United States display, it was said, had a country fair atmosphere where many pioneer daguerreotypists renewed friendships of years past, and the fair also brought together, for the first time, a truly representative group of photographers from all sections of the country. New York galleries dominated the competition, of course, but many

Niagara Falls, from Prospect Point, ca. 1855. Whole-plate daguerreotype. By Platt D. Babbit (attributed). The challenge of capturing the majesty of the falls proved irresistible to early daguerreotypists. An engraving in N. P. Lerebours' Excursions Daguerriennes (1841–1842) was reproduced from a daguerreotype taken by an Englishman, H. L. Pattinson, of Newcastle, who, according to the editors, was "one of the first to practice the art in America." Babbit was granted a monopoly to take views from Prospect Point on the American side of the falls in about 1853. Courtesy of Josephine Cobb.

Rachel A. Webster of Lancaster, Pennsylvania, at age twenty, September 17, 1853. Sixth-size daguerreotype. Artist unknown. After this daguerreotype reached a collector's hands in 1934, he renewed (cleaned) the plate by what he referred to in his notebook as the P. C. method; this could be assumed to mean potassium cyanide. Since then deterioration appears to have occurred, namely, a whitish film around the perimeter and some dots where the silver has lifted. An excellent example of a recorded renewal spanning a time period of almost fifty years. Anonymous collection.

entries came from other cities of the East, the South, and the West. The contending exhibits displayed an intensity and a challenge not seen before in daguerreotyping, and complete proficiency in the art was routine rather than exceptional—competition had reached the highest peak it would ever reach!

Horace Greeley, editor of the *New York Tribune* and one of the country's leading journalists, minutely examined each exhibit in the photographic section, and his opinions were more accurate than those of the Crystal Palace's jury. His comments on photography in general and his analysis of the daguerreotypes displayed were interesting and objective. Greeley was never one to conceal his criticisms or opinions (on any subject), and his observations reflected the views of an informed and skilled observer.

The opinions and awards of the Crystal Palace judges are given below, in brackets, immediately after each of Greeley's opinions:

Advertisement, ca. 1855. In 1852 Lawrence was cited by The Photographic Art Journal *as preparing daguerreotypes on plates thirteen by seventeen inches which, when completed, "will be the largest in the world." Paper photographs were also being promoted by the gallery from 1854 onward.*

Anonymous collection.

Daguerreotypes and Photographs.

LAWRENCE'S GALLERY is one of the most splendid and extensive in the world, and his pictures are not excelled either in Asia, Africa, Europe, or America, having received the highest premium, the

PRIZE MEDAL,

AT THE

LONDON AND NEW YORK EXHIBITIONS,

OF THE

"INDUSTRY OF ALL NATIONS."

The attention of the public is called to his new style of Miniature, Cabinet, and Life-size Photographs, or Daguerreotypes on paper, combining the truthfulness of the Daguerreotype with the beauty of the finest Miniature and Oil Painting. Persons having small and inferior Daguerreotypes can have them copied to any desired size, and colored to nature. Those residing at a distance, by forwarding such pictures, with a description of the complexion, color of the eyes and hair, or send a lock of the hair, can depend on having a truthful likeness. Every one coming to the city of New York should call and examine pictures made by this beautiful process. Cabinet and Life-size Photographs on Canvas, and colored in Oil. They can be taken from life, or copied from Daguerreotypes and other pictures. This style was introduced by the undersigned, and has now become very popular.

Rooms, 381 Broadway, corner White Street, N. Y.

M. M. LAWRENCE.

Martin M. Lawrence—exhibits case—softness of tone and distinctness of image united in artistic arrangement—'The Three Ages' the daguerreotype which won a prize at the London Crystal Palace Exhibition, 1851 . . . [awarded bronze medal, N.Y. Crystal Palace, 1853, excellent daguerreotypes]; Mathew B. Brady's collection not very large, but there are a few very good pictures . . . well selected heads—two of President Pierce—one of Lieut. Maury. [awarded bronze medal, N.Y. Crystal Palace, 1853]; In Jeremiah Gurney's collection the coloring of the background has a fine effect; there are some very well executed portraits, among them Mr. Forrest, worth notice as a work of art; less softness and more distinctness in his collection than Lawrence. The picture of Ware and sister an instance picture well developed when chemical action extends to the margin of plate. [awarded Honorable Mention, N.Y. Crystal Palace, 1853]; Meade Bros.—fair—great variety—some of merit. 'Daguerre' only one of kind in United States—Shakespeare's 'Seven Ages' are illustrated on many plates, taken from life; one represents the Soldier and the Lover. No heads or largest-sized plates; some colored represent miniatures on ivory; termed Instantaneous Daguerreotypes (not remarkable). [awarded Honorable Mention, N.Y. Crystal Palace, 1853]; Marcus A. Root—large and respectable collection on view—many specimens of his crayon daguerreotypes [not mentioned by Greeley were talbotypes exhibited by Root]. [awarded bronze medal, N.Y. Crystal Palace, 1853]; D. Clark, New Brunswick, N.J.—four pictures of merit. [no award, N.Y. Crystal Palace, 1853]; Von Schneidau [of Chicago]—some collection of well selected heads. [no award, N.Y. Crystal Palace, 1853]; J. Brown—collection of portraits of Commodore Perry and the officers of the squadron of the Japan Expedition, in half size plates; the interest of his collection marred by the names of officers not attached underneath the plate. [no award, N.Y. Crystal Palace, 1853]; Haas has a whole-plate allegorical figure of a family man reading the paper at home—excellent idea and executed. Also couple of others—though most mediocre. [no award, N.Y. Crystal Palace, 1853]; Harrison and Hill—excellent artistic arrangement with very indifferent mechanical execution. In the mammoth plates occupied by allegorical designs, the background is wretchedly brought out—plates nor properly cleaned, and are full of scratches; there are a few half and whole-sized pictures set in gaudy frames. [awarded Honorable Mention for fine daguerreotypes, N.Y. Crystal Palace, 1853]; Webster, of Louisville, Ky., has 23 pictures possessing clearness, exposed too much to camera, lack warmth, otherwise well developed and exhibit good mechanical execution. [no award, N.Y. Crystal Palace, 1853]; Alexander Hesler [of Galena, Illinois]—collection of whole plates handsomely executed—nice arrangement of drapery, which has effect of throwing head out in good relief. Artistic arrangement in his collection—evinced in picture 'Driving a Trade,' one of a series illustrating character and passion. The panoramic views of Galena, Ill., show that city to advantage; and the three views of the Falls of St. Anthony great merit. [awarded a bronze medal—beautiful daguerreotypes, 'The Three Pets,' 'The Toilet' and oth-

Seated woman, ca. 1850.
Sixth-size daguerreotype.
By John Fitzgibbon.
The popular and gregarious
"Fitz" was probably acquainted
with more daguerreotypists from
all over the country than was
any other practitioner of the art.
His advice (given without re-
straint) and his reputation,
which was impeccable, made him
the authoritative spokesman for
early photographers.
Reverend John Jones Collection,
University of Georgia Libraries,
Athens.

ers, N.Y. Crystal Palace, 1853]; Mr. North—of Cleveland, Ohio
—case of pretty fair likenesses, exhibiting lights too strongly.
[awarded Honorable Mention, N.Y. Crystal Palace, 1853]; Bisbee
of Dayton, Ohio, exhibits a panoramic view of Cincinnati from
Newport upon six large plates. This view is without exception,
the finest thing in whole room . . . finest view by the Da-
guerrean process ever exhibited. The mechanical execution is
excellent, the perspective good and the development unsur-
passed. The effect of the smoke over southern part of the city is
very finely given. The distinctness of the letter-signs, three
quarter of a mile distant and across the Ohio River, is well
brought out. The rest of collection fair. [no award, N.Y. Crystal
Palace, 1853]; Williamson [of Brooklyn] exhibits poor collection.
[no award, N.Y. Crystal Palace, 1853]; Dobyn, Richardson and
Co [Moissenet, Dobyns, Richardson and Company, New Orleans]
have several whole-size—well executed specimens. The 'Cupid
Reposing' is a very ungraceful posture of an ill-formed child, and
the coloring is bad. That of the Bateman children, in character, is
good. Well executed heads in collection. [awarded Honorable
Mention, N.Y. Crystal Palace, 1853]; Long [Enoch], of St.
Louis—four frames of 180 heads of Wyman's School, in that city,

Two little girls, ca. 1854.
Sixth-size daguerreotype.
By George M. Howe.
Anonymous collection.

with the edifice and principal; no merit. A likeness of Prof. Mitchell, Cincinnati—well executed. Some pictures invested with papier mâché frames inlaid with mother-of-pearl and tinsel. This style frame few other collections—too gaudy and wholly unsuitable for daguerreotype plates—adds to glare. [awarded Honorable Mention, N.Y. Crystal Palace, 1853]; Fitzgibbon [of Saint Louis]—richest exposition in Fair. Most expensive frames, with a large and passable collection. The mammoth plate of Judge Colt very good—Jenny Lind best in exhibition—those of McAllister, Julia Dean, Kate Hayes, and Kossuth are good pictures. His collection of Indian Warriors very fine, which we understand is to be forwarded to the Ethnological Society of London, to have copies and busts made from them. [awarded Honorable Mention, N.Y. Crystal Palace, 1853]; Masury and Silsbee, Boston—12 very pretty and tasteful plates, with good arrangement—well finished. [no award, N.Y. Crystal Palace, 1853]; Kelsey, Beals, and Howe [C. C. Kelsey, Chicago; Albert A. Beals, New York City; George M. Howe, Portland, Maine] do not require notice. [no award, N.Y. Crystal Palace, 1853]; Whitehurst, a few good pictures in large and passable collection, 10 pictures illustrating the Falls of Niagara, well executed. Some of

A prototype trade card.
When the carte de visite *became popular, many of the logotypes used on the rear of the card would resemble Howe's earlier original design.*
Courtesy of Josephine Cobb.

Advertisement from The Daguerreian Journal, *1851. The Harrison camera, in the early 1850s, was the first American camera to successfully challenge the superiority of Voigtländer's German apparatus.*

Mrs. Charles Jones of Georgia, ca. 1852.
Sixth-size daguerreotype.
By David C. Collins.
It was not unusual during the daguerreian era for wealthy southerners to visit Philadelphia and, during their stay, have a portrait taken by a prominent daguerreotypist.
Reverend John Jones Collection, University of Georgia Libraries, Athens.

his large heads—features out of proportion. [awarded Honorable Mention, N.Y. Crystal Palace, 1853]; Whipple, Boston—collection of photographic pictures—Crystallotypes taken hyalotypes; there are a plate of the moon daguerreotyped and one of the spots of the sun [Greeley had his terms mixed up: for hyalotypes, read glass negatives]. [awarded silver medal for Crystallotypes, N.Y. Crystal Palace, 1853]; McDonnell and Co., Buffalo —poor collection (shouldn't be in exhibition). However—views of Niagara fine. [no award, N.Y. Crystal Palace, 1853]; Hawkins, Cincinnati—exhibits on paper [Solographs]. [no award, N.Y. Crystal Palace, 1853]; Drummond, 8 plates of the Order of Freemasons in their Lodge dress. [no award, N.Y. Crystal Palace, 1853].[16]

While Greeley's résumé was an excellent survey of American photography, he failed to mention a few exhibitors: Alexander Butler, whose daguerreotypes won a bronze medal; Otis T. Peters, who won an honorable mention for his stereoscopes; and Charles C. Harrison, awarded a bronze medal for his camera. But not many displays were overlooked, particularly not the photoengraving plates exhibited by John H. Fitzgibbon. Greeley commented:

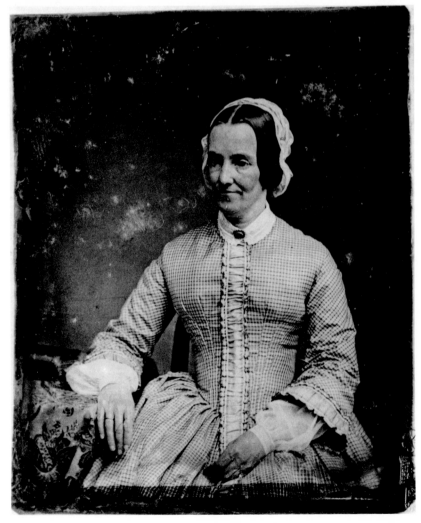

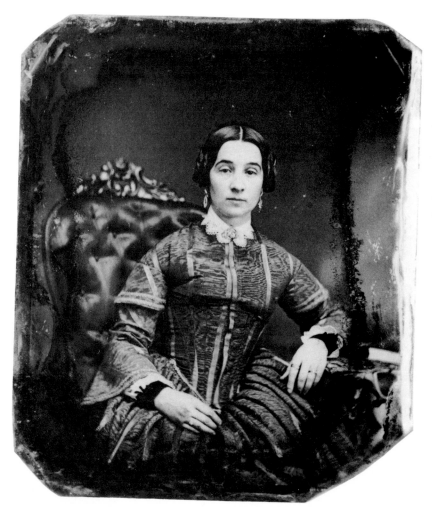

Seated woman, ca. 1853.
Sixth-size daguerreotype.
By Abraham Bogardus.
After opening a daguerreotype
studio in New York City in 1846,
Bogardus pursued a career in
photography until 1887. The rib-
bon on the woman's costume was
hand-tinted blue, giving interest
to an otherwise routine portrait.
Rinhart Collection,
the Ohio State University,
Columbus.

Very interesting case—a frame of electrotype copies from da-
guerreotype plates, very beautifully executed. It should not be
looked upon as a mere curiosity to place a daguerreotype plate in
a copper solution and take a copper cast from its surface by
means of electricity. It is to be regretted Fitzgibbon did not com-
plete this frame by insertion of a third plate, by taking a second
copy from the copper copy. This would be in relief, like the origi-
nal silver plate, and is susceptible of being treated like the
original silver plate, yielding, when inked, prints resembling
mezzotints.[17]

In many respects the photographic exhibition at the New York
Crystal Palace had been the only great convention of pioneer da-
guerreotypists, an exclusive fraternity soon to disappear into the
maze created by new photographic processes and methods. Many of
those present had shaped and developed the art from its humble be-
ginnings to its world renown. For many the exhibition marked the end
of the first era in American photography.

Woman and child with hat,
ca. 1851.
Sixth-size daguerreotype.
By S. B. Barnaby.
Courtesy of Donald Lokuta.

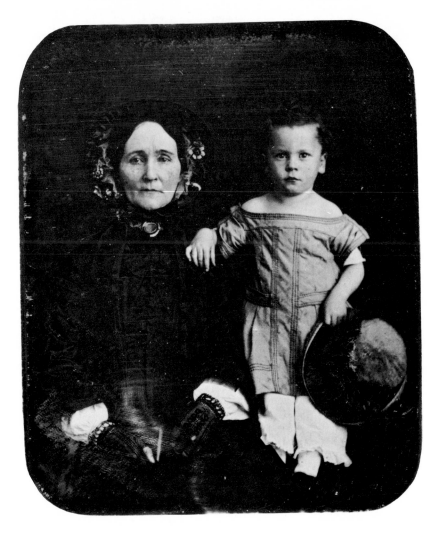

SUPPLY HOUSES AND MANUFACTURERS

One of the curious aspects of the New York Crystal Palace exhibition had been the lack of displays of daguerreotype apparatus and materials. American apparatus was now shipped all over the globe, and even in Paris the American photographic salon flourished.[18] During this period of great expansion in the art, supply houses were keeping pace with the demands of America's photographers. Factories were being renovated or expanded as new inventions and improvements in the art necessitated new materials and equipment.

By the early 1850s, the largest manufacturers of photographic apparatus and, for a brief period, cameras were William Lewis and his son, William H. Lewis. The two held a variety of patents for improved daguerreotype apparatus, ranging from galvanic batteries to a daguerreotype camera plate holder. This plate device was one of their more important inventions—the holder was designed to slide across and replace the frosted (ground) focusing glass at the rear of the camera with a sensitized daguerreotype before the image was recorded. The Lewis family was unique in photographic history. Sons Henry J. and Richard

Seated smiling boy, ca. 1854.
Sixth-size daguerreotype.
Artist unknown.
Anonymous collection.

A. Lewis were primarily daguerreotypists and gallery operators, although they were occasionally involved in the manufacturing sector of the family enterprises.[19]

By the early 1850s, the facilities on Chatham Street in New York City were totally inadequate to meet the heavy demands for apparatus, and the Lewis family operation was relocated about a mile south of Newburg, on the Hudson River. The new manufactory, if it could be called that, was really a village—which they named Daguerreville. A stream which ran through the complex—a small cluster of buildings, each having its function in the production of apparatus—provided cheap power from a thirty-horsepower waterwheel, a prime factor in nineteenth-century industry. The center for operations was a large five-story building (fifty by one hundred feet). Each floor had a separate function: the ground floor, where six to eight men were employed, contained a large planing machine, a circular saw, and a large boiler for heat; the second floor had an office, a machine shop, and a japanning room, all employing about fifteen to twenty workers; on the third floor, fifteen to twenty men made camera boxes, Jenny Lind stands, headrests, buffing machines, and any apparatus needing gluing, nailing, or

SPREAD EAGLE DAGUERRIAN GALLERY.

And Premium Manufactory of

Daguerrian Apparatus, Straw Hat Pressing Machines,

&c., **No. 142 Chatham-street,** first floor, N. Y.,
Opposite the Chatham Theatre, and over Smith & Risley's
Boot and Shoe Store, Sign of the Silver Eagle.

W. & W. H. LEWIS,

**Respectfully inform their friends and the public generally, that they have
enlarged their Gallery, and fitted it in a style unsurpassed by any other
in the city. They have perfected a powerful light, yet so mellow that
they are enabled to take likenesses of Children and others in a few se-
conds, with perfect ease to the sitter, retaining a perfectly natural expres-
sion. The attention of strangers visiting the city, and others, is particu-
larly called to the fine Likenesses of the Chippewa Indian Chief and his
Sons, on the door posts and in their Gallery; they are dressed in full
Indian costume, the same in which they appeared before all the crowned
heads of Europe during their travels with Geo. Catlin, Esq.**

**They have paid particular attention to taking Children, having an
Apparatus expressly for that purpose, acting in one-fourth the usual
time. Hours for Children from 9 A. M. to 2 P. M.**

**Likenesses taken in Clear or Cloudy Weather, in a style unsurpassed,
for ONE DOLLAR and upwards—including a neat Morocco Case;
also inserted in Lockets, Breastpins, &c., at various prices. Likenesses
of Sick or Deceased Persons taken.**

Painted or Daguerreotype Likenesses accurately copied.

**W. & W. H. L., having been the first regularly established manu-
facturers of Daguerreotype Apparatus in the United States, have steadily
advanced in improvements in the various departments, and are now
prepared to furnish every article of superior quality at the lowest prices.**

**Patent Machines for pressing Straw and Leghorn Hats, of the latest
improvements. Hand, Brim, and Fluting Irons, Galvanic Batteries for
Electro Plating, &c.**

**Frames for Daguerreotype and other Pictures constantly on hand and
made to order.**

Do not mistake the Sign of the Silver Eagle,
On the Pedestal at the Door.

hand-finishing; the fourth floor was divided into areas for polishing and
varnishing camera tubes, as well as pattern and inspection rooms; on
the top floor, lenses were ground by a total of twenty workers. Other
buildings on the property included a blacksmith shop, a foundry, and a
storehouse.[20]

The Lewis family hoped that Daguerreville would become the na-
tion's center for photographic apparatus, but within a few years they

had returned to the country's photographic center—New York City. Apparently their isolated plant had been unable to compete with Anthony and Scovill, both of whom had moved with great energy into the manufacture of photographic apparatus.

By 1851, sideline dealers in photographic materials had just about disappeared, with the exception of certain businesses in rural areas and a few daguerreotypists who advertised as vendors of supplies. However, new and formidable competition soon appeared. Some specialty suppliers, such as Louis Beckers of Philadelphia, who had sold only chemicals, now stocked a full line of materials. In Baltimore, William Wisong began building up his stock of daguerreotype materials, and in New York the well-financed Levi Chapman, a former leather goods dealer, expanded his daguerreotype supply business by 1850 on a large scale. Part of Chapman's success was due to his ability to negotiate exclusive franchises with manufacturers; he also had in 1851 several salesmen traveling across the country from town to town.[21] Holmes, Booth, and Hayden, another well-financed concern, established a supply center in New York City in 1853. The company carried a very complete line of photographic supplies; they manufactured their own daguerreotype plates, and they also specialized in making plastic daguerreotype cases from about 1856 onward.

In the early 1850s, both E. Anthony and Company and the Scovill Manufacturing Company decided that further expansion was necessary and proceeded to manufacture daguerreotype apparatus on a wide scale. The companies had been faced with growing competition, not only from new and larger supply houses but from smaller local suppliers, who were inclined to cut prices. Edward Anthony had prepared the way for future profits back in 1848, when his name became linked nationwide with the smaller, out-of-town supply depots. His talent for sales promotion was by far his greatest asset. When he graduated from college in 1838, he became a merchant, although he had been trained as an engineer.[22] Anthony knew how to prejudge the market and, even more important, he knew when it would become profitable. He knew his merchandise and how to sell it—to a banker he would have been a sound financial investment.

Anthony's first major move toward becoming a prime supplier of daguerreotyping materials came in 1850, with the opening of a case manufactory on Fulton Street.[23] The New York City plant proved profitable, but its output could not meet the growing demand. In 1853, the operation was moved to a vast loft over the New York, Harlem, and Albany Railroad terminal—to a warehouse with the best shipping facilities. Here machinery was installed to manufacture not only cases, mats, and preservers but almost every other item necessary for daguerreotyping, including cameras. As a jobber, Anthony warehoused a complete line of glass and many brands of daguerreotype plates, including the highly publicized eagle (HB) French plate.

Anthony had created a network of smaller wholesalers across the nation. He offered out-of-town jobbers a price-protection plan against direct selling by his company, and with his new manufacturing facility his prices were low enough to compete with direct selling by other apparatus and case manufacturers. However, despite his assured price-protection plan, he still solicited business from many of the larger daguerreotype galleries, especially in New York City. In keeping with the competitive spirit among the profession, he sponsored a contest

Advertisement from The Daguerreian Journal, *1851.*

for daguerreotypists, with prizes to be given in the late fall of 1853 for the best daguerreotypes. The judges included Morse and Draper, and the prizes were awarded in a festive holiday spirit four days before Christmas, amid the popping of corks—Jeremiah Gurney won the first prize, a magnificent pitcher emblazoned with a portrait of Daguerre, and Samuel Root (brother of Marcus) won a second prize of two silver goblets.[24]

Scovill's New York outlet was by now completely separated from the Waterbury connection, although many daguerreotype materials and cases were still made there. The Scovill pattern of growth had been roughly parallel to that of the Anthony operation, and by the middle of the decade the company stood second behind E. Anthony and Company as the nation's largest supplier of photographic materials. However, from 1853 to 1855, prices of daguerreotype materials took a downward slide because of heavy competition from a larger number of supply houses.

Seated boy, ca. 1855.
Quarter-size daguerreotype.
By Jeremiah Gurney.
Gurney specialized in mother-and-child portraits and portraits of young people.
Rinhart Collection,
the Ohio State University,
Columbus.

LOTTERIES

Advertising now became a new and more intense medium, with innovations unthinkable back in the 1840s. One such innovation was the introduction of lotteries to promote business. Lotteries were not a new way to create patronage. Art unions during the 1840s held lotteries, with the winners receiving paintings or engravings as prizes.

During the summer of 1854, Jesse Whitehurst placed large announcements in a number of newspapers: "$50,000 Worth of Real and Personal Estate for the People—Magnificent Enterprise—Liberal, Equitable and Certain. Whitehurst's Daguerreotype Enterprise." In small print he stated that a three-dollar share entitled the holder to win a house or a lot in various towns, a total of nine properties being available. Additional prizes included five pianos, gold watches, silver pitchers, diamond rings, bracelets, and one thousand copies of *The Photographic Art Journal*. A shareholder was also entitled to one of "Whitehurst's $3 World's Fair Premium Daguerreotypes" at any of his studios or at participating galleries—Gurney's in New York City; David C. Collins in Philadelphia, Springfield, and Westfield; A. C. Partridge in Wheeling, West Virginia; or William S. Porter in Cincinnati. Any waiting or inconvenience was eliminated because the galleries were capable of taking 1,100 daguerreotypes a day.[25] Unfortunately, no record exists of how many shares were sold or who the winners were.

J. Wesley Jones, who had become well known through his lectures, "The Pantoscope of California," also conducted a lottery in 1854 by offering prizes of paintings taken from his daguerreotypes of the West. The success of his lottery remains uncertain, and the whereabouts of the paintings—estimated to be worth $40,000—are unknown. Another 1854 lottery was held by M. W. Lockwood, who had bought out C. G. Page's gallery in New York City. The Lockwood Gift Enterprise resembled Whitehurst's in having 21,936 valuable gifts worth about $25,000: the prizes included 100 whole-plate daguerreotypes worth $15 each and 500 sixth-size plates set in fine gilt frames. Shares went for $1 each, but the winners remain unknown.[26]

THE GALLERIES

The prosperity and expansion of supply houses and the introduction of lotteries, along with increased advertising, illustrate the affluence of the art not only in New York but all over the country—in Philadelphia, Boston, Charleston, New Orleans, Saint Louis, or San Francisco the meter was the same.

In New York, for example, in 1851, seventy-one galleries employed 127 operators.[27] The nation's richest and most bedecked daguerreian galleries of the 1850s were found along Broadway, clustered together, like jewels on display. No other galleries in the world could equal those beautiful galleries along Broadway—even London or Paris could not rival this group. The Broadway galleries were operated by many of the foremost daguerreotypists in the country—those pioneers and masters of the art who had successfully weathered the difficult years—and the galleries reflected the aesthetic qualities of their mas-

Advertisement from the Richmond Whig and Public Advertiser, *June 23, 1854.*

ters. Brady, Gurney, Insley, Lawrence, and the Meade Brothers were but a few of the artists who had large studios along Broadway.

Mathew Brady's new gallery at 359 Broadway, as an example of the opulent daguerreian studio of 1853, probably typified the gallery which would be most imitated about the country. The reception room was two flights of stairs above the highly varnished main entrance, which was embellished with magnificent daguerreotype specimens set in gilt rosewood cases. Folding doors, artistically glazed with frosted and figured cut glass, opened from the landing into the remarkable reception room and a virtual fairyland. The floor was carpeted with a colorfully patterned velvet tapestry; satin and gold paper covered the walls. A large six-light chandelier hung from the ceiling, and the windows were curtained with costly needle-worked lace and festooned with damask. Ceiling-to-floor mirrors gave the twenty-six by forty feet room an illusion of even more space. The furnishings, both elegant and comfortable, were made of the finest rosewood, and the tables were topped with marble. The daguerreotype portraits displayed on the walls were impressive—the famous from all nations, including kings and queens. An office led from the reception room, and here a large collection of miniature cases, lockets, and frames was on display for the patron's selection.

The ladies' parlor, beyond the business office, was even more elegant. The walls were covered with green velvet, satin, and gold paper; the ceiling was frescoed; and a large enameled chandelier dominated the room. The furnishings were feminine—cottage chairs, rosewood tête-à-têtes covered with green and gold brocade, and a pier glass. On the same floor were two rooms where the daguerreotypes were taken—one had a northern light, the other had a southern exposure

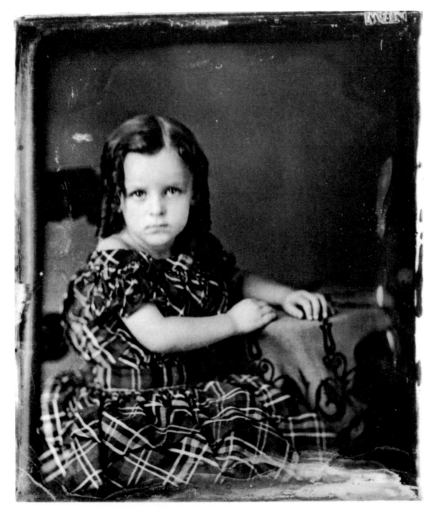

Seated girl, September 27, 1855.
Sixth-size daguerreotype.
By John J. Outley.
Courtesy of W. Robert Nix.

A view of Brady's original
gallery at 205 Broadway.
From an old letterhead.
Courtesy of Walt Craig.

Young woman on sofa, ca. 1855. Sixth-size daguerreotype. American or European artist unknown. The vividness of the camera's eye brought a new dimension to the long tradition of erotic art. Along lower Broadway, it was rumored, certain unscrupulous operators were producing illegal erotic daguerreotypes on Sundays and at odd hours. Since daguerreotypes were family keepsakes, it might be assumed that the pornographic ones would have been destroyed at an early date. This rare portrait was found uncased and completely obscured by a heavy coating of tarnish. Authors' collection.

for different lighting effects. Brady hired only the most competent of daguerreotypists, and no expense was spared in equipping the operating rooms with the best and latest apparatus. The gallery also had two other floors above the reception area. On the first, plate cleaning and electroplating were done; the top floor provided a storeroom for supplies and chemicals and, if special lighting effects were required, a room with a skylight inclined nearly flat toward the west.[28]

While Brady's gallery was representative of the elite and luxurious daguerreian establishments, there also existed galleries along Broadway where prices were lower and volume greater. Called portrait factories or cheap Johns by the trade, they turned out likenesses at twenty-five cents a head, and in many ways their efficient operation was a testimonial to American ingenuity. When the English photographer John Werge visited America in the early 1850s, he stopped in one of these cheap galleries to see its operation. The experience cost Werge one dollar; as he later described it:

> At the desk I paid my money, and received four tickets. . . . I was shown in a waiting room crowded with people. The customers were seated on forms placed around the room, sidling their way to the entrance of the operating room, and announcing the cry of 'the next'. . . . I being 'the next', at last went into the operating room, where I found the operator stationed at the camera which he never left all day long. . . . He told the next to 'sit down' and 'Look thar', focussed, and, putting his hand into a hole in the wall which communicated with the 'coating room' he found a dark slide ready filled with a sensitized plate, and putting it into the camera, 'exposed' and saying 'that will dew', took

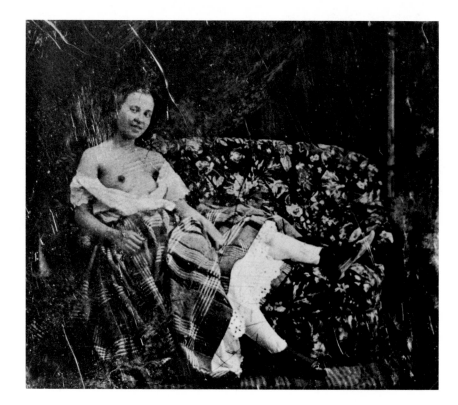

the dark slide out of the camera, and shoved it through another hole in the wall communicating with the mercury or developing room. . . . The operator . . . was responsible only for the 'pose' and 'time', the 'developer' checking and correcting the latter occasionally by crying out 'Short' or 'Long' as the case might be. Having had my number of 'sittings', I was requested to leave the operating room by another door . . . that led me to the 'delivery desk' where, in a few minutes, I got all my four portraits fitted up in 'mat, glass, and preserver', the pictures having passed from the developing room to the 'gilding' room thence to the 'fitting room' and the 'delivery desk', where I received them. Thus they were all finished and carried away without the camera operator ever having seen them. Three of the four portraits were as fine Daguerreotypes as could be produced anywhere.[29]

In other areas of the country the age of opulence had also arrived, with great galleries becoming established in New England, the Far West, the South and Southwest, and the Midwest. The masters of the art had spread out into the far reaches of America to establish hard-won reputations.

Wofford College, main building, Spartanburg, South Carolina, 1854. Half-size daguerreotype. Artist unknown. A rare scene, taken shortly after the building's completion, which provides documentation for the establishment of this southern college. Reverend John Jones Collection, University of Georgia Libraries, Athens.

Marcella L. Brown, 1855.
Sixth-size daguerreotype.
Artist unknown.
Anonymous collection.

Perhaps no other city was more of a focal point for inland daguerreotyping than Cincinnati. Many skilled artists of the camera had settled there, including the pioneers Ezekiel Hawkins and Thomas Faris in 1843, Charles Fontayne in 1846, and the black James P. Ball, who opened a one-room studio in 1847—and, of all the galleries to be established in Cincinnati, the most famous and certainly the most ornate was Ball's Great Daguerrian Gallery of the West. Ball's ascent from a small gallery to one of the great galleries of the Midwest makes an excellent example of a successful enterprise far from the eastern centers of daguerreotyping.

Ball had learned the art from another black daguerreotypist, John B. Bailey of Boston, after a meeting in 1845 at the resort of White Sulphur Springs, West Virginia. For nearly two years Ball was an itinerant, traveling first around the Pittsburgh area and then to the more financially profitable area of Richmond. In 1847 he returned to his hometown, Cincinnati, where he opened his first permanent studio. Two years later he opened a studio in the heart of Cincinnati, and by 1854 his gallery had become so famous that *Gleason's Pictorial Drawing-Room Companion* published an article on Ball and his busy gallery, describing it as occupying the third, fourth, and fifth floors of the Weeds Building.[30]

Man with top hat, ca. 1857. Ninth-size daguerreotype. By Wyman & Co. An example of a twenty-five-cent daguerreotype; the price included image, case, glass, mat, and preserver. A card advertising the daguerreotypist's name, location, and price was on the back of the image unit. Anonymous collection.

The gallery was divided into four rooms plus an antechamber; two were fitted up "in the best manner" as operating rooms—one for children, the other for adults, the latter being called the great gallery and measuring twenty by forty feet. The walls in the adults' room were decorated with cream-colored paper, bordered with gold leaf and flowers; the panels on two of the walls were ornamented with colorful art figures. The north wall displayed 187 of Ball's finest pictures, including a very large panorama of black life along the Ohio, Susquehanna, and Mississippi rivers and Niagara Falls.[31] Also included were portraits of Jenny Lind and other famous people of the era, as well as six fine landscape paintings by the black artist Robert S. Duncanson (rumor has it that he was employed by Ball for a time). Bright mirrors hung on the east wall, and to create a comfortable atmosphere piano music entertained the patrons. The other rooms were used for service, where "plates were prepared and likenesses perfected." *Gleason's Pictorial* described Ball's employees as nine men "superintending and executing work of the establishment," with each man "perfect in his

PRATT'S VIRGINIA SKY-LIGHT DAGUERREAN GALLERY,

AT THE GOTHIC WINDOW, 145, MAIN STREET.

This Gallery is now permanently located at the above number.

We have fitted up and furnished our new rooms with every thing requisite for convenience and splendid pictures, and hope our friends will call and examine.

W. A. PRATT, *Proprietor.*

PRATT'S DAGUERREAN GALLERY.

Mr. Pratt's Daguerrean Gallery forms a gothic centre to the handsome row of brick buildings known as "Eagle Square," No. 145, Main street, up stairs. The exterior of the second, third, and fourth stories of the tenement have been entirely remodelled, from drawings designed and executed by the proprietor.

On the first floor, the visiter is ushered into a superb reception room, which, in the form of a semi-circle, occupies the entire front. The statuettes, curtains, divans, carpets, mirrors, together with the stained glass, the immense bow window, all aid, from their subdued tones and admirable contrast, to produce a harmonious whole, well adapted to show the daguerrean pictures which grace the walls, to the best advantage. Immediately in rear of this handsome apartment, is a Ladies' retiring room, which has been fitted up and furnished with taste ; midway between these two rooms is a staircase, leading to the operating rooms above, which, being immediately over the show rooms, enables the proprietor to obtain an unobstructed light from a Northern point of the horizon, by means of sky-lights thirty feet in height by twelve feet in width. This sky-light, in combination with the gothic window, constitutes the distinguishing feature of Mr. Pratt's Gallery, and enables him, as he verily believes, to surpass all other operators in his art, in this meridian, at least. His pictures, it is due to him to say, are life-like and faultless ; and we do not hesitate to recommend his gallery to the patronage of all who may be desirous of "securing the shadow ere the substance fades."

Richmond Times.

EXTRACTS.

Mr. Pratt has fitted up his new establishment in a style which reflects much credit upon his taste and liberality.—*Daily Dispatch.*

His reception room is as prety a boudour as we have recently seen, elegantly fitted up with splendid carpets, rich velvet divans, statuetts, immense bay window, with stained glass, &c.—*Enquirer.*

The arrangement of his show room is exquisite, whilst his Sky-Light is superb.—*Whig.*

N. B.—To DAGUERREANS :—We are now receiving our own importation of French plates, warranted 40s. Eagle Brand $1 00; Star, 75 cts. Cases at all prices.

FONTAYNE'S GALLERY OF

DAGUERREOTYPE PORTRAITS,
AND FAMILY GROUPS,
No. 6 West Fourth Street, between Main and Walnut.

Advertisement from William's Cincinnati directory, 1855. Fontayne's advertisement is a prototype combination of a cherubic figure and a camera.

E. Cutter (Cutler?), 1851. Sixth-size daguerreotype. Artist unknown. One of the early innovations of photography was the recording of portraits for educational institutions; daguerreotypes of students were used as models for class book engravings. A note with this image identifies "E. Cutter, Yale 1851. Taken for Class Book." Anonymous collection.

peculiar branch."[32] Apparently the gallery was a family affair, with Ball's brother-in-law, Alexander Thomas, joining the firm in 1852; also, in 1854, it was recalled that "he has a brother, Mr. Thomas Ball, and a white gentleman to assist him."[33]

While the daguerreian galleries throughout America were prospering and were producing excellent work for the most part, the European galleries were not flourishing in this branch of the art, although a number of excellent daguerreotypists practiced in England—Mayall, Claudet, and Kilburn, to name a few. And in Paris, despite the wonderful advancements made by the French in the early years of the art, commercial daguerreotype studios were far behind those of the Americans in efficiency and appointments. The French had many excellent photographers but, ironically, in the birthplace of the daguerreotype interest was almost totally focused on the paper photograph. Consequently, the French daguerreotype studio in the 1850s brought but little honor to the name of Daguerre.

Man and woman with large hat, 1852. Quarter-size daguerreotype. By Mathew B. Brady. Rinhart Collection, the Ohio State University, Columbus.

An article translated from the French which appeared in *The Knick-erbocker* in August of 1853 described the writer's visit to a typical Paris daguerreotype studio. The account makes an excellent contrast to John Werge's experiences in America:

> Attracted by the frame of portraits, you walk upstairs, and into a room that looks something like a shop without the wares. There is no display of goods here to beguile customers; nothing looks like business but the small compartment at the window, screened off with canvas, in which recess the sitter is placed. But this little chamber is not always unoccupied on your arrival; for there are, usually, a good many people there on the same errand as yourself, and every body has to wait until his turn comes. . .
>
> 'Dear me! how long one has got to wait!' cried the pretty lady, addressing herself to one of the assistants, who was polishing a plate. 'I thought, Sir, that portraits in this style were taken in an instant.'
>
> 'The sitting for a portrait, Ma'am, does not occupy more than fifty seconds; but some time must elapse before the plate is ready for delivery, even when the image comes out well upon the first trial, which is seldom the case.'
>
> '. . . when the process fails, what do you do then?'
>
> 'We try over again, ma'am, and keep repeating the process until the image is properly developed . . .'
>
> Here, a young gentleman who has been waiting some time for his turn, rises from his chair, saying, 'Fifty reasons for a failure, and try it on fresh every time! Oh, that's a good one! Catch me waiting any longer!'
>
> 'That's the way with the Parisians,' said the daguerreotypist; 'if you don't play mountebank with them, they mistrust you . . .'
>
> 'The sitting-room is ready, Ma'am: walk in, if you please' . . . he ushers the pretty lady into a tent-like sitting-room; where she is seated in a chair fitted with a peculiar apparatus for keeping the sitter's head in a proper position . . .
>
> 'Now, Ma'am,' says the operator 'remain perfectly still for a moment, if you please; do not even wink, if possible.' But the minute appears an age to her, and her eyes are just beginning to shrink from the intense light, when the daguerreotypist shuts up the lens, saying, 'That will do, Ma'am.'
>
> . . . The lady rejoins her party. There have been several fresh arrivals during her short absence . . .
>
> In a few minutes the daguerreotypist again enters, saying 'Perfectly successful, Ma'am! I don't think I ever saw a portrait come out better.'
>
> 'Oh, how glad I am! But where is it?'
>
> 'You shall have it in a minute or two, Ma'am.'
>
> In about a quarter of an hour he returns with the portrait. The likeness is acknowledged by every body, even by the lady herself . . .

The daguerreotypist was not always so fortunate as he was with this young lady. The range of his problems encompassed humanity—the man with a twitch in the corner of his mouth, the gentleman with a head that quivered "like calf-foot jelly," and the lady who insisted on

raising her eyebrows during the exposure time—which, being from thirty to fifty seconds long, was hardly conducive to an instantaneous daguerreotype. The writer concluded with these words: "And if you observe closely the persons who depart with their portraits you will perceive that, for the most part, they do not look pleased; the plain moral of which is, that the daguerreotype does not flatter, and it is hard to put up with the plain wholesome, unadulterated Truth."[34]

THE DECLINE OF DAGUERREOTYPING

The pattern and path of American photography changed greatly in about the mid 1850s. The events occurring earlier in European photography would become the channel for change in America. The daguerreotype would no longer reign supreme, and, although its beauty would remain unsurpassed, new and easier processes of photography would replace it in popularity. The cumbersome equipment, the lengthy process, and the lack of flexibility made the daguerreotype

Profile portrait, ca. 1855.
Sixth-size daguerreotype.
Artist unknown.
An unusual pose in
daguerreotyping.
Rinhart Collection,
the Ohio State University,
Columbus.

DAGUERREOTYPES EXTRAORDINARY.

WORLD'S FAIR OF 1851 AND 1853.

ONLY ONE DOLLAR FOR A PERFECT LIKENESS.

New-York Daguerreians' Defined Daguerreotypes taken on plates 150 square inches, larger than by any other Artist in the world,

MAKING THEM AS LARGE AS LIFE.

HARRISON & HILL,

OF

283 *FULTON-STREET*,

BROOKLYN,

Offer the strongest inducements to all who may desire an imperishable and perfect likeness.

With a Gallery the largest and most beautifully fitted up in the United States, and a light so arranged as to be able to suit any complexion or color, and strength of eyes, we may well defy New-York to compete with us in producing these Sun Drawings with equal Truth! Brilliancy!! and Softness of Tone!!!

It is well to state, that the work of Mr. Harrison received the highest prize, a Bronze Medal and Premium, at the New-York World's Fair of 1853, the highest honors ever received by any one man of the Daguerreian Art.

more difficult to produce (and more expensive) than a positive photograph on glass. Also, paper prints had the advantage of being larger, and, unlike the daguerreotype, a number of prints could be made from the same negative. Antoine Claudet had pioneered the large daguerreotype, sixteen by thirteen inches, back in 1843, but it was still small compared to some of the larger paper prints produced in the 1850s. The daguerreotype, too, had a reflective quality resulting from its highly polished silver surface that made viewing difficult, although those made in vignette style or those made with a soft white background during the 1850s overcame this problem.

The first major factor to cause a gradual decline in daguerreotype sales came in 1854, when James A. Cutting patented his ambrotype—a positive photograph on glass, when backed with a dark color—a process widely advertised as imperishable.[35] Another cause of this decline in sales was the fact that many prominent American photographers

DAGUERREOTYPE GALLERY,

No. 201 BROADWAY.

NEW AND GREAT IMPROVEMENT.

The Proprietors of this Gallery respectfully invite Ladies and Gentlemen to visit their Rooms, and see their Collection of Pictures, taken after the new and wonderful discovery and improvement, which represents the person daguerreotyped with all the fulness and roundness of nature itself. This Gallery is also the only place at which pictures by means of the Speculum are taken in the actual position, without their right side being reversed to the left, as occurs in the looking-glass, and has been the customary effects in the Daguerreotype. Patrons can only obtain Daguerrotypes with these latest improvements and inventions, tending to perfectly embellish and enrich the truthful picture, at this Gallery.

PICTURES OF YOUNG CHILDREN

are here made the subject of particular care. The production of these is usually very difficult, in consequence of the impossibility of confining the attention, but as we have instruments for these peculiar cases, by which we are enabled to seize the expression of a happy moment, frequently in a single instant, we produce by them the most truthful Portraitures, even of Infants.

PICTURES COPIED,

and reduced or enlarged to any required size.

FAMILIES ATTENDED at their Residences for
PICTURES OF THE INFIRM OR DECEASED.

FRAMES AND CASES, in beautiful fancy styles, appropriate as Birthday or Holiday Offerings, are constantly on hand.
TERMS will be found moderate, and the undersigned pledge themselves to give to their Visitors and Patrons the most perfect satisfaction. Respectfully,

BECKERS & PIARD.

were now experimenting with or being instructed in the art of making glass negatives and paper prints. Also, Talbot had given up his patent for the talbotype in England, which proved an incentive for American photographers. The trend inaugurated by Whipple and Root back in 1850 with the crystallotype, followed quickly by Frederick Scott Archer's collodion process, introduced in 1851, opened a broad new field in America for paper photography. Charles Fontayne of Cincinnati and Charles Fredericks of New York City produced some large paper photographs in 1854, and Victor Prevost, a Frenchman, opened a studio in New York in the early 1850s and began making superb views on paper of the city.[36]

The second major factor in the decline of the daguerreotype process came in 1857, when David A. Woodward patented an enlarger for negatives—no longer would photographers have to rely on mammoth cameras for large pictures.[37] Life-size portraits became the rage in the larger galleries, and they proved to be both money-makers and important symbols of prestige for the galleries.

Ella N. Osborn, October 1856.
Ninth-size daguerreotype.
Artist unknown.
A note with the case identifies the
subject: "Presented to Jos. S.
Thombs by Ella N. Osborn Oct
1856 just before marriage, aged
20 years weighing 100 lb. Mar-
ried Oct 11, 1856 by Rev. Mr. Tib-
bets, baptist minister at Belfast."
Rinhart Collection,
the Ohio State University,
Columbus.

Henry Hunt Snelling, with the sentimentality of old age and with his memory for exact dates dimmed, reminisced in 1888 about the "good old days" of daguerreotyping and about the superiority of American daguerreotyping:

> It was not long before the public were informed that they could have their likenesses taken by the wonderful daguerreotype process, and although skepticism . . . had followed the excitement of its announcement, curiosity was the principal inciter to the daguerrean galleries. . . . Some progress was made in the reduction of time and the comparison of the American daguerreotype with that produced in Europe showed so favorable for the American that our daguerreotypes became famous everywhere. This reputation the American daguerreotype never lost . . . always improving on European improvements and improving on points not touched by their foreign brethren, especially in the reduction of time and in the delicacy of detail. . . . They began to crow, too, and justly, over their brethren across the big salt-water

Hill family portrait, November 23, 1858. Sixth-size daguerreotype. Artist unknown. A note in the case identifies "Mrs. Anne T. Hill, Claremont, Minnesota." Rinhart Collection, the Ohio State University, Columbus.

pond, for they were outstripping them in every point of quality, mechanical and artistic. The boldness, distinctness and pose were unparalleled. At first this superiority of the American daguerrean was not only a surprise but a wonder. . . . The Frenchman shrugged his shoulders and acknowledged the corn with a generous heartiness. The Englishman confessed the fact but was unwilling to concede any superiority over himself in skill or taste, and ascribed the contrast between his own pictures and those of America to the clearness and actinic force of our atmosphere. . . . The fact, however, as to the superiority of the American daguerreotype remains, and we must needs be proud of it as an evidence of American talent and skill.[38]

In retrospect, America had experienced a golden era of portraiture from 1840 to 1860—one which not only documented itself in portraits of its people but created an art resplendent with an almost magical breath of life, of truth, and of intensity.

Boys in soldiers' uniforms, ca. 1863.
Quarter-size daguerreotype.
Artist unknown.
By the Civil War years, only a few of the "old-time" photographers still offered daguerreotype portraits—other easier-to-produce and less expensive forms of photography had made the daguerreotype almost obsolete.
Courtesy of Josephine Cobb.

PART 2. THE IMAGES

6. DAGUERREOTYPE PLATES, APPARATUS, AND PROCESSES

DAGUERREOTYPE PLATES

It was a Frenchman, August Brassart, who made the world's first successful daguerreotype plate for Daguerre. A few years later, Brassart settled in America, and in 1856 he began working for Holmes, Booth, and Hayden as a daguerreotype plate-maker. Brassart later recalled that he was scarcely in his teens when his father, an artisan in Paris, began to instruct him in the art of silver working. At eighteen he entered the employment of a Mr. Gandois, furnisher for King Louis Philippe. The Gandois factory was the largest of its kind in the world, and all its gold and silver work was done by hand.

Daguerre, Brassart recalled, had used "rolled or drawn silver plates, none of which were absolutely free from pores and all made poor pictures." He vividly remembered Daguerre's visit to the factory: "After numerous crude tests of his plates M. Daguerre came to our factory one day and informed M. Gandois that he wanted some plates polished to the required smoothness with hammers." The proprietor said that the idea was utterly impracticable. Then Daguerre said that he would like to see the polisher. The two proceeded to Brassart's bench, and the first question Daguerre asked was:

> Can you make plates perfectly smooth and free from pores? When the question was put, my employer stepped behind the famous inventor and motioned me to reply in the negative. I paid no heed to Gandois' advice and answered: 'I am confident sir, I can do it.' 'See what the young man says,' remarked Daguerre, smiling blandly. M. Gandois and my fellow workmen declared that I could not do it. Their attempt to discourage me made me work with enthusiasm. I succeeded in producing the kind of a plate M. Daguerre needed to make perfect pictures. On this plate the first flawless photograph was made. That was in 1839 [1838(?)]. I think I may say without boasting that my work with the hammer was what made the daguerreotype possible. Thereafter I devoted my time to the making of plates for pictures and was for a long while the only man in the establishment who could do the work successfully. A year after I made the first plate I enlisted in the French army, where I remained four years. Upon my return I resumed my work making daguerreotype plates. Henry Hayden, representing the firm of Holmes, Booth & Hayden, of Waterbury, Conn., came to Paris in 1856 to procure a man who understood the making of daguerreotype plates. He visited my place in company with Mr. Johnson, an American resident of Paris. The first thing Johnson said was: 'August, here is a man who is after you.' I had been in political

trouble owing to my strenuous opposition to the army of Napoleon, which placed the great French capital in a state of terror, and immediately supposed I was under arrest. You can imagine my joy on learning his real mission. I came with Mr. Hayden to America and continued in his employ until 1857, when the tintype appeared. The new improvement killed the daguerreotype. I severed my connection with Holmes, Booth & Hayden and branched out as an independent photographer. . . . My accomplishment for the art of photography was not much, perhaps, but I am satisfied with it. I do not want laurels for what I have done. There is sufficient compensation for me in the knowledge that I accomplished what my superior in the old workshop in Paris pronounced impossible.[1]

Daguerre's instruction booklet stressed the great importance both of the type of plate used and the way it was held in the camera during the predetermined exposure time. The type of plate recommended was a sheet of thin copper, plated with high-quality silver, having no impurities and as smooth as possible.

After the daguerreotype came to America in September 1839, experimenters struggled to obtain satisfactory plates on which to record

Seated woman, ca. 1858. Sixth-size daguerreotype. By Rufus Anson. H.B.H. plate. August Brassart pioneered the manufacture of H.B.H. plates for Holmes, Booth, and Hayden in 1856. Anonymous collection.

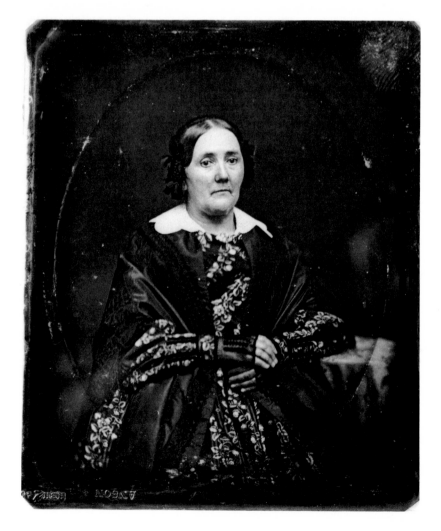

the new images. Just where D. W. Seager procured his plates to make his first scenes of New York remains unrecorded. Samuel Morse later recalled, in 1855, that he himself had "obtained the common plated copper in coils at the hardware shops, which of course was very thinly coated with silver, and that impure."[2] John Johnson, in his account, made no mention of where he bought his plates in early October to produce the Wolcott-Johnson portraits, although New York did have manufacturers who rolled silver and gold onto metals by special order.

J. M. Lamson Scovill, who played an important role in this early platemaking, was in New York when the *British Queen* arrived on September 20, and the excitement generated by Daguerre's process did not go unnoticed by him. The Scovill Company of Waterbury, Connecticut, a partnership of the brothers J. M. Lamson and William H. Scovill, had made plated ware from the early 1830s. Their method, adopted from the English, involved, simply stated, soldering a silver plate onto a copper ingot and rolling the combination down to the required thickness, keeping the original proportions between the silver plate and the copper ingot.[3]

Far from satisfied with the available daguerreotype plates, Samuel Morse called on Lamson Scovill on October 15. He explained that he

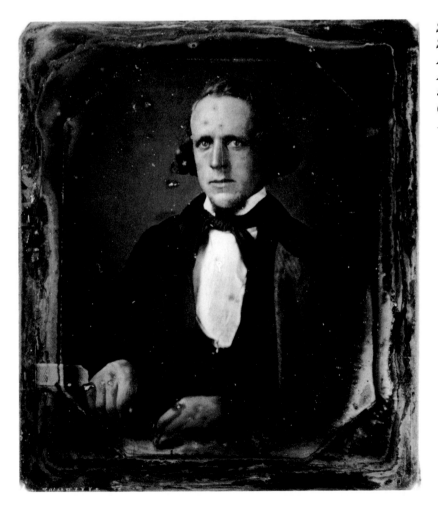

Seated man, ca. 1841.
Sixth-size daguerreotype.
Artist unknown.
A Scovills plate illustrating some nonadhesive spots of silver (blisters) on the copper plate.
Anonymous collection.

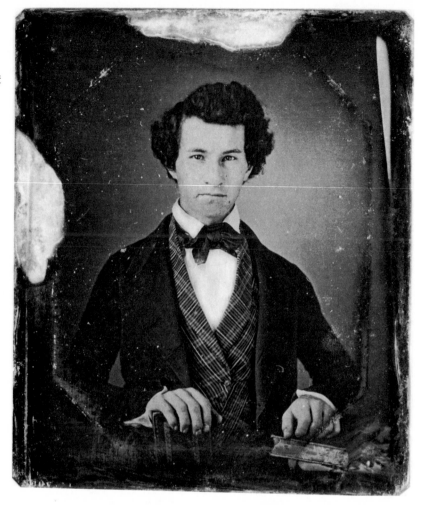

had ordered from Chamberlin, Scovill's New York agent, thirty-eight plates 6½ by 8½ inches for his experiments with the "daguerreotype which are going to be all the go here for a time." Scovill encouraged Morse by saying that he felt that their present system of plating silver would work well. In fact, he told Morse: "We might have some pieces of plate we could roll for a trial and send down this week." Scovill's instructions to the factory were to make the plates perfectly flat and to solder the silver on perfectly—"no marks from the rolls or in scouring or blisters."

Two days later Scovill again wrote his brother at the Waterbury factory, urging quick delivery: "The men . . . hope you will have some plates sent Saturday. . . . They want to get the views before the leaves are off the trees." The plates came on Monday, October 21, two days late, and they were a miserable failure, according to Lamson Scovill:

> The bundles of plates were received today and am surprised you should have cut them in the way you have after I wrote and said about the smoothness of the surface wanted. We never sent a piece of plate out so badly rolled and full of specks and imperfections it appears to me, at any rate they will not answer as they are. Mr. Morse says they look now as though they had been un-

Seated girl, ca. 1842.
Sixth-size daguerreotype.
Artist unknown.
An example of a dull image on a
Scovills plate, probably
ungilded.
Anonymous collection.

der the operation of the daguerreotype by the shades and unevenness of the surface. The rolls must be in the very *best order* and as smooth surface on the metal as possible before it is scoured down with stone. [Morse] wishes you to anneal 4 or 5 of the best of these, and roll so as to make out two of one for a trial. They may be too thin, but he thinks they may answer, or we may have to roll it to 10 inch by 8½ and lose 3½ inches on them. They ought not to cost over 75 cents he says and if well covered with silver if it is thin he thinks it will answer. . . . He says the curve of the metal as it comes out of the Rolls will not hurt it, but kinks or spots bends will spoil it. . . . They have to be polished down as smooth as Plate Glass.[4]

Later that week, Scovill traveled to Philadelphia to see Robert Cornelius; Cornelius and Son, as manufacturers of fine silver-plated ware, lamps, and chandeliers, were already important customers of his company. Robert Cornelius, by this time deeply interested in the daguerreotype, ordered "one pc. Rich Plate for the daguerreotype business 7 lb at 2 or 3 dollars a lb." He also told Scovill that "they have been trying it at the mint but do not make it go so well as they wish on account of the Silver . . . the Silver not being *perfectly* pure, the iodine will not work on it in consequence of the copper alloy in the sil-

ver."[5] While Scovill did not tell Cornelius that he already knew this fact, he did recommend to his brother that the transaction be kept secret—"For most people think the silver is pure we use now."[6] Actually the Scovills had used silver coins in their plating work for some time.

Both Morse and Cornelius had given Lamson Scovill the impression that daguerreotype platemaking would become a large business. Also, Scovill thought that Cornelius might begin making plates cut from large sheets of metal supplied by the Waterbury company. However, despite their optimism about filling the demand for plates, the Scovills continued to have trouble producing satisfactory ones until, in November, they tried English copper bars and found them superior for platemaking.

A Frenchman was often mentioned in the Scovill business correspondence between New York and Waterbury. This could have been none other than François Gouraud, who expressed his pessimism about the ability of Americans to make good plates. Lamson Scovill wrote his brother: "A person in Paris has sixty hands constantly employed in making plates . . . and the Frenchman calculates to make a fortune by importing them from France."[7] Obviously incensed by the

Seated young woman, ca. 1843.
Sixth-size daguerreotype.
Artist unknown. Scovills plate.
Reverend John Jones Collection,
University of Georgia Libraries,
Athens.

Frenchman's attitude, Scovill closed with the avowed intention of dis-
appointing him.

Unquestionably, in the fall of 1839, French plates were superior to
any that the Americans could produce. French law required that the
proportion of silver to copper be stamped on their plates, and the stan-
dard plates were stamped 40, signifying a ratio of one part silver to
thirty-nine parts copper. However, they also produced plates stamped
20, 30, 50, and 60. A hallmark composed of the maker's symbol and his
initials or name further identified all French plates; although Ameri-
cans also used hallmarks, they did not include the silver content with
their identifying symbol or name. The often superior French plates
would continue to compete with those of the Americans throughout
the daguerreian era.

Meanwhile, Lamson Scovill stated that American plates should be
marked like those of the French, if for no other reason than to "tell the
Frenchman they are like Paris plate." By the year's end, however, the
Scovill Company was still unable to produce really good daguerreo-
type plates, as evidenced by Scovill's letter of December 31, 1839:

Seated girl, ca. 1851.
Sixth-size daguerreotype.
Artist unknown.
A standard French hallmark in
the upper right corner illustrates
the 40 stamp.
Anonymous collection.

The daguerreotype Metal sent turns out good for nothing for it must be perfect or it will not answer and 18 plates is all they could get from 41 lbs. and those come to dress down are imperfect. Butler, Professor Morse and all hands are Chop Fallen about it, but do not give up yet. Butler [probably William H. Butler] says they shall want 300 lb. per week if it can be made here, and the only difficulty is in the plating. The Frenchman commences his courses of lectures next week and explains all about it and there are hundreds of Plates now ordered from Butler and not one yet made, there is hardly an hour in the day but someone is at Chamn [Chamberlin] after the Plated Metal. One called today and said he had seen them roll it in Paris, and it is rolled in the usual way up to the last time through the Rolls, when it is put through double, the two silver sides put together, and but a slight pressure put on. As to the silver, they all say it must be ½0 or 1 lb. Silver to 19 Copper, Butler says the Rolling of the 41 lb. was good enough, it is the want of silver on the surface, say thin places, and small dents and scratches in transporting is the trouble, he now wants 40 lb. plated on Cast Bars, say 5 pieces, and put on 1 to 19 and take special care with it in every process from the commencement and convince the Frenchman it can be done here, and at as low a price as in France. We can afford to try some experiments rather than give it up for it will be a large and profitable business when once it is a successful operation. Even put on the quantity of silver they name, it would pay well at $2.00 a lb., say 12 oz. Fine silver at $1.42 is $17.04, and 19 lb. Metal at 28¢ is $5.32, making together $22.36 to yield 18 lb. of Plate at $2.00 is $36. At any rate, they make one more trial and as soon as possible. They do not know how to wait one week for it. Hope you can get it here in all next week. It would be well to try one piece rolled double for experiment, but be sure and not get it thinner than easy 25 . . . Cloth or Tissue paper must be put on the surface of the Plate all through the roll when sent again.[8]

Despite attempts by the Scovill Company to capture the daguerreotype plate business, their competitors were also busy. A small New York firm, Corduan and Company (Joseph Corduan) or Corduan, Perkins and Company, began making plates in the fall of 1839 which they sold to the early practitioners. However, the Corduan plates, according to an account written by John Johnson, rarely had an even surface.[9] The Corduans, like the Scovills, had used an alloy in the silver plating instead of the pure silver which was absolutely necessary. When daguerreotypists polished such plates preparatory to taking portraits, the pure metal was often removed, exposing the surface of the alloy, and the resulting portrait after processing would show unsightly stains or spots.[10] The fact is that all extant American-made daguerreotype plates from 1839 and 1840 show pitting, spots, and often traces of copper through the silver—this serves to identify these early plates.

In early 1840, Johnson and Wolcott ordered the Scovill Company to prepare a roll of silver-plated metal, using pure silver. The roll was satisfactory, but the price was too high—nine dollars a pound! Shortly after, English plated metal of excellent quality was obtained, and

Johnson said that they were then relieved of the task of making and plating one plate at a time for their steadily increasing business of taking portraits.[11] Now, with a good supply of metal on hand, Johnson and Wolcott cut it into the desired size, and with true Yankee ingenuity they worked out a timesaving method for polishing their plates much more rapidly than Daguerre had recommended:

> This metal was cut to the desired size, and having a pair of "hand rolls" at hand, each plate with its silvered side placed next to the highly polished surface of a steel die, were passed and repassed through the rolls many times, by which process a very smooth perfect surface was obtained. The plates were then annealed, and a number of plates thus prepared were fastened to the bottom of a box a few inches deep, a foot wide, and eighteen inches long; this box was placed upon a table and attached to a rod connected to the face plate of a lathe, a few inches from its centre, so as to give the box a reciprocating motion. A quantity of emery was now strewn over the plates, and the lathe set in motion. The action produced was a friction or rubbing of the emery over the surface of the plates. When continued for some time, a grayish polish was the result. Linseed, when used in the same manner, gave us better hope of success, and the next step resorted to, was to build a wheel and suspend it after the manner of a grindstone. The plates being secured to the inner side of the wheel or case, and as this case revolved, the seeds would constantly keep to the lower level, and their sliding over the surface of the plate would polish or burnish their surfaces. This with the former, was soon abandoned; rounded shots of silver placed in the same wheel were found not to perform the polishing as well as linseed. Buff-wheels of leather with rotten stone and oil proved to be far superior to all other contrivances; and, subsequently, at the suggestion of Professor Draper, velvet was

Advertisement from the New York City business directory, 1841.

Seated man with unknown object on table, ca. 1842. English-size plate, 2⅞ by 3¾ inches. Artist unknown. The words "new metal" are inscribed on the back of the plate—possibly a later Wolcott-Johnson experimental plate.
Rinhart Collection, the Ohio State University, Columbus.

used in lieu of buff leather, and soon superseded all other substances, both for lathe and hand buffs, and I would add . . . those who are familiar with its use, prefer cotton velvet. The only requisite necessary, is that the buffs made of cotton velvet should be kept *dry* and *warm*.[12]

Although most daguerreotypists polished their plates by hand in the 1840s, the Johnson-Wolcott operation pioneered the use of a rotary polishing apparatus. On December 14, 1841, John Johnson received the second patent for photography in the United States for his method of polishing metal plates.[13]

Once the problems in manufacturing suitable daguerreotype plates were solved, the Americans commanded the home market for the first seven or eight years after 1839. The Scovill Company reached its highest sales in 1845, for example, and claimed to have completely dominated the market for that year.[14] Advertisements of the period give excellent references to the materials and plates which early daguerreotypists were using. Samuel Broadbent advertised in the *Savannah Republican* on December 9, 1843: "Mr. B. has just received a large

supply of French Plates, no. 20; also Scovill's, Corduan's and German Plates, and Morocco Cases: which he offers for sale by the gross or dozen, at New York prices. Mr. B. is agent for the sale of German Instruments, and has them for sale at the importer's price."

The pioneer daguerreotypist Edward White, who began producing plates in 1843, probably ranked next to the Scovills in sales potential— his "E. White Maker, N.Y. Finest Quality A. no. 1," undoubtedly the highest-quality plate made, won the first premium from the American Institute in 1845. Among the agents for the E. White plate were such noted daguerreotypists as the Langenheim brothers, John Whipple, and the Meade brothers. The amateur daguerreotypists Joseph Parker and William G. Mason, also a painter and engraver, of Philadelphia were also agents for White in 1846. During this year E. White and Company had a daguerreian studio in New Orleans, as well as the New York gallery, and they advertised in the *New Orleans Picayune* from October 10, 1846, until April 10, 1847: "We are prepared to furnish Daguerreotype Artists at New York prices with apparatus and all materials used in the business, wholesale and retail. Medium size cases [one-sixth size] and Plates, best quality, at $3 per dozen; all other articles at the same reducing rates." Because of increasing competition

Seated woman, ca. 1846.
Sixth-size daguerreotype.
Artist unknown.
An example of a heavy American plate superbly silvered and carefully hand-polished.
Authors' collection.

Woman holding a book, ca. 1845.
Sixth-size daguerreotype.
Artist unknown.
An example of Edward White's
"Finest Quality" plate.
Courtesy of Josephine Cobb.

from good-quality but less expensive daguerreotype plates, Edward White ceased making plates in 1849.

One of White's strong competitors was Louis B. Binsse, owner of a fancy goods store in New York City.[15] Binsse was primarily an importer of foreign products, and whether he importéd special French plates and stamped his name on them or manufactured his plates in New York remains unknown. Very little is known about Binsse or his operation, but he did achieve notable sales with his plates in the 1840s.

With the exception of the Scovill Company and, later, in the 1850s, the Holmes, Booth, and Hayden Company, most American plate manufacturers were small concerns which produced only limited quantities of plates. A few daguerreotypists during the 1840s made plates as a sideline, including Joseph Corduan and Edward White of New York City and J. E. McClees and Washington Germon of Philadelphia. Many platemakers were in business for only short periods of time—perhaps a year or two at the most—and then presumably moved into other fields.

Meanwhile, the French plate which did so well in the earliest days of the art generally did not compete too successfully with the heavier American plate during photography's first eight years. Those earlier

Advertisement from Sheldon and Company New York business directory, 1845.

French plates achieving limited sales acceptance were marked LLB & Ce (*cie* meaning "company" in French) and Grise; LLB & Ce may have been the hallmark of Louis L. Bishop, a platemaker from 1845 to 1847. Later, however, a number of popular French daguerreotype plates, led by the HB brand and followed closely by those marked JP and A Gaudin, began flooding the American market, and by 1850 French plates had captured the greatest proportion of sales. American platemakers had apparently become indifferent to the needs and demands of the daguerreotypists and had stopped improving their plates, whereas the French were making plates which were easier to bend, with a better polish and finish. One of the common complaints about the stiffer and slightly heavier American plates concerned their inability to be properly bent at the perimeter, a common procedure before buffing. The edges of flat daguerreotype plates tended to rip the buckskin or any other material used on the buffing stick.[16] Thus, for the bending operation, the improved French plates proved superior in malleability.

One strong reason for the French plate influx, after 1848, was provided by Edward Anthony's superb sales promotion. By 1850, Anthony was the country's leading supplier of daguerreotype materials

Seated woman, ca. 1843.
Sixth-size daguerreotype.
Artist unknown.
An example of the Louis B.
Binsse plate. The image is hand-
tinted blue on the dress and blue
and pink on the flowers.
Anonymous collection.

and apparatus and the largest importer of French plates. His sales manager, Henry Snelling, wrote in *The History and Practice of the Art of Photography* in 1849 that the qualities needed to take a good daguerreotype were possessed to an eminent degree by the French plate.

All throughout the 1840s, the Scovill brothers had resisted using pure copper and pure silver for their plates, thus making them hard to bend. In the spring of 1850, with their sales declining sharply, the brothers decided to bring over a Frenchman to solve their platemaking problems, but no action was taken on this decision. However, as a temporary expedient they began selling imported plates, some 120,000 in 1850, while during the same year their New York outlet sold only 183,624 of their own brand of plates.[17] In September 1850, they took important steps to improve their product when they closed their rolling mill for major renovations: the plant was rebuilt and ready for operation by the end of November. Whatever steps had been taken to improve their sales potential, a revolutionary new plate was now produced—lighter in weight, more malleable, and with a silver finish so smooth that the need for buffing (like the competing French plate) was eliminated.[18]

Seated man, ca. 1848.
Sixth-size daguerreotype.
Artist unknown.
An example of unsightly bending on the edges of a daguerreotype plate, probably caused by the use of a roller-type bending apparatus. Daguerreotype plates were less malleable, which was a source of trouble in the 1840s, and the daguerreotypist beveled the perimeter (about one-eighth inch from the edge) toward the rear (nonsilvered side) for strength and ease of buffing. Authors' collection.

Unquestionably, however, throughout the 1850s and in fact until the end of the daguerreian era, French plates dominated the American market. Neither the Scovills, with their fine-quality Scovill Mfg. Co. Extra plate, nor Holmes, Booth, and Hayden, with their later H.B.H. (eagle) and "wreath" brands (showing a bust of a man in a wreath), were able to capture a significant portion of the market.

At least two individual experimenters also sought to change or improve the daguerreotype plate. J. G. Moffet, owner of a brass-rolling mill in Bloomfield, New Jersey, and a dealer in brass mats and protectors for daguerreotypes, manufactured German silver daguerreotype plates in 1850;[19] whether his plates ever became popular is unknown. In 1853, George Englehard of New York City spoke of patenting a new type of daguerreotype plate which would take a better picture, a plate of zinc electrocoated with copper and then silver.[20] Again, whether such a plate came on the market or received acceptance is not known.

Throughout the daguerreian era one of the most pressing problems for plate manufacturers concerned delivering their products to dealers and daguerreotypists in good condition, without scratches or dents. Scovill and other makers used rectangular wooden shipping boxes, designed to hold a particular plate size. Slots or grooves on the inside of

Two girls, 1853.
Sixth-size daguerreotype.
By Hiram Y. Terwilliger.
An example of the new "Scovill
Mfg. Co. Extra" plate.
Anonymous collection.

the boxes kept the plates separated and in a standing vertical position.[21] This method of packaging was not outmoded until the advent of cardboard boxes for ferrotypes in the late 1850s.

Daguerreotypists were strongly opinionated about their choice of plates, and favorite brands were often endorsed in no uncertain terms. Each daguerreotypist was as careful with his plate selection as an artist with his canvas: a masterpiece could not be produced without a proper base! The rise and fall of various plate brands illustrates the fact that the daguerreotypists were always seeking something better and easier to work with, and this partially explains why platemakers were constantly struggling to keep abreast of the market. This preference by daguerreotypists for a particular brand of plate did not go unnoticed by Henry Snelling, editor of *The Photographic Art Journal*, who published a satirical article in 1854 on the fickleness of the daguerreotyper:

> In regard to the view we have taken, relative to daguerreotype plates, we would simply say, that they have been formed after nearly four years intimate acquaintance with the various kinds and brands sold in the New York market. We know of no brand from the guarantee 20th and 30th to the poor miserable star

60th—too often imported and imposed upon operators by men of loose principles for 40th that have not come under the ban of disapprobation. We could mention hundreds of instances where plates have been condemned by one artist, on some one of the grounds of complaint alluded to in our first article, have by others been pronounced most excellent.

Instances have occurred where whole plates have been cut up, after being carefully selected, and distributed among artists proverbial for their complaints—taken too, from the same importation, out of which hundreds had been sold too, and no fault found, by some of the best artists in the country, and pronounced by some the most worthless plates ever used and excellent by others.

We can go still further, and say that we know of instances where plates have been cleaned, and exhibited to the vendor with pictures on them, marred by either copper or black spots, which have been taken by another operator, recleaned, and submitted to the light in the camera, and again exhibited free from those imperfections. When operators can explain these simple facts, and many more like them, to the prejudice of the plate, we

Seated woman in evening dress, ca. 1859. Sixth-size daguerreotype. Artist unknown. An example of a Holmes, Booth, and Hayden wreath plate. Anonymous collection.

Drucella Sarah Curtis (1826–1857), ca. 1856. Sixth-size daguerreotype. Artist unknown. An example of an I H plate, maker unknown. A note in the back of the picture unit reads: "This picture was taken in Lexington, Mo. Born near Cynthiana, Ky. March 3, 1826. Died May 29, 1857 at Lexington, Missouri."
Anonymous collection.

will, without hesitation, yield to them the palm. . . . In nine cases out of ten . . . the fault lies entirely with the operator himself.

Before we dismiss the subject entirely, we would caution our readers as to the purchase of their plates. It is a well known fact, that thousands of plates are brought into the United States from France, by persons of narrow judgement, marked and sold for 40ths, when, in fact, they contain but one part in sixty and one in eighty of silver. They are generally introduced by small importing houses, not in the daguerreotype stock business, and who think and care more for making an extra profit than for their reputation and as the plates invariably pass through several hands before they reach those of the consumer, they are, in a measure, shielded from the odium attached to such cupidity; but it falls heavily upon the unsuspecting dealers who buy them. The safest and surest way is for the operators to make his purchases of those dealers in daguerreotype stock who make their own importations, and whose characters, for honesty and probity, are above reproach.[22]

Snelling's article gives some insight into the abuses relevant to the manufacture and distribution of plates, and it shows how large and important the platemaking business had become.

Charles F. Thomas, taken January 1, 1851, ten years old. Sixth-size daguerreotype. Artist unknown. An example of a Chapman plate, a popular American plate of the early 1850s. Levi Chapman's New York City firm was primarily a whole-sale supply house for a wide range of daguerreotype materials. These plates were probably made under a subcontract with an unknown maker.
Rinhart Collection,
the Ohio State University,
Columbus.

Sharp practices concerning the daguerreotype plate were evident, particularly in the 1850s. Both American and French platemakers offered plates precut to the size needed for portraits (see the dictionary of terms for standard plate sizes). The one-sixteenth size (1⅜ by 1⅝ inches) was an exception; it was not manufactured to size. Also, sizes were made larger than the standard whole-size plate, which measured 6½ by 8½ inches; they were known as mammoth plates, listed by Anthony in 1854 as 11 by 14 inches and 14½ by 16½ inches. A few daguerreotypists favored the use of these very large plates for special work where a large image was required, although most preferred not to use the larger plates because of the difficulty in handling them. The one-sixth size (2¾ by 3¼ inches) was the most popular among the trade. Practitioners with limited capital bought whole plates and cut them into the various sizes needed for their daily work; from one whole plate, six one-sixth-size plates could be cut with only (theoretically) about ¼ by 6½ inches of waste. But a sharp operator could gain extra plates and thus extra profits by narrow cutting on the width, depending on the necessary portrait size. Generally this shorted plate does not bear its maker's name, and no record exists of when the practice was first introduced or how many daguerreotypists took part.[23]

Seated man, copy, ca. 1855.
Sixteenth-size daguerreotype.
Artist unknown.
An example of the smallest size of daguerreotype, made for a miniature case.
Anonymous collection.

Seated woman, ca. 1856.
Ninth-size daguerreotype.
Artist unknown.
An example of a shorted plate.
Anonymous collection.

POLISHING THE PLATE

Daguerreotypists considered the cleaning and polishing of the plate to be the most important manipulation in the art. John Fitzgibbon, the famous Saint Louis daguerreotypist, wrote in 1850:

> In the first place it is of the utmost importance to have the plates, designed for the reception of the impressions, as clean as possible, for herein lies the great secret of success,—and nineteen out of twenty operators of the present day don't half clean their plates. I have known operators to spend an hour in cleaning one plate and in the end it would be less fit for use than when they begun, and again in five minutes others will prepare their plates in the most perfect manner. The mind as well as the hand must be busy in the operation.[24]

A thorough cleaning and buffing of the plate increased its sensitivity to the later chemical action of the process and produced a luster of great beauty, thus creating a superior daguerreotype. American daguerreotypists polished their plates with a precision and a care unrivaled elsewhere, particularly in the 1840s. Usually the plate was brushed, as with a violin bow, using a buffing stick covered with deerskin; for a final polish a silk or velvet covering was used. The buffing action was done with straight-across strokes, parallel to the long or the short edge of the plate. The direction was alternated—first the long side of the plate was polished, then the short side. If the image were on the vertical, and most portraits were, the final polish was done crosswise—on the short dimension of the plate. Daguerreotypists believed that this procedure resulted in a better picture, making the minute lines left from the polishing process less evident after the image had been recorded. Again much diversification existed regarding the abrasives used to polish the plates. A few favorite substances were rottenstone, pumice powder, and jeweler's rouge; occasionally a highly refined charcoal was used.[25]

The Europeans polished their plates differently, in both manner and materials. Robert Hunt wrote of polishing: "The hand-buff . . . is to be dusted over with animal charcoal and moistened with a little spirits of wine: some operators employ tripoli in a state of impalpable powder mixed with essential oil of lavender."[26] Hunt cautioned that the plate, when done, must be free of grease. In contrast to this European method, Levi Hill, the American daguerreotypist and an innovator with much practical experience, recommended:

> Rub the plate . . . with *rotten stone* and well filtered *spirits of turpentine*. Dry off *as much as possible* with a clean cotton; and with another clean cotton, *well wet* with good alcohol, rub the plate again for *some time*, keeping it wet with alcohol. Dust on another clean cotton an abundance of *very finely powdered starch* and rub *one or two minutes*, frequently renewing the dose of starch. Then buff as usual, only use on the first buff *frequent doses* of starch, instead of buff powder, and use the velvet buff naked. Carefully dust off the plate and it is ready for coating.[27]

Yet another method of polishing plates was practiced by British daguerreotypist Antoine Claudet, who had developed a roller from

which a piece of drab-colored velvet could be drawn over a flat surface. The daguerreotype plate was pressed down on the velvet, and the polishing was done with a rapid circular motion.[28]

Most daguerreotypists held that hand-buffing was the best method for producing top-quality daguerreotypes; however, a few preferred to use a mechanical buffing apparatus. Altogether six United States patents were issued for buffing apparatus, beginning with Johnson's patent of 1841 and ending with a patent issued to Charles Ketcham in 1858.

The quest for an improved method of holding a daguerreotype plate during the buffing process occupied inventive daguerreotypists more than did any other problem in the art. Identifying marks left on extant daguerreotypes indicate the use of many more devices than those actually patented during the era of the daguerreotype.[29] The earliest plate holder was a simple block of wood, usually dowel-shaped, on which the copper side (the nonsilvered side) of the plate was glued, usually with a red wax material which had a capacity for hardening very quickly. Levi Hill described this type of holder in 1850: ". . . a block of wood, surface not quite the diameter of the plate. The plate is fastened by means of a composition of one part of rosin, two parts of gum shellac. Formed into sticks . . . it is melted over a spirit lamp and

Rear of a sixth-size daguerreotype plate, ca. 1847. Artist unknown. A specimen showing traces of a red wax-type glue and an outline of a wooden block—one of the many devices used to hold a daguerreotype plate firmly while hand-polishing the silvered surface of the image side.
Anonymous collection.

dropped on the back of a plate. It is then softened over the blaze, the face of the plate laid on a clean pad or piece of paper, and the block instantly pressed upon the plate."[30]

Another similar holder was employed by both the English and the Americans. The English used a flat piece of wood, slightly smaller than the plate to be polished; two small clamps were fastened at the diagonal corners, one being movable. The Americans sometimes used a device invented by an otherwise unknown Mr. Black which employed fast-acting spring clips at two diagonal corners. The difficulty with these devices was that the clips, being above the plates, interfered with the buffing tool.

Those plate holders which do not appear to have been patented include four listed in the American Institute's catalog for 1846, invented by George G. Hidden, 285 Delancy Street, New York City—no description or functional value was given for them. Another popular holder, used in the 1850s, for which no patent or description has been found left two small identations on each edge of the plate's perimeter.[31] The first plate holder to be patented, on June 13, 1846, was a complex affair invented by Southworth and Hawes. Its intricate machinery include a vibration factor—a factor not mentioned in other holder pa-

Rear of a sixth-size daguerreotype plate, ca. 1853. Artist unknown. A specimen illustrating the pressure indentations (two on each edge) left by an unknown device used to secure the plate while hand-polishing the silvered surface of the image side. This is also an example of a plate resilvered by a daguerreotypist through the use of electrolysis.
Anonymous collection.

tents. The device gripping the plate was finely tuned for its purpose. It was a clever device but, for the average daguerreotypist, the cost of the apparatus must have been prohitive even it it were available on the market.

Later in the decade, two patents for daguerreotype plate holders were issued on the same day—Tuesday, October 23, 1849—one to W. & W. H. Lewis, the other to Alexander Beckers. The Lewis holder was a simple arrangement—a small bench device with a convenient flip-over lever to clamp the short side (close to its edge) of a plate to the block. The Beckers holder adopted clips acting at the diagonal corners of the plate to be polished. Two diagonal corners of the daguerreotype plate were bent downward and placed on the surface of the holder by the operator, who clamped them in the holder by turning a tension knob on the reverse side. Judging from a review of extant daguerreotypes for evidence of plate holders, the Lewis holder appears to have been the most widely used.

The plate holder second in popularity, one which was widely distributed by supply houses, was patented by Samuel Peck, a daguerreotypist from New Haven, on April 30, 1850.[32] Before using the Peck plate holder, the daguerreotypist clipped the four corners of the plate

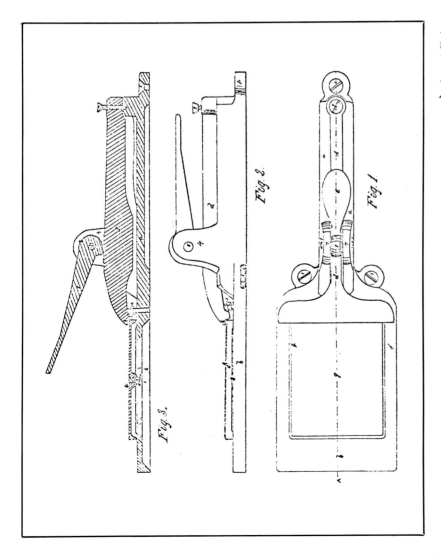

Patent drawing for a daguerreotype plate holder.
W. and W. H. Lewis, October 23, 1849.
Anonymous collection.

Rear of a sixth-size daguerreo-type plate, ca. 1850. Artist un-known. This specimen shows diagonal corners bent toward the rear of the plate, indicating that an Alexander Beckers plate-holding device had been used to secure the plate when the hand-polishing occurred.
Anonymous collection.

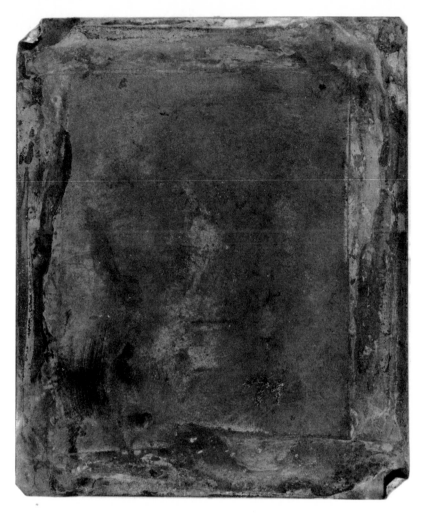

PLATE HOLDER.

The above cut represents a plate-holder invented and patented by Mr. Samuel Peck, of New Haven, Ct.

Patent illustration from The Daguerreian Journal, *1851.*

and then bent the plate's perimeter (about one-sixteenth of an inch in from the edge) to a ninety- to one hundred–degree angle.[33] The plate was then laid flat on the top side of the holder, and the four L bends on the plate were gripped in the holder as tension was applied. Two expansion springs and a locking device prevented the plate from moving.

During the polishing operation, the daguerreotypist used extreme care to avoid touching the silver surface of the plate and thus contaminating it with the oil from his body. To prevent this a pair of light pliers or nippers was his constant companion throughout the process. These special pliers were semidelicate and could be deftly handled. The upper and lower jaws were flat, about a quarter of an inch wide; the inside opposing surfaces were lightly roughened and the points of the jaws duck-billed for ease of operation.

A number of daguerreotypists preferred to resilver their plates immediately after buffing, because this considerably increased the sensitive qualities of the metallic surface, an essential ingredient for producing a good impression.[34] The operation was done by galvanizing or electroplating the plate with an additional light coating of silver. The special batteries—Smee's or Grove's—available for this process consisted of from three to six units (jars), depending on the size of the plate to be resilvered. After the poles were attached to the silver anode (Levi Hill recommended a silver dollar) and to the opposing da-

guerreotype plate, the cathode, a time lapse of from one to two minutes was needed. When a fine uniform sky blue color appeared on the plate, it was taken out, rinsed, and dried and was then ready for the sensitizing box. Daniel Davis, Jr., the pioneer daguerreotypist and an authority on electricity, wrote: "A very pure coating of silver is thus given to a plate from which the best pictures are obtained."[35]

Seated man, ca. 1851.
Sixth-size daguerreotype.
Artist unknown.
An image and the rear side of a
plate on which the Peck patented
plate holder had been employed
during polishing.
Anonymous collection.

Smee's battery for resilvering
daguerreotype plates. From
Daniel Davis, Jr., A Manual of
Magnetism, *1847.*

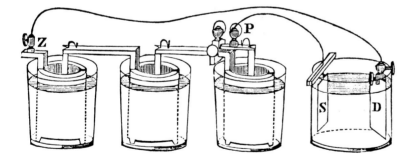

SENSITIZING THE PLATE

After the early practitioners had reduced the exposure time needed for each sitting in 1840 and 1841, they began to slowly improve their sensitizing mixtures, which were still in an experimental stage, by gradually building on Daguerre's basic vapor of iodine. The use of bromine and chlorine and many other chemical preparations became more or less standardized among daguerreotypists.

During the 1840s, secrecy surrounded each new sensitizing compound or quick appearing on the market. As the decade progressed, special quicks were made for specific purposes—some for outdoor scenes, some for strengthening tone for light clothing and blue eyes, some for taking portraits of children, when a faster exposure time was necessary. A high-quality image, one as perfect as possible, was the goal of the daguerreotypist if he were to guard his hard-won reputation, and the number of quicks flooding the market in the 1840s reflect the fact that daguerreotyping was a strongly competitive business. American quicks were sold in England, English quicks were sold in America. Some mixtures like Broadbent and Carey's required a special camera with an electrical device for fast exposure time. A number of mixtures required a double exposure of the plate to the chemicals— Mayall's Quick was the best known of the double types. Louis Beckers offered a compound called "Root's 15 seconds Process" which had some popularity. Other well-known mixtures were Charles Johnson's Quick, Herber's Boston Quick, and McCartey's Dry Sensitive.[36]

Samuel Humphrey, editor of *Humphrey's Journal*, wrote in 1853 about the chemical ingredients for sensitizing plates: "The use of fats, oils, or greasy substances, has been one of the most emphatic prohibitions about the Daguerreotype plate. Yet it has been proved that its presence in a small quantity upon the silver surface has the effect of reducing the time of exposure in the camera, from two-thirds to three-fourths."[37] Humphrey's statement illustrates the wide difference of opinion regarding the methods of sensitizing plates.

The boxes in which the plates were sensitized demonstrated American ingenuity, and many daguerreotypists made their own containers. Henry Snelling described, in 1854, a coating box which was probably a composite of those in use during the 1840s:

> The usual form for the iodine and bromine box is a wooden box having firmly embedded within it, a stout glass jar, the edges of which are ground. Over this is placed the sliding cover frame double the length of the box, one half occupied by a piece of ground glass tightly pressed upon the glass pot by a spring and fits the pot so accurately that it effectively prevents the escape of the vapor of iodine, bromine or other accelerating liquid contained therein. The other half of the lid is cut through, shoulders being left at the four angles for the different sizes of frames designed to receive the plate while undergoing the coating process. Above the sliding frame is a stationary top lid cover. The sliding frame with the plate in place, is then slid under the top cover and rests above the glass pot, and when coated to the proper degree, it resumes its former position, and the plate is then placed in the holder of the camera box.[38]

During the colder months, one of the daguerreotypist's first chores of the day was to heat his coating boxes on a warm stove for a few minutes. In the summer months, he placed about half an ounce of chloride of calcium in the boxes, which acted as a dehumidifier; the stove was used only for keeping the buffing sticks dry.

Each daguerreotypist must have had his own unique method of operation. For example, Levi Hill cut a three- to four-inch hole in the bottom of his box so that the heat could circulate around the glass jar

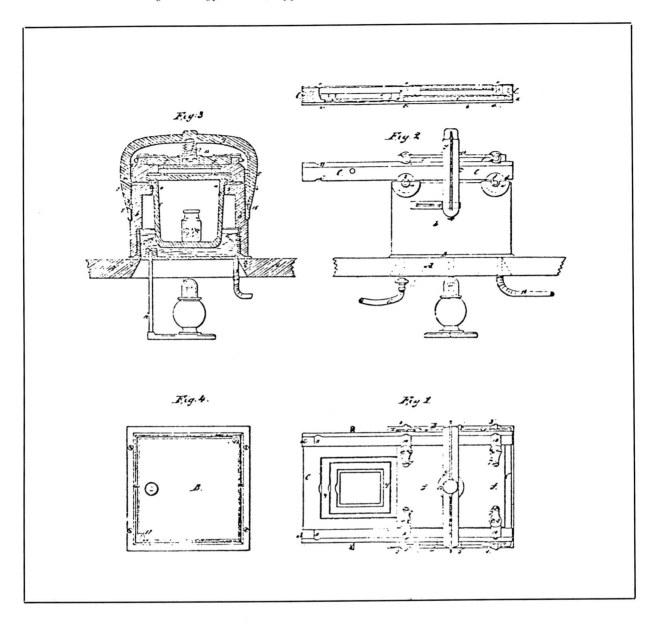

containing the chemicals.[39] The desirable temperature for the bottom of the jars was between sixty and seventy degrees Fahrenheit. The jars were kept at this temperature by standing them on the stove when necessary (with precautions to protect the glass from the heat) or by using a spirit lamp four or five times throughout the day.[40]

During the era of the daguerreotype, not many coating boxes were patented. W. & W. H. Lewis received a patent on November 15, 1853, for a highly improved version of the earlier wooden box; one refinement cited in the patent was the use of rollers for sliding the top of the apparatus back and forth. The sealing device had a thumbscrew positive arrangement to keep moisture and air from the sensitizing chamber (not unlike that on a mason jar). The patent claimed that this controlled the evaporation of chemicals, which was an important factor in the coating operation, of course.

Patent drawing for coating daguerreotype plates.
W. and W. H. Lewis, November 15, 1853.

Boy with arm on table, ca. 1845.
Sixth-size daguerreotype.
Artist unknown.
An example of a Scovills plate
with the sensitizing chemical
improperly applied.
Rinhart Collection,
the Ohio State University,
Columbus.

Another interesting coating box, patented by J. H. Tompkins on January 15, 1856, differed in many respects from those already in use. Tompkins' claim was not for the box, which resembled earlier ones, but for a new arrangement of coating through the use of an India rubber flask (a bulb) and a tube. A compression device installed in the tube leading to the box controlled the chemical emissions when the bulb was squeezed. Another feature was a diaphragm to filter sensitizing chemicals.

Coating the daguerreotype plate was sometimes a rather complex affair, depending on the operator and the effect he desired in his finished image. Most studios had a darkroom where the daguerreotypist was able to work in semidarkness when coating the plate.[41] He needed skill, experience, and the ability to judge when a plate had just the right amount of a sensitizing chemical to produce the correct color reaction when heated. In sensitizing a plate, he used several different chemicals, each of which produced a distinctly different color when heat was applied. The color of the plate, when ready for the camera, guided the daguerreotypist in producing the quality of the image desired. By 1850 many progressions of chemicals were used to coat a plate, and many daguerreotypists preferred to make up their own chemical accelerators for coating rather than use the commercial prod-

A bill of sale for a camera purchased by Levi L. Hill in 1849. Courtesy of Walt Craig.

ucts available from stock dealers. Levi Hill described the coating of "chloro-bromide of iodine": I iodize to the deepest of *yellow*, without red, bromine to a deep *cherry*, just verging on the *blue*. . . . My coating for 'chloride of bromine' is iodine to a *gold* color, quick to a *rosy yellow* and back one fourth."[42] If the operator projected a finish portrait with intense light and shadow in strong contrast, the plate was iodized to a pale lemon color and "bromined" to a light gold color. Otherwise, if the plate were iodized to a deep red and "bromined" to a steel blue, the effect of the finished portrait would be dull and heavy.

A successful daguerreotypist needed to be very careful in all his coating manipulations. If too much moisture was left in the iodine box, oversolarization occurred, often producing bluish whites on the finished portraits. Dull images and dirty plates also went hand in hand. Weak images allowed an undersensitizing when a standard exposure time was used. A lack of tone in an image indicated a need for more "chloride of iodine." The list of faulty coating manipulations was long. The best daguerreotypists were knowledgeable in chemistry, had a good eye for color tone, and had an infinite amount of patience for the fine detail necessary to produce beautiful images.

After the daguerreotype passed through the coating process, it was placed in a light-proof plate holder and was now ready for the camera. The sitter was positioned, and lighting arrangements were made ready. After the sensitized plate and its holder were substituted for the ground glass focusing device (after proper focus), the plate was then exposed for the seconds judged to be correct for a particular sitter or object.

THE MERCURY BATH

After the operator removed the plate with the image still invisible, he was ready for the next step in the daguerreotype process: developing the latent image by placing it over the vapors of mercury.

Patent drawing for a
photographic bath.
J. Moulson, September 2, 1851

The apparatus used for developing a plate in the early 1840s was mostly patterned after Daguerre's original drawings. The ungainly three-piece affair consisted of a lamp, a funnellike unit with a mercury reservoir in its base, surmounted by a nearly square box having an airtight lid, usually placed at a forty-five-degree angle. On one side of the box was a viewing window of yellow glass which enabled the operator to check the progress of the "mercurialization." The mercury unit also had a thermometer for temperature control.[43] Over the years many supply houses sold improved versions of the original boxes, and later in the 1840s it was found that, when plates were laid flat in the apparatus, they received a more even application of mercury—an improvement necessitating a new arrangement of the viewing glass, but otherwise the design remained unchanged.

The first of the mercury box patents in the United States appeared on September 2, 1851, issued to John Moulson. Moulson's apparatus was improved in that it provided even vapor dispersement through the constant agitation of the cup which held the heated mercury. A thermometer placed in the hollow axis rod insured the correct temperature for the mercury. The top arrangement for holding the daguerreotype plate resembled the sliding top features of the coating box.[44] Another interesting mercury bath was patented by Benjamin Franklin Upton, a daguerreotypist from Bath, Maine, on April 12, 1853. His model, like Moulson's, was designed to keep the temperature constant and the vapors of mercury evenly distributed on reaching the

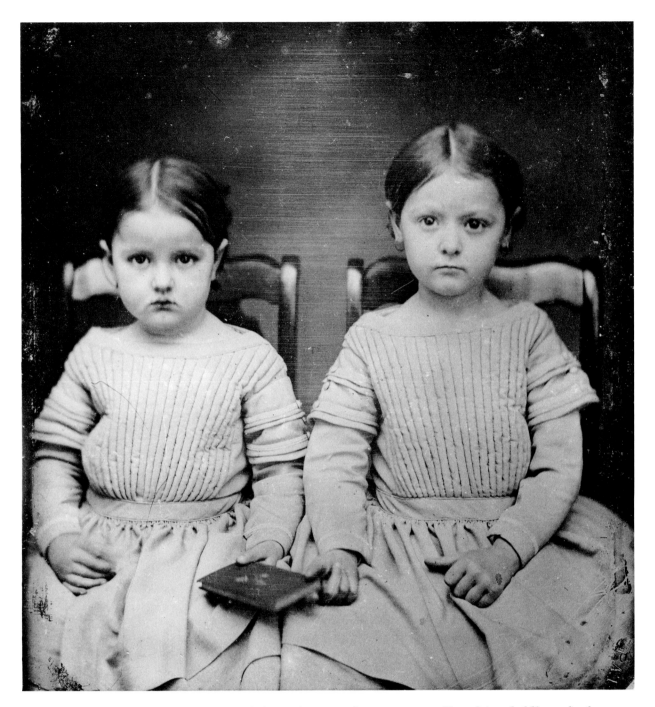

daguerreotype plate. The key to Upton's invention was a lever to control the lamp wick, thus maintaining steady heat output.

Samuel Humphrey claimed that failures in the mercury process, while related to the even distribution of vapors, were not always primarily caused by uneven distribution. He maintained that poorly buffed plates or unevenly buffed plates caused a "mercurializing" failure because the plates were not uniform in thickness and that finely polished spots on plates would take the mercury more readily.[45]

The amount of mercury employed also underwent changes in the 1840s. Whereas the early daguerreotypist had used from one to two pounds in the process, only one to eight ounces were needed by 1850,

Two sisters holding a book, ca. 1853.
Sixth-size daguerreotype.
By Benjamin F. Upton.
An example of a daguerreotype image "mercurialized" by Upton's mercury bath. The plate is die-stamped "Pat. 1853."
Rinhart Collection,
the Ohio State University,
Columbus.

Seated man, ca. 1840.
Sixth-size daguerreotype.
Artist unknown.
Before the process of gilding the daguerreotype with a gold chloride solution, the image appeared weak and dull. Note the primitive lighting as well.
Courtesy of W. Robert Nix.

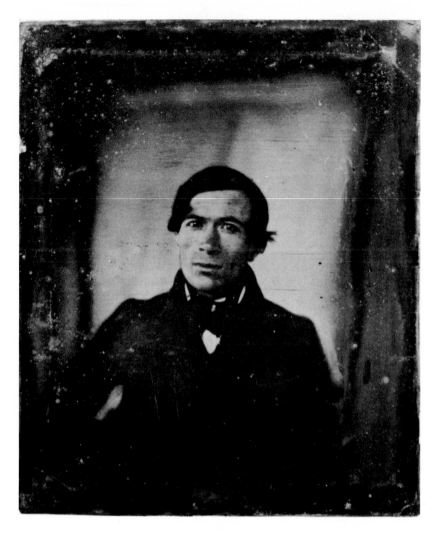

possibly due to the improvement of the boxes. The mercury in the box was used over and over again; only a small amount was dissipated by each plate. One mode of mercurializing a plate was noted by Levi Hill in 1850:

> I use in my bath about one ounce of mercury—*pure distilled mercury*. If I have any doubts of the purity of my mercury, I distill it myself. . . . I use my mercury at a heat 175 F. a little below the point at which a plate will cloud and keep the plate over it, as a general rule two minutes. I keep the bath in a dark room by itself, as far as possible from the coating boxes. My mercury, I filter *every day* through a cone of paper with a fine opening. . . . I consider the above simple process *absolutely essential to success*.[46]

The mercury process was basically simple, nearly mechanical, and failures were few compared to those in the complex sensitizing procedure. An excess of mercury was easy to discern—parts of the finished image that should have been black showed a rather brown ashy hue, and often a bluish scum settled in the shades or the entire picture was dim. A like reaction could also be produced by an excess of bromine.[47]

FIXING THE IMAGE

After the mercury process was completed and the plate removed from the mercury box, the next step was to fix the image. In the entire daguerreotype process, this was the only procedure to cause no disagreement among the profession. Fixing the image was a relatively easy operation. The plate was washed with a solution of hyposulfite of soda to remove all traces of the undecomposed chemicals; if the plate were not washed thoroughly, the image would slowly darken.

Preparatory to the washing operation, the daguerreotypist, using a pair of nippers or pliers, gripped the lower left-hand corner of the plate (image side up) about one-quarter of an inch from the edge. Then, holding the plate at a slight incline, he poured hyposulfite of soda over the surface; the plate was gently rocked in all directions until no sign of the chemicals remained. Next, the plate was drenched in pure (distilled) water to ready it for the final process—gilding—both processes being continuous.

GILDING

Gilding, which toned and strengthened the image, was done while the plate was still wet. It was again lifted, this time to a level position, and enough gold chloride solution was poured upon its surface to cover it completely. While still being held by the pliers, the plate was now placed over a very strong blaze from a spirit lamp. As the plate was heated, the image at first darkened and then gradually assumed a bright and lively appearance. The image at this stage was ready for color application if desired; next, it was framed with mat, glass, and protector, placed in an attractive miniature case, and within minutes the patron could walk out of the studio with a treasured keepsake.

Although "patent" gilding solutions were available, many daguerreotypists made their own. Generally they used one pint of pure soft water to which were added fifteen grains of pure chloride of gold, mixed together in a light-proof bottle. In a second bottle, the same amount of water was mixed with sixty grams of hyposulfite of soda or hyposulfite of potash, and to this was added one teaspoon of alcohol. The bottles were then agitated until the contents were completely dissolved. The gold solution was poured slowly, pausing to mix well at intervals, into the second bottle; the solution was then ready for use. Except for the alcohol, the solution was very similar to Fizeau's original discovery for gold-toning the image.[48]

Another method of gilding, using electrolysis, was employed by some daguerreotypists. At about the same time that the Frenchman Fizeau announced his gold toning process, in 1840, another native of France, a Mr. de la Rive, succeeded in gilding metals through the use of chloride of gold and electric current.[49] De la Rive's method would provide a basic foundation for subsequent gilding methods by galvanic battery.

Among the first daguerreotypists to gild by the battery were Wolcott and Johnson, who received an extra fee of $1.25 per plate for the process, in 1841, when they were associated with the Richard Beard gallery in London.[50] John Plumbe used a galvanic battery for gilding daguerreotypes in 1842, when he was assigned the Daniel Davis patent

Rear of a sixth-size daguerreotype plate, ca. 1850. Artist unknown. The dark circle indicates the use of a round wick spirit lamp when heat was applied during the gilding operation. Authors' collection.

for coloring daguerreotypes, a method which used various metallic agents in solution. By the close of the 1840s, attempts to gild daguerreotypes with electricity appeared to have been abandoned; however, in 1852, the practice was again revived: a patent was issued to Charles L'Homdieu, a daguerreotypist from Charleston, on October 26 for "Improvement in Gilding Daguerreotypes." In the patent specifications, the inventor stated that gilding with the galvanic battery had been tried in the early days of photography but, because the resulting image was often cloudy, it had been discontinued. The patent called for five different styles of plate carriers; the bottom part of each carrier was to be a thin sheet of zinc about the size of the daguerreotype plate to be gilded. After the plate was placed in a carrier, the unit was put into a hot solution of cyanide of gold (previously boiled), and the electric current was applied. L'Homdieu claimed that his process would produce an image with a deep warm golden tone of long durability, highly superior to images gilded by the usual method.[51]

Another patent which facilitated gilding was issued to W. & W. H. Lewis on May 8, 1849. The improvement called for a relatively small piece of equipment—a three-piece stand made up of a base, a vertical support, and a carrier platform extending in the opposite direction from the base held the daguerreotype plate while the gilding process

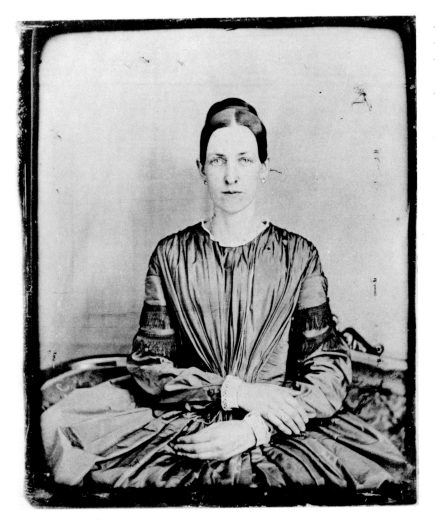

Seated woman on sofa, ca. 1848.
Sixth-size daguerreotype.
Artist unknown.
This is probably an example of gilding by electrolysis. An unknown metallic substance coats the plate.
Anonymous collection.

took place, thus eliminating the need for pliers. The plate frame or platform had small sharp raised points to accommodate different-size plates on their corners.[52] The vertical support was sufficiently high above the base that a spirit lamp could be placed under the plate while the gilding process went on.

Many years later, when daguerreotyping was at best a faded memory, *Wilson's Photographic Magazine* published an article by an "old-timer" titled "The First and Best the Daguerreotype." The writer recapped the various ways of making a plate and sensitizing it, but his remarks about the gilding process were especially interesting:

> There were many dodges connected with the process, for there has been no process more dependent on man and less on cannibals. . . . Some American photographers have developed a method of brightening their pictures by pouring secret solutions on the surface and applying heat in the same way as gilding. One of these solutions consisted of ordinary muriate of ammonia which had a marvelous whitening effect. Another solution for increasing brilliancy was a solution of water of carbonate of potassium of cyanide, a little alum and borax and some other things many of which probably had no effect whatever. The brilliancy was certainly very much increased, and it was to some

Patent drawing for gilding
daguerreotypes.
C. L'Homdieu,
October 26, 1852

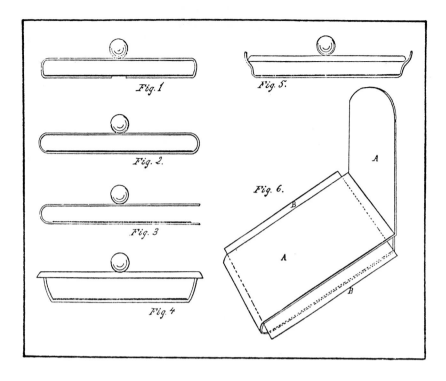

such treatment that the excellence of American daguerreotypes was attributed. Muriate of ammonia was an extremely effective agent in the case of badly solarized pictures. When the face was properly exposed, the bluing action would take place on any white article such as the shirt breast. This was called solarization and to avoid it many workers inserted a piece of black velvet in the waistcoat of the sitter until the exposure was half complete. But if the solarization had taken place, the bluish tint could be removed by means of muriate of ammonia, and the shirt breast, etc. took on its proper lightness.[53]

The American daguerreotype process, although it had its roots in Europe, was innovative and superior in all of its techniques to the English or French daguerreotype process. Those who practiced the art in America were inventive, with some exceptions, and they had the needed business acumen to promote and develop new ideas, a distinguishing quality among Americans in the daguerreian era.

7. STEREOSCOPIC DAGUERREOTYPES

American tourists, including daguerreotypists, visiting the Crystal Palace exhibition in London in 1851 admired the photographic displays, which proved to the world that America had surpassed all competitors in the art of the daguerreotype. But Americans interested in photography did not overlook an English innovation—the stereoscope—which would, in the next few years, have a great effect on the history of photography in America.

This new branch of photography had gone almost unnoticed until the exhibition. Sir Charles Wheatstone, the English physicist, had discovered the principle of the stereoscope, which was made public in an address read before the Royal Society on June 21, 1838.[1] However, because it was impractical to produce dissimilar views with sufficient accuracy by engravings, the stereoscope did not come into general use until after the introduction of photography.

Wheatstone applied his principle of the stereoscope in the construction of an instrument in which binocular pictures were made to combine by means of mirrors, but this instrument, although effective, was cumbersome. A few years later Sir David Brewster, the eminent physicist who was interested in optics, improved the stereoscope by introducing the use of lenses for uniting the dissimilar pictures. He invented a lens stereoscope in which a series of pictures could be observed in rapid succession. His binocular camera for reproducing objects of art for his stereoscope was reported in the *Journal of the Franklin Institute* in 1849:

> . . . The Binocular Camera described . . . is composed of two semi-lenses, obtained by bisecting an achromatic lens. These semi-lenses are placed at the distance of the two eyes, or at such multiples of that distance as may be necessary to take dissimilar drawings of full-sized or colossal statues for the purpose of reproducing the statue in the stereoscope.[2]

One of Brewster's stereoscopes was displayed at the great fair of 1851, among the scientific toys. Queen Victoria, very taken with the instrument, was entertained by the pictures she saw through the twin lenses in three dimension. On hearing of her pleasure, Brewster presented the queen with a magnificent instrument constructed in Paris by Jules Duboscq, the optician. Soon other opticians began making the stereoscope, and it became very popular in England.

The French account of the introduction of the stereoscope into that country is an amusing one—a comedy of optical obstacles had to be conquered before the merits of the stereoscope were admitted. In Paris, Abbé Moigno—who expressed great interest in the stereoscope after viewing one brought to the city by Brewster—wrote a pamphlet on the subject. He lost no time in taking his manuscript and instrument to call upon the great scientist Arago, who, although very cour-

Wheatstone's reflecting stereo-scope, 1838. Behind the central figure are two mirrors at right angles to each other; the drawings were placed on each side of the mirrors, facing each other. "The observer must place his eyes as near as possible to the mirrors, the right eye before the right hand mirror, and the left eye before the left hand mirror." The binocular pictures were thus made to combine by means of the mirrors.
British Crown copyright.
Science Museum, London.

The Brewster stereoscope, ca. 1850 (left), was made of lacquered wood inlaid with mother-of-pearl floral decorations. The stereoscope on the right, measuring four by five inches, was patented in 1853 by John Mayall of London.
Sotheby-Parke-Bernet Galleries.

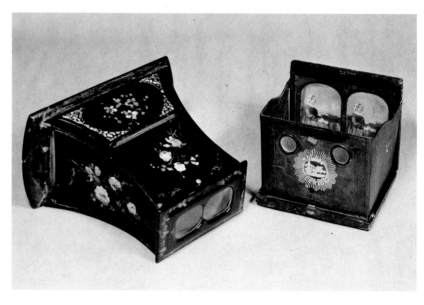

teous, now had an eye defect—he saw double. So, when Arago handed back the stereoscope, he said he had seen nothing.

Moigno then called upon a Mr. Savart, another member of the physical sciences section of the French Academy of Science. Unfortunately, he had a defective eye. After applying his one good eye to the instrument, he said: "I can not see a bit." The next call was made upon the celebrated Alexandre Edmond Becquerel, who was almost blind. Moigno began to despair of his mission, but he made another try, upon a Mr. Pouillet, but he also had an eye defect—he squinted and saw nothing but a fog.

One member of the physical sciences section had excellent eyes— the illustrious Jean Baptiste Biot—but the great man refused to look at the stereoscope until assured that the phenomenon did not contra-

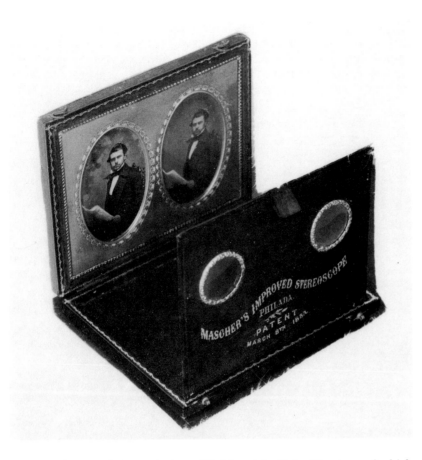

Seated man holding sheet music, ca. 1854. Quarter-size Mascher stereoscope (two daguerreotype plates, 3¼ by 2 inches). Artist unknown. The Mascher viewer was a simple and durable adaptation of the miniature case. Brass hinges were used for the image cover; for a clearer view of the three-dimensional image, the lens leaf (which folded flat when not in use) could be moved slightly forward or backward. Rinhart Collection, the Ohio State University, Columbus.

dict the theory of the emission of light put forth by Newton, of which Biot was a brilliant defender.[3]

The son-in-law of Abbé Moigno, the optician Jules Duboscq, saw that the stereoscope was much more than a toy. He began making stereoscopes for sale, and he also produced a series of daguerreotypes—portraits from life, art objects, and natural history subjects.[4]

John F. Mascher of Philadelphia improved on the Brewster stereoscope in 1852. Mascher, an inventor, had read an article in the *Scientific American* describing an English stereoscope, using two almost identical daguerreotypes. In a very short time he constructed an improved model and wrote a letter to the *Scientific American*, published on June 26, 1852.

> Messrs. Editors—Directly after seeing extract . . . in no. 34 of the *Scientific American*, I succeeded in reproducing the solid daguerreotype. My stereoscope is 9 inches long, 6 high, and 5 deep; my daguerreotypes are half sizes, placed upright in each end of the box (stereoscope); I have two mirrors; diverging at an angle of sixty degrees from the centre of the front of the box; the light is admitted from the back. This instrument produces the most astonishing effect; it brings out the picture in bold relief; just as if the subject were standing before you in reality. It requires to be seen to be fully appreciated.
>
> I have made a decided improvement on the above instrument: I take two pictures on one plate, two and a quarter inches apart; or, what is still better, on two plates joined together afterwards.

I always place my two cameras at an angle of thirty degrees, in taking the pictures, keeping the eye of the subject directed in a line drawn directly between the two cameras, thereby producing what we might call a right and left picture. . . . I perceive that our leading daguerreotypists have taken the matter in hand and I expect to see them produce beautiful pictures which will rapidly take the place of the old kind.

In his reference to leading daguerreotypists, Mascher undoubtedly meant such pioneer photographers as Southworth and Hawes of Boston and Frederick Langenheim and Frederick De Bourg Richards of Philadelphia, who were already experimenting with stereoscopic daguerreotypes.

Richards also developed a new-style stereoscope in 1852. Richards, who had taken up daguerreotyping in 1848, was also a landscape painter of some importance, having exhibited at the National Academy. By 1853 his daguerreian studio was located at 144 Chestnut

Standing boy and young women holding a scrapbook, ca. 1857. Quarter-size stereoscope (two daguerreotype plates, 3¼ by 2 inches). By Samuel Broadbent. An illustration of an uncased single stereoscopic daguerreotype plate without mat or protector. Rinhart Collection, the Ohio State University, Columbus.

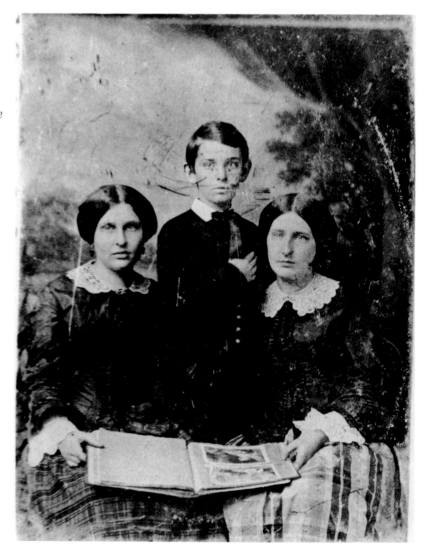

Street, an area which had become the center of daguerreotyping in Philadelphia. His close neighbors and competitors were Montgomery P. Simons, Myron Shew, and Marcus Root, all notable daguerreian artists. The *Journal of the Franklin Institute* printed a November letter from Richards concerning his stereoscope:

> To the Committee on Science and the Arts of the Franklin Institute.
> Gentlemen:—I offer for your consideration some explanation of the Stereoscope I had on exhibition at the Franklin Institute, and what I consider my improvements.
> 1. In the imported instruments, and all that I have seen, the light is admitted to the picture by a small opening at the top; to view the picture, you have to bend neck and body over, which is a very unpleasant position. This I obviate by leaving the box open for a very short space at the back, so that the light can fall upon the picture properly when the body is upright.
> 2. I have increased the focal distance and power of the lenses, so as to take in much larger pictures than formerly, which pictures I have found by experience have to be taken at a different angle from those for small instruments.
> 3. I have placed at the back of the instrument a screw, so as to lessen or increase the distance of the picture from the lenses, so as to suit any focus. The same alteration has been made by drawing out the tube in front: there is a great objection to this, as those not familiar with the instrument are apt to throw the lenses off their centres.
> 4. That which I consider the most important of all the changes I have made is, placing a rack and pinion or a lever in front, by which means I widen or lessen the distance between the lenses, so as to bring their centres on a line with the centres of the eyes; thus obviating that straining effort which many persons have to use in viewing pictures in the ordinary instrument.
> I remain your obedient servant,
> F. De B. Richards[5]

Critical analysis of Richards stereoscope, from the Committee on Science and the Arts, was surprisingly laudatory:

> Report on Mr. Richards' Improvement on the Stereoscope. That, as will be seen by the letter of Mr. Richards, appended hereto, he claims for his arrangement of the Stereoscope four advantages, viz:
> First. "Leaving the box open for a short space at the back, so that the light can fall upon the picture properly, when the body is upright." This arrangement is undoubtedly advantageous, inasmuch as it not only relieves the body from a constrained position, but also allows more light to fall upon the picture than can frequently be gained in the usual construction. It is, however, not new, as a very favorite form of the instrument has been the skeleton stereoscope, in which the whole upper part and sides are open to the light.
> Secondly. The "increase of the focal distance and power of the lenses, so as to take in much larger pictures than formerly, which

The figure below represents a young lady viewing a Likeness of the object of her affections through one of

PETER'S
PATENT IMPROVED STEREOSCOPES,
OBTAINED AT HIS
ORIGINAL STEREOSCOPE GALLERY,
394 BROADWAY, N.Y.

The Likeness itself was also taken at the same place, and by the same artist.

Those who have had the happiness to become acquainted with this wonderful discovery, will not wonder at her apparent admiration and the intensity of her gaze—so natural does the representation appear, in all its lifelike rotundity and breathing beauty.

The Public are hereby informed, that the above-named Gallery has been established between three and four years, and at least two years longer than any other in the State, and that ten times more Stereoscope Pictures have been taken there than in all the city besides.

Let the Public call and judge for themselves. Every style of daguerreotype taken in the highest perfection of the art, and every kind of Stereoscope furnished at lower rates and in greater perfection than at any other place.

which pictures I have found by experience have to be taken at a different angle from those for smaller instruments." This enlargement of the capacity of the instrument is undoubtedly in many cases an advantage; but as it is obtained simply by increasing the focal distance and power of the lenses, cannot be considered as an invention, although it may be a very happy suggestion.

Thirdly. "The placing at the back of the instrument a screw, to lessen or increase the distance of the picture from the lenses, so as to suit any focus." The Committee consider this arrangement as constituting a very great improvement, the ordinary mode of accomplishing this end by drawing out the tube in front, being, as Mr. Richards remarks, apt to throw the lenses out of adjustment, when attempted by those not familiar with the instrument.

Fourthly. "The placing a rack and pinion or lever in front, by means of which the distance between the lenses may be widened or lessened, so as to bring their centres in a line with the centres of the eyes; thus obviating the straining effort which many persons have to use in viewing pictures through the ordinary instrument."

Mr. Richards considers this as the most important of his improvements, and the advantage of it will easily be seen by any one who will try the experiment by altering the adjustment as indicated. It is believed that this means of adjustment has been applied before to opera glasses, but the employment in the stereoscope the Committee consider as new and valuable.

On the whole, the Committee consider Mr. Richards' form of the stereoscope as an ingenious and improved modification of the ordinary instrument, and recommend that a description of it be published in the Journal of the Institute.

By order of the Committee.

Wm. Hamilton, Actuary[6]

Meanwhile, Southworth and Hawes said that they had discovered the principle by which stereoscopic daguerreotypes could be made free from distortion and suitable for copying as models, which, according to Southworth, neither Wheatstone nor Brewster had accomplished.[7] As early as 1846 and 1847, Southworth and Hawes had invented a camera for "making several different pictures in the axis of the lens successfully at different times," and this apparatus was later patented.

By 1853 the partners had made a stereoscope capable of holding twelve whole-plate daguerreotypes. This instrument, called "The Parlor or Gallery Stereoscope," resembled a pianoforte; exhibited in the Southworth and Hawes gallery, it made an excellent addition to the spacious room, which already housed a fine display of daguerreotypes. When John Werge, the English photographer, came to Boston in the early 1850s, he was impressed with the instrument and later described it in a British photography publication:

> I saw one of the largest and finest revolving stereoscopes that ever was made. The pictures were all taken on whole-plates, and set vertically on the perpendicular drum on which they revolved. The drum was turned by a handle attached to cog wheels, so that a person sitting before it could see the contents with the greatest ease in an upright position. It was an expensive instrument, but it answered the double purpose of beguiling the time of a 'sitter' while waiting, and being a capital advertisement as well, for many went to see it out of curiosity alone.[8]

Meanwhile, in England, there was controversy between Sir David Brewster and Antoine Claudet, the famous London daguerreotypist. Claudet had been making highly colored stereoscopic daguerreotypes, for which Brewster had awarded him the only gold council medal at the great Crystal Palace exhibition. The *Scientific American* reported on this controversy in June:

> Sir David Brewster asserts that photographic portraits deviate more and more from truth as the lenses increase in diameter. He advised the search after more sensitive materials and the use of small lenses. He says, 'that while M. Claudet will continue to

THE STEREOSCOPE.

This is a name very properly affixed to a new invention or discovery by which pictures, upon plain surfaces, have all the appearance of solidity and weight, and the perspective of the objects themselves. The word is a compound term from the Greek, which literally means " *to see solids*," and thus becomes suggestive of its peculiar property and design. Let the word stereoscope be considered as legitimately and inseparably adopted into the English language.

By this simple apparatus, two shadows become, to appearance, so real and so beautiful as to startle with surprise, and charm the beholder beyond all previous conception. A description of the Stereoscope has been repeatedly given in the public prints, still few know what it is. An opportunity is now offered to inspect and examine, and thoroughly understand its optical principles, a far more satisfactory and perfect manner than from description alone.

About eight months since, Messrs. Southworth & Hawes, in their first application of Professor Wheaton's Stereoscope to Daguerreotypes, were sensible of imperfections which it was necessary to remedy before its application to the fine arts could please the artistic eye, though its effects might truly excite surprise and wonder. These imperfections had been observed by Sir David Brewster and others, and attributed to a wrong cause. Nor is it strange that in a discovery so recent, a few (for it was not known to many) should have overlooked an important principle, or mistaken the path for a time, whilst seeking for truth. Messrs. Southworth & Hawes were so fortunate as to arrive in their experiments to a result which developed the cause of all the difficulty, and pointed at once to a perfect and philosophical remedy, and enabled them to produce the first perfect Stereoscopic pictures ever made. But there was still a difficulty. The pictures shown were very diminutive in size, and there was great inconvenience in varying or changing the views.

Messrs. Southworth & Hawes undertook, in earnest, to invent an apparatus which should be susceptible of an indefinite increase in the size of the pictures, and in the number to be contained in the instrument; and vary or change the views readily at the option of the beholder. After six months' constant labor, without allowing themselves a day's recreation, they most successfully accomplished their purpose. The work is complete, and far more perfect than their most sanguine hopes anticipated.

They have affixed the name of " *The Parlor or Gallery Stereoscope*" to their new apparatus. It may be made as ornamental as a piano-forte, (perhaps more so,) and in its general form somewhat resembles it. It may contain any number of different Daguerreotypes perfectly arranged—requiring only the turning of a wheel to change places, which can easily be done by a child. The whole thing is compact and elegant, being a complete Picture Gallery in itself. The light of any window is sufficient, and a good lamp or gas light serves equally well. Its simplicity renders it not likely to get out of repair. This apparatus is surely destined to become the ornament of the Parlor, of the Picture Gallery, and Exhibition Room. The public can at once appreciate, on examination, both its use and its value. It is applicable to everything that can be daguerreotyped. The Single Likeness—the Family Group—the Daguerreotype of the Street—or Landscape—or Dwelling—Interior Views—Copies of Statuary —Models—Machinery—Shipping,—indeed, almost everything that can be thought of for a picture.

The Parlor and Gallery Stereoscope (the only one yet made) is now on exhibition at the " ARTISTS' DAGUERREOTYPE ROOMS," 5½ Tremont Row, opposite Brattle street. A spacious Room has been purposely fitted up, making in addition to the usual exhibition, the largest and finest display of Daguerreotypes ever shown. Visitors will be sure of a rich treat.

A large list of names, interesting to the public, might be mentioned, whose likenesses are on exhibition; but as it is not so much our design to exhibit faces as specimens of all the various pictures of which the art is capable, we think it unnecessary to advertise every " official" or distinguished character who visits us.

Messrs. Southworth & Hawes would gratefully acknowledge the many favors of their friends and of the artists and lovers of art in Boston, and vicinity. It is with great satisfaction and perfect confidence, that we are again able to invite them to an examination of the last most wonderful and most beautiful improvement in Daguerreotypes; the transformation of shadows into substance—the change of pictures upon a plain surface into statuary and solidity.

The Proprietors of these Rooms also take great pleasure in offering, for exhibition, an apparatus so elegant in its form and proportions, so compact and durable in its machinery, and so appropriate for the Family Parlor or Picture Gallery. It is new in every respect—newly invented machinery by ourselves—our own design in form, and our own new application to an entirely new discovery, and we know that it will give to all lovers of mechanical ingenuity—to all lovers of beauty and art—new and exquisite pleasure to examine it. Measures have been taken to secure a patent.

SOUTHWORTH & HAWES,

ARTISTS' DAGUERREOTYPE ROOMS, 5½ TREMONT ROW, OPPOSITE BRATTLE STREET.

practice his art . . . with large lenses, others,' he hopes, 'will not disdain to guide the light of the sun by the light of science.'. . . M. Claudet . . . says he will prove 'that perfect lenses, of 3¼ inch aperture, and a sufficiently long focus, operating at a distance of 12 feet, are capable of giving a correct representation of the human form, and producing binocular portraits, to be raised into relief by the stereoscope without exaggeration and he stands ready to repeat them before any scientific persons interested in the question.[9]

Brewster's simplified instrument—beautiful in appearance but rather small in size—was equipped with two semilenses having a focal length of about six inches, mounted in two tubes spaced as far apart as the distance between one's eyes, about two and one-half inches. Groups of statuary, portraits, and street scenes taken by the da-

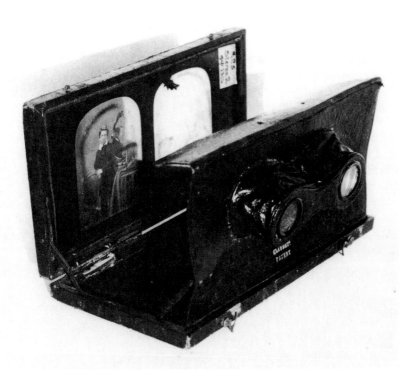

guerreotype were viewed with what was said to be "the most wonderful solidity, fairly standing out with all the rotundity and beauty of nature."[10]

In America, the search to improve the stereoscopic daguerreotype was not limited to northern daguerreotypists. William H. Harrington, a pioneer daguerreotypist associated with Frederick A. P. Barnard in Tuscaloosa in 1840 and 1841, had become a prominent New Orleans daguerreotypist, well versed in all aspects of the art. Like Southworth and Hawes, Harrington was concerned with the exaggerated relief of the daguerreotypes when viewed through the stereoscope. In 1853, he wrote a series of articles for *Humphrey's Journal* titled "Hints on Practical Photography." One section was about the "Stereoscope Camera and Pictures":

> A very remarkable feature in the majority of stereoscopic Daguerreotypes exposed for sale—particularly those brought from Europe—is the *extravagant relief* they exhibit when viewed through the instrument. This objectionable defect converts the astonishment first excited by the apparent solidity, into regret at the want of truth, and robs the subject of much of its philosophical beauty.
>
> It therefore becomes an interesting inquiry to determine whether this manifest fault belongs to the principle of the discovery itself, or to a want of scientific skill in the production of the Daguerreotypes. A little reflection is sufficient on this point: because if two *positively flat* surfaces can by any means be made to assume the appearance of *excessive relief*, the inference is reasonable that this relief may be graduated. . .[11]

Harrington went on to point out the causes for this exaggerated relief and gave rules and mathematical formulas to correct it.

Of great interest to historians of photography is the fact that Harrington cites Maj. John G. Barnard of the United States Army as giving him permission to use his rules and formulas in the article.[12] Major Barnard is an interesting figure because he was the brother of Frederick Barnard, who was also experimenting with stereoscopic daguerreotypes. A graduate of West Point in 1833, Major Barnard was an accomplished mathematician and author; he obtained his degree of A.M. from the University of Alabama in 1838, a year after Frederick had become a professor of mathematics and natural philosophy there. In 1852 Major Barnard had surveyed the mouth of the Mississippi River, and he would have been in the vicinity of New Orleans when Harrington wrote his article.

In November of 1853, Frederick Barnard, still a professor at the University of Alabama, published an article titled "Method of taking Daguerreotype Pictures for the Stereoscope, simultaneously, upon the same plate, with an ordinary camera":

> Prof. Dana.—In the September number of the Journal of Science, just published, I observe a mention of a method of taking photographic pictures for the stereoscope, the two pictures being taken simultaneously. This has brought to my mind an arrangement employed by myself about a year ago for a similar purpose, which is so simple and satisfactory in its results, that you may possibly think it worth publishing. It has the advantage of requiring no modification of the construction of the camera; and also the additional one of producing both pictures, if desired, upon one plate. This last result cannot be secured with a camera having two object-glasses, without, at least, a very inconvenient arrangement of mirrors, because, of the two pictures produced in which should belong to the left eye, and vice versa.[13]

Barnard continued by giving mathematical formulas, illustrated by drawings, which explained the adjustment of mirrors and camera. In his summation of his method, he remarked:

> The photographs which I have prepared in this way are not surpassed by any others I have tried. I am accustomed to adjust them on the plate at a distance from each other somewhat less than that of the eyes (say between 2 and 2¼ inches from centre to centre). I employ no optical artifice, (i.e., interposed prisms, or lenses excentric to the eyes,) to superpose them; but looking through the centres of the lenses, the superposition takes place naturally and easily. If the pictures are rather large, however, they must be more widely separated, and then some optical expedient must be employed to produce deflection and aid the eye.
> Tuscaloosa, Sept. 6, 1853.
> P.S.—In every daguerreotype for the stereoscope which I have seen (as purchased from the opticians) the relief is grossly exaggerated. You will not find such the case with this. The error of the manufacturers has been to make the points of view (in taking the photographs) too widely different.[14]

An advertisement in the *Richmond Whig and Public Advertiser* of June 17, 1853, illustrates how quickly the stereoscopic daguerreotype had come into use:

World's Fair Premium Daguerreotypes.—The public are respectfully invited to call and see those wonderful Stereoscopic or Solid Daguerreotypes, at WHITEHURST'S Gallery, 77 Main street, Richmond, whether they sit for them or not. They are truly the wonder of the age. Stereoscopy, or the art of giving to pictures on a flat surface the appearance of all the solidity and roundness of life, has been pronounced, by scientific men, the most wonderful discovery ever made in optics. The effect is really magical, beyond conception. The picture appears nearly the size of life, and stands out in *alto relievo*, like a piece of sculpture, or the living being. Likenesses taken by this extraordinary improvement, may now be had at WHITEHURST'S Galleries. They may be found in many of the principal cities of the Union.

Woman with vase of flowers, ca. 1853.
Quarter-size Mascher stereoscope (two daguerreotype plates, 3¼ by 2 inches). By McClees and Germon.
Courtesy of Josephine Cobb.

Meanwhile, Mascher had converted an ordinary daguerreotype case into a stereoscope by simply arranging a supplementary flap inside into which were fitted two ordinary magnifying lenses; a patent was issued to him for this on March 8, 1853.[15] The editors of the *Scientific American*, highly impressed with Mascher's invention, were also pleased that he had embarked on his experiments after reading about

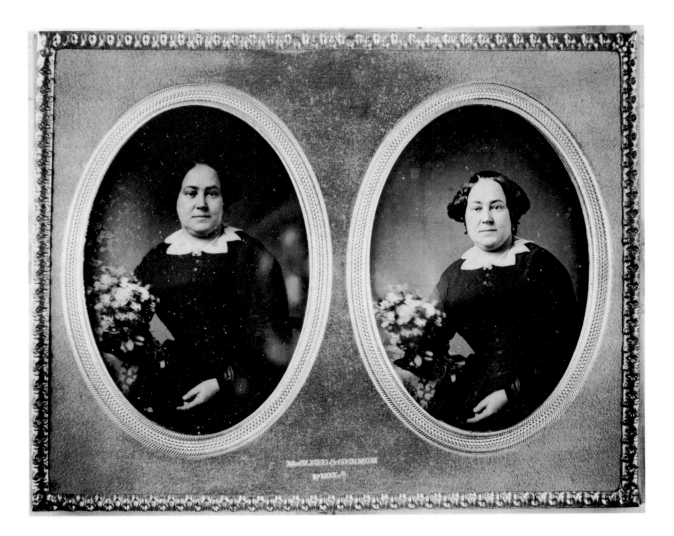

the principles of binocular vision and the operations of the stereoscope in their publication. In an item praising Mascher, the editors also noted the social advantages of his innovation:

> By this improvement, husbands, will, when thousands of miles separate, be enabled to see their wives standing before them in breathing beauty, wives their husbands, and lovers their sweethearts . . . it will enable us to see them as they once were with us, and posterity will know how they and ourselves looked without trusting to the flattery or faults of a limner's pencil.[16]

Mascher lost no time in advertising his ingenious new stereoscope. For example, an advertisement in the *Scientific American* for June 25 read:

> Mascher's Patent Stereoscopes—Illustrated in no. 37, Sci. Am., are manufactured and for sale wholesale or singly, as samples by the inventor at 408 North Second Street, Philadelphia; also for sale by the Scovill Manuf'g Co., 57 Maiden Lane; Meade & Brother, 233 Broadway, N.Y.; Jno. Sawyer, 123 Washington St., Boston; Myron Shew, 118 Chestnut Street, Philadelphia; Dobyns & Co., New Orleans, and Scammon & Co., Chicago, Ill. The prices are for one-sixth size, $12, $15, and $30, and one-quarter size $15, $18, $26, $24, $33 and $36 per dozen furnished with plate glass, and some with black, others with fine gilt borders, and preservers.

In 1854, Edward Anthony's New York City photographic supply house also carried Mascher's daguerreotype cases in three different sizes—one-sixth, one-quarter, and one-half. The sixth-size model was supplied in embossed leather with two hooks, as an "imitation Turkey morocco leather snap case"; it was also available in a thermoplastic Union case.[17]

The Committee on Science and the Arts of the Franklin Institute belatedly reported on Mascher's stereoscope on February 8, 1855:

> That the instrument submitted by Mr. Mascher, consists of a light lid or flap fitted into a case similar to those commonly used for daguerreotype pictures, and containing two lenses of short focus, and fitted to the view of any stereoscopic pictures fitted permanently or temporarily into the case. The advantages presented by this very neat apparatus of Mr. Mascher are; 1st, That from its simplicity it can be made much more cheaply than almost any other form of stereoscope; 2d, That when in action it allows the light to fall upon the pictures at any required angle, and in any desirable quantity, there being no solid sides to interfere with the arrangement of the light. In these two respects it shares its advantages with a light and cheap form of instrument which has been for several years in use. But, 3d, Mr. Mascher's instrument is very compact, the bent frame folding down into the case, thus allowing a stereoscopic daguerreotype to be kept with its proper lenses in the same case that is used for ordinary pictures; and the mobility of the lens frame by its rocking motion on its hinge, gives very greatly increased facility for the arrangement of the focal distance to suit any eyes, and for the other adjustment of the lenses for distinct vision. . .[18]

The popularity of the Mascher stereoscope case was relatively short-lived but intense while it lasted. Mascher attempted to increase the versatility of his case in 1856, but by then larger box-type stereo-viewers were being produced, using easier-to-handle paper or glass photographs which could be changed with little or no difficulty. Also, competing with Mascher were the Philadelphians John Stull and W. Loyd, who received patents for cases of a somewhat similar nature.[19] In 1855 Mascher received a patent for a stereoscopic medallion which resembled a popular locket of the day when it was closed. This inge-nious device, which sold for twelve dollars,[20] had "two supplementary lids, each containing a lens, which folded up inside the medallion lid and stood opposite when opened, converting the medallion into a stereoscope."[21]

While stereoscopes were receiving more attention among daguerre-otypists in 1853 and 1854, cameras for taking stereoscopic daguerreo-types were being patented. Silas A. Holmes, a well-known Broadway daguerreotypist who was awarded a diploma for excellent daguerreo-type views in 1852, received a patent for "An Improvement in Cameras

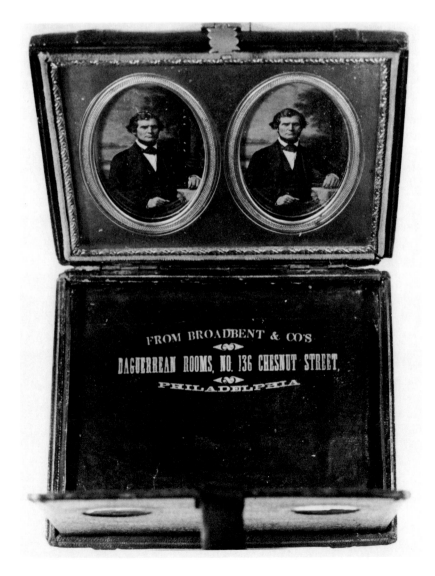

Seated man, ca. 1856. Quarter-size Mascher stereoscope (one daguerreotype plate, 3¼ by 4¼ inches). By Samuel Broad-bent. Broadbent probably used a two-lens camera, still a novelty in 1856, to produce these images on one plate. Good vision was a requisite for viewing images through the lenses of a stereo-scope in three-dimensional effect. To produce good pictures, the cameras were placed at an angle of about thirty degrees. When processed, the left and right plates were reversed, thus providing bold relief from the dissimilar images on each plate (note the position of this subject's head).
Courtesy of W. Robert Nix.

Patent drawing for a stereoscopic camera. S. A. Holmes, May 30, 1854

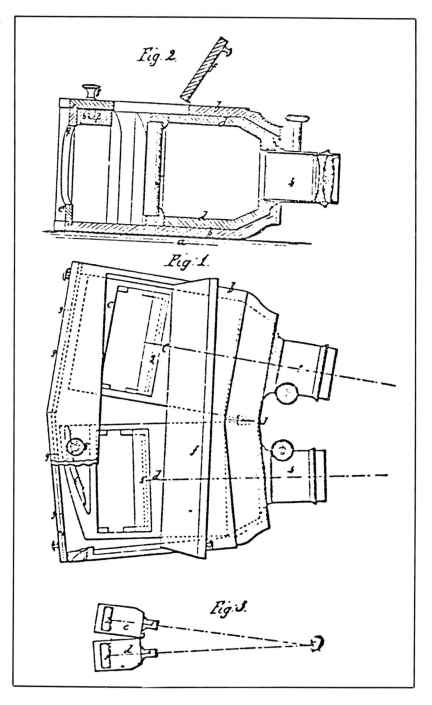

for taking Stereoscope or other Daguerreotypes" on May 30, 1854. Holmes' claim for his patent was:

> I do not claim the mere operation of taking two pictures with two cameras, but I am not aware that two camera boxes have ever been attached together at the forward edge, to be directed on to one object to be taken, by which means the axis of the cameras are directed on to the same object, and the object glasses are always the same distance from the object, which would not be the case of the two cameras were not connected together, the axis of the camera at the object glasses (or da-

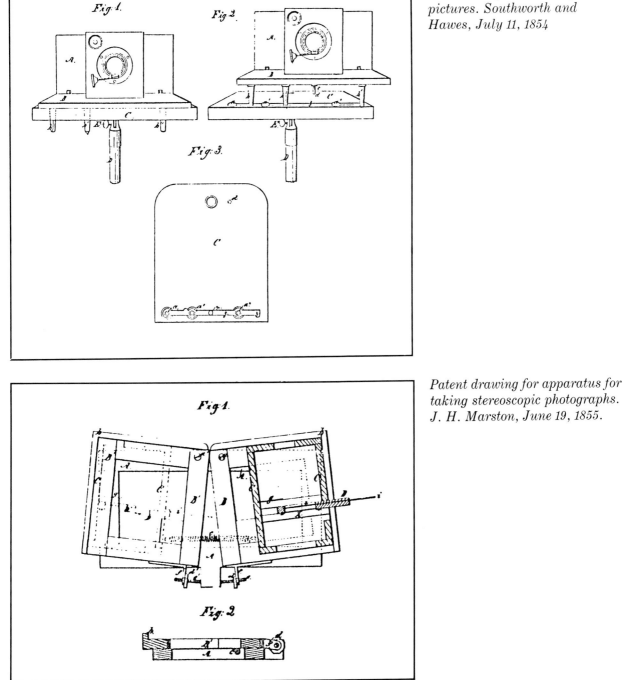

Patent drawing for a camera attachment for stereoscopic pictures. Southworth and Hawes, July 11, 1854

Patent drawing for apparatus for taking stereoscopic photographs. J. H. Marston, June 19, 1855.

guerreotype plate) forming an isosceles triangle to the object, as indicated, whether the object be near to or distant from the cameras. Both cameras might be so fitted as to be adjusted in the inclosing but it is believed to be superfluous. I claim attaching two camera boxes together, at or near their front vertical edges, and adjusting one or both of said cameras on to the object of which a daguerreotype or other view is taken, by means of the pinion and rack, or its equivalent, as described.[22]

The Southworth and Hawes camera attachment was patented on July 11, 1854. The partners did not claim to take the stereoscope with the camera placed in two different positions or with two lenses attached to the same instrument when the two points were on the same horizontal line, but they did claim as their invention "the within described method of taking stereoscopic pictures in which the two positions of the camera are upon a line making an angle of forty-five degrees with the horizon."[23]

On June 19, 1855, Joseph H. Marston of Philadelphia patented a camera attachment for taking stereoscopic daguerreotypes. Marston claimed in his patent:

> The particular arrangement of two frames, or guides or boards, that shall work on and be fastened or pivoted on the camera board at the centre and front of the camera board, the frames or guides to be at right angles, so that when closed together they form the raised ledge parallel with each other by which to adjust and centre the angle board previous to setting the angles for stereoscoping. Also, the application of the spring to hold the frames together, the right and left screws and nuts and eye plates to force apart, and hold the frame in any desired angle. The above described apparatus is claimed, for moving the camera box and giving the true stereoscopic angle at one and the same time.[24]

PINHOLE PHOTOGRAPHY

An interesting event in the history of American photography was the inadvertent discovery of pinhole photography, in 1855, by John Mascher. Pinhole photography utilizes a light-proof box, not an ordinary camera. Instead, a minute hole or holes are made at one end of the box, and at the other end is placed the sensitive plate or paper for making negatives. No focusing is required, but the larger the plate the wider the angle, and the greater the distance the larger the image.

During Mascher's experiments with stereoscopic daguerreotypes, he came upon this phenomenon. Questioning why two pictures taken by two cameras placed two and a half inches apart did not show sufficient stereoscopic relief, and why the cameras had to be placed about eight times farther apart than the human eyes to produce the proper relief, he decided that it was because the lenses in the camera (one-quarter size) were twelve times larger than the human eye. To prove his assumption, Mascher began experimenting with two cameras—each having a diaphragm, the openings in which were one-eighth of an inch in diameter (the diameter of the diaphragm of the human eye). He was surprised to find that the range of the cameras, when focused on a house on the opposite side of the street, was "increased to an extraordinary extent." The moment the diaphragm in the cameras was introduced, "the sash in the window, which before was invisible, suddenly became as sharp and distinct as the house on which the focus had been previously drawn."[25] Now seeking to ascertain the cause of his findings, Mascher removed the lenses from the tubes but retained the diaphragm: the houses and other objects were depicted as precisely as if the lenses had been used. His next step was to see whether the pictures possessed photogenic properties, which was done by substitut-

ing for the paper a metal diaphragm with an aperture one-fiftieth of an inch in diameter. He placed a coated plate in the camera for a fifteen-minute exposure—and a beautiful view resulted.[26]

Now that the truth was self-evident, Mascher decided that, since such a picture could be produced with one camera, he should be able to take two images with one camera. The camera used for the experiment was a one-quarter size. As a quarter-size daguerreotype plate was four and one-fourth inches long, and as it was desirable to take two pictures on one plate, Mascher made two apertures one-sixty-sixth of an inch in diameter on the metal diaphragm, only two and one-fourth inches apart. After twenty minutes of exposure, the result was two stereoscopic views taken on one plate with one camera without lenses or reflectors or refractors of any kind! The pictures taken on one plate were in stereoscopic reverse—the right picture was on the side where the left one should be, and vice versa. However, Mascher remedied this by cutting the plate in two and "pasting" it together again. He later described one advantage to using this type of camera:

> You may make two, four, six, or more sets of holes in the same camera, either all of the same diameter, by which means you will obtain an equal number of stereoscopic pictures with the number of sets of holes, or you may make one set with apertures $\frac{1}{200}$ of an inch, another $\frac{1}{100}$ of an inch, one set $\frac{1}{70}$ of an inch, and still another set with $\frac{1}{250}$ of an inch in diameter, where you will be certain to obtain at least one set of pictures properly 'timed' especially as other pictures which are not properly timed can be rubbed out before gilding, thus saving the plates.[27]

Mascher concluded that he had proved the superiority of small lenses over large lenses in photography (Sir David Brewster also shared this belief). He suggested that, to assist the quick action of the small lenses: "I would set the subject in the open air; take advantage of all the light that can be obtained. Who will be the first to build a sky-light room, with the roof and walls removed?"[28] However, pinhole photography was not recognized as an established art until later in the century.

Although the stereoscopic daguerreotype was interesting, it was quickly superseded by the glass and paper photographs which were gaining in popularity as the 1850s progressed. The daguerreotype was easily scratched, it was bulky and hard to handle, and it was more expensive to produce than the newer type of photographic images.

Also, competition in the stereoscopic daguerreotype field had appeared very quickly. The Langenheim brothers of Philadelphia, already well known for their magic lantern slides, began promoting the sale of stereoscopic views in 1854. In 1850, the brothers had obtained a patent for their hyalotype, which was actually a frosted-background glass, suitable for glass stereographs.[29] The collodion wet plate process received attention from many notable photographers after 1854, and paper prints were quickly adapted for use with the stereoscope. However, although the stereoscopic views, especially on glass and paper, were reasonably popular in the later 1850s, it was not until Oliver Wendell Holmes, an enthusiastic advocate of the stereoscope, invented a simple hand stereoscopic viewer in 1859 that the invention began to appeal to the public.

8. COLOR AND THE DAGUERREOTYPE

Once technical and chemical improvements had made the daguerreotype a medium for portraiture, more thought was given to the aesthetic aspects of the image. Only one important ingredient was lacking for the daguerreotype to fully compete with the art of miniature painting: color.

In 1840, Hippolyte Louis Fizeau introduced a gold toning method which made the first dim images obsolescent—they now had brilliance and warm tones, and the total effect of the portrait was one of natural softness. After this innovation, various hand-coloring methods were employed by daguerreotypists to bring life and vigor to their images. The color was usually applied by artists or limners familiar with the delicate procedures; otherwise results were often crude and ineffective. Thus, many painters became associated with daguerreotypists shortly after the art form became established.

The first American patent for coloring a daguerreotype was issued to Benjamin R. Stevens and Lemuel Morse of Lowell, Massachusetts, on March 28, 1842. Their method was quite simple—the finished daguerreotype was protected by a transparent solution of varnish or gum, and paints and colors could then be applied to the surface of the daguerreotype.[1]

A more complex method of coloring daguerreotypes—patented on October 22, 1842, by Daniel Davis, Jr., of Boston—was assigned to John Plumbe, Jr.[2] The method outlined in the patent involved gilding the image by using a galvanic battery; a positive wire was employed with three different solutions, with the basic agents being copper, gold, or silver. The wire of the battery was held longer on areas in which a deeper tint of transparent color was desired. This gilding process greatly improved the lights and shades of the daguerreotype image, and Plumbe, realizing the sales potential of the improvement, quickly advertised his new "Colored Photographs" for the reasonable price of three dollars. The new gilding method, although effective, was not without problems, however, as the daguerreotypes were often clouded and spoiled if colored by inexperienced operators.

In December of 1842, Charles Grafton Page conducted a series of experiments which would, in retrospect, become very important in the history of color and the daguerreotype and would seem to explain some of the puzzling color aspects of certain extant daguerreotype plates. The physicist Page, an 1832 graduate of Harvard, had settled in Virginia in 1838 and was called to the chair of chemistry at Columbian University in Washington, D.C., in 1840. Page was a man of many interests—electricity, medicine, chemistry, and rose culture—he also became an examiner in the patent office in 1840, when there were but two examiners.

In an 1844 article in the *Journal of the Franklin Institute*, Page recounted both his experiments to determine the effects of oxidation upon the surface of daguerreotypes and his methods of obtaining beautiful results in fixing, strengthening, and coloring the impressions:

First, a mode of fixing and strengthening pictures by oxidation:—The impression being obtained upon a highly polished plate, and made to receive, by galvanic agency, a very slight deposit of copper from the lupreous cyanide of potassa, (the deposit of copper being just enough to change the color of the plate in the slightest degree,) is washed very carefully with distilled water, and then heated over a spirit lamp until the light parts assume a early transparent appearance. The whitening and cleaning up of the picture, by this process, is far more beautiful than by the ordinary method of fixation by a deposit of gold. A small portrait fixed in this way, more than a year since, remains unchanged, and continues to be the admiration of persons interested in this art. One remarkable effect produced by this mode of fixing, is the great hardening of the surface, so that the impression is effaced with great difficulty. I have kept a small portrait thus treated, unsealed and uncovered for over a year, and have frequently exposed it in various ways, and rubbed it smartly, with a tuft of cotton, without apparently injuring it; in fact, the oxidized surface is as little liable to change as the surface of gold, and is much harder. As copper assumes various colors, according to the depth of oxidation upon its surface, it

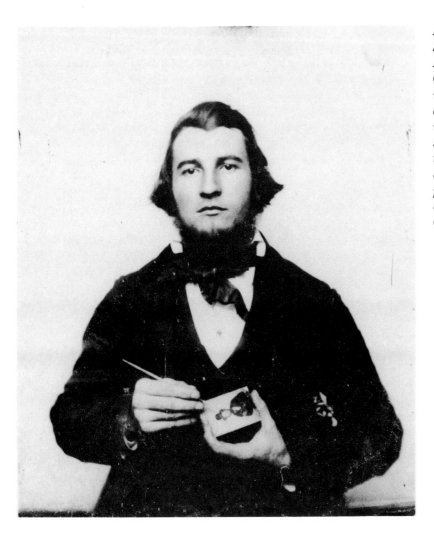

Artist at work, ca. 1860.
Sixth-size ambrotype.
Artist unknown.
One of photography's first innovations was the employment of artists to hand-color the images with flesh and rosy tints on the skin areas, and occasionally touches of color were added to the costume or to the tablecloth for pleasing accents to the total composition.
Courtesy of Josephine Cobb.

follows that if a thicker coating than the first mentioned can be put upon the plate without impairing the impression, various colors may be obtained during the fixation. It is impossible for me to give any definite rules concerning this last process, but I will state, in a general way, that my best results were obtained by giving the plate such a coating of copper as to change the tone of the picture, that is, give it a coppery color, and then heating it over a spirit lamp until it assumes the color desired. I have now an exposed picture treated in this way at the same time with the two above mentioned, and it remains unchanged. It is of a beautiful green color, and the impression has not suffered in the least by the oxidation. Should this process be perfected, so as to render it generally available, it will be greatly superior to the present inartistical mode of stippling dry colors upon the impression; for the color here is due to the surface of the picture itself. For pure landscapes, it has a pleasing effect, and by adopting some of the recent inventions for the stopping out the deposit of copper, the green color may be had wherever desired. In some pictures a curious variety of colors is obtained, owing to the varying thickness of the deposit of copper, which is governed by the thickness of the deposit of mercury forming the picture. In one instance a clear and beautiful ruby color was produced, limited in a well defined manner to the drapery, while all other parts were green. To succeed well in the first process, viz., that for fixation and the production of a pearly appearance, the impression should be carried as far as possible without solarization, the solution of the hyposulphite of soda should be pure and free from the traces of sulphur, the plate should be carefully washed with distilled water, both before and after it receives the deposit of copper, in fact, the whole experiment should be neatly performed, to prevent what the French significantly call taches upon the plate, when the copper comes to be oxidized.[3]

Page explained in a footnote that the presence of sulfur was a fault found in most of the hyposulfite of soda used commercially and that the action of the sulfur upon the silver puzzled many daguerreotypists by clouding, staining, and marking the plates in various ways. He suggested continuously filtering the solution. Page's process was not patented, as far as is known, but many daguerreotypists must have experimented with his method after reading his article.

A patent for a coloring process which used a galvanic battery was issued to Warren Thompson of Philadelphia on May 12, 1843, and assigned to Montgomery P. Simons, the pioneer Philadelphia daguerreotypist. As outlined in the patent, the daguerreotype plate, when ready for color, was steeped in a gum solution; then grease—any oily substance, wax, spermaceti, or any soluble resin or gum—was applied with a camel's hair brush to those parts of the image not to be colored. The plate was then immersed in a mixture containing pure gold, held in solution by cyanuret of potassium. An ordinary galvanic battery was used, the negative pole being placed under the daguerreotype and the positive pole being held over the portrait until the desired tint was obtained. The daguerreotype was then washed in boiling lye to remove the grease. If another tint was desired, the same procedure was followed, using a different metallic solution.[4]

John Mayall, a pioneer Philadelphia daguerreotypist who settled in England, later claimed a color patent for 1843, one similar to the Langenheim patent of 1846. However, some confusion exists, because the patent in question belonged to Montgomery Simons, having the same date of issue and the same number. Mayall claimed that his partner, Samuel Van Loan, brought the process back from England at the time, so it is possible that he was using a coloring method similar to that of Beard's English patent, which employed a stencil method.[5]

After Frederick Langenheim, the well-known daguerreotypist of Philadelphia, bought a patent held by Johann B. Isenring of Switzerland, he improved on the original process by fixing his colors more permanently, and he received a patent for this improvement on January 30, 1846. Langenheim covered the parts of the completed portrait to be colored with powdered gum. The daguerreotype was then fastened with pins into a frame, the edges of which projected up and were even with the surface of the plate; the parts of the image to be colored were masked with a cutout stencil. The prepared daguerreotype was then placed in a box which had been previously shaken so that the heavier particles of the dry earth pigments had partially settled. Timing was important. After the remaining fine color dust had settled on the plate, heat was applied to fuse the gum and the pigment on the daguerreotype.[6]

During the same year, a color patent was issued to William A. Pratt of Richmond, Virginia, on March 14. Pratt's daguerreotype was prepared in the usual way, including gilding. The portrait was then covered with glass, and he proceeded to paint on the glass itself, using oil colors, such clouds, walls, curtains, chairs, couches, and so on, as he desired. The daguerreotype was then laid on the glass so that a complete junction was made from the adhering varnish, and it was kept under pressure until dry. Pratt then used nitric acid to reduce the thickness on the back of the daguerreotype plate; after this, any part of the picture could be cut away at the artist's discretion. According to the patent, a different picture, using the same process, could be attached to the first, and by this method one or more portraits could be joined together. When complete, the picture had an enameled appearance, and the image beneath was protected from the elements.[7] This unique process was possibly a first in trick photography.

Meanwhile, in London, Richard Beard had obtained an English patent for coloring daguerreotypes on March 10, 1842. His process used a pattern or screen somewhat resembling a stencil plate. The finished daguerreotype was put into a frame, and about one-twentieth of an inch above the surface of the plate a very thin sheet of glass was placed. A camel's hair brush traced on the glass the part of the daguerreotype plate to be colored. When the glass screen was cut away, color was filtered down to the surface of the plate. The colors had been ground with a suitable adhesive material, dried in an oven, and then sifted through very fine sieves. Each color was placed in its own box; and, when the portion of the daguerreotype requiring a particular color was exposed, a fine dust was raised by beating on the proper box, and the correct color gradually settled on the uncovered area of the plate.[8]

Despite the available color patents, it is likely that many daguerreotypists gilded their plates by one of the many known methods and then simply protected their images for coloring with a film of isinglass or

some other gum solution, which provided a base for the addition of dry pigment. Coloring boxes were sold to daguerreotypists by supply dealers, complete with all needed items—brushes, blender, gold saucer, and dry colors, which included carmine, Prussian blue, white, chrome yellow, yellow ocher, light red, indigo, burnt sienna, burnt umber, and mixed tints. The colors were applied to the daguerreotype plate with a camel's hair brush, or a sable pencil, as it was often called. The daguerreotypist rubbed the color very gently to make it adhere to the plate, and sometimes the color was fused by heat.[9]

Many daguerreotype portraits and scenes of the 1840s and 1850s now in private and institutional collections are beautifully colored. Most of the portraits have some color on the face, especially on the cheeks and lips. While some red or pink colors were subtly blended with the rest of the portrait, others were crudely daubed on and the portrait is spoiled. A few specimens show lovely flesh tints which are well blended; these were probably colored by artist assistants or by the proprietor of the gallery if he were also an artist. Many specimens also show tablecloths tinted in blue, pink, and green; these usually appear to have been colored by the dry pigment methods. Occasionally one finds specimens in which a dress or a vest has been delicately colored. Flowers held in the hand were often brilliantly colored with oil paint in shades of yellow, pink,and red, with green leaves. Stones in jewelry were sometimes touched with dark red, probably to simulate rubies or garnets; gold paint was used for women's brooches, bracelets, and rings and for men's jewelry. A diamond or silver effect for jewelry was achieved by scratching the surface of the daguerreotype plate with a sharp instrument.

The iridescent color effect viewed on some daguerreotype plates, when tilted from side to side, was undoubtedly produced by chemicals, possibly using a variant of the process proposed by Page.[10] So much secrecy surrounded the various processes that almost every capable daguerreotypist developed his own special method of enhancing his portraits. While never extensively employed, chemical coloring must have entered the daguerreian gallery to some degree, because the famous Meade brothers were awarded a diploma by the American Institute in 1850 for "superior chemically colored daguerreotypes." The brothers are also credited with making great improvements in chemically colored backgrounds, which were said to have been patented by Levi Chapman.[11]

PHOTOGRAPHY IN NATURAL COLOR

Experimenters in the art had always been interested in producing photographs or daguerreotypes in the colors of nature. Sir John Herschel, the eminent scientist, wrote to Robert Hunt, the British authority on photography: "I have got specimens of paper, *long kept*, which give a considerably better representation of the spectrum in its *natural colours* than I had obtained at the date of my paper (February 1840), and that *light* on a *dark ground*; but at present I am not prepared to say that this will prove an available process for coloured photographs, *though it brings the hope nearer.*"[12] Hunt wrote of his experiments, which gave him colored pictures of the prismatic spectrum. The most beautiful specimens he had obtained were upon "the

daguerreotype iodidated tablets, on which the colours have, at the same time, had a peculiar softness and brilliancy." He also noted: "Daguerre himself has remarked, that when he has been copying any red brick or painted building, the photograph has assumed a tint of that character."[13]

An unobtrusive item which appeared in the *Chemical Gazette* in April 1843, missed by other historians and scholars, is of great importance to the history of color photography:

> We also learn from the 'Polytechnic Journal' for March 28th, that Proff. Böttger of Frankfort has succeeded in producing Daguerreotypes in colour; the results of his experiments were shown to A. von Humboldt, who was delighted with them. The professor has however as yet only succeeded in obtaining three colours, the most perfect of which is flesh-colour.[14]

Rudolph Christian Böttger was an able chemist, inventor, experimenter, and author; his work was said to have been ingenious and accurate. Besides his many applications of research, he is credited with the independent discovery of guncotton, first announced by Christian Friedrich Schönbein in March 1846. Alexander von Humboldt, it might be recalled, was one of the three eminent scientists familiar with Daguerre's work from its beginning.[15]

On February 7, 1848, Alexandre Becquerel, the distinguished scientist, sent the French Academy of Science a description of a method for preparing plates to obtain the image of the solar spectrum. A committee consisting of Biot, Chevreul, and Regnault recommended his memoir, and directions were issued to have it printed and placed in the collection of memoirs presented to the academy by nonmembers.[16]

Becquerel obtained his color images by placing a silver plate into a jar of muriatic acid diluted with from one to two parts of water; the plate was connected beforehand with the positive pole of a galvanic battery—the negative pole was terminated by a strip of platinum. "The silver and platinum plates were kept about one inch apart until the former became coated with the nascent chlorine to a violet hue. It was then rinsed and dried, and exposed to the coloured rays. After an exposure of from one to two days a coloured image was formed. It was but seldom he obtained more than one or two colours at once."[17] The *Scientific American* announced that Becquerel had obtained an image with orange, yellow, green, and blue; however, there was still no way to permanently fix the colors.[18]

Ironically, Americans were unaware that they had an inventor experimenting with color photography until November 1850, when Levi L. Hill declared in his technical manual, *Treatise on Daguerreotype*: "Several years of experiments have led us to the discovery of some remarkable facts, in reference to the process of daguerreotyping in the colors of nature. For instance, we can produce blue, red, violet, and orange on one plate, at one and the same time."[19] Hill described landscapes in color, and his new process reduced the usual time exposure needed for a standard daguerreotype by one-third. He promised to make his process available to the public at a moderate price within a reasonable length of time. All over the country newspapers eagerly publicized this great discovery, while daguerreotype sales slumped— the public was waiting to have portraits taken in natural color!

In the 1840s Hill, an itinerant daguerreotypist and Baptist minister

of New York, had visited with Asher B. Durand, America's leading landscape painter, and asked for instruction in coloring a daguerreotype. Durand had laughed and remarked: "Reproduce by the means of light, the beautiful colored image you see on the ground glass of your camera, and you will be ahead of all painters!"[20] Henceforth, Levi Hill's life was dedicated—personal possessions and health were sacrificed to a magnificent objective: color photography.

From the spring of 1847, Hill was busy at his Catskill Mountain home. He studied chemicals and chemistry and purchased some ten thousand dollars' worth of apparatus and chemicals, some imported. Sustenance came mainly from teaching the daguerreian art at fifty dollars a course and taking portraits of the general public; every penny he could afford went into his nightly experiments, and he even placed a mortgage on his home. In his autobiography, he complained of his nightly experiments as being "brain-reaching" investigations and bitter trials. He worked with dangerous chemicals, had hairbreadth escapes from explosions, and impaired his health by breathing harmful fumes. Finally he found success by renouncing the theories of others and following his own ideas, taking suggestions from nature at every step of the color theory.

Congratulations came after Hill's premature announcement. The editor of *The Photographic Art Journal*, Henry Snelling, complimented him in the January 1851 issue, but with the reservation that Hill should make his discovery public. Hill answered Snelling in a letter dated February 4, explaining that, while the process was complete with all colors, he was still having trouble producing yellow satisfactorily. (This was an important point because yellow has been a major problem with contemporary color processes.) He further stated that he would not make his process public until he had the assurance of adequate compensation.[21]

Edward Anthony, New York's largest wholesaler of daguerreotype materials, wrote Hill on February 13, offering to put up a liberal reward, with Hill to name the amount after a committee of Morse, Draper, and others had judged the invention a success.[22] Hill answered on March 28, saying that he had been ill and that he had decided to finance and market his process independently. In this way, he explained, he would not become involved with advance payments or be dependent on a partnership.[23] Hill's statement is important because it reveals his strong character—he would not be rushed or pushed in any direction other than that of his own choosing. As controversy raged in the future, Hill remained steadfast. After March 28, two definite camps would exist—Hill and his loyal friends and, as he defined his opponents, his humbugging enemies.

Samuel Morse wrote Anthony near the end of May, stating that he had visited and talked with Hill at Westkill and that, although he had not seen any examples of Hill's work, he had no doubt that the discovery was a reality.[24] Not having seen the hillotypes, Morse found it difficult to defend Hill, and he wrote him a carefully worded letter to that effect on June 21, 1851. And so the summer passed, with Hill's process still unexplained.

In November, the New York State Daguerreian Association met with the determination of forcing Hill to reveal samples of his discovery. A committee of prominent daguerreotypists—Daniel Davie, John M. Clark, and William Tomlinson—was appointed. After they went to

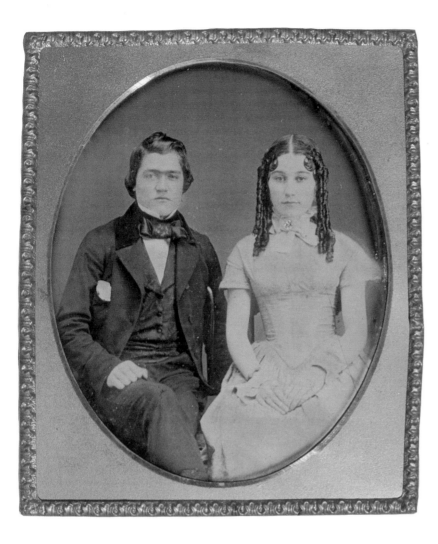

Young couple, ca. 1852.
Quarter-size daguerreotype.
Artist unknown.
A specimen with poorly applied
color. The portrait has been
hand-tinted, but the flesh tones
were overdone and the blue was
unevenly applied.
Rinhart Collection,
the Ohio State University,
Columbus.

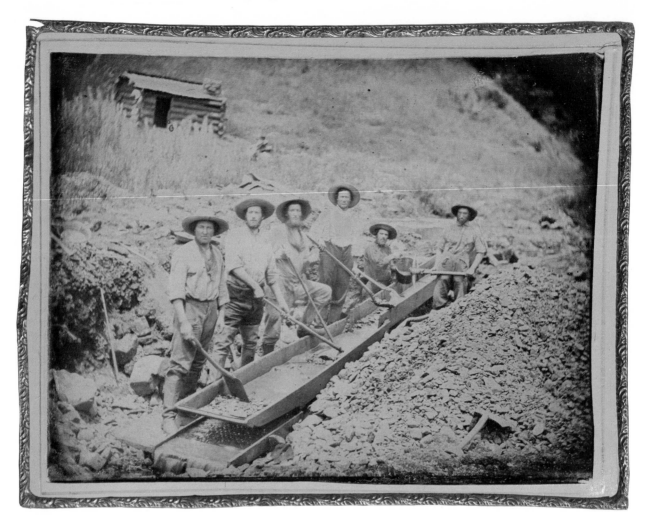

Miners at work, ca. 1851.
Half-size daguerreotype.
Artist unknown.
How the color was produced on
this daguerreotype remains a
matter for conjecture. Possibly
some unknown chemical process
was used—a remarkable feat in
the rough wilderness of the Cal-
ifornia gold rush.
Courtesy of Josephine Cobb.

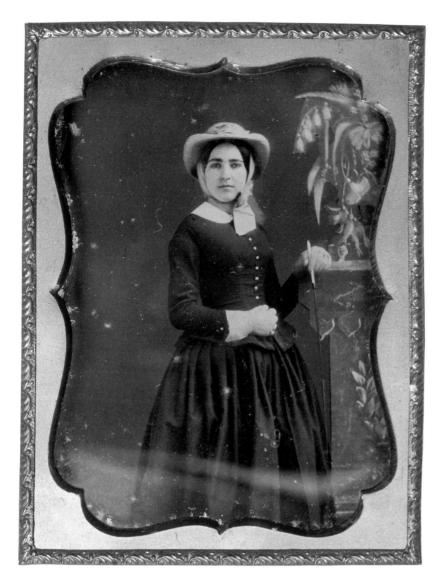

Lady in riding habit, ca. 1856.
Quarter-size daguerreotype.
Artist unknown.
No determination of the process
that resulted in the colors on the
hat, flowers, and leaves has been
made, but the chemical charac-
teristics are similar to those of
daguerreotypes in the colors of
nature.
Rinhart Collection,
the Ohio State University,
Columbus.

The golden portrait, ca. 1847.
Sixth-size daguerreotype.
By Lorenzo Chase.
Chase probably used some form
of electrolysis to create the beau-
tiful golden tone on the original
daguerreotype. The addition of a
ripple finish provides an artistic
overlay not unlike that on a min-
iature painting.
Rinhart Collection,
the Ohio State University,
Columbus.

*Baby on red and blue chair, ca.
1851. Sixth-size daguerreotype.
Artist unknown. The flesh tones
are lovely and appear to be in
natural color. However, the chair
was apparently hand-touched
with color to strengthen the origi-
nal color tones.
Rinhart Collection,
the Ohio State University,
Columbus.*

Girl hugging child, ca. 1853.
Sixth-size daguerreotype.
Artist unknown.
A pyramidal composition with
protectiveness as the central
theme. The lips of the children
are skillfully hand-colored a
deeper red than usual. The col-
ors on the dresses were probably
produced by masking the figures
and electroplating the exposed
surface—a process similar to
that patented by Warren Thomp-
son in 1843. Rinhart Collection,
the Ohio State University,
Columbus.

Boy in velvet jacket, ca. 1858.
Half-size daguerreotype.
Artist unknown.
An expressive, nicely propor-
tioned portrait. The tablecloth is
beautifully hand-tinted in bright
colors, probably by an artist.
Rinhart Collection,
the Ohio State University,
Columbus.

Woman holding flowers, ca. 1848.
Sixth-size daguerreotype.
Artist unknown.
The flowers are hand-tinted pink
and yellow, with green leaves,
and the brooch and cross are del-
icately touched with gold paint.
Rinhart Collection,
the Ohio State University,
Columbus.

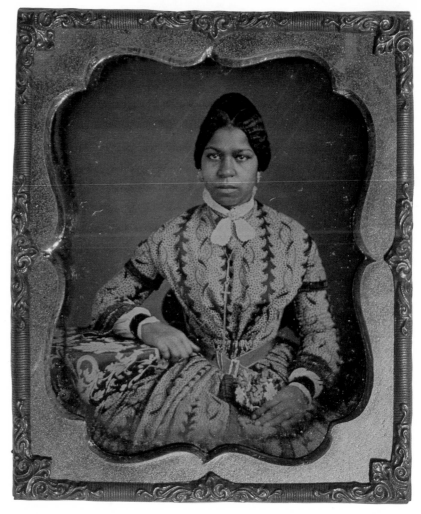

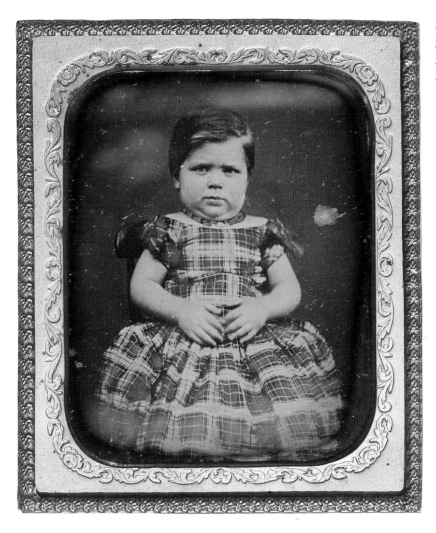

Girl in plaid dress, ca. 1855.
Sixth-size daguerreotype.
Artist unknown.
A hand-tinted specimen. The
color is too strong and the flesh
tones are overdone, yet this por-
trait is still pleasing to the eye.
Plaids of the gayest colors were
often worn by little girls of the
daguerreian era.
Rinhart Collection,
the Ohio State University,
Columbus.

Lady with furs, ca. 1855.
Quarter-size daguerreotype.
Artist unknown.
The delicate pink on the ribbon
has a well-defined line of demar-
cation, under magnification, a
general indication of chemically
produced coloration on daguerre-
otypes. This daguerreotype was
found with Hill's "Country Boy."
Rinhart Collection,
the Ohio State University,
Columbus.

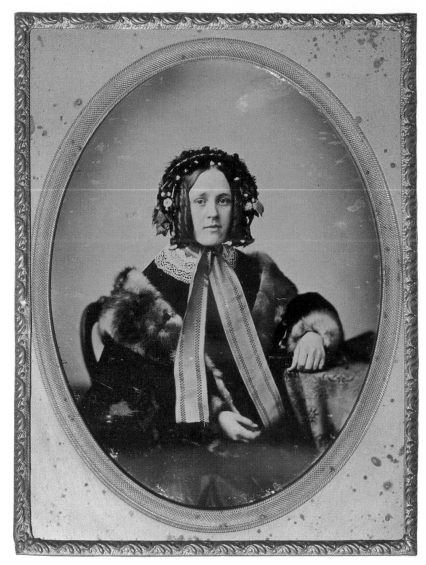

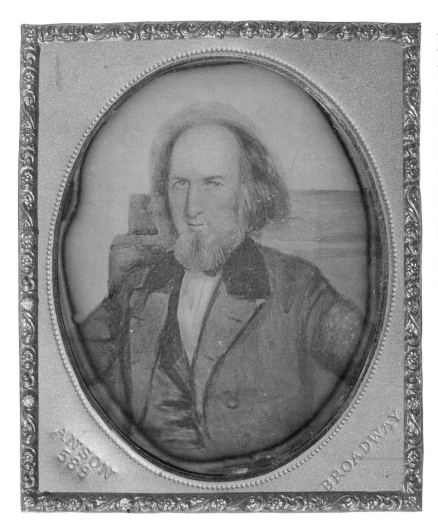

Man with gray beard, ca. 1858.
Sixth-size daguerreotype.
By Rufus Anson.
This daguerreotype is possibly a
reproduction of a painting, yet
the face appears photographic.
The smooth photographic surface
of the original plate, under mi-
croscopic magnification, would
indicate that the specimen is a
daguerreotype in natural colors.
The process which produced the
photographic coloration remains
unexplained.
Rinhart Collection,
the Ohio State University,
Columbus.

Country boy, ca. 1852.
Sixth-size daguerreotype.
By Levi L. Hill.
An example of a signed da-
guerreotype in the colors of na-
ture. The red and blue colors on
the original plate are in the same
range as those found on a da-
guerreotype with geometric de-
signs made by Niepce de Saint
Victor in 1867 (George Eastman
House collection). Certain parts
of the boy's yellow hat and white
ribbon are hand-touched.
Rinhart Collection,
the Ohio State University,
Columbus.

Eugenie Bayley, ca. 1851.
Quarter-size daguerreotype.
By Levi L. Hill.
The original specimen of this da-
guerreotype is probably the most
beautiful of extant color da-
guerreotypes, having the widest
range of color seen on a single
plate. A plain photographic tex-
ture is revealed under micro-
scopic examination. A note in
the miniature case provided
identification: "Aunt Eugenie
Bayley. Sister named Susan."
Perhaps Eugenie Bayley was a
member of one of the Bayley
families residing near Hill in
Greene County, New York, in the
1850s.
Rinhart Collection,
the Ohio State University,
Columbus.

Man in blue shirt and sombrero, ca. 1853. Sixth-size daguerreotype. By Levi L. Hill. The original daguerreotype is a unique specimen of a color failure—examination under microscopic magnification reveals no noticeable photographic definition between the present blue area and the area where the blue has presumably disappeared.
Rinhart Collection,
the Ohio State University,
Columbus.

Mary Hill seated on a trunk, 1852. Quarter-size daguerreotype. By Levi L. Hill. The original specimen of this portrait has a number of signatures along the border, including those of Morse, Root, and Richards—perhaps Hill secured these signatures before processing the image to document the plate for posterity. The flesh tones are superb. The blue and gray colors on the dress are similar to the Saint Victor plate of 1867.
Rinhart Collection, the Ohio State University, Columbus.

Girl holding book, ca. 1855.
Sixth-size daguerreotype.
By Levi L. Hill.
Following the practice of artists,
Hill signed his name near the
border of the oval mat—a signa-
ture identical with those on the
United States patent records he
later obtained. To prove that he
had some success in producing
yellows, the gold on the girl's
book presents an uninterrupted
surface under magnification.
Rinhart Collection,
the Ohio State University,
Columbus.

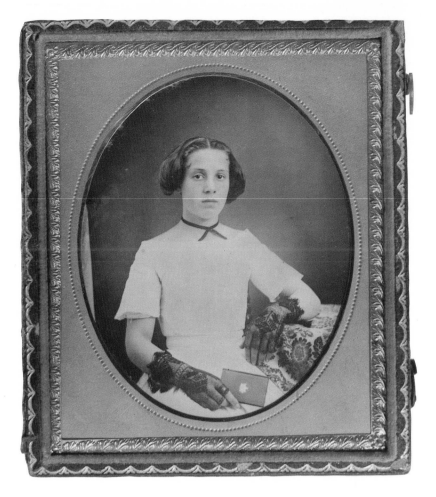

Westkill to see Hill, however, they reported that they received a courteous reception but that Hill refused to show them anything. Hill's account of the visit differed completely from that of the committee: he claimed that, after they failed to win their objective through flattery, Davie began to intimidate him, threatening not only to expose him as a humbug but to physically harm him. Alarmed, Hill promptly bought a revolver and borrowed Colonel Pratt's watchdog.[25] Ironically, in the same month as the association's visit, the *Scientific American* noted: "A beautiful landscape of Mr. Hill's residence was said to have been done, and exhibited at Albany . . . a number of persons had seen several beautiful colored pictures by Hill, one of which was that of his own child, or some other child, painted by the sun in all its rosy colors, and displaying a pearly tear on its cheek."

Back in New York City, the committee published a report which, in their opinion, proved Hill a fake, and they doubted that he had fooled anyone but himself. To quote from the report:

> That the origin of the discovery was a delusion—that the assumed progress and improvement of it was a delusion—and that the only thought of respecting it, in which there is no delusion, is for everyone to abandon any possible faith in Mr. Hill's abilities to produce natural colors in daguerreotypes—of which the whole history has been an unmitigated delusion.[26]

Such strong language caused Hill to ask the *New York Tribune* to print a request that the general public grant him a little more time. Also, he said, his health had been poor. It might be said that at this point the daguerreian world, with exceptions, had dismissed Hill and his claims as a fraud.

Meanwhile, in Europe, in the summer and early fall of 1851, Niepce de Saint Victor, a nephew of Daguerre's partner, had reproduced Becquerel's experiments with some success. He communicated the results of his work with heliochromy to the French academy, and on September 20 the *Scientific American* described three of the heliochromes:

> Three heliochromes now in London are copies of colored engravings, representing the one a female dancer, the other male figures in fancy costumes; 'and every color of the original,' says the *Athenaeum*, the editor of which has examined them. . . . The plate, when prepared presents evidently a dark brown, or nearly a black surface—and the image is *eaten out* in colors. . . . The third picture was injured in some parts; but it is, from the number of colors which it contains, the most remarkable of all. Red, blue, yellow, green and white are distinctly marked; and the intensity of the yellow very striking.[27]

The editor of the *Scientific American* went on to say that the yellow was the most interesting, because this was the color which Hill had the most difficulty with and which he had never been able to fix on his plates in any hue brighter than buff. Saint Victor's colored images required two or three hours in the camera obscura, and they could not be permanently fixed.

Other Europeans were experimenting with color photography. On July 21, *Comptes Rendus*, the publication of the French academy, had announced:

M. Letillois announces that he has discovered a colorless liquid by means of which he can fix in a durable manner, upon white paper, all the colors of the prism. Two specimens of paper thus prepared accompany the note, and present, in truth, colors which, at certain incidences of the light, are very bright and very pure. M. Letillois thought he could obtain the approbation of the Academy for this discovery, by communicating to one member, whom he designates, his process, which he might in other respects keep secret. The usages of the Academy do not permit them to accede to a request made under these conditions.[28]

Things were relatively quiet in America until Hill wrote Samuel Morse in February 1852, asking if Morse would write a certificate endorsing his process. Morse wrote back, declining the request but pointing out that, if Hill would show the results of his process to a few friends of standing, they could then testify that they had seen them. By this manner, Morse said, Hill could then be acknowledged as the first discoverer of color photography.[29] Hill followed this advice and subsequently received testimonials from well-known daguerreotypists, local dignitaries, and friends. A partial list follows:

Philadelphia, Jan. 6, 1852
I have seen Mr. L. L. Hill's finished pictures, portraits from life, taken with the Camera, upon silver surfaces, or usual Daguerreotype plates, and must say, in reference to their perfect exactness of transcription from their originals . . . I can not only endorse all he has said of them, but would speak even more strongly . . . I have also seen numerous specimens of Mr. Hill's "experiments," produced by the action of light, such as copies of prints, flowers, etc. . . . His portraits from life . . . are all that the most enthusiastic Daguerrean artist can desire.
 M. A. Root, *Daguerreotypist*
 140 Chestnut street,
 Philadelphia

New York, June 12, 1852
They present every possible variety of color and tint, in a most brilliant form—the whites are peculiarly bright and glossy—and the aspect of the pictures is one of astonishing boldness and relief. The flesh tints of the pictures from life, the color of the hair, drapery, background, etc. are fine beyond description.
 J. Gurney
 189 Broadway, N.Y.[30]

Boston, Mass.
August 30, 1852
Examined a portrait from life and upwards of thirty copies of colored engravings—fully convinced me he discovered chemical process by which he can take daguerreotypes in natural colors. Impression more readily seen than in common daguerreotypes and appears embedded in silver, instead of on the surface.
 John Whipple
 Daguerreotypist
 96 Washington Street[31]

The prominent Saint Louis daguerreotypist, John Fitzgibbon, wrote the editor of *Humphrey's Journal* on August 9, 1852, about his recent visit with the "indefatigable" Hill at work in his laboratory. Informing Fitzgibbon of many great improvements in his process, Hill said that he was bringing out colors more distinctly and with more brilliance and accuracy. Fitzgibbon saw about thirty of the hillotypes, some from life—he was particularly impressed with one taken from a highly colored lithograph of a lady and child, showing bright red, pink, dark blue, light blue, and orange and their respective tints. Another plate was described as "a yellow basket filled with fruit, containing peaches, black and white grapes, with beautiful bright green and darkly tinted leaves." There were other hillotypes of different varieties of flowers with rich coloring, in which a charming effect had been produced by a sprinkling of small yellow and blue flowers.[32]

Although Marcus Root had given Hill a glowing testimony, he later repudiated him in his 1864 book, *The Camera and the Pencil.* However, his denouncement may very well have been founded on the fact that Root had been unsuccessful in securing Hill's process for George Mallory, an agent for the Scovill Manufacturing Company who hoped to put the process on a commercial basis. In return for help in persuading Hill to agree to his proposition, Mallory was to give Root 50 percent of his proposed share in the process. However, Hill refused the offer of money or equipment from the Scovill Company and would not commit himself to Mallory until "I have done what I can to secure my purpose—the completion of the process as far as I can carry it. Especially do I feel the importance of my reducing the process to a degree of certainty which will enable me to feel, when I negotiate, that I cannot fail on so essential a point."[33] Hill's refusal to show any results to a Scovill committee or to see Root must have infuriated him.

After Hill had acquired his testimonies, he still needed an important authority to endorse his process, so he wrote Morse in September 1852, explaining that he had been sick, feared death, and needed his name in testimony. He implored Morse to come to Westkill. Morse did make the trip, saw twenty of the hillotypes, and immediately wrote of his visit to the *National Intelligencer*, a Washington newspaper; his letter was printed on October 8, 1852, and reprinted, in part, in the October 23 issue of the *Scientific American.* Morse wrote that the colors from Hill's process were so fixed that the most severe rubbing with a buffer only increased their brilliancy and that no exposure to light had been found to impair their brightness. He also said that the hillotypes were produced in twenty seconds and went on to say that:

> Mr. Hill has made a great discovery. It is not perfected. There is much yet to be done to make it perfect, but he is in advance of all others, and has, within the year, successfully overcome two of his difficulties. Both yellow and white were defective in quality and truth a year ago—both are now comparatively obtained. There are other colors which, in order to make them so true as to satisfy an artist's mind, will require yet further experimenting. Is not this reason enough for not at present giving his process to the public? Who, indeed, has a right to demand it at any time?

A second letter from Morse to Hill was reprinted in the *New York Times* on October 26:

Poughkeepsie
October 6, 1852

Rev. L. L. Hill,

My dear sir:

It gives me great pleasure to testify from ocular demonstrations, to the reality of your discovery of a process for fixing the colors of the camera obscura. The results you showed me, especially one of a bird of varied plumage, taken in two seconds show conclusively that the blues, yellows and reds were distinctly given and fixed. That there should be imperfections in the manipulations of a new process and that you should therefore desire to be so familiar with it as to bring it before the public in perfect form, are circumstances natural and to be expected. But the reality of your discovery is beyond question; you have laid the foundation on which will be built a splendid structure. Every stone and the finish of each of the whole building, it may not be in your power, from your future health to give, but whoever builds must build on your foundation. The astonishing tenacity of the colors upon your plates, yielding neither to rubbing nor ordinary exposure, is a distinct feature of greatest importance. So also is the quickness of the process, which when more exactness of manipulation is attained will enable you to fix at will the more fleeting hues of nature, particularly in the atmosphere, tints, and the expressive colors of the complexion of a portrait. The beauty of the flesh tints in two female heads from nature and those also in the full length of your little daughter, fully verify this. M. Becquerel, one of the most indefatigable and illustrious Savans of Europe has had his great mind with all its garnishments of the problem of fixing the colors of the camera image and the results, if the report is true, is failure: 'He was never able to fasten the colors.' M. St. Victor has also obtained results, ingenious and beautiful, but I have learned they are equally evanescent. But even if they were permanent, the length of time required to fix the image is fatal for all the varied practical purposes to which yours is applicable. Portraits cannot be taken by a process requiring 'two hours or even fifteen minutes.' Your discovery, so far as I am yet appraised of the labors of the scientific men is unequalled, and yet the only one which promises, in its perfected state, the great ends desired.

With respects, your friend and servant,

Samuel F. B. Morse

With the publication of these letters, Hill's claim had assumed formidable proportions on the national scene and, perhaps, even on the international scene. Now, for the first time, he had acquired indisputable support from America's foremost scientific expert; as an eyewitness to the veracity and validity of Hill's discovery, Morse was an authority in art and photography and his integrity could not be challenged. Also, John Draper, the chemist and early experimenter in photography, defended Hill's claim. Other artists of the brush were also staunch defenders, including Harding, Vanderlyn of Kingston, New York, Waugh of Philadelphia, Hite, and Wyeth.[34]

Hillotypes seen by well-known daguerreotypists, an editor, and lo-

cal dignitaries included portraits of living persons; copies of paintings; various plates of colored prints, a rosebush, a wreath of roses, a blackberry bush, and a bird of varied plumage; a full-length portrait of Hill's daughter; French engravings; two cameo-sized female heads; a portrait of an elderly woman; a large color lithograph of the village of Prattsville, New York; a sunset scene, with a play of colors in the clouds; a picture of a laboring man with a sunburned face, blue eyes, auburn hair, a red flannel shirt, and a red and blue cravat; and a portrait of Hill's daughter posed on a trunk. Hill documented some of the daguerreotypes themselves with writing. Interestingly, black-and-white photo copies do not show this writing but color prints do, although not all of it can be discerned. One of his daguerreotypes, titled "Girl in Yellow Dress," shows in a color print the tiny handwritten signature so clearly that it can easily be read without magnification. This daguerreotype changes color as it is moved from side to side; it appears a deep yellow, then blue, and, in negative, red. The gold lettering on the book held by the girl is perfectly natural.

One of the most important testimonies for Hill, aside from that of Morse, came from the editor of the *Ulster County Examiner*, whose account was partially reprinted in the *Scientific American* on July 10, 1852. The editor was shown some specimens by Hill, and he also witnessed the entire color process:

> That the uncovered plates were put in his hand for the most rigid examination by the full light of an unclouded summer day. And one which had not been burnished, was put to that process in his presence, when it took in an instant, the rich enamel-like surface, which distinctly marks the Hillotype from those of the daguerreotype. The fact is (as we saw from Experiment), the Hillotype is very difficult to remove from the plate as compared with the daguerreotype, nor is it sensitive to the effect of the atmosphere like the latter.

In October, the *Scientific American* published a letter from James Campbell of Dayton, Ohio, who had been experimenting with Saint Victor's color process, which he had read about in the *Annual of Scientific Discovery* for the year 1852. He briefly described the process, which involved using certain chlorides and a galvanic battery, in his letter to the editor. Of his own experiments, he wrote:

> I have taken very good pictures in an hour and a half, but it generally takes three or four. . . . The pictures resist most of the ordinary chemical agents and heat very well, but are rapidly dissolved by the hyposulphite of soda. In one instance, I brought out a picture which was invisible when the plate was taken from the camera, by using the sulphate of iron and bichromate of potash, but the colors were fainter than usual. In this case chlorochromic acid was the accelerator. I have not been able to produce colors on the mercurialized plate, though I have not experimented much on it . . . a difficult but perhaps not impossible problem . . . M. Niepce says that no bodies but chlorine or chlorides are capable of producing colored images. I am inclined, however, to suspect that when the problem of instantaneous photographic images is solved, that fluorine will be found as one of

the principals, if not the principal agent in their production. . . .
I intend to devote a part of the little leisure time I have to the
prosecuting of this interesting subject.[35]

Meanwhile, as an interesting result of Morse's published letters in
support of Hill, Anthony's offer to buy his process was raised from
$50,000 to $100,000.[36] But Hill again delayed publishing or revealing
his process, stating that he was having difficulties due to the "invisible
goblins of a new photogenic process." He was still having trouble with
the yellows, he said. This infuriated the daguerreian world anew, and
Hill was attacked again, with renewed vigor, in *The Photographic Art
Journal.*[37]

One reason for Hill's refusal was probably the realization that he had
no legal protection for his process. He petitioned the United States
Senate in February 1853: "Having discovered a method of heliotyping
objects in their natural colors, upon ordinary Daguerreotype plates,
and also upon glass, through the medium of the Camera Obscura, and
whereas my process, being strictly chemical in its nature, could not
find security in an ordinary Patent . . . I ask, at least, such an exam-
ination of my claim to this important discovery, as will tend to secure
to my native land the credit of the invention." Thus, on March 3, Sena-
tor Charles James of Rhode Island submitted the following report:

> The committee on patents and the patent office, to whom was
> referred the memorial of Levi L. Hill, in reference to his alleged
> discovery in heliochrome or sunpainting as denominated by Mr.
> Hill, ask leave to submit the following report: Mr. Hill, having
> been before the committee, explained to them the history and
> principles of his invention and submitted to their inspection, nu-
> merous specimens of the production of his art or invention. The
> committee had in their hands the plates, unprotected by glass or
> any other covering, and saw them freely, rubbed and otherwise
> tested, confirming in their minds the fact of the invention and
> the durability of pictures. It is believed that most of the pho-
> tographers in both Europe and America, long since gave up as
> hopeless, the search after this branch of science which has now
> been discovered by one of our citizens on one of the wide valleys
> of the Catskill Mountains far removed from the schools of art.
> The committee learned that Mr. Hill has arrived at this discov-
> ery by which the works of nature may be copied in their original
> hues through three years of persevering toil. The committee is
> informed by Mr. Hill that his discovery has not yet been per-
> fected in the practical details which is not surprising, it being a
> little over two years since he obtained his first results. But the
> beauty of the results which the process has already attained
> would seem to afford evidence that it will be perfected at no
> very distant day. The prospective ability and improvement of
> this invention are very apparent in its application to portraits,
> landscape, botany, morbid anatomy, numerology, conchology, ab-
> original history, the reproduction of valuable paintings and to
> various ornamental purposes. The committee are satisfied of Mr.
> Hill's claim to originality and priority of invention and deem it
> 'but just and right that he should be suitably protected and en-
> couraged' and they deem it most particularly so seeing that a

rival claim has been set up in France since the announcement of the discovery has been made. The means by which the process is carried out being strictly chemical, it would seem that the existing patent laws would not afford the inventor the security required. Owing, however, to the short period remaining of the present congress and the press of business, the committee have been unable to devise any better or more efficient mode by which to recognize the claim of Mr. Hill, than by recommending that his memorial together with this report be placed on the records of the Senate.[38]

The editors of the *Scientific American*, reprinting the Senate report in their March 26 issue, questioned its validity; they pointed out that they would need more than the report of the Senate committee on patents and that this committee was in no way suited, scientifically, to judge the discovery. It was noted that Hill's process could not be confirmed by displaying a few samples of his work to the committee. In any event, notwithstanding these adverse comments, the fact remained that Hill's process could not be patented and that the Senate committee had made an official public statement to that effect—which more or less vindicated Hill's persistent refusal to reveal his process to the public. (During this era, other inventors were constantly troubled with patent infringements on their inventions.)

Earlier, on February 26, the *Scientific American* printed another letter from James Campbell, who had continued his experiments with color photography. To quote the letter in part:

> Now M. Becquerel and Niepce de St. Victor have proved that if chloride of silver containing a slight trace of copper be exposed to the prismatic spectrum, or to rays of different colors, while undergoing this reduction, it is susceptible of coloration after a protracted exposure. From this it would seem that this process might be much accelerated. . . . I will show by a few experiments that this may be done. . . . If the plate, covered with the enamelled chloride of silver prepared by Niepce's process, be exposed to a current of hydrogen while receiving the image, the process will be much accelerated, and the image will be impressed in from half an hour to an hour; according to the amount of gas passed into the camera. . . . This experiment may be very easily performed, it only requiring a few grains of zinc in a small vial, containing dilute sulphuric acid. The vial and its contents may be placed in the camera, and the hydrogen being nascent is in its most active state, and as it is perfectly transparent, it permits the light to act on the plate, while it is itself engaged in reducing the chloride, which it is only capable of doing in sunlight. . . . Following this train of investigation, I have tried many other reducing agents both liquid and gaseous. . . . The principal gaseous agents tried are hydrogen alone and in combination with carbon and sulphur, ammonia, sulphuric ether in vapor, chloroform vapor, sulphuret of carbon, chloride of sulphur, hydro-sulphuret of ammonia, and sulphurous acid. . . . Sulphurous acid abstracts oxygen from organic bodies, with which it combines, forming sulphuric acid, and sulphuric acid renders chloride of silver unchangeable to light by destroying the organic

matter with which it is combined. I hence inferred that it might be used for the double purpose of reducing and fixing the picture. That it is a powerful accelerator is certain, the fixing requires further experiment. Pictures may be obtained with this gas in half an hour, by passing it nascent and in sufficient quantity in the camera and the colors are preserved. . . . I obtained one picture in five minutes, by passing into the camera gases generated from the distilling alcohol and sulphuric acid in a retort. The gases formed were olefiant gas and sulphurous acid, mixed with a little light carburetted hydrogen and sulphuric ether. The colors were very fairly represented, but not as good as I had previously obtained. . . . As electricity is a powerful agent in decomposing chemical compounds, it might be naturally inferred that it would aid in this process. . . . Dry chloride of silver is not decomposed by electricity, yet its decomposition by light, and other agents, may, by it, be much accelerated, and I did not at first use a sufficiently powerful current. I now render the plate a part of the conducting medium which terminates at the positive pole, and terminate the poles in water. . . . By using the gases at the same time that the plate is thus excited, I have been able to take pictures in from four to five minutes, which would otherwise require from three to five hours for their production. These pictures are developed under a hard, tough enamel of chloride of silver, cannot be rubbed out by the fingers, and will even bear considerable buffing, and, if the enamel is thick, are improved by the operation. I have not been able to permanently fix the picture, but it will keep a long time, if not exposed too often and too long, to the light. From the above experiments it seems that a prolonged exposure is not necessary to produce coloration, hence agents of great energy may be employed in reducing the chloride. That coloration may be produced, it is important, I think, that the picture by whatever process it is taken, be positive, and complete on its removal from the camera. For fixing, it is important that all the organic matter be destroyed, and then, I believe, it will be fixed. I am at present experimenting with iodine, bromine, fluorine, sulphur, chrome, and copper, and their compounds, deposited on the silver plate by electric action, or otherwise, but have not as yet, any results sufficiently matured to publish, though I have produced coloration. . . . I am not a daguerrean artist, am under many obligations to Messrs. Bisbee and Robinson, of this city, for the loan of a camera and other apparatus for my experiments. Having been obliged also to make the greater part of the chemicals used, I have as yet, been able to make, but a very meagre investigation of this interesting subject.[39]

By turning away from Saint Victor's process to perform his own experiments, using gases as accelerators, Campbell had obtained color on daguerreotype plates in from four to five minutes. His manner of using gas and other chemical compounds, although not exactly like those given later in Hill's formula for hillotypes, showed a striking similarity between his experiments and those of Hill. Unquestionably, also, his approach was very different from that of European experimenters.

In the spring of 1853, now backed with letters and documents attesting to the validity of his discovery, Hill sought world recognition as the inventor of color photography. After an editor of the *Scientific American* challenged his claim,[40] the two exchanged a series of bitter and sharply written letters, all of which were published. The work of the French experimenters was exalted, much to Hill's chagrin. Unable to receive the recognition he sought, Hill refused either to continue any correspondence or to reveal his process. No more was heard of him until December 1854 when through the medium of the press, he asked interested daguerreotypists to write him regarding his plan for publishing his heliochromatic process. And he frankly declared that he was still having trouble with the yellows.[41]

In 1856, Hill published *A Treatise on Heliochromy*, and in one of the chapters the hillotype process was explained in detail. Complete instructions were included, along with his formula. The plate to be prepared was first carefully cleaned and then electroplated in a chemical solution until it assumed a deep blue hue. Next, the plate was exposed to a series of separate chemicals and compounds which turned it a bright pink in color. From there, diffused light, heat, and more chemical reaction produced a light bluish cast. The plate was then placed in a jar of chlorine gas until it turned a faint yellow; if kept in total darkness, it would be ready for use when wanted. To render the plate sensitive, it was necessary to immerse it in a special solution until it appeared almost black (candlelight was suggested for this operation); then, after being rinsed with water and dried, it would produce colors after prolonged exposure to the image. To reduce exposure time, the plate was placed in a "quickener" solution. The strength and brilliancy of the picture could be increased by heating the plate until it assumed a red color, or it could be exposed to the action of orange rays of light. After the plate was placed in the camera and exposed, a developer was used to bring out the latent color images. The plate was then fixed, using a special solution, and rinsed and dried. A polish was applied with a soft buckskin if desired.[42]

Obviously a considerable working knowledge of chemistry was necessary for a correct execution of Hill's process. As Samuel Morse had written, back in 1852, the process "must be in the hands of no ordinary man, but will require the production of the perfect picture, the taste, the skill, the feeling of thorough and accomplished artists."[43]

After the publication of his book, a product of nine years of hard labor and difficult experiments, Hill must have concluded that the daguerreotype had passed into history and that major recognition of his process would never come. He moved to Hudson, New York, where his talent for chemistry and chemical experiments led him into the field of illuminating gas and burning fluids. His first endeavor had as its purpose the manufacturing of an economical-to-burn gas from water, to be done by separating the liquid into its original elements and rearranging the chemical components into gas. He successfully produced the gas, but, upon checking production costs, he found that it cost more to make than it was worth on the market. Meanwhile, he had moved to New York City.

Sometime in the early 1860s, Hill turned to the manufacture of petroleum. He organized a stock company which, by 1864, was a financial success. Also, between the years 1858 and 1864, he had secured four

United States letters patents and three reissues on these. One of his patents was for a hydrocarbon-vaporizing apparatus; another was for a method of producing inexpensive light and heat and applying the same. Just when fortune seemed within his grasp, Levi Hill died on February 7, 1865, at the age of almost forty-nine, his claim for color photography unresolved and public interest in the process at an end.

The story of Levi Hill is a tragic one because, while he had been waiting to release his discovery of color daguerreotypes in book form, other styles of photography had been quickly gaining in favor and the daguerreotype process was beginning to die. The newer processes, especially photographs on paper which could be beautifully colored by artists, had been gaining in popularity with many notable photographers. The ambrotype, an image on glass, had also become popular with the public, and in 1856 the ferrotype, an image on iron sheet metal, was introduced. Both processes were cheaper, and both hastened the downfall of the beautiful daguerreotype.

In referring to Hill's color daguerreotypes, Morse had said that "whoever builds must build on your foundation." Could Hill's process be similar in theory to the Kodachrome film introduced in 1935? Interestingly, yellow has continued to give trouble into the twentieth-century color processes. Hill had stated that he could not chemically explain why he produced color photographs. His only explanation in reference to the preparation of the plates was "on this one thing, molecular arrangement—the whole phenomenon of coloration depends."[44]

The Hill controversy continues to intrigue students: if the daguerreotype had continued in popularity beyond the 1850s, would color photography have been commonplace decades before its twentieth-century development? Experiments to recreate Hill's process might put this continuing controversy to rest.[45]

9. ART INFLUENCES

The daguerreotype was born during a flourishing period of American art. British art critic Anna Brownell Jameson, while visiting America in 1837, wrote of seeing swarms of artists roaming about the countryside; although the work of many was "outrageously bad," she said, there was too much genius among the artists to produce mediocrity. This view seems to have been substantiated by later art historians—the self-taught artists did show wit, originality, imagination, and a flair for color and design, as evidenced by the excellent paintings from this period.

Many fine native-born painters became prominent during the eighteenth century—John Singleton Copley, James Claypoole, and Ben-

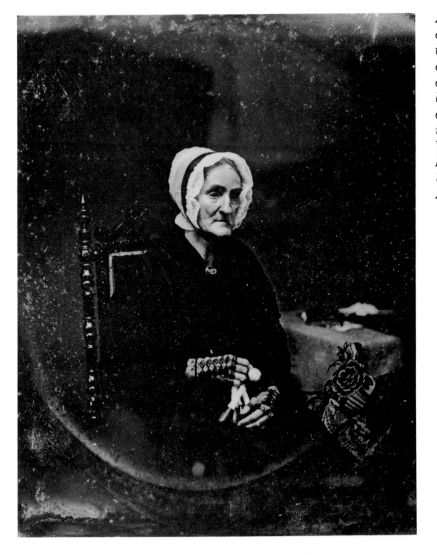

Aged woman with handiwork, ca. 1851. Whole-plate daguerreotype. Artist unknown. This well-composed portrait evokes history and drama. The dark shadowy background brings out the character of the sitter, somewhat reminiscent of the later painting by Whistler of his mother.
Reverend John Jones Collection, University of Georgia Libraries, Athens.

jamin West, among others. Painting in America had passed through several phases in treatment of subject matter from colonial days—the solitary portraits, historical scenes, religious subjects, and landscape painting emerging into genre painting, a less formal school of art depicting scenes of everyday life, casual images of family life and scenes with political nuances, and scenes of social significance in the West and South. Genre painting would capture the scenes of American life as the daguerreotype would record the visages of the people.

When artists first heard about the daguerreotype in 1839, opinions were sharply divided over what the effects of this new "mechanical contrivance" would be. Some felt that painting was doomed because of the new realistic images, while others believed that the images would contribute greatly to art. For example, French artist Paul Delaroche, after viewing Daguerre's work in January 1839, thought that the daguerreotype might give "useful hints to the most skilful painters, in the manner of expressing by light and shade, not only the relief of objects, but the local tint."[1]

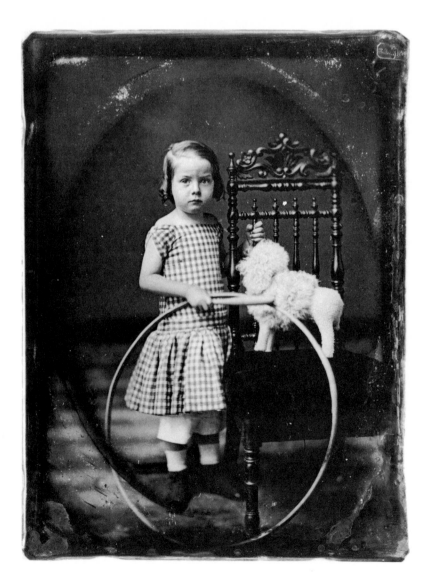

Girl with toys, ca. 1854.
Quarter-size daguerreotype.
By Samuel Broadbent.
Broadbent has brought to this winsome portrait his artist's knowledge of lighting and proportion.
Courtesy of Wiley Sanderson.

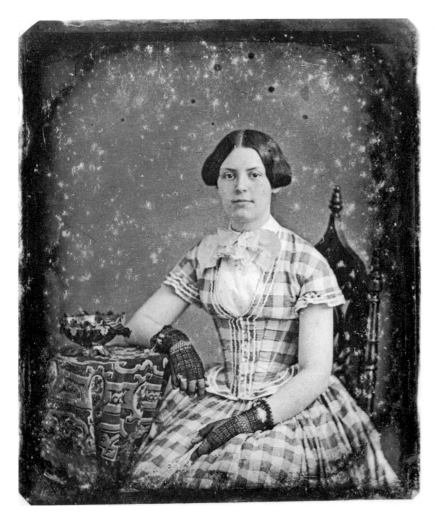

Mrs. Carrie Howard, ca. 1852.
Sixth-size daguerreotype.
By George Smith Cook.
The artist Cook began daguerreo-
typing in the South in 1840, and
his work became widely known
after the 1850s in both the North
and the South. The vase, figured
tablecloth, and decorative chair
add interest to an otherwise
simple portrait.
Reverend John Jones Collection,
University of Georgia Libraries,
Athens.

During the first years of photography in America, many portrait, landscape, and miniature painters, lithographers, and engravers ventured into the new art, led by Samuel Morse and his assistant, Samuel Broadbent, a friend and miniature painter from Wethersfield, Connecticut, who helped Morse in his daguerreotype studio until August 1841. Those who had studied art under the tutelage of known painters began learning the daguerreotype process in the 1840s. Among the artists were Erastus Salisbury Field, Gabriel Harrison, Philip Haas, Augustus Morand, Jane Cook from New York; Robert Cornelius, William G. Mason, John F. Watson, Marcus A. Root, Frederick De Bourg Richards, and Washington L. Germon from Philadelphia; Josiah Johnson Hawes, Loyal Moss Ives, and Lorenzo G. Chase from Boston; Ezekiel C. Hawkins, Thomas Faris, and the sculptor Theodatus Garlick from the Midwest; William H. Kimball, J. W. Stancliff, William Augur Tomlinson, and Henry Bryant from New England; and John Houston Mifflin, George Smith Cook, Solomon Numes Carvalho, and Edward Samuel Dodge from the South. The influx of artists to photography continued, as the art progressed, well into the 1850s and beyond.

The idea that miniature painting would soon be dead had been frequently expressed in the early days of photography. Miniature painting did not in fact die, but it did have to share its patrons with the new art of "sun painting" or "nature's sun drawings," as daguerreotypes were often called by the romantic writers of the day. Some miniature painters like John Carlin and James Goodwyn Clonney turned to genre and landscape painting after the advent of photography. However, a few miniaturists became daguerreotypists soon after Morse endorsed the art, and many of these men also continued their work as miniature painters.

Edward Samuel Dodge is an excellent example of an artist who turned to daguerreotyping. Dodge had exhibited miniatures at the National Academy of Design and the American Institute in 1842, and sometime during the formative years of photography he became a practicing daguerreotypist in Augusta, Georgia. The editor of *The Daguerreian Journal* fondly referred to Dodge as an "old veteran accom-

Children of Augusta, ca. 1853.
Sixth-size daguerreotype.
By Edward Samuel Dodge.
A rare example of the work of
Dodge, who was also a well-
known miniature painter.
Rinhart Collection,
the Ohio State University,
Columbus.

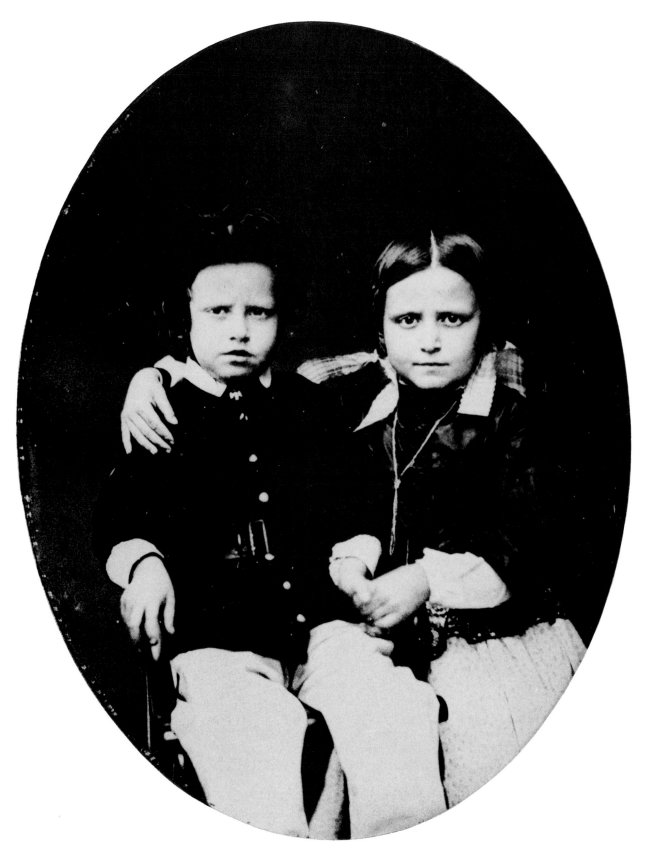

plished artist and paints miniatures on ivory."[2] Dodge's gallery was
visited by the editor of the *Georgia Weekly Constitutionalist* in 1851,
who wrote: "His specimens of miniature paintings are gems of that
beautiful art. . . . He also has a superior apparatus for taking da-
guerreotypes."[3] The editor also said that Dodge attracted people to his
gallery from the surrounding states.

Of the many daguerreotypists who had been miniature painters be-
fore taking up photography, Josiah Johnson Hawes of Boston would
become the most famous. Hawes' knowledge of painting and portrai-
ture, combined with his partner's talent for fine craftsmanship and
their true devotion to the art, makes an excellent example of the
strong influence of art in the development of the daguerreotype:
Southworth and Hawes became widely known for producing daguerre-
otypes enhanced by art techniques.

The influence of miniature painting is evident in many specimens of
the daguerreian art, particularly in the treatment of color. Some da-
guerreotype portraits have a darkish brown or slate gray background
similar in effect to that in many miniature paintings, and the delicate
tinting of the image and the superb lighting on the face reflect the art
of the miniature. Also, in the 1850s, the vignette-style portrait shows
an affinity to early miniature painting. And the gold-chased mats
which frame daguerreotypes and their placement in leather-covered
cases follow an art tradition for miniatures.

Engravers and lithographers quickly realized the potential of pho-
tography in relation to their art. Whereas the painter used the da-
guerreotype as an aid to his sketching, the engraver needed a model
for his scenes and portraits. After the advent of photography, the en-
graver's images would be more precise and realistic. Indeed, one por-
trait painter, lithographer, and print seller of Philadelphia considered
the daguerreotype as a work of art in 1840. Thomas J. Natt and Son
advertised in the *United States Gazette* on December 17, 1840:

> Daguerreotype Views—Elegant Articles for Christmas and New
> Year Presents
> Thomas Natt & Son beg to inform lovers of the fine arts, and the
> public generally, that they have just received from Paris a few
> choice Daguerreotype Views of Paris and Rome, among which
> are three splendid Interiors, by Colignon, the son-in-law of Da-
> guerre. To those wishing to possess a perfect specimen of the
> most wonderful and beautiful discovery of the age, these ex-
> quisite pictures, pencilled entirely by the rays of the sun itself,
> are now offered for sale. Purchasers are invited to call and ex-
> amine at 192 Chestnut street, near 8th.[4]

One of the earliest engravers and painters to become interested in
daguerreotyping was William G. Mason of Philadelphia, who became
an amateur daguerreotypist in 1839. Another early practitioner was
Prussian-born Selmar Rush Seibert, a copper engraver and map-
maker, who worked in Philadelphia in 1839 and 1840 to prepare da-
guerreotype plates more sensitive to light.[5] Probably the best-known
lithographer to become a daguerreotypist in the 1840s was Philip
Haas, who made lithograph views of Washington and Mount Vernon
between 1837 and 1845. His work also included technical prints and
portraits. Many other lithographers and engravers continued to work

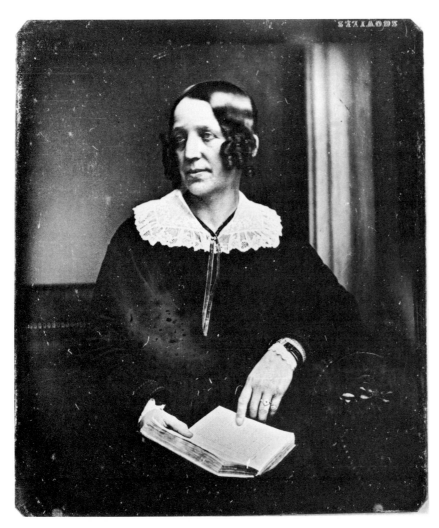

Seated woman on sofa, ca. 1846.
Sixth-size daguerreotype.
By Southworth and Hawes.
An excellent example of the da-
guerreian art—the classical pose
and fine lighting bring out the
character of the sitter.
Anonymous collection.

in the era of the daguerreotype, and the illustrations in the periodicals and books of 1840 to 1860 reflect their influence.

The westward expansion, the literature of the day, and the political and industrial changes in America were all factors influencing the art of the daguerreian era. While there was considerable European influence on American painters, and some artists studied and worked abroad, like Benjamin West in earlier years, many American artists improvised their own form. Although primitive by European academy standards, the work of many native American artists had a pleasing informality and flamboyance in the use of color and design—an approach that appealed to the general public. The native school of art reflected the mood of America, including an unprecedented interest in nature—Henry Thoreau is an example of this trend in literature.

American social influences from 1830 to 1860 helped create a public taste for art and a predisposition for images both realistic and allegorical in the form of public entertainment—such as the dioramas and panoramas with their accompanying lectures. Art was promoted by art unions and art exhibitions and by the enormous popularity of illustrated literature.

The diorama, coinvented by Daguerre, became a popular entertainment after its initial exhibit at the Paris diorama building in 1822. The following year, a similar establishment was put into operation by Daguerre in Regent's Park, London. The diorama buildings were constructed so that the amphitheater slowly revolved about four times an hour, enabling spectators to see changing views of the stationary painted scenery. Special lighting above and behind the canvases gave the audience realistic effects of day and night.[6] Often depicting realistic scenes of actual events, the diorama may have stimulated the use of the daguerreotype to record local and national scenes of interest. In its treatment of historical dramas and events, the art would both educate and entertain the many spectators who flocked to see the latest dioramas, which were widely advertised in the newspapers of the day.

Exactly when these huge painted canvases came to the United

Child at mother's knee, ca. 1845.
Quarter-size daguerreotype.
Artist unknown.
A pyramidal composition evoking sadness.
Courtesy of George R. Rinhart.

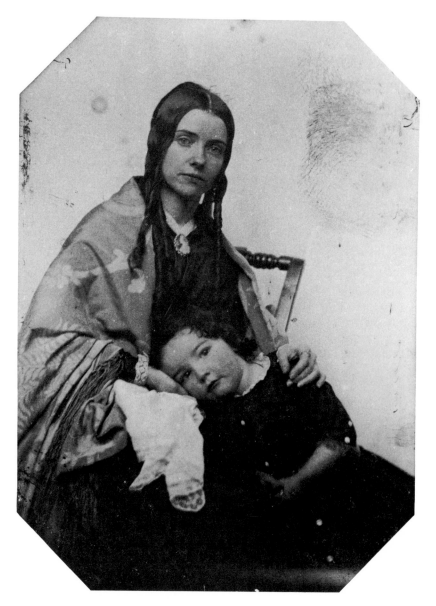

States is not clear, but William J. Hannington and his brother produced a great many spectacular moving dioramas which toured New York City, Philadelphia, Cincinnati, and other cities between 1832 and 1856—*Creation and Deluge, Conflagration of Moscow, New York Fire of December 16, 1835, Stellar Universe,* a moving telescopic diorama, and others.[7]

The diorama entertainments usually featured four different subjects having historical, religious, or geographical themes. These productions were presented in almost all of the larger cities of the North and South and, in some instances, in smaller cities and towns. Artist-promoters Maffey and Lonati, who imported dioramas from Paris, traveled about the eastern seaboard in the early 1840s advertising "Daguerre's Chemical Pictures," large oil paintings which had nothing to do with daguerreotypes but represented the wonderful effects of

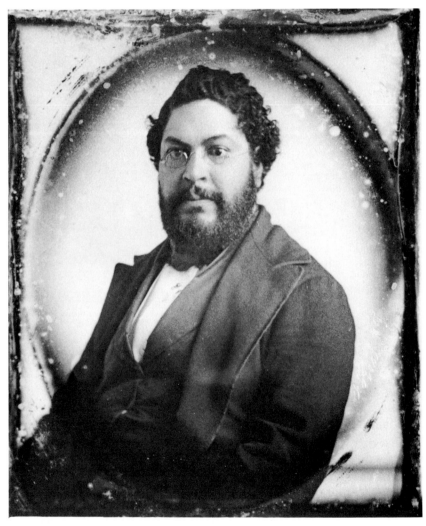

"My Dear Professor," 1856.
Quarter-size daguerreotype.
By Philip Haas.
In the back of the miniature case, under the portrait, is a note dated April 21, 1899, and a lock of very black hair. Etched on the original daguerreotype plate is "P. Haas, N.Y."
Courtesy of Josephine Cobb.

Portrait of Belle, 1859.
Sixth-size daguerreotype.
Artist unknown.
*The artist has employed a scenic
background to give depth to his
portrait, and the elaborate cos-
tume and gracefully held fan
add interest.*
*Rinhart Collection,
the Ohio State University,
Columbus.*

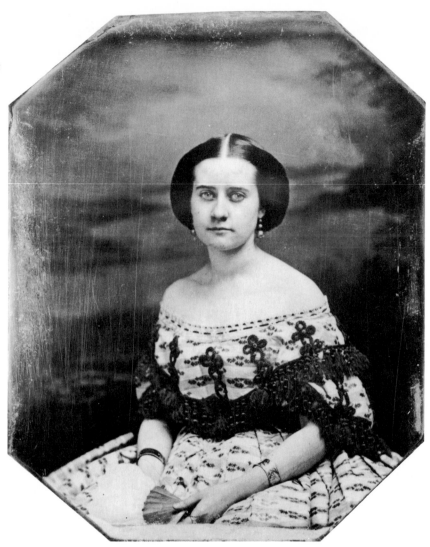

Woman in ball gown, ca. 1853.
Half-size daguerreotype.
Artist unknown.
*A very rare and elaborate stage
setting for a portrait, which sug-
gests that the daguerreotype may
have been taken in a theater
rather than in a photographer's
studio.*
*Rinhart Collection,
the Ohio State University,
Columbus.*

"Day and Night." "Chemical Pictures" shown in December 1842 in New Orleans were *The Sicilian Vespers, or Palermo in 1282, The Charming Valley of Goldau, in Switzerland, Church St. Etienne Du Mont*, depicting a midnight mass, and *City of Venice on a Festival Night*. The exhibition opened at noon and at seven in the evening; admission was fifty cents.[8] Unfortunately, the entire set of "Daguerre's Chemical Pictures" was destroyed by fire the following month on January 30, 1843. (Reportage of the fire in newspapers erroneously led future historians to believe that daguerreotype specimens executed by Daguerre and brought to America by Gouraud had been destroyed.)

The panorama, a similar form of entertainment using very large scenes painted on canvas, had been introduced in America at a much earlier date. The first such canvases by an American were displayed in 1795 in Philadelphia, when Edward Savage, a pupil of Benjamin West's, showed scenes depicting London. A Philadelphia newspaper noted that the panorama was "in a circle and looks like reality."[9] The

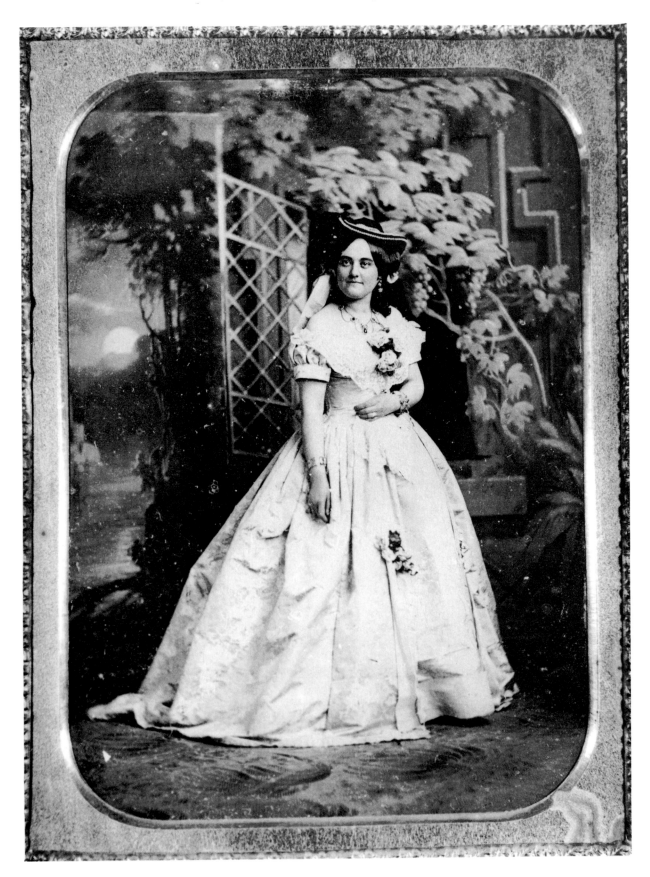

Woman seated in garden,
ca. 1850.
Half-size daguerreotype.
Artist unknown.
By posing his subject in a natu-
ral setting, the artist has created
a feeling of a solitary figure in
an open space—an unusual com-
position for a daguerreotype.
Authors' collection.

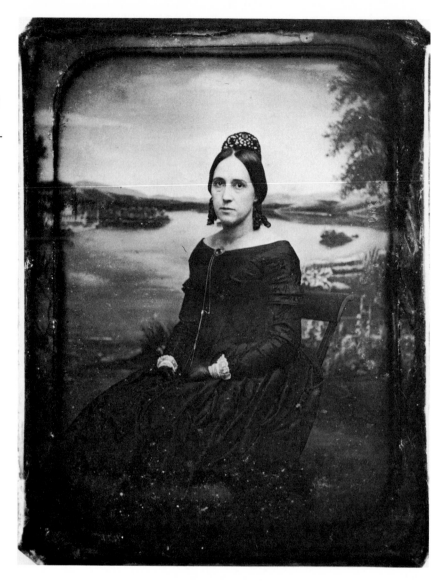

panorama had become big business by the late 1830s. One successful venture was that of the Englishman Frederick Catherwood, who had been trained by the artist Robert Burford of London. His opening attraction, *Jerusalem*, in New York City drew large audiences. The panoramas were described in the *New York Commercial-Advertiser* on July 3, 1839, as "covering surface of ten thousand square feet, painted from drawings taken by Mr. Catherwood in 1834. The Panorama of Thebes, in Egypt painted likewise from Mr. Catherwood's drawings. . . . The panoramas are brilliantly illuminated every evening by upward of 200 gas lights—explanation of pictures given in the forenoon and 8:30 in the evening. Admission 25 cents to each Panorama. Books 12½ cents." Catherwood's enterprise was so popular that he soon imported Burford's panoramas, which were not only shown in New York but were taken on tour to other eastern cities.

Catherwood, also an architect and an archaeologist, traveled to Central America in late 1839 and 1840 with John Lloyd Stephens, a

The ruins of Copán, Yucatán. An engraving by Frederick Catherwood. From John L. Stephens, Incidents of Travel in Central America, Chiapas, and Yucatán, *1845.*

businessman and explorer, to study the ancient ruins. In 1841 and 1842, he traveled with Stephens to the Yucatán; this time he brought a camera and daguerreotyped scenes of Maya ruins, many of which would be used as models for illustrations in Stephens' book, published in several editions after 1841.[10] Catherwood's most important work was certainly this series of illustrations of the Maya ruins of Yucatán and Guatemala, thus creating an early interrelationship between art and the daguerreotype.

By midcentury the panorama was no longer static: great strips of canvas were wound from one concealed roller to another as the audience listened to the lecturer. Of particular interest and popularity were panoramas of the Mississippi River by Henry Lewis and John Banvard. Both were created independently—Banvard's canvas, completed in 1846, was about twelve hundred feet long, while Lewis' was twelve feet high, about three times the length of Banvard's, and included the whole of the river from Saint Paul to New Orleans.[11] Both panoramas were taken on highly successful tours of the United States and Europe. The *Southern Literary Messenger* for August 1859 praised the panorama:

> As the canvas rolls by, unfolding to our view Alps and oceans, conflagrations, volcanic eruptions, etc., we hear, in the pauses of a cracked piano, the voice of the Showman, as of one crying in the Wilderness, who tells us all about the localities represented, with a good deal of pleasant information to be obtained in no other manner, because it is improvised for the occasion.[12]

The popularity of the panorama in America must have influenced daguerreotypists to take panoramic views of rivers and cities. As early as 1845, for example, the Langenheim brothers took views of Niagara Falls, using five daguerreotypes for each framed panorama. Eight sets were made, with one set each being sent to President Polk, Daguerre, Queen Victoria, the duke of Brunswick, and the kings of Prussia, Saxony, and Württemberg.[13] The Langenheims found that the publicity

Panoramic view of San Fran-cisco (three of five plates), 1852. Whole-plate daguerreotypes. By William Shew. The daguerreo-type panorama, using photoreal-ism, contrasted sharply with the huge, bulky, and often romantic canvases which depicted the scenic wonders of the world. Smithsonian Institution.

generated from this venture contributed to their subsequent business success. Also, Fontayne and Porter's magnificent panorama of Cincinnati won a first premium award at the Franklin Institute exhibition of 1848.[14]

San Francisco, scene of great activity in the gold rush days, was daguerreotyped in panoramic views from 1850 to 1852. A five-plate view of the city, taken by Sterling C. McIntyre of Tallahassee and Charleston, was noted in the *Alta California* of January 1851 as "the finest thing in the fine arts produced in this city."[15] William Shew, a Boston daguerreotypist who took up permanent residence in San Francisco in 1851, made his famous five-plate panorama in 1852, showing the rotting and abandoned ships in the harbor—one of the truly great scenes of early photography.[16]

In 1851 Alexander Hesler, a prominent Illinois daguerreian artist, photographed the Mississippi River from Galena to Saint Paul from the deck of the steamboat *Nominee*; engravings made from these daguerreotype scenes were used in *Harper's Illustrated Guide*.[17] As the 1850s progressed, more and more editors were employing photography as an integral part of their art and literary publications. And landscape painters used daguerreotype scenes as models for sketching their large panoramas. At least one daguerreotypist is known to have

followed this procedure when presenting frontier western scenes in the form of a panorama to spectators in the East.

Like so many Americans, J. Wesley Jones, a resident of Melrose, Massachusetts, and William N. Bartholomew, a drawing teacher from Boston, traveled to California in the gold rush days of 1850.[18] Jones' many adventures in the West were published in 1854 in John Ross Dix's *Amusing and Thrilling Adventures of a California Artist While Daguerreotyping a Continent*. It is not known whether Jones himself daguerreotyped most of about fifteen hundred scenes of the Rocky Mountains, California, and the plains of the Missouri River from 1850 to 1851, and history does not record whether he had conceived his idea of using the daguerreotypes for a panorama of the West before he left on his travels. However, an item in the *Oregon Spectator* for September 23, 1851, does shed light on how he accomplished his large-scale enterprise:

> Mr. J. Wesley Jones being engaged in taking views of the route across the plains and prominent places on the Pacific Coast, desires us to state that he wishes some artist or daguerreotypist,

J. W. Jones, artist, ca. 1856. Sixth-size daguerreotype. Artist unknown. This portrait, believed to be of J. Wesley Jones, was found in Burlington, Vermont, where Jones resided in the late 1850s. Rinhart Collection, the Ohio State University, Columbus.

to take some 50 views of different scenes in Oregon, viz: the important towns, and the most interesting mountains and river scenery; for which he will pay $5.00 each for "half plate views"— delivered at any of the eastern cities or St. Louis, the coming winter. Persons wishing to embark in the enterprise can see Mr. Jones letter by calling at the office. We quote from the letter . . . as to mode of sending them: "The plates may be sent marked in grooved boxes—well soldered; Daguerreotypists understand this. There must be notes accompanying each picture—of the color of the prominent buildings—or trees—or rocks, etc., etc. Also of the character of the country it represents; and its where-abouts or geographical position. This any school boy could soon do. Anything historical or legendary concerning any particular place we will be glad to get and make proper allowance for it properly gotten up."

When Jones returned home to Melrose in 1852, he commissioned Thomas Mickell Burnham and other artists to use the daguerreotype scenes chosen for his project as models for painting large scenes on canvas for his lecture series, "The Pantoscope of California." [19]

Advertised widely in New York and other seaboard cities during 1853 and 1854, the pantoscope proved very popular—Americans could see realistic views of the new frontier! The paintings were raffled off by lottery in March of 1854, and their subsequent whereabouts are unknown. [20]

Another favorite form of entertainment in both America and Europe was provided by the magic lantern—pictures painted on glass or some other transparent material were projected, highly magnified, on a white wall or screen. This early use of images projected through glass is interesting because when the collodion negative process became popular in the 1850s, the same format would be employed with photographs for projection in magic lanterns. The daguerreotype was exhibited with the magic lantern as early as the winter of 1846–47 by the Langenheim brothers. The condensed light of two hydro-oxygen burners upon the daguerreotypes sent the reflective image through a large magnifying lens to the screen, which was placed in front of the strongly illuminated plate. [21] Whether this type of exhibition was widespread is unknown.

A very important influence on the artist, the daguerreotypist, and the general public was created by the establishment of art unions in all the major American cities—these encouraged mass participation in the arts by people from all levels of society. The enterprise began in 1838, when an artists' cooperative known as the Apollo Gallery, in New York City, was having trouble selling American paintings. The gallery changed its name to the American Art Union and invited the public to subscribe five dollars a year per member in return for engravings of paintings. At the end of the year, a drawing was held and the lucky winners received the originals. [22] The American Art Union, the most famous of all, promoted American paintings, whereas the American Academy, founded in 1803 by a group of leading New York families, promoted European art.

The American Art Union prospered more than any other similar society. At the close of 1849, 18,960 members received as prizes "460 paintings, 20 statuettes, 30 books of outlines by Darley, illustrations

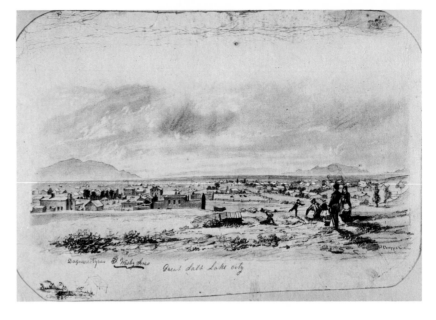

Irving's 'Legend of Sleepy Hollow,' 250 'Trumbull' medals, 150 'Stuart' medals, and 100 'Allston' medals."[23] By the end of 1850, after twelve years of operation, the union's members had spent more than $200,000 on native art.

In the Midwest, public support for art was shown by the success of the Western Art Union of Cincinnati, which featured a picture gallery open to subscribers; displayed were paintings, statuary, and engravings. During its three years of existence, until 1850, the union distributed among its patrons 196 oil paintings, 50 casts from the bust of Egeria by Baker, and 2,497 prints.[24]

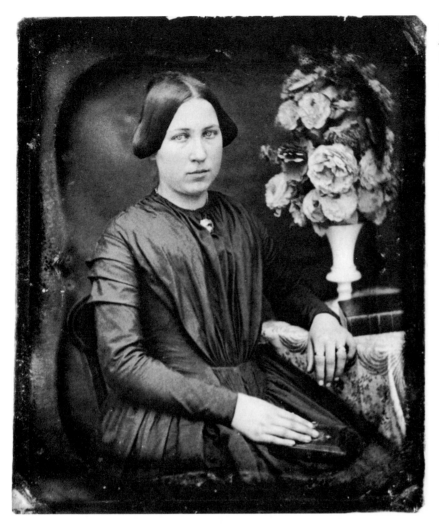

Seated woman with vase of flowers, ca. 1849. Sixth-size daguerreotype. Artist unknown. The soft folds and drapery of the woman's costume complement the full-blown flower arrangement. Possibly a mourning portrait.
Courtesy of Henry J. Hulett.

In 1853 the editor of *Putnam's Monthly Magazine* wrote about the downfall of the American Art Union and its effects on art and artists:

> The utter extinction of the Art-Union, by a decision of our courts, has had a temporary depressing effect upon the course of Art in this country. . . . Our artists will now be compelled to depend upon chance visitors to their studios and the Annual Exhibition, for the purchases of their pictures, and we do not doubt but they will be better off in consequence. They will work better, and generally, find more discriminating customers than they have done for the past five years![25]

According to this editor, it would seem that, although popular demand for paintings would lessen, the artists would do well with connoisseurs of art as their patrons.

The idea of an art union had spread to daguerreotypists by 1845, when the Daguerreotype Art Union and Photographic Association was established in Chicago—subscribers were offered an opportunity to own examples of the daguerreian art.[26] It is not known whether similar societies to promote the daguerreotype were founded in other areas.

However, lotteries which included daguerreotypes as prizes were conducted by Jesse Whitehurst and M. W. Lockwood in the 1850s.

Their continuing interest in historical, religious, allegorical, and solitary portrait paintings must have made Americans receptive to and appreciative of the daguerreian art. Art galleries and exhibitions of original paintings by American and European artists drew crowds in the larger cities, and works of art were reviewed in the periodicals of the day—*The Knickerbocker, Godey's Lady's Book, Harper's Monthly Magazine*, and many others. Most of the popular publications in America and Europe promoted the arts.

The allegorical theme, always the painter's domain, was pioneered in daguerreotypes by John Mayall (later famous in London as a daguerreotypist) and Samuel Van Loan of Philadelphia, who produced a set of ten daguerreotypes with each plate representing a line from the Lord's Prayer.[27] These were later exhibited by Mayall at the Crystal Palace in London in 1851. Allegorical themes were favored by many daguerreotypists for exhibitions. Martin Lawrence displayed his allegorical "Past, Present, and Future" at the Great Exhibition. (Although whether the prizewinning daguerreotype was taken by Lawrence or by Gabriel Harrison, who worked for Lawrence, was a matter for conjecture among daguerreotypists).[28] The famous Meade brothers exhibited twenty-four daguerreotypes, among them allegorical compositions of Europe, represented by a "beautiful group, surrounded by the arts"; Asia, shown by an Asiatic in costume, seated cross-legged on a divan, with a pipe; Africa, shown by two blacks, naked except for a tunic from the waist; and America, depicted by a group of Indians.[29] Daguerreotypists from all over the country displayed specimens at the New York Crystal Palace in 1853. Martin Lawrence again exhibited "Past, Present, and Future"; the Meade brothers showed Shakespeare's "Seven Ages" on many plates taken from life, one representing the Soldier and the Lover; Philip Haas displayed a whole-plate allegorical figure of a family man reading a paper at home; Harrison and Hill exhibited on mammoth plates "allegorical designs"; Alexander Hesler, of Galena, Illinois, showed a series "illustrating character and passion." One of these, titled "Driving a Trade," was particularly noted by Horace Greeley when he wrote about the daguerreotype section of the exhibit.[30]

If photography were given valuable direction by the great influx of artists from the older schools, the daguerreian art, in turn, was of great help to portraiture and lithography, and, the daguerreotype was an aid to engravers almost from the beginnings of photography. As early as 1841, the *United States Magazine and Democratic Review* was illustrated with engravings of famous men taken from daguerreotypes by Chilton and Plumbe. To provide authenticity, engravers usually noted, below each portrait, that it was "From a Daguerreotype," thus impressing upon the reader that the portrait had been taken from life.

An early use of the daguerreotype to publicize engravings of notable people for profit was found in the *New-Mirror* in August 1844:

> Messrs. Anthony, Edwards and Co. of the 'National Miniature Gallery' have recently published a very excellent likeness of the Hon. Theodore Frelinghuysen. The engraving is a very superior mezzotint, and the resemblance a remarkable one for a paper

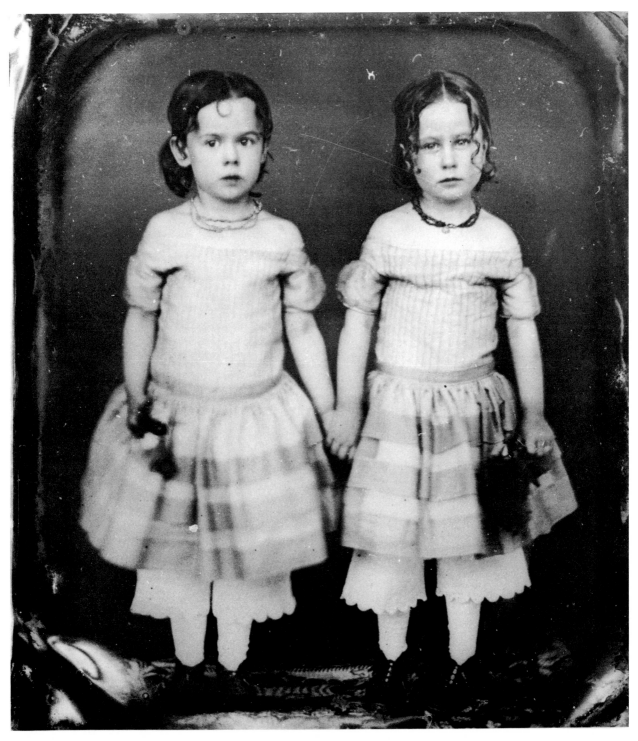

Girls holding flowers, ca. 1853.
Sixth-size daguerreotype.
Artist unknown.
The solemnity in pose and com- *position show an influence from* *American primitive painting.* *The flowers on the original da-* *guerreotype are colored by hand.* *Rinhart Collection,* *the Ohio State University,* *Columbus.*

Isaac Van Amburgh, ca. 1850.
Half-size daguerreotype.
Artist unknown.
An allegorical portrait. Van Am-
burgh was a popular stage per-
former with his "cats" both at
home and abroad.
Rinhart Collection,
the Ohio State University,
Columbus.

likeness. We observe that it has received the decided commendation of Mr. F., and of those who are familiar with his features. This is, we believe, the first really successful effort to engrave from a daguerreotype, and we welcome it as another evidence of our progress in the arts, as well as of the volume of the National Miniature Gallery now in progress of completion by these gentlemen.[31]

Engravings for profit were also published by Mathew Brady in his 1850 *Gallery of Illustrious Americans*—the engravings were done from daguerreotype models by F. D. D'Avignon, also a lithographer. Although the work was critically acclaimed, it failed financially—thirty dollars was too high a price for the average American.[32]

Daguerreotype scenes were not as popular for illustrations as were portraits of the prominent, and engravings using them as models were rarely identified as being "From a Daguerreotype." A group of daguerreotype scenes taken for the express purpose of illustating a series of articles about New York City were published in *Putnam's Monthly Magazine* in 1853. Hotels, restaurants, churches, colleges and schools, benevolent institutions, places of amusement, and public buildings were shown, as well as private houses and the life of the commercial metropolis. The artist who daguerreotyped the scenes remains unknown, and not one of the daguerreotypes has survived; possibly the engraver discarded the daguerreotype plates after the project was completed. Richardson and Cox, New York engravers and well-known illustrators, did most of the work, and John William Orr also did some of the engravings.[33]

Very little has been written about the influence that the daguerreotype had on landscape painting of the day, but it is known that the public preferred realism in landscape painting during the daguerreian era.

Woman with parasol entering gate, ca. 1851. Quarter-size daguerreotype. Artist unknown. The daguerreotypist has brought to this scene an artistic blending of light and shadow. The original daguerreotype has been colored by an unknown process which brings out, very effectively, various tones of green on the trees and grass and the sand color of the road. The parasol has been etched on the original daguerreotype to make it more visible. Courtesy of Josephine Cobb.

Samuel Morse, the first American to realize the potential of interaction between the daguerreotype and painting, revealed some of his thoughts about the use of the new art to painters in a letter to his old friend Washington Allston, a popular and romantic painter during the first half of the nineteenth century:

> You have heard of the Daguerreotype. I have the instruments on the point of completion, and if it be possible I will yet bring them with me to Boston and show you the beautiful results of this brilliant discovery. Art is to be wonderfully enriched by this discovery. How narrow and foolish the idea which some express that it will be the ruin of art, or rather artists, for every one will be his own painter. One effect, I think, will undoubtedly be to banish the sketchy slovenly daubs that pass for spirited and learned; those works which possess mere general effect without detail, because forsooth detail destroys the general effect. Nature, in the results of Daguerre's process, has taken the pencil into her own hands, and she shows that the minutest detail disturbs not the general repose. Artists will learn how to paint, and amateurs, or rather connoisseurs, how to criticise, how to look at Nature, and therefore how to estimate the value of true art. Our

Boy orator, ca. 1848.
Sixth-size daguerreotype.
Artist unknown.
The artist has used a dark back-
ground and a white pillar to
bring out his subject in sharp re-
lief. All details of costume and
figure, except the collar and but-
tons, have been omitted for a
dramatic effect.
Rinhart Collection,
the Ohio State University,
Columbus.

studies will now be enriched with sketches from Nature which
we can store up during the summer, as the bee gathers her
sweets for winter, and we shall thus have rich materials for com-
position, and an exhaustless store for the imagination to feed
upon.[34]

Morse spoke of the daguerreotype's role in the art and its influences
before an annual supper of the National Academy of Design on April
24, 1841:

The daguerreotype is undoubtedly destined to produce a great
revolution in art, and we, as artists, should be aware of it and
rightly understand its influence. This influence, both on our-

Lady in black, ca. 1849.
Sixth-size daguerreotype.
Artist unknown.
A dramatic study in light and
shade. The white pedestal gives a
classical feeling to this portrait.
Rinhart Collection,
the Ohio State University,
Columbus.

selves and the public generally, will, I think, be in the highest
degree favorable to the character of art. . . . Its influence on the
artist must be great. By a simple and easily portable apparatus,
he can now furnish his studio with fac-simile sketches of nature,
landscapes, buildings, groups of figures, etc., scenes selected in
accordance with his own peculiarities of taste; but not, as here-
tofore, subjected to his imperfect, sketchy translation into
crayon or Indian ink drawings, and occupying days, and even
weeks, in their execution; but painted by nature's self with a
minuteness of detail. . . . To the architect it offers the means of
collecting the finest production of modern architecture, with
their proportion and details of ornament, executed in a space of
time, and with an exactness.[35]

Again in 1841, in reply to a request to paint a picture, Morse said: "My
ultimate aim is the application of the Daguerreotype to accumulate for
my studio models for my canvas."[36]

Another influence on both daguerreotypists and artists of the brush
was their close proximity in the larger cities. In New York City, artists
resided in the New York University and the Art Union buildings, as
well as the Granite Building, where Wolcott and Johnson opened their

Two men and a young lady, ca. 1849. Two-thirds-size daguerreotype.
Artist unknown.
A superb example of the da- *guerreian art. The lounging grace of the subjects, off-centered from the vertical pillar, and the startling purity of the focus, unusual for a group portrait, bring* *a breath of life to the composition.*
Department of Art, Photographic Archives, University of Georgia, Athens.

gallery in 1840. Certain famous artists who lived in the Granite Building in the early years of photography were George Harvey, William Page, and Jasper Cropsey, among many others. A few residents were daguerreotypists in the 1840s. Henry Bryant, one of the many associates of the National Academy living in the building in 1840, later became a daguerreotypist in Richmond and still later took up painting again, exhibiting at the National Academy from 1852 to 1854. Mathew Brady, who later said he had roomed with William Page when he first came to New York, probably had a room in the Granite Building in 1842 or 1843; otherwise, there seems to be no close relationship between Brady and Page.[37]

Artists favored the Granite Building from 1840 to 1847. In 1857, on West 10th Street, a building designed by Richard Morris Hunt was

Vignette portrait of a young girl, ca. 1853. Ninth-size daguerreotype. Artist unknown. A crayon portrait.
Rinhart Collection,
the Ohio State University,
Columbus.

James H. and William E.
Bowditch, ca. 1853. Half-size
daguerreotype. By Southworth
and Hawes (attributed). This
vignette-style portrait is a mas-
terpiece of pose and lighting. On
the original daguerreotype, the
mercury process used to develop
the image casts a halo of various
rainbow tints around the por-
trait in the manner described in
Henry Insley's patented illumi-
nated daguerreotypes of 1852.
Rinhart Collection,
the Ohio State University,
Columbus.

constructed for artists' studios; residents included Frederick Church,
J. F. Kensett, Albert Bierstadt, Sanford Robinson Gifford, Emanuel
Leutze, and William Stanley Haseltine.[38] The same close proximity of
daguerreotypists and artists was found in Boston and Philadelphia.

Beginning in 1849, daguerreian artists developed a new technique
which somewhat softened the realism of the photographic art and in-
fluenced portrait painters of the era to popularize the "crayon por-
trait." In the new-style portrait, the outline of the subject blended
softly into the background, giving a bust effect which eliminated cos-
tume details and brought the face into relief. These vignette daguerre-
otypes, produced by a patented method, so pleased Marcus Root that
he wrote Henry Snelling: "A series of beautiful portraits are about
being prepared by the Crayon Process for the express purpose of
being placed in the exhibition at the 'art union,' when amateurs, art-
ists, and the public generally will have an opportunity of witnessing its
effects." John Sartain, a famous Philadelphia engraver, was, wrote
Root, one of several distinguished artists to recognize and endorse the
crayon daguerreotype; Sartain used them as models for engraving

*Girl holding little boy, ca. 1852.
Sixth-size daguerreotype. Artist
unknown. An excellent example
of why the public preferred real-
ism in their portraiture to ide-
alized images painted by the
traveling limner. No brush could
capture this beautiful moment or
bring out the expressiveness of
the child's face and body.
Authors' collection.*

portraits for book or magazine illustrations, and at this time he was
publishing *Sartain's Union Magazine of Literature and Art*.

After Americans became accustomed to realistic portraits of them-
selves rather than the idealized images painted by the traveling limner
or the established portrait painter, they actually preferred, with some
exceptions, the realism of the photographic art. This acceptance, in
turn, influenced traditional painting of the day in that the objective im-
agery of the daguerreotype was now used extensively for guidance by
portrait artists. This practice was usually kept secret, although a few
painters and sculptors were quick to acknowledge the photograph as
an aid. As early as 1846, an article in *Littell's Living Age* tells of the
new trend toward realism in portrait painting:

> [The daguerreotype] is slowly accomplishing a great revolution
> in the morals of portrait painting. The flattery of countenance
> delineators, is notorious. No artist of eminence ever painted an

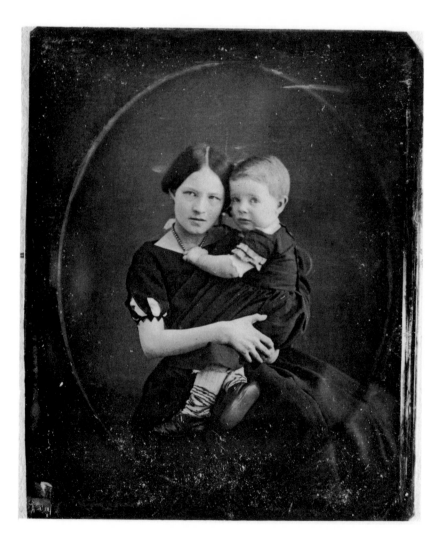

ugly face, unless perchance, now and then a fancy sketch, or a copy of some antique, *so* antique that it is impossible to trace the original. Everybody who pays, must look handsome, intellectual, or interesting at least—on canvas. These abuses of the brush the photographic art is happily designed to correct. Your sun is no parasite. He pours his rays as freely and willingly into the cottage of the peasant, as into the palace of the peer; and he vouchsafes no brighter or purer light to the disdainful mistress than to her humble maid. Let it once become the *bon ton* for plain-looking, homely, and ugly people to sit for likenesses that *are* likenesses—let a few hideous men and women of distinction consent to be daguerreotyped—in fine, let nature and art in their combined efforts be suffered to have fair play, and 'it must follow as the night the day,' that this moral revolution will be achieved. There are gratifying proofs that the custom is rapidly

Mother and daughter, ca. 1853.
Sixth-size daguerreotype.
Artist unknown.
The sweet-faced likenesses of mother and daughter are brought out by a soft neutral background. The flower arrangement is hand-tinted pink.
Anonymous collection.

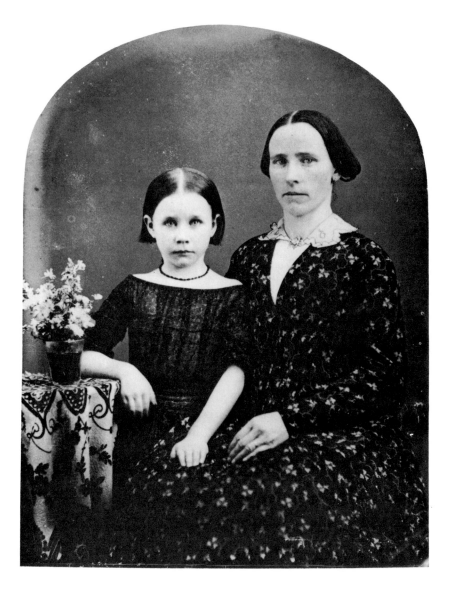

*Little girl leaning on a table, ca.
1846. Sixth-size daguerreotype.
Artist unknown. The posing
in this charming portrait is a
prototype of later nineteenth-
century sentimental advertising
used by lithographers.
Rinhart Collection,
the Ohio State University,
Columbus.*

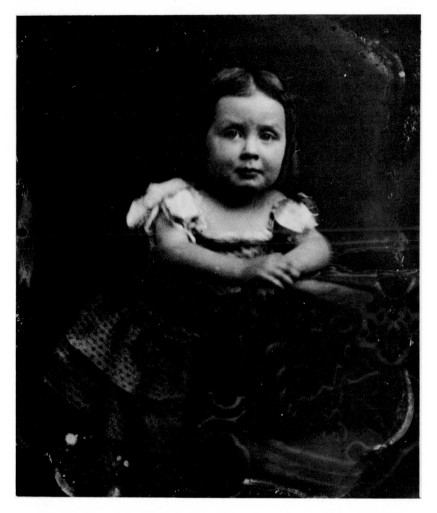

advancing into general favor; as any one may convince himself
by examining the numerous daguerreotypes exposed to public
view.[39]

When John Werge, English daguerreotypist and colorist, visited the
United States in 1851, he toured Boston and New York daguerreotype
studios, and he later wrote of his experiences. While visiting John
Whipple's gallery in Boston, Werge was impressed with the paper
photography (crystallotypes) patented and pioneered by Whipple from
his 1849 patent for using glass negatives to produce paper prints. Writ-
ing of the artists' use of reflecting photographic images upon canvas,
Werge commented:

> Long before the 'ambrotype' days, pictures were taken on glass,
> and thrown upon canvas by means of the oxyhydrogen light, for
> the benefit of artists, who sketched the proportions of the sub-
> ject from the shadow on the canvas, and painted from the
> photograph, filling in the light and shade at their leisure in their
> studios.[40]

After collodion wet-plate photography came to America in the early
1850s, the practice of copying daguerreotypes on glass plates became

even more common; a solar camera, which was used extensively in the 1850s for enlarging, reflected the image life-size onto canvas, to be painted in oil.

In at least one instance, daguerreotypists hired artists to paint these reflected daguerreotype portraits of famous men. Mathew Brady commissioned two prominent artists—John F. Neagle of Philadelphia and Henry F. Darby of Washington, D.C.—to paint canvases of Daniel Webster, John Calhoun, and Henry Clay. The Webster portrait was done by Neagle, Calhoun and Clay by Darby, and the portraits were later purchased by the Joint Committee on the Library on February 23, 1881.[41] When writing the Joint Committee, Brady related the circumstances of the original sittings:

> Clay's picture was taken in City of New York, during the winter of 1849. . . . I made five different sittings on this occasion. In Washington in 1850 I made another sitting and Darby made his study at the same time for the oil painting. Calhoun visited my gallery in Washington in the year 1849 during the month of

Girl with book, ca. 1858.
Sixth-size daguerreotype.
Artist unknown.
The pose, the simplicity of the costume, the elegance of the chair with its subdued design, the open book, and the precise yet soft focus make this a superb example of the daguerreian art.
Rinhart Collection,
the Ohio State University,
Columbus.

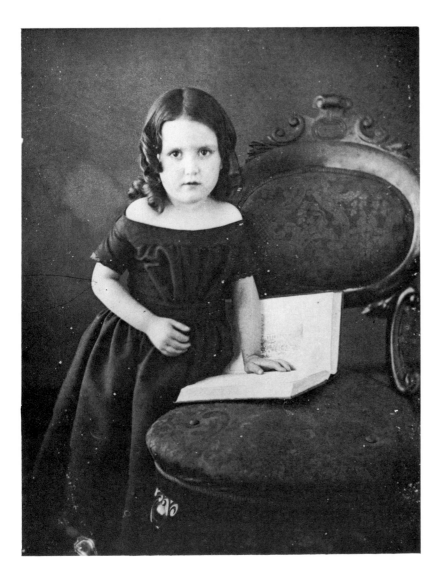

March and April . . . the same artist, Darby, made his study for the paintings. Webster visited my gallery in June 1849 . . . Five different sittings at the same time. The material no longer exists to produce these portraits with such lifelike fidelity and accuracy.[42]

These life-size portraits became very popular in the 1850s. Such works of art sometimes cost hundreds of dollars, and they gave substantial employment to many accomplished artists and prestige to the famous Broadway galleries of Brady, Gurney, Fredericks, and others.

During the era of the daguerreotype, advertisements by daguerreotypists almost always included a service for photocopying paintings, engravings, and statuary. Almost all collections of any size which contain daguerreotypes have one or more art copies, a fact which would seem to indicate that this service was popular with the general public. Perhaps it provided a kind of insurance for those who owned valuable paintings or other works of art. Another speculation might be that many of the portrait paintings copied were of ancestors, and owning a copy would provide a keepsake for relatives interested in family genealogy.

In the centuries before photography, the camera obscura was used as an aid to painters for landscape and figure painting. The artists of the 1850s made extensive use of the solar camera or other reflecting and magnifying devices to enlarge copies of daguerreotypes or other photographs onto canvas. A visit to any art gallery displaying American paintings of the 1840 to 1860 era, or a perusal through American art books will dispel any doubt that the daguerreotype influenced art as well as being directed by traditional art.

The great impact of the daguerreotype upon artists is seen, for example, in Erastus Salisbury Field's work, which shows the new art's influence in the posing of subjects and in the overall composition of portraits. A later painting of a young woman of the 1870s, by Jesse Bolles of Charleston, shows an affinity to the posing and the light and shadow effects of many daguerreotype portraits of the 1840 to 1860 period. The major influence of the daguerreotype's realism, correct proportions, and individual and stylized lighting techniques continued well into the latter part of the nineteenth century and, perhaps, beyond.

10. ART AND THE PORTRAIT

A native school of photography became established after portraiture gained acceptance with the public—practitioners of the art often called themselves daguerreian artists and their creations were termed daguerreian art. (Some daguerreotypists preferred to spell the word "daguerrian" and others adopted "daguerrean," thus giving the art a variety of spellings in the advertisements and literature of the era.)

A traditional influence from art was present in the work of many daguerreotypists in the lighting, posing, and composition of their creations. Although the daguerreotype was a precise and realistic image, it could nevertheless be constructed in much the same manner that the artist used when painting a canvas. The careful selection of the plate, the creative use of the camera, the choice of certain chemicals, and an overall fine craftsmanship produced a daguerreotype with much more than a realistic image in its finished state; a finely done daguerreotype displayed a beautiful blending of light, shading, and color. A daguerreian artist had to be flexible in his talents; he not only needed an artist's eye for composition but, of utmost importance, he had to be an able chemist and improviser.

In 1852, Gabriel Harrison, a landscape and portrait painter, actor, and pioneer daguerreotypist after 1841, published an article in which he compared the artist and the daguerreotypist with his camera:

> The painter draws with his pencil while the daguerreian draws with the camera, and each instrument in unartistic hands will undoubtedly produce abortions; for if the painter is without the knowledge of the general rules of perspective we may expect faulty productions with their distorted proportions and bad lines, no matter how good the coloring may be or how effective the arrangement of lights and shade, and it will be disagreeable to look upon. The same rule holds good in daguerreotyping. . . . Another evidence of the relativeness of photography and pure art is, that the operator must observe all of the identical rules necessary of the production of a work of merit that a painter or sculptor would follow to secure graceful position, proper distribution and degrees of light and shade, also tone of picture, arrangement of drapery, etc.[1]

With portrait and miniature painters influencing the new art, traditional art and the daguerreotype interacted. The daguerreian artists gathered ideas for their work by studying paintings by the old masters as well as contemporary paintings, both European and American. The charming simplicity of American primitive art exerted a powerful influence during the daguerreian era, especially in its first decade. During the 1850s, photography followed the general trend of the country away from simplicity: a study of daguerreotypes taken in the 1840s compared with those taken in the 1850s will reveal this trend toward a

Nude baby, ca. 1854.
Ninth-size daguerreotype.
Artist unknown.
A rare example of a nude baby

photographed in the era of the
daguerreotype. The light and
shadow of the baby's body
against a background of lively

printed fabric make a master-
piece of photographic design.
Courtesy of George R. Rinhart.

Two little girls, one holding a spool doll, the other a book, ca. 1849. Sixth-size daguerreotype. Artist unknown. The simplicity of the pose and the treatment of the subjects, in folk tradition, are reminiscent of American primitive painting. Anonymous collection.

more formal portrait—more elaborate costuming, more color, new background techniques, and more elegant studio accessories.

In reviewing the artist-daguerreotypists of 1840 to 1860, it will be found that their inventive talents later existed among the famous photosecessionists at the turn of the century—among those artist-photographers who were determined that photography take its place in the fine arts.

The importance of art techniques in creating fine daguerreotypes was brought to the public's notice in T. S. Arthur's "The Daguerreotypist," published in 1849 after he had visited Marcus Root's well-appointed Philadelphia gallery:

> It is often a matter of surprise to some that two portraits of the same person by different Daguerreotypists should appear so unlike, it being supposed, at first thought, that nothing more than mechanical skill was required in the individual managing the instrument, and that it was only necessary for the image of the face to enter the lens and impress itself upon the chemically prepared plate, to have a correct likeness; but this is an error. Unless the daguerreotypist be an artist; or have the educated eye of an artist, he cannot take good pictures, except by the

merest accident; for, unless the sitter be so placed as to throw the shadow on his face in a certain relation to his prominent features, a distortion will appear, and the picture, therefore, fail to give satisfaction. The painter can soften the shadows on the face of his sitter as to make them only serve the purpose for which he uses them, but the Daguerreotype exercises no discrimination, and reflects the sitter just as he present himself. It was owing to bad positions and bad management of light that the earlier Daguerreotypists made such strange-looking pictures of faces, one side of which would be in dark shadow and the other a white surface, in which features were scarcely distinguishable. But great improvements have taken place, and some establishments are turning out pictures of remarkable beauty and excellence. In order to obtain a good picture, it is necessary to go to a Daguerreotypist who has the eye and taste of an artist, or who employs such a person in his establishment; and it is also necessary to dress in colors that do not reflect too much light. For a lady, a good dress is of some dark or figured material. White,

Seated woman with frilly bonnet, ca. 1851. Sixth-size daguerreotype. By Chauncey Barnes. A rare specimen showing Barnes' work. The dark background is in sharp contrast to the light costume, giving a three-dimensional effect. The hands are gracefully posed, and all studio accessories have been omitted to direct full attention to the elaborate costume.
Anonymous collection.

pink or light blue must be avoided. Lace work, or a scarf or shawl sometimes adds much to the beauty of the picture. A gentleman should wear a dark vest and cravat. For children, a plaid or dark-striped or figured dress is preferred by most Daguerreotypists. Light dresses are in all cases to be avoided.[2]

LIGHTING

Lighting was as important to the daguerreian artist as to the painter. To produce fine portraits indoors, it was essential that the photographer's studio be equipped with a large skylight. Lacking this, as would be the case if a daguerreotypist were called to a residence or a public building to take a portrait, he would need a room with a large window having, preferably, a northwest exposure. When a window was used for light, the rays were reflected by a white curtain or by mirrors in such a way as to accentuate the shaded side of the sitter's face. Da-

Girl with doll, ca. 1853.
Sixth-size daguerreotype.
Artist unknown.
A superb example of balanced
light and shade which brings out
the character of the sitter.
Courtesy of George R. Rinhart.

guerreian artists devised many ways of using light in conjunction with various colors of curtains—blue was a favorite—to create the light and shade effects desired in their finished portraits.

In searching for proper lighting techniques, many daguerreotypists were guided by existing works of art, and, of course, the city daguerreotypist had the advantage of being near changing art exhibitions. Rembrandt's paintings, for example, with backgrounds of warm brown and gray tones, brought the face into bold relief; his handling of light and shadow, his sparing highlights, made excellent models for the daguerreian artist. Many existing daguerreotypes show this influence in their dramatic effects of light and shade, and the subjects are often brought out with startling intensity. On the other hand, daguerreotypes taken by the quick-profit operators indicate a lack of study of lighting.

Most successful daguerreotypists followed art precepts with their lighting techniques. The daguerreian artists Southworth and Hawes of Boston became masters of lighting, using three qualities of light—diffused, direct, and reflected—in their portrait photography. Southworth liked to reminisce in later years about his first attic skylight, built in 1842: "It was a hard light to work in but I could make just as good pictures with it as in any light I ever saw."[3] The partners placed their sitters so that they could circle around them with their camera, thus capturing certain light or shadow effects on the face or other lines desirable for the total composition;[4] they believed in having as much diffused light on the face as the eye could bear in comfort. In addition to the adjustment of the skylight, sidelights were employed as needed for the desired shadow effects.

Daguerreotypists employed certain lighting techniques to meet particular situations. If the sitter had blue eyes, they were shadowed to strengthen their tone (on some daguerreotypes, the eyes lack tone). The hands also posed a problem: they sometimes appeared too light in the finished daguerreotype, especially in seated portraits. To overcome this difficulty, a vertical light (higher than the head) was effective. As for dark-skinned sitters, it was best to place them in a very diffuse light (coming in from all sides) for the least possible shade—when the light was too direct, the harmony between light and shade was lost.[5] George Harrison Hite, a popular portrait and miniature painter working in New York City, advised daguerreotypists that deep shadows under the brow, though rich and strongly marked, must be transparent in the daguerreotype: "Delicate features—women and children—require a treatment as delicate . . . enough shadow must, however, be introduced to preserve the roundness, and render expressive every sweet and tender undulation."[6]

Mirrors and screens were found from the beginnings of photography to be very effective in the distribution of light and shadow. Alexander Hesler, a master daguerreotypist of Illinois, used a mirror hung on a screen for reflection and for balancing the light on the subject. He wrote of lighting: "By it we live, move and have our being as daguerreotypists."[7] Artistic lighting brought out the "beautiful eye," and the shaded areas often revealed the elusive character of the sitter. The artist-photographer had an almost unlimited opportunity to put his ideas to work in the play of light and shade and to create an illusion of space in his portrait—a three-dimensional feeling. The judicious use of

Daniel Webster (1782–1852), 1851. Whole-plate daguerreotype. By Southworth and Hawes. This daguerreotype shows the masterful lighting techniques used by Southworth and Hawes. Note the play of light about the face, the understated hands, and the faint vertical lines of the column in the background.
The Metropolitan Museum of Art, gift of I. N. Phelps Stokes, Edward S. Hawes, Alice Mary Hawes, Marion Augusta Hawes, 1937.

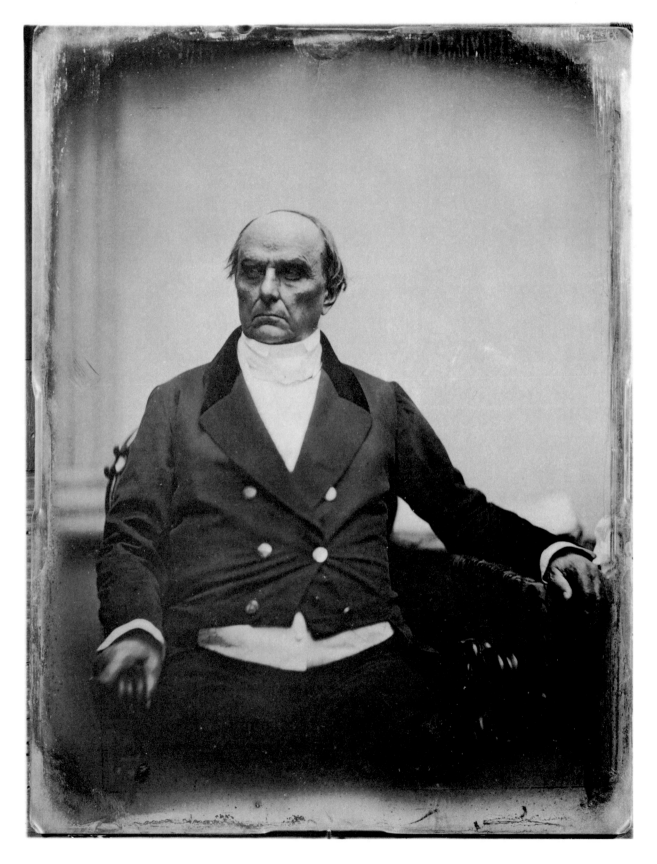

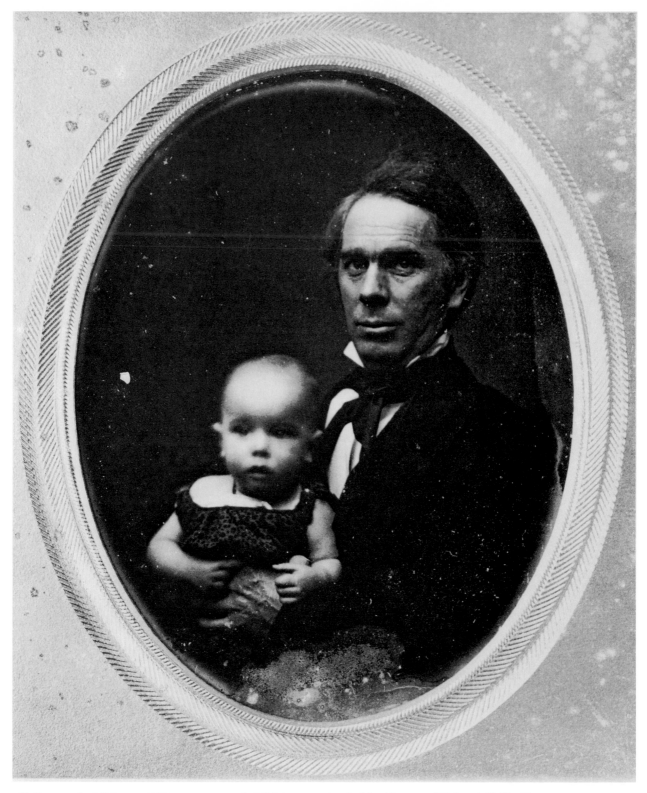

Father and child, ca. 1855. Sixth-size daguerreotype. Artist unknown. The interesting play of light and shade on the faces of the father and child is accentuated by the dark tones of their clothing. The baby's forehead has too much light, but light and shadow bring out the tiny hand.

Rinhart Collection, the Ohio State University, Columbus.

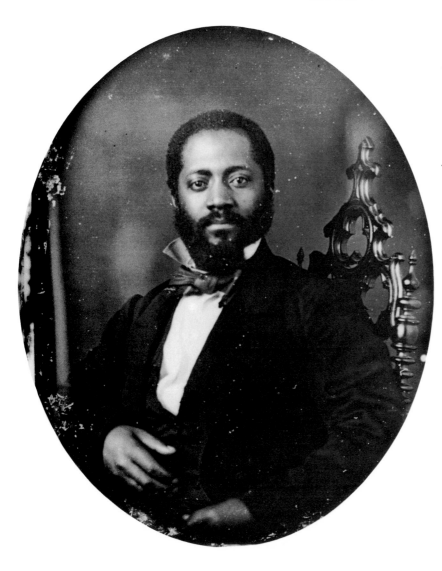

light in the portrait helped suppress or subdue unimportant details of drapery or background that might detract from the subject and thus weaken the overall effect of the composition.

BACKGROUNDS

When the daguerreotypist set the stage for the creation of a portrait, the background was carefully considered in relation to the total composition. Viewing daguerreotype collections, one is surprised to see just how many ingenious methods were developed during the 1840 to 1860 era to vary background effects.

During the very early 1840s, before skylights were installed in galleries, the outdoors provided an artistic setting. A body of water in the background or a scene with an illusion of space was especially effective, sometimes giving the effect of a mezzotint or a painting. It might be assumed also that some of the early itinerants, and even later artists, used the outdoor scenic background not only to make interesting portraits but to reduce their exposure time.

Just when American daguerreotypists first used painted scenic backgrounds is not known, but England's Claudet used scenic backgrounds at the Adelaide Gallery in London in the spring of 1842, according to an article published in *Chambers' Edinburgh Journal* on May 28:

> The addition of a background of trees, architecture, or a library, takes away from the metallic effect of the plate, and gives to the miniature the appearance of an exquisitely finished mezzotint engraving seen through the wrong end of an opera-glass. This addition is made by simply placing a scene, painted in distemper in neutral tint, behind the sitter.

If created and used with taste and skill, a painted landscape background or mural behind the sitter could give the finished portrait the effect of a painting. An illusion of space was needed behind the sitter; otherwise the background was out of proportion to the subject. Some

Seated man, ca. 1858. Sixth-size daguerreotype. By Alexander Hesler. The character of this subject is brought out by Hesler, who had a reputation for being a master of lighting techniques. Rinhart Collection, the Ohio State University, Columbus.

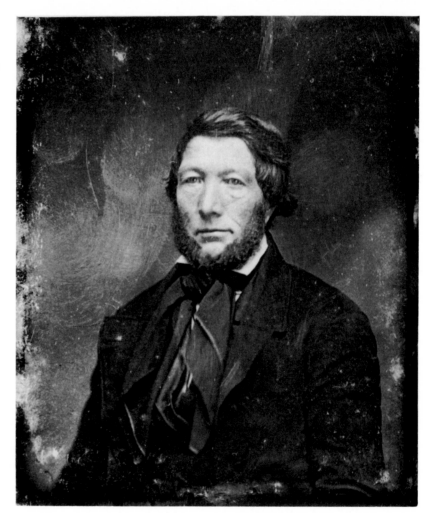

extant daguerreotypes show the background too close to the sitter, thus spoiling the effect of the total composition.

Levi Hill, writing of backgrounds in 1850, said that the folded drapery and landscapes once in vogue should be discarded for a more artistic background:

> A plain, dark ground to a daguerreotype, such as are seen in rich steel engravings, is certainly preferable to all others. This may be produced in various ways. Where there is plenty of room behind the window, ordinary buff flannel answers well. Rose blankets, on account of their fuzzy surface are excellent. If they are wanted darker, they may be sprinkled over with lampblack and water, by means of a short broom, in a manner similar to that used by bookbinders in sprinkling the edge of books, Canvass or muslin, painted a dead color may be used. A mixture of the paint, in milk and water, to which a little glue is added,

Advertisement from the Illinois state directory, 1854.

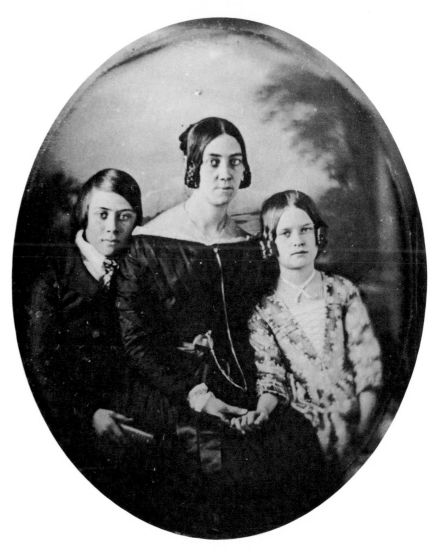

should be applied evenly over the whole surface. Yellow ochre, with a little red-lead, forms an orange tint, which comes out a good slate color. Black and white paint form a grey, which works well. An artist should take great pains to prepare a background of just the right tint. One of the best we ever saw was made of what is called 'sheep's grey' cloth.[8]

Most daguerreotypists preferred to place a movable cloth-covered frame behind the sitter which concentrated the light rays for the desired background tone of the portrait—the frames, usually six to twelve feet long and six to eight feet high, were supported by posts at the end. A "chromatic background" consisted of two wooden frames, one covered with light yellow canvas or cloth, sometimes perforated; perpendicular to the floor, the lower part of this frame was attached to another, smaller frame with hinges rising at an angle of forty-four degrees. This part of the frame was covered with a piece of black or brown lace.[9]

The color or texture of the background varied according to the judgment of the individual photographer or his artist assistant. Rough blanket backgrounds, used by itinerant daguerreotypists, gave a primitive appearance to the portrait. Seams and wrinkles are seen in many existing specimens, whereas those done by known studio daguerreotypists usually show more sophisticated background techniques.

VIGNETTE BACKGROUNDS

The quest for a background which would cut the glare from the mirror-like finish of the daguerreotype had begun early in the art with various gilding techniques. In 1849 both John Whipple and Jesse Whitehurst set a vogue for backgrounds which would make the daguerreotype image stand out boldly with the effect of a crayon drawing. The gradual blending of the subject with the background, giving a bust effect, was achieved on the daguerreotype plate by the manipulation of screens or other apparatus between the camera and the sitter during exposure.

Whipple was issued a patent on January 23, 1849, for his vignette invention.[10] His premise was basically simple—during the process of

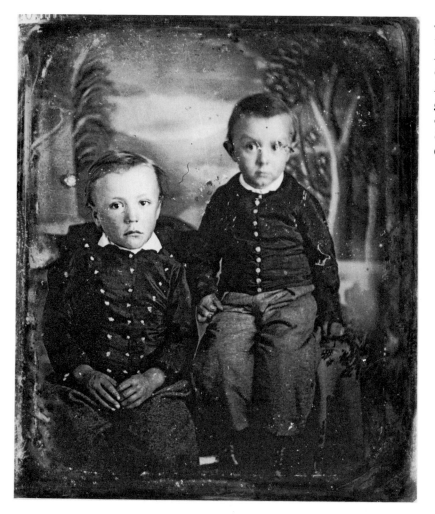

John Morrison and Tell Coleman Curtis, September 6, 1857, Lexington, Missouri. Sixth-size daguerreotype. Artist unknown. By introducing a wooded background, the artist has given this expressive portrait a feeling of boyhood.
Courtesy of George R. Rinhart.

Mother and child, ca. 1853.
Sixth-size daguerreotype.
Artist unknown.
A lively interplay of design in
the costumes and the river and
forest background creates an un-
usual portrait.
Anonymous collection.

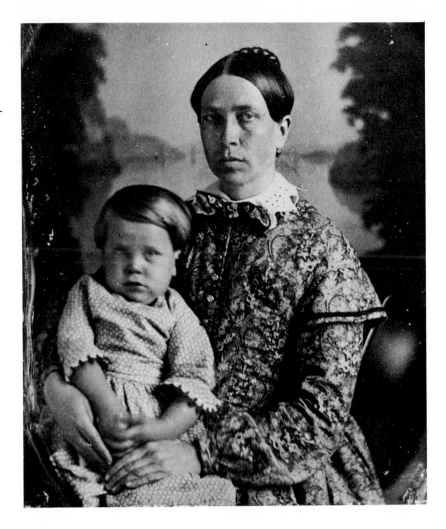

photographing, a light screen was placed to the rear of the subject. At the same time, a darker screen—having an aperture cut somewhat larger than the sitter's face—was gently moved up and down, sideways, and in various other directions to prevent any defined outline of the aperture from being formed on the picture.[11] Marcus Root quickly acted to secure the agency for Whipple's patent in all states except those of New England, and his advertisements for Marcus and Samuel Root, his brother, always referred to the "crayon daguerreotypes" taken in their Philadelphia and New York galleries.[12]

Samuel Humphrey, writing about crayon daguerreotypes in his 1853 *American Handbook of the Daguerreotype* described mechanical devices which differed from those in Whipple's patent. Although the method was much the same, he told how to make a screen by putting a piece of thin paper, scalloped into a semicircle, into motion when the subject or object was exposed in the camera—the device being kept straight with a wire frame. Another method, apparently a popular one, employed a wheel with a twelve-inch hole cut to resemble the teeth of a large saw. When the wheel was set in motion between the camera and the sitter, the sawtooth effect caused a blur on the outer edge of the portrait. The side of the wheel facing the sitter was usually painted black, giving a dark border rather than a light one.

Two girls, ca. 1850.
Sixth-size daguerreotype.
Artist unknown.
An unusual fringed-background
treatment, probably used by an
itinerant daguerreotypist.
Rinhart Collection,
the Ohio State University,
Columbus.

A method of producing a bust or vignette style similar to but more sharply defined than Whipple's invention was patented by Charles J. Anthony of Pittsburgh, a daguerreotypist who had practiced in Portland, Maine, in 1846 and in Providence, Rhode Island, in 1847.[13] The process, patented on January 1, 1851, and picturesquely named the "Magic Background," used the camera or darkroom to achieve its ends.[14] The process was actually used before the final patent was issued—Schoonmaker and Morrison, successors to the Meade Brothers, advertised in the *Albany Daily Knickerbocker* on November 15, 1850, that their firm was "the only establishment north of New York that has the right to take daguerreotypes with the Patent Magic Background— an improvement that this establishment has just taken the first premium for at the New York American Institute."[15] In May of 1850, the *Scientific American* noted that Anthony could provide any kind of background: "Light, dark or imitation sky, or draperied canopy. One sample we saw had a background in imitation of pearly, with picture in full relief." In June of 1851, Anthony's process was advertised in *The Daguerreian Journal*—Levi Chapman offered the patent rights for twenty-five dollars.

The "Magic Background" was relatively simple in principle. The daguerreotype plate, sensitized and prepared in the usual manner, was

Woman and little girl with doll, ca. 1848. Sixth-size daguerreotype. Artist unknown. An unusual mottled background, possibly used by an itinerant daguerreotypist.
Courtesy of George R. Rinhart.

then placed in a camera and exposed as usual. To achieve the magical effect, a rectangular piece of glass was inserted in the camera in front of the daguerreotype plate (after it had been exposed). This inserted plate had a center patch of dark or black paper, shaped to whatever fancy desired. From the center patch a series, usually of four semitransparent papers, each patterned in the same shape as the patch and each having a larger opening than its predecessor, was layered on the glass. This arrangement—used if a light background had been employed during the first exposure—would produce a halo of light from behind the subject. A dark studio background would require that the papers be applied in inverse order.

The length of time for the second exposure in the camera varied from five to fifteen seconds, depending on the effect desired by the daguerreotypist. After this second exposure, the plate was now ready

Woman in bonnet and paisley shawl, ca. 1848. Quarter-size daguerreotype. By Samuel L. Carleton. A well-composed daguerreotype with excellent lighting on the face and costume. Note the small reflecting mirror on the upright spindle.
Anonymous collection.

Girl with freckles, ca. 1846.
Sixth-size daguerreotype.
Artist unknown.
The background shows an im-
promptu arrangement often used
by itinerants—a blanket or sheet
of a color which would give a
neutral tone to the portrait.
Rinhart Collection,
the Ohio State University,
Columbus.

for the darkroom, where it was put through the usual mercury and gilding processes. By the use of the galvanic battery and, usually, a solution of cyanide of gold, or whatever chemical was selected, a tint of the desired effect was produced in the final gilding.

Perhaps the most popular vignette process was invented by Henry E. Insley, a practicing daguerreotypist after 1840—his invention for illuminated daguerreotypes was patented on January 6, 1852.[16] Again, the process was used and known before the patent became final: Insley had written the patent office on August 29, 1851, that the American Institute had awarded him a silver medal for his illuminated daguerreotypes.

Insley's method involved taking a daguerreotype in the usual manner, using a white background; then a special frame was used when the plate was exposed to the vapors of mercury. The bottom part of the

frame was a mat or "contractor" cut into a round, oval, rectangular, or other form. A thin border (probably of wood) acted as a spacer and held the daguerreotype plate three-sixteenths of an inch above the contractor. When the frame holding the daguerreotype was placed over the mercury bath, the vapors of mercury passed freely onto the center of the plate but gradually diminished toward the outer edges, thus producing various tints and giving strength and relief to the image.[17] Insley claimed in his patent that his illuminated daguerreotypes produced "an image of greater boldness in relief, at the same time casting a halo of various tints around the image, blending in the dark or black outer edge."[18]

In March of 1852, Alexander Hesler, always an experimenter, wrote *The Photographic Art Journal* about his new style of picture, which was actually a variation on the popular vignette daguerreotype.[19]

Seated girl, ca. 1852.
Sixth-size daguerreotype.
Artist unknown.
An interesting example of a
landscape mural being placed
too close to the subject.
Anonymous collection.

Vignette of Richard M. Hoe, ca.
1852. Sixth-size daguerreotype.
Artist unknown. The oval outer
halo on the original daguerreo-
type is blue, as described in
Charles Anthony's "Magic Back-
ground" patent. The light seems
to come from behind the subject,
giving the portrait a three-
dimensional feeling.
Rinhart Collection,
the Ohio State University,
Columbus.

Patent drawing for a vignetting
process using a mercury bath.
H. E. Insley, January 6, 1852.

Hesler's method was somewhat similar to Whipple's—he used a paste-board cutout inside the camera and a large sheet of pasteboard be-tween the sitter and the camera, with the background being kept in motion. The sitting was slightly longer and the daguerreotype plate was "mercurialized" about one-half or three-fourths longer than usual. The *Galena Advertiser* wrote of these vignettes: "The pictures now appear with the same soft, clear back ground, but the line of back ground is broken by a circle of rays in which is exhibited *all the tints of the rainbow,* in regular prismatic succession. This invention lends an additional charm to the portraits of ladies and children."

The William Yarnall method of vignette-style portraits, called "chromo-photographic painting" or the "prismatic daguerreotyping process," was patented on December 28, 1852.[20]

Yarnall went back to a basic premise—that of controlling photo-sensitizing by the layering of iodine, bromine, or other accelerating agents in the preparation of the daguerreotype plate. The invention used a plate holder with a number of pattern slides of graduated sizes. Yarnall suggested that the shape of the central opening be the same as that of the framing mat selected for the final casing of the portrait. On

Vignette of seamstress holding scissors, 1854. Sixth-size daguerreotype. Artist unknown. A rare occupational portrait done in the Anthony "Magic Background" vignette process. This example shows one of the many shapes produced according to the whim of the sitter.
Anonymous collection.

the rear of the holder was a locking cover used to keep the daguerreotype plate to the back of the pattern slide.

Yarnall prepared his plate over a coating box in the dark closet. After the daguerreotype had been placed in the holder with the slide having the smallest pattern opening, it was held over the diffused fumes of iodine or other chemical agents. After this first coating, another slide with a larger center opening was inserted in the holder, and the plate was then exposed to the fumes of bromine or other accelerating agents. Next a third slide, with an even larger opening, was held over iodine fumes once again, and finally a fourth slide could be used if desired. The plate was now ready for exposure in the camera. The required effect was not produced in full until the plate was withdrawn from the camera and developed over the mercury bath, which brought out the "various borders or ornamental circles." Yarnall's patent stated that this method would produce a clear, fully developed, well-defined sharp circle, design, or border to highlight the image.[21] However, the prismatic process does not appear to have been advertised or widely used among daguerreotypists.

The last of the ornamental or bust-type backgrounds was patented

*Nathaniel H. Morgan of
Hartford, ca. 1852. Quarter-size
daguerreotype. Artist unknown.
An unusual example of a crayon
portrait having a soft green back-
ground, probably brought out by
the Henry Insley vignette method
or a similar process which used
mercury to produce the color.
Rinhart Collection,
the Ohio State University,
Columbus.*

by James Sidney Brown, a painter, engraver, and successful daguerre-
otypist, on November 15, 1853.[22] Brown employed a diaphragm, with a
suitable opening, placed in front of the sitter "for the purpose of pro-
ducing a portrait or picture, with an appropriate or tasteful ornamen-
tal border, either with or without the name of the person or subject,
and the name of the artist."[23]

ACCESSORIES

From the earliest days of daguerreotyping, patrons were seated by a
table covered with a decorative cloth. This tablecloth, more than any
other accessory, was important to the daguerreotypist's composition—
its designs and graceful folds imparted lines and curves and gave a
lively feeling to an oftentimes dull portrait. A few daguerreotypists
posed their patrons by a bare table, but this does not seem to have
been the usual practice.

An object was sometimes placed on the table—a simple vase of
flowers or a book, for example. Mathew Brady, in his early days as a
daguerreotypist, placed a simple Grecian urn on the table—a very
effective accessory that embellished an otherwise plain portrait.

Patent drawing for a vignetting process used for the prismatic daguerreotype. W. Yarnell, December 28, 1852.

Vignette of a young man, ca. 1856.
Ninth-size daguerreotype.
By George M. Howe.
An interesting background effect probably produced by the Yarnall method or a similar type of vignetting.
Rinhart Collection, the Ohio State University, Columbus.

Woman holding daguerreotype case, ca. 1855. Sixth-size daguerreotype. Artist unknown. The book on the table and the elaborate mother-of-pearl case in the sitter's hand are typical accessories used in the daguerreian gallery. Note the bottom edge of the background frame and a protruding leg of the headrest. Anonymous collection.

Girl with hair ribbon, ca. 1848. Boy with book, ca. 1848. Sixth-size daguerreotypes. Artist unknown. These portraits, probably taken on the same day, illustrate the use of accessories in the daguerreian gallery. Courtesy of George Moss.

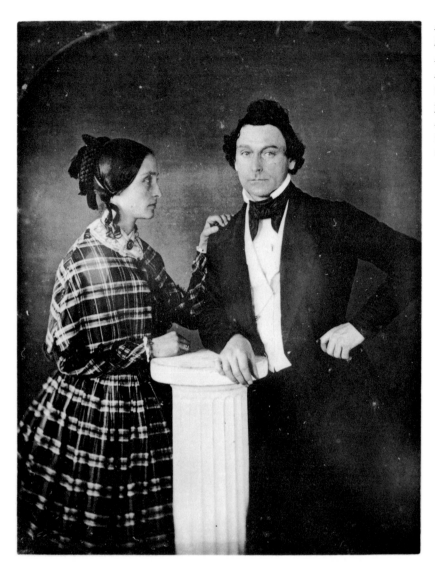

Portrait by the pedestal, ca. 1848.
Sixth-size daguerreotype.
By Nathaniel C. Jaquith.
An unusual allegorical pose with
the pedestal adding drama to the
portrait.
Rinhart Collection,
the Ohio State University,
Columbus.

In composing his portraits, the daguerreian artist often used symbolic objects, long used by painters, to identify the personality of his sitters—an open book, flowers in hand, a pet cat or dog, a hobbyhorse, a cane or riding whip, musical instruments—the list is long. The Roman pedestals and Grecian columns, made of cast iron, occasionally used as accessories gave vertical lines and classical feeling to the composition.

Two design patents for pedestals suitable for the photographic trade were issued in 1851 and 1852. The first, issued to Wm. and Wm. H. Lewis of New York City on March 25, 1851,[24] was described in the patent as a fluted shaft with the top part having bunches of leaves, surmounted by egg-shaped ornaments. The second design patent was issued to Thomas Law of New York City on November 9, 1852.[25] Law's pedestal and column could be attached together or could be used separately as a camera stand or headrest. The design featured the human face in alto-relievo, and scrolls of grapes and leaves ornamented the base. The patent was assigned to Levi Chapman.

BEFORE THE CAMERA

A successful daguerreian artist spared nothing to give his patrons a luxurious and restful atmosphere—surroundings complete with comfortable chairs, sofas, rich carpets, paintings, sculpture, displays of beautiful daguerreotypes, music, and sometimes educational exhibits. Edward Dodge, the popular artist and daguerreotypist of Augusta, offered his patrons a tastefully furnished parlor with an elegant piano. Andrew Van Alstin of Worcester displayed many mounted specimens of foreign birds gathered during a trip around the world.

In the great city galleries a pleasant atmosphere helped put the sitter at ease before the actual taking of the portrait—and this was considered essential for taking a good likeness. In an article written in 1852 for *The Photographic Art Journal*, Gabriel Harrison advised daguerreotypists how to obtain fine likenesses:

> The ultimatum looked for in a daguerreotype of a person is a strong likeness, and the proper position of the camera for such a result is to have the centre of the lens precisely opposite to the centre of the face at the same time taking care to have the position of the head as near plumb as possible, and if the glasses are purely achromatic, the proper degree of reach and field, the likeness must be perfect. For instance, place the centre of the lens as high as the top of the head, and so as to get the face to come into the proper place on the plate by pitching the tube downward: and, behold, the imperfect likeness that will be produced; the top side of the lens beyond the centre being nearest to the forehead, that part of the face will undoubtedly be the largest and most disproportional to the nose, mouth and chin.[26]

George Harrison Hite was of the opinion that the sitter, looking downward, should be about three yards from the camera. Also, for a three-quarter pose, he said that the eye nearest the camera should be in the middle of the breadth of the daguerreotype plate and that the size of the plate used must be considered for proportion according to the subject.[27]

The experienced daguerreotypist knew how to use his camera to achieve flattering images. Whereas artists painted their sitters to best advantage by removing undesirable blemishes and molding the features to a more pleasing aspect, the daguerreotypist, by raising and depressing his camera, could proportion the features for the desired effect. If a sitter's forehead were broad and high and his lower face thin, the camera was placed slightly lower than the chin and the head was positioned a little forward. If the head were small and the face full and heavy, the camera was elevated while the head and body were brought slightly forward. An eye defect was overcome by directing the eyes toward an object in the opposite quarter. Freckles, often a problem, were later overcome by rubbing the face until very red, thus lessening the contrast; with the photographic intensity about equal, a clear-seeming complexion could be achieved.[28]

Abraham Bogardus, the famous Broadway daguerreotypist, later wrote of stout sitters wanting to look thin and thin people wishing to look round and those with small eyes demanding large ones. Bogardus gave no indication that he used deception in taking his portraits to sat-

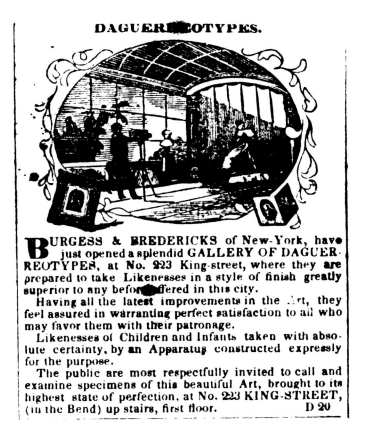

DAGUERREOTYPES.

BURGESS & BREDERICKS of New-York, have just opened a splendid GALLERY OF DAGUER-REOTYPES, at No. 223 King-street, where they are prepared to take Likenesses in a style of finish greatly superior to any before offered in this city.

Having all the latest improvements in the Art, they feel assured in warranting perfect satisfaction to all who may favor them with their patronage.

Likenesses of Children and Infants taken with abso-lute certainty, by an Apparatus constructed expressly for the purpose.

The public are most respectfully invited to call and examine specimens of this beautiful Art, brought to its highest state of perfection, at No. 223 KING-STREET, (in the Bend) up stairs, first floor. D 20

Advertisement from the Charleston Courier, *January 1, 1852.*

isfy his sitters, but he did say that he kept sticking wax on hand to keep ears from standing out and wads of cotton called "plumpers" to fill out hollow cheeks![29] Many sitters complained that their hands or their other features were magnified and thus greatly out of proportion to the rest of the figure. Samuel Humphrey wrote of the problems of proportion:

> As this cannot be wholly remedied . . . it is necessary to present the figure in such a position as to bring it as nearly as possible upon the same plane, by making all parts nearly at equal dis-tance from the lenses. This must be done by the sitter inclining the head and bust formed to a natural, easy position, and placing the hands closely to the body, thus preserving a proper propor-tion. . . . It is not an uncommon fault among our less experienced operators to give a front view of the face of nearly every individual . . . and this is often insisted upon by the sitter, who seems to think the truth of the picture exists principally in the eyes staring the beholder full in the face. Nothing, in many instances, can be more out of place in a Daguerreotype portrait than this, for let a man with a thin, long defeated-politician face, be represented by a directly front view, we have, to all ap-pearances, increased the width of the face to such an extent as to reveal it flat and broad. . . . The method we should adopt . . . would be to turn the face from the camera, so as to present the end of the nose equally distant from the lenses, and then focus-

sing on the corner of the eye towards the nose, we cannot in
many cases, fail to produce an image with the lips, chin, hair,
eyes and forehead in the minutest possible definition.[30]

About three-quarters of all single portraits taken by daguerreotyp-
ists were of pyramidal composition, an influence stemming from the
early Italian masters of painting. The graceful and flowing lines of the
mother holding a child are an example of this pose.

In full-length and three-quarter poses, a horizontal or vertical line
was often introduced into the composition. For example, the use of the
column and pedestal gives drama and dignity to the portrait. Titian
often introduced horizontal and vertical lines into his paintings, but
they were subdued so as not to interfere with the subject's head.
Sometimes a sharp line between light and shade gave the same effect.

From the early days of photography, group posing presented special
problems of lighting, focus, and positioning. However, these diffi-
culties did not seem to deter any practitioners of the art. The earliest
record of an itinerant daguerreotypist advertising the taking of groups
comes from an 1840 Saint Albans, Vermont, broadside: a Mr. Larra-
bee, of Boston, noted that he would take likenesses of "Family Groups,
and Companies of Twelve or more, taken at discount from usual

Woman with earrings, ca. 1853.
Sixth-size daguerreotype.
Artist unknown.
The miniature painter, George
Harrison Hite, suggested to da-
guerreotypists that the eye near-
est the camera be in the middle
of the breadth of the daguerreo-
type plate and that the plate size
be in proportion to the sitter.
Anonymous collection.

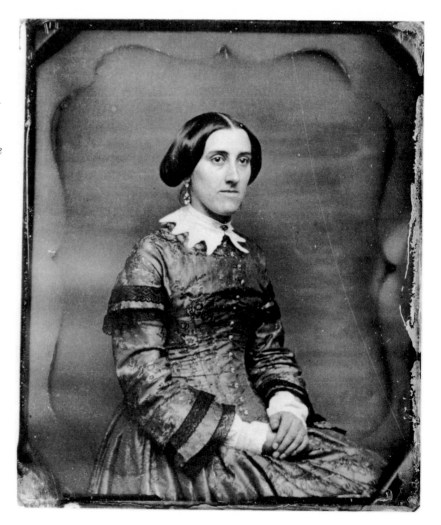

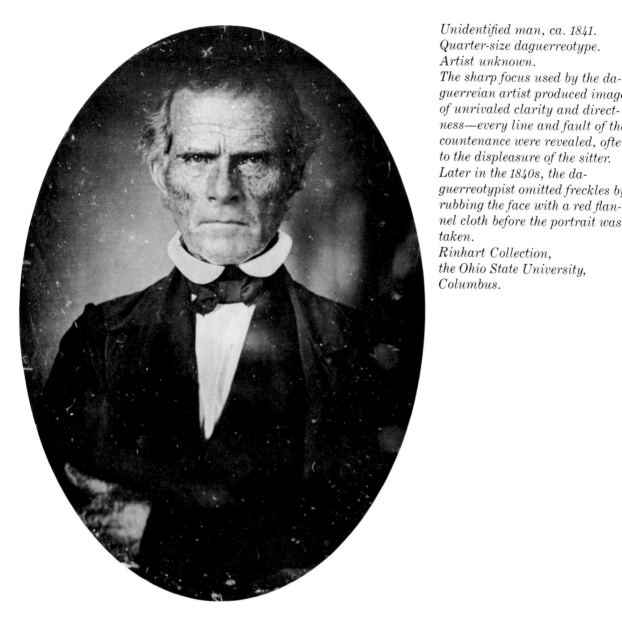

Unidentified man, ca. 1841.
Quarter-size daguerreotype.
Artist unknown.
The sharp focus used by the da-
guerreian artist produced images
of unrivaled clarity and direct-
ness—every line and fault of the
countenance were revealed, often
to the displeasure of the sitter.
Later in the 1840s, the da-
guerreotypist omitted freckles by
rubbing the face with a red flan-
nel cloth before the portrait was
taken.
Rinhart Collection,
the Ohio State University,
Columbus.

prices." However, it is possible that Larrabee may have been offering group discounts; the broadside does not make this point entirely clear. A few months later, in August, the first class reunion (Yale class of 1810) was recorded by a fellow member, Samuel Morse, in the yard north of the president's house. Two daguerreotypes were taken of the eighteen members, and the likenesses of most of those in the portrait were said to have been "distinct and good."[31]

Advertisements by daguerreotypists offering group portraits continued in the 1840s and well into the 1850s. Alexander Beckers advertised in 1844: "Portraits taken on small or large plates, of one person, or in groups of from two to six."[32] And Martin Lawrence advertised in 1853: "Family and School Groups taken without difficulty—Plates containing 20 and 30 persons all perfect, on exhibition."[33]

Very little was written, at least in America, about group posing until Henry Snelling noted in 1853 that it was impossible to give any defi-

Seated woman, ca. 1853.
Sixth-size daguerreotype.
By R. N. Keely.
The daguerreotypist has posi-
tioned his subject slightly side-
ways to give a more slender
appearance.
Anonymous collection.

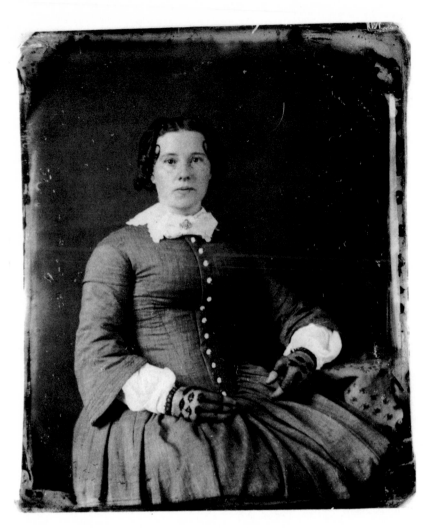

A Jenny Lind headrest. From
Humphrey's Journal, *1854.*

nite directions for forming a group composition: "So much depends upon the individual nature and conformation of the models, and upon the nature of the accessories called into requisition." Marcus Root, in his 1864 *The Camera and the Pencil,* wrote about posing groups: "Some should stand, while others should sit on stools or an ottoman, leaning lightly and with a lounging grace upon their companions; all meanwhile having some special object in view, to concentrate attention." [34] Most experts agreed that the individual artist should judge the proper arrangement of family groups, stipulating only that the persons of the group be in the same focal distance.

HEADRESTS

The use of the headrest in daguerreotype portraiture had been advocated from the beginning of the art. After Daguerre had expressed the opinion that taking portraits would be impossible because of the long exposure time, the London *Athenaeum* of August 24, 1839, suggested that a subject's head could be fixed by a supporting apparatus. On March 26, 1840, the *Boston Daily Advertiser and Patriot* published François Gouraud's method for taking portraits. Gouraud coated his

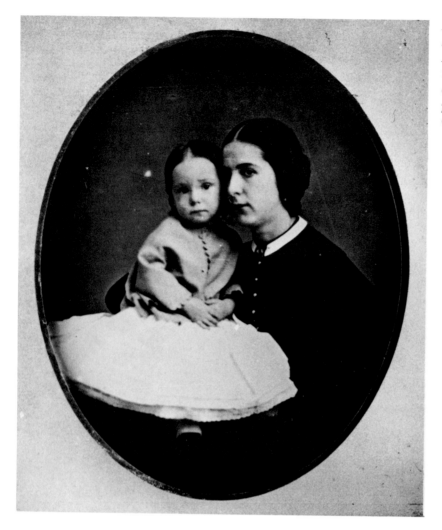

Mother and child, ca. 1860.
Sixth-size daguerreotype.
Artist unknown.
This expressive pose shows a tra-
ditional theme taken from the
paintings of the old masters.
Courtesy of Josephine Cobb.

plate well with iodine, and the sitter was then fixed into position: "His head should be placed in a semi-circle of iron, fitted to the back of the chair."

For years studio patrons considered the headrest to be an instrument of torture. The instrument had an adjustable iron ring at the end of a staff which rested on the floor or was fastened to a chair. This ring could be moved in various directions to suit the attitude of the sitter.

In his 1850 publication, Levi Hill recommended the use of the "Iron Independent Head Rest"; he wrote that it was very difficult to accommodate the "Chair Head Rest" to the position of the sitter. He also said that the "Independent Head Rest" would not create too much extra luggage for the traveling artist and, with the addition of one or two chair rests, he could be prepared to take group portraits.[35]

Many daguerreotypists did away with headrests for children, especially for boys, because the little ones were drawn to examine and play with them! Rather than being secured by a headrest, little children were often tied to the chair with a soft belt or sash. Babies were sometimes kept in place by the draped arm of the mother—her figure in the portrait being obscured by the framing mat when the daguerreotype was ready for casing.

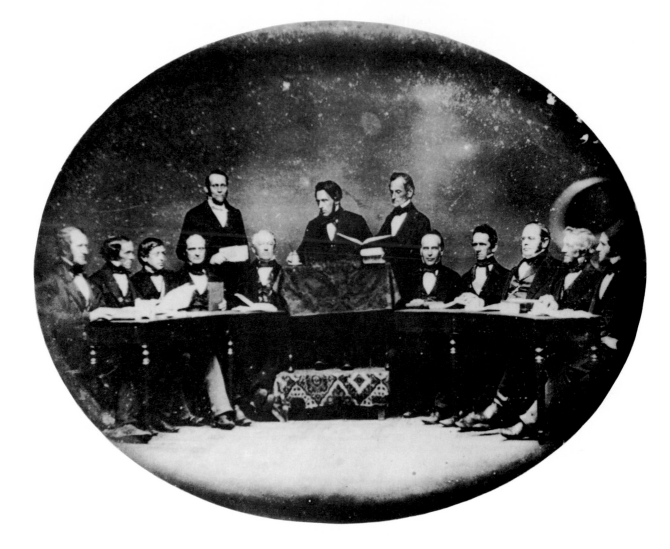

"*Governor Boutwell and his Council, 1852.*" *Whole-plate daguerreotype. By John Whipple (attributed). An impressive group portrait of thirteen men in a historical composition. George Sewall Boutwell, elected in 1851, is the central figure among other distinguished gentlemen of Massachusetts. Whipple was well known in Boston for his remarkable success in the posing of large groups.*
Courtesy of Josephine Cobb.

CHILD PORTRAITURE

The charming primitive portraits of children painted a few years before the advent of photography were revived in the portraits created by artists of the camera. Children with wistful and solemn faces were posed with charming simplicity, often holding flowers or toys.

The children of this fast-moving age before the Civil War grew up in the days when business, politics, and religion formed a man's world and children, fashion, church, and charity were the woman's domain. Children of the middle-class family were brought up with discipline and responsibility, with religion as a steadying influence. Science and scholarship, especially for boys, were stressed both at school and at home, while girls became very adept at homemaking and the arts.[36]

Photographing adults had become routine in the 1840s, but photographing children was an art in itself—a difficult task for the daguerreotypist but one financially rewarding, since a successful portrait of a child often led to innumerable sittings among family and friends. In an age when death was swift and sure, especially to children, parents felt

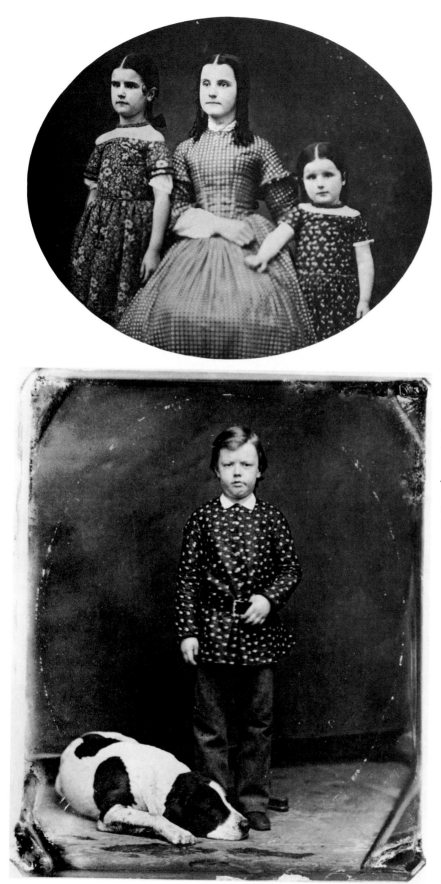

*Family portrait, ca. 1850.
Half-size daguerreotype.
Artist unknown.
The daguerreotypist has dis-
regarded all the rules for posing
this group, yet the effect is
fascinating.
Courtesy of George Moss.*

*Standing boy with dog, ca. 1859.
Sixth-size daguerreotype.
Artist unknown.
An unusual full-length pose.
Note that the foot of the headrest
is showing and the background
frame does not reach the floor.
The dog appears content to sleep
during the photographic session.
Courtesy of Josephine Cobb.*

that they must preserve the fleeting image of childhood. Many penciled notations in the rear of daguerreotype cases show this to be only too true.

In the early 1840s, the appearance of an infant in his gallery was enough to make any stouthearted daguerreotypist give up in despair. Montgomery Simons wrote of such an experience. The mother of a wee subject wanted her darling posed alone and full-length—a most trying task. The infant exercised his tiny lungs to such an extent that Simons was about to give up. Just then a large Newfoundland dog, intent on watching his young master undergo the operation, stepped up to the baby's side and "with an air of defiance sat looking me full in the face and then gently nestled his head on the child's lap." The appearance of the dog acted like magic on the little one, who threw his dimpled arm about his protector's neck. The picture of the baby and dog was natural and beautiful and the room was still and everyone was spellbound. Simons recalled: "I was afraid to stir lest I might break the charm and spoil this picture. My plate had grown sensitive by standing. With breathless silence I drew the shield and in an instant was fixed upon silver, a picture worthy of being wrought in gold."[37]

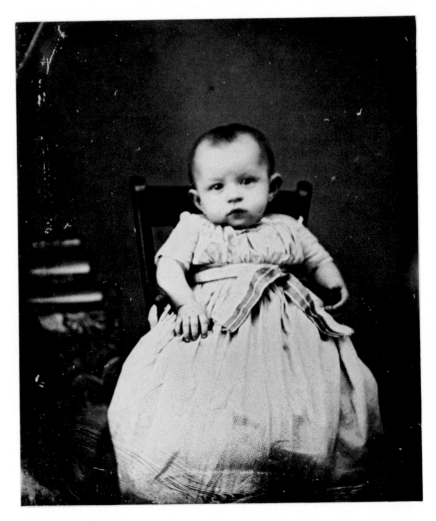

Baby in high chair, ca. 1847.
Sixth-size daguerreotype.
Artist unknown.
The daguerreotypist has secured
the baby to the back of the chair
with a decorative sash. Note the
absence of a headrest.
Courtesy of Josephine Cobb.

Daguerreotypists often advertised their special ability to take children's portraits, and it was usually noted that the hours between ten and two were best for a sitting. The primary reason for this regimented time (and also the weather) was that, the light being strongest between these hours, an instantaneous impression could be taken. Also, the notice was possibly meant as a warning to any adults who did not wish to be in a waiting room with restless children! Mathew Brady advertised a room especially designed for taking portraits of children in his magnificent Broadway gallery: "We have never seen anything finer than the tone of light . . ."

A child's first entrance into a daguerreian gallery was very important. If the surroundings were friendly, quiet, and interesting, the photographer and his assistant reassuring, the child had fewer misgivings about this adventure into the unknown. The fewer people accompanying the child the better, because too many warnings and injunctions about behavior and clothing were unwise. After the child was spotlessly attired, he must have been aware that something extraordinary was about to happen.

The photographer usually preferred that only one person enter the

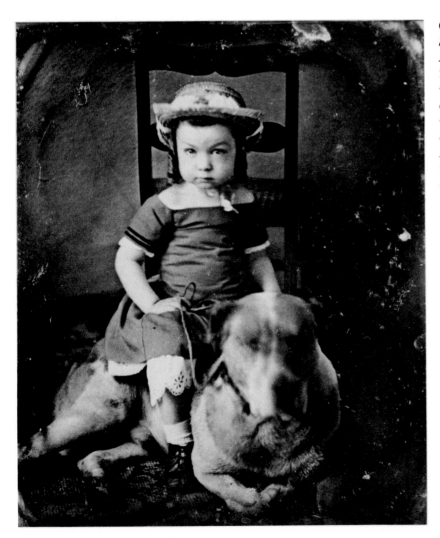

Child seated on dog, ca. 1850.
Sixth-size daguerreotype.
Artist unknown.
This unusual portrait shows the versatility of the daguerreian artist in posing his subjects. An unforgettable image of childhood.
Rinhart Collection,
the Ohio State University,
Columbus.

THE above cut represents the *Infant's Daguerrian Gallery,* which, in addition to our already extensive Saloon, we have erected for the purpose of taking little children and adults of a nervous temperament. This, together with the increased rapidity of the *Cala-otype,* and other improvements both chemical and optical, enable us to set competition at defiance, both as regards rapidity, brilliancy of execution, and artistic arrangement. In this latter, the facility which a thorough knowledge and long practice of Portrait Painting gives, can only be estimated by calling and examining the specimens at *No.* 139 *Main street, above Governor.*

N. B.—All materials at New York prices.

no 17—tf WM. A PRATT & CO., Proprietors.

operating room with the child—the mother—and, if the child were unruly, the appearance of the father brought instant obedience. A photographer in the South wrote, in 1851, about his problems with children who misbehaved:

> The tiny faces separate and then in groups—the boy who is never still, or quiet the girl whose rompings are innate? Oh for some potent drug to harmonize the whole. . . . What a wearisome time we had with the little folk before they were ready for them in the operating room. What keys and blocks and other unbreakables, were placed at their disposal; what cake crumbs, nut-shells and candy papers from the hands of their fathers, were by these little ones lavished at will upon my carpet.[38]

Some galleries provided various devices for keeping children quiet and happy. One studio had a jumping jack bird for the amusement of children, who responded with wide-open eyes and mouths, and a variety of toys for all ages proved useful for gaining attention during the exposure of the plate in the camera. Babies were especially attracted to bright objects or music boxes, and such an object held in their tiny hands had a quieting effect. A daguerreotypist who was a good storyteller often found it quite helpful to chirp or whistle like a bird during his anecdotes.

If several children were to be photographed, one following the other, the wise daguerreotypist chose the boldest child first, and the others then gathered courage when nothing bad happened to their brother or sister. The successful photographer of children was relaxed with them. Marcus Root stressed the importance of being patient with

children and advised: "No effort should be spared for producing a pleasing picture of them. . . . Therefore, I would advise the operant to indulge and play with them, and strive to win their confidence and good-will."

Proportion was a problem when a child was being photographed at close range, especially if the camera looked down on the subject—in some cases this produced a large head and dwarfish figure. For a simple remedy, the daguerreotypist used a low stand for his camera or elevated the child on a footstool, bench, or high chair so that the camera's lens could be at least parallel to the face.

Three children, ca. 1851.
Sixth-size daguerreotype.
Artist unknown.
The daguerreotypist has grouped two chairs together for posing his three subjects. The arrangement of the legs of the little girls is unusual but gives a delightful impression of childhood.
Anonymous collection.

The curious sisters, ca. 1846.
Sixth-size daguerreotype.
Artist unknown.
The daguerreotypist must have
used some kind of entertaining
device, perhaps a toy bird or a
jumping jack, to have produced
such rapt expressions.
Rinhart Collection,
the Ohio State University,
Columbus.

Edward Tompkins Whitney, a well-known pioneer daguerreotypist of Rochester, advised his fellow artists on how to take images of children:

> I generally use an elevated platform, about five feet square, and one foot high, for several reasons, viz: to get nearer to the light, and a better range for the instrument, than the height ordinarily used. . . . If a very young child is to be taken, I have an ordinary highchair, the back rail stuffed, against which the head will naturally rest; a band of red cloth nailed on one side, with strings at the end to tie around the child, hugging it close to the cushioned back rail; thus it is held as in its mother's arms. If this fail, and it will not rest his head, turn the chair half-way around; this will cause it to turn the head back towards the operator, and give a steady look for a second, which you must catch. I use, with good success, a little toy bird, that I make sing inside the camera, occasionally showing a part of it to attract attention to the instrument. . . . Have two or three plates at hand, and as soon as the child is placed, when parents, nurse, and all present, are talking, laughing, and baby is struck dumb with surprise at its strange position, then is the golden moment—then, if ever, you will get it; you may try after the child has become familiar with you and the room, but the more you try the worse you are off.[39]

If a daguerreotypist doubted that the child would keep still, the little one was placed closer to the window for stronger light and the reflecting screen was brought nearer. By doing this, and by suspending a white muslin cloth above the child's head, the exposure time

*Baby in white dress, ca. 1851.
Sixth-size daguerreotype.
Artist unknown.
A rare portrait of a black baby.
The chair has been hand-tinted
blue and pink, and the flowers on
the baby's lap (at circle of tar-
nish) have been tinted pink with
green leaves. Apparently no
headrest or other support has
been used.
Rinhart Collection,
the Ohio State University,
Columbus.*

could be cut by one-third.[40] One daguerreotypist advised using a lower
light within three feet of the floor as well as an experimental raising
and lowering of the window shades.[41] If the child did move, or if the
daguerreotype plate became exposed to the light, it was restored to its
original sensitivity by placing it over an accelerator for one or two sec-
onds.[42] In *The History and Practice of the Art of Photography*, Snell-
ing wrote that "Chloride of Bromine" was a very sensitive solution and
"by means of it daguerreotype proofs are obtained in half a second,
and thus very fugitive subjects are represented, making it the very
best compound for taking children."[43] Also, other accelerating sub-
stances designed to cut exposure time were advertised by supply
houses.[44]

The daguerreian artist must have communicated well with his
young sitters, because daguerreotypes of children reflect a directness,
a simplicity, and a revealed personality often worthy of a fine art. In
the long history of art, however, it was rare for the artist to suc-
cessfully portray the personality and character of the child on canvas.

Many early painters depicted the little ones with heads of knowing older people—their eyes alight with wisdom. Most artists of the brush or pen, finding it difficult to remember with any clarity the child's outlook on the world, often eliminated them from their work. It took the American daguerreian artists, in the golden age of portraiture, to capture the most charming and relaxed images of childhood.

THE POSTMORTEM PORTRAIT

During the 1840s, the republic's agrarian society was changing: industry, with its emphasis on material objects, was altering the American way of life and death. The American people in matters of death now began to depend on the undertaker, whose services were fast supplanting those of the church or the town sexton.[45] A new custom was introduced: photographing the dead. Now an image of a loved one or a friend could be preserved and treasured as a memorial keepsake.

Very little was recorded in the daguerreian era about photographing the dead, but information can be gleaned from extant daguerreotypes

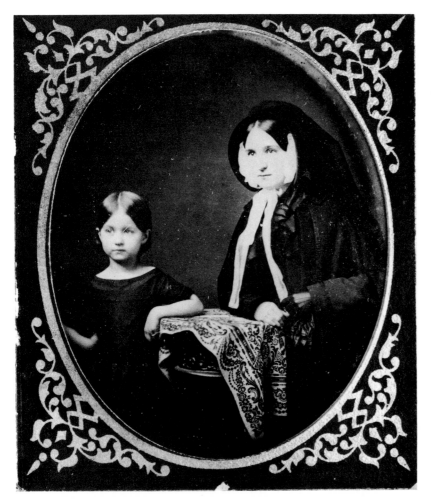

The mourners, ca. 1856.
Sixth-size daguerreotype.
Artist unknown.
Note the black pillar and black
framing mat appropriately
used for this particular
daguerreotype.
Rinhart Collection,
the Ohio State University,
Columbus.

and from the advertisements of the times. Southworth and Hawes, for example, advertised in 1846: "We take miniatures of children and adults instantly, and of Deceased persons either at our rooms or at private residences. . . . We take great pains to have miniatures of deceased persons agreeable and satisfactory, and they are often so natural as to seem, even to Artists, in a quiet sleep." Southworth later recalled his experiences with taking death images in the early years of the art:

> We had to go out then more than we do now and this is a manner that is not easy to manage but if you work carefully over the various difficulties you will learn very soon how to take dead bodies—arrange them just as you please . . . the way I did to have them dressed and laid on the sofa, just lay them down as if they were in a sleep, that was my first effort. . . . You may do just as you please as far as handling and bending of corpses is concerned. You can bend them until the joints are pliable and make them in a natural and easy position.[46]

Most daguerreotypes taken of the dead were of children—a grim reminder of the current mortality rate. Babies and children under five

would provide death's greatest triumph throughout the nineteenth century. A belief existed that the dead child was blessed with eternal youth and innocence—comforting thoughts to overcome grim statistics.[47]

The most complete account of photographing the dead was written by the pioneer daguerreotypist Nathan G. Burgess in 1855 for *The Photographic and Fine Art Journal.* In his opinion, the only object in taking a portrait of the deceased would be to provide an outline of the face to assist the "painter in the delineation of the portrait, and in this particular it has been found of essential service." (It is interesting to note that the postmortem daguerreotype was used by the artist to create a lifelike image.)

Burgess said that, in his considerable experience in this branch of the art, he had succeeded much better with the death portrait at the house of the deceased. He brought almost all his apparatus with him, the only exception being his cleaning block, which he replaced with a portable one. All equipment was placed in a box or a basket, including his camera and stand, coating boxes, mercury, and buff. Before leaving on his daguerreotyping assignment, Burgess cleaned a number of daguerreotype plates, about eight or ten, and buffed them ready for coating. These were placed in a plate box, well cleaned and free of dust. The plates were covered with a piece of tissue paper, and the box was tightly closed and wrapped with black cloth.

After arriving at the home of the deceased, Burgess retouched his plates slightly with the buff to make sure that all dust was removed. Many operators, he said, coated their plates before leaving for the assignment and, although they successfully produced the death portrait, black spots would sometimes appear on the finished daguerreotype, owing to particles of dust. The problem of a darkroom was solved by using a small closet or even a corner of a room with the blinds closed. On the question of lighting, Burgess said that a north light was best but, if this were not available, any window would do if free from the direct rays of the sun.

If the portrait were to be taken of an infant, it was suggested that it be placed in the mother's lap, as though asleep, and photographed in the usual manner, using a side light for illumination. An older child would photograph best placed on a table or a bed with his head toward the light, slightly raised, and diagonal with the window and with his

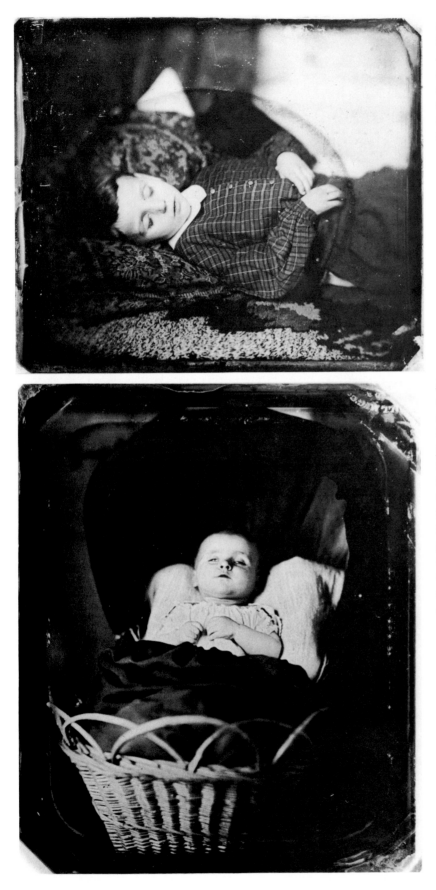

*Deceased boy on couch, ca. 1850.
Sixth-size daguerreotype.
Artist unknown.
Life was uncertain for children
of this era, and the daguerreo-
type provided for the bereaved a
treasured memorial.
Courtesy of Josephine Cobb.*

*Deceased baby in black-draped
canopied basket, ca. 1854. Sixth-
size daguerreotype. Artist un-
known. A rare portrait—it is
possible that the baby was
brought to the studio in the
mourning basket. Sometimes de-
ceased infants were carried to
the daguerreian gallery in a
secretive manner to be photo-
graphed. This daguerreotype is
one of three portraits of the same
baby; the others were posed in a
slightly different way.
Anonymous collection.*

*Deceased child holding open da-
guerreotype case, ca. 1851. Sixth-
size daguerreotype. Artist
unknown. The child has been
posed upright on a draped chair
to simulate sleep, and the image
in the case displays the boy as he
appeared in life.
Anonymous collection.*

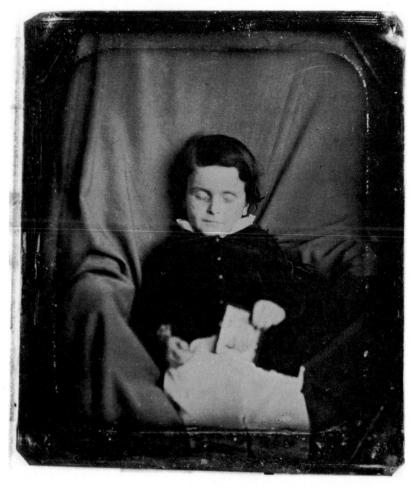

feet closer to the middle of the window. For a suitable background, Burgess suggested using a common woolen blanket, which could be held behind the body by two assistants; a sheet could be used as a reflector, held by assistants or fastened to the wall. It was important, also, that the table or bed be arranged so the light would fall down on the face and the shadows would appear below the nose and eyebrows. A skylight effect could be obtained by shutting out light in the lower portion of the window with a dark cloth. If needed, the light could be increased by opening the upper portion of the window.

Burgess advised that, if the body were already in the coffin, the portrait could still be taken—but not as conveniently or as well. The coffin must be placed near a window and the head must be in the same position as if photographed on a table. If the outline of the coffin were not to appear in the portrait, the edges were covered with colored cloth, a shawl, or any other drapery to conceal it from view.[48]

Each daguerreotypist brought his own ideas to the death scene. Sometimes the body was placed on a couch covered with a lively printed material; sometimes it was seated on a chair and posed as though asleep. Often a flower or a bouquet or some other object was placed in the hands; this object was occasionally brightly colored in the finished daguerreotype.[49] Because of the lack of movement, a long exposure time was possible, resulting in an almost faultless portrait of shocking intensity.

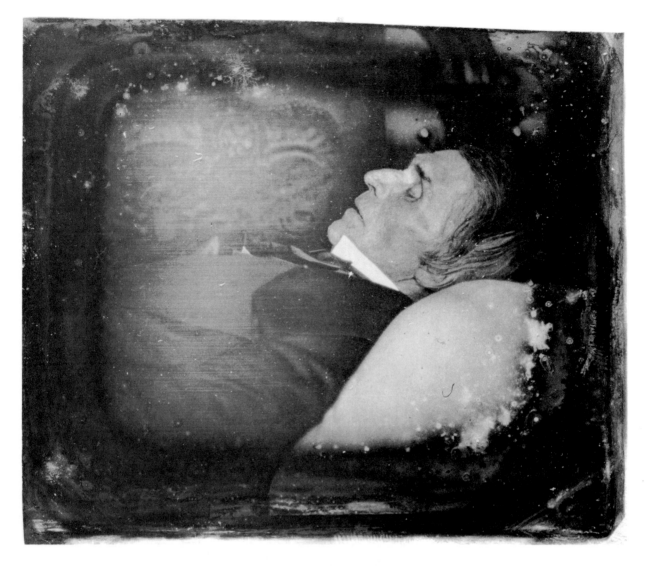

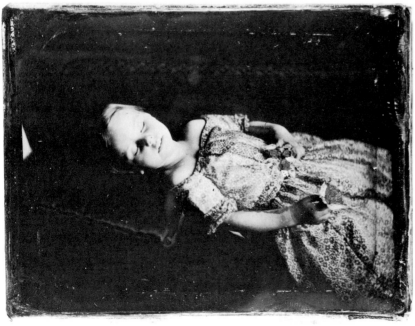

Deceased man, said to be Henry Clay, ca. 1852. Sixth-size daguerreotype. By Jesse H. Whitehurst. Authors' collection.

Mary Elizabeth Jones (1849–1852), daughter of Reverend and Mrs. John Jones, Marietta, Georgia. Quarter-size daguerreotype. Artist unknown. The daguerreotypist has highlighted the child's face and, with his very dark background, has given an ethereal quality of floating space to the portrait. Reverend John Jones Collection, University of Georgia Libraries, Athens.

Photographers were also called upon to take daguerreotypes of monuments, burial plots, and mourners—all mementos for the album of death. One daguerreian gallery in New York City, Beckers and Piard, advertised "Views of Greenwood Cemetery—a choice collection may be seen in our galleries and from which copies will be furnished to order."[50]

DAGUERREOTYPES IN TOMBSTONES

Daguerreotypes were sometimes secured to monuments or tombstones to record the image of the deceased. Just how popular this practice may have been is not known, but the custom did spread to the Far West in the early 1850s.

Two patents were issued for this purpose, the first to Solon Jenkins, Jr., of West Cambridge, Massachusetts, on March 11, 1851, for "Securing Daguerreotypes in Monumental Stones."[51] The daguerreotype, coated with a protective varnish, was framed with a metallic border which, in turn, was cemented to a plate of glass. The glass-covered daguerreotype was then placed within a frame or a case of metal or molded plaster. After a cavity was cut into the headstone, plaster was poured into the niche, and when placed in position the front of the shield rested flush upon the stone face of the monument.

In the second patent, issued to Langley, Jones, and Drake of Stoughton, Massachusetts, on December 6, 1859,[52] it was stated that other attempts to preserve the image on a tombstone had failed because of dampness. To remedy this, the likeness was placed in a glass case or a flat bottle which was closed by a tightly fitting glass stopper, placed in the prepared recess, and then cemented to the tombstone.

From 1840 to 1860, the pioneer daguerreotypists had laid the foundation for the future of photography in America, especially in the field of portraiture. Techniques for taking images had been influenced by traditional portrait painting, but the foundation stones had been carefully cemented by trial and error, hard work, and an inventive approach to a subject both complex and challenging in an age fraught with continual change.

11. MINIATURE CASES

When the first daguerreotype scene taken in America was displayed in New York City, the *New York Morning Herald* of September 30, 1839, commented: "It is the first time that the rays of the sun were ever caught on this continent, and imprisoned in their glory and beauty, in a morocco case with golden clasps." The newspaper also reported that the daguerreotype was equal in size to a miniature painting. Leather-covered rectangular cases had long been used by artists to contain miniature paintings, and the tradition would be followed by the early practitioners of the new art.

A beautifully framed daguerreotype or miniature, as a daguerreotype was often called, was as dramatic as the display of diamonds on black velvet. The gold-colored frame and the red, blue, green, or purple silk or velvet pad, opposite the image side of the miniature case, enhanced the beauty of the portrait and created precious heirlooms for the years to come.

Americans, unlike Europeans, would almost always prefer their portraits and scenes framed by a golden mat, protected with glass, and placed in a miniature case. These cases were selected from an array of attractive designs displayed at the daguerreian gallery where the image was taken. In Europe, patrons had their daguerreotypes

Minny Warriner, June 30, 1853. Sixth-size daguerreotype. Artist unknown.
Courtesy of Donald Lokuta.

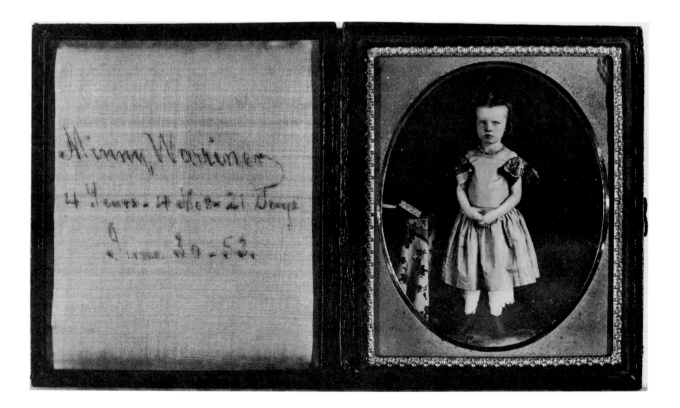

framed in passe-partouts, which were usually gilt or black with gilt, backed with papier-mâché and covered with glass. However, the English often had their portraits placed in miniature cases.

Very little is known about the actual beginning of the manufacture of these cases, so essential for protecting daguerreotypes from finger marks, scratches, and the elements. Most early casemakers did not advertise, so information must come from city directories or from the cases themselves. However, one case manufacturer did advertise his product in the *New York Tribune* in 1841:

> MOROCCO CASE MANUFACTORY.
> The oldest, cheapest, and the best Morocco Case Manufactory in the United States. C. Cole's manufacturer of all kinds of Morocco goods; wholesale and retail. Principally 100 per cent less than the original prices, at 192 Broadway, corner of John street. Jewelers Cases of every description. Chests for Silver-plate portably arranged. Writing and traveling Desks, Jewelers Show Cases fitted up with Trays in a superior style, etc.
> N. B. Fine Miniature Cases made with metallic frames to any pattern or size, at short notice—Cases for Daguerreotype likenesses, varying from $1.50 to $7 per dozen, all orders thankfully received and executed with neatness and dispatch.[1]

This advertising of prices for daguerreotype cases is important to the history of the craft, because it is almost impossible to establish selling prices in the very early days of photography.

Other New York names appear early in the manufacture of daguerreotype cases. Edward White is listed in the New York business directory in 1840 as a morocco case manufacturer. The following year, the directory lists three daguerreotype case manufacturers—C. Coles, corner of Broadway and John; C. and J. Hartnett, 2 Cortlandt St., and Edward White, 183 Broadway—showing how quickly the demand had increased. This pattern was indicative of the growth elsewhere. In 1839 and throughout the 1840s, the chief sources of daguerreotype cases were generally those modest concerns primarily engaged in the manufacture of instrument, jewel, or other small cases. The introduction of morocco leather and other styles of daguerreotype cases presented only minor difficulties to these businesses, since the cases were closely related to their other products. Some daguerreotypists bought cases directly from box makers, but mainly they entered into contractual arrangements with photographic supply depots. While the box makers' output represented the main source for the supply of miniature cases in about 1842, several specialized firms were established which manufactured only daguerreotype cases—the men involved in these new manufactories were primarily daguerreotypists searching for additional income.

In Philadelphia, Montgomery Simons began making cases in partnership with a Mr. Willis in 1843, an enterprise continuing until 1848, when Willis formed a partnership with a Mr. Gordon.[2] The Philadelphia manufacturers, unlike some other early casemakers, did not mark their products. Only a handful of casemakers identified their work. Occasionally a maker's name was placed inside the case or a name was embossed on the front cover. The Meade brothers, who began to manufacture cases in 1843, and Mathew Brady, who also made cases around that time, clearly marked their names and addresses on the

*English miniature case,
ca. 1850.
Embossed morocco leather.
English miniature cases varied
in size from their American
counterparts, and usually the
royal coat of arms appeared on
the front cover or inside the case.
Courtesy of George R. Rinhart.*

front covers of their cases.[3] In contrast, Edward White's embossed name was almost indiscernible within the cover design motif.[4] John Plumbe was one of the first casemakers to place an identifying label inside the case. William Shew followed this tradition in 1844 when he opened his Boston case manufactory, which continued for the balance of the decade. Shew's brothers, Myron in Philadelphia and Jacob in Baltimore, also labeled their cases; undoubtedly, their cases were made by the Boston manufactory.[5] Studley and Gordon, another Boston firm, placed labels in their cases beginning in 1846—the name changed to Studley in 1848, when presumably Gordon withdrew from the venture.[6]

Most daguerreotypists bought stock miniature cases without identity imprints. However, a number of practitioners requested that their cases be stamped or embossed with their own name and address, usually on the fabric (velvet or plush) pad inside the cover, and some manufactories provided this custom service for imprinting on the pad or on the outside front cover of the case. John Plumbe was probably the first to introduce a decorative imprint on the outside cover of his miniature

Image compartment. Sixth-size "Crocket Theme" miniature case, ca. 1840. Larwill was probably the earliest daguerreotype casemaker to place a trade label inside the case. Anonymous collection.

Image compartments. Sixth-size miniature cases, ca. 1848. Examples of casemaker trade labels. Anonymous collection.

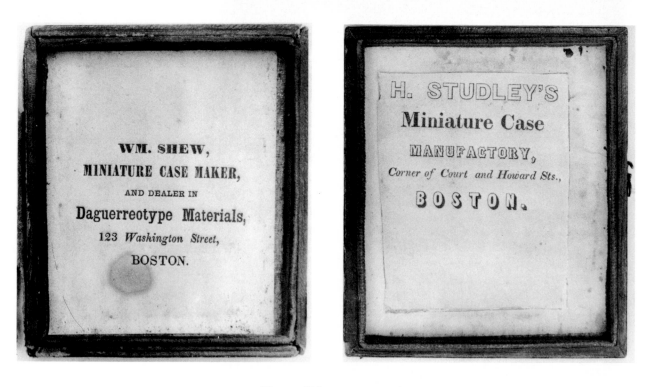

cases. Many of his representations were quite eye-catching, especially some used in his Boston gallery. In about 1845, one case cover was ornamented with a coin-shaped gilt medal, surmounted by a flying eagle (in gold); the large letters stamped on the coin proclaimed "Gold Medal Awarded to Plumbe," reminder of his many awards for fine daguerreotyping.

In the early years of the art, besides the case and the image plate itself, two additional items were needed for the completed keepsake. (Later, in about 1845, a "protector" was added to the essential package.) One was the clear glass, always in plentiful supply, used to protect the image; the other was the framing mat which covered the unsightly edges of the daguerreotype plate. The demand for mats began with the art itself. In the first days of daguerreotyping, improvised hand-cut paper and crudely milled brass mats were used. Just when mass-produced daguerreotype mats were first made is not clear: the first recorded deliveries by the Scovill Company were made in 1842, when shipments were sent to White in New York and Plumbe and Southworth in Boston.[7]

By 1850, the small part-time box maker had faded as a factor in the production of daguerreotype cases. The demand for cases had increased many times over, and their manufacture and distribution had altered sharply. Over the years, from about 1847, the larger wholesale photographic supply houses—such as the Scovill Company and E. Anthony

Fabric compartment.
Quarter-size miniature case, ca. 1850.
Embossed designs similar to this one were often used by daguerreotypists for prestigious advertising.
Anonymous collection.

and Company—had become increasingly aware that their sources for cases were inadequate.

The Scovills, who primarily manufactured metal products, had delegated the buying of miniature cases to the New York store, which negotiated with a number of case manufactories, each having limited facilities for producing cases. Theoretically, the arrangement was ideal, but events proved otherwise. The problems facing the case industry are illustrated by the small manufactory owned by Ogden Hall in New Haven, one of Scovill's suppliers. The factory, plagued with other casemakers "stealing" Hall's workers, was unable to keep to a satisfactory production schedule.[8]

In 1850, the Scovill brothers decided to change their policy regarding buying miniature cases. They had always worried about maintaining a well-balanced stock of cases, and now complaints were coming in about the tendency of their wooden cases to warp during periods of high humidity. Samuel Broadbent, who was daguerreotyping in Wilmington, Delaware, in 1850, wrote a letter of complaint: ". . . I think your cases warped badly, much more than some I had from Anthony— His are rather prettily embossed—don't get behind him and I know you won't long at a time."[9]

By early fall, the Scovill management had come to a decision—they bought the Ogden Hall factory and negotiated with Samuel Peck to manage the establishment. Peck, a daguerreotypist in New Haven and a customer of the New York store who had impressed the management with his abilities, had recently invented a clever plate holder which was selling well. In November, he disposed of his studio in preparation for his association with the Scovill Company, but it was not until March 1851 that the arrangements were formalized for the Scovill Company to take over the property and put Peck in charge.[10]

Meanwhile, in New York, Edward Anthony had also found it necessary to insure an adequate supply of daguerreotype cases and had opened a manufactory on Fulton Street in 1850.[11] As it turned out, this action only partially solved the miniature case problem—within just a few years the demand had become overwhelming. In 1853, Anthony moved his factory to a spacious loft over a railroad terminal, where 25 percent of the space was used for the making of miniature cases.[12]

The new factory was geared to mass production. The room where the case wood was readied was long and well lighted, with two lines of shafting running the entire length of the area—the shafting carried the pulleys which drove the different saws and lathes, standing in two parallel lines beneath. Placed but a few feet apart, each saw and lathe was tended by a boy who was responsible for one particular operation of a process which required at least twenty different manipulations to turn the rough blocks of wood into smoothly sanded and well-proportioned boxes with nicely fitting tops. The case wood preparation was described in Anthony's catalog of 1854:

> The revolution of the pullies, the rapid motion of the belting which every four feet extends from the ceiling to the floor, the brisk motions of the boys, the flying of the nascent 'woods' from the saw or lathe to the box in which it is conveyed to the next operation in the course of 'development,' the flashes of saw dust evolved in the process of 'grinding,' the 'chirr' of the saws and

the hissing of the sand paper which present to the beholder a busy sound.[13]

The wooden boxes were brought to the covering shop, which occupied two rooms—each twenty-four by forty-eight feet. The work of covering the cases with embossed leather, paper, or cloth was mostly done by boys and girls, who glued strips of material to the tops and bottoms of the cases. Strips of leather called inside and outside backs formed the hinges for the miniature cases. As a finishing touch, the cases were creased, the front edge varnished, and the hooks put on. They were then "trimmed" by placing a silk- or velvet-covered pad in the side opposite the hollow which would hold the image, and a plain piece of paper was placed in the image side on the inside bottom of the case.

Integral to the case furnishing were the mat and the preserver. Formed of sheet brass, these were known by various terms—"common," "fire-gilt," "engraved," "embossed," or "stamped"—the difference being in the relative value of the metal used or the cost and the style of the finished product. Powerful steam-driven presses were used to make these articles. First, the mats were cut into the shape

Daguerreotype mat styles, sixth-size. Top row, left to right: octagonal (1840s), oval (1853 to 1855), double elliptical (ca. 1855); bottom row, left to right: elliptical (1840s), ornate elliptical (ca. 1850 to 1855), nonpareil (1850 to 1855).
Authors' collection.

desired, straightened, and passed on to the "dipping room," where they underwent an acid bath to give a "frosted" or "marked" appearance. After dipping, they were lacquered and dried rapidly on a table of copper which had been steam heated. Next, the edges of the mat openings were chamfered and burnished. The preservers, the narrow outer frame which enclosed the sandwich of the daguerreotype, mat, and glass, were made by a similar process, except that they were dipped to a bright instead of a matte finish.

By the 1850s, mats had become more sophisticated: the octagonal and oval frame openings with a pebble finish of the 1840s had changed to a variety of opening designs with a brightly finished surface in brass or gold oroide. The quality of the mats depended on the manufacturer —the gauge of the metal and the finish determined the price.

Not all mats were metallic, however. In 1853, the Scovill Manufacturing Company introduced the "Union Mat," made of a hard-type composition board and lacquered black with floral designs around the opening; others were painted in gold. They varied in thickness from one-sixteenth to half of an inch, depending on the daguerreotype plate size.[14] In 1855, Holmes, Booth, and Hayden were issued a United States design patent for a group of highly ornamented cast brass mats.[15] These were probably the highest-quality mats ever produced, and they proved popular for a few years until competition undersold them with a variety of patented designs on very light stamped brass metal.

The beautiful designs on miniature cases represent a separate art form. These were usually made with brass die cylinders which were used in conjunction with a heavy screw-type press. The die-engravers who produced so many lovely designs for case covers reflected the interests of an era which embraced the arts—painting, literature, architecture, and music. Themes from the arts, as well as designs inspired by the Americans' great love of nature, were depicted on the covers of miniature cases. Scenes and faces from history seldom appeared on leather-covered cases, although a few were represented, including Wolfert's Roost, the home of America's beloved Washington Irving. George Washington was not neglected—and the Washington Monument was beautifully embossed on a leather-covered case in the early 1850s.[16]

NOVELTY CASES

Other containers were used to hold daguerreotypes from the early 1840s. Lockets worn by women enclosed tiny images, and this custom remained popular throughout the era of the daguerreotype. Also, small daguerreotypes were placed in brooches, rings, bracelets, and sometimes even in the heads of canes—occasionally they were used in men's hats for identification! Some patrons preferred their large-size daguerreotypes placed under glass in rosewood or gilt frames suitable for decorative wall ornaments. However, most customers of the daguerreian galleries wished to preserve their images in miniature cases, and, to please the ever changing public taste, new styles began appearing late in the 1840s.

One of the new styles, shaped like a book, was made of papier-mâ-

ché inlaid with mother-of-pearl. The designs on these latest covers were often very beautiful—with attractive flower motifs and gold accents. Romantic scenes showing colorful landscapes, complete with castles or other picturesque images, were painted by artists on the papier-mâché covers. The edges of the "book" were painted in gold to simulate pages, and the hinges of the case were usually lettered in gilt with the words—"token," "souvenir," or "bijou." The cases were secured with clasp hinges or snap-type closures.

Some book-style cases were covered with morocco, imitation tortoiseshell, or silk or velvet in a choice of colors—red, blue, or green. Often, as a variation, the front covers of the velvet-covered cases had an inset of a cameo or some other decorative object. In 1854, the Scovill Company announced a "new and beautiful case" of an octagonal shape, covered with silk or velvet; the manufacturer also carried preservers of the same shape to go with the new style.[17]

In the mid 1850s, a variation on the rectangular miniature case was introduced by Henry A. Eichmeyer of Philadelphia, for a design referred to in the trade as a band. The two edges on which the hinges and clasps were placed were rounded—and the case thus gave the appearance of being encircled by bands.[18] Soon imitation leather cases of the same type were competing with the original leather-covered ones. Also during the 1850s, two magnifying-style cases were introduced. The first, a conical affair, was patented in 1850 and had a brief run of popularity. Another, more practical magnifying case was introduced in 1855 by Myron Shew, who advised in his circular:

Daguerreotype jewelry.
Center: bracelet (band made from human hair, silver case);
lower left: brooch (silver case);
upper right; watch-style locket (gold case).
Authors' collection.

Seated woman holding mother-of-pearl case, ca. 1856. Sixth-size daguerreotype. Artist unknown. The miniature case was often a favorite accessory for the daguerreotype portrait. Anonymous collection.

Its object is to show the picture magnified. It is so constructed that when the flap, or secondary lid, in which the lens is inserted, is folded down within the lid of the case, it appears like any ordinary case, and occupies only the same space. . . . Here the object is attained with but little additional expense to the case, and attained with no extra trouble or inconvenience. Daguerreian artists in want of something to attract attention to their rooms, will find these cases admirably calculated for that purpose. The prices are as follows, fitted with engraved mats and white glass:—Quarter size, per dozen, $13.50; Sixth size, per doz., $9.00; Ninth size, per doz., $7.50. A sample of the sixth size will be sent to any part of the United States, free of expense, on the receipt of one dollar.[19]

UNION CASES

After Samuel Peck took over the management of the New Haven case factory, in partnership with the Scovill Company, he continued to

make cases in the traditional way. The case-covering materials and the velvet pads were embossed with dies made by the company's Hiram W. Hayden or were bought elsewhere. The number of die-makers in the East was relatively small, a factor which often caused a delay in introducing the new designs which were always in great demand.

The factory began going into the "fine case" trade in a small way by making the popular papier-mâché cases, constructed of a boardlike material formed from thin sheets of paper glued together and submitted to powerful pressure. Soon Peck began experimenting with a plastic composition, one suitable for molding deep designs, and after May 1852 he gradually worked out the right formulas and consistency for his plastic material, which was composed mainly of gum shellac and woody fibers.[20] Peck had problems with the high temperatures required to press the plastic composition into the design dies; sometimes his heated "roll pipes" failed, and his "cast iron" proved inadequate for such extreme temperatures. The dies for the case designs also presented problems for use with the new material—they had to be made by special order.

Designs for the case covers were cut by diesinkers, who practiced the ancient art of die-engraving or diesinking on steel molds. In preparing his die, the artist used his metal in a soft state for engraving and worked the reverse way—cutting or sinking those parts of the design which appeared to be round in the finished product. As the work progressed, impressions in clay were taken to judge the correctness of the design. After the steel die was completed, it was hardened by fire —a red heat was necessary—and it was then placed in a small amount of water, in which it remained until cold. Since the risk of breakage or splitting was great, considerable care had to be taken during the process. The finished die, with its inverse ornament, could now be cast in relief. The dies for making plastic daguerreotype cases were used in a mold press having a powerful screw-type pressure.

Peck's thermoplastic cases appeared on the market in early 1853, months before he was granted a patent on October 3, 1854.[21] Another inventor who developed a plastic compound for daguerreotype cases was Alfred P. Critchlow, an English diesinker and button maker of Florence, Massachusetts. Critchlow had his thermoplastic cases ready for marketing sometime during 1853; his case composition and style were similar to Peck's. These new and different daguerreotype cases, with their deep and rich designs, were immediately accepted by the patrons of daguerreian galleries. Peck's new Union cases, as they were named, sold in quantity in 1854; offered at the prices of the traditional cases,[22] they did not, however supplant the great variety of other cases, but they did give the studio patron a wider choice.

Shortly after Peck's patent was issued, his brother-in-law, Halvor Halvorson, an inventor who held a variety of patents, applied for and was granted a daguerreotype case patent identical to Peck's except for two words. Why this was done remains a mystery, but the patent may have been sought for additional protection. The two patents were merged, as evidenced by patent information found inside thermoplastic cases.

The hinge arrangement on the Union cases gave both Peck and Critchlow trouble, because breakage often occurred where the hinges were riveted to the case. Both men began experimenting individually to improve the case hinges—Peck was issued a patent for hinge im-

Halvorson's patent drawing for picture cases. The examiners in Washington seemed confused when granting patents for thermoplastic cases, since Halvorson's patent differed only slightly from Peck's patent of October 3, 1854, and his patent drawings did little to illustrate his written specifications. Halvorson and Peck both claimed to combine thick paper or thin cardboard with the plastic composition in the interior of the case; in addition, it was claimed that the process could "produce a beautiful gilt impression from the die" by applying gold to paper and transferring it to the outside of the composition design.

Critchlow's patent drawing for improving hinges on picture cases. The weakest part of a plastic case was the point where the hinges were joined to the composition, and a number of patents were granted to correct the difficulty. His patent claim was for L-U-shaped hinges riveted to the face of the covers.

provement on February 5, 1856;[23] Critchlow received his patent for hinge improvement on October 14, 1856.[24] Another hinge improvement was patented on June 1, 1858, by Edward G. Kinsley and Samuel A. W. Parker, Jr.[25] Plastic cases were produced under the Kinsley and Parker patent by Wadham's Manufacturing Company of Torrington, Connecticut.

Meanwhile, Peck's plastic cases were produced under the watchful eye of the Scovill's New York store. However, Peck made his own hinges and clasps and, except for obtaining brass, was quite independent of Waterbury. He established prices for the cases, and he was able to buy elsewhere, even from Edward Anthony if necessary, although the Scovill Company financed his inventories and restrained him from overexpanding production.[26] Peck's affiliation with the New York store allowed him to buy at competitive prices from foreign sources—when Scovill's agents, George Mallory or Samuel Holmes, visited English or French markets, Peck could purchase velvets, silks, or leathers. The New York store was also allowed freedom; it could go elsewhere for cases if demand warranted and could also control the designs and quantities of cases produced by Peck.[27]

By 1855, Samuel Peck's thermoplastic cases were widely sold both at home and abroad, but the New York store was receiving an increasing number of complaints about slow deliveries and faulty workmanship. Whether this caused the rift which gradually developed between the Scovill Company and Peck or whether demand was more than the factory could meet is not known, but Peck left the company in 1857, after being bought out by the Scovills. However, the name of Peck was continued for many years.[28]

Critchlow sold his business sometime in 1857, and the firm's name changed to Littlefield, Parsons and Company—the new company produced a large number of successful designs in the late 1850s and early 1860s. The corporation once again changed its name, on May 23, 1866, to Florence Manufacturing Company.[29] A few plastic cases were produced by the company, in addition to other products, but by this date the demand for cases had declined because of the popularity of paper photography, which did not require miniature cases. Other competing thermoplastic casemakers in the late 1850s included Holmes, Booth, and Hayden of New York City, who offered a wide variety of attractive designs. In later years the Union case, often called gutta-percha or hard rubber, became an art craft highly prized for its many and varied designs, taken from such sources as historical paintings, themes from literature, old book covers, carpet designs, symbolic Christian art, and nature.

The miniature case, in all its many varieties, had played an important part in the pioneer history of American photography. Its life span had been relatively brief—it had been very popular in the first half of the 1850s, yet by 1862 it was obsolescent and by 1870 it had almost faded into obscurity. Other less expensive and easier-to-use mounts for photographs had come into vogue. But the case in its era was a personal art form, finding a place among the treasured ornamental objects displayed as part of our American family heritage.

AMERICAN DECORATIVE MINIATURE CASE DESIGNS FOR PHOTOGRAPHIC IMAGES

The plates are numbered in sequence to *American Miniature Case Art.*

DESIGNS FROM HISTORICAL SCENES AND PORTRAITS

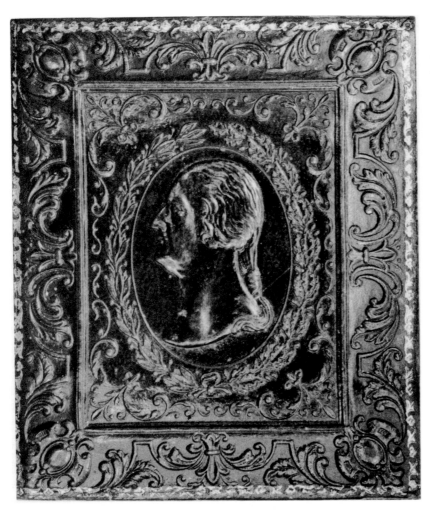

George Washington
Casemaker: Unknown.
Leather, 3⅝ by 3⅛ inches, ca.
1850.
Very rare.
Courtesy of George R. Rinhart.
Plate R230

*General Marion sharing yams
with a British officer
Casemaker: Littlefield, Parsons
and Company.
Plastic, 4 by 5 inches, ca. 1858.
From a painting by John B.
White.
Uncommon.
Courtesy of Beaumont Newhall.
Plate R231*

*The ride of Paul Revere
Casemaker: Wadham's Manufac-
turing Company.
Plastic, 3⁷⁄₁₆ by 3⁷⁄₈ inches, ca.
1859.
Very rare.
Courtesy of Mary Sayer
Hammond.
Plate R232*

Henry Clay
Casemaker: Frederick C. Key
and Sons.
Plastic, 3⅞ by 3½ inches, ca.
1860.
Die-engraver, Frederick C. Key.
Extremely rare.
Courtesy of Norman Mintz.
Plate R233 (obverse)

Henry Clay
Casemaker: Frederick C. Key
and Sons.
Plastic, 3⅞ by 3½ inches, ca.
1860.
Die-engraver, Frederick C. Key.
Extremely rare.
Courtesy of Norman Mintz
Plate R233 (reverse)

HENRY CLAY,
BORN IN HANOVER CO. VIRGINIA,
APRIL 12, 1777.
U.S. SENATOR, 1806.
SPEAKER OF THE HOUSE, 1811.
TREATY OF GHENT 1814.
MISSOURI COMPROMISE, 1821.
SEC. OF STATE, 1825.
TARIFF BILLS OF 1833-42.
COMPROMISE OF 1850,
DIED AT WASHINGTON.
JUNE 29, 1852.

Statue of Habana
Casemaker: Littlefield, Parsons
and Company.
Plastic, 4⅞ by 4 inches, ca. 1860.
Rare.
Courtesy of Norman Mintz.
Plate R234

PLEASANT PASTIMES

Boy playing with rabbit
Casemaker: Scovill Manufactur-
ing Company.
Plastic, 3 by 2½ inches, ca. 1860.
Rare.
Courtesy of Beaumont Newhall.
Plate R235

The dancer
Casemaker: Unknown.
Plastic, 2½ by 3 inches, ca. 1860.
Rare.
Courtesy of Beaumont Newhall.
Plate R236

The tight cork
Casemaker: Samuel Peck and
Company.
Plastic, 3¾ by 3⅜ inches, ca.
1857.
Very rare.
Courtesy of Beaumont Newhall.
Plate R237

The water carriers
Casemaker: Unknown.
Plastic, 5¾ by 4⅛ inches, ca.
1859.
Extremely rare.
Courtesy of Dennis O'Kain.
Plate R238

Lalla Rookh
Casemaker (?): Henning and
Eymann.
Plastic, 5 by 4¼ inches, ca. 1859.
Die-engraver, Henning and
Eymann.
Uncommon.
Courtesy of Beaumont Newhall.
Plate R239

The elopement
Casemaker: Wadham's Manufac-
turing Company.
Plastic, 3 by 2½ inches, ca. 1858.
Very rare.
Courtesy of Beaumont Newhall.
Plate R240

ART AND REFLECTIONS FROM ABROAD

The voyage of Cytherea
Casemaker: Frederick P. Goll
(attributed).
Plastic, 3½ by 3⅞ inches, ca.
1856.
Die-engraver, Frederick P. Goll.
Rare.
Courtesy of Beaumont Newhall.
Plate R241

Cameo of Shakespeare
Casemaker: Unknown.
Plastic, 3¾ by 3⅜ inches, ca.
1861.
Die-engraver, Frederick C. Key.
Very rare.
Courtesy of Beaumont Newhall.
Plate R242

Una
Casemaker: Wadham's Manufac-
turing Company.
Plastic, 5 by 4 inches, ca. 1861.
From Spenser's Faerie Queene.
Very rare.
Courtesy of Beaumont Newhall.
Plate R243

RELIGIOUS DESIGNS

THE VISION OF EZECHIEL

The vision of Ezechiel
Casemaker: Holmes, Booth, and Hayden.
Plastic, 6⅛ by 5 inches, ca. 1858.
After Raphael.
Uncommon.
Courtesy of Beaumont Newhall.
Plate R244

The rural church
Casemaker: Unknown.
Papier-mâché, 4⅝ by 3⅜ inches,
ca. 1848.
Hand-painted, inlaid mother-of-
pearl.
Extremely rare.
Anonymous collection.
Plate R245

Medieval scene
Casemaker: Unknown.
Leather, 4¾ by 3¾ inches, ca.
1852.
Extremely rare.
Courtesy of Josephine Cobb.
Plate R246

FRUIT AND FLOWER DESIGNS

Two clusters of grapes
Casemaker: Samuel Peck and
Company.
Plastic, 3 by 2½ inches, ca. 1857.
Uncommon.
Courtesy of Wiley Sanderson.
Plate R247

A cluster of grapes
Casemaker: Holmes, Booth, and
Hayden.
Plastic, 3¾ by 3¼ inches, ca.
1858.
Produced in moderate
quantities.
Courtesy of Levon Register.
Plate R248

The friendship motif
Casemaker: Unknown.
Leather, 3⅝ by 3⅛ inches, ca.
1845.
Very rare.
Anonymous collection.
Plate R249

*Six-pointed star with circle motif of fruits and flowers
Casemaker: Unknown.
Leather, 3⅝ by 3⅛ inches, ca. 1849.
Produced in moderate quantities.
Anonymous collection.
Plate R250*

*A bouquet of fruit
Casemaker: Unknown.
Leather, 3⅝ by 3⅛ inches, ca. 1856.
Produced in quantity.
Anonymous collection.
Plate R251*

Vase of flowers
Casemaker: Unknown.
Papier-mâché, 6 by 4¾ inches,
ca. 1850.
Hand-painted, inlaid mother-of-
pearl.
Rare.
Courtesy of Wiley Sanderson.
Plate R253

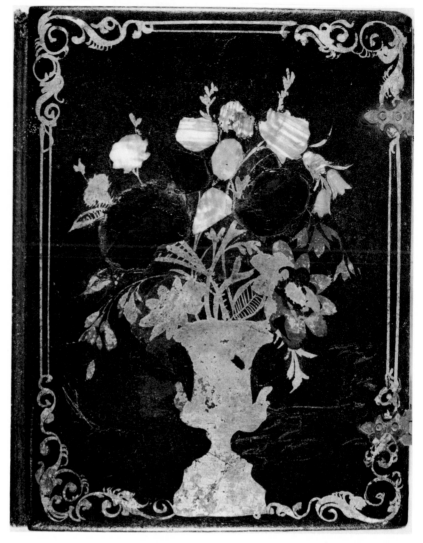

A bouquet of flowers
Casemaker: Unknown.
Papier-mâché, 9¼ by 7½ inches,
ca. 1852.
Hand-painted, inlaid mother-of-
pearl.
Very rare.
Courtesy of Beaumont Newhall.
From the Zelda P. Mackay
Collection.
Plate R252

Flower arrangement
Casemaker: Unknown.
Mother-of-pearl inlay, 4 by 3⅜
inches, ca. 1860.
Extremely rare.
Courtesy of Beaumont Newhall.
Plate R254

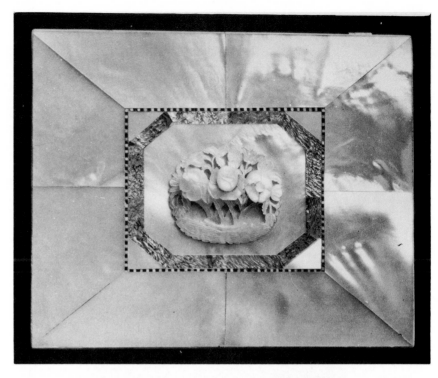

Flower cross motif
Casemaker: Littlefield, Parsons
and Company.
Plastic, 3¾ by 3⅜ inches, ca.
1858.
Uncommon.
Department of Art,
Photographic Archives,
University of Georgia, Athens.
Plate R255

Delicate flowers
Casemaker: Unknown.
Leather, 3⅝ by 3⅛ inches, ca.
1848.
Produced in quantity.
Anonymous collection.
Plate R256

Three flowers
Casemaker: Unknown.
Leather, 3⅝ by 3⅛ inches, ca.
1847.
Produced in some quantity.
Anonymous collection.
Plate R257

Two roses and mixed flowers
Casemaker: Unknown.
Papier-mâché, 3 by 2½ inches,
ca. 1856.
Hand-painted on imitation
tortoise shell.
Rare.
Department of Art,
Photographic Archives,
University of Georgia, Athens.
Plate R258

*Roses in octagonal scroll
Casemaker: Unknown.
Leather, 3⅝ by 3⅛ inches,
ca. 1855.
Produced in moderate
quantities.
Anonymous collection.
Plate R259*

Roses and bluebells
Casemaker: Unknown.
Leather, 4¾ by 3¾ inches, ca.
1853.
Produced in some quantity.
Authors' collection.
Plate R260

The lily motif
Casemaker: Unknown.
Leather, 3 by 2⅜ inches, ca. 1852.
Uncommon.
Anonymous collection.
Plate R261

GEOMETRIC AND TRADITIONAL DESIGNS

Fern leaf motif
Casemaker: Unknown.
Leather, 3⅝ by 3⅛ inches, ca.
1856.
Produced in some quantity.
Anonymous collection.
Plate R262

The golden tendrils
Casemaker: Unknown.
Leather, 4¾ by 3¾ inches, ca.
1848.
Uncommon.
Author's collection.
Plate R263

The feathery gold motif
Casemaker: Unknown.
Leather, 3⅝ by 3⅛ inches, ca.
1849.
Uncommon.
Anonymous collection.
Plate R264

Abstract leaf design
Casemaker: Littlefield, Parsons
and Company.
Plastic, 3¾ by 3⁵⁄₁₆ inches, ca.
1856.
Rare.
Department of Art,
Photographic Archives,
University of Georgia, Athens.
Plate R265

The bow motif
Casemaker: Unknown.
Leather, 3⅝ by 3⅛ inches, ca.
1855.
Uncommon.
Anonymous collection.
Plate R266

Eight-point sunburst
Casemaker: Unknown.
Leather, 3⅝ by 3⅛ inches, ca.
1851.
Produced in quantity.
Anonymous collection.
Plate R267

The oval in gold
Casemaker: Samuel Peck and
Company (Peck and Halvorson's
patent).
Plastic, 3¾ by 3⅜ inches, ca.
1856.
Very rare.
Department of Art,
Photographic Archives,
University of Georgia, Athens.
Plate R268

The linked scroll
Casemaker: Unknown.
Leather, 3⅝ by 3⅛ inches, ca.
1853.
Produced in some quantity.
Anonymous collection.
Plate R270

Scroll and flower motif
Casemaker: Unknown.
Papier-mâché, 2⅞ by 2⅜ inches,
ca. 1855.
Produced in quantity.
Anonymous collection.
Plate R271

The gold rectangle
Casemaker: Unknown.
Leather, 4¾ by 3¾ inches, ca.
1846.
Rare.
Anonymous collection.
Plate R272

Leaf and ripple design
Casemaker: Unknown.
Leather, 3⅝ by 3⅛ inches, ca.
1853.
Produced in moderate
quantities.
Anonymous collection.
Plate R273

12. REFLECTIONS OF AN AGE

In the era before the Civil War, the itinerant daguerreotypist traveled from town to town by stagecoach, steamboat, railroad, and wagon. Because he was such a familiar figure, he was sometimes characterized in the literature of the day. An 1854 story which pictured a young daguerreotypist as a fortune hunter provided a description of his travel by stagecoach:

> On the front seat, bolt upright, sat a spruce-looking, red-and-white complexioned, dark-haired and dark-whiskered young gentleman, trimly dressed in a linen sack, worn over a black coat and white marseilles, with his very red lips sucking the ivory head of a yellow rattan cane. I guessed at once that he was a daguerreotype artist, materially aided in this sagacious conjecture by the appearance of a tripod, which lay helplessly on the roof of the coach, its legs tied together and sticking out of the canvas bag in which its head works were bundled up.[1]

Romantic tales aside, the early photographers were hardworking men, and at one time or another some of the best daguerreotypists packed their cameras and equipment and took to the open road like the Yankee peddlers of old. In the summer, or whenever weather permitted, they traveled to find new patrons, thus augmenting their slim incomes after the long winter days when business was very slow. Some enterprising northern daguerreotypists toured the South during the cold winter months and sought patrons in the northern resorts in the summer, while southern daguerreotypists, who found their own resort towns lucrative in the winter, spent their summers in the North, where customers were always plentiful.

One such southern daguerreotypist who spent the summer months in the North was George Smith Cook, an artist and a daguerreotypist from Charleston. Cook later won fame during the Civil War as the southern counterpart to Mathew Brady. After he learned the art in about 1840, he worked as an itinerant daguerreotypist with his home base in New Orleans until 1845, when he opened a daguerreian gallery in that city before moving to Charleston. How often he traveled north in his early years is not known, but he did operate Brady's New York City gallery during Brady's absence overseas in 1851.[2] In May of that year, he purchased Charles Harrison's extensive daguerreian gallery at 923 Broadway. Cook installed William A. Perry as operator—Perry was a well-known daguerreotypist who had traveled south in the winters, advertising in Georgia resorts in the 1840s as taking portraits in the "best and latest styles."

The traveling daguerreian artist sometimes brought his camera into remote areas, under hazardous conditions, to photograph scenery and people not hitherto recorded. John Fitzgibbon, who became one of the prominent photographers of the century, ventured into the wilderness in 1846 for a month's trip. Leaving from Lynchburg, Virginia, he

scaled the Blue Ridge Mountains and forded the Kanawha and Ohio rivers, en route to Cincinnati and Saint Louis. Sometime in 1853 or before, he packed his photographic equipment for a trip through southwest Missouri to the camps of the Indian Nation. In typical itinerant fashion, he advertised his impending arrival in local newspapers of certain towns—he set up his camera in ten townships over a period of thirty-two days, usually traveling at night to meet his time schedule. The money he made from daguerreotyping was excellent, averaging upward of one hundred dollars a day.[3] The Indians said that Fitzgibbon was the first "image man" ever seen in that territory.[4] Fitzgibbon's collection of Indian portraits, exhibited at the New York Crystal Palace in 1853, attracted much attention.

The itinerant daguerreotypist usually advertised, along with his arrival dates, glowing descriptions of the excellence of his work. He also passed out handbills in the various villages and towns, offering the public an opportunity to examine the beautiful daguerreotype specimens on display in his temporary quarters. Villagers soon spread the word about where the artist could be found—often in the parlor of the local inn or in the best room of a boardinghouse. Sometimes the itinerant set up his wagon or tent on a convenient empty lot.

Many traveling daguerreotypists fitted up horse-drawn vans, built in much the same manner as twentieth-century mobile homes. The vans, called saloons, were equipped as miniature studios with sky-

The tin peddler, ca. 1850.
Half-size daguerreotype.
Artist unknown.
Brooms and pails bartered for daguerreotypes, perhaps, produced this unforgettable meeting between a tin peddler and a traveling daguerreotypist on some backcountry road. Like the peddlers of old, the itinerant daguerreotypist traveled the byroads of America—north in the summer and to the Deep South come wintertime.
Rinhart Collection,
the Ohio State University,
Columbus.

lights for adequate lighting. When the daguerreotype saloon arrived in town, an advertisement was placed in the local newspaper; for example, the *Bloomville Mirror* in New York State of May 17, 1853, advertised "If you want a good daguerreotype of yourself, or a valued friend, just stop into the Car of Mr. Burhans, opposite Thompson's Hotel, sit down and 'have your face taken,' If it suits you, pay for the same and keep it; if otherwise, take your hat and leave, or have the artist try again!"

Occasionally advertisements by daguerreotypists provided information about the traveling vans. In 1851, *The Daguerreian Journal* carried an advertisement for the sale of a "Daguerreian Saloon" which stood in North Adams, Massachusetts. The advertisement stated that the saloon was in the best of running order and had been completely refitted that season; interestingly, the saloon could be easily transported by rail. On the same page, another van was offered for sale at $250.[5]

The most convenient way for a traveling daguerreotypist to take views of the countryside was to carry a portable dark tent. An ingenious affair, this tent utilized one of the forms of independent headrests which had three additional sockets sliding on the upright iron rod, secured in place by thumbscrews. The upper socket supported the roof of the tent, which was an ordinary umbrella of the largest size, covered with thin black glazed muslin. On the outside of each whalebone of the umbrella top was sewn a large loop to which the curtain forming the sides of the tent was hooked. The curtain, made of thick black muslin, was long enough to lie a few inches on the ground, and the edges of all openings overlapped at least a foot to keep the curtain closed and the light out. At intervals the bottom edges of the curtain were fastened to the ground with light stakes to prevent a breeze from letting in light. This in effect was a camera box or camera obscura in which the artist stood while the picture was forming.

On the top of the tripod was placed a small shelf for the mercury bath, and near the top of the upright pole, just under the socket carrying the umbrella, was the socket for holding the port-lens, which was a tube containing the lens which protruded outside the curtain. This ingenious affair was described in detail in *The Daguerreian Journal* in 1851:

> The lens and tube are screwed to a thick piece of wood on the end of the horizontal rod, and on the inside of this piece of wood is secured a plane mirror at an angle of 45° to throw the rays downward on the movable shelf below. This movable shelf is attached to the third socket, and moves on the upright rod up and down nearer to or farther from the lens, in order to obtain the focus, which is received on a thin board of slate, covered with a middling large white card, and having guide lines on it showing the different sizes of plates. No ground glass is required; the white card answering every purpose for obtaining the focus. The thickness of the board or slate under the card should be precisely the same as the part of the frame under the plate, so that the surface of the plate may on replacing the card be exactly where the surface of the card was when the focus was being adjusted.
>
> The spectrum shelf and card should be somewhat larger than the largest picture is expected to be, so that by placing the plate

Greenwood Plantation, Thomasville, Georgia, ca. 1853. Half-size daguerreotype. Artist unknown. Views of plantation homes in the Deep South during the antebellum period are rare. Construction on this building was started in the 1830s and completed nine years later; the large central hallway and the second-floor veranda were traditional in southern constructions. Thomas Jones Collection, University of Georgia Libraries, Athens.

Rural home, ca. 1851.
Sixth-size daguerreotype.
Artist unknown.
This instantaneous outdoor view
affirms the rapid progress made
by American daguerreotypists in
the first decade of photography
(note the chickens' immobility).
The modest home, nestled among
the hills, with chickens on the
lawn and one wall newly
painted, provides an insight into
rural life in the years before the
Civil War. The scene was prob-
ably taken by an itinerant
daguerreotypist.
Rinhart Collection,
the Ohio State University,
Columbus.

in any position, or on any portion of the shelf, on which the desired part of the view is delineated, such portion only may be taken.[6]

Traveling artists were also advised that they should have a box containing all complete polishing apparatus, together with a stock of chemicals, a coating box, and a supply of plates. However, it was suggested that, wherever possible, the box be kept at the photographer's lodging and the plates buffed and coated beforehand, thus saving time in the field.

If a landscape view were taken, a long exposure time brought out a well-developed impression with a rich depth of tone. Samuel Humphrey, in his *American Handbook of the Daguerreotype*, suggested coating daguerreotype plates for outdoor views with "Chloride of Iodine" as an accelerator—he wrote that this worked too slowly for widespread use in the indoor studio but that for views it was "not to be met with in the productions of any other substances."[7] About buffing the plates, Humphrey said that, when a view was to be taken, the buffing marks should always be horizontal when the "picture" was in position.[8] He also praised Harrison's newly introduced camera for taking views; his only objection to the camera was that the exposure time was increased.[9] Many photographers, he said, kept to the old way of using the speculum or the mirror as a reflector.

In *The Camera and the Pencil*, Marcus Root stressed that, when taking an outdoor view of a building, landscape, or street scene, it was best to choose the most appropriate hour of the day, and he suggested that the photographer place his camera correctly to get the finest artistic effect from light and shadows. In executing a landscape scene, with living objects included, it was necessary for the daguerreotypist to use a faster accelerator in preparing his plates to shorten exposure time. In doing this, he had to sacrifice accuracy of form in the background objects, which could be obtained only by a long exposure time.

During the 1840s and 1850s, the easiest and probably the most pleasant way to travel was by boat. America led the world in inland navigation, and the colorful paddle-wheel river steamboat was the major carrier of people and goods.[10] This was not by any means a perfectly safe way to travel—mechanical failures and steamboat explosions were all too frequent. However, the railroad also had frequent wrecks.

New Orleans was the fourth-largest port in the world and steamboat traffic was heavy on the Mississippi, carrying not only goods of all description but emigrants and traders. Flatboats were also used in great numbers by merchants, doctors, dentists, showmen, and any other kind of trader or professional imaginable, including daguerreotypists. Indeed, a Mr. S. F. Simpson, in a letter to the editor of *The Photographic and Fine Art Journal* in 1855, said: "You could not name any business from the quack doctor to the Bar tender, that is not represented on the western rivers."[11]

Simpson, a daguerreotypist, wrote that his business was conducted wholly on the Mississippi River. He had already run two floating daguerreotype galleries down the river and was at work fitting up another, and these floating galleries, although rather new to the East, were popular in the West. The boats were fitted out with every convenience—in front was the reception room, the next room to the rear was a sitting room, and still further back was the chemical room. The sitting room was equipped with a large sidelight and a skylight, providing the operator with an exposure time of from five to ten seconds in good weather. Although guarding against dampness, Simpson said that it did not affect the operation as much as would be supposed.

In Simpson's opinion, the floating gallery was superior because, as soon as the boat docked, the traveling daguerreotypists were ready for business—with no need to unpack and set up equipment. As soon as things were slow, the operators could "untie our lines, spring upon deck, catch hold of our oars, and are off to another port."[12] There was also time for hunting and fishing, as ducks, wild geese, and many kinds of fish were plentiful.

In ending his letter, Simpson said that the year before he had left New Albany, Indiana, on the first of March, had stopped at about fifty landings, and had taken about one thousand daguerreotypes and traveled some fourteen hundred miles. However, the weather became too warm for his northern blood, and in June the yellow fever season was close, so he boxed up all his equipment, sold the boat (at a loss), boarded a fine steamer—the *Belle Sheridan*—and arrived back home in a little less than six days.

Other traveling daguerreotypists roamed the countryside of the East and invaded the West and the Southwest, including Texas; in the 1840s quite a few were in Mexico during the Mexican War. Still others

CAMERA FOR VIEWS.

Illustration of Charles C. Harrison's camera for taking reversed outdoor scenes. From The Daguerreian Journal, *1851. Words in daguerreotype scenes taken with regular camera lenses appear reversed—similar to those reflected by a mirror. Harrison's apparatus enabled the daguerreotypist to reverse the letters in scenes back to normal.*

Country portrait, ca. 1848. Half-size daguerreotype. Artist unknown. A typical portrait of an average rural family—note the work-worn hands on both man and woman. This daguerreotype is either a "reversed" daguerreotype or a copy from the original. Courtesy of George R. Rinhart.

toured South America, including the well-known Augustus Morand and Charles Fredericks.[13]

THE CALIFORNIA DAGUERREOTYPISTS

After gold was discovered in 1848, a considerable number of daguerreotypists appeared in the gold fields. Where many of these men came from or where they disappeared to after the first fevered days of the gold rush in unknown. Some left after only brief stays, while others with a more pioneering spirit would settle permanently to pursue successful careers in the fast-growing state. Albert Southworth visited from 1849 to 1850, when he returned east to his famous gallery. Frederick Coombs, who had daguerreotyped in Saint Louis in 1846 and in Chicago until 1849, came to San Francisco in 1850; he was best known for his views of Montgomery Street, but he did not linger in the city. A Mrs. Julia Shannon briefly advertised as a midwife and a daguerreian artist in 1850.

One of the first daguerreotypists to be lured west in search of gold was William H. Rulofson, who later became one of the great photographers of the West. Rulofson, a native of Maine, first learned the art of

Blacksmith's shop, ca. 1851.
Half-size daguerreotype.
Artist unknown.
To the far left of the scene is shown the rear of an itinerant daguerreotypist's van. These traveling saloons were often large and roomy, like one seen near Syracuse, New York, which was twenty-eight feet long, eleven feet wide, and nine feet high; it had a skylight and was reported to have been furnished with all the decor found in the best city galleries.
Courtesy of Norman Mintz.

daguerreotyping at about the age of seventeen in the establishment of L. H. Hale and Company, Boston. (James W. Black was the chief buffer at the gallery at that time.) After leaving Boston in 1845, Rulofson traveled far and wide and is believed to have carried his daguerreotype equipment with him, touring the eastern states, Canada, England, Ireland, and Wales, going from there to the Azores and Western Islands, then through Mexican territory to the southern states. By 1848, he was in Newfoundland briefly before leaving for the California goldfields with his camera and apparatus.[14] *The Philadelphia Photographer* later carried an account of his pioneer days there:

> He at length arrived safely on the shores of the new 'Land of Ophie,' and after a few short months of sun-painting, joined the ranks of the 'Honest Miners,' in which capacity he failed to distinguish himself for 'heavy finds,' and relinquished the gold-washing cradle for the camera, and returned to his first love. About the year 1850 he located in the flourishing town of Sonora . . . and here with a rapidly increasing family . . . together with a growing business, he was deterred from further migrations.[15]

A daguerreotypist from Charleston, Sterling C. McIntyre, advertised in March 1848 that he was selling his rooms and equipment and would be leaving the city.[16] It is likely that he practiced the art at towns along the way to California because, in December 1848, he advertised in the *Floridian* that he would be in Tallahassee for a few days with his apparatus to take likenesses. McIntyre reached California in 1850, and his panorama of San Francisco and its harbor received

Wealthy man and boy in buggy, Lebanon, New Hampshire, ca. 1847. Half-size daguerreotype. Artist unknown. Daguerreotype scenes often reflect the growing prosperity of American society: in about 1854, in a companion daguerreotype, this house was painted a lighter color, a new stable had been added, and the same man sat alone on his porch.
Courtesy of Josephine Cobb.

Conway Mutual Bank, Conway, Massachusetts, ca. 1855. Daguerreotype size not known. Artist unknown. A tableau of a banking day. The scene has been carefully posed to depict a gathering of entrepreneurs in front of a small town's social center.
Northampton Historical Society, Northampton, Massachusetts.

Faculty of the Albany Normal School, 1850. Sixth-size daguerreotype. Artist unknown. The Kingston Journal *wrote about the Albany Normal School on June 5, 1850: "The summer term of this institution commenced three weeks ago. The school contains 207 pupils. . . . There are nine teachers including the principal George R. Perkins . . . there is also a exper-imental school, containing 88 pupils—these being younger children. . . . The Legislature . . . made an appropriation of $1,000 to provide for the support of a number of Indians, not exceeding ten. . . . Eight Indians have already made their appearance . . . three . . . in the experimental school while five passed the examination for the Normal School and one of these takes high rank. There is also another Indian on his way who has not reached Albany." Out of the presumed nine daguerreotypes (the original and eight copies) of this school made in 1850, only two are extant.*
Rinhart Collection,
the Ohio State University,
Columbus.

praise in the *Alta California* on January 19, 1851. By March, he is be-
lieved to have left the city.

The pioneer daguerreotypist William Shew, who came from Boston
in 1851, would remain as a photographer in California until his death.
Shew and his brothers, Myron, Jacob, and Trueman, were said to have
learned the art from Samuel Morse, and they must also have received
instruction from John Plumbe, because William was the operator for
Plumbe's Boston gallery in 1841.[17] He became a miniature casemaker in
1844 in Boston and later in the decade advertised as a daguerreotypist.[18]

Shew arrived in San Francisco with an itinerant's wagon and, using
this well-equipped portable studio, began operating in the city; he is
best known for his five-plate panorama of San Francisco, taken in 1851.
Jacob Shew, who had operated Plumbe's Baltimore gallery in the early
years, had preceded William to California in the summer of 1849, had
worked in the goldfields, probably until his brother arrived, and had
then returned to Baltimore.[19] Myron Shew sold daguerreotype materi-
als in Philadelphia and, in 1851, bought out Van Loan's gallery; in 1856,
he also went to San Francisco.

Robert Vance was the first daguerreotypist to have his scenes of
California and the hectic days of the gold rush reach the people back
east. With the eye of a photohistorian, he took some three hundred

A day at the factory, ca. 1850.
Quarter-size daguerreotype.
Artist unknown.
America was undergoing an in-
dustrial change in the 1840s and
1850s. The small factory employ-
ing fifteen to thirty people was
emerging as a basic unit of pro-
ductivity—a move toward a more
efficient mass fabrication of com-
modities. Some were located
alongside rivers and streams
while others used steam as a
source of energy. This rare scene
shows the waterwheel racing on
while twenty-four people and two
horses were stilled for their mo-
ment before the camera's lens.
Rinhart Collection,
the Ohio State University,
Columbus.

Advertisement from the
Charleston Courier, *March 1,*
1847.

PHOTOGRAPHIC LIKENESSES,
Taken by the recently much improved Daguerrian
Process.

MR. McINTYRE respectfully invites the attention o
his friends and the public to the specimens he has
just received.

Persons wishing LIKENESSES of themselves or
friends, separately or in groups, either in the Engraving
or Colored style, neatly set in Cases, Frames, Gold Lock-
ets or Breast Pins, can have them completed in a few
minutes; the time required for sitting being much redu-
ced from that of last season.

Ladies are respectfully recommended to dress in figur-
ed or dark material, avoiding white or light blue; a scarf
or shawl gives a pleasing effect to the picture. Gentle-
men—a black or figured vest, also figured scarf or cravat;
so that the bosom be not too much exposed. Children—
plaid stripped or figured dresses; lace work adds much to
the beauty of the picture. The best hour for Children is
from 11 A. M. to 2 P. M ; a cloudy day preferred for very
light complexions.

Many persons are impressed with the belief that the
Daguerreotype Likenesses will fade in a few years. The
following testimonial from the greatest Chemist in the
world is conclusive testimony against this opinion.

Professor Faraday says : "Likenesses taken by this in-
teresting art in its earlier days were liable to fade in a few
years. The late improvement of Chemical gilding on
the surface of the plate, forms a pure image of silver and
gold which must retain its brilliancy for ages."

ON HAND, FOR SALE,
German and American CAMERAS, French and Am-
erican Plates, Cases, Sensitives, and other Chemicals.
N 27 f 190 KING-STREET.

House and outbuilding with man
and boy in foreground, ca. 1850.
Quarter-size daguerreotype. Art-
ist unknown. An interesting
primitive out-of-focus daguerreo-
type, probably done by an ama-
teur attempting to take a view of
his homestead.
Anonymous collection.

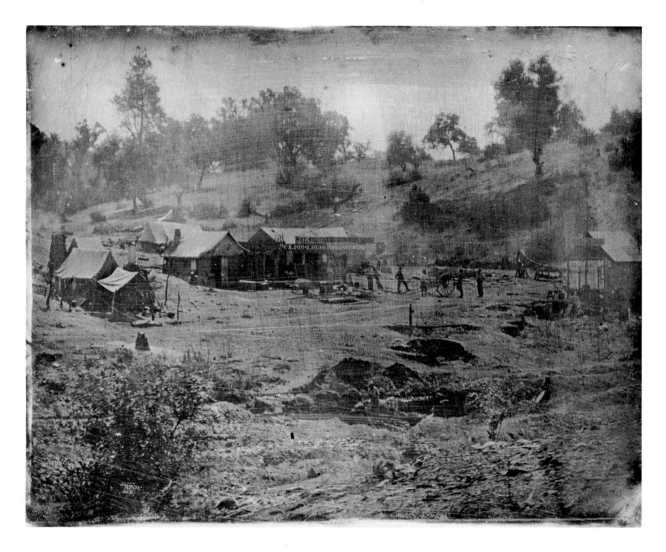

daguerreotype views of the towns and the miners, probably beginning in late 1850 or early 1851, because among the views were scenes of the May 1851 fire in San Francisco, as well as a number of views before and after the conflagration, a practice which later photojournalists would adopt as standard procedure when covering disasters. Later in 1851, Vance brought his collection to New York, where he issued a catalog with a preface and a detailed description of each view:

> . . . the Artist flatters himself that the accompanying Views will afford the information so much sought after. . . . They embrace . . . San Francisco . . . Stockton, Coloma, Carson's Creek, Mokelame Hill, where gold was first discovered, Nevada, Gold Run, Marysville, Sacramento, Benicia, etc., etc. Also a large collection of views taken of the miners at work . . . a likeness of Capt. Sutter, and a large collection of sketches of the different tribes of Indians on the Pacific Coast. Embracing in all some 300 views, on the largest size plates, elegantly framed in rosewood and gilding.[20]

Mining camp, Jamestown, California, ca. 1851. Half-size daguerreotpe. Artist unknown. This scene demonstrates the sluiceway method of mining gold. In the foreground may be seen a lucky miner holding a large nugget in his outstretched hand. S. Woodworth, a Vermont native, shrewdly opened his wheelwright, carpenter, and blacksmith shop convenient to mining activities.
Rinhart Collection,
the Ohio State University,
Columbus.

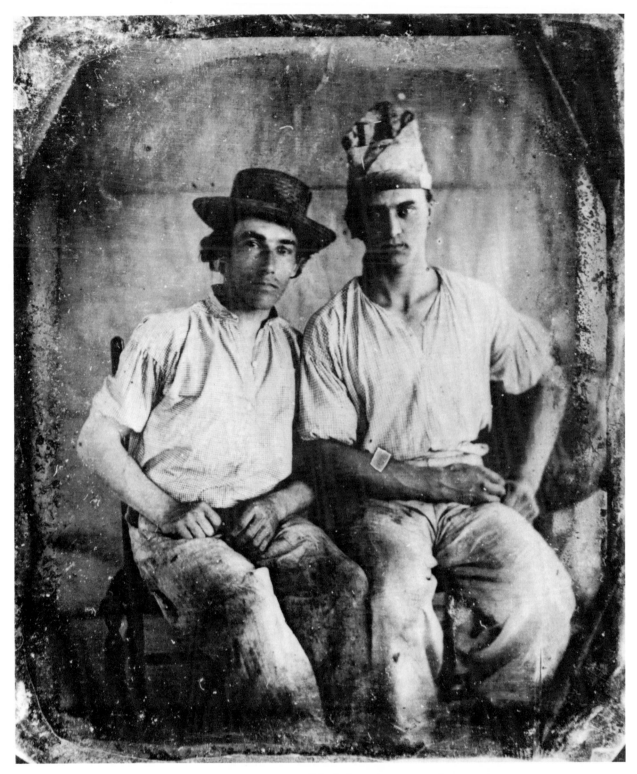

The bakers, ca. 1849.
Sixth-size daguerreotype.
Artist unknown.
A haunting primitive portrait of
two men, possibly bakers in a
mining camp, dressed in work
clothes. The man to the right
wears a hat fashioned from a
flour sack.
Rinhart Collection,
the Ohio State University,
Columbus.

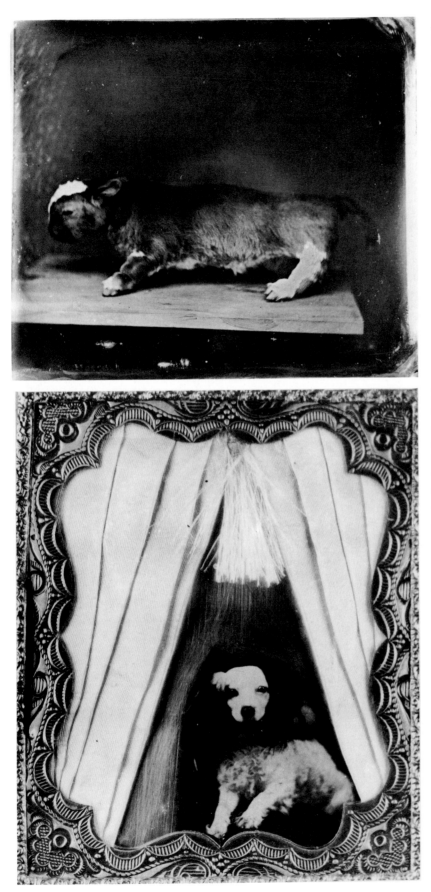

A mutant calf, ca. 1850.
Sixth-size daguerreotype.
Artist unknown.
Americans were fascinated with oddities of nature, as evidenced by the success of P. T. Barnum's museum on Broadway. This specimen has been stuffed for display.
Rinhart Collection, the Ohio State University, Columbus.

The fancy poodle, ca. 1855.
Sixth-size daguerreotype.
Artist unknown.
In 1846 a fad appeared in Boston of dyeing lapdogs to match the color of each owner's dress—pink and blue were the most popular colors. The owner of this daguerreotype removed all details on the plate except the dog's image and framed the portrait under glass with silk and tassel.
Rinhart Collection, the Ohio State University, Columbus.

Man with twelve fingers,
ca. 1856.
Sixth-size daguerreotype.
Artist unknown.
The oddities of the human race
were often exploited, with adver-
tisements in newspapers telling
where or when the subject could
be seen. This man, who has an
extra finger on each hand, ap-
pears to be a stage performer
dressed in an unusual striped
coat and holding a rod or cane.
Rinhart Collection,
the Ohio State University,
Columbus.

Vance placed his collection on display at Whitehurst's gallery at 349 Broadway; also included were a number of Central and South American views of Panama, Cuzco, and Valparaiso. Whitehurst charged an admission fee of twenty-five or fifty cents for a season pass to see the collection;[21] when he sold the gallery to Jeremiah Gurney in late 1852, the entire display remained with the gallery as part of the sale.[22] In 1853, Gurney sold the Vance collection to John Fitzgibbon, and the views were exhibited in Fitzgibbon's Saint Louis gallery. The gallery was sold in 1861, and the ultimate fate of the collection remains unknown.

EXPEDITIONS AND EXPLORATIONS

The American frontier was turning westward during the era of 1840 to 1860 with railroads, canals, turnpikes, and river transportation which accommodated the increasing number of settlers traveling to the West. Also, in this era of westward expansion, the United States was seeking international recognition by sending expeditions to the Antarctic, Japan, and elsewhere.

Possibly the first man to accompany a government expedition with a camera was Edward Anthony. One of the great names in photography, Anthony was a member of the United States government survey of the northeast boundary—headed by Professor James Renwick of Columbia University, where Anthony had studied engineering—with duties as a civil engineer and a photographer. The purpose of the expedition was to determine the northeast boundary between Canada and the United States.

Anthony became interested in the daguerreotype process after viewing François Gouraud's exhibit in 1839 and began experimenting on his own by inserting an ordinary twenty-five-cent spectacle lens into a cigar box.[23]

Professor Renwick wrote to the secretary of state on August 29, 1840, that the survey party had arrived at Bangor, Maine, and that

Surveyor in the field, ca. 1854.
Quarter-size daguerreotype.
Artist unknown.
A rare portrait of a surveyor
who typifies American expansion
from 1840 to 1860.
Courtesy of Norman Mintz.

Anthony was "2nd assistant," to be paid two dollars a day.[24] The daguerreotypes taken during the survey were used as models for drawings; the *British Journal of Photography* later noted, when writing of Anthony, that these photographic views of the disputed territory were invaluable in determining the difficult question of boundary. Also, it was noted that this was "the first instance of the employment of photography in the service of nations."[25] The subsequent whereabouts of the daguerreotypes are unknown.

Meanwhile, expeditions were being sent to the West. In 1841, Charles Wilkes, commanding a naval squadron, explored the Pacific coast of North America. While wagon trains were California-bound in fairly large numbers in mid decade, the government dispatched the Pacific fleet in 1845 on a secret mission which led to the eventual takeover of California by the United States.[26] Part of the California acquisition was indirectly due to the Frémont expeditions to explore the Far West. On his first expedition, in 1842, Frémont had been unable to produce daguerreotypes.[27] His first success with photography came in 1853 and 1854, during the fifth expedition, when he brought two professional photographers along—Solomon Carvalho, an artist and daguerreotypist, and a Mr. Bomar, who took photographs on glass.[28]

In his *Incidents of Travel and Adventure in the Far West*, Carvalho later recounted attempts to capture the exact image in the camera's lens and complained of the effects of low temperatures, high altitudes, and other difficulties encountered in the taking of daguerreotypes.[29] He brought back daguerreotype scenes of landscapes and portraits of Indians; while the subsequent whereabouts of the original daguerreotypes are unknown, Mathew Brady copied them in the winter of 1855–56, by the wet-plate process.[30] The prints were used for preparing plates for Frémont's proposed report.

In the spring of 1853, John Mix Stanley, a celebrated painter of Indians and a daguerreotypist, accompanied a party surveying a northern route to the Pacific under the command of Isaac I. Stevens. Stevens wrote of Stanley's work with the camera: "Mr. Stanley commenced taking daguerreotypes of the Indians with his apparatus. They are delighted and astonished to see their likenesses produced by the direct action of the sun, and they consider Mr. Stanley was inspired by their divinity and he thus became in their eyes a great medicine man."[31] An experienced daguerreotypist having practiced the art as early as 1842, Stanley had taken a camera with him when he went to Fort Gibson in Arkansas Territory in that year. An item appeared in the *Maine Democrat*, in 1842, which had been reprinted from the *Arkansas Intelligencer*: "Stanley and Dickerman are here employing their time in taking Indian portraits both with the pencil and Daguerreotype apparatus." What became of Stanley's daguerreotypes and scenes is unknown—they were possibly destroyed in the Smithsonian fire of 1865, which burned most of the institution's Indian paintings.

With Matthew Perry's opening of the Japanese treaty ports to world trade in the early 1850s, a new view of the American navy was given to the world—and the government expedition to Japan was considered one of the great nineteenth-century achievements. Accompanying the Perry expedition was the artist, lithographer, and daguerreotypist Eliphalet M. Brown, Jr., who had exhibited at the National Academy in 1841 and had earned an excellent reputation for his work in lithogra-

George Gordon Meade,
June 1842.
Half-size daguerreotype.
Artist unknown.
Meade as a young officer serving
as topographical engineer in the
United States Army, one month
following his appointment as
second lieutenant. Meade went
on to distinguish himself in a
long military career.
Rinhart Collection,
the Ohio State University,
Columbus.

Advertisement from the
Charleston city directory, 1852.

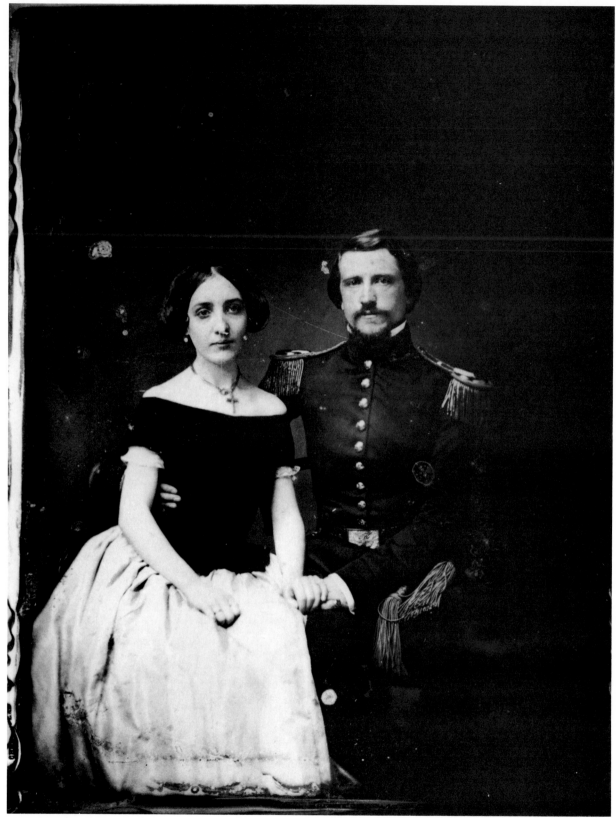

The general and his lady, *By Mathew B. Brady.* *and his lady.*
ca. 1856. *A rare and beautiful portrait of* *Courtesy of Josephine Cobb.*
Half-size daguerreotype. *a distinguished military man*

An engraving showing the trials and tribulations of a daguerreotypist in the Far West. Authors' collection.

phy. The expedition reached Macao, China, on April 7, 1853; sometime during the month, Commodore Perry reported the occupation of a house at Macao where "the artists were to bring up their work at the house hired for the purpose. The several apparatuses of the Magnetic Telegraph, the Daguerreotype, and the Talbotype were established and put in full operation. . . . While Lt. Bent was employed in preparing fair copies of the charts, Messrs Heine, Brown and Patterson were constantly engaged in bringing up and completing their sketches and drawings of which more than two hundred and fifty had already been made."[32]

The squadron left Macao on April 28 for Shanghai, where Perry spent two weeks before leaving for what is now known as Okinawa. In a letter to the secretary of the navy, dated June 25, 1853, Perry reported that the "exhibition of the Daguerreotype, the Magnetic Telegraph, the Submarine Armor and other scientific apparatus have been made to the utter astonishment of the people."[33] Also in late June, Perry gave notice to Brown that "he must prepare his materials, occupy the building, and commence the practice of his art." The building occupied by Brown and others was called the House at Tumai, in Lew-Chew. Perry's ships arrived off Tokyo on July 8, his errand ostensibly being to deliver in peace a letter from President Fillmore. He departed on July 17 and spent the winter along the coast of China. On his return trip to Japan in 1854, he reported that much work was accomplished with their collections of natural history, drawings, and sketches, and a collection of daguerreotypes would have been included.[34]

Brown had received permission from Perry to publish four original sketches of the landings in Japan that were too large to be used in the report of the expedition; they were published in 1855 by the lithographers Sarony and Major. In Perry's official report of the expedition, thirteen lithographs and six wood engravings refer to the daguerreotype work of Brown.[35] Eliphalet Brown petitioned Congress from 1857

until his death in 1886 for compensation for his services as an artist on the expedition. His petition of March 23, 1860, stated that he had taken over four hundred pictures, many of which were used to illustrate Perry's report of the expedition.[36] The ultimate fate of his daguerreotypes is unknown.

PORTRAITS OF AN AGE

Before the advent of the daguerreotype, portraits of Americans and scenes depicting their lives and occupations were often idealized and lacked the accuracy provided by the camera's eye. A realistic portrayal of American life was possible only when the daguerreotypists focused their cameras to record the faces and scenes of America. Once the first scenes from abroad were displayed for public view, the world

Japanese dignitaries. From a daguerreotype by Eliphalet Brown. National Archives.

was brought closer in pictorial realism. The small nucleus of daguerreotypists quickly spread out across America, and the people flocked in great numbers to have their images taken.

Pictures of the prominent men of the day and the heroes of the Republic, photographed in the early years of the art, were hung in galleries for all to see—the clergy, the politicians, the military, the authors, the scientists, all the people who made the nation great. Among the remarkable early portraits were those taken of contemporaries of George Washington, not a few of whom may have remembered the French and Indian Wars. Many would have been mature citizens by the time of the Revolution. Some daguerreotypists of the era, sensing the historical importance of such images, advertised that people over one hundred years old could have their portraits taken without charge.

After the daguerreotypists had almost completed their twenty

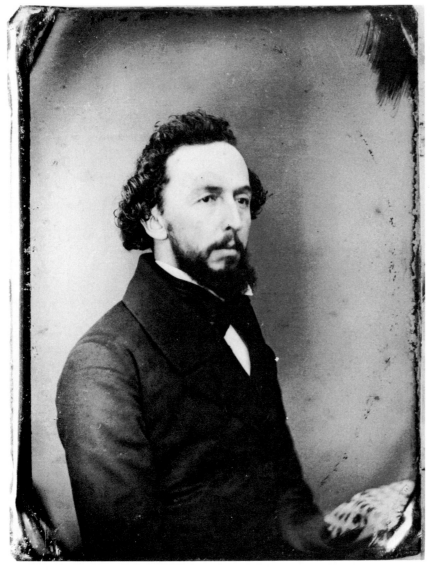

Bayard Taylor (1825–1878), early in 1851. Quarter-size daguerreotype. Artist unknown. Taylor, a popular nineteenth-century author and world traveler, became the United States minister to Germany in 1877. Inside the daguerreotype case are two newspaper clippings—one notes the death of Taylor in Berlin, the other the fact that Mrs. Taylor and her daughter were to spend the summer of 1891 at Kennett Square, Pennsylvania—the town where Taylor was born.
Courtesy of Josephine Cobb.

Man with quill pen, ca. 1847.
Sixth-size daguerreotype.
Artist unknown.
Posed with pen and paper, this
subject is possibly an author.
Courtesy of Josephine Cobb.

Chess players, ca. 1856.
Quarter-size daguerreotype.
Artist unknown.
In 1858 national attention was
centered on Paul Morphy, the
leading American chess player,
when he toured Europe and de-
feated the best chess players on
the Continent.
Courtesy of Norman Mintz.

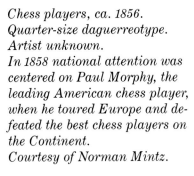

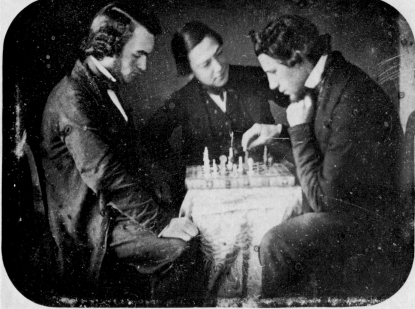

Actor, ca. 1855.
Half-size daguerreotype.
Artist unknown.
Theatrical productions in the cit-
ies were very popular with the
general public, and success on
the stage often brought immedi-
ate fame and fortune in the
1850s.
Courtesy of Josephine Cobb.

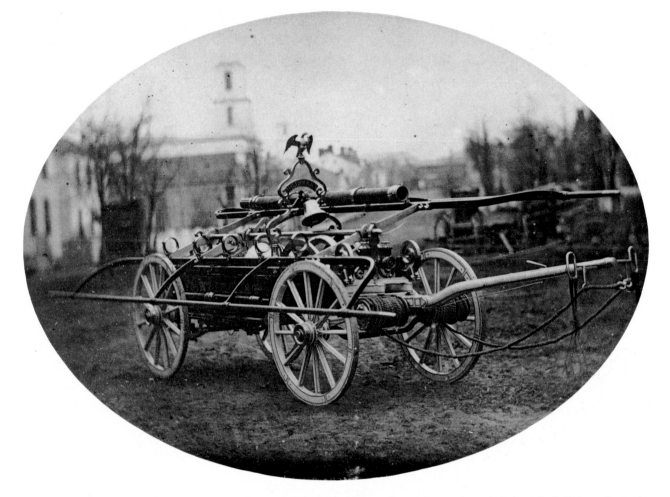

The Franklin, 1848.
Half-size daguerreotype.
Artist unknown.
Volunteer fire companies were
political factors in the mid nine-
teenth century—the annual
balls, parades, chowder parties,
and picnics promoted by firemen
were all helpful for the politi-
cally minded.
Courtesy of Norman Mintz.

years of work, the character of the era's people was indelibly reflected on the mirrorlike daguerreotype plates, but these first exact images were little understood by many later historians, who often had a stereotyped view of the age before the Civil War. Daguerreian portraits, with the exception of those of famous people, were seldom recognized or appreciated because the hundreds and thousands of these images were mostly owned by individuals or were assembled in small, scattered collections owned by museums, historical societies, or other institutions. Not enough specimens were available for a mass grouping—but a remarkable panorama of an age is revealed when this is done, representing a historical record as well as a powerful art.

In 1855, Nathan Burgess, a pioneer daguerreotypist from 1840, wrote an article titled "The Value of Daguerreotype Likenesses." His prophetic words should be repeated as the daguerreian art now takes its place in the history of photography:

> In after ages, when these images on the silver plate have become an olden theme like the sublime creations of the painter's skill of a former age, then indeed their true value will be known and appreciated. When the speaking eye and warm cheek of loved ones, and the thousands of living statesmen and men of learning shall have passed away and left only their impress upon the tablet, then, and not till then, will this art assert its true greatness.[37]

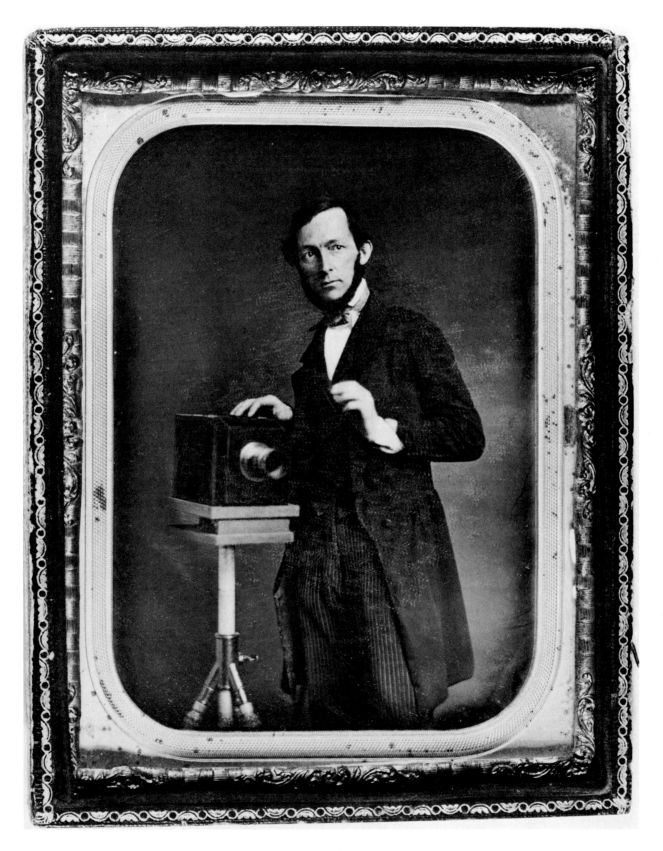

Daguerreotypist with camera. *Artist unknown.*
Half-size daguerreotype. *Courtesy of George S. Whiteley IV.*

BIOGRAPHIES

For ease of referral, the biographies of daguerreotypists and those of the allied supply industry have been separated into several categories: biographies of professional and amateur daguerreotypists, biographies of manufacturers and wholesale suppliers, and biographies of miniature casemakers and engravers. Throughout the biographies, arbitrarily, the term "daguerreotype" demarcates the process from other forms of photography.

Among the practitioners of daguerreotyping, many were also actively engaged in the photographic supply sector. They have been placed under the heading in which they were best known or most successful. The names are often cross-indexed for reference.

The data are limited to existing citations obtained by us; thus, it is highly probable that a gallery, daguerreotypist, or supplier was in operation before or after the dates indicated. Excluded from the listings are a number of photographers who may have practiced daguerreotyping after 1854, but enough evidence has not been found to warrant their inclusion.

An asterisk indicates that the daguerreotypist was an artist or had received art instruction.

KEY TO ABBREVIATIONS

AA	*American Advertiser* (Belden's, N.Y., 1850)
ACB	*Appleton's Cyclopaedia of American Biography*
AI	*Transactions of the American Institute*
AJP	*American Journal of Photography*
AMCA	Floyd Rinhart and Marion Rinhart, *American Miniature Case Art* (South Brunswick & New York: A. S. Barnes & Company, 1969)
APB	*Anthony's Photographic Bulletin*
BD	Business directory or register for the city and date noted
BJP	*British Journal of Photography*
BN	Beaumont Newhall, *The Daguerreotype in America* (New York: Duell, Sloan & Pearce, 1961)
CAS	Charles A. Seeley Catalog, 1859
CD	City directory for the date noted
CHS	Chicago Historical Society
Dag'type	Daguerreotype
Dag'typing	Daguerreotyping
Dag'typist	Daguerreotypist
DJ	*The Daguerreian Journal*
FIJ	*Journal of the Franklin Institute*
HHS	Henry Hunt Snelling, *A Dictionary of the Photographic Art* (New York: H. H. Snelling, 1854)
HJ	*Humphrey's Journal*
MAR	Marcus A. Root, *The Camera and the Pencil* (Philadelphia: M. A. Root, 1864)
NDJ	*The New Daguerreian Journal*
Nsp	Newspaper for the city and date noted
NYHS	George C. Groce and David H. Wallace, *The New-York Historical Society's Dictionary of Artists in America, 1754–1860* (New Haven: Yale University Press, 1957)
OSU	Floyd and Marion Rinhart Collection, Department of Photography & Cinema, the Ohio State University at Columbus
PAJ	*The Photographic Art Journal* and *The Photographic and Fine Art Journal*
PP	*The Philadelphia Photographer*
PWB	Notes of Philip W. Bishop (Scovill business records)
RBD	Regional business directory for the area and date noted
RT	Robert Taft, *Photography and the American Scene* (New York: Macmillan Company, 1938)
SA	The *Scientific American*
SBD	State business directory for the state and date noted
SLP	*St. Louis Practical Photographer*
SV	William Culp Darrah, *Stereo Views* (Gettysburg, 1964)
USC	United States census for the date noted

PROFESSIONAL AND AMATEUR DAGUERREOTYPISTS

A & H Photographic Rooms. *See* Artault, Hubbell.

Abel, Henry I. Dag'typist. Bought out J. F. S. Huddleston, Sept. 1, 1841. Gallery at 123 Washington St., Boston, 1841–1842. Nsp, *Evening Transcript;* Boston almanac.

Abell, E. Dag'typist. Gallery, Erie, Pa., 1857. CD.

Adams, Charles H. Dag'typist. Gallery at 190 Washington St., Boston, 1849–1851. CD.

*Adams, Daniel. Engraver, dag'typist. Gallery, Nashville, Tenn., 1845; over Gowdy's Jewelry Store, Public Sq., Nashville, 1854–1859. Took dag'type of Andrew Jackson, 1845. Adv. instruction and supplies. BN; BD.

Adams, D. G. Dag'typist. Gallery at 196 Washington St., Boston, 1847. CD.

Adams, George. Dag'typist. Gallery at 142 Main St., Worcester, Mass., 1847–1853. Gallery sold to Wm. H. Fitton, 1867. CD; nsp; HJ; BD.

Adams, Samuel. Dag'typist. Gallery, Hallowell, Me., 1849. SBD.

Adams, Thadeus. Dag'typist. Born 1829, Tenn. Gallery, McNair Co., Tenn., 1850. USC.

*Adams, William G. Engraver, dag'typist. Gallery, Memphis, Tenn., 1849–1852; Main and Front Row, Memphis, 1853. CD; nsp adv., 1853.

Aduddell, George M. Dag'typist. Gallery, Barnesville, Ohio, 1853. SBD.

Alexander, I. B. Dag'typist. Room in Robertson Hotel, Charlotte, N.C., 1843. Nsp adv., *Jeffersonian,* June 1843.

Alger, A. C. Dag'typist. Gallery on Canal St., Grand Rapids, Mich., 1856. CD.

Allen & Plant. Dag'typists. Rooms at 131 Congress St., Savannah, Ga., 1845. Nsp adv.

Allen, Amos M. Dag'typist, photographer. Born 1823, New England; died July 15, 1907, Pottsville, Pa. As young man moved to Middleton, Pa. Became established as dag'typist, Pottsville, in early 1850s. Awarded highest premium for "Daguerreian Profiles" at the fair of the Schuylkill County Agricultural Society. Continued as photographer in Pottsville and was well known for his photographs and stereo views of mining activities, town scenes, and countryside. Retired in 1893. Active politically in Pottsville. CD; HJ, 1853, p. 174; nsp, Pottsville, 1907.

Allen, A. P. Dag'typist. Associated with Luther P. Dodge. Gallery at 151 Jefferson Ave., Detroit, Mich., 1853. CD.

Allen, C. V., & Co. Dag'typist. Gallery, Keene, N.H., 1849; listed at 258½ Washington St., Boston, 1855, and 173 Washington St., 1856. RBD, 1849; BD.

Allen, J. L. Dag'typist. Gallery, Memphis, Tenn., 1849. CD.

Allen, Wm. A. Dag'typist. Listed at 204 Chatham St., NYC, 1850; 30 (?) Broadway, NYC, 1851. BD.

Alschuler, Samuel D. and Simon. Dag'typists. Gallery at cor. Randolph and Canal, Chicago, 1853–1854; 139 Lake St., 1855; 142 Lake St., 1856–1858; Alschuler & Florence (Chas. A.), 1858; 1365 Clark St., 1859–1860. CHS; SBD; Charles Hamilton and Lloyd Ostendorf, *Lincoln in Photographs: An Album of Every Known Pose,* 1963.

Alvord & Talmadge. Itinerant dag'typists. Rooms in Franklin House, Athens, Ga., 1851. Nsp, Jan. 28; nsp adv., Feb. 6.

Anderson, D. H. Dag'typist, photographer. Born 1827, NYC. After graduating from Kingston, N.Y., academy, became interested in mercantile pursuits. Took up dag'typing, 1854; in southern and western cities as photographer until about 1866; Richmond, Va., 1866–1875. Traveled in Europe 1873 and visited Vienna Exposition; met M. Dagron, photographer to emperor, and was encouraged to remain but returned to Richmond. APB, June 1875, p. 175.

Anderson, J. D. Dag'typist. Gallery, Worcester, Mass., 1853. SBD.

Anderson, Wm. Dag'typist. Gallery, Bloomington, Ill., 1854. SBD.

Andrews, John D. Dag'typist. Worcester, Mass., 1850–1855. Publications of the Worcester Historical Society, 1928.

Andrews, J. Thomas. Dag'typist. Gallery, Young, Ill., 1854. SBD.

Anson, Rufus. Dag'typist, photographer. Gallery, NYC, ca. 1851–1867. In an 1856 article, "The Photographic Galleries of America," his gallery is described: "Anson's gallery is decidedly superior. It is most tasteful in its arrangement, and great order and cleanliness are preserved throughout. The specimens all show the artist's hand. This gallery deserves the most liberal patronage." HJ, 1851–1854; CD; PAJ, 1856, p. 20.

Anthony, Charles J. Dag'typist, inventor. Providence, R.I., 1847; gallery, Pittsburgh, Pa., 1850–1851. Invented vignette process, patented Jan. 1, 1851 (7,865). The dag'type process, called "Magic Background," had a measure of success among dag'typists. *See also* Hough & Anthony. CD; SA, May 1850, p. 276.

Anthony, Edward. *See* Manufacturers and wholesale suppliers.

Anthony, Edwards & Co. Dag'typists. Gallery at 247 Broadway, NYC, 1844. *See also* individual biographies. BD; nsp, 1844.

Anthony (E.), Edwards (J. M.) & Chilton (H.). Dag'typists. Gallery at 247 Broadway, NYC, 1843–1844. *See also* individual biographies. BN; BD, 1843.

Anthony (E.), Edwards (J. M.) & Clark (J. R.). Dag'typists. National Miniature Gallery at 247 Broadway, NYC, 1844–1845. *See also* individual biographies. BD (*The Gem*), adv., 1844.

Anthony, Henry T. *See* Manufacturers and wholesale suppliers.

Anthony, J. B. Dag'typist. Poplar Grove, S.C., 1852. HJ.

Appleby, R. B. Dag'typist. Gallery at 14 Arcade St., Rochester, N.Y., 1854. PAJ.

Armitage, George. Dag'typist. Columbus, Ohio, 1856. CD.

Armsted, G. Dag'typist. Partner with A. L. Feller, Columbus, Ohio, 1856. CD.

Armstrong, A. Dag'typist. Gallery at 51 S. Front St., Philadelphia, 1854–1855. BD.

Armstrong, James S. Dag'typist. Gallery at 175 Broadway, NYC, 1846; exhibited at American Institute, two frames of dag'types, 1846; gallery at 315 Broadway, 1848–1851. AI; BD.

Arnold, J. L. Dag'typist. Mendon, Ill., 1854. SBD.

Artault & Hubbell. Dag'typists. Gallery, New Haven, Conn., 1844. CD.

Artault, François A. Dag'typist, supplier of dag'type apparatus. Listed at 235 Broadway, NYC, 1844–1845; 149 and 151 Broadway, 1846; 151 Broome St., 1845–1847. Employed a Mrs. H. Shankland as dag'typist, 1846. CD; *The East,* 1846.

Atkins, Joseph. Dag'typist. Gallery at 219 Fulton St., Brooklyn, 1848–1851. Listed at 263 Fulton St., 1852–1859. CD; DJ.

Atwood, N. C. Dag'typist. Keene, N.H., 1849. RBD.

Auxer, G. H. Dag'typist. Gallery, Chambersburg, Pa. Miniature case imprint on velvet with name and location of gallery.

Avery, Charles. Amateur dag'typist, teacher. Pupil of Morse. Taught at Hamilton College, Clinton, N.Y., and took dag'type portrait of John Quincy Adams in Aug. 1843 (portrait owned by National Portrait Gallery, Washington, D.C.). Information courtesy of John Duncan.

Babb, Wm. G. Dag'typist. Gallery at 219 Greenwich St., NYC, 1849; 177 Greenwich St., 1853–1854. BD.

Babbitt, Lewis. Dag'typist. Worcester, Mass., ca. 1849. Publications of the Worcester Historical Society, 1928.

Babbitt, Platt D. Dag'typist, photographer. Pavilion on Prospect Point, Niagara Falls, N.Y., 1853–1870. BN; RT.

Bacon, James E. Dag'typist. Gallery at 472 W. Baltimore St., Baltimore, 1858–1859. CD.

Badcock, George. Dag'typist. Gallery at Clark St. near Lake St., Chicago, 1847–1848. CHS.

Badger, H. L. Dag'typist. Gallery, Galena, Ohio, 1853. SBD.

Bailey, ———. Dag'typist. Winchester, Va., 1852. OSU.

Bailey, John B. Black dag'typist. From Boston. Practiced dag'typing White Sulphur Springs, W.Va., 1845. Taught James P. Ball dag'typing. Information courtesy of Romare H. Bearden.

Bailey (Bayley [?]), Morris. Dag'typist. Gallery at 88 Merrimac St., Lowell, Mass., 1851–1852; Ashland, N.Y., and Lowell, 1853–1855. Levi L. Hill, *A Treatise on Heliochromy* (1856); CD adv., 1853; SBD.

Bailey, Thomas Ives. Dag'typist. Gallery, Columbia, Tenn., 1851–1854. DJ; HHS.

Baker, Elisha W. Dag'typist. "Daguerreotype Institute" on Market St., Providence, R.I., 1847–1849. CD; SBD.

Baker, F. S. Dag'typist. Gallery, Baltimore, 1850–1851. DJ.

Baker, Isaac. Itinerant dag'typist. San Francisco, 1850s. Information courtesy of Robert A. Weinstein.

Baker, S. Dag'typist. Gallery at N.W. cor. Baltimore St. and Center Market, Baltimore, 1849. BD.

Baker, Samuel. Dag'typist. Gallery, Lowell, Mass., 1853. CD.

Baker, W. D. Dag'typist. Gallery at 116 Chestnut St., Philadelphia, 1854–1855. SBD.

Balch & Hale. Dag'typists. Gallery at 118 Bowery St., NYC, 1853–1854. BD.

Balch, Mrs. Eliza. Dag'typist. From Mass. and Vt., living in NYC in 1860 with two sons, Leland, Jr., and Eugene, both artists. USC; NYHS.

Baldwin, H. Dag'typist. Location unknown, ca. 1853. Image mat stamped H. Baldwin.

Ball, James P. Black dag'typist, photographer. Learned art from John B. Bailey at White Sulphur Springs, W.Va., 1845. Itinerant traveling in mid 1840s around Pittsburgh, Pa., 1846, and on to Richmond, Va. Opened gallery, Cincinnati, Ohio, 1847; gallery listed at Weeds Bldg., 1849; 28 & 30 W. 4th St., 1852. Associated in 1852 with Alexander Thomas. Listed as Ball & Thomas at 120 W. 4th St. (James P. Ball, Alexander S. Thomas, and Thomas C. Ball), 1854–1858. Branch photographic studio, Hamilton, Ohio, 1866. Gallery at 30 W. 4th St. as late as 1874. In 1855 a very large panorama of black life along the Ohio, Susquehanna, and Mississippi rivers was displayed in the gallery. A lecture commenting on the panorama, by James P. Ball, was published by Achilles Pugh, Cincinnati publisher and abolitionist—"Ball's Splendid Mamoth Pictorial Tour of the U.S. Comprising Views of the African Slave Trade of Northern and Southern Cities of Cotton and Sugar Plantations of the Mississippi, Ohio, and Susquehana Rivers, Niagara Falls, etc." Ball also employed the black artist Robert S.

Duncanson in his gallery and displayed six landscape paintings by the artist. *See also* Thomas, Alexander S. SBD, 1852, 1866; CD, 1857; *Southern Pictorial Advertiser*, 1858; Wendell P. Dabney, *Cincinnati's Colored Citizens*, 1926. Information also courtesy of Romare H. Bearden and James de T. Abajian.

Ball, Thomas C. Black dag'typist, photographer. Brother of James P. Ball. Associated with brother's Cincinnati gallery, 1852; T. A. Ball & Harlan, 28 W. 4th St., 1857; Ball & Thomas Gallery (James P. Ball, Alexander S. Thomas, and Thomas C. Ball), 120 W. 4th St., 1858. Graduated from Cincinnati High School. CD, 1857; *Southern Pictorial Advertiser*, 1858; Wendell P. Dabney, *Cincinnati's Colored Citizens*, 1926. Information also courtesy of Romare H. Bearden and James de T. Abajian.

*Bamborough, Wm. Portrait painter, dag'typist. Born 1792, Durham, Eng.; died 1860. Came to U.S. and settled in Columbus, Ohio, 1819. Friend of J. J. Audubon, traveled with him in South, 1824–1832. Living in Columbus with wife, Lucy (born ca. 1811, Pa.), and daughter, Mary (born ca. 1844, Ohio); listed as dag'typist, High St., Columbus, 1853. NYHS; SBD, 1853.

Banta, Jacob C. Dag'typist. Gallery at 284 Bleecker St., NYC, 1851. BD.

Barcolow, Richard G. Dag'typist. Gallery at 80 Bowery St., NYC, 1849–1854. BD.

Bardwell, J. J. Dag'typist, photographer. London, Eng., 1843; practiced dag'typing with J. E. Whitney, St. Paul, Minn., 1853; photographer, Detroit, Mich., 1850 to ca. 1870. PP.

Bargodus, Wm. Dag'typist. Washington, Ill., 1854. SBD.

Barker, H. Dag'typist. Gallery at 373 Broadway, NYC, 1851. BD.

Barnaby, S. B. Dag'typist, educator, teacher. Born 1817, Mass. Moved westward to Ohio and in 1845 established Barnaby's Mercantile College of Accounting and Bookkeeping in the Clogg Bldg., Dayton, Ohio. Taught calligraphy and was principal of school. Later in 1840s operated Barnaby's Gallery of Daguerreotypes on E. 3d St. and Main, Dayton. Information courtesy of Dr. Robert W. Wagner.

Barnard, Frederick Augustus Porter. Educator, scientist, author, dag'typist. Born May 5, 1809, Sheffield, Mass.; died April 27, 1889, NYC. Graduate of Yale, 1828. From 1837 to 1848, professor of mathematics and natural philosophy at University of Alabama and, afterward, of chemistry until 1854. Learned dag'typing from Morse, ca. 1840 (?). Associated with W. H. Harrington in Tuscaloosa, Ala., taking dag'type portraits, 1840–1841—first studio in the South; published research for reducing exposure time in *Ameri-*

can Journal of Science and Arts, Oct. 1841; experimented with stereoscopic dag'types and published article in *American Journal of Science and Arts*, Nov. 1853. Became professor of mathematics and astronomy, University of Mississippi, 1854, and became president of university, 1856. Left Mississippi in 1861 and in 1864 became president of Columbia University, NYC. In 1867, U.S. commissioner to Paris exposition; in 1878, U.S. assistant commissioner general to Paris exposition. Author of many works after 1836. In 1860 elected president of the American Association for the Advancement of Science; in 1865 of board of experts of the American Bureau of Mines; in 1872 of the American Institute. One of the original corporators named in charter of the National Academy of Sciences and, 1874–1880, foreign secretary. ACB; RT; John Fulton, *Memoirs of Frederick A. P. Barnard*, 1896.

Barnard, George N. Dag'typist, photographer. Practiced dag'typing, Oswego, N.Y., 1851–1854. Bought Clark Bros. gallery, Syracuse, N.Y., 1854. Official photographer, Civil War, Chief Engineer's Office, Division of the Mississippi, U.S. Army. Took stereo views of Charleston, S.C., ca. 1868–1878. Published book with sixty-one photographs—*Photographic Views of Sherman's Campaign* (1866)—which sold for $100. BN; HHS; SV.

Barnes, Chauncey. Dag'typist, merchant, photographer. Opened rooms, Mobile, Ala., 1845. Listed at 48 Dauphin St., 1852–1858; over 54, 56, & 58 Dauphin St., 1859. Took dag'type of eclipse of sun in 1854 and displayed in gallery as curiosity. Employed portrait painter in gallery in 1859 and exhibited portraits. In 1860 had sewing machine depot at 56 Dauphin. Listed as photographer, 1868; 87 Dauphin as photographer, 1870; employed artist to color life-size portraits. CD; PAJ, 1854, p. 224.

Barnes, James T. Dag'typist. Gallery at 170 Broadway, NYC, 1849–1850; 262 Broadway, 1851–1854. BD.

Barr, D. W. Dag'typist. Harrisburg, Pa., date unknown. Imprint on velvet in miniature case.

Barrett, Henry. Dag'typist. Born 1819, Eng. Practiced dag'typing in Philadelphia, 1850. USC.

Barrows & Jenkins. Dag'typists. Gallery at 379¼ Washington St., Boston, 1848; as James Barrows, 1849. BD; RBD.

Barry, G. Dag'typist. Rooms at 3 St. Charles, cor. of Canal St., New Orleans, 1843. Nsp adv., *New Orleans Picayune*, Jan. through May.

Bartholomew, Charles G. Dag'typist. Gallery at 99 Genesee St., Auburn, N.Y., 1859. CD.

Bartholomew, G. Dag'typist. Ithaca, N.Y., 1854. A. S., E., and A. H. Heath, *Photography, A New Treatise*, 1855.

Bartlet (Bartlett), ———. Dag'typist. Gallery at 102½ Main St., Boston, 1859. *See also* Bartlett & Evans. HJ.

Bartlett & Evans. Dag'typists. Gallery at 168 Hanover St., Boston, 1859. BD.

Bartlett, Henry H. Dag'typist. Born 1813, Mass. Listed as Bartlett & Fuller, 194 Main St., Hartford, Conn., 1848 and 1849; listed alone in 1850 and 1851. In 1850 resided with wife, Mary A., age thirty-five (born Conn.); Lucius W. Jones (daguerreian artist), age twenty; and two children, Catherine and Mary. Listed as Bartlett & Nichols, 1852; listed alone, 1853–1854. CD; USC.

Barton, Samuel K. Dag'typist. Washington Daguerreian Gallery at 74 Chambers St., NYC, 1848–1849. BD.

Bartons, ———. Dag'typist. Gallery at 20 Main and 5th, Cincinnati, Ohio, 1853. SBD.

Batchelder, Nathaniel. Dag'typist. Danvers Port, Mass., 1853. SBD.

Batchelder, Pérez M. Itinerant dag'typist. San Francisco, 1850s. Moved permanently to Melbourne, Australia, ca. 1861. Information courtesy of Robert A. Weinstein.

Batchelder, Wm. Dag'typist. Haverhill, Mass., 1859. CD.

Battell & Gray. Dag'typists. Gallery at 171 Broadway, NYC, 1856–1857. CD.

Battersby, Joseph. Dag'typist, photographer. Gallery at 136 Church St., Chicago, 1858. Took stereo views, 1869–1878. CD; SV.

Bauer, T. Dag'typist. Columbus, Ohio, 1856. CD.

Bayles & Bradley. Dag'typists. Gallery at 315 Broadway, NYC, 1854. *Gleason's Pictorial Drawing-Room Companion.*

*Beale, Oliver S. Artist, dag'typist. Gallery at E. Market Sq., Bangor, Me., 1846. CD.

Beals (Charles S.) & Chase. Dag'typists. Gallery at 197 Essex St., Lawrence, Mass., 1857. CD.

Beals & Cox. Dag'typists. Gallery at 181 Broadway, NYC, 1850–1851. BD.

Beals, Albert A. (J.). Dag'typist. Gallery at 156 Broadway, NYC, 1846–1854. Exhibited one frame of dag'types at American Institute, 1846; exhibited N.Y. Crystal Palace, 1853. AI, 1846; BD; BN; AA.

Beals, H. S. Dag'typist. Sacramento, Calif., 1854. CD.

Beals, Henry S. Dag'typist. Gallery at 195 Broadway, NYC, 1851–1854. Possibly the same dag'typist who went to Calif., 1854. BD.

Bean, Lothrop G. Dag'typist. Lowell, Mass., 1859. CD.

Beck, Jacob, & Sons. Dag'typists. Gallery at 35 N. Front St., Philadelphia, 1854–1855. Possibly the artist J. Augustus Beck. SBD.

Beckers (Alexander) & Piard (Victor). Dag'typists. Gallery at 201 Broadway, NYC, 1849–1856. *See also* individual biographies. BD.

Beckers, Alexander. Dag'typist, inventor. Born in Germany. In Philadelphia, 1836. Studied dag'typing under Frederick Langenheim, 1842. Operator for Langenheim, 1843. Moved to NYC, 1843. Worked briefly for Edward White, 1843–1844; own business at 33 John St., cor. Nassau, 1844–1845; Langenheim & Beckers, 201 Broadway, Ca. 1846–1848, and had agency for Voightländer's lenses and Louis Beckers' chemicals. Partnership with Victor Piard, 1849–1856; removed to 411 Broadway, 1857. Sold business in 1859 to Augustus Morand and commenced manufacture of his patented revolving stereoscope. Invented dag'type plate holder (6,812), 1849; cabinet stereoscopes (five patents in all), 1857, 1859; hinge for stereoscope reflectors, 1859. Located at 560 Broadway, 1869–1870. Won first prize, American Institute, 1869, for revolving stereoscope and stand. BD; BJP, 1886, p. 363; *The Gem*, 1844; BN; PP, 1869.

Beckwith, Marvin E. Dag'typist, photographer. Born Nov. 24, 1823, Erie Co., N.Y.; died 1888. To Cleveland, Ohio, Dec. 1839. Operated several businesses and also took part in running a newspaper. Began making dag'types under instruction of Samuel Crobaugh (date unknown). Gallery at 9 Pearl St., 1859. Continued as photographer as late as 1869 and possibly after. APB, 1888, p. 53.

Bededict, R. B. Dag'typist. Alton, Ill., 1854–1855. SBD.

Bedell & Gray. Dag'typist. Gallery at 308 Broadway, NYC, 1851. BD.

Beers & Mansfield. Dag'typists. Gallery at 144 W. Chapel St., New Haven, Conn., 1858–1859. CD.

Bell & Clayton. Dag'typists. Gallery, ca. 1850s, at 142 S.E. cor. Chestnut and 5th St., Philadelphia. Imprint on velvet inside miniature case.

Bell, Charles Dag'typist. Rockton, Ill., 1854. SBD.

Bell, W. Dag'typist, photographer. Jenny Lind Gallery at 86 N. 2d St., Philadelphia, ca. 1851. Photographer in 1869 at 1200 Chestnut St. Information courtesy of George R. Rinhart; PP, 1869, p. 356.

Bemis, Samuel. Amateur dag'typist, jeweler, dentist. Born 1789; died 1881, Boston. Learned dag'typing from François Gouraud, 1840. BN.

Benedict, P. H. Dag'typist. National Daguerreotype Gallery at Granger Block, Syracuse, N.Y., ca. 1855. Information courtesy of Kenneth Thompson.

Benjamin, Orrin C. Dag'typist, teacher, photographer. Born De Ruyter, N.Y.; died Sept. 9, 1895. Moved to N.J. at age twenty, taught school. Bought dag'typing outfit and learned some finishing touches from Richard A. Lewis, NYC. Established gallery, Milburn, N.J., then moved to Rahway

and finally bought a gallery in Newark. Listed at 274 Broadway, Newark, 1857–1858. Before the war had two skylights and did considerable business. In 1865 lost everything in fire. Bought farm in Elmira, N.Y.; opened gallery, Corning; finally settled in Orange, 1867. Injured in 1878 in fall from horse. CD; APB, 1895, p. 338.

Bennet, ———. Dag'typist. Gallery on 8th St., Philadelphia, 1856. PAJ, p. 126.

Bennet, John A. (Juan). Dag'typist, dry goods merchant. Listed as Bennet & Tournier, dry goods, at 69 Dauphin St., Mobile, Ala., 1842. Listed as dag'typist at 55 Royal St., 1843; 59 Royal St., 1844. Bought out by Marcus A. Root, 1844. Traveled as dag'typist to Montevideo, 1842–1843; Buenos Aires, 1845; Bogotá, 1852. CD; BN.

Bennett, Nathan S. Dag'typist. Adv. as "Boston Photographer" at 109 Washington St., Boston, 1844. CD.

Bennett, William. Dag'typist. Providence, R.I., 1850–1854. CD.

Benson, W. Dag'typist. Boonville, Mo., 1851, DJ.

Bent, Israel. Dag'typist. Gallery at 62 State St., Newburyport, Mass., 1851–1852; listed at 142 Washington St., Boston, 1859. CD; BD.

Bently, J. Dag'typist. Roscoe, Ill., 1854. SBD.

Betts, Charles J. Dag'typist. Assumed to be a practicing dag-typist in Mexico in the 1840s. Information courtesy of Josephine Cobb.

Bird, ———. Amateur dag'typist, Philadelphia, 1839. MAR.

Bisbe, C. A. Dag'typist. Chardon, Ohio, 1853. SBD.

Bisbee, Albert. Dag'typist, photographer, inventor, author. Practiced dag'typing, Dayton, Ohio, in 1850s and probably before. Bisbee & Robertson, Main St., 1853. Exhibited N.Y. Crystal Palace, dag'type scenes, 1853; won first premium for dag'types and ambrotypes at the Ohio State Fair, Sept. 1856. Patented photographic glass process, "Sphereotype," May 27, 1856 (14,946). Author of *History and Practice of Daguerreotyping*, 1853. SBD; PAJ, 1856.

Bishop, ———. Amateur dag'typist. Took daguerreotype with Charles Avery of John Quincy Adams at Hamilton College, Clinton, N.Y., Aug. 1843. Information courtesy of John Duncan.

Bishop & Cornelius. Dag'typists. Gallery at N.W. cor. Main St. and 5th, Cincinnati, Ohio, 1853. SBD.

Bishop, Louis L. *See* Manufacturers and wholesale suppliers.

Black, James Wallace. Dag'typist, photographer. Born Francistown, N.H.; died Jan. 14, 1896. At age of about eighteen, employed in a Lowell, Mass., tannery or leather-dressing establishment; then employed in a cotton mill and also as a house painter. Studied

dag'typing under John Lerow, Boston, 1845; employed in gallery of L. H. Hale & Co. and did some of best work in New England; partner, Ives & Black; joined John A. Whipple and became partner in gallery, 1856–1859. Bought out J. B. Heywood, 1859. Took first successful aerial photograph in U.S. in Boston, Oct. 13, 1860; photographed eclipse, 1869. APB, Dec. 1874, pp. 389, 390; BN; RT; CD; PP, 1869.

Blake, Charles E. Dag'typist. First dag'typist in Brunswick, Me., 1845. George A. Wheeler and Henry W. Wheeler, *History of Brunswick, Topsham, and Harpswell, Maine*, 1878.

Blakeslar, G. B. Dag'typist. Le Porte, Ind., 1855. From dag'type dated May 30.

*Blanchard, Mrs. E. H. Portrait and miniature painter, dag'typist. From Providence, R.I. Adv. as dag'typist in Athens, Ga., 1849: "Mrs. B. and son are also prepared to take Daguerreotypes in a superior style." NYHS; *Southern Literary Gazette*, Mar. 17.

Bliss, T. G. Dag'typist. New Bedford, Mass., 1853. SBD.

Blodgett. *See* Mann & Blodgett.

Bloodgood, I. Dag'typist. Rochester, N.Y., 1852. RBD.

Bobo, H. F. Dag'typist. Born 1824, Tenn. Practiced dag'typing Robertson Co., Tenn., 1850, USC.

*Bogardus, Abraham. Dag'typist, artist, photographer. Born Nov. 29, 1822, Dutchess Co., N.Y.; died 1908, Brooklyn. In 1837 engaged as clerk in dry goods store. Exhibited painting at American Institute, 1845. Learned dag'typing from George W. Prosch. Opened gallery at 363 Broadway, NYC, cor. Barclay and Greenwich St., 1846. Listed at 217 Greenwich, 1847–1851, and also operated a branch gallery at 126 Washington St., Newark, N.J., 1849, and 8 Clinton St., Newark, 1850–1851; located 229 Greenwich, NYC, 1851–? In 1869 moved to new studio at 1153 Broadway, NYC, but continued old establishment at 363 Broadway. First president of the National Photographic Association, 1868–1874. In 1873 made dag'types of bank note designs for the American Bank Note Co. Left photography in 1887 after long and successful career. BD; PP, 1869, p. 368; PP, 1871, pp. 313–315; BN; NYHS.

Bogert, William. Dag'typist. Gallery at 345 Bleeker St., NYC, 1846–1856. BD.

*Boisseau, Alfred. Portrait, genre, and landscape painter, art teacher, art dealer, dag'typist. Born 1823, Paris. Exhibited at French salon, 1842. New Orleans, 1845–1846; NYC, 1849–1852, exhibiting at the National Academy and American Art Union. Advertised as teacher of drawing and painting and as portrait and landscape painter, Cleveland, Ohio, 1852; advertised as

dag'typist at 111 and 113 Superior St., 1855. Specialized in taking dag'types with landscape background. In Cleveland as late as 1859. Nsp, Cleveland, 1855; NYHS.

*Bolles, Jesse. Artist, dag'typist, photographer. Bolles Temple of Art listed at cor. King and Liberty St., Charleston, S.C., 1856. Employed artist Frederick A. Wenderoth; partnership Wenderoth & Bolles, 1857; located at King and Market St., 1867; 281 King St., 1869. CD; NYHS; nsp, 1856.

Bommer & Rolle. Dag'typists. Gallery at 247 Broadway, NYC, 1853–1854. BD.

Bourges, A. Dag'typist. Gallery at St. Anthony, near Prosper, New Orleans, 1859. CD.

Boutelle, Thomas E. Dag'typist. Born about 1819; died after 1904 (?). Practiced dag'typing in Amesbury, Mass., 1856. Exhibited Whittier's portrait in showcase at door. Samuel T. Pickard, *Whittier-Land*, 1964.

Bowdoin & Litch, Dag'typists. Gallery at 49 Tremont Row, Boston, 1855–1856. BD.

Bowdoin, D. W. Dag'typist. Gallery at 208 Essex St., Salem, Mass., 1849–? Bought Cutting's ambrotype rights for $1,000 in 1854. Partnership, Bowdoin & Litch, 1856. RBD; SBD; PP, 1869, p. 295.

Bowen, N. O. Dag'typist. Norwich, Conn., 1851. DJ.

Bower, Philip. Dag'typist. Gallery at 263 2d Ave., NYC, 1853–1854. BD.

Bowes, ———. Dag'typist. Providence, R.I., 1849. RBD.

Boyd, J. S. Dag'typist. Gallery at 23 E. 4th St., Cincinnati, Ohio, 1851. CD.

Boyer, George. Dag'typist. Ft. Browder, Ala., ca. 1855–1857. Imprint on velvet lining of miniature case.

*Boyokin, S. H. Portrait painter, dag'typist. Rooms over store of Mace & Hart, cor. Public Sq. and Main St., Belleville, Ill., 1851–1852. Nsp adv., *Belleville Weekly Advocate*. Information courtesy of Allan Miller.

Bradbury, Charles. Dag'typist. Lowell, Mass., 1853. SBD.

Bradlee, J. E. Dag'typist. Boston, 1851. DJ.

*Bradley, Henry W. Artist, dag'typist. Born Wilmington, N.C. To Calif., ca. 1850, listed as artist and dag'typist, San Francisco; 177½ Clay St., ca. 1852–1857. Partner, Rulofson, 1863–1878. CD; BN; PAJ, 1857, p. 112.

Bradley's Gallery. Gallery at 340 Market St., Philadelphia, ca. 1849. Imprint on velvet in miniature case, OSU.

*Brady, Mathew B. Dag'typist, photographer, author. Born ca. 1823, Warren Co., N.Y.; died 1896, NYC. Copied sketches for artist William Page and moved with Page to NYC in about 1837. Learned dag'typing ca. 1840–1842; manufactured miniature cases, 1843–? Opened gallery late 1843 or

early 1844. Published *Gallery of Illustrious Americans*, 1850; exhibited dag'types at Crystal Palace, London, 1851, which included portraits of General Taylor, Calhoun, General Cass, and James Perry—forty-eight dag'types in all—for which he won a bronze medal for excellence. Opened gallery in Washington, D.C., 1858. Most famous for his photographic battlefield scenes of the Civil War. CD; BD; RT; BN; Josephine Cobb, *Mathew B. Brady's Photographic Gallery in Washington*, 1955.

Brainard, C. H. Dag'typist. From New York. Exhibited at Crystal Palace, London, 1851, dag'types of president's cabinet. *Exposition of 1851 on Industries at Crystal Palace, London*, 1852.

Brandon, D. F. Dag'typist. Belvidere, Ill., 1854–1855. SBD.

Brayton, ———. Dag'typist. Providence R.I., 1849, SBD.

Brescott, G. P. Dag'typist. Location unknown, 1855. From daguerreotype dated 1855.

Bridge, Erastus T. Dag'typist. Lawrence, Mass., 1853; gallery at 166 Essex St. and also 4 Bay St., 1857. SBD; CD.

Bridge, J. P. Dag'typist. Gallery at 34 Tremont Row, Boston, 1847. BD.

Brigham, Charles B., & Co. Dag'typists. Gallery at 92 Lake St., Chicago, 1858. CD.

Brill, Julius. Dag'typist. Gallery at 204 Chatham St., NYC, 1851–1854. BD.

Brinckerhoff & Co. (J. De Witt). Dag'typist, photographer, inventor. Gallery at 383 Broadway, NYC, 1851–1852. Awarded diploma for third-best dag'types by American Institute, 1852. Located 388 Broadway, 1853–1855. The first American to successfully solve the technical problems of photographing directly on woodblocks for use of engravers. An example of his technique was illustrated in the *Photographic and Fine Art Journal*, 1855: a portrait of C. C. Harrison. The process was not patented, but patents for a similar process were obtained by others in 1857 and 1859. BD; RT, p. 422; AI; 1852.

Bristol. William. Dag'typist. Utica, N.Y., 1850. DJ.

*Britt, Peter. Portrait and landscape painter, dag'typist. Born Mar. 11, 1819, Obstalden, Switzerland; died 1909 (?), Oregon. To America in 1843. Practiced dag'typing, Highland, Ill., 1844–1847 (?). Studied under J. H. Fitzgibbon, St. Louis, Mo.; 1847. Itinerant in Oregon Territory, 1850–1853; settled in Jacksonville, Oreg., and established gallery, the first in the territory, 1854. Displayed his oil portraits and landscapes in gallery. RT; R. Peattie, *The Pacific Coast Range*; NYHS.

*Broadbent, Samuel. Dag'typist, miniature and portrait painter, photographer. Born 1810; died July 24, 1880,

Philadelphia. Native of Wethersfield, Conn., and descendant of Dr. Samuel Broadbent, portrait painter. Engaged in merchandising in early life. Studied and practiced portrait and miniature painting with success. Traveled in South as miniature painter, 1840. Learned dag'typing from friend Samuel Morse. Associated with Morse as assistant in gallery until Aug. 1841 in NYC. NYC, 1842; traveled south in winter dag'typing, 1843–1847; worked as dag'typist, Savannah, Ga., 1843–1844; Macon and Athens, Ga., 1845; worked in Wilmot's studio, Savannah, and as partner with Cary, 1847; Wilmington, Del., ?–1850; Philadelphia, 1851, gallery at 138 Chestnut St.; Broadbent & Hewes (Mrs. S. G.), 1852–1855; took partner, Frederick A. Wenderoth (artist and photographer), 1856; Broadbent & Co., 814 Chestnut St., 912, 914, 916 Chestnut St., 1860–1865; Broadbent & Taylor, 915 Chestnut St., ca. 1866–1870; Broadbent & Phillips, 1206 Chestnut St., ca. 1870s. APB, 1880, p. 253; BD, NYC, 1841; DJ; PWB; nsp adv., 1843–1847; Athens information courtesy of Dr. W. Robert Nix; SBD, 1854; PAJ, 1855, p. 319; PAJ, 1856, p. 125; *Pennsylvania Freeman*, Jan. 1, 1852.

Brocaw, David. Dag'typist. Oberlin, Ohio, 1850–1853. USC; SBD.

Bronk, Edwin. Dag'typist. Operator for Mathew Brady, NYC; T. C. Dobyns, St. Louis, Mo.; and D. D. Winchester, Columbus, Ohio. Dates unknown. BN.

Brousins, J. C. Dag'typist. Decatur, Ill., 1854–1855. SBD.

*Brown, Eliphalet M., Jr. Lithographer, portrait, historical, and marine artist, dag'typist. Born 1816, Newburyport, Mass.; died Jan. 23, 1886, NYC. Lithographer for Currier & Ives, NYC, 1839–1845. Exhibited at National Academy, 1841. E. & J. Brown, 1846–1848; Brown & Severyn, 1851; Currier & Ives, 1852. Artist and dag'typist with Perry's expedition to Japan, 1852–1854. Employed by U.S. Navy, 1855–1875. NYHS.

Brown, F. A. (Frank). Dag'typist. Gallery at Museum Bldg., Manchester, N.H., 1849–1856. RBD; DJ; CD.

Brown, George W. Dag'typist. Providence, R.I., 1850. CD.

Brown, H. S. Dag'typist. Milwaukee, Wis., 1846–1852; gallery at 201 E. Water St., 1851–1852. CD; DJ.

Brown, Jacob F. Dag'typist. Albany, N.Y., 1853. CD.

*Brown, James Sidney. Artist, engraver, dag'typist, inventor. Born Apr. 14, 1819; died 1893, NYC. Apprenticed as young man to silversmith. Brown's brother had him admitted to the antique school of the National Academy of Design, 1841. After graduation had portrait studio at 181 Broadway, NYC. One of the founders of the American Society of Water-Color Artists. Operator at

Brady's gallery, ca. 1843. Listed as dag'typist, American Gallery, 28 Catherine St., 1848; 181 Broadway, 1851–1854. Exhibited at N.Y. Crystal Palace, 1853, a collection of portraits of Commodore Perry and officers of the squadron of the Japan expedition. Probably brother of Eliphalet Brown. A friend of Napoleon III, Samuel Morse, and other famous men. Patent for vignette-style dag'type (10,225), Nov. 15, 1853. Went to St. Louis, Mo., and returned to NYC after the war. Engraver for the Bible Society and *Harper's* for some years. Last position with the photographer R. A. Lewis, 142 Chatham St. Died penniless but bequeathed two old trunks to his friend Alonzo J. Drummond, photoengraver, with collection of oil paintings, watercolors, wood engravings, pencil sketches, etc. APB, 1893, p. 282; BD; BN; DJ.

Brown, Nicholas. Dag'typist, photographer. Gallery at 41 N. 4th St., St. Louis, Mo., 1857–1865. Missouri Historical Society.

Brown, S. H. Dag'typist. Gallery at 425 Washington St., Boston, 1851–1853; 221 Washington St., 1854–1855; 21 Hanover St., 1856. BD.

Brown, William. Dag'typist. Listed as "Philadelphia Photographist," 1847, Philadelphia. CD.

*Bryant, Henry. Portrait and landscape artist, engraver, dag'typist. Born 1812, Manchester Green, E. Hartford, Conn.; died Dec. 7, 1881, E. Hartford. Apprenticed as engraver, itinerant portrait painter, ca. 1832. Albany, N.Y., 1834–1835; NYC, ca. 1840 or before. Elected an associate of the National Academy, 1837. Exhibited at academy, 1837–1840, and the Apollo Gallery, 1838–1839. Learned dag'typing, Hartford; practiced dag'typing in Richmond, Va., 1844–1846. Landscape painting, ca. 1850. Exhibited at National Academy, 1852–1854. Returned to Hartford, ca. 1850. NYHS.

Buchanan, William. Dag'typist. Learned dag'typing from Meade Bros., NYC, 1852. Traveled to Central America as itinerant: Nicaragua, Costa Rica, Guatemala, San Salvador, 1853; returned to U.S., studied dag'typing, etc., under Harrison, then went to Mexico, 1854–? To Panama, San Salvador, Costa Rica, and Guatemala, 1857–1862. Information courtesy of Josephine Cobb.

Buchtel, Joseph. Dag'typist, photographer. Born Stark Co., Ohio. Journeyed west in 1852 with wagon train; left the group to complete trip on horseback; worked for a few months as deckhand on river steamers. Purchased Wakefield's gallery. Portland, Oreg., in 1853. Became well-known photographer in Oregon. Ralph W. Andrews, *Picture Gallery Pioneers of the West*, 1964.

Buckingham, H. Dag'typist. Gallery at 61 Water St., Bridgeport, Conn., 1854. CD.

Buell, E. M. Dag'typist. Pittsfield, Mass., 1849–1853. RBD; SBD.

Buell, Lorenzo. Dag'typist, photographer. Gallery on Monroe St., Grand Rapids, Mich., 1856. CD.

Bugby, Norman. Dag'typist. Gallery at 64 Dauphin St., Mobile, Ala., 1844. Same address as Alfred S. Waugh, miniature painter. CD.

Bumpass, Green L. Dag'typist. Born 1812, Ky. Practiced dag'typing, Henry Co., Tenn., 1850. USC.

Burgess, Nathan G. Dag'typist, author. Learned dag'type process in Paris, 1840. Gallery at 192 Broadway, NYC, 1844; 187 Broadway, 1846–1851; branch gallery at 223 King St., Charleston, S.C., 1852 (partner with C. D. F. Fredericks); 293 Broadway, NYC, 1856–1858. Author of *The Ambrotype Manual* (1856), with other editions and titles to 1862, and of *The Photograph Manual* (1863). BN; *The Gem*, 1844; nsp, 1844, 1852; BD.

Burnham, Asa M. Dag'typist. Gallery at 2½ Kenduskeag Bridge, Bangor, Me., 1855. CD.

Burnham, John W. P. Dag'typist. Gallery at 4 Main St., Bangor, Me., 1848; listed at 19 Main St., 1851–1855. CD.

Burns, R. E. Dag'typist. Location and date unknown. Information courtesy of George R. Rinhart.

Burrett (Burritt), E. Dag'typist. Gallery at 48 Market St., St. Louis, Mo., 1850–1851, trading as National Daguerrean Gallery; Burritt National Daguerrean Gallery, cor. 4th and Olive, 1852. Missouri Historical Society; nsp, *Belleville Weekly Advocate*, Apr. 7, 1852. Information courtesy of Allan Miller.

Bushnell, J. H. Itinerant dag'typist. Adv. in Athens, Ga., Apr. 20 to May 4, 1848, and on July 20 adv. as "J. H. Bushnell, M. D., photographist"; on Aug. 21, 1849, adv. taking groups of adults and children. Information courtesy of Dr. W. Robert Nix.

Bussell, J. P. Dag'typist. Chelsea, Mass., 1847; 115 Court St., Boston, 1850–1851. CD; BD.

Buswells, Luther D. Dag'typist. Gallery at 314 2d St., NYC, 1853–1854. BD.

Butler & Griffin. Dag'typists. Galesburg, Ill., 1854–1855. SBD.

Butler, Alexander. Dag'typist. NYC (?), 1853–1854. Exhibited several excellent dag'types at the N.Y. Crystal Palace, 1853, for which he received a bronze medal. PAJ, 1854, p. 64.

Butler, Charles D. Dag'typist. Gallery at 464 Pearl St., NYC, 1848. BD.

Butler, George H. Dag'typist. Gallery at 257 Washington St., Boston, 1855. BD.

Butler, George W. Dag'typist. Hallowell, Me., 1855. SBD.

Butler, Harrison. Dag'typist. Waterloo, Ill., 1854. SBD.

Butler, William H. Dag'typist. Experimented dag'typing, 1839. Adv. as dag'typist and photographic materials supplier at 7½ Bowery, NYC, 1841; 251 Broadway, 1848–1854. Did dag'type "in oil" in 1851 which had "the beauty of a fine miniature painting combined with the detail of the Daguerreotype." PWB; nsp, 1841, 1851; BD.

Byerly, Jacob. Dag'typist. Frederick, Md., 1842. RT.

Byron & Bent. Dag'typists. Gallery at 155 Atlantic St., Brooklyn, 1851–1852. Formerly with Meade Bros., according to adv., portraits taken at private residence as well as gallery. CD.

Cady, James. Dag'typist. NYC, 1851. RT.

Cahill, Miles S. Dag'typist. Gallery at 293 Washington St., Boston, 1853–1860. BD.

Caldwell, Alonzo B. Dag'typist. Gallery at 166 Merrimack St., Newburyport, Mass., 1851, CD.

Cameron, David. Dag'typist. Byron, Ill., 1854. SBD.

Cameron, Henry S. Dag'typist. Partner with Rulofson, Sonora, Calif., 1850–1851. BN.

Campbell, B. F. Dag'typist. Gallery at 69 Hanover St., Boston, 1848–1850; Hammer & Union St., and 69 Howard and 63 Court St., 1851; 61 and 69 Hanover St., 1852–1853; 137 Hanover St., 1854–1855; 145 Hanover St., 1856–1859. RBD; BD.

Campbell, James. Teacher, chemist, amateur dag'typist. Dayton, Ohio. Experimented color dag'type process, 1852–? Wrote articles on photographic chemistry for *Humphrey's Journal* and other publications during the 1850s. CD; HJ; SA.

Campbell, John. Dag'typist, photographer. Jersey City, N.J., 1852–1860. Took dag'type of eclipse of sun, 1854. BN.

Campbell, William. Dag'typist (?). Jersey City, N.J. Invented and patented the "ectograph." MAR.

*Canfield, H.D. Dag'typist, miniature and landscape painter. In St. Louis, in 1851, used dag'types for painting miniatures; S.E. cor. 4th and Chestnut, 1853. Missouri Historical Society; Lillian B. Miller, *Patrons and Patriotism*, 1966.

Cannon & Gibson. Dag'typists. Gallery at 247 Washington St., Boston, 1847. BD.

Cannon, John. Dag'typist. Gallery at 139 Washington St., Boston, 1847–1848; 99 Court St. and 2 Blanchard Block, 1849; Cambridge, Mass., 1850; 20 Washington St., Boston, 1852. BD; CD.

Cannon, Marsena. Dag'typist. Born 1813; died Apr. 29, 1900, Salt Lake City, Utah. Practiced dag'typing, Boston, 1844; 123 Washington St., 1849–1851. To West, ca. 1850, and opened gallery in Salt Lake City, 1852. CD; BD; PAJ, 1852, p. 190.

Carden & Co. Dag'typist. Gallery at 293 Broadway, NYC, 1853–1854; diploma for dag'types from American Institute, 1853; Carden & Norton, 203 Broadway, 1854. AI; BD.

Carden, R. A. Dag'typist. Gallery at cor. Clay and Kearny St., San Francisco, 1856. CD.

Carey, P. M. *See* Cary, P. M.

Cargos, ———. Dag'typist. Gallery at 76 4th St., Pittsburgh, Pa., 1855. Nsp.

Carleton, Samuel L. Dag'typist, teacher of writing, temperance reformer, lawyer. Born 1822, Whitefield, Lincoln Co., Me.; died Apr. 12, 1908, Portland, Me. Moved to Portland, 1845, as teacher of writing. Studied dag'typing in Boston. Listed at 90 Middle St. and 49 Middle St., Portland, 1847–1848. Last listing as dag'typist, 1857. Studied law while dag'typist with Gen. Samuel Fessenden. After admitted to bar established an office as lawyer. In 1850 he moved into a castle bought from a foreign architect, on cor. Congress and St. Lawrence St., one of first mansions on Munjoy Hill. Advocate of temperance and close friend of Gen. Neal Dow, instrumental in having a prohibitory law as part of state constitution. Alderman in First Ward, 1853–1854. CD; SBD; nsp, 1908; scrapbook, Maine Historical Society.

Carlisle, Nelson. Dag'typist. Gallery at 95 Market St., Wilmington, Del., 1857, CD.

Carlton, G. C. Dag'typist. Amesbury, Mass., 1849, RBD.

Carnon, J. Dag'typist. Gallery at 17 Hanover St., Boston, 1851. BD.

Carpenter & Swymmer. Dag'typists. Gallery at 517½ Main St., Louisville, Ky., 1855–1856. CD.

Carr. J. Dag'typist. Gallery at 249 Elm St., Lawrence, Mass., 1857. CD.

Carr, W. L., & Co. Dag'typist. From New York and Philadelphia, adv., July–Aug. 1846, Athens, Ga. Rooms over J. Bancroft & Co.; moved Aug. 4 to Newton's new hotel and, on Aug. 11, moved to W. L. Mitchell's new hotel. Information courtesy of Dr. W. Robert Nix.

Carr, Y. A., & Co. Dag'typist. Born 1820, Alabama. Practiced dag'typing, Memphis, Tenn., 1850; gallery at 31 Front Row, 1855–1859. USC; CD.

Carson & Co. Dag'typist. Located on Sartwell Block, Cleveland, Ohio, 1850. Reproduced portrait of Jenny Lind for sale; took dag'type of moon; Superior and Senca St., 1851. Nsp.

Carter & Lippincott. Dag'typists. Gallery at Bromwell's Bldg., Cincinnati, Ohio, 1850; 4th and Vine, 1851. BD.

Carthy, ———. Dag'typist, photographer. Washington, D.C., 1856. PAJ, p. 317.

*Carvalho, Solomon Numes. Portrait and landscape painter, dag'typist, photographer, explorer, author, inventor. Born 1815, Charleston, S.C.; died 1899, NYC. Began career as artist after being shipwrecked in West Indies, 1835. To Baltimore, 1828; Philadelphia, 1835. Charleston, S.C., and Washington, D.C., in 1840s. Gallery at 4th and Pennsylvania Ave., Washington, D.C.; 205 Baltimore St., Baltimore, 1849. Exhibited paintings at Pa. Academy, Philadelphia, 1849. Gallery in Charleston, 1850–1852. Invented enameled dag'type, 1852. Operator for J. Gurney, 1853; exhibited at Maryland Historical Institute, 1850 and 1856 (paintings). With Frémont's expedition as dag'typist and artist, 1853–1854. Author: *Incidents of Travel and Adventure in the Far West with Col. Frémont's Last Expedition*, 1860. To Baltimore, late 1850s; NYC, ca. 1860. Gallery at 765 Broadway, NYC, 1869–1870. Listed as artist or photographer, NYC, until 1880. NYHS; BN; RT; CD; Josephine Cobb, *Mathew B. Brady's Photographic Gallery in Washington*, 1955; PP, 1869.

Cary (Carey), P. M. Dag'typist, photographer. Worked at Wilmot's studio with Samuel Broadbent, Jan. 1847; adv., Macon, Ga., Feb. 1848, and Athens, Ga., May 1848; opened gallery, Feb. 15, 1850, cor. Bryan St. and Market Sq., Savannah, Ga. Closed gallery in June; NYC, July 1850 to Jan. 1851, at 187 Broadway. Awarded silver medal for dag'types by American Institute, 1850. Continued to operate gallery seasonally, working in NYC July–Jan. Cary & Perkins, Bryan St. & Market Sq., 1854; during the sumer learned how to take stereoscopic dag'types. In 1856 adv. photographs colored by a Mr. Hunt, London artist. Partner with Powelson (B. F.), 1856. Cary & Mr. Malambre (artist) and Mr. White (photographer), 1859. Nsp, Savannah, 1847–1857; AI, 1850; CD.

Case, C., & Son. Dag'typists. New York Daguerrean & Ambro Gallery, Rock Island, Iowa, 1856. CD, Davenport, Iowa.

Case, J. C. Dag'typist. Gallery at 299½ Washington St., Boston, 1856–1859. *See also* Silsbee, George M. CD.

Cathan, Lucius H. Dag'typist. Born 1817; died ca. 1890. Practiced dag'typing, Vt., 1843–?; 113 Washington St., Boston (Pettee & Cathan), 1848; 20 Washington St., 1849–1850; Townshend and 20 Washington St., 1851; Cambridge, Mass., 1854. Made speculum to reverse dag'type image. BN; BD; RBD; HHS, p. 213.

*Catherwood, Frederick. Architect, historical and panoramic painter, archaeologist, amateur dag'typist. Born Feb. 27, 1799, London, Eng.; died Sept. 27, 1854, in *Arctic* steamship disaster en route to NYC. NYC, 1839–1840, where he exhibited panoramas. Traveled to Central America with John Lloyd Stephens, 1840–1841; NYC, 1841–1842; Yucatán with Stephens, 1842–1843,

made 120 dag'type views and drawings which were later engraved for a book by Stephens under his (Catherwood's) supervision; NYC, 1843–1844; London, 1844–1845; NYC, 1846–1849; British Guiana, 1850; Panama, 1851–1853; Calif., 1854; to England from Calif. His most important work was the illustrating of the Maya ruins of Yucatán and Guatemala, many engraved from dag'type scenes. NYHS; John L. Stephens, *Incidents of Travel in Yucatán* (1843), vol. 1, p. 175; *American Heritage*, June 1961, pp. 8, 9.

Catlin, Theodore B. Dag'typist. Gallery at 222 Canal St., NYC, 1850–1851. BD.

Chamberlain, William G. Dag'typist, photographer. Born Nov. 9, 1815, Newburyport, Mass. Learned dag'typing in Lima, Peru, early 1847, from "two young men," possibly the Ward Bros. Gallery at 131 Lake St., Chicago, 1852–1856; 15th and Market St., Denver, Colo., 1861; Larimer St., 1862; Graham's Block, Larimer St., 1864. Traveled in mountains taking stereo views in 1860s and 1870s. Retired from photography, late 1881. Ralph Andrews, *Pioneer Photographers of the West*, 1964, nsp, Chicago, 1852; SBD.

Chamberlin, Philo. Dag'typist. Brunswick, Me., 1849. RBD.

Champney, L. C. Itinerant dag'typist. Learned dag'typing from Albert S. Southworth, ca. 1842. Traveled in Mass. and Vt., 1842–1844. BN.

Chandler, Martin. Dag'typist, photographer. Practiced dag'typing, Marshfield, Mass., 1853. Took stereo views, ca. 1868–1878. SBD; SV.

Channing, Samuel S. Dag'typist. New Bedford, Mass., 1849, RBD.

Chapin, Joshua B. Physician, dag'typist. Providence, R.I., 1854. CD.

Chapin, Moses Sanford. Dag'typist, cabinetmaker. Native of Milford, Mass. Cabinet trade until ca. 1849. Dag'typist in Worcester, Mass., ca. 1849–1865. Returned to earlier trade, ca. 1865. Worcester Historical Society has collection of dag'types done by Chapin. *See also* Swasey & Chapin. Publications of the Worcester Historical Society, 1928; BN.

Charter, Miss S. R. Dag'typist. Gallery at 8 Tremont Temple, Boston, 1845–1849. CD; BD; RBD.

Charters, J. Dag'typist. Xenia, Ohio, 1853. SBD.

Chase, E. B. Dag'typist. Associated with gallery of Lorenzo G. Chase (possibly brother), Boston, 1846–1849. RBD; BD.

*Chase, Lorenzo G. Artist, dag'typist. Partner with Loyal M. Ives, Boston, 1844–1846; Chase's Daguerrian Rooms, 247 Washington St., Boston, 1846–1851. Listed as artist, 299½ Washington St., 1852–1853, and located at 173 Washington St., 1854–1856. MAR; BN; BD; CD.

Chase, Theodore. Dag'typist. Philadelphia, 1847. CD.

Cheesman, J. F. (Jonathan). Dag'typist. Gallery at 30th and State St., Trenton, N.J., 1850; 109 Front St., 1854; cor. Greene and State St., 1857. SBD; CD.

Cheney, L. C. Dag'typist. Associated with J. W. Thompson, 315 Broadway, NYC, 1848–1849. Adv., L. G. (?) Cheney & H. V. Williams, offering discount of one-third to clergymen. *Gazette of the Union* (Odd Fellows), 1848.

Chilton & Co. Dag'typist. Gallery at 281 Broadway, NYC, 1844–1845, BD.

Chilton, B. A. Dag'typist. Associated with W. W. Chilton. Adv. rooms at 269 King St., Charleston, S.C., Dec. 1841. Nsp.

Chilton, Howard. Dag'typist. Pioneer in NYC, 1839–1840; 247 Broadway, partnership, E. Anthony, J. M. Edwards, National Miniature Gallery, 1843–1844. MAR; BD (*The Gem*), 1844; BN.

Chilton, James R. *See* Manufacturers and wholesale suppliers.

Chilton, Robert S. Dag'typist. NYC, 1844. CD.

Chilton, W. W. *See* B. A. Chilton.

Church, Edwin. Dag'typist. Louisville, Ky., 1848; St. Louis, Mo., 1851, sold gallery to Dobyns. To NYC, worked for Martin M. Lawrence, 1852. CD; BN.

Churchill, Remmett E. Dag'typist. Gallery at 57, 54, 55 State St., Albany, N.Y., 1850–1853. Nsp. Nov. 15, 1850; BD; HJ; CD.

Claflin, Charles R. B. Dag'typist, photographer. Born 1817; died Nov. 7, 1897, Worcester, Mass. Practiced dag'typing Worcester, 1851–1858. Took stereo views, ca. 1868–1878. Retired in 1892. Prominent Mason and sportsman. Large collection of negatives of Worcester Co., etc. Trained many photographers. APB, 1897, p. 383; SBD; CAS (1859); SV.

Clark & Holmes. Dag'typists. Troy, N.Y., dates unknown. Imprint on velvet in miniature case.

*Clark, Alvan. Optician, inventor of telescopes and manufacturer, portrait painter. Born Mar. 8, 1804, Ashfield, Mass.; died Aug. 19, 1887, Cambridge, Mass. Said to have been the first person in U.S. to make achromatic lenses. ACB; NYHS.

*Clark, Anson. Dag'typist, designer of motifs for picture frames. Born 1788; died 1847, Hartford, Conn. Practiced dag'typing, W. Stockbridge, Mass., 1841–1844. BN; *Antiques*, July–Dec. 1958, p. 244.

Clark Bro. & B. L. Higgins. Dag'typists. Galleries at 551 Broadway, NYC; 28 Genesee, Utica, N.Y.; Franklin Bldg., Syracuse, N.Y.; Tremont Row, Boston, 1850–1851. The name Higgins was dropped in 1851. Sold to George N. Barnard in 1854. DJ.

Clark, Damon P. Dag'typist. Gallery at

163 S. 5th St., Brooklyn, 1859. CD.

Clark, David. Dag'typist. New Brunswick, N.J., 1853–1854. Exhibited at N.Y. Crystal Palace, 1853. BN.

Clark(e), F. H., & Co. Dag'typist, jeweler, silversmith. In the 1840s, jeweler and silversmith. Gallery at 1 Clark's Marble Block, Memphis, Tenn., 1855; Memphis, 1857; cor. Main, Madison, 1859. CD.

Clark, George, Jr. Dag'typist. Gallery at 59 Court St., Boston, 1853–1859. BD.

Clark, Henry H. Dag'typist. Baltimore, 1851–1857; gallery at 23 W. Baltimore St., 1858–1860. CD; PAJ.

Clark, Isaac S. Dag'typist. Began dag'typing in 1848, location unknown. Gallery at 53 Dauphin St., Mobile, Ala., 1852–? Joined the gallery of C. Barnes, 1855 or before, and left in 1856. In Dec. 1855, dag'typing in Tampa, Fla. CD; nsp, Tampa.

Clark, James R. Dag'typist. Died 1848. Partnership with E. Anthony and J. M. Edwards, National Miniature Gallery, 1844–1845, 247 Broadway, NYC; partnership with E. Anthony, 247 Broadway, "National Miniature Gallery," Anthony, Clark, & Co., 1845–1847. BD (*The Gem*), 1844; BN; *Gazette of the Union* (Odd Fellows), 1848.

Clark, John M. & Bro. Dag'typists. Member of N.Y. State Daguerreian Association to investigate Hill's color process. Gallery at 551 Broadway, NYC, 1851. BN; BD.

Clark, P. Dag'typist. San Francisco, 1852. CD.

Clark, Peter G. Dag'typist. Gallery at 36 Washington St., Boston, 1851; 103 Court St., 1854. *See also* Clark & Smith. BD.

Clark (Peter G.) & Smith (Charles J.). Dag'typist (Clark). San Francisco, 1860. CD.

Clark, William. Dag'typist. Gallery at Watson's store, Cleveland, Ohio, 1848; 78 Superior St., 1849. Nsp.

Clarke, Ephraim. Dag'typist. Gallery at 226 Bleecker St., NYC, 1849. BD.

Clarke, J. W. Dag'typist. Jerseyville, Ill., 1854–1855. SBD.

Clayton. *See* Bell & Clayton.

Cleaver, Hiram. Dag'typist. Havana, Ill., 1854. SBD.

Clemerson, Daniel. Dag'typist. Born 1827, Georgetown, D.C. Practiced dag'typing, McMinn Co., Tenn., 1850. USC.

Clemons, John R. Dag'typist. Gallery at 516 N. 2nd St., Philadelphia, 1854–1856. SBD; PAJ.

Clendenen & Foster. Dag'typists. Paris, Ill., 1854–1855. SBD.

*Clifford, R. A. Portrait painter, dag'typist (?), photographer. Milwaukee, Wis., 1850s. NYHS.

Cobb (Luther) & Co. Dag'typist, boot and shoemaker. Gallery at 137 Westminster St., Providence, R.I., 1849–1856. Adv., boots and shoes, 1856. RBD; CD.

Cobin, C. S. Dag'typist. Gallery at 179 High St., Providence, R.I., 1849. RBD.

Coburn & Cerveau. Dag'typists. Adv., rooms, Feb. and early Mar. 1841, Savannah, Ga. Nsp.

Coffin, A. K. Dag'typist. Gallery at 28 Hanover St., Boston, 1855; 365 Washington St., 1856. *See also* Drew & Coffin. BD.

Cohen, ———. Dag'typist. Gallery cor. King and Liberty St., Charleston, S.C., 1854; partner with Lafar, 1854; Charleston, 1857. Nsp; *Harper's Monthly Magazine*, 1857, p. 20 (some of the scenes in an article about Charleston were taken from dag'types by Cohen).

Cohen, James. Dag'typist. Gallery at 54 Canal St., NYC, 1849–1851. BD.

Colburn, James M. Dag'typist. Wyoming, Ill., 1854. SBD.

Colby, John. Dag'typist. Gallery at 99 8th Ave., NYC, 1851. BD.

Cole, C. Dag'typist. Gallery at 63 Court St., Boston, 1849–1850. BD.

Cole, E. J. Dag'typist. Saco, Me., 1855. SBD.

Coleman, Joseph. Dag'typist. Baltimore, 1860. CD.

Coles, J. P. Dag'typist. Lacon, Ill., 1854. SBD.

Collins, David C. Dag'typist. Exhibited, with brother T. P. Collins, twenty frames of dag'types at American Institute, 1846. Partnership with brother, 1846 to ca. 1851, Philadelphia; 100 Chestnut St., 1851–1856; adv., "two silver medals awarded at fairs of the Franklin and Amer. Inst." in 1852. *See also* Collins, T. P. AI; CD; DJ; SBD; PAJ, 1856, p. 126; *Pennsylvania Freeman*, 1852.

Collins, J. B. Dag'typist. Louisville, Ky., 1848. CD.

Collins, T. P. Dag'typist. Partnership with brother, 1846 to ca. 1851, Philadelphia. Itinerant, N. Adams, Mass., 1851; Westfield and Springfield, Mass., 1853. *See also* Collins, David C. CD; DJ; SBD.

Collomar, George W. Dag'typist. Born, 1827, Vt. Worked for Andrew B. Tubbs, Harrisburg, Pa., 1850. USC.

Colwell, Reuben H. Dag'typist. Gallery at 176 6th Ave., NYC, 1851. BD.

*Cone, D. D. Dag'typist, artist. Practiced dag'typing in Fisherville, N.H., 1849. RBD.

Connelly, A. H. Dag'typist. Gallery at 138½ Washington St., Boston, 1852–1853. BD.

Cook, George M. Dag'typist. Gallery at 131 Lake St., Chicago, 1858. CD.

*Cook, George Smith. Dag'typist, artist, photographer. Born 1819, Stratford, Conn.; died 1902, Bel Air, near Richmond, Va. Settled in New Orleans and studied painting, ca. 1838–1845. Began dag'typing, ca. 1840; itinerant, 1840–1844. Opened gallery, New Orleans, 1845. Exhibited five frames dag'types at American Institute, 1846; Charleston, S.C., 1849–1850. Operated Mathew Brady's NYC gallery, 1851. Purchased the gallery of C. C. Harrison, 293 Broadway, NYC, in May 1851 and installed W. A. Perry as operator. Listed at 235 King St., Charleston, 1852. Exhibited S.C. Institute, 1851–1852. Specialized in copying small dag'types into large from quarter to double whole-plate size. Pioneer in paper photography from 1854. Purchased gallery of Marcus A. Root, Philadelphia, 1856, and was associated with Root in gallery. Made some dag'type scenes for article published in *Harper's Monthly Magazine*, 1857, about Charleston. Opened Photographic Art Gallery opposite the Girard House, Philadelphia, 1859. Also gallery in Charleston, 1852–1872, when address became 281 King St. and a George La G. Cook, photographer, was associated with him. Well known as Civil War photographer on the Confederate front. Moved to Richmond, 1880. BN; AI, 1846; DJ; HJ, 1853; CD, Charleston, 1852–1873; PAJ, 1852, 1854; RT; A. L. Kocher and H. Dearstyne, *Shadows in Silver*, 1954.

Cook, H. S. Dag'typist. Brunswick, Me., ca. 1854. George A. Wheeler and Henry W. Wheeler, *History of Brunswick, Topsham, and Harpswell, Maine*, 1878.

Cook, James D. Dag'typist. NYC, 1844. CD.

*Cook, Miss Jane. Amateur artist, dag'typist. Exhibited drawings and rice paintings, American Institute, 1842, 1846, 1849, 1856; exhibited India ink portrait and one dag'type, American Institute, 1846. Gallery at 425 Broadway, NYC, 1846. NYHS; CD; AI.

*Cook, Wesley D., & Co. Artist, dag'typist. Listed as W. D. Cook & Co., 42½ Canal St., NYC, 1844; 243 Broadway, 1846–1847. Wesley Cook, artist, age thirty-five, native of N.Y. state, is listed in census as residing in NYC, 1850. CD; BD; NYHS.

Cooley, ———. Dag'typist. Adv., rooms at 100 Broughton St., Savannah, Ga., Feb. 24, 1845, with partner Doratt. Possibly Samuel A. Cooley. Nsp.

Cooley, Otis H. Dag'typist. Tauton, Mass., 1849; Springfield, Mass., 1850–1853. RBD; SBD.

Cooley, S. A. Dag'typist. Gallery at 40 and 42 State St., Hartford, Conn., 1849. Possibly Samuel A. Cooley. RBD.

Coombs, Frederick C. Dag'typist. St. Louis, Mo., 1846–1847; 48 Clark St., Chicago, 1848–1849; San Francisco, 1850–1851. BN; CHS; DJ, 1850; nsp, San Francisco, 1851.

Cooper, ———. Dag'typist. Philadelphia, 1850s. MAR.

Cooper & Demarest. Dag'typists. Gallery at 222 Canal St., NYC, 1853–1854. BD.

Cooper, James C. Dag'typist. Gallery at 24 6th Ave., NYC, 1851. BD.

Cooper, M. A. Dag'typist. Adv., Oct. 1852, rooms over post office, Athens, Ga.; adv., Feb.–July 1853, dag'typing, Athens. Information courtesy of Dr. W. Robert Nix.

*Copeland, O. P. Portrait painter, teacher of drawing and painting, dag'typist. Adv., Raleigh, N.C., Nov.–Dec. 1855. Nsp.

Corduan, Benjamin. Dag'typist. Rear, 28 Cherry St., NYC, 1842–1843; associated with C. R. Parker (artist) at 55 Royal St., Mobile, Ala., 1844. CD; nsp, 1844.

Corley, S. T. Dag'typist. Adv. rooms over Mr. Swinney's grocery, Albany, Ga., 1848. Nsp, Apr. 29.

Cornelie, Miss A. Dag'typist. Bativia, Ill., 1854–1855. SBD.

*Cornelius, Robert. Dag'typist, silver-plated ware, lamp, and chandelier business, inventor. Born 1809, Philadelphia; died 1893. Associated with father as a manufacturer of silver-plated ware from ca. 1827. Studied chemistry under Dr. Troost, Nashville University, and drawing under James Cox. Admitted as partner, Cornelius & Son, 1831. Invented and patented a solar lamp for burning lard or sperm oil; experimented dag'typing, 1839, and was first to use bromine, with Dr. Paul Beck Goddard, to reduce exposure time to ten seconds. Listed as dag'typist, N.E. cor. 8th St. & Lodge Alley, Philadelphia, in adv. in *U.S. Gazette*, July 2, 1840. Continued as dag'typist until ca. 1843, not professional after this date. Also experimented with many processes of plating by electric and galvanoelectric methods and applied the "electrophorous"—an arrangement by which the gas is lighted by electricity and not affected by weather. After 1851, the famous lamp and chandelier firm consisted of Cornelius and his three sons; five hundred workmen were employed in 1871. MAR; nsp, 1840; FIJ, 1840, p. 393; *Great Industries of U.S.*, 1871, p. 315.

Cornu, F. Dag'typist. Bayou Rd. near Galvez, New Orleans, 1859. CD.

Cox, J. B. Dag'typist. Cox's Daguerrian Gallery, Danville, Pa., ca. 1854. Imprint on velvet in miniature case.

Cralle, W. Dag'typist. Gallery at 37 Main St., Richmond, Va., 1854. CD.

Crane, H. A., & Son (Henry L.). Dag'typists. Adv., Tampa, Fla., 1857, as formerly Mann & Crane. Nsp.

Crawford, William. Dag'typist. Born 1822, Tenn. Practiced dag'typing, Trenton, Tenn., 1850. USC.

Cressey & Emerson. Dag'typists. Dover, N.H., 1849. RBD.

Cridland, T. W. Dag'typist, frame maker. Student of Morse. Practiced dag'typing, Lexington, Ky., 1840. RT.

Crobaugh, Samuel. Dag'typist, photographer. Gallery at 4 and 6 Ontario St., Cleveland, Ohio, 1852–1853; also gallery at 106 Superior St., 1855; listed as

photographist at 28 Hoffman's Block, 1859. Nsp, 1852; SBD; CD.

Crockett, E. Dag'typist, photographer. Practiced dag'typing in East Thomaston, Me., 1849; Rockland, Me., 1855. Took stereo views, ca. 1868–1878. CD; SBD; SV.

Crompton, J. D. Dag'typist. Naples, Ill., 1854. SBD.

Crosby, Robert R. Dag'typist. Gallery at 17 Hanover St., Boston, 1847–1849; 58 Hanover St., 1851; 1-1/2 Tremont Row, 1852–1854; 168 Hanover St., 1855–1856. BD.

Crowell, S. Horton. Dag'typist. Gallery at 63 Fulton St., Brooklyn, 1846–1849. CD.

Crown, L. Dag'typist. Chester, Pa., 1854. BD.

Cullow, T. Dag'typist. Gallery at 129 Superior St., Cleveland, Ohio, 1845. Nsp.

Cummings, ———. Dag'typist. Date and location unknown. Imprint on velvet in miniature case.

Cunningham, A. Dag'typist. NYC, 1842. PWB.

Currier, John Q. Dag'typist. Lowell, Mass., 1853. CD.

Dabrann, M. Dag'typist. From Holland. NYC, 1850. USC.

Daggit, E. Dag'typist. Feb. 1856, location unknown. Information written in rear of picture unit. OSU.

Dale, Thomas. Dag'typist. Born 1812, Tenn. Practiced dag'typing, Robertson Co., Tenn., 1850. USC.

Danielson, Frank M. Dag'typist. Portland, Me., 1855. SBD.

Danks, H. P. Dag'typist. Gallery at 39 Clark St., Chicago, 1853–1856. CHS; SBD.

Darling, J. C. Dag'typist. Haverhill, Mass., 1859, CD.

Darling, T. H. Dag'typist. Gallery at 62 Milk St., Boston, 1841. Nsp adv.

Dart, C. Dag'typist. Gallery on Main St., Bennington, Vt., 1855. Took stereo views, ca. 1869–1878. SBD; SV.

David, Amos. Dag'typist. Born 1804, Va. Practiced dag'typing, Fayette Co., Tenn., 1850. USC.

*David, Louis P. Portrait painter, commercial artist, drawing master, dag'typist. Worked as sign and ornamental painter during the late 1830s and the 1840s in New Orleans. Began portrait painting and teaching, ca. 1850. Dag'typist from ca. 1855; listed at 152 Royal St., New Orleans, 1859. Listed in 1866 as painter. NYHS; CD.

Davie, Daniel T. Dag'typist, photographer, author. Born 1819. Began dag'typing, 1846. Utica, N.Y., 1848–1851; opened gallery at Syracuse, N.Y., 1852. Member N.Y. State Daguerreian Association to investigate claims of Hills' color process. Took portraits of Washington dignitaries. Author of *Photographer's Pocket Companion* (1857); *Secrets of the Dark Chamber* (1870). BN; DJ.

Davis, ———. Dag'typist. Cincinnati, Ohio, 1852; gallery at 14 Main and 5th, 1853. HJ; SBD.

Davis & Perry. Dag'typists. Gallery at 257 Washington St., Boston, 1852. *See also* Davis, J. J. P. PAJ.

Davis, Ari. *See* Manufacturers and wholesale suppliers.

Davis, Asahel. Dag'typist. Boston, 1841. BN.

Davis, Benjamin F. Dag'typist. Phoenixville, Pa., 1854–1855. BD.

Davis, Daniel, Jr. *See* Manufacturers and wholesale suppliers.

Davis, H. Dag'typist. Cadiz, Ohio, 1853. SBD.

Davis, J. D. (Joseph). Dag'typist. Gallery at 101 Fulton St., Brooklyn, 1856–1860. CD.

Davis, J. J. P. Dag'typist. Gallery at 34 Tremont Row, Boston, 1847–1850; 257 Washington St., 1851–1854. BD; RBD.

Davis, William. Dag'typist. Gallery at 121 W. Baltimore St., Baltimore, 1858–1860. CD.

Daws, E. Jr. Dag'typist. Richmond, Va., July 1841. Nsp.

Dawson, ———. Dag'typist. Located on Chestnut St., Philadelphia, 1856. PAJ, 1856, p. 126.

De Bruns, B. Dag'typist. Gallery at 105 South St., Philadelphia, 1854–1855. SBD.

De La Hay, J. J. Dag'typist. Taylorsville, Ill., 1854–1855. SBD.

Delano, Douglas C. Dag'typist (?), photographer. Adv. as a photographist in Steubenville, Ohio, 1853–1856. SBD; CD.

Dellinger, J. Dag'typist. Lancaster, Pa., 1854–1855. BD.

Demarest, Abraham G. Dag'typist. Gallery at 328 Bleecker St., NYC, 1851–1854. BD.

Demarest, Warren C. Dag'typist. Gallery at 166 Grand St., Brooklyn, 1856. CD.

Denison, D. Dag'typist. Partner with P. H. McKernon, Albany, N.Y., 1853. CD.

Dennis, Albert S. Dag'typist. Gallery at 71 Newberry St., Lawrence, Mass., 1857. CD.

Denny, Conrad B. Dag'typist. Partner with E. T. Whitney, Rochester, N.Y., 1851–1854. BN.

Derby & Bros. Dag'typists. Jerseyville, Ill., 1854–1855. SBD.

Deshong, W. H. Dag'typist, photographer. Mobile, Ala., 1852; Memphis, Tenn., 1857; gallery at 182 Main St., 1859. CD.

De Zavala, Alexander, (M.D.). Dag'typist. From New Orleans. Gallery in Franklin Bldg., Superior and Water St., Cleveland, Ohio, 1845–1846. Operator in the gallery, C. Stimpson. Nsp.

Dibble, E. Dag'typist. Rooms in Franklin Bldg., Superior and Water St., Cleveland, Ohio, 1842. Adv. said dag'types taken "in all weathers." Nsp.

*Dickerman, Sumner D. *See* John Mix Stanley.

Dickerson, ———. Dag'typist. Gallery on Market St., Philadelphia, 1856. PAJ, p. 126.

*Dickman, W. Artist, dag'typist. Born ca. 1824, Pa. Living in Sacramento, Calif., in June 1860. Dag'typist, San Francisco, 1854–1856. NYHS; CD.

Dietrich, C. J. Dag'typist. Rochester, N.Y., 1852. Nsp adv.

Disbrow, Charles. Dag'typist. Gallery at 8 and 9 Brewsters Bldg., New Haven, Conn., 1849. RBD.

Dixon, Joseph. Inventor, amateur dag'typist. Born Jan. 18, 1799, Marblehead, Mass.; died June 17, 1869, Jersey City, N.J. Experimented with the dag'type in 1839 and was one of the first persons to take portraits with the camera. Invented method of taking dag'types with reflector so they could be reversed; originator of process of photolithography; perfected collodion process; assisted Harrison in system of grinding lenses. ACB; PP, 1869, p. 252.

Dobyns & Co. Dag'typist. Gallery at 180 Main St., Memphis, Tenn., 1855. CD.

Dobyns (T. C.) & Co. Dag'typist. Gallery at 24 W. 5th St., Cincinnati, Ohio, 1848–1849; 26 W. 5th St., 1850. CD; SBD.

Dobyns & Harrington. Dag'typists. Gallery at Canal and Camp St., New Orleans, 1858; 6 Camp St., 1853–1859. *See also* Harrington, W. H. PAJ, 1858, p. 244; CD, 1859.

Dobyns & Spaulding. Dag'typists. Gallery at N. E. cor. Olive and 4th St., St. Louis, Mo., 1854–1857. SBD.

Dobyns, Richardson & Co. Dag'typists. Exhibited whole-plate dag'types, N.Y. Crystal Palace, 1853. Gallery at 299 Broadway, NYC, 1854. *Gleason's Pictorial Drawing-Room Companion*, 1854.

Dobyns, Richardson & Moissenet. Dag'typists. Gallery at 303 Broadway, NYC, 1853–1854. BD.

Dobyns, T. I. Dag'typist. Gallery at cor. Main and Jefferson St., Memphis, Tenn., 1853–1854. CD.

Dobyns, Yearout, & Richardson. Dag'typists. Gallery on N. College St., upstairs, Nashville, Tenn., 1853–1854. SBD; RBD.

*Dodge, Edward Samuel. Miniature painter, dag'typist. Born July 8, 1816; died Apr. 6, 1857. Worked as artist, NYC, 1836; Poughkeepsie, N.Y., 1837–1842; adv. Richmond, Va., 1844; exhibited miniatures at the National Academy and the American Institute, 1842. Dag'typist in Augusta, Ga., 1850–1853 and possibly before. Sold gallery in late 1853 to Dr. William H. Chalmers, P.O. cor. over Clark & Co., Jewelers. NYHS; HJ; nsp, *Augusta Chronicle*, Jan. 19, 1854.

Dodge, James H. Dag'typist. Gallery at 3 Bowman's Block, Bangor, Me., 1855. CD.

Dodge, Luther P. Dag'typist. Gallery at

151 Jefferson Ave., Detroit, Mich., 1852 (rooms used before by McDonnell); cor. Griswold, upstairs over Ives Exchange office, 1853; adv. as photographic chemist at 198 Superior St., Cleveland, Ohio, 1859. CD.

Doe, R. H. Dag'typist. Haverhill, Mass., 1853. SBD.

Done, T. C. Dag'typist. Montreal, Canada, 1851. DJ.

Dorat, Dr. ———. Scientific dag'typist. Resided in Brooklyn. Lectured on combination of chemicals used in dag'type before American Photographic Institute, 1851. Called by Henry Hunt Snelling a scientific dag'typist. SLP, 1877, p. 216; HHS.

Doratt, ———. Dag'typist. Partner with Cooley at 100 Broughton St., Savannah, Ga., Apr. 1845. Nsp adv.

Dorr, James. Dag'typist. Lowell, Mass., 1859. CD.

Douglas, C. Dag'typist. Gallery at 105½ Fulton St., Brooklyn, 1859–1860. CD.

Douglas, E. M. Dag'typist, photographer. Gallery at 345 Fulton St., Brooklyn, 1858–1860; Fulton St., 1863. CD.

*Douglass, Robert M. J. Black portrait, sign, and ornamental painter, lithographer, dag'typist. Born Feb. 8, 1809; died Oct. 26, 1887, Philadelphia. Studied painting under Thomas Sully. Exhibited portrait at Pa. Academy, 1834. Traveled to Kingston, Jamaica, 1848. Listed as dag'typist at 54 Arch St., Philadelphia, 1854–1855. Except for visits to Haiti and England, worked in Philadelphia. NYHS; SBD, 1854–1855; *Journal of Negro History*, 1925, p. 643. Other information courtesy of James de T. Abajian.

Douglass, W. H. Dag'typist. Worked for J. Thompson, Albany, N.Y., ca. 1850. Gallery at 5 4th St., St. Louis, Mo., 1852; moved to Fla., 1853. Missouri Historical Society; HJ, 1853.

Dowd, Albert. Dag'typist. Gallery at 233 Broadway, NYC, 1846–1849. BD.

Drake, Charles, & Co. Dag'typist. Gallery at 366 8th Ave., NYC, 1853–1854. BD.

Drake, J. L. Dag'typist. Effingham, N.H., 1849. RBD.

Draper, John William. Scientist, teacher, author, dag'typist. Born May 5, 1811, St. Helen's, near Liverpool, Eng.; died Jan. 4, 1882, Hastings-on-Hudson, N.Y. Came to U.S. with mother and sister in 1832, settling in Christiansville, Va. Graduated from medical dept., University of Pa., 1836; appointed professor of chemistry, City of New York University, 1837, and continued until 1881. Began experimenting with dag'type in 1839. Associated with Morse in experiments in dag'typing and shared a dag'type studio briefly until ca. 1841. Presented to the Lyceum of Natural History, NYC, a photograph of the moon's surface, Mar. 1840 (?). Made important contributions to science in

researches on light and heat. Rumford medal from American Academy for researches in "Radiant Energy" in 1875. Over one hundred learned papers from 1832–1880. Also wrote numerous volumes on scientific historical subjects. BN; ACB.

Dresser, R. Dag'typist. Danville, Me., 1855. SBD.

Drew & Coffin. Dag'typists. Gallery at 365 Washington St., Boston, 1856. BD.

Drummond, Alonzo J. Photoengraver, dag'typist. Exhibited eight plates of the Order of Freemasons in lodge dress at N.Y. Crystal Palace, 1853. *See also* James Sidney Brown, *Art and Industry Exhibition Crystal Palace, N.Y., 1853.*

Dumphy, Henry. Dag'typist. Gallery at 229 Bowery, NYC, 1853–1854. BD.

Dunchee, Francis. Dag'typist. Born 1829, Vt. Practiced dag'typing, with brother Horace, in Taunton, Mass., 1850. USC.

Dunshee, Edward S. Dag'typist, photographer. Practiced dag'typing, Fall River, Mass., 1853–1855; photographer, 1869–1875; 3 Tremont Row, Boston, 1875. BD; CD; photograph dated 1875.

Dupee, Isaac H. Dag'typist. Augusta, Me., 1855; Bath, Me., 1855. BD.

Durang (Dorang), William H. Dag'typist. Gallery at 303 Broadway, NYC, 1848–1851. BD; sheet music, 1848.

Durgin, J. O. Dag'typist. Brunswick, Me., 1854. George A. Wheeler and Henry W. Wheeler, *History of Brunswick, Topsham, and Harpswell, Maine*, 1878.

Duryea, Townsend. Dag'typist. Gallery at 140 Grand St., Brooklyn, 1854–1856. CD.

Dwight, ———. Amateur dag'typist. Pupil of Morse, fees paid by Charles Avery of Hamilton College, 1840, Carleton Mabee, *The American Leonardo: A Life of Samuel F. B. Morse*, 1943, p. 243.

Dyer, William D. Dag'typist. Gallery at 144 Chestnut St., Philadelphia., 1854–1855; San Francisco, 1860. SBD; CD, 1860.

Easterly, Thomas M. Dag'typist. Born 1809, Brattelboro, Vt.; died 1882. Associated in Liberty, Mo., with F. F. Webb, 1846–1847; St. Louis, Mo., 1848–1882. Captured a flash of lightning on dag'type plates. BN.

Eastman, Walter B., & Co. Dag'typist. Gallery cor. Court and Howard St., Boston, 1847; 11½ Tremont Row, 1848–1849. Bought out John Plumbe's Boston gallery, 75 Court St., ca. 1850. The original Plumbe address continued until 1859, with the exception of 1850–1853 when he is listed at 2 Blanchard Block Ct. Listed at this address, 1850–1851, as Hadley & Eastman. Listed also in Charlestown, Mass., 1856, as dag'typist. BD; CD.

Eaton, ———. Dag'typist. Partnership, Halsee & Eaton, in Apr. 1843 at Lyce-

um Hall, Savannah, Ga. Nsp adv.

Eddy, Amos. Dag'typist. Gallery at 182 7th St., NYC, 1849; 107 Bowery St., 1853–1858. BD; CAS.

Eddy, Mrs. J. Dag'typist. Naperville, Ill., 1854–1855. SBD.

Eddy, L., & Co. Dag'typist. Gallery at 218 7th, NYC, 1851; 21 Ave. D, 1853–1854. BD.

Edgerton, ———. Dag'typist. Went to Japan, 1855. Made harbor scenes. Information courtesy of Josephine Cobb.

Edmonds, ———. Wentworth St., Charleston, S.C., 1852. Nsp adv.

Edwards, Capt. ——— Itinerant dag'typist. Operated floating gallery, Bowling Green, Ky., ca. 1850s, and along the Ohio River at landings. APB, 1874, p. 417.

Edwards, Jonas M. Dag'typist. Learned dag'type process from Morse. Partnership with T. N. Starr, Main St., Richmond, Va., Dec. 7, 1841–?; Washington, D.C., and NYC, partnership with E. Anthony, 1842–1843; Washington, D.C., and 247 Broadway, NYC, partnership with E. Anthony and H. Chilton, 1843–1844; 247 Broadway, NYC, partnership with E. Anthony, 1844–1845. Nsp Richmond; BD (*The Gem*); nsp adv., *N.Y. Tribune*; BD; RT.

Edwards, William S. Dag'typist. Gallery at 199 Hanover St., Boston, 1855. BD.

Elliot, E. Dag'typist. Gallery on Main St., Chester Court House, S.C., 1851. DJ.

Elliot, T. J. Dag'typist. Pawpaw Grove, Ill., 1854–1855. SBD.

Elliott, William B. Dag'typist. Adv. in Philadelphia as photographist, 1847. CD.

Ellis, ———. Dag'typist. Providence, R.I., 1852; Lynn, Mass., 1853. HJ.

Ellis Daguerrian Gallery. Gallery at 2½ Smith's Block, Bangor, Me., 1848–1849; Bath, Me., 1849; Burnham & Ellis, 19 Main St., Bangor, 1851. CD; RBD; DJ, 1851.

Ellis, J. P. Dag'typist. Location unknown, 1854. From dated dag'type. Sotheby-Parke-Bernet cat. 119, 1970.

Ellis, Lemuel. Dag'typist. Gallery at 123 Washington St., Boston, 1854. BD.

Elrods, John. Dag'typist, photographer. Practiced dag'typing in Louisville, Ky., 1848; gallery at 71 4th St., St. Louis, Mo., 1860, as dag'typist and photographer. CD.

Emerson, A. E. Dag'typist. Gallery at 123 Washington St., Boston, 1841. Nsp adv., *Boston Evening Transcript.*

Emerson, J. M. Dag'typist. Richmond, Va., 1843; gallery in Merchants Exchange Bldg., Cleveland, Ohio, 1844. Sold gallery to Jenkins, July 1844. Nsp.

Emmons, Charles. Dag'typist. Concord, N.H., 1856. CD.

England & Gunn (Mlle.). Dag'typists. Philadelphia, 1848. Won second premium for dag'types at Franklin Institute, 1848. FIJ, 1848, p. 424.

Ennis, T. J. Dag'typist. Born 1815, Pa. Practiced dag'typing, Philadelphia, 1850; 106 Chestnut St., 1851; Arch St., 1856. USC; DJ; PAJ, 1856, p. 126.

Enseminger, E. Dag'typist. Ashland, Ohio, 1853. SBD.

Enterprise Gallery. Dag'typist. Gallery at 74 4th St., Pittsburgh, Pa., 1855. Nsp.

Esselman & Wilson. Dag'typists. Gallery at 27 St. Clair St., Pittsburgh, Pa., 1854–1855. CD; BD.

Esten, John. Dag'typist. Belfast, Me., 1855. SBD.

Esterly, D. Dag'typist. Newburgh, N.Y., 1847. Took dag'type of Uzal Knapp (1759–1856), last survivor of Washington's Life Guard. New-York Historical Society's collection of dag'types.

Evans, Charles. Dag'typist. Sun Beam Gallery at 106 Chestnut St., Philadelphia, 1851; 380 Market St., 1854–1856. SBD; PAJ, 1856, p. 126.

Evans, G. Dag'typist. Worcester, Mass., Dec. 1841, 6 Stone Block, cor. Main and Central St. Adv., "Photographic Miniatures taken in a few seconds." Nsp.

Evans, O. B. Dag'typist. Gallery on Main St., Buffalo, N.Y., 1850–1851. Exhibited at Crystal Palace, London, 1851, portraits of Rev. Ingersoll, Dr. Nott, Dr. Lord, and Dr. Shelton, etc. Records Crystal Palace Exhibition.

Evans, Oliver J. Dag'typist. Leedsville, N.J., 1850. SBD.

Everett, Lorenzo C. Dag'typist. Fitzwilliam, N.H., 1849. RBD.

*Fahrenberg, Albert. Portrait painter, associate dag'typist, cigar maker. Born ca. 1825, Cologne, Germany. Came to NYC in about 1850. Employed by G. T. Shaw, Louisville, Ky., as associate dag'typist, 1859. CD; NYHS.

Fales, Charles. Dag'typist. Gallery at 22 Cheapside, New Bedford, Mass., 1849–1853. RBD; SBD.

Fardon, R. G. Dag'typist. Gallery at 146 Kearny St., San Francisco, 1855–1856; 203 Clay St., 1857–1860. CD; PAJ, 1857, p. 112.

*Faris, Thomas. Dag'typist, portrait painter, photographer. Began dag'typing, 1841. Partner with Ezekiel C. Hawkins, 5th St., between Main and Walnut, Cincinnati, Ohio, 1843, and also listed as portrait painter. Own galleries in Cincinnati, 1844–1857. Bought out Samuel Root's gallery at 363 Broadway, NYC, ca. 1858, listed as Faris & Irwin. Faris & Hawkins, Cincinnati, 1856 and 1857. Awarded bronze medal for heliographics on glass by American Institute, 1856. Worked as photographer for Kurtz Gallery, in charge of one of the depts., 23rd St., near Broadway, NYC, 1877. BN; CD, 1843–1857; BD, NYC, 1858–1859; AI, 1856; SLP, 1877, p. 340.

Farnsworth, ———. Dag'typist. Gallery at 32 5th St., Cincinnati, Ohio, 1853. SBD.

Farrand, Camillus. Dag'typist. Gallery at 307 Broadway, NYC, 1853–1855. CD; BD.

Farrell, O. F. Dag'typist. Adv. as dag'typist, June 24–Aug. 28, 1851, in Athens, Ga. Information courtesy of Dr. W. Robert Nix.

*Fassett, Samuel Montague. Artist, dag'typist. Gallery at 131 Lake St., Chicago, 1856; Fassett & Cook, 1857–1858; Fassett & Cook, 122 S. Clark St., 1859–1860. Continued listing as photographer to 1863. NYHS; CHS; MAR.

Fay & Stanley (John Mix). Dag'typists. Rooms on Pennsylvania Ave., Washington, D.C., 1842. Nsp adv., Mar. 1842.

Feller, A. L. Dag'typist. Columbus, Ohio, 1856. *See also* Armsted, G. CD.

Felton, George W., Jr. Dag'typist. Salem, Mass., 1853. SBD.

Fesenden, C. *See* May & Fesenden's.

*Fessenden, Benjamin. Artist, dag'typist. Born ca. 1809, Westminster, Mass. Gallery at 17 Hanover St., Boston, 1851–1853; 47 Hanover St., 1854–1859. NYHS; BD.

*Field, Erastus Salisbury. Primitive painter, portraits and scenes, dag'typist. Born May 19, 1805, Leverett, Mass.; died 1900, Sunderland, Mass. Largely self-taught; studied painting with Samuel Morse for three months, 1824–1825. Married Phebe Gilmore, also an artist. Resided in Hartford, Conn., Monson, Mass., and Palmer, Mass., 1832–1842; NYC, 1842–1848. Became dag'typist in NYC during the 1840s. Moved back to Palmer, 1848–1859; Sunderland, 1859–1900. A portrait painter but famous for scenes from classical mythology and biblical history and for his "Historical Monument of the American Republic," ca. 1875 or later. NYHS; Jean Lipman, *American Primitive Painting*, 1942.

Finley, M. Dag'typist, photographer. Practiced dag'typing in Canadaigua, N.Y., 1850; Ontario, Canada, 1851; Canadaigua, 1858. Took stereo views as Finley & Sons, 1868–1878. CAS; SV.

Fischer, Arthur F. Dag'typist, photographer. Gallery on High St., Columbus, Ohio, 1853; 103 W. Baltimore St., Baltimore, 1858; Central, 1860. SBD; CD.

Fish (Addison A.) & Co. Dag'typist. Adv., Mammoth Daguerrian Rooms, Lowell, Mass., 1855; 228 Washington St., Boston, 1855. CD.

Fish & Heywood. Dag'typists. Gallery at 228 Washington St., Boston, 1856. *See also* Fish & Co. BD.

Fitch, C. L. Dag'typist. Partner with T. Callow, 129 Superior St., Cleveland, Ohio, 1845. Nsp.

Fithian, ———. Dag'typist. Gallery at 24 4th St., Cincinnati, Ohio, 1853. SBD.

Fitz, Henry. Telescope maker, dag'typist. Born 1808, Newburyport, Mass.; died Nov. 6, 1863, NYC. Became printer and later learned trade as locksmith. To Cincinnati and established lock manufactory, which he sold. To New Orleans and sold another lock manufactory. Made his first reflecting telescope, 1835. Returned to NYC soon after discovery of dag'type process. Assisted Alexander Wolcott and John Johnson in polishing a speculum for their reflecting camera. Opened first dag'type gallery in Baltimore, 1840, and continued taking dag'types through 1842. Listed at 112 Baltimore St., Baltimore, as "Daguerreotype likeness taker." Exhibited at the American Institute a telescope which brought him favorable notice among astronomers and met great success producing instruments for observatories. During his last days, he had been about to sail for Europe to select a glass for a twenty-four-inch telescope and to procure patents for a camera involving a new style of lens. ACB; HJ, 1863, pp. 217–218; CD, Baltimore, 1842; BN.

Fitzgibbon & Bourges. Dag'typists. Gallery at cor. P.O. and 21st St., Galveston, Tex., with branches in Houston and Austin, Tex., 1851. HJ.

Fitzgibbon, John H. Dag'typist, photographer, publisher. Born, 1816 (?), London, Eng.; died 1882. Listed as saddler, Philadelphia, 1839; Lynchburg, Va., hotel keeper and dag'typist, 1841–1846. Itinerant dag'typist, Cincinnati and westward, 1846. Gallery in St. Louis, Mo., 1846–1860, 1866–1876. Itinerant, southwest Mo., 1853. Traveled Central and South America, 1858; Vicksburg, Miss., 1860–1863; New Orleans and NYC, 1863–1865. Exhibited at N.Y. Crystal Palace, 1853, honorable mention. Bought Vance dag'type collection of Calif. views, 1853. Produced large and life-size paper photographs with C. D. Fredericks, 1854–1855. Made views for *Leslie's* and other illustrated publications, 1856–1860. Editor and publisher of *St. Louis Practical Photographer*, 1877 until later, when the magazine was carried on by his wife, also a photographer. "Fitz," as he was called by other photographers, was probably the most widely traveled and the most popular among the pioneer dag'typists. CD; HJ; PAJ; Missouri Historical Society; Rudolph Schiller, *Early Photography in St. Louis*, ca. 1890s; APB, 1875, pp. 81–82, BN.

Flandrau, B. R. Dag'typist. Gallery on Congress at River, Albany and Troy Co., N.Y., 1852. CD.

Fletcher, S. Dag'typist. Gallery at 32 Joy's Bldg., Cleveland, Ohio, 1850–1851. BD.

Flint, A. Dag'typist. Montpelier, Vt., 1849. RBD.

Fly, William M. Dag'typist. Philadelphia, 1856; S.E. cor. 8th and Spring Gardens, ca. 1857. PAJ, 1856, p. 126; imprint on velvet inside miniature case.

Fogg, C. W. Dag'typist. Waltham, Mass., 1853. SBD.

Folger & Co. Dag'typist. Gallery at 142 Washington St., Boston, 1856. BD.

Fontayne & Porter. Dag'typists. Cincinnati, Ohio, 1848–1853; gallery at 30 W. 4th St., 1848–1852. *See also* individual biographies. SBD; CD; BN.

Fontayne, Charles H. Dag'typist, inventor. Born 1814; died 1858, Clifton, N.J., Cincinnati, Ohio, 30 W. 4th St., 1846–1847; 30 W. 4th St., partnership with W. S. Porter, 1848–1852; 2 W. 4th St., with Porter, 1853; Chillicothe, Ohio, 1853; 6 W. 4th St., Cincinnati (alone), 1854–1855. Exhibited eight whole-plate panorama of Cincinnati waterfront at the Franklin Institute, 1848, and at the Crystal Palace exhibition, London, 1851. Produced life-size paper photographs, 1854, and 5½ by 7 ft. enlargements, 1855. Invented apparatus for bulk printing, 1858. MAR; BN; CD; SBD.

Forbus, John H. Dag'typist. Gallery at 72 Chartres St., New Orleans, 1856. CD.

Ford, J. M. Dag'typist. Galleries, Sacramento, Calif., and San Francisco, 1854; Clay & Kearney St., San Francisco, 1855–1856. BN; CD.

Forest, ———. Dag'typist. Exhibited at N.Y. Crystal Palace, 1853. HJ.

Fortney, T. S. & J. G. Dag'typists. Lancaster, Pa., 1854–1855. BD.

Foss & Plummer. Dag'typists, photographers. Gallery at 190 Washington St., Boston, 1847; 190 Washington St. and 115 Court St., 1848–1849. Exhibited colored photographs in Boston, 1869. BD; PP, 1869, p. 332.

Foster, B. Dag'typist. Portland, Me., 1843. BN.

Fowler, Elbert W. Dag'typist. Milwaukee, Wis., 1856, CD.

Fowler, William H. Dag'typist. Gallery at 257 7th St., NYC, 1849–1851; 208 Bowery St., 1851; 371 Bowery St., 1853–1854. BD; CD.

Fox & Moore. Dag'typists. St. Louis, Mo., 1856. Sent adv. to *Photographic Art Journal* which was considered "vulgar and disgraceful" and not copied. PAJ, 1856, p. 128.

Fox, Andrew J. Dag'typist, photographer. Gallery at 57 S.E. cor. Chestnut and 4th St., St. Louis, Mo., 1854–1857; 25 N. 4th St., 1858; 93 Washington Ave., 1860; 402–406 Olive St., 1868–1869. Missouri Historical Society; PP.

Frach, R. Dag'typist. Gallery at 138 Myrtle Ave., Brooklyn, 1859. CD.

Fraizer, Samuel H. Dag'typist. Gallery at N.E. cor. 2d and Otter St., Philadelphia, 1854. SBD.

Franklin, William H. Dag'typist. Gallery at 138 Fulton St., Brooklyn, 1847; 237 Grant St., NYC, 1850–1851. CD.

*Franquinet & Weston. Artists, dag'typists. Gallery at 12 Park Place, NYC, 1842–1843. Made views of the Astor House and also the New York City Hall in late 1842—"beautifully executed and are the most exact representations of

public buildings that can be imagined . . . some daguerreotype portraits . . . for finish, and artistical disposition, are superior to any which have come before us." *The Artist*, 1843, p. 235; NYHS (under James Franquinet and James Weston); *The Gem*, 1844, adv. for Franquinet as historical portrait painter.

Fraser, J. L. Dag'typist. Gallery at 7½ Bowery St., NYC, 1846. Exhibited one frame at American Institute, 1846. AI.

Frazer, Prof. John Fries. Scientist, amateur dag'typist. Born July 8, 1812, Philadelphia; died Oct. 12, 1872, Philadelphia. Made first English translation of Daguerre's booklet in America, published in the *Journal of the Franklin Institute*, Nov. 1839. Also produced dag'types, fall of 1839. ACB; MAR.

Frear, W. H. Dag'typist. Montgomery, Ala., 1854. RBD.

Fredericks, Charles De Forest. Dag'typist, photographer. Born 1823; died May 26, 1894, NYC. Learned dag'typing from J. Gurney, NYC. Traveled with camera in Venezuela, 1843; West Indies and South America, 1844–1851. 223 King St., Charleston, S.C., partnership with N. G. Burgess, winter 1852; Paris, 1853; NYC, partnership with Gurney, 1854–1855; 585 Broadway, NYC, 1856–1858, branch gallery in Havana, Cuba. Continued as photographer, NYC, until about 1889. Exhibited at American Institute, won silver medal for best photographic oil colors, bronze medal for best photographic watercolors, and diploma for pastel colors, 1856. Fredericks spoke Spanish fluently, having spent some time in Havana as a youth. A pioneer in paper photography; in 1854 began making enlarged photographs; became one of New York's most fashionable photographers. Became well known for his *cartes de visite* of famous people in the 1860s. BN; nsp, Charleston, 1852; RT; AI; PP, 1869, p. 332; APB, 1894, pp. 236–238.

Fredericks, Penabert & Germon. Dag'typists, photographers. Gallery on Chestnut St., Philadelphia, 1856. PAJ, 1856, p. 126.

Freeborn, L. H. Dag'typist. Exeter, Ill., 1854. SBD.

Freeman, H. C. Dag'typist. Adv. as dag'typist with rooms over George M. Logan & Co. store, Macon, Ga., Nov. 26, 1845. Nsp.

French, J. W. Dag'typist, photographer. Practiced dag'typing in Vt., 1860. Nsp.

Frink & Co. Dag'typist. Saco, Me., 1849. RBD.

Frisbie, J. M. Dag'typist. Sandusky City, Ohio, 1853, SBD.

Frnt (?), Mrs. S. R. Dag'typist. Quincy (Frost), Ill., 1854–1855. SBD.

Frost, A. J. Dag'typist. Gallery on Broadway, Paterson, N.J., 1850. SBD.

Frost, Allen J. Dag'typist. Gallery at 110 6th Ave., NYC, 1851–1854. BD.

Fry, P. W. Dag'typist. 1854. Location un-

known. HHS, p. 56.

Fuller (Lorenzo F.) & Co. Dag'typist. Born 1823, Conn. Hartford, Conn., 1847; Bartlett & Fuller, 194 Main St., 1848–1849; State Bank Bldg., 1850; Hartford, 1854. USC; CD.

*Fuller, George. Portrait, landscape, and figure painter, amateur dag'typist. Born 1822, Deerfield, Mass.; died 1884, Brookline, Mass. Bought dag'type camera in 1840; took dag'type of family homestead. Took up painting, 1841; Boston, 1842–1847; studied in NYC, painted portraits in Philadelphia and the South, 1847–1859. To Europe, 1860. Operated family farm, 1861–1875. NYHS; Josiah B. Millet, *The Life and Works of George Fuller*, 1886, p. 14.

Fuller, John S. Dag'typist, photographer. Gallery next to post office, Madison, Wis., 1855; Main St., 1858; employed artist to finish photographs in oil. CD.

Fuller, N. Dag'typist. Gallery at cor. Main and S. 13th St., Richmond, Va., 1851. CD.

Gage, E. D. Dag'typist. Gallery at 90 Lake St., Chicago, 1843–1844. CHS.

*Gage, Franklin B. Dag'typist, photographer, artist, author. Practiced dag'typing St. Johnsbury, Vt., 1851–? Well-known New England photographer. Began taking stereo views, ca. 1858. Author of *Theoretical and Practical Photography on Glass and Paper*, 1859. HJ; NYHS; PP, 1869, pp. 96, 324; BN; SV.

Galphin, S. S. Dag'typist. Gallery at 54 Church St., New Haven, Conn., 1849. RBD.

Ganaway, B. Z. Dag'typist. Gallery at E. cor. Sq., Murfreesboro, Tenn., 1853; Shelbyville, Tenn., 1857. SBD; BD.

Gardiner, J. C. Dag'typist. Traveled to Mexico in the 1840s. Information courtesy of Josephine Cobb.

Gardner, John B. Dag'typist. Gallery at 293 Broadway, NYC, 1848–1851. BD.

*Garlick, Theodatus. Sculptor, wax portraitist, doctor, dag'typist. Born Mar. 30, 1805, Middlebury (?), Vt.; died Dec. 9, 1884, Bedford, Ohio. Blacksmith and stonecutter, Cleveland, Ohio, before 1834. Medical degree, University of Md., 1834; listed as dag'typist at 18 Franklin Bldg., Cleveland, 1841. NYHS; nsp, Cleveland, 1841.

Garthwait, Isaac. Dag'typist. Adv. as "Photographic Daguerreotype likeness taker," over 97½ Baltimore St., Baltimore, 1842. CD.

Gatewood, E. H. Dag'typist. Boonville, Mo., 1851. HJ.

Gautchier, J. M. Dag'typist. Gallery at Clark cor. N. Water, Chicago, 1854. CHS.

*Gavit, Daniel E. Dag'typist, engraver. Born ca. 1819; died 1875, NYC. Gallery at 480 Broadway, Albany, N.Y., 1850; 247 Broadway (bought out Edward White, formerly Anthony, Clark, & Co.), NYC, 1850. Included in the pur-

chase were 170 dag'types of famous personages, such as Andrew Jackson, Sir John Herschel, and "all the military and naval." Exhibited American Institute, silver medal, 1850. Also listed at 192 Broadway, NYC, 1851; exhibited at Crystal Palace, London, 1851. Gallery destroyed by fire, 1852. Gave up dag'typing in 1852 and became an engraver for Gavit & Co., 1859–? HJ; CD; BD; SA, Jan. 25, 1851, p. 149; AI; BN; NYHS.

Gay, C. H. Dag'typist. New London, Conn., 1850–1851. DJ.

Gaylord, H. & E. Dag'typists. Cleveland, Ohio, 1845. Nsp.

*Germon, Washington L. Dag'typist, engraver, artist. Partner with J. E. McClees at 182 Chestnut St., Philadelphia, 1847–1855 (dag'typist and engraver). Listed as an artist, 1856–1859. Photographer, 1860–? *See also* McClees & Germon. FIJ; AI; NYHS; SBD.

Gerrish & Rodgers. Dag'typists. Gallery at 142 Chapel St., New Haven, Conn., 1853. CD.

Gibbs, Peter E. Dag'typist. Gallery, Lynchburg, Va., 1853–? Branch on Main St., Richmond, Va. (ambrotypes), 1856–1857. Bought use of Cutting's ambrotype patent, 1855. OSU; PAJ, 1857, p. 31; nsp, Richmond, 1856.

Giddings, Senter B. Dag'typist. Gallery at 179 Broadway, NYC, 1851–1854. BD.

Gilchrist, George C. Dag'typist. Gallery at 82 Merrimack St., Lowell, Mass., 1849–1860. RBD; CD.

Gledhill, William. Dag'typist. Gallery at 378 Market St., Philadelphia, 1854–1856. SBD; PAJ, 1856, p. 126.

Glen, D. L. Dag'typist. Palmetto Daguerrean Gallery, 221 King St., over W. J. Jacobs & Sons, Charleston, S.C., 1852–1857. One of the Charleston dag'typists to take scenes for article in *Harper's Monthly Magazine*. CD; nsp, 1856; *Harper's Monthly Magazine*, 1857, p. 20.

*Goddard, Emerson. Portrait painter, dag'typist, photographer. Practiced dag'typing Woonsocket, Cumberland, R.I., 1849; Woonsocket, 1869. BD; NYHS; PP, 1869.

Goddard, Dr. Paul Beck. Physician, author, amateur dag'typist. Born Jan. 28, 1811, Baltimore; died July 3, 1866, Philadelphia. Began experimenting with dag'typing, Oct. 1839, with Robert Cornelius. In Dec. 1839 discovered that bromine added to iodine would lessen the exposure time necessary for dag'typing. In the 1840s and 1850s acquired a considerable reputation as editor of medical books. Member Franklin Institute. FIJ; CD; HJ; SA; MAR; ACB.

Godfrey, William M. Dag'typist, photographer. Born 1824; died Nov. 5, 1900. First gallery in Placerville, Calif., date unknown. Los Angeles, 1854; Sunbeam Gallery, 55 N. Main St., Los Angeles, 1860. Continued as photogra-

pher, ca. 1870s and later. Ralph W. Andrews, *Picture Gallery Pioneers*, 1964. AJP, 1900, p. 391.

Goebel, Rudolph. Dag'typist, photographer. Practiced dag'typing, St. Charles, Mo., 1856. SLP, 1906, p. 467.

Goodman, Thomas. Dag'typist. Gallery at 360 Grand St., NYC, 1850–1851. BD.

Goodridge, Glenalvon J. Black dag'typist. Wilmington, Del., 1848; York, Pa. (with son), 1851. *Rochester North Star*, 1848; Martin Robison Delany, *The Condition, Elevation, Emigration, and Destiny of the Colored People in the U. S.*, 1852. Information also courtesy of James de T. Abajian.

Gorgas, John M. Dag'typist, photographer. Practiced dag'typing, Pittsburgh, Pa., 1847; floating gallery on the Ohio and Mississippi rivers, 1853–1856; Madison, Ind., 1869, photographer, "Views of Ohio." BN; PP, 1869, p. 324.

Gouraud, François (Jean-Baptiste Fauvel-Gouraud). Dag'typist, author, lecturer on memory training. Born West Indies (?); died 1848 (?), U.S. agent for Alphonse Giroux & Co., Paris. Arrived NYC, Nov. 1839. Exhibited dag'types by Daguerre, Dec. 3–5, 1839. Proclaimed discovery of "Daguerrelite," Dec. 24, 1839. Lectured and taught dag'typing, Dec. 1839–Feb. 1840; Boston, Mar.–June 1840; Providence, R.I., 1840. Dag'typist, Niagara Falls, N.Y., 1842. Lectured on mnemonics, NYC, Dec. 1842–1843; itinerant, 1843–1844. Published three books on mnemonics and a shorthand manual. Spoke French, Spanish, and English fluently, was more influential than any other man in the spread of dag'typing in America, 1839–1840. RT; BN; nsp, NYC, Boston, Philadelphia; National Archives, ship arrivals.

Grabel, Daniel. Dag'typist. Perry, Ill., 1854. SBD.

Grant, Prof. ——. Amateur dag'typist. Produced dag'type view the third day after the account of the process had been published in Boston. RT.

Graves, E. R. Itinerant dag'typist. Lockport, N.Y., 1853. BN.

Green & Benedict. Dag'typists. Syracuse, N.Y., 1851. DJ.

Green, George. Dag'typist. Gallery at 270 Grand St., NYC, 1853–1854. BD.

Greene, James B. Dag'typist. Thompson & Green, Albany, N.Y., 1853. CD.

Greene, Stephen P. Dag'typist. Providence, R.I., 1856. CD.

Gregory, Albert. Dag'typist. Portsmouth, N.H., 1855. SBD.

Grelling, G. Dag'typist. Detroit, Mich., 1856. CD.

Grenell, Dewitt C. Dag'typist. Gallery at 236 Grand St., NYC, 1850–1851. BD.

Gridland, T. W. Dag'typist. Pupil of Morse, 1840–1841. Known as "the first professional west of the Alleghenies." Carleton Mabee, *The American Leonardo: A Life of Samuel F. B. Morse*, 1943, p. 243.

Griffin, Charles. Dag'typist. Providence, R.I., 1854. CD.

Griffing, N. Dag'typist. NYC, 1840–1841. Mentioned in John Johnson's article in *Eureka*, 1846.

*Griswold, Victor M. Dag'typist, portrait and landscape painter, lawyer, chemist, inventor, manufacturer. Born Apr. 14, 1819, Worthington, Ohio; died June 18, 1872, Peekskill, N.Y. Gave up law in early 1840s to take up portrait painting; studied under William Walcutt in Columbus, Ohio, and exhibited at the American Art Union and National Academy, 1848–1858. Began dag'typing (with brother), Tiffin, Ohio, 1850–1853; Lancaster, Ohio, 1852. Originated word "ferrotype" (adopted by nineteenth-century photographers to denote the "tintype" process). Manufactured ferrotypes, Lancaster, 1856–1861; Peekskill, 1861–1867. U.S. patents: addition of albumin to collodion (15,326), July 15, 1856; addition of bitumen to collodion (15,924), Oct. 21, 1856. Stamped his ferrotypes "Griswold's patent," but no record of issuance exists in U.S. patents. Produced ferrotypes in various colors, 1857 (not patented). Patented "Opal pictures on the Ferrotype Plate" (53,815), Apr. 10, 1866. Author of *A Manual of Griswold's New Ferro-Photographic Process for Opal Printing on the Ferrotype Plates*, 1866. NYHS; BN; SBD; PP, 1869, p. 221.

Guildford, E. (Edwin) R. Dag'typist. Amesbury, Mass., 1853. Lowell, Mass., 1853, "at Chase's daguerreotype rooms." CD.

Guldin, Charles H. Dag'typist. Gallery at 175 Houston St., NYC, 1846–1847. BD.

Gunn, Mlle. ——. Dag'typist. Partner with England, Philadelphia, 1848. Won second premium, Franklin Institute, 1848; 8th and Carpenter, 1856. FIJ; PAJ, 1856, p. 126.

Gurney, Henry D. Dag'typist, photographer. Natchez, Miss., 1850s. Gallery at Washington and Clay St., Vicksburg, Miss., 1858; Washington St., Vicksburg, 1860. Natchez, 1860s. Information courtesy of Charles East. CD.

Gurney, Jeremiah. Dag'typist, photographer, jeweler, inventor, author. Born 1812, N.Y. state, near Hudson River; died sometime after 1886, Saratoga, N.Y. (?). Owner of jewelry and spectacle store, 18½ Maiden Lane, NYC, 1839–1840. Learned dag'typing in the spring (Mar. onward) of 1840. Opened gallery, Broadway, 1840–1843; 189 Broadway, 1844–1852; 349 Broadway (bought out Whitehurst Gallery, Aug. 1852), 1852–1857; 707 Broadway, 1857–1869; cor. 16th and 5th Ave. (Gurney & Son), 1869–? Partnerships: Gurney & Litch (chemicals), 1852; Charles Fredericks, 1854–1855; John Bishop Hall (distribution of hallotypes), 1857. Exhibited at American Institute, 1846, 1847, 1848, 1850, 1853, 1856, 1857; Crystal Palace, London, 1851; N.Y. Crystal

Palace, 1853, honorable mention. Won Anthony prize competition, 1853. Operators for Gurney: T. Hayes, W. A. Perry, 1852–1853; Solomon N. Carvalho, 1853. Pioneered mammoth dag'type plates, 11 by 13 in., 1850; paper photography (mezzographs and oil colors), 1853 onward. Author of *Etchings on Photography*, 1856. Gurney's son took a photograph of Lincoln's body as it lay in NYC Hall, 1865. Issued U.S. patent for "Improvement in processes of coloring enameled photographs" (157,510), Dec. 8, 1874. Nsp, NYC; CD; BD; *The Gem*, 1844; SA; AI; DJ; HJ; PAJ; *Illustrated News*, Jan. 1853; BJP, June 1886; BN.

Gurney, M. J. Dag'typist. Natchez, Miss., 1850. Died of yellow fever, Oct. 1858, Natchez. Member of Adams Light Guard. PAJ, 1858, p. 96.

Guthrie, John T. Dag'typist. Born 1818, N.Y. Practiced dag'typing in Hamilton Co., Tenn., 1850. USC.

*Haas, Philip. Dag'typist, lithographer, publisher. Lithographer, Washington, D.C., 1837–1845; dag'type gallery, 289 Broadway, NYC, 1844–1851; listed as dag'typist, Washington, D.C., 1851; 371 Broadway, NYC, 1851–1857. Exhibited at American Institute, silver medal, 1846; N.Y. Crystal Palace, 1853. Haas became a sensational figure in Washington when he was nearly murdered in Feb. 1840. Lithographed and published scenes of Washington and Mt. Vernon. NYHS; BD; DJ, 1850, p. 19; nsp, Washington, D.C., 1840. Also information courtesy of Josephine Cobb.

Haddington, Lewis L. Dag'typist. Gallery at 138 Broadway, NYC, 1849. BD.

Hadley & Bro. Dag'typists. Gallery at 49½ Hanover St., Boston, 1853. BD.

Hadley & Eastman. Dag'typists. Gallery at 2 Blanchard Block, Boston, 1850. BD.

Hadley, Nathaniel. Dag'typist. Cambridge, Mass., 1850. CD.

Hadley, S. D., Jr. Dag'typist. Gallery at 105 Hanover St., Boston, 1854. BD.

Haines & Hubbard. Dag'typists. Saco, Me., 1855. SBD.

Hale, Charles E. Dag'typist. Gallery at 36 Washington St., Boston, 1842; 109 Washington St., 1844–1845. *See also* Hale, Luther Holman. BD; CD.

Hale, J. W. Dag'typist. Newark, N.J., 1851. DJ.

Hale, Luther Holman. Dag'typist, photographer. Gallery at 109 Washington St., Boston, 1846–1859; 294 Washington St., 1864. Some sort of relationship existed between L. H. and Charles E. Hale. The Hales taught many prominent dag'typists, including Black and Rulofson, in the 1840s. BD; RBD; OSU.

Hale, Moses. Dag'typist. Ellsworth, Me., 1855. SBD.

Hale, W. H. Dag'typist. Rouse's Pt., N.Y., 1851. DJ.

Hall, Alfred. Dag'typist. Lawrence, Mass., 1853; 142 Essex St., 1857. SBD; CD.

Hall, George. Dag'typist. Russia Township, Lorain Co., Ohio, 1850, age twenty-one. USC.

Hall, George E. Dag'typist. Gallery on Jefferson Ave., Detroit, Mich., 1852–1855. CD; BD.

Hall, George P. Dag'typist, photographer. Born Oct. 7, 1832, Troy, Ohio; died Oct. 26, 1900, NYC. Apprenticed in Dayton, Ohio, 1854; gallery in Indianapolis, Ind., 1855; Fulton St., NYC, 1872. APB, 1900, p. 229.

Hall, George W. Dag'typist. Gallery at 156 Bowery St., NYC, 1851. BD.

Hall, Harvey S. Dag'typist. Gallery at 32 George St., New Haven, Conn., 1854–1855. CD.

Halsee & Eaton. Dag'typists. Adv., Lyceum Hall, Savannah, Ga., Apr. 1843. Nsp adv.

Halsey, A. H. Dag'typist. Traveled to Mexico in 1840s as itinerant. Information courtesy of Josephine Cobb.

Ham, Francis W. Dag'typist. Gallery in Congress Hall, Portsmouth, N.H., 1849. RBD.

Hamilton, Charles F. Dag'typist, photographer. Practiced dag'typing in San Francisco, 1852; partner, George McKown, 1856; 163 Clay St., 1857; partner, Jacob Shew, 1863–1878. CD; PAJ, 1857, p. 112.

Hamilton, George D. Dag'typist, photographer. Gallery at 63 Court St., Boston, 1852–1864. BD.

Hamilton, J. F. Dag'typist, photographer. Gallery at Broughton and Whitaker St., Savannah, Ga., 1855–1858. Nsp; CD; PAJ, 1858, p. 127.

Hamilton & Lovering (Reuben F.). Dag'typists. San Francisco, 1860. CD.

Hamilton & Shew. Dag'typists, photographers. Gallery at 163 Clay St., San Francisco, 1855–1856. *See also* Hamilton, George D.; Shew, William. CD.

Hankins, Thomas. Dag'typist. Nashville, Tenn., date unknown. From small paper label glued on dag'type plate.

*Hanson, Peter. Lanscape painter, tulip authority, dag'typist. Born 1821, Denmark; died Feb. 22, 1887, Brooklyn. Came to America, ca. 1847, settled in Brooklyn. Gallery at 189 Bowery St., NYC, 1849 only. NYHS; BD.

Hardy, Jason. Dag'typist. Lawrence, Mass., 1853. SBD.

Harmon, ———. Dag'typist. Adv., Cleveland, Ohio, 1847, golden dag'type: "invented a new method of taking portraits by the daguerreotype, whereby all the outlines are like the common portraits, but having a fine gold color." SA, Oct. 1847.

Harrington & Bushwell. Dag'typists. Broadway Daguerreian Gallery, 323 Broadway, NYC, 1850–1851. BD.

Harrington, Lewis L. Dag'typist. Gallery at 413 Broadway, NYC, 1851–1854. BD.

*Harrington, Dr. William H. Dag'typist, artist. Born 1810, Pa. Learned dag'typing jointly (?) with F. A. P. Barnard, University of Alabama, 1839–1840. Opened gallery Tuscaloosa, Ala. (Barnard & Harrington), first studio in the South, 1840–1841. Madame Page's house, New Orleans, opened Feb. 8, 1842; Camp St. (Maguire & Harrington, agency for talbotypes), 1850–1851; 6 Camp St. (alone), 1852; 6 Camp St. (Dobyns & Harrington), 1853–1859. In the South, Harrington possibly did more than any other man to spread the art in its very early days. Maguire, possibly George S. Cook, and others were taught dag'typing by Harrington. In 1853 wrote series of articles for *Humphrey's Journal*. Nsp; CD; NYHS; USC; HJ.

Harris, Hiram V. Dag'typist, actor. Gallery at 333 Broadway, NYC, 1849–1851; 132 Bowery St., 1851–1854; 236 Grand St., 1854; Portland, Me., 1869. Harris was secretary of the American Histrionic Association, which met in his gallery in the fall of 1851. BD; nsp, *N.Y. Times*, 1851.

Harris, Theodore. Dag'typist. Gallery on Main between 4th and 5th St., Louisville, Ky., 1855–1860. CD.

Harris, William T. Dag'typist. Adv., rooms in Athens, Ga., opposite post office, Jan., Mar., Apr., July 1854. Information courtesy of Dr. W. Robert Nix.

Harrison & Holmes. Dag'typists. Gallery at 289 Broadway, NYC, 1849–1851. BD.

Harrison, Charles C. Dag'typist, photographer, camera maker, inventor. Died Nov. 23, 1864. Practiced dag'typing, NYC, 1846; Harrison & Holmes, 289 Broadway, 1849–1851; 293 Broadway (alone), 1851; sold gallery to George S. Cook, 1851. White and Elm, daguerreotype apparatus, 1854–1855; gallery at 428 Broadway, 1853–1854. Exhibited at American Institute, won silver medal, 1850. Began manufacturing a high-quality camera, ca. 1849, equal to or better than Voightländer's camera. Made camera improvement in lens (reversal of image), useful for taking scenes, 1851. Awarded bronze medal for camera at N.Y. Crystal Palace, 1853. Obtained patent (with Schnitzer), diaphragm for photographic cameras (21,470), Sept. 7, 1858. Made one of the best cameras in the world in 1850s, and his globe lenses, introduced in the 1860s, were recognized abroad as superior. MAR; BD; HJ; DJ; BN; AI, 1850; PP, 1865, p. 16.

*Harrison, Gabriel. Landscape and portrait artist, actor, dag'typist. Born Mar. 25, 1818, Philadelphia; died Dec. 15, 1902, Brooklyn. Made debut as actor in Washington, D.C., at Wallack's National Theater as Othello. Studied dag'typing under John Plumbe, Jr., ca. 1841. Worked for William Butler, 1844–1848. Meanwhile a member of the Park Theater, NYC, a favorite supporter of

Charles Kean in Shakespearean revivals, 1845. Gallery with partner L. F. Harrison, 411 Broadway, NYC, 1848–1849; worked for Martin M. Lawrence, 1849–1852. Moved to Brooklyn, ca. 1848, where he became prominent in dramatic, literary, and art circles. Organized Brooklyn dramatic academy, 1851. Dag'type gallery at 283 Fulton St., 1852–1859; listed as Harrison & Hill, same address, 1853, 1855. Took dag'type of Walt Whitman which was used for engraving in *Leaves of Grass.* Exhibited at N.Y. Crystal Palace, allegorical dag'types on mammoth plates, 1853, honorable mention. Painted a portrait of Edwin Forrest. Author of many dramatic publications. NYHS; ACB; BN; BD; HHS; OSU (dag'type of Whitman); *History of Kings County, Brooklyn,* 1884.

Hart, Truman. Dag'typist. New Haven, Conn., 1844. CD.

*Hartman, A. d'Othon. Artist, dag'typist. Gallery at 627 Broadway, NYC, 1853–1854. BD.

Hartmann, F. R. Dag'typist. Gallery at 270 Grand St., NYC, 1851. BD.

Hartshorn, Samuel W. Dag'typist. Providence, R.I., 1847; partnership with Masury, 1847–1850; sold out to Manchester Bros., 1850. Continued as partner with William S. Johnson. Listed in Providence, 1856. CD; BN.

Harvey, G. M. Dag'typist. Gallery at 77 Lake St., Chicago, 1854–1856. CHS.

Harvey, S. S. Dag'typist. Albion, N.Y., 1852. Levi L. Hill, *Treatise on Heliochromy,* 1856.

Haskins, Frederick W. Dag'typist, photographer. Practiced dag'typing, Fitchburg, Mass., 1853; gallery at 14 Hanover St., Boston, 1859. SBD; BD.

Hastings, S. H. Dag'typist. Gallery at 146 Merrimack St., Lowell, Mass., 1849. RBD.

Hathaway, Thomas & William. Dag'typists. Worcester, Mass., 1850–1857. Publications of the Worcester Historical Society, 1928.

Hathaway, William. Dag'typist. Born 1820, NYC. Practiced dag'typing, New Bedford, Mass., 1850–1853. USC; CD; SBD.

Havens, T. J. (I?). Dag'typist. Raleigh, N.C., ca. 1852. Imprint on case cover.

Hawes & Somerby. Dag'typists. Boston, 1840–1841 (?). NY Historical Society for Somerby family; BN; Beaumont Newhall and Nancy Newhall, *Masters of Photography,* 1958, p. 22.

Hawes, Charles E., & Co. (Bros.). Dag'typist. Gallery at Liberty Hall, New Bedford, Mass., 1849–1853; adv., ambrotype artist, 1859. CD; SBD.

*Hawes, Josiah Johnson. Dag'typist, portrait and miniature painter, inventor, photographer. Born 1808, Sudbury, Mass.; died Aug. 7, 1901, Crawford Notch, N.H. Apprenticed as a carpenter. Became portrait and miniature painter, Boston, 1838–1839. Became

interested in photography after Gouraud's lectures, 1840. Partnership with Somerby, ca. 1841. Worked with A. S. Southworth, 1843. The firm became known as Southworth & Hawes, 1845. Married Southworth's sister, Nancy, assistant in gallery. Issued U.S. patents in conjunction with Albert Southworth. Dag'typed many famous people, including Webster, Charles Sumner, Rufus Choate, Lajos Kossuth, Theodore Parker, Emerson, Channing, Jenny Lind, Bronson Alcott, Lyman Beecher, Dorothy Dix, and Oliver Wendell Holmes. Specialized in relaxed portraits of children. In 1850 arranged a solar camera with a movable mirror or reflector and a twelve- or thirteen-in. condensing lens. Listed in 1864 at 19 Tremont Row, same as former site but street number had changed from 5½ Tremont Row. Exhibited, Boston, 1869, panoramic view of Beacon St., thirty ft. long. Still engaged in photography in his ninety-fourth year. In late years was said to have revived the dag'type with considerable success; he clung to the albumin paper process and dag'types. *See also* Albert S. Southworth for patents. BD; BN; NYHS; PP, 1869, p. 220; Beaumont Newhall and Nancy Newhall, *Masters of Photography,* 1958; *Photo Era;* AJP, 1901, p. 119, 1906, pp. 104–107.

Hawkes, Benjamin F. Dag'typist. Gallery at 113 Washington St., Boston, 1852–1853; over 205 W. Baltimore St., Baltimore, 1858. BD; CD.

*Hawkins, Ezekiel C. Portrait and landscape painter, commercial artist, dag'typist, photographer. Baltimore, 1806; Steubenville, Ohio, as windowshade painter; Wheeling, Va., 1829; Cincinnati, Ohio, artist. Gallery at 5th St., between Main and Walnut St., Cincinnati (Hawkins & Faris), 1843, also 1856 and 1857; 132 5th St. (alone), 1844–1847; Canal and Exchange Place, New Orleans, 1846; Apollo Bldg., 5th and Walnut St., Cincinnati, 1848–1851; Vine between 4th & 5th St., 1852–1853; Race and 4th St. (Hawkins & Mullen), 1855; Cincinnati, 1856–1860 (?). Exhibited at N.Y. Crystal Palace, 1853. NYHS; CD; SBD; DJ; BN; BD (*The East*), New Orleans.

Hawkins, Richmond. Dag'typist. Gallery at 306 Broadway, NYC, 1852. *Illustrated News,* Jan. 1853.

Hawley, J. P. Dag'typist. Born 1823; died Oct. 10, 1900. Practiced dag'typing, Appleton, Wis., 1852. AJP, 1900.

Haworth, John. Dag'typist. Born 1826, Eng.; died Mar. 20, 1900, Philadelphia. Dag'typist for fifteen years in Pittsburgh, Pa. Gallery S.W. cor. Market St., 1855. AJP, 1900, p. 130.

Haws, Albert F. Dag'typist. Boston, 1849. Passenger on ship *Regulus,* Boston to Calif., 1849. Information courtesy of James de T. Abajian.

Hayes & Co. Dag'typist. Gallery at 257

Broadway, NYC, 1851. BD.

Hayward, George W. Dag'typist. Gallery at 425 Washington St., Boston, 1848–1849; Armory Hall, Washington St., 1850–1851; 1½ Tremont Row, 1856; 13 Tremont Row, 1859. BD; OSU.

Hazeltine, Martin M. Dag'typist, photographer. To San Francisco, 1853, opened dag'type studio there. Later moved to Baker, Oreg., where he continued as photographer. Ralph W. Andrews, *Picture Gallery Pioneers,* 1964, p. 104.

Hazelton, Benson C. Dag'typist, photographer. Gallery at 69 Central St., Lowell, Mass., 1855; 268 Washington St., Boston, 1859; 140 Washington St., 1863–1864. CD; BD.

Heard, John A. Dag'typist, photographer. Gallery at 138½ Washington St., Boston, 1851; 10 Tremont Row, 1864. BD.

Heath, James. Dag'typist. Gallery at 55 Emporium Block, Main St., Rochester, N.Y., 1852; Lowell, Mass., 1859. CD.

Heisenbuttel (Heirsenbutte), Jacob. Dag'typist. Louisville, Ky., 1848–1856. CD.

Helme, John C. Dag'typist. Gallery at 111 Bowery St., NYC, 1846–1854. Member of Protective and Collegiate Institution, NYC, 1851. One of three members of Finance Committee meeting of American Daguerre Association, NYC. PAJ, 1851, p. 243; BD; OSU.

Helsby, Thomas C. Dag'typist. American practicing dag'typing in Buenos Aires, 1846; dag'typing in Apr. 1856 in Tahiti. BN; information about Tahiti courtesy of Patrick O'Reilly, Musée de L'Homme, Paris.

Hendee, J. S. Dag'typist. Ca. 1857, location unknown. Name stamped on brass mat framing dag'type.

Hender, D. H. Dag'typist. Portland, Oreg., ca. 1850s. Ralph W. Andrews, *Picture Gallery Pioneers,* 1964, p. 91.

Henderson, John. Dag'typist. Gallery at 92 Bowery St., NYC, 1849; 108 Bowery St., 1850; 1 Bowery St., 1851–1854. CD; BD.

Henerey & Talbird. Dag'typists. Adv., rooms at Julian St. and Market Sq., Savannah, Ga., Sept.–Dec. 1848. Nsp.

Henry, Eliza. Amateur dag'typist. Exhibited, Oct. 1840, at Franklin Institute. *Philadelphia Public Ledger,* Oct. 20, 1840.

Henry, G. W. Amateur dag'typist. Exhibited, Oct. 1840, at Franklin Institute. *Philadelphia Public Ledger,* Oct. 20, 1840.

Hesler, Alexander. Dag'typist, photographer. Born 1823, Montreal, Canada; died 1895, Evanston, Ill. Boyhood in Vt. until 1833, then Racine, Wis. Learned dag'typing, Buffalo, N.Y., 1847. Opened gallery, Madison, Wis., 1847. Galena, Ill, 1848–1857. Gallery, 113 Lake St., Chicago, 1855–1860; Hesler & Joslin, Chicago, 1855; 96 State St., Chicago, 1884. Exhibited at N.Y. Crystal Palace, 1853, bronze medal;

Chicago Mechanic's Institute, stereoscope views, 1854; photographs on ivory and canvas, 1855. Won silver medal, American Institute, for best watercolor photographs and dag'types, 1856. Hesler was a leading figure in nineteenth-century photography. His dag'type of Minnehaha Falls inspired Longfellow's poem, *Hiawatha*. The portrait of Lincoln, taken June 1860, is considered one of the finest made of the president. Also one of the first professional photographers to turn from wet-plate to dry-plate photography, beginning in 1879. RT; BN; PAJ; SBD, Ill.; CD; OSU; CHS.

Hewes, Mrs. S. G. *See* Broadbent & Hewes.

Hewett, W. H. Dag'typist. Cited by Samuel Humphrey for instantaneous process for procuring dag'types—his plan for using vapor of ammonia upon the chemically coated plate was published in 1845. Samuel Humphrey, *American Handbook of the Daguerreotype*, 1853, pp. 116–117.

*Hewitt, John M. Miniature painter, dag'typist. Hewitt & Wolford, miniature painters, 461 Market St., Louisville, Ky., 1845; Hewitt's National Daguerrean Gallery, 477 Main St., 1848; also listed as Hewitt & Dobyn, 1848; Louisville, 1851, CD; OSU.

Heywood & Heard. Dag'typists. Gallery at 10 Tremont Row, Boston, ca. 1855. OSU.

Heywood, John D. Dag'typist, photographer. Gallery at 103 Court St., Boston, before 1856; 228 Washington St., 1856–1859; 228 Washington St. and 3 Summer St., 1862. In the 1860s, Heywood specialized in a series of stereo views of New England and N.Y. state. *See also* Fish & Heywood. BD; OSU; SV.

Higgins, Benjamin L. Dag'typist. NYC, 1853. Information courtesy of James de T. Abajian.

Higgins, O. T. Dag'typist. Gallery at 94 Hanover St., Boston, 1854; 114 Hanover St., 1855–1859; 109 Washington St., 1864. BD.

Hill & Co. Dag'typist. Gallery at 546 N. 2d St., Philadelphia, 1854–1855. SBD.

*Hill, Levi L. Dag'typist, clergyman, author, inventor, teacher, chemist. Born Feb. 28, 1816, Athens, N.Y.; died Feb. 7, 1865, NYC. Father murdered, 1828. Print-setting apprentice, *Hudson Gazette*, 1829–1831. Studied rudiments of drawing and painting, 1831–1832. Printer, *Ulster Plebeian*, Kingston, N.Y., 1832–1833. Student, Literary and Theological Seminary, Hamilton, N.Y., 1833–1835. Minister, Baptist Church, New Baltimore, N.Y., 1835. Married, Emeline, 1836. Minister, Baptist Church, Westkill, N.Y., 1843. Published *The Baptist Library*, 1843; *The Baptist Scrapbook*, 1845. Began printing shop with brother, Robert H. Hill, Prattsville, N.Y., ca. 1844 or before; sold shop to brother. Learned

dag'typing from Meade Bros. and F. Norwood, 1845. Itinerant dag'typist, N.Y. state, 1845–1847. Experimented to produce dag'types in natural colors, 1847–1856. Published *Treatise on Daguerreotype*, 1849; 2d ed., 1850; 3d ed., titled *Photographic Researches*, 1851. Announced successful color dag'types (hillotypes), 1850; controversy, 1851–1852. Author of *A Treatise on Heliochromy*, 1856. Moved to Hudson, N.Y., experimented with illuminating gas, 1856–1865. Granted four U.S. patents (and three reissues): "Improvement in the Manufacture of Burning Fluids" (20,558), 1858; "Hydrocarbon-Vapor Apparatus" (26,497), 1859; "Improvement in Making Illuminating Gas" (35,610), 1862; "Improvement in Producing Light and Heat and Applying the Same" (38,137), 1863. Organized a petroleum stock company, successful by 1864. Opened a gallery briefly at 373 Broadway, NYC, 1853–1854. BN; DJ; HJ; PAJ; SA; USC; AI, 1857; nsp, *Kingston Journal*, 1850, *N.Y. Herald*, Feb. 8, 1865.

Hill, Robert H. Dag'typist. Kingston, N.Y., 1851. Brother of Levi L. Hill, DJ, 1851, p. 220.

Hillyer, John F. Dag'typist. Adv., room under Masonic Hall, Athens, Ga., May–June 1847. Information courtesy of Dr. W. Robert Nix.

Hilt, Martin. Dag'typist, photographer. Born 1811; died 1897, Philadelphia. Said to have been "old time daguerreotypist and one of first to enter photography in Philadelphia." AJP, 1897, p. 273.

Hirst, J. W. Dag'typist. Pittsfield, Mass., 1853. SBD.

Hobday, J. Dag'typist. Ca. 1853, location unknown. Name imprinted in miniature case.

Hoffman, Edward B. Dag'typist. Gallery on the square, Cleveland, Ohio, 1855. Nsp.

Holbrook, C. G. Dag'typist. Buffalo Grove, Ill., 1854. SBD.

Holbrook, Eber C. Dag'typist. Gallery at 156 Fulton St., NYC, 1849. BD.

Holcomb, J. G. Dag'typist. Augusta, Me., 1851–1855. BD.

Holcomb, Sarah. Itinerant dag'typist. N.H. and Mass., 1846. BN.

Holland, William A. Dag'typist. Gallery at 196 Green St. between Preston and Jackson, Louisville, Ky., 1855–1856. CD.

Holmes, A. Dag'typist. Gallery at 15 Tremont Row, Boston, 1849. RBD.

Holmes, Silas A. Dag'typist, inventor, photographer. Gallery at 289 Broadway, NYC, 1850–1852; 283 Broadway, 1852–1855; 575 Broadway, 1869. Awarded diploma for excellent dag'type views, American Institute, 1852. Issued U.S. patent for double camera for taking two pictures at once (10,987), May 30, 1854. Awarded a medal and a diploma for large plain photographs of cattle and outdoor work

by American Institute, 1869. OSU; BD; AI; *Gleason's Pictorial Drawing-Room Companion*, 1854.

Holmes, William. Dag'typist. New Vienna, Ohio, 1853. SBD.

Holmes, William B. Dag'typist, photographer. Gallery at 289 Broadway, NYC (with C. C. Harrison), 1849–1851; 360 8th Ave. (alone), 1852–1853; 555 Broadway, 1869. Took stereo views, 1863–1878. BD; DJ; PP, 1869; SV.

Holmwood, John. Dag'typist. Gallery at 357 8th Ave., NYC, 1853–1854. BD.

Holt, George. Dag'typist. Gallery at 156 Bowery St., NYC, 1853–1854. BD.

Hood, John. Dag'typist. Born 1826, Pa. Practiced dag'typing in Camden, N.J., 1850. USC.

Hook, Josiah S. Dag'typist. Kenduskeag Bridge, Bangor, Me., 1848. CD.

Hope, G. W. Dag'typist. Easton, Pa., 1854. OSU.

Hopkins & Hayden. Dag'typists. Gallery at 94 Market St., St. Louis, Mo., 1846. Missouri Historical Society.

Hopper, Abraham D. Dag'typist. Gallery at 109 8th Ave., NYC, 1853–1854. BD.

Hopper, H. Dag'typist. American Daguerreotype Gallery, 142 Chapel St., New Haven, Conn., 1854. CD.

Horn, ———. Dag'typist. Philadelphia, 1850. MAR.

Horn, Edward. Dag'typist. Milwaukee, Wis., 1856. CD.

Horsley, Peter N. *See* Manufacturers and wholesale suppliers.

Horton, O. W. Dag'typist, photographer. Gallery on Monroe St., Grand Rapids, Mich., 1856. CD.

Horwell, E. C. Dag'typist. Gallery at cor. Gay and Front St., Baltimore, Md., 1849–1850. SBD.

*Hospes, Caroline. Dag'typist, artist. Gave training in drawing and painting in conjunction with dag'typing, St. Louis, Mo., 1846. Missouri Historical Society.

Hough (George S.) & Anthony (Charles J.). Dag'typists, inventor (Charles). Portland, Me., 1846; Providence, R.I., 1847; Pittsburgh, Pa., 1851–1853; 62 4th St., 1854. Exhibited at American Institute, seven frames of dag'types, 1846. *See also* Anthony, Charles J. AI; CD; BD.

*Hough, Eugenio K. Artist, dag'typist. Primitive pastels, Vt., ca. 1850. Peterburg, Va., artist and dag'typist, 1858. NYHS; CAS.

Hough, George S. Dag'typist. Portland, Me. (partner, Charles Anthony), 1846; Providence, R.I. (with Anthony), 1847; Pittsburgh, Pa. (Anthony), 1851–1853; 62 4th St. (Anthony), 1854; 101 Wylie St. (alone), 1854–1855. *See also* Anthony, Charles J. CD; BD.

*Housekeeper, Cheney H. Artist, dag'typist. Born 1812, Philadelphia, Pa. Worked in Van Loan's gallery, 118 Chestnut St., Philadelphia, 1851; 159 Chestnut St. (own gallery), 1851. NYHS; USC; DJ; OSU.

Hovey, Daniel. Dag'typist, manufacturer. Born 1828, Hampton, Conn.; died 1886, Rochester, N.Y. In Samuel Root's gallery, Philadelphia, as operator, 1849; Rochester, partner with John Kelsey, 1854; Rochester, partner with Henry Hartman, 1857–1863; Rochester (own business), 1866. Manufactured albumin paper, 1868. BN.

Howard, David. Dag'typist. Gallery at 109 Washington St., Boston, 1854. BD.

Howard, L. Norman. Carpenter, dag'typist, teacher. Born 1823, Eatonton, Ga. Carpenter, 1840–1844; teacher of penmanship, 1845–1847; gallery at 492 Grand St., NYC, 1848–1851. Itinerant, N.Y. state and Pa., 1852–1855, St. Louis, Mo., 1855–1870. In charge of Fitzgibbon's St. Louis gallery, 1858. BD; OSU; SLP, Oct. 1891, p. 422.

Howard, Thomas. Dag'typist. NYC, 1844; 190 Fulton St., Brooklyn, 1859–1860. CD.

Howe, Elias. Dag'typist, inventor of sewing machine. Born 1819, Spencer, Mass.; died 1867, Brooklyn. Worked as instrument maker for Daniel Davis, Jr., Boston, prior to 1840. Partner with John A. Whipple, manufacture of photographic chemicals and supplies, 1840–1841; to Cambridgeport, Mass., as dag'typist, 1841–? U.S. patent, sewing machine, 1846. BN; nsp.

Howe, George M. Dag'typist, musician, photographer, teacher. Worked as clerk and painter in Edmund Howe's English Goods, Portland, Me., 1844–1848. Secretary, Portland Orchestral Society, and first tenor, 1845. Listed as dag'typist, 112 Middle St., 1853–1858. Exhibited at N.Y. Crystal Palace, 1853. Listed as photographer at 112 Middle St., 1866 (the year of Portland's great fire). No listings from 1866 until 1879, when occupation was musician. From 1882–1886 listed as music teacher. CD; SBD; BN; OSU.

Howe, Leland. Dag'typist. Andover, Mass., 1849. Passenger on ship *Regulus* from Boston to Calif. Information courtesy of James de T. Abajian.

Howell, ———. Dag'typist. Philadelphia, 1856. PAJ, 1856, p. 126.

Howell, W. B. Dag'typist. Lexington, Mo., 1851. DJ.

*Howes, Samuel P. Portrait, miniature, and landscape painter, dag'typist. Boston, painter, 1829–1835; Lowell, Mass., painter, 1837–1855. Dag'type gallery, 112 Merrimack St., Lowell, 1849–1856; Clay and Kearny St., San Francisco (bought out J. M. Ford's gallery), 1857–1860. Operator for Vance, ca. 1857. RBD; CD; PAJ; NYHS.

Hoyt, Mary S. Dag'typist. Member of N.Y. State Daguerreian Association committee, 1851. DJ, 1851, p. 249.

Hoyt, Samuel. Dag'typist. Gallery at 31 Merrimack St., Lowell, Mass., 1849. BD.

Hubbart, John E. Dag'typist. Gallery at 30 Union St., Nashville, Tenn., 1853. SBD.

Hubbell & Artault, Dag'typists. New Haven, Conn., 1844. CD.

Huddleston, J. S. F. *See* Manufacturers and wholesale suppliers.

Hudson, John. Dag'typist. Gallery at 85 Chatham St., NYC, 1846–1847. BD.

Hughes Bros., F. M. & C. C. Dag'typists, wholesalers. Gallery at 59 N. College and Union St., Nashville, Tenn., 1855–1859. The Hughes Bros. became one of the largest southern supply houses in the late 1850s and the 1860s. CD; BD.

Hughes, Frederick N. Dag'typist. Gallery at 88 8th Ave., NYC, 1849. BD.

Hull, J. Dag'typist. Gallery at 418 Grand St., NYC, 1844–1845. BD.

Hull, R. B. Dag'typist. Richmond, Va., 1855. CD.

Hulsbizer, Godfrey. Dag'typist. Walkonding, Ohio, 1853. SBD.

Humphrey, Samuel Dwight. *See* Manufacturers and wholesale suppliers.

Humphreys, J. P. & E. B. Dag'typists. Gallery at 254 Broadway, NYC, 1854. *Gleason's Pictorial Drawing-Room Companion.*

Humphreys, O. A. Dag'typist. Gallery at 94 Canal St., NYC, 1849. BD.

Hunt & Weeks. Dag'typists. Gallery at 32 W. 4th St., Cincinnati, Ohio, 1853. SBD.

Hunt, Caleb. Dag'typist. Operator for Gurney, date unknown; Cleveland, Ohio, 1854. BN.

Hunt, Cornelius D. Dag'typist. Gallery at 307 Broadway, NYC, 1851; 297 Bowery St., 1853–1854. BD.

Hunt, Isaac O. Dag'typist. NYC, 1844. CD.

Hunt, John W. Dag'typist. Gallery at 113 Bowery St., NYC, 1851, BD.

Hunter, ———. Dag'typist. Muscatine, Iowa. HHS.

Hunter, John. Dag'typist. Gallery at 85 Lake St., Chicago, 1849–1850. CHS; CD.

Hunting, J. M. Dag'typist. Gallery at 36 Washington St., Boston, 1852–1856. BD.

Hutchings, George. Dag'typist. Gallery at 196 Greenwich St., NYC, 1846–1847. BD.

Hutchings, Nathaniel H. Dag'typist. Gallery at 317 Grand St., NYC, 1851. BD.

Hutchings, W. H. Dag'typist. Gallery at cor. Canal and Chartres St., New Orleans, 1845–1847. Nsp.

Hutchins, A. Bleecker. Dag'typist. Gallery at 395 Broadway, NYC, 1853–1854; Athens, Ga., Apr. 1856. BD; PAJ; Athens information courtesy of Dr. W. Robert Nix.

Hutchinson, ———. Dag'typist. Gallery at 234 N. 2d St., Philadelphia, 1854–1856. SBD; PAJ, 1856, p. 126.

Huylar, Edward P. Dag'typist. Gallery at 186 W. 18th St., NYC, 1851; 165 8th Ave., 1853–1854. BD.

*Hyatt, Augustus. Engraver, seal cutter, dag'typist. Engraver and seal cutter, NYC, 1840–1848; adv., Athens, Ga., June 6, 1849, "solar miniatures." Rooms at Franklin House, Athens. Information courtesy of Dr. W. Robert Nix.

Hyde, F. W. Dag'typist. Fairfield, Vt., 1849. RBD.

Ingalls, Lymen. Dag'typist. Lowell, Mass., 1855. CD.

Insley, Henry E. Dag'typist, inventor. Born 1811 (?); died Aug. 7, 1894, Nannet, N.Y. Brother-in-law of George W. Prosch. Gallery at 81 Liberty St., NYC (same location as 149 Broadway), was opened before July 28, 1840 (Insley & Prosch); one of the earliest dag'type studios in NYC. Gallery at 122 and 124 Broadway, 1846–1850; 311 Broadway (new gallery), 1851–1857. Moved to Jersey City, N.J., in later years (?). When George Prosch moved to Newark, N.J., ca. 1843, Insley continued with his own gallery in NYC. Invented the "illuminated daguerreotype," a vignette which featured a colored halo around the image, patented (8,633), Jan. 6, 1852. One of the few skilled pioneer dag'typists in 1840, advertising thirty-second dag'types in Oct. 1840. Credited with first instantaneous dag'type (no date). CD; BD; nsp, NYC; *Niles' National Register*, Oct. 10, 1840; SA; DJ; PAJ; APB, 1894, p. 285.

Irving & Webb. Dag'typists. Gallery at 112 N. 4th St., St. Louis, Mo., 1847. Missouri Historical Society.

Irving, Mrs. ———. Dag'typist at cor. 4th and Market St., St. Louis, Mo., 1847. Missouri Historical Society.

Irving, James. Dag'typist, photographer. Born 1818 (?); died 1901. Itinerant as far west as Chicago before opening studio in Troy, N.Y. 218 River St., 1852–1854; Market Bank Bldg., 1854. Took stereo views, 1868–1878. APB; CD; PAJ; SV.

Isaacson, Solomon. Dag'typist. Gallery at 63 Canal St., NYC, 1851. BD.

Ising, C. M. Dag'typist. Exhibited at Franklin Institute, Philadelphia, 1852; Arch St., Philadelphia, 1856. HJ, 1852, p. 238; PAJ, 1856, p. 126.

Ives, Ezra. Dag'typist. Gallery in Buswell Bldg., Norwich, Conn., 1849. RBD.

*Ives, Loyal Moss. Portrait painter, dag'typist. Partner with Lorenzo Chase, Boston, 1844–1846; 142 Washington St. (own gallery), 1847–1852; partner with Callagan, ca. 1850. Portrait painter, New Haven, Conn., late 1850s; NYC, ca. 1863–1890. NYHS; MAR; CD; DJ.

Jackson, H. & E. Dag'typist. Gallery at cor. Market and Diamond St., Pittsburgh, Pa., 1854. BD.

Jackson, H. P. Dag'typist. Gallery at 122 Broadway, NYC, 1846–1847. BD.

*Jacobs, Edward. Portrait painter, art dealer, dag'typist, photographer. Johnson & Jacobs, cor. Camp and Canal St., New Orleans, 1845–1846; 73 Camp St.,

1851–1856; 93 Camp St., 1858–1859. Displayed paintings by old masters, 1858. NYHS; CD; *The East*, 1845; PAJ, 1858, p. 244.

James & Co. Dag'typist. Gallery at 1 Winter St., Boston, 1856; 4 Summer St., 1859. BD.

James, Mrs. D. H. Dag'typist. Cincinnati, Ohio, 1851. CD.

James, Henry. Dag'typist. NYC, 1855–1860 (?). HHS, p. 345.

Jaquith, Nathaniel C. Dag'typist. Gallery at 98 Broadway, NYC, 1848–1854; 167 Broadway, 1858. BD; OSU.

Jarvis, Charles W. Dag'typist. Gallery at 103 Canal St., NYC, 1844—1845. BD.

Jeanes, Joseph, Sr. Dag'typist, photographer. Born 1829 (?); died June 16, 1904. Gallery at 121 Market St., Wilmington, Del., ca. 1854; 117 Market St., 1857. CD; OSU; *Wilson's Photographic Magazine*, 1904, p. 431.

Jeffers, George A. Dag'typist. Gallery at 2 1st St., Albany and Troy Co., N.Y., 1852. CD.

Jenkins, J. F. Dag'typist. Bought out Emerson, July 1844; Merchants Exchange Bldg., Cleveland, Ohio, 1845. CD; nsp, 1845.

Jenkins, Solon, Jr. Dag'typist, inventor. Died of yellow fever, Nov. 19, 1854, Columbia, S.C. West Cambridge, Mass., 1851; 77 Bowery, NYC, 1851; Richmond, Va., operator for Whitehurst, 1852—1853; Charleston, S.C., 1854; Columbia, S.C., operator for Tucker, 1854. U.S. patent for securing dag'types in monumental stones (7,974), Mar. 11, 1851. BD; HJ, 1854, p. 311.

Jenks Bros. Dag'typists. Date and location unknown. OSU.

Jenne Bros. Dag'typists. 1850s, location unknown. OSU.

Jenney, James, Dag'typist. Middleborough, Mass., 1853. SBD.

Jenny, W. S. Dag'typist. Hardwick, Mass., 1848. OSU.

Jerome & Co. Dag'typist. Gallery at Kenduskeag Bridge, Bangor, Me., 1849. CD.

Johnson, ———. Dag'typist. Gallery at 408 S. 2d St., Philadelphia, 1854–1855. SBD.

Johnson & Bush, Dag'typists. Gallery at 138 Montgomery St., San Francisco, 1855–1856. CD.

Johnson (Charles E.) & Fellows. Dag'typists, jobbers. Gallery at cor. Superior and Bank St., Cleveland, Ohio, 1851–1853. SBD.

Johnson & Jacobs. Dag'typists. Cor. Camp and Canal St., New Orleans, 1845–1846. *See also* Jacobs, Edward. *The East.*

Johnson & Keller. Dag'typists. Hartford, Ill., 1854–1855. SBD.

Johnson Bros. (George H.). Dag'typists. Pioneer Gallery, 185 Clay St., San Francisco, 1855–1857. CD; PAJ, 1857, p. 112.

Johnson, C. A. Dag'typist. Madison, Wis., 1855. CD.

Johnson, Charles. Dag'typist. NYC, 1844. CD.

*Johnson, Charles E. Engraver, dag'typist. Gallery at cor. Superior and Bank St., Cleveland, Ohio, 1850–1851; Merchant's Bank Bldg., 1852–1853; partner with Fellows, 1851–1853. Nsp, 1850; DJ; CD.

Johnson, D. B. Dag'typist. Utica, N.Y., 1850–1854. Said to have been one of the best dag'typists west of N.Y. DJ; PAJ, 1854, p. 352.

Johnson, D. (?) G. Dag'typist. Pupil of Morse, 1840. Carleton Mabee, *The American Leonardo: A Life of Samuel F. B. Morse*, 1943, p. 243.

Johnson, George H. Dag'typist. Born 1823 (?). To Calif., 1849; Sacramento, 1850–1851; San Francisco, 1852; NYC, 1879–1880 (?). *See also* Johnson Bros. CD; information courtesy of James de T. Abajian.

Johnson, James W. Dag'typist. San Francisco, 1852; gallery at cor. Clay & Kearny St., 1855–1856. CD.

Johnson, John. Dag'typist, inventor, mechanician, scientist, photographer. Born May 28, 1813, Saco, Me.; died May 3, 1871, Saco. Engaged in farming, 1825–1832; trip to Europe, 1833; machinist, 189 Cherry St., NYC, 1838–1839. Took first dag'type portrait, Oct. 6, 1839 (with A. S. Wolcott, using the speculum camera. Improved speculum camera, Oct. 1839–Jan. 1840. Opened first commercial studio in the world (with Wolcott). cor. (273) Broadway and Chambers St., NYC. Adv., Mar. 13, 1840. Sent father to Eng. Feb. 1840, to negotiate contract with Richard Beard, London, spring 1840. Exhibited dag'types at Franklin Institute, Apr. 23, 1840. Developed the Wolcott-Johnson system of studio lighting, Feb.–June 1840. To Eng. Oct. 1840, to aid Beard in opening the first English studio (Mar. 1841). Gave dag'typing instruction, Eng., 1841. Opened studio, Manchester, Eng. 1842–1843 (Wolcott in London). Patented dag'type-copying apparatus (Wolcott-Johnson), Mar. 1843. Developed and marketed an accelerator called "Wolcott's Mixture," 1841–1843. Returned to U.S. about 1843. Listed E. Broadway, NYC, as machinist, 1844–1847; assistant to Dr. Robert Ogden Doremus, chemist and inventor, 1850s. Involved with the manufacture of gas fittings, 1854. Listed as engineer 111 E. 18th St., 1860–1861. Elected treasurer, American Photographical Society, 1859. Returned to Saco, ca. 1862. Founded York Institute, Saco, 1866. Conducted a laboratory, Saco, electrotyping process for making dentures (?), 1870. Patented an apparatus for "Polishing metal Plates" (2,391), Dec. 14, 1841, the second patent for photography. Johnson and Wolcott, working in close partnership, made many important contributions to pho-

tography during its formative years. CD; BD; RT; *American Repertory of Arts, Sciences, and Manufactures*, 1840; AJP, Sept. 15, 1860; *Eureka*, 1846; DJ; HJ; PAJ; CD, Saco; nsp, *York County Independent*, May 9, 1871; other information courtesy of the York Institute, Saco.

Johnson, R. C. Dag'typist. Hillsville, Va., 1851. SLP, 1877, p. 215.

Johnson, Walter Rogers. Chemist, educator, amateur dag'typist. Born June 1794, Leominster, Mass.; died Apr. 26, 1852, Washington, D.C. From 1839–1843, professor of physics and chemistry, medical dept., University of Pa. Amateur dag'typist, Philadelphia; lectured on process, 1839–1840. ACB; BN; RT.

Johnson, William S. Dag'typist. Providence, R.I., partner of Hartshorn, 1850. CD.

Johnson, William Short. Associated with early photography; father of John Johnson. Born 1788, Saco, Me.; died Jan. 1846, NYC. Negotiated contract with Richard Beard, London, Eng., for the Wolcott-Johnson camera, spring 1840.

Johnston, ———. Dag'typist. Lancaster, Pa., date unknown. Private collection.

Johnston, John. Dag'typist. Boston, 1849. Passenger on ship *Regulus* from Boston to Calif. Information courtesy of James de T. Abajian.

Joiner, W. S. Dag'typist. Marion, Ill., 1854. SBD.

Jones, C. D. Dag'typist. Gallery at 208 Bowery St., NYC, 1853–1854. BD.

*Jones, J. (John). Artist, dag'typist. Born 1802, Md. Probably same J. Jones who adv. in 1848 that he had produced an imperishable dag'type which could be wiped with a cloth. Baltimore, 1848. SA, 1848; NYHS.

*Jones, J. Wesley. Artist, lecturer, dag'typist. Born 1826, Philadelphia; died after 1897, Brooklyn (?). To Calif., 1850, with the artist William N. Bartholomew of Boston. Dag'typed and purchased some fifteen hundred dag'type landscape scenes embracing the Missouri River westward to the Pacific Ocean. Lectured in eastern cities, using paintings and sketches made from dag'types, under the title, "The Pantoscope of California," 1853–1854. Paintings were sold in lottery, 1854. Fate of dag'types unknown. Burlington, Vt., dag'typist (?), 1856–1861. First lieutenant, 12th U.S. Infantry, Burlington, 1861–1863, in charge of purchases. Incompetency, dismissed from service May 4, 1863. Endeavored in postwar years to clear his name of charges. President, Volunteer Life Saving Corp., State of New York (Brooklyn); founded corp. in 1890. Presented silver loving cup by corp., 1897, for meritorious service. RT; NYHS (under Bartholomew); Calif. Historical Society; OSU; National Archives; other

information courtesy of George Moss, Jr.

Jones, Samuel S. Dag'typist. Gallery at 77 Bowery St., NYC, 1853–1854. BD.

Jones, William B. Dag'typist, inventor. Assistant to John Whipple, Boston, 1848–1849; 265 Washington St., 1850. Copatentee with Whipple on glass photographic process called crystallotypes (7,458), 1850. Jones assisted Whipple in dag'typing the moon (1848). BD; *Photographic News*, Mar. 2, 1866; BN.

Jones, William L. Dag'typist. Gallery at 210 Atlantic St., Brooklyn, 1856; Brooklyn, 1859–1860. CD.

Jordan & Merrill. Dag'typists. Gallery at Kenduskeag Bridge, Bangor, Me., 1849; Bangor, 1855. SBD; BD.

Jordan, Merritt. Dag'typist, photographer. Partner with Merrill, 1849; 21 2 Smith's Block, Bangor, Me., 1851–1855; 34 Main St., 1859. CD.

Jordan, William N. Dag'typist. Gallery at 142 Hanover St., Boston, 1854. BD.

Joslin, ———. Dag'typist. Philadelphia, 1856. PAJ, 1856, p. 126.

Joslyn, J. E. Dag'typist. Took photograph of eclipse, 1854. PAJ, 1854, p. 224.

Jourdan (Jordan), G. E. Dag'typist. Gallery at 44 Dearborn St., Chicago, 1854–1857. CHS.

Jube, Mary A. Dag'typist. Gallery at 83 Bowery St., NYC, 1853–1858 (same address as Thomas Jube); 230 Bowery St., 1860. BD.

Jube, Thomas S. Dag'typist. Gallery at 83 Bowery St., NYC, 1851; Bowery St., NYC, 1856. BD; HJ, 1856.

Judd, Myron E. Dag'typist. Albany, N.Y., 1853. CD.

Kearsine; William F. & G. T. Dag'typists. Gallery at 323 Bowery St., NYC, 1848; 177 Broadway, 1849. BD.

Keeler, ———. Dag'typist, photographer. Gallery on Market St., Philadelphia, 1856. PAJ, 1856, p. 126.

Keely, R. N. Dag'typist, Cor. 5th and Coates St., Philadelphia, 1846 (?); 232 N. 2d St., 1854; Philadelphia, 1856. Exhibited at Franklin Institute, 1852. SBD; HJ, 1852, p. 238; PAJ, 1856, p. 126.

Keen, L. W. Dag'typist, photographer. Born 1824, Tenn. Practiced dag'typing in Sullivan Co., Tenn., 1850; Blountville, Tenn., 1854. USC; SBD.

Keenan, J. A. Dag'typist. Philadelphia; gallery at 248 S. 2d St., 1854; Philadelphia, 1856–? MAR; SBD; PAJ, 1856, p. 126.

Keer, L. W. Dag'typist. Tenn., 1851. SLP, 1877, p. 216.

Keill, W. A. Dag'typist. Gallery at 107 N. Clark St., Chicago, 1854–1855. SBD.

Keith, L. L. Dag'typist. East Machias, Me., 1855. SBD.

*Keller, Francis. Dag'typist, lithographer. Gallery at 360 Market St., Philadelphia, 1854–1855; lithographer, Philadelphia, 1858–1860. SBD; NYHS.

Kelley, R. P. Dag'typist. San Antonio,

Tex., 1852. Information from dag'type dated Nov. 7, 1852, from collection of John Duncan.

*Kelsey, C. C. Dag'typist, portrait painter. Gallery at 136 Lake St., Chicago, 1848–1851; 96 Lake St., 1851–1858 (?); 160 W. 4th St., Cincinnati, Ohio, 1865–1866. Sold out to Cady & Co. Exhibited at Chicago Mechanic's Institute, gold medal, 1852; N.Y. Crystal Palace, 1853. CHS; SBD; HJ, 1866, p. 352, 1852, p. 269.

Kelsey, John. Dag'typist. Born 1823, Pa. Lived in the same boardinghouse as Myron Shew (also dag'typist) in Philadelphia, 1850. Worked for Myron Shew, dates unknown. To Rochester, N.Y., 1853 (partner with James Heath); partner with Daniel Hovey, 1854; took dag'type of eclipse of sun, May 26, 1854. USC; BN.

Kennedy, ———. Dag'typist. Philadelphia, 1839–1840. MAR.

Kennedy, Levi. Dag'typist. Warsaw, Ill., 1854–1855. SBD.

*Kern, Edward Meyer. Artist of landscapes and figure studies in watercolor, pencil, and oils, topographer, explorer, dag'typist. Born Oct. 26, 1823, Philadelphia; died Nov. 25, 1863. Exhibited at Artist Fund Society, 1841. Topographer on Frémont's third expedition, served under Frémont in Calif. during Mexican War, 1845–1847; Frémont's fourth expedition to the Colorado Rockies, 1848–1849; topographer with Simpson's expedition into Navajo Country, 1849. Dag'typist and artist with the exploration and survey of the China Seas and Bering Straits of the North Pacific ocean aboard the sloop, *Vincennes*, 1853–1854; artist of the Ringold exploration of the North Pacific to 1856. Joined U.S. Navy survey of a route from Calif. to China, 1858–1860. NYHS; Smithsonian Report, 1854.

Kilburn, Hervey. Dag'typist. Gallery at S.E. cor. 4th and Chestnut St., St. Louis, Mo., 1850. Missouri Historical Society.

Kimball, J. A. Dag'typist. Exhibited at N.Y. Crystal Palace, 1853. BN.

Kimball, Joseph L. Dag'typist. Concord, N.H., 1855–1856. SBD; CD.

Kimball, M. H. Dag'typist. Gallery at 5th and W. Main St., Cincinnati, Ohio, 1850. BD.

*Kimball, William H. Miniature painter, dag'typist. Born Apr. 6, 1817, Goffstown, N.H.; died Mar. 10, 1892, Concord, N.H. Studied miniature painting, Boston; painted in Manchester, N.H., Lowell, Mass., and Philadelphia. Edited newspaper, Manchester, 1842–1844. Began dag'typing, 1844; 142 Main St., Concord, 1849. State librarian, N.H., 1867–1890. NYHS; RBD.

King & Keith. Dag'typists. Adv., Athens, Ga., a new process of gilding, Mar. 13, 1845. Information courtesy of Dr. W. Robert Nix.

King, Charles L. Dag'typist. Sacramento, Calif., 1854. CD.

King, Horatio B. Dag'typist. Taunton, Mass., 1850–1855. CD; SBD.

King, William H. Dag'typist. Gallery at 37 Chatham St., NYC, 1849; 105 Bowery (with brother), 1850–1854. BD.

Kingsberry, H. K., & Co. Dag'typist. Gallery at 546 Broadway, NYC, 1853–1854. BD.

Kingsley, Joseph. Dag'typist. Berlin, Ill., 1854. SBD.

Knapp, ———. Dag'typist. Opened new gallery at 559 Broadway, NYC, 1851. PAJ, 1851, p. 255.

Knapp, A. H. Dag'typist, photographer. Practiced dag'typing, Boston, 1852; 123 Washington St., 1855–1856; Briggs & Knapp, Boston, 1856. BD.

Knapp, A. K. Dag'typist. Born 1827, Mass. Practiced dag'typing in Norton (Bristol), Mass., 1850. USC.

Knapp, William R. Dag'typist. Gallery at 103 Bowery St., NYC, 1846–1859. BD.

Knight, W. M. Dag'typist. Racine, Wis., 1851. CD.

Knowles, Lucius James. Inventor, dag'typist, politician. Born July 2, 1819, Hardwick, Mass.; died Feb. 25, 1884, Washington, D.C. As a young man invented and constructed machinery; in 1840 put into operation working models of steam engines and invented the Knowles safety steam-boiler feed-regulator. After photography came to America manufactured a variety of machinery and tools used for the art. Adv. in 1842, "Worcester Photographic Apparatus Manufacturing and Daguerreotype Rooms," Brinley Row, Worcester, Mass. Retired from dag'typing in 1844 and devoted his time to inventions; at time of death had patented more than one hundred. Also listed as a gilder and plater in Worcester. Left Worcester, ca. 1845. In 1858 constructed his patent steam pump. The Knowles pump works became the most extensive of their kind in U.S. Elected member of Mass. legislature, 1862; Senate, 1869. ACB; Publications of the Worcester Historical Society, 1928.

Knowlton, W. F. Dag'typist. Farmington, Me., 1855. SBD.

Knuckles, D. B. Dag'typist. Gallery at Cass St. and Jefferson Ave., Detroit, Mich., 1853–1854. CD.

Lacey, Z. Dag'typist. Great Barrington, Mass., 1853. SBD.

Lacy, W. Dag'typist. Danville, Ill., 1854. SBD.

Lafar, ———. Dag'typist. Gallery at cor. King and Liberty St., Charleston, S.C., 1854; partner with Cohen, 1854. Nsp adv.

Lainsena, M. Dag'typist. Gallery at 203 Broadway, NYC, 1849. BD.

Laird, B. R. Dag'typist. Princeton, Ill., 1854–1855. SBD.

Lamartine & Sullivan. Itinerant dag'typists. Floating gallery on Muskingum River, Ohio, 1851. DJ, 1851, p. 117.

Lancy (Lancey), Samuel F. Dag'typist. Gallery at 82 Washington St., Roxbury, Mass., 1850; Roxbury, 1853–1856. CD; SBD.

Landy, James. Dag'typist, photographer. Born Aug. 12, 1838 (?); died Nov. 18, 1897. Apprenticed with Silas A. Holmes, NYC, 1850; later in charge of Meade Bros. gallery, NYC, date unknown; Cincinnati, Ohio, opened gallery, 1863. AJP, 1897.

Lane, W. N. Dag'typist. Main St., Nashua, N.H., 1849. RBD.

Lang, L. Dag'typist, Gallery at 17½ Mark Sq., Portland, Me., 1849–1850; 161 Middle St., 1850–1851. CD.

Langdell, John. Dag'typist. Gallery on Main St., Nashua, N.H., 1849. RBD.

Langden, William A. Dag'typist. Gallery at 106 Chestnut St., Philadelphia, 1854–1855. SBD.

Langenheim & Beckers. *See* individual biographies.

Langenheim Bros. (William & Frederick). Dag'typists, photographers. William Langenheim: soldier, dag'typist, inventor, photographer. Born 1807, Brunswick, Germany; died 1874, Philadelphia. Texas, 1834–1836; Philadelphia, 1840–1874. Frederick Langenheim: editor, dag'typist, inventor, photographer. Born 1812, Brunswick, Germany; died Jan. 10, 1879, Philadelphia. Brothers opened gallery at 26 and 27 Exchange Bldg., Philadelphia, Aug. 1842–1874. Branch gallery at 201 Broadway, NYC (Langenheim & Beckers), ca. 1846–1848. Bought Edward White's gallery, 247 Broadway, NYC (Hite, Langenheim, & Fanshaw), 1850–1851. Purchase two U.S. patents (4369, 4370) from Johann B. Isenring for coloring dag'types, 1846. Purchase formalized May 11, 1849, U.S. rights for talbotypes from W. H. Fox Talbot, U.S. patent (5171), 1847. Patented (Frederick) "Improvement in Photographic Pictures on Glass" (frosted background—hyalotypes), Nov. 19, 1850 (7784). Made eight-inch-diameter dag'types, 1842. Improved the magic lantern using dag'types illuminated by hydro-oxygen light, 1843–1847. Developed glass negatives for paper photography, 1849–1850. Pioneered glass stereographs (American Stereoscopic Co.), 1852–1854. Pioneered miniature glass slides for magic lanterns, 1855–1856. Exhibited at Franklin Institute, 1844–1849; Crystal Palace, London, 1851, dag'types and talbotypes. Took early panorama of Niagara Falls, July 1845; portrait of Henry Clay, 1848; photographed solar eclipse, May 26, 1854. Nsp, NYC, Philadelphia; SA; *Gazette of the Union* (Odd Fellows), 1848; BD; RBD; CD; USC; PAJ; PP; BN; OSU.

*Lanneau, Charles H. Portrait painter, dag'typist. Painter from ca. 1836; dag'typist from 1850; Greenville, S.C., as dag'typist, 1856. PAJ, 1856, p. 26.

Larrabee, ——. From Boston. Dag'typist before Apr. 1840. Information from file of RA15, Revolutionary War pension file, N.H. Privateer Enoch Runes of Canada, R9075. File contains a broadside possibly used as a mailing cover for the petition. Broadside has imprint, "Messenger Office, St. Albans, Vt." Concerning undated dag'types advertising the work of Mr. Larrabee of Boston. The petition, no. 14,144, dated Apr. 25, 1840, has a postal cancellation on it; the petition of Frances, widow of Enoch. Husband died after July 7, 1838. Rejected. Information courtesy of Josephine Cobb.

Latch & Granias. Dag'typists. Waterbury, Conn., 1851. DJ.

Laugie, D. G. Dag'typist. Gallery at 257 Washington St., Boston, 1849. RBD.

Law, Joseph C. Dag'typist. Gallery at 47 Ave. D, NYC, 1853–1854. BD.

Lawrence, Martin M. Dag'typist, photographer, jeweler. Born 1808. Apprenticed at sixteen to jeweler. Listed as watch man, 114 Chatham St., NYC, 1838–1839; clocks, 128 Fulton St., 1842. Studied chemistry and became dag'typist, ca. 1842; gallery at 303 Broadway, 1844–1845; 152 Broadway, 1845–1849; 203 Broadway, 1850–1852; Newport, R.I., summer gallery, 1851; 381 Broadway, 1853–1860. Exhibited at American Institute, eight frames, 1845, received a diploma, 1848; Crystal Palace, London, 1851, bronze medal; N.Y. Crystal Palace, 1853, bronze medal. Lawrence was said to have introduced a copying box by which dag'types were copied as large or larger than the original. Specialized early 1850s in large dag'types, 10½ by 12½ in., 1851; 13 by 17 in., 1852. Pioneer in paper photography. Reputation as one of the best pioneer dag'typists. CD; BD; AI; nsp, NYC; DJ; HJ; PAJ, 1854, p. 352; *Illustrated News*, 1853; OSU; BN.

Lawrence, William. Dag'typist. Born 1828, Ohio. Practiced dag'typing, Blount Co., Tenn., 1850. USC.

Lazarus, Charles L. Dag'typist. Gallery at 74 Chambers St., NYC, 1850–1851. BD.

Leathers, James B. Dag'typist. Gallery at 101 Fulton St., Brooklyn, 1847. CD.

Leeds, Frederick W. Dag'typist. Gallery at 134 Hamersley St., NYC, 1846–1847; W. 347 Hudson St., 1848; 72 Carmine St., 1850–1851. BD.

Leigh, Tucker & Perkins. Dag'typists. Augusta, Ga., 1850–1853. Nsp; PAJ, 1851, p. 256.

Leonard, W. Dag'typist. Gallery at 139 Lake St., Chicago, 1854–1855. SBD.

Le Plongeon, Augustus. Dag'typist. Gallery at 166 Clay St., San Francisco, 1855–1856. CD.

Lerow, Jacob. Dag'typist. Boston, ca. 1845; 91 Washington St., 1847; Lerow & Co., 1848–1850; 148½ Washington St., 1851. BD; RBD.

Lester, B. J. Dag'typist. Adv., rooms in Capitol, Tallahassee, Fla., 1848; Albany, Ga., 1850. Nsp, *Floridian*, Aug. 12, 1848, Albany, Mar. 29, 1850.

Letellier, F. R. Dag'typist. Hopkinsville, Ky., 1852. Taught William G. Randle. RBD.

Lewis, Loozinski L. Dag'typist. Gallery at 9 Bowery St., NYC, 1850; 333 Broadway, 1851–1852; 411 Broadway, 1853–1854. BD; HJ, 1852, p. 202.

Lewis, N. E. Dag'typist, photographer. Gallery at 211 Superior St., Cleveland, Ohio, ca. 1862. Information on *carte de visite* adv. "Successor to A. Bisbee."

Lewis, R. H. Dag'typist. Adv., rooms opposite bank, former Bushnell's, Athens, Ga., Aug.–Oct. 1853. Information courtesy of Dr. W. Robert Nix.

Lewis, Richard A. Dag'typist, inventor, photographer. Born 1820, Eng.; died Sept. 23, 1891, Brooklyn. Chatham Sq., NYC, 1839 (?); 142 Chatham St., 1844–1854; NYC, 1868–? Son of W. Lewis and brother of W. H. and Henry J. Lewis. Richard was primarily the dag'typist and photographer for the family, although he is credited with contributing to several inventions marketed by the Lewis family. An early practitioner in the 1850s of paper photography. Estimated to have left 400,000 glass negatives when he died. *See also* W. & W. H. Lewis under Manufacturers and wholesale suppliers. BD; HJ; APB, 1891, p. 606.

Lewis, William H. Dag'typist. Morristown, Pa., 1854–1855. BD.

L'Homdieu, Charles. Dag'typist, inventor. Born 1819, N.J. Gallery at cor. King and Market St., Charleston, S.C., 1847–1852. Invented and patented "Improvement in Gilding Daguerreotypes" (9,354), Oct. 26, 1852. Nsp; CD; USC.

Libolt, Dr. Adam. Dag'typist, doctor. Wife, Mrs. S. H. Libolt, miniaturist, from NYC. Adv., May–June 1843, Athens, Ga., "miniatures and views." Information courtesy of Dr. W. Robert Nix.

Lillibridge, C. H. Dag'typist. Gallery at 75 Lake St., Chicago, 1854; 77 Lake St., 1855–1860. CHS.

Lindell, H. Dag'typist. Gallery on High St., Columbus, Ohio, 1853. SBD.

*Lion (Lyons), Jules. Black portrait and miniature painter, lithographer, dag'typist. Born ca. 1816, France. New Orleans, ca. 1837. Credited as first dag'typist in New Orleans; listed in directory as "free man of color," 1851. Painted portrait of Audubon. NYHS.

Litch, Albert. Dag'typist. Age listed, thirty to forty, 1840 census. Litch, Whipple & Co., Boston, 1844–1846; 96 Washington St. (alone), 1846–1847; operator for J. Gurney, NYC, ca. 1848–1852. Chemical manufacturer for dag'types (Gurney & Litch), 1852. To Eng., 1853; 49 Tremont Row, Boston (Bowdoin & Litch), 1855–1856. MAR; SA, 1846; BN; USC.

Lloyd, John B. Dag'typist. 1852, location

unknown. HJ.

Lloyd, S. H. Dag'typist. Gallery at 91 Washington St., Boston, 1851. BD.

Locke, A. C. Dag'typist. Lewiston, Me., 1855. SBD.

Locke, John. Physician, scientist, inventor, chemist, teacher, amateur dag'typist. Born Feb. 19, 1792, Lempster, N.H.; died July 10, 1856, Cincinnati, Ohio. Professor of chemistry and pharmacy, Medical College of Ohio, 1835–1853. In early 1839 experimented with photography processes. Public lecture on dag'typing, Cincinnati, May 1840. Nsp; ACB.

Lockwood, M. W. Dag'typist. Adv. as successor to C. G. Page, cor. 14th and 8th Ave., NYC, 1854. Adv. whole plates with frame $15.00 and regular quarter plate $5.00. *Citizen*, June 17, 1854.

Long Bros. Dag'typists. Enoch Long: dag'typist, photographer, author. Born 1823, Hopkinton, N.H.; died Jan. 3, 1898, Quincy, Ill. Horatio H. Long: dag'typist. Born Hopkinton, N.H.; died summer of 1851, St. Louis, Mo., or Vt. (funeral in Vt.). The Long Bros. learned dag'typing under Robert Cornelius, July 1842. Augusta, Ga., 1842–1845; itinerants, South and New England, 1843–1844; 96 Washington St., Boston (H. H. Long), 1844 (bought out Whipple?). Gallery at cor. 3d and Market St., St. Louis, 1847–1854; 100 Market St. (E. Long), 1854–1860. Galleries, Alton, Quincy, and Galena, Ill., 1860–1898. Gallery operated by widow and son, George E. Long, 1898–? Exhibited at N.Y. Crystal Palace, 1853, honorable mention. Introduced first solar enlarger, St. Louis, 1854. E. Long wrote manuals "Crayon Portraits on Solar Enlargements," and "Pastel Portraits on Solar Enlargements," 1888. Missouri Historical Society; CD; HJ; PAJ, 1854, p. 352; BN; SLP, 1877, p. 215; Schiller, *Early Photography in St. Louis*, ca. 1890s; *Photographic Times*, 1898.

Longman, F. Dag'typist. Partner with Smith, 233 King St., Charleston, S.C., 1851. Nsp.

Loring, Davis. Dag'typist. Eastport, Me., 1855. SBD.

Lougee, D. G. Dag'typist. Gallery at 257 Washington St., Boston, 1849. BD.

Lovell, J. L. Dag'typist, photographer. Practiced dag'typing in Ware, Mass., 1849; Brattleboro, Vt., 1852–1856. Made a large number of studies for Larkin G. Meade, the sculptor, who was just beginning his later famous work. Studied photography under Black & Whipple, Boston. Made photographs for book on geology of the Conn. Valley, published by the Smithsonian (one of first books with actual photographs in America). Chief photographer of the Lick Observatory for Transit of Venus, 1882. *American Annual of Photography & Photographic Times Almanac*, 1886, pp. 28–32.

Lovering, Reuben F. Dag'typist. Operator, Plumbe's Gallery, Boston, 1843–1847; Broad St., Columbus, Ga., winter 1846; 257 Washington St., Boston (own gallery), 1848; 34 Tremont Row, 1849–1850; 203 Washington, St., 1851. San Francisco (partner with Hamilton), 1860. CD; BD; RBD; nsp, Columbus.

Lowry, ———. Dag'typist. Belvedere, Ill., 1854–1855. SBD.

Loyd, Lester. Dag'typist. Adv., National Daguerreian Rooms, 270 Grand St., cor. Forsyth St., NYC, 1850–1851. BD.

Lucas, Stephen. Dag'typist. Middlebrough, Mass., 1853. SBD.

Lufkin, Merchant H. Dag'typist. Gallery, Lowell, Mass., 1855–1859. CD.

Lumley, A. T. Dag'typist. Gallery on High St., Columbus, Ohio, 1853. SBD.

Lumley, R. Dag'typist. Columbus, Ohio, 1856. CD.

Lunquest, John M. Dag'typist. Gallery at 261 King St., Charleston, S.C., 1847–1848. Nsp adv., June 1847, Mar. 1848.

Lyman, Wooster. Dag'typist. Momence, Ill., 1854–1855. SBD.

Lyndall, H. Dag'typist. Columbus, Ohio, 1855. A. S., E., and A. H. Heath, *Photography, A New Treatise*, 1855.

Lyons, ———. Dag'typist. Gallery at 252 Chestnut St., Philadelphia, 1854–1855. SBD.

Lyons, J. L. Dag'typist. Gallery on State St., New London, Conn., 1849. RBD.

McArthur, J. A. Dag'typist. Successor to Bent (Israel) and McArthur, 62 State St., Newburyport, Mass., after 1851, date unknown. CD; OSU.

McBride, H. Dag'typist. Albany, N.Y., 1852–1853. CD.

McCargo, R., & Co. Dag'typist. Gallery in Lafayette Bldg., Pittsburgh, Pa., 1854–1855. BD; mat, OSU.

McCarty, Augustus. Dag'typist. Gallery on Pennsylvania Ave., Washington, D.C., 1853. CD.

*McChesney, William J. Dag'typist, engraver. Born 1809, N.J. Gallery at cor. 2d and Pine St., Philadelphia, 1854–1855. NYHS; SBD, 1854.

*McClees (J. E.) & Germon (Washington L.). Dag'typists, platemakers, engravers, lithographers. Gallery at 189 Chestnut St., Philadelphia, 1847–1855. Exhibited at Franklin Institute, first place, 1847; American Institute, 1848, diploma; Franklin Institute, 1848, second premium. Partnership terminated, ca. 1855. Date of platemaking activities unknown. *See also* separate listings. FI; AI; NYHS; SBD; PAJ.

*McClees, J. E. Dag'typist, engraver, lithographer. Partner with Washington L. Germon, 189 Chestnut St., Philadelphia, 1847–1855; won bronze medal for best photographic view, American Institute, 1856; gallery, Washington, D.C., 1857–1858. Pioneer in stereo views and made many scenes of Washington, ca. 1854–1861. Julius Vannerson managed the Washington studio for

McClees. *See also* McClees & Germon. FIJ; AI; NYHS; PAJ; SBD. Also information courtesy of Josephine Cobb.

McCline, J. Dag'typist. Beardstown, Ill., 1854–1855. SBD.

McCowat, P. C. Dag'typist. Born 1819, Va. Practiced dag'typing, Jackson, Tenn., 1845–1850. Nsp, 1845; USC.

McCracken, J. C. Dag'typist. Harrison, Ohio, 1853. SBD.

McDonald & Co. Dag'typist. Tiffin, Ohio, 1853. SBD.

McDonell, William. Dag'typist. Gallery at 95 Lake St., Chicago, 1847–1848. CHS.

McDonnell, Donald, & Co. Dag'typist. Gallery at 9 Main St., Buffalo, N.Y., 1850–1851; Toronto, Canada, 1851; 208–210 Main St., Buffalo, 1853–1854. Exhibited at Crystal Palace, London, 1851, dag'types of distinguished Americans; N.Y. Crystal Palace, 1853, dag'types including those of Niagara Falls. HJ; CD; PAJ, 1854; SLP, 1877, p. 215; BN.

*MacDougall, John Alexander. Miniature painter, dag'typist. Born 1810 (or 1811), Livingston, N.J.; died 1894. Visited New Orleans as miniature painter, 1839, also traveled at other times to Charleston, S.C., and Saratoga Springs, N.Y. Studio NYC; exhibited at National Academy, American Art Union, and won first prize for miniatures American Institute, 1845, 1847, 1848. Dag'typist, Broad St., Newark, N.J., 1846 and possibly before. NYHS; AI; Harry B. Wehle and Theodore Bolton, *American Miniatures, 1730–1850*, 1927, p. 91.

McElroy, John. Dag'typist. Locke, N.Y., 1859. CD, Auburn, N.Y.; OSU.

McFarland, Robert. Dag'typist. Camden, Me., 1855. SBD.

McGill, William A. Dag'typist. Gallery at 98 4th St., Louisville, Ky., 1855–1856. CD.

Machan, ———. Dag'typist. Exhibited at Franklin Institute, 1852. HJ, 1852, p. 283; FI.

McIntyre, A. C. Dag'typist. Mammoth Skylight Daguerrean Gallery over Anderson & Gilmer's Store, Montgomery, Ala., 1854. Probably the same photographer who took stereo views of Thousand Islands, N.Y. state, 1860s and 1870s. RBD, 1854.

McIntyre, Sterling C. Dag'typist, dentist. Adv. as dentist with G. A. McIntyre, Mar.–Sept., Tallahassee, Fla., 1844. Adv. as dag'typist, Nov. 10, 1844, Tallahassee; adv., Jan. 28, 1845, "taking colored Daguerreotype Likenesses in the latest style and will continue, as heretofore, the practice of Dentistry in all its branches." He advertised in the *Florida Sentinel*, May 13, 1845, that he would be in Marianna about the 20th for a few days and then proceed to Pensacola. Gallery at 190 & 200 King St., Charleston, S.C., 1847–1848. To Tallahassee, 1848. Adv. that he would be ready to execute likenesses about Dec.

16 in the old office of the *Sentinel*. An item in *The Floridian* on Feb. 3, 1849, informed the public that he was leaving for Key West. Listed at 663 Broadway, NYC, 1850–1851. To San Francisco sometime during 1850. Took panorama of San Francisco in early 1851. Nsp, *Floridian*, *Florida Sentinel*, *Charleston Courier*; BD, NYC; BN. Also information courtesy of Joan Morris and Dr. Dorothy Dodd.

McIver, ———. Dag'typist. Jonesboro, Tenn., 1846. Partner with Stearn. Nsp adv., *Old Hickory*, June 6.

McKeachnie, Allen. Dag'typist. Gallery at 170 Broadway, NYC, 1851. BD.

McKernon, P. H. Dag'typist. Partner with D. Denison, Albany, N.Y., 1853. CD.

Maester, L. Dag'typist. Exhibited at Franklin Institute, 1852. HJ, 1852, p. 238.

Maguire, James. Dag'typist. Learned dag'typing from F. A. P. Barnard and Wm. Harrington, Tuscaloosa, Ala., 1840. Opened studio at 3 Camp St., New Orleans, Feb. 1841; 6 Canal St., 1842–1850. Traveled in Europe, 1844. Partnership with Harrington, 1850–1851, and acquired rights for talbotype patent from Langenheim Bros., 1850. Nsp adv., *New Orleans Picayune*.

Magwire, George. Dag'typist. Adv., "Knickerbocker Daguerreian Gallery, established in 1840." Gallery at 106 Broadway, NYC, cor. Pine St., 1850–1851. BD.

Mahan & Good. *See* Thomas T. Mahan.

Mahan, Miss ———. Dag'typist. Gallery on Market St., Philadelphia, 1856. PAJ, 1856, p. 126.

Mahan, Thomas T. Dag'typist, photographer. Born 1823; died 1900, Atlantic City, N.J. Mahan & Good (Jonathan), Market St., Philadelphia, 1856; Baltimore, 1860 (?). PAJ, 1856, p. 126, CD.

Mainwaring, William. Dag'typist. Detroit, Mich., 1853. CD.

Maitland, Rebecca E. Dag'typist. Gallery at 179 Broadway, NYC, 1848–1849; 74 Canal St., 1849–1854. BD.

Mallon, J. A. Dag'typist. Jacksonville, Ill., 1853. SBD.

Manchester & Bros. (Henry N. & Edwin H.). Dag'typists, photographers. Bought out gallery, Hartshorn & Masury, Providence, R.I., and Newport, R.I., 1850. Took portrait of Edgar A. Poe, ca. 1848. Stereo views, Providence, 1860–1868. CD; BN; SV.

Mandeville, L. H. Dag'typist. Born 1825, Trumansbury, N.Y. Practiced dag'typing, Mich., 1850. USC; CD.

Mann, James. Dag'typist. Gallery at 4 Pleasant St., Newburyport, Mass., 1851. CD.

Mann & Blodgett. Dag'typists. Gallery at 149 Washington St., Boston, 1854–1856. BD.

Mansfield, ———. *See* Beers & Mansfield.

Mansfield & Hall. Dag'typists. Bruns-

wick, Me., 1856. George A. Wheeler and Henry W. Wheeler, *History of Brunswick, Topsham, and Harpswell, Maine*, 1878.

*Mapes, James Jay. Chemist, inventor, amateur miniature painter, editor. Born May 29, 1806, Mapeth, Long Island, N.Y.; died Jan. 10, 1866, NYC. Aided Wolcott and Johnson in their first portrait dag'type experiments, Oct. 1839. Displayed Wolcott-Johnson dag'types at the Franklin Institute, 1840. Wrote articles on the dag'type. Inventor of artificial fertilizer. ACB; NYHS.

Marble, C. Dag'typist. Wilmington, Ohio, 1853. SBD.

Marker, Joseph E. Amateur dag'typist (?). Endorsed use of E. White Maker plates, 1845. SA.

Marks, H. R. Dag'typist. Mark's Premium Daguerrean Gallery, 159 Baltimore St., Baltimore, 1851–1852; 57 Dauphin St., Mobile, Ala., 1855–1858. Exhibited at Md. Institute, "Dag'type of San Francisco and 17 Japanese Mariners who were picked up in distress"; awarded premium, 1852; premium, 1855. CD, Baltimore, Mobile; *Illustrated News*, Jan. 1853.

Marshall & Porter. Dag'typists. Gallery at 136 Chestnut St., Philadelphia, ca. 1847–? Imprint on velvet in miniature case.

Marshall, J. P. C. Dag'typist. Gallery at 268 Washington St., Boston, 1849–1850. BD.

Marston, James. Dag'typist. Ottawa, Ill., 1854–1855. SBD.

Martin, Mrs. G. P. Dag'typist. Gallery over post office, Main St., Paterson, N.J., 1850. SBD.

Martin, J. E. Dag'typist. Detroit, Mich., 1849–1853. Sold out to Sutton & Bro., 1853. Exhibited at Mich. State Agricultural Fair, 1849, won first premium. HJ; CD.

Mason, A. P. Dag'typist. Gallery on High St., Columbus, Ohio, 1853. SBD.

Mason, James H. Dag'typist. Born 1828, R.I. Practiced dag'typing, Maury Co., Tenn., 1850. USC.

Mason, John. Dag'typist. Providence, R.I., 1847. CD.

Mason, L. Dag'typist. Tauton, Mass., 1849. RBD.

Mason, Thomas. Dag'typist. Mt. Pulaski, Ill., 1854–1855. SBD.

*Mason, William G. Engraver, landscape painter, amateur dag'typist. Began as artist, ca. 1822. Mason, of Philadelphia, was one of the first amateur dag'typists in America, 1839. He is also credited with taking the first dag'type with artificial light. Exhibited landscape painting, Pa. Academy, 1843. Agent for E. White Maker dag'type plates at 46 Chestnut St., 1846. MAR; NYHS; SA, 1845; RBD, 1846.

Masury & Silsbee. Dag'typists. Partnership at 299½ Washington St., Boston, 1852–1856. *See also* individual biographies. BD; BN.

Masury, Samuel. Dag'typist. Partnership with S. W. Hartshorn, Providence, R.I., 1847–1850; Salem, Mass., 1849; Providence, 1850; sold business to Manchester & Bros., 1850; 299½ Washington St., Boston, partnership with G. M. Silsbee, 1852–1856; 299½ Washington St., partnership with Silsbee and J. C. Case, 1857–1858; 289 Washington St. (alone), 1858–1866. Exhibited at N.Y. Crystal Palace (with Silsbee), 1853. CD; SBD; RBD; SA; PAJ, 1854, p. 160; BN.

Masury, Silsbee & Case (Samuel Masury, J. C. Case, George M. Silsbee. *See* individual biographies.

Matear, John. Dag'typist. Gallery at 466 Pearl St., NYC, 1851–1854. BD.

Mathews, W. B. Dag'typist. Ravenna, Ohio, 1853. SBD.

Matteson & Co. Dag'typist. Augusta, Me., 1855. BD.

Mauzy, John A., Paul & James. Dag'typists. Gallery at 45 N. 4th St. and 112 N. 4th St., St. Louis, Mo., 1848. Missouri Historical Society.

Mauzys, P. Dag'typist. Gallery at 8 2d St., Alton, Ill., 1850. Nsp, *Alton Telegraph & Democrat*, July 19.

Maxham, Benjamin D. Dag'typist. Worcester, Mass., 1850–1855. Proceedings of the Worcester Historical Society, 1928.

Maxwell, A. D. Dag'typist. Marietta, Ohio, 1853. SBD.

May (H. J.) & Fesenden's (E. R.). Dag'typists. Gallery on Kearny St., cor. Sacramento, San Francisco, 1856–1857. CD; PAJ, 1857, p. 112.

Mayall, John James Edwin. Dag'typist, inventor, photographer. Born U.S. (?); died 1901, Eng. Learned dag'type process from Dr. Paul B. Goddard, Philadelphia, 1840. Partnership with Samuel Van Loan, 140 Chestnut St., 1845–1846. Sold gallery to Marcus Root, 1846. To London, Eng., 1846–1864. Brighton, Eng., 1864. Established chain of galleries in England. Exhibited at Crystal Palace, London, in both English and U.S. sections; won honorable mention (U.S.). Obtained English patents for stereoscope and other inventions. MAR; RBD; CD, Philadelphia; DJ; SA; BN.

Mayer, T., & Co. Dag'typist. Gallery at 167 Bowery St., NYC, 1853–1854. BD.

Mayers, John S. Dag'typist. Gallery at 72 Canal St., NYC, 1848; 82 Canal St., 1849–1852; 94 Canal St., 1853–1854. BD.

*Mayr, Christian. Portrait and genre painter, designer, dag'typist. Born ca. 1805, Germany; died Oct. 19, 1851, NYC. Exhibited at National Academy, 1834; Boston, 1839; Charleston, S.C., 1840–1843; visited New Orleans, 1844; returned to home on Lespenard St., NYC, 1845–1851. Associate of National Academy, 1836–1849; elected academician, 1849. Date and location of dag'type activities unknown. NYHS.

Meade Bros. (Charles Richard & Henry W.). Dag'typists, jobbers, manufacturers, photographers. Charles Richard Meade: born 1827; died Mar. 2, 1858, St. Augustine, Fla. Henry W. Meade: born 1823, Eng.; died Jan. 25, 1865, NYC. Said to have been the first dag'typists in Albany, N.Y., ca. 1842–1843, in a small room in Down's Bldg. Albany Exchange Bldg., 1843. From 1842–1843 practiced the art with success in different towns and cities and had permanent establishments in Albany, Buffalo, and Saratoga Springs, N.Y. Engaged as jobbers and manufacturers of photographic materials, including miniature cases. Exhibited one frame of dag'types at American Institute, 1846; also in 1846 sent views of Niagara Falls (dag'types in frames) to the French king and emperor of Russia. Letters of praise from these monarchs published throughout U.S. Traveled (Henry) through France and Germany and principal cities of England, 1847–1848. Charles visited Europe, 1848; besides taking dag'type views, he took several dag'types of Daguerre. Exhibited 1848, at American Institute, calotypes for which they were awarded a silver medal. Sold Albany gallery in fall of 1850 to Schoonmaker & Morrison. Opened gallery at 233 Broadway, NYC, 1850, and in 1850 won a silver medal for excellent dag'types and a diploma for chemically colored dag'types at the American Institute. Exhibited twenty-four dag'types at the Crystal Palace, London, 1851. Employed in gallery, in 1852, ten assistants; collection of one thousand pictures; Awarded silver medal for second-best dag'types, American Institute, 1852; awarded gold medal (highest award) for "double whole plate, single and half plate pictures," American Institute, 1853. Exhibited at N.Y. Crystal Palace, 1853, honorable mention. Henry married Sarah A. Meserole, Brunswick, Long Island, at the Trinity Church, Sept. 7, 1853. Planned to open a branch gallery, May 1, 1853, in Williamsburg, L.I. (not known if venture became a reality). Henry Meade sailed on the *Indiana* to Europe, 1854, to visit Constantinople to give sultan stereoscopic views of Washington's tomb at Mt. Vernon. Also brought views of Washington, D.C., and NYC and presented a stereoscope inlaid with mother-of-pearl. Introduced photographs on silk, 1856; portraits on handkerchiefs, hat linings, etc., useful for badges—prelude to election photographs. The firm suffered business reverses and was said to have been taken over by Levi Chapman. Henry Meade committed suicide, 1865. AI, 1846, 1848, 1852, 1853; nsp, Albany, 1850; BN; DJ; HJ, 1853, 1865, p. 304; *Illustrated News*, Jan. 1853; PAJ, 1851,

p. 189, 1852, pp. 294–295, 1853, p. 259, 1854, p. 288, 1856, p. 95; RT.

Mendenhall, J. Z. Dag'typist. Delaware, Ohio, 1853. SBD.

Mendham & Beals. Dag'typists. Gallery at 407 Broadway, NYC, 1853–1854. BD.

Mercer, ———. Dag'typist. Died, 1852. Partner with E. T. Whitney, Rochester, N.Y., 1845–1849. CD; HJ, 1852.

Merchant's Gallery. Dag'typist. Name of owners unknown. Gallery at 77 Greenwich St., NYC, 1852. Nsp, *New York Times*, July 2.

Merreman, H. Dag'typist. Gallery at 111 4th St., Pittsburgh, Pa., 1854–1855. SBD.

Merrick, Dr. G. W. Dag'typist. Adrian, Mich., 1851–1854. Won several prizes at various exhibitions, 1854. PAJ, 1854, p. 96.

Middlebrook, C. S. Dag'typist. Gallery at cor. State and 61 Water St., Bridgeport, Conn., 1850. CD.

Middlebrook, George F. Dag'typist. Gallery at 314 Bowery St., NYC, 1851. BD.

*Mifflin, John Houston. Portrait and miniature painter, dag'typist. Born 1807, Pa., died 1888, Columbia, Pa. Studied painting at Pa. Academy; exhibited there, 1832. Pupil of Thomas Sully. To Europe, 1836–1837, for further study. On return worked in Philadelphia and Ga. Gave up painting, 1846. Adv. as dag'typist, Athens, Ga., 1841. NYHS; nsp, Athens, July 23, 1841; Athens information courtesy of Dr. W. Robert Nix.

Miles, Charles T. Dag'typist. Fayette, Miss., 1851. DJ.

Miller & Co. Dag'typist. Gallery on 6th Ave. near W. 40th St., NYC, 1853–1854. BD.

Miller, Miss A. L. Dag'typist. Gallery at 77 Lake St., Chicago, 1854–1855. SBD.

Miller, Alanson (?) G. Dag'typist. Gallery at 131 Lake St., Chicago, 1847–1849. CHS.

Miller, Henry. Dag'typist. Gallery at 72 W. Hollis St., Nashua, N.H., 1856. CD.

Miller, James S. Dag'typist. Nashua, N.H., 1853–1856; gallery at 72 W. Hollis St., Nashua, 1856. CD.

Miller, J. W. Dag'typist. Gallery at cor. Julian St. and Market Sq., Savannah, Ga., 1853–1856. Nsp.

Miller, Russell A. Dag'typist, photographer. Practiced dag'typing, Lowell, Mass., 1853–1855; gallery at 19 Central St., 1855. Moved to Boston (?). Took stereo views, ca. 1868–1878. CD; SBD; SV.

Miller, Rev. S. Amateur dag'typist. Practiced dag'typing, Pottsville, Pa., 1839. Wrote for *Humphrey's Journal*, Feb. 15, 1863. HJ.

Miller, S. S. Dag'typist. Akron, Ohio, 1853. SBD.

Miller, Samuel P. Dag'typist. Partner with Marcus Root, 4th & Chestnut St.,

St. Louis, Mo., 1844. Missouri Historical Society.

Miller, W. A. Dag'typist. Gallery at 20 Washington St., Boston, 1847–1849. BD.

Mills, A. M. Dag'typist. Princeton, Ill., 1854–1855. SBD.

Miles, Charles T. Dag'typist. Fayette, Miss., 1851. DJ.

*Minnis (Minis), ———. Miniature painter, dag'typist, photographer. Practiced dag'typing in Petersburg, Va., and said to be one of the most prosperous dag'typists south of NYC. Photographer and miniature painter, Petersburg, 1857. PAJ, 1854, 1856, p. 123; William B. O'Neal, *John Toole*.

Mitchell, George E. Dag'typist. Lowell, Mass., 1859–1860; 89 Merrimack St., Lowell, 1860. CD.

Mitchell, P. E. Dag'typist. Dexter, Me., 1849. RBD; CD.

Moffet, C. R. Dag'typist. Dated dag'type, Sept. 19, 1848, Danvill, Mo. Sotheby-Parke-Bernet cat., 1967.

Mohl, F. Dag'typist. Gallery at 7½ Bowery St., NYC, 1846. Exhibited one-frame dag'types, American Institute, 1846. AI.

Moissenet, F. Dag'typist. New Orleans, 1850; 134 Royal St., 1851; partnership of Moissenet, Dobyns, Richardson & Co., 1853–1855; partnership of Moissenet & Law, 1 Camp St., 1856–1858. CD; BN.

Monroe's Sky Light Gallery. Dag'typist. Gallery over post office, Allegheny City, Pa., 1855. Nsp.

Montalvo, Ramon. Dag'typist. Gallery at 323 Broadway, NYC, 1849. BD.

Moore & Ward. Itinerant dag'typists. Brown's Hotel, Washington, D.C., Jan 1841; Va., Mar. 1841; Bank of Columbia, Georgetown, D.C., Apr. 1841; Nashville, Tenn., 1841; Louisville, Ky., Aug 1841; Main and Market St., St. Louis, Mo., 1841; Committee Room, Capitol, Washington, D.C., 1841–1842. Nsp, Washington, D.C., Louisville; NDJ; *Perley's Reminiscences*, 1886; Missouri Historical Society.

Moore, Daniel. Dag'typist. Gallery at 415 8th Ave., NYC, 1853–1854. BD.

Moore, Gabriel. Dag'typist. Born 1808, Pa. Practiced dag'typing, Camden, N.J., 1850. USC.

Moore, Henry. Dag'typist. Lowell, Mass., 1843. BN.

Moore, J. B. (Moore & Co.). Dag'typist. Gallery at 59 Court St., Boston, 1849–1852. RBD; CD.

Moore, Justus E. Dag'typist. Adv., July 1840, Philadelphia, claiming instantaneous dag'type. Reprint in N.Y. nsp.

Moore, O. Dag'typist. Gallery over Gryhame Lacy's, south side of Jefferson Ave., between Griswold and Woodward Ave., Detroit, Mich., 1853. CD.

Moore, W. B., & Co. Dag'typist. Jenny Lind Portrait & Daguerrian Parlor, opened at cor. Congress and Jefferson St., Savannah, Ga., 1850. Nsp.

Morand & Co. *See* Augustus Morand.

*Morand, Augustus. Dag'typist, artist, photographer. Established NYC gallery, 1840. Listed as an artist, NYC, 1841. Itinerant dag'typist, Brazil, 1842; itinerant to southern states, 1843–1844; 71 Chambers St., NYC, 1844–1847; Market & 4th St., St. Louis, Mo., 1847; 132 Chatham St., NYC, 1848–1851; 65 Chatham St., 1851–1859; bought out Alexander Beckers' gallery, 411 Broadway, 1859; over Tices, Fulton St., Brooklyn (with G. H. Morand), 1860–1862. Morand had a number of dag'types reproduced as engravings in the *U.S. Magazine and Democratic Review*, Nov. 1842, Pres. John Tyler; Sept. 1842, Churchill C. Chamberlain of N.Y.; Aug. 1842, T. W. Dorr. He became president of the N.Y. State Daguerreian Association, 1851; president of the Chippewa Club, NYC, 1852; member of the Henry Clay Club and marched under the club banner in the Clay obsequies, NYC, July 5, 1852. *Illustrated News*, May 1853, p. 335; MAR; BN; BD; DJ; PAJ; BJP, 1886, p. 363; Missouri Historical Society; *History of King's County, Brooklyn*, 1884.

Morand, Philip. Dag'typist. Gallery at 535 Broadway, NYC, 1851; opened suite of rooms, Broadway near Spring St., 1852. BD; PAJ.

Morgan, ———. Dag'typist. Philadelphia, 1850s. MAR.

Morrill (S. G.) & Smith. Dag'typists. Gallery on Market St., S. Newburyport, Mass., 1849–1851. RBD; CD.

Morris, John C. Jeweler, dag'typist. Gallery at 10 Main St., Bangor, Me., 1848. CD.

Morrison, J. W. C. Dag'typist, photographer. Practiced dag'typing, Bath, Me., 1849; 130 Middle St., Portland, Me., 1858. RBD; CD.

Morrison, William H. Dag'typist. Born 1832, Ala. Practiced dag'typing, Bedford Co., Tenn., 1850. USC.

Morse, Mrs. ———. Dag'typist. Beardstown, Ill., 1854–1855. SBD.

*Morse, Samuel Finley Breese. Portrait, miniature, and historical painter, sculptor, inventor, pioneer dag'typist. Born Apr. 27, 1791, Charlestown, Mass.; died Apr. 2, 1872, NYC. Graduated Yale, 1810. Studied under Washington Allston and Benjamin West (London), 1811–1814. First experiments related to photography, ca. 1808–1810, while at Yale. Painted portraits in New England and Charleston, S.C., 1815–?; settled in NYC, 1823. One of the founders of the National Academy of Design (1825) and its first president. Traveled abroad, art studies, 1829–1833. Began work on electric telegraph, 1832; first displayed, 1836; patented, 1837; practical completion, May 24, 1844. Introduced details and news of Daguerre's discovery to America in spring of 1839. First successful dag'type, Sept. 28, 1839. Studied dag'typing under François Gouraud, Dec. 1839–Jan. 1840. Opened gallery (with Dr. John W. Draper), 1840, and taught and made dag'types 1840 to ca. 1842. Gave up dag'typing to pursue acceptance of telegraph, 1842–1843. Became involved in the Levi L. Hill color dag'type controversy, 1851–1852; judge, Anthony Prize competition, 1853. Morse continued his active interest in art and science, 1853–1872. Honored by European countries for invention of telegraph, 1858. RT; BN; NYHS; Samuel I. Prime, *The Life of Samuel F. B. Morse*, 1875; *Encyclopaedia Britannica*, 1909; Carleton Mabee, *The American Leonardo: A Life of Samuel F. B. Morse*, 1943.

*Moses, Morris. Crayon portraitist, dag'typist. City Hall, 30½ E. State St., Trenton, N.J., 1850–1865. NYHS; CD; SBD.

Moss, James. Dag'typist. Born 1825, Eng. Practiced dag'typing in Sumner Co., Tenn., 1850. USC.

*Mote, Marcus. Portrait and religious painter, dag'typist, photographer. Born June 19, 1817, Ohio; died Feb. 26, 1898, Richmond, Ind. Painted portraits, Lebanon, Ohio, also painted coaches. Engaged in lithographic work, took dag'types and photographs. During 1853 and 1854 painted panorama of Uncle Tom's cabin and other subjects. Moved to Richmond, Ind., ca. 1866; taught public and Sunday schools and had drawing academy. NYHS.

Moulthrop (M.) & Hart (Truman). Dag'typists. Brewster's Exchange Bldg., New Haven, Conn., 1846–1848. *See also* individual biographies. CD.

Moulthrop, M. Dag'typist. Brewster's Exchange Bldg., New Haven, Conn. (partner, T. Hart), 1846–1848; 6 and 15 Phoenix Bldg., 1849–1850; 24 Phoenix Bldg. (Moulthrop's Sun Beam Gallery), 1851–1859. Changed name of gallery in 1857 to Gallery of Photographic Art. CD; RBD.

Moulton, H. D. W. Dag'typist. 349 Broadway, NYC, 1857. Extant dag'type, ca. 1850. Courtesy of Mary Sayer Hammond; CAS.

Moulton, J. C. Dag'typist, photographer. Practiced dag'typing and later photography in Fitchburg, Mass., 1853–1878. SBD; SV.

Moulton, J. W. Dag'typist, photographer. Practiced dag'typing, Salem, Mass., 1853. Took stereo views, ca. 1868–1878. SBD; SV.

Mowrey, F. Dag'typist. Gallery in Union Bldg., Main St., Rutland, Vt., 1855. SBD.

Mozart, J. M. Dag'typist. Gallery at 265 Washington St., Boston, 1851. BD.

N., J. Dag'typist. Adv., Portland, Me., July 16, 1841. Nsp, *Portland Advertiser*.

Naramore, William. Dag'typist. Gallery on State St., Bridgeport, Conn., 1849– 1855; 23 Main St. (Naramore & Lewis), 1856–1857. RBD; CD.

*Natt, Thomas J. & Son. Print seller, portrait painter, lithographer. 192 Chestnut St., Philadelphia, 1840. Sold Paris and Rome dag'type scenes in his shop, Dec. 1840. NYHS; nsp, *U.S. Gazette.*

Neel, John B. Dag'typist. Uniontown, Ohio, 1853. SBD.

Nelson, H. T. Dag'typist. Circleville, Ohio, 1853. SBD.

Nelson, J. Dag'typist. Gallery in Philo Hall, 3d St., Pittsburgh, Pa., 1854–1855. BD.

Newby, William H. Black dag'typist, newspaper editor. Born Va.; died 1859, San Francisco. Also lived in Philadelphia and Haiti. Calif., 1851. Date of dag'typing activities unknown. Editor of first black newspaper in Calif. Nsp, *San Francisco Pacific Appeal*, June 20, 1863; information courtesy of James de T. Abajian.

New York Gallery. Dag'typist. Operator unknown. Gallery at 4th St., Pittsburgh, Pa. Nsp.

Nichols, D. B. Dag'typist. Gallery entrance below Biddle House, Detroit, Mich., 1853. CD.

Nichols, John P. Dag'typist. Plumbe Daguerrian Gallery, 75 Court St., Boston, 1849–1852. BD; BN.

Nichols, Sheldon K. Dag'typist. Gallery at 188½ and 194½ Main St., Hartford, Conn. (Bartlett & Nichols), 1852; Hartford, 1853–1854. Exhibited at N.Y. Crystal Palace, 1853. BN; CD.

*Nicholson, John. Portrait and sign painter, dag'typist. Born July 12, 1825, Jefferson Co., Ind.; died 1893, Ind. Columbus, Ind., 1847; Franklin, Ind., 1850–1860. NYHS.

Nimmo & Co. Dag'typist (?), photographer. Probably T. J. Nimmo, agent for Whitehurst's gallery, Washington, D.C. Considered a first-class operator. Imprint on mat in dag'type case; PAJ, 1858, p. 98. Byerly and Nimmo became partners in the late 1860s and the 1870s and probably practiced photography in Tarboro, N.C. (from a *carte de visite*).

Noel, Clarence. Dag'typist. Columbus, Ohio, 1856. CD.

Noessel, George. Dag'typist. Gallery at 18 Royal St., New Orleans, 1846. *The East.*

North, Enrique. Dag'typist. American dag'typist in Buenos Aires, 1848. BN.

North, Walter C. Dag'typist, photographer. Born Oct. 31, 1831, Roundout, N.Y.; died Sept. 6, 1891, Kingston, N.Y. Resided in Wilbur, Ulster Co., N.Y., 1840. At age fifteen, worked in general store for two years. To Brooklyn, 1848, clerk in bookstore. Youngest member of choir (bass) in Henry Ward Beecher's church, where his uncle Horatio B. Abbey was leader and composer. Returned to Roundout, 1850, and worked as dag'typist in his uncle's gallery (William C. North). Fol-

lowed uncle to Cleveland, Ohio, where he opened a dag'type gallery, 1851–1853. Moved to Mansfield, Ohio, 1853, and opened own gallery. Remained until 1856, returned to Cleveland, and bought out uncle's gallery. In 1857 sold it back to him again. Sold Quaker City Sewing Machines until ca. 1860. Returned to Roundout, opened a photography studio. To Utica, N.Y., and went into partnership with the photographer Mr. Raymond, Dec. 24, 1861. In 1864 removed to Franklin Sq., Utica, and operated gallery until 1873. Traveled to Europe, 1867, to see Paris Exposition; became interested in retouched negatives. Learned retouching process and brought back specimens. Aroused interest and wrote at length on the subject, and many photographers came to him to learn the art. Member of the National Photographic Association of America and served on an executive committee. Awarded gold medal by the *Photographic Journal* in 1873 for the best set of negatives, and prints were published in the journal. Traveled in Ohio and other western states, 1874–1878, giving instructions to photographers. Also known for his talents in music, bass singer, organist. RT; SLP, 1877, 1891; OSU.

North, William C. Dag'typist, photographer. Gallery at 142 Washington St., Boston, 1849; Roundout, N.Y., 1848–1850. To Cleveland, Ohio, 1850, and bought out dag'type gallery of Tilton, Melodeon Bldg., Superior St. Took dag'type of "Hibernian Guards" in square fronting courthouse. Exhibited at N.Y. Crystal Palace, 1853, honorable mention. Photographed the North Star, 1855. Sold business to nephew, 1856, but bought it back in 1857. Introduced the melainotype to Cleveland, Apr. 1858. Listed at 205 Superior St., 1859. SBD, 1849; nsp, Cleveland, 1850; DJ; PAJ; SLP, 1891.

Norton & Carden. Dag'typists. Gallery at 369 Broadway, NYC, 1854. PAJ, 1854, p. 224.

Norton, E. F. Dag'typist. Cleveland, Ohio, 1845–1846. Adv. that he was from the U.S. Gallery, 175 Broadway, NYC. CD, 1845; nsp, Cleveland, 1846.

Norwood, Francis. Dag'typist. Scholarie Co., N.Y., 1843. Taught dag'typing to Levi L. Hill. Levi L. Hill, *Treatise on Heliochromy*, 1856.

Norwood, Z. Itinerant dag'typist. Date and location unknown. Sotheby-Parke-Bernet cat., 1967.

Nunn, R. J. Dag'typist, photographer. Practiced dag'typing, Savannah, Ga., gallery at Broughton St., 1858. Continued as photographer to ca. 1865. CD; nsp.

Nye, A. G. Dag'typist. Weymouth, Mass., 1853. SBD.

Orbeton, William S. Dag'typist. Gallery at 136 Hanover St., Boston, 1850. CD.

Ore, Caleb A. Dag'typist. Gallery at 532 Grand St., NYC, 1853–1854. BD.

Ormsbee, A. Dag'typist. Saco, Me., 1849, RBD.

Ormsbee, Marcus. Dag'typist, inventor, photographer. Opened rooms at 62 Milk St., Boston, 1842. Moved to Portland, Me., 144 Middle St., 1844–1851. Adv. in 1844 dag'type and case, $3.00; listed at 203 Washington St., Boston, 1852–1860. Bought out Holden's Gallery (formerly Morand's) at 411 Broadway, NYC, 1862. Became involved with Simon Wing in the development of the "multiplying" camera, ca. 1860. Also held patents for "Photographic Printing Frame" (38,326), Apr. 28, 1863; "Mounting Photographs" (39,166), July 7, 1863. CD; BD; nsp, *Portland Tribune*, July 31, 1844; BN.

Osborn, James M. Dag'typist. Adv. as Sun Daguerrian Sky Light Gallery, 156 Bowery, NYC, 1850; Osborn & Holt, 156 Bowery St., 1851. AA; BD.

Osborne, George W. Dag'typist. Gallery opposite Exchange Bank, Main St., Richmond, Va. 1855–1856. *See also* Roads, William. CD; PAJ, 1856, p. 217.

Osborn's First Premium Daguerreian Gallery. Dag'typist. Gallery located at 223 King St., Charleston, S.C., 1853. RBD.

Ostrander, John E. Dag'typist. Gallery at 103 N. 4th St., St. Louis, Mo., 1848. Missouri Historical Society.

Outley, John J. Dag'typist. Opened rooms at 138 and 140 N. 3d St., St. Louis, Mo., 1851–1856. Bought out Davis gallery, cor. 5th and Locust, 1857. Partnership (?) with Williams, 1857; listed at 138 N. 3d St., 1858–1860, ambrotypist. Missouri Historical Society; SBD.

Owens, N. Dag'typist. Goshen, N.Y., 1851. CD.

Page, A. Dag'typist. Gallery at 204 Broadway, NYC, 1841. Adv. portraits taken in a few seconds. Nsp, *N.Y. Herald Tribune*.

Page, Charles Grafton. Physicist, chemist, author, U.S. patent examiner, amateur dag'typist, authority on electricity. Born Jan. 25, 1812, Salem, Mass.; died May 5, 1868, Washington, D.C. Graduated Harvard, 1832; studied medicine, Boston. Moved to Va., 1838. Professor of chemistry, Columbian University, Washington, D.C., 1840. U.S. patent examiner, 1840–1868. Experiments to produce dag'types in color, 1842–1844. Developed electric machinery as a locomotive force. Believed to have been associated with Daniel Davis, Jr., in the manufacture of electrical machinery, ca. 1833–1838. FIJ, 1844; ACB; *Harper's Monthly Magazine*, 1850, p. 564; BN.

Page, Cyrus G. Dag'typist. Gallery on 8th Ave., cor. W. 14th St., NYC, 1851–1854; sold gallery to M. M. Lockwood, 1854. BD; *Citizen*, June 17, 1854.

Page, Mary E. Dag'typist. Gallery at 174

W. 14th St. NYC, 1853–1854. BD.

Paige, Blanchard P. Dag'typist. Gallery at Concert Hall, Pennsylvania Ave., Washington, D.C., operator for Plumbe's gallery, 1843; bought Plumbe's gallery, Washington, D.C., 1850–1856; "Root's Gallery," Washington, D.C., 1858. Columbia Historical Society; BN; PAJ, 1858, p. 98.

Paine, George P. Dag'typist. Gallery at 57 N. 4th St., St. Louis, Mo., 1854. BD.

Palmer, T. Adams. Dag'typist. Gallery at 252 Grand St., NYC, 1848. BD.

*Pardee (Parde), Phineas, Jr. Painter, dag'typist. Born ca. 1819, Conn. Began dag'typing, New Haven, Conn., 1842–1844. Tomlinson & Pardee, 15 Phoenix Bldg., 1845. Listed as an artist, Assembly House Hotel, 1850. NYHS; PWB; CD.

Park, Albert G. Dag'typist. Born Aug. 10, 1824, Newark N.J. Took lessons in dag'typing from C. Barnes, Mobile, Ala., 1844–1845; itinerant, Ala., 1845–? Worked for Mathew B. Brady, NYC, one year in 1840s; employed by George S. Cook, Charleston, S.C., in 1850s; King and Market St., Charleston, 1853–1854; employed in Memphis, Tenn., at F. H. Clark & Co., Park & Peplow, Sheldon Park, 1856–1857. PAJ, 1856, p. 59; nsp adv., Charleston, 1853; CD; BD; nsp, Memphis, 1857.

Park, Charles A. Dag'typist, photographer. Learned dag'typing from J. F. Ryder, ca. 1850, at Elyria, Ohio; 171 Superior St., Cleveland, Ohio, 1859. Continued as photographer in Cleveland. CD.

Parke & Bailey. Dag'typists. Gallery at 387 Market St., Philadelphia, 1854–1855. SBD.

*Parker, C. R. Portrait painter. Partner with Corduan, dag'typist from NYC, 55 Royal St., Mobile, Ala., 1844. Nsp adv., *Mobile Register & Journal*, Jan. 18–Mar. 23.

Parker, George F. Dag'typist. Worked at H. S. Brown's, Milwaukee, Wis., date unknown. Information courtesy of James de T. Abajian.

Parker, Joseph E. Amateur dag'typist. Philadelphia, 1839–1846. Displayed, at Franklin Institute, "varied collection of dag'type views taken by himself." Won certificate of honorable mention for display, 1840. Agent for E. White's plates, 1846. MAR; *U.S. Gazette*, Oct. 8, 1840; SA; RBD (*The East*).

Parker, Theodore. Dag'typist. Columbus, Ohio, 1856. CD.

Parker, T. M. Dag'typist. Burlington, Vt., 1849. RBD.

Parker, W. J. Dag'typist. Millerburg, Ohio, 1853. SBD.

Parkhurst, Otis J. Dag'typist. Milford, Mass., 1853. SBD.

Parks, George A. Dag'typist. Lockport, Ill., 1854. SBD.

Parsons, George F. Dag'typist. Gallery in S. Waverly Bldgs., Hartford, Conn., 1849. SBD.

Parsons, Seth E. Dag'typist, photographer. Practiced dag'typing, Albany, N.Y., 1853; gallery in Albany, 1868. CD; PP.

Partridge, A. C. Dag'typist. Gallery at 36 Munroe, between Market and Main St., Wheeling, W.Va., 1853–1854. SBD; PAJ, 1854.

Partridge, H. T. Dag'typist. Gallery at 63 Court St., Boston, 1851. BD.

Patterson, Mrs. A. Dag'typist. Quincy, Ill., 1854–1855. SBD.

Patterson, L. G. Dag'typist. Born 1819, N.Y. Practiced dag'typing, White Co., Tenn., 1850. USC.

Peabody, A. J. Dag'typist. Unity, Ohio, 1853. SBD.

Peabody, W. S. Dag'typist. Gallery N. of bridge, Main St., Nashua, N.H., 1853. CD.

Peal, Howard. Dag'typist. Born 1830, Philadelphia. Practiced dag'typing, Philadelphia, 1850. USC.

Peale, ———. Dag'typist. Gallery at 159 Chestnut St., Philadelphia, 1854–1855. SBD.

Pearson & Grove. Dag'typists. Gallery at 128 Merrimack St., Lowell, Mass., 1849. RBD.

Pearson, ———. *See* Ropes & Pearson.

Pearson, Charles H. Dag'typist. Lowell, Mass., 1859. CD.

*Pease, Alonzo. Portrait artist. Worked for W. C. North, 1857. NYHS; PAJ, 1857, p. 31.

*Pease, Benjamin F. Dag'typist, wood engraver, photographer. Born Nov. 17, 1822, Poughkeepsie, N.Y. Worked NYC, 1845–1846; Pease & Baker, 1846 (engravers). To Lima, Peru, 1852, where he practiced dag'typing. Residing in Peru in 1869. NYHS; *History of Photography: An International Quarterly,* Apr. 1979.

Peck, Samuel. *See* Case manufacturers and engravers.

Pennell, Joseph. Dag'typist, teacher. Graduated Bowdoin College, Me. Student and assistant of Morse, 1840. Partnership with A. S. Southworth, Cabotsville (Chicopee), Mass., 1840; to Boston with Southworth, 1841–1844, as partner. Traveled south as schoolteacher. Worked in Waterbury, Conn., for Scovill as a platemaker, 1845–1848. BN.

Pennington, John. Dag'typist. Dexter, Me., 1855. SBD.

Perkins, Elijah R. Dag'typist. Topsfield, Mass., 1853 to ca. 1855. DJ; OSU.

Perkins, J. S., Jr. Dag'typist. Newburyport, Mass., 1853. SBD.

Perkins, J. W. Dag'typist, photographer. Died Feb. 4, 1898, Kirkwood, Ga. Partnership with Leigh and Isaac Tucker, Augusta, Ga., 1850–1853; partnership with P. M. Cary, Savannah, Ga., 1854; partnership with Tucker, Augusta and Athens, Ga., 1856–1860; Atlanta, Ga., with Tucker 1865 or later (?). During the 1860–1870 era the firm of Tucker &

Perkins became famous for views of Georgia, particularly of Augusta and Atlanta. HJ, 1853, p. 137; *Wilson's Photographic Magazine,* 1898, p. 142.

Perkins, John W. Dag'typist. Perkins & Co., Baltimore, 1853; gallery at 217 W. Baltimore St., 1858–1860. CD.

Perkins, Palmer Lanfield. Dag'typist, photographer. Born 1824; died 1900, Baltimore. Practiced dag'typing in Baltimore, 1850–1852; N. St., 1853; 99 W. Baltimore St., 1857–1860. Won silver medal at Md. Institute Fair, 1857, for ambrotypes. Retired, 1890. PAJ, 1858, p. 12; APB, 1900, p. 391; CD.

Perry & Bro. Dag'typists. Gallery at 271 Broadway, NYC, 1846–1847; 267 King St., Charleston, S.C., winters of 1846, 1848. BD; nsp adv., Charleston.

*Perry, Edward H. Engraver, dag'typist. Exhibited wood engraving, American Institute, 1845. Danville, Vt., 1849; 139 Lake St., Chicago, 1854–1855; Lancaster, Erie Co., N.Y., 1857. Possibly Perry & Co., NYC, 1846–1847. RBD; CHS; CAS.

Perry, J. M. Dag'typist, photographer. Gallery opposite city hall, Main St., Nashua, N.H., 1856, CD.

Perry, William A. Dag'typist. Operator at Plumbe's gallery, Boston, 1843 (?); Macon, Ga., Nov.–Dec. 1846; Macon, Jan.–Mar. 1847; 115 Court St., Boston, 1847; 303 Broadway, NYC, 1851; 923 Broadway (operator for George S. Cook), 1851; Mobile, Ala., 1852; 257 Washington St., Boston (Davis & Perry), 1852. Operator for Gurney, 1853. *Photographic Art Journal* quoted him as "a man of genius," 1851, and "one of best dag'typists in U. S.," 1852. BD; DJ, 1851, p. 180; HJ, 1852, p. 32, 1853, p. 111; PAJ, 1851, pp. 124, 191, 1852, p. 258; nsp adv., Macon, Charleston, S.C.

Peter, Dr. Robert. Amateur dag'typist. Bought dag'typing equipment, Paris, summer of 1839, with Dr. James M. Bush of Transylvania College, Lexington, Ky. Took dag'type copy of the death mask of Talleyrand. RT; nsp, Lexington.

Peters, M. B. Dag'typist. Pittsfield, Mass., 1849. RBD.

Peters, Morris. Dag'typist. W. Chester, Pa., 1854–1855. BD.

Peters, Otis T. Dag'typist. Specialized in stereoscopic dag'type views (won honorable mention at N.Y. Crystal Palace, 1853). Dag'typist at 411 Broadway, NYC, 1849; 111 Broadway, 1850; 394 Broadway, 1850–1855. Adv., O. T. Peters Stereoscope Gallery, 1855. BD.

Pettee & Cathan. Dag'typists. Gallery at 113 Washington St., Boston, 1848–1850. BD.

Pettee, Joseph. *See* Pettee & Cathan.

Peyroux, C. B. Dag'typist. New Orleans, 1854. PAJ, 1854, p. 224.

Phelphs, C. D. Dag'typist. Belleville, Ohio, 1853. SBD.

Phelps, J. M. Dag'typist. Sandusky City, Ohio, 1853. SBD.

Phillippe, C. L. Dag'typist. Reading, Pa., 1854–1855. BD.

Phillips, Albert B. Dag'typist. Gallery at 87 S. 4th St., St. Louis, Mo., 1854–1858; 91 Franklin St., 1859–1860. SBD, Ill.

Phillips, L. J. Dag'typist. Unknown location in Calif. Information courtesy of Robert A. Weinstein.

Phipps, A. W. Dag'typist. Lexington, Ky., 1854. PAJ, 1854, p. 256.

Piard, Victor. Dag'typist, photographer. Washington, D.C., and NYC, operator for Anthony, Edwards & Co. and Anthony, Clark, & Co., 1842–1848; 201 Broadway, NYC, partnership with Alexander Beckers, 1849–1856. Worked with C. D. Fredericks, date unknown. Dag'types taken by him in NYC, in 1842 and 1843, were said to have had no superior. BD; BN; CD, Brooklyn, adv. 1855; PAJ, 1857, p. 376.

*Pierce, David. Portrait painter, dag'typist. Born 1820, Mass. Listed as dag'typist in Detroit, Mich., 1861. NYHS.

Pierce, William. Dag'typist, photographer. Practiced dag'typing in Brunswick, Me., 1853. Continued as photographer until ca. 1875. George A. Wheeler and Henry W. Wheeler, *History of Brunswick, Topsham, and Harpswell, Maine,* 1878.

Pierpont, James. Dag'typist. Born 1810, NYC. Practiced dag'typing, San Francisco, 1850–1851. Listed in 1870 census as clergyman. CD; information courtesy of James de T. Abajian.

Pike & Arbuckle. Dag'typists. Gallery at 4 Merchant's Row, Northampton, Mass., 1849. RBD.

Pinkham, Charles. Dag'typist. San Francisco, 1852. CD.

Place, Spence, Dag'typist. Kyte River, Ill., 1854. SBD.

Plant (Allen & Plant), ———. Dag'typist. Gallery at 131 Congress St., Savannah, Ga., 1845. Nsp adv.

Plitt, Angus. Dag'typist. Gallery at 145 N. 3d St., St. Louis, Mo., 1854–1860. Missouri Historical Society; SBD, Ill.

Plumbe, John, Jr. Dag'typist, surveyor, author, editor, publisher. Born 1809, Wales; died May 30, 1857, Dubuque, Iowa. Emigrated to U.S., 1821. Railroad surveyor, 1830s. Washington, D.C., 1840. Opened gallery in Dec. 1840 in Harrington Museum, Boston; 75 Court St., 1840–1847; 173 Chestnut St., Philadelphia, Dec. 1841–1847; Saratoga Springs, N.Y., 1842–1847; 251 Broadway, NYC, 1842–1847; 199 Baltimore St., Baltimore; Market St., Albany, N.Y., 1843–1847; Pennsylvania Ave., Washington, D.C.; 56 Canal St., New Orleans; Market St., St. Louis, Mo.; Main St., Dubuque, Iowa; Main St., Newport, R.I.; 33 Main St., Louisville, Ky., 1844–1847. 127 Vieille Rue du

Temple, Paris; 32 Church St., Liverpool, Eng.; 4th & Walnut St., Cincinnati, Ohio; Mechanic's Hall, Petersburg, Va.; Norfolk, Va.; Middle St., Portland, Me., 1845–1847. (Street addresses often vary in Plumbe's advertisements.) In 1847 Plumbe sold many of his galleries to his operators, and he withdrew from dag'typing by 1848. He also manufactured many items used in the art. He maintained a supply house in Boston, ca. 1841–1842; NYC, 1844–1847 (case manufactory). Over the 1841–1847 period he manufactured cameras, miniature cases, and possibly mats and dag'type plates. Bought patent rights for coloring dag'types from Daniel Davis, Jr., 1842; U.S. patent, improvement for galvanic battery (2,984), Mar. 4, 1843. Awarded eight medals from institute fairs in Mass., N.Y., Pa., and Ohio for most beautiful dag'types and best apparatus exhibited. In 1846–1847 turned to publishing to promote his galleries; issued *The National Plumbeotype Gallery* and the *Plumbeian*. Plumbe was probably the greatest promoter of photography, rivaled only later by George Eastman. Also a historical figure—envisioning a transcontinental railroad route to the Pacific, years before the influential Asa Whitney proposed a railroad to the Pacific, Plumbe had petitioned Congress in 1838 for a survey grant and, although ridiculed by its members, received $2,000 for his project. Again, in 1840, appeared before Congress for a railroad survey pushing west of the Mississippi, a petition not granted. In 1849 again turned to vision of transcontinental railroad and wrote several memorials to Congress in 1850 and 1851, which proved unsuccessful. Returned to Dubuque. On May 30, 1857, committed suicide. CD; BD; nsp advs.; BN; RT; SA; AI; FIJ; U.S. patent records; Columbia Historical Society Records, 1900.

Plumbe, Richard. Dag'typist. Brother of John Plumbe, Jr.; with Plumbe's gallery, 75 Court St., Boston, ca. 1844–1851; moved to Dubuque, Iowa, ca. 1852.

Pollock, Henry. Dag'typist, photographer. Gallery at 147 Lexington St., Baltimore, 1849–1850; 155 Baltimore St., 1851–1858. Employed Hugh O'Neil as operator, 1857. Continued as photograper, 1860s. SBD; CD; BD; PAJ, 1857, p. 202. PP.

Polock, L. H. Dag'typist. Traveled as itinerant in Mexico, 1840s. Information courtesy of Josephine Cobb.

Popkins, Benjamin F. Dag'typist, photographer. According to an adv., began dag'typing, 1844. Greenfield, Mass., 1853; partnership with John S. Woodbridge, 1856–1858, Columbus, Ga. SBD; nsp advs., Columbus.

Porter, Martin. Dag'typist. West Cornwall, Conn., 1849. RBD.

Porter, William Southgate. Dag'typist, photographer. Born 1822; died 1889. Practiced dag'typing, Philadelphia, 1840s (?); partnership with Charles H. Fontayne, Cincinnati, Ohio, 1848–1853; 4th and Vine, Cincinnati, 1858. Fontayne & Porter took an eight wholeplate panorama of the Cincinnati waterfront—considered one of the best dag'types ever produced. Exhibited panorama at Franklin Institute, 1848, and at Crystal Palace, London, 1851. CD; BN; FIJ.

Post & Willis. Dag'typists. Rochester, N.Y., 1851. CD.

Potter & Co. Dag'typist. Gallery at 130 Main St., Cincinnati, Ohio, 1850–1853. BD; CD.

Potter, F. Dag'typist. Milam, Ohio, 1853. SBD.

Potter, Mrs. F. Possibly the Mrs. Potter cited by the *Photographic Art Journal* in 1854, who managed the photographic dept. of Dobyns, Richardson & Co., NYC; Maquon, Ill., 1854–1855. SBD; PAJ, 1854, p. 64.

Poulsen, ———. Dag'typist. Adv. as dag'typist, Athens, Ga., 1842. Nsp. Athens, Feb. 18.

Powelson (Abraham) & Co. Dag'typist. Gallery at 177 Broadway, NYC, 1850–1851; 307 Broadway, 1858–1860. DJ; BD; CD.

Powers, E. M. Dag'typist. Gallery at 139 Main St., Richmond, Va., 1855; 51 Main St., 1858–1859. CD.

Pratt, D. C. Dag'typist, photographer. Practiced dag'typing, Downers Grove, Ill., 1854–1855. Took stereo views, Aurora, Ill., ca. 1868–1878. SBD; SV.

Pratt, E. W. Dag'typist. Operator for Plumbe prior to 1845. Gallery at 293 Broadway, NYC, 1845. SA.

Pratt, William A. Dag'typist, inventor. Born, 1818, Eng. Emigrated to U.S., 1832. Gallery at 130 Main St., Richmond, Va., 1844–1858. (Street number changes to 139 and 145 Main in late 1840s and 1850s.) Pratt constructed on the roof of his gallery, ca. 1849 or 1850, a Gothic-style skylight studio, adv. as "Virginia Sky-light Daguerrean Gallery at the gothic window." Exhibited at London Crystal Palace, 1851. Issued U.S. patent for coloring dag'types (4,423), Mar. 14, 1846. The gallery adv. in 1856 as being under the management of John Sanxay. Nsp advs.; CD; BD; BN; SA; PAJ, 1856, p. 217.

Prentice, William V. Dag'typist. Rooms in Feb. 1850 at St. Julian St. and Market Sq., Savannah, Ga.; Feb. 1851, Savannah; June–Jan 1852, Savannah; reopened rooms Feb. 1853 over Music Store, Savannah. Nsp adv.

Price, R. T. Dag'typist. Elizabethtown, N.J., 1850. SBD.

Proctor, Alfred N. Dag'typist, photographer. Ritchies Block, Boston, 1852–1855; 2 Lewis St., East Boston, 1856–1859; 2 Lewis St. as Proctor & Dodge, 1864. BD.

Prosch, Miss Charlotte. Dag'typist. Daughter or sister of George W. Prosch (?). Listed at 30 Walker St., NYC, 1845, as dressmaker. Listed as dag'typist at 235 Broadway, 1845–1846; 259 Broad St., Newark, N.J., 1848–1852. CD; DJ, 1850; BD, Newark.

Prosch, George W. *See* Manufacturers and wholesale suppliers.

Pruden, Henry. Itinerant dag'typist. Practiced dag'typing in Lockport, N.Y., 1853. BN.

*Prud'homme, John Francis Eugene. Engraver, dag'typist. Born Oct. 4, 1800, St. Thomas, West Indies; died 1892, District of Columbia. Elected associate of National Academy, 1838; academician, 1846. Listed as dag'typist at 663 Broadway, NYC, 1851. DJ; CD; NYHS.

Pryce, James. Dag'typist. Gallery at 181 Broadway, NYC, 1848. BD.

Quackenbush, D. F. Dag'typist. Gallery at S. 7th cor. 1st St., Brooklyn, 1856. CD.

Quail, John. Dag'typist, inventor. Practiced dag'typing in Philadelphia, 1848. Invented, 1848, and used in gallery for several years a "multiplying" camera whereby several impressions could be taken at one sitting. MAR, p. 369.

Queen City Daguerrian Rooms. Located in Walton Hall, Cincinnati, Ohio, 1851. BD.

Quimby, P. P., & Son. Dag'typists. Belfast, Me., 1855. SBD.

Rafferty & Leash. Hat manufacturers, dag'typists. Gallery at 57 Chatham St., NYC, 1852–1854. Adv. free dag'type inside hat with every hat sold. CD.

Rainetaux, Anthony. Dag'typist. Gallery at 107 Atlantic St., Brooklyn, 1859–1860. CD.

Ramsdell, John. Dag'typist. Gallery at 252 Broadway, NYC, 1851. BD.

Ran & Son. Dag'typists. Gallery on Market St., Philadelphia, 1856. PAJ, 1856, p. 126.

Randle, William G. Itinerant dag'typist. Learned dag'typing from F. R. Letellier. Henry Co., Tenn., 1852. *Tennessee Historical Magazine*, vol. 9, p. 195.

Rawson, Charles S. Dag'typist. Pa. and Milwaukee, Wis., 1853–?; Erie, Pa., 1857; Albany, N.Y. (?); 233 and 257 Fulton St., Brooklyn, 1859. CD, 1857; *History of King's Co., Brooklyn*, 1884.

Rea, Sampson. Dag'typist. National Daguerreian Gallery at 23d and 4th St., Cincinnati, Ohio, 1850. BD.

Read, George. Dag'typist. Philadelphia, 1842. BN.

Reed & Humphry. Dag'typists. Quincy, Ill., 1854–1855. SBD.

Reed, G. M. Dag'typist. NYC, 1854. BN.

Reed, James. Dag'typist. Peach Bluff, Ill., 1854. SBD.

Reed, M. V. Dag'typist. Gallery at 208 3d Ave., NYC, 1851. BD.

Reed, W. A. Dag'typist, photographer. Location when dag'typing unknown; listed at 78 Dauphin St., Mobile, Ala.,

1881. Sotheby-Parke-Bernet cat., 1967; CD.

Rees & Co. Dag'typist. Gallery at 289 Broadway, NYC, 1854; 389 Broadway, 1854; 385 Broadway, 1857. BD; BN.

Reeves, Nelson B. Dag'typist. Gallery at 237 Grand St., NYC, 1851–1853. BD.

*Rehn, Isaac. Dag'typist, ambrotyper, sign painter, lithographer. Came from York, Pa., worked as painter. Dag'typist in Philadelphia, ca. 1848– 1853; 126 Arch St., 1854–1858. Became part owner of the Cutting's patents (1854) and in 1855 or 1856 went with James A. Cutting to Iowa for brief trip. Exhibited at Franklin Institute, photolithography, 1858. BN; MAR; PP, 1868, p. 290; PAJ, 1856, p. 126, 1858, p. 347; NYHS.

Reid, A. Dag'typist. Location unknown, ca. 1853. OSU.

Reimer, Benjamin F. Dag'typist. Born 1826; died Nov. 1899. Gallery at 397 N. 2d St., Philadelphia, 1854–1856. Identified with antislavery movement. MAR; SBD; PAJ, 1856, p. 126; APB, 1899, p. 358.

Remington, Judge Charles H. Judge, dag'typist. Practiced dag'typing, Thomasville, Ga., 1854–1856. Married Ellen P. Sharp, daughter of a minister. Judge Remington was believed to have been the only professional dag'typist on the bench in U.S. PAJ, 1854, p. 96, 1856, p. 64.

Rest, John. Dag'typist. Gallery at 456 N. 2d St., Philadelphia, 1854–1856. SBD; PAJ, 1856, p. 126.

Retzer, ———. Dag'typist. Philadelphia, 1840–1841. MAR.

Reynolds, G. L. Dag'typist. Lexington, Va., 1851. SBD.

Rice & Heard. Dag'typists. Gallery at 32 Joy's Bldg., Boston, partnership with J. A. Heard, 1848–1849. BD.

Rice, L. C. Dag'typist. Gallery at 257 Washington St., Boston, 1849–1851. BD.

Rice, Samuel N. Dag'typist. Gallery at 180 Canal St., NYC, 1848; 194 Canal St., 1849–1853. BD.

Richard, P. Dag'typist. Fitchburg, Mass., 1853. SBD.

*Richards, Frederick De Bourg. Landscape painter, dag'typist, photographer, author, inventor. Born 1823, Del. Painter, NYC, 1844–1845; dag'typist, Philadelphia, 1848–1856 (?); gallery at 144 Chestnut St., 1853; 179 Chestnut St., 1854–1856. Exhibited paintings at the Pa. Academy, American Institute, American Art Union, National Academy. Developed a new-style stereoscope in 1852. Pioneered the *carte de visite* in America, 1857. Published book with salt prints from his trip to Europe, 1857; demonstrated photographic prints as a use by painters. Continued as a photographer in Philadelphia. On Friday, Feb. 22, 1861, took three different photographs of Abraham Lincoln—scenes of the flag raising at Independence Hall. To Paris in 1868, where he pursued landscape painting. USC; BN; NYHS; SBD, 1854, 1855; PAJ, 1856, p. 126; Charles Hamilton and Lloyd Ostendorf, *Lincoln in Photographs: An Album of Every Known Pose*, 1963. Information also courtesy of George R. Rinhart.

Richards, Landon. Dag'typist. Born 1824, Md. Practiced dag'typing, 1850. Probably brother and associate of Frederick De Bourg Richards. USC.

Richardson, Richard. Dag'typist. Port Byron, Ill., 1854; Vicksburg, Miss., operator for H. D. Gurney, 1860. SBD; CD.

Richardson, S. B. Dag'typist. Gallery opposite post office, Nashua, N.H., 1853; Main St., Nashua, 1856. CD.

Riddle, A. J. Dag'typist, photographer. Rooms over Mygatt's store, Columbus, Ga., Jan.–Feb. 1856; cor. Broad and Randolph, 1856; over Purples Jewelry Store, 1858; 69 Broad St., 1859. Nsp advs.

Rider, George W. Dag'typist. Providence, R.I., 1856; 258½ Washington St., Boston, 1859. CD; BD.

Ritten, E. D. Dag'typist. Danbury, Conn., 1851–1854. HJ, 1851; dated dag'type.

Rivers, T. L. Dag'typist. Jacksonville, Ill., 1854. SBD.

Roads, William. Dag'typist. Partner with George W. Osborne, Main St., Richmond, Va., 1855. CD.

Roberts, C. W. Dag'typist. Fairfield, Ill., 1854. SBD.

Roberts, H. M. Dag'typist. Took dag'type scenes in N.H. prior to 1855; Ludlow, Vt., 1856. BN.

Roberts, Jane E. Dag'typist. Gallery at 135 Bowery St., NYC, 1846–1847. BD.

Roberts, William S. Dag'typist, Gallery in State Bank Bldg., Hartford, Conn., 1850–1852; 156½ Main St., 1853–1854. CD.

*Robinson, Joseph C. Portrait painter, dag'typist. Listed as dag'typist, 170 Broadway, NYC, 1848; 38 W. 4th St., Cincinnati, Ohio, 1850; Foster Hall, 5th and Walnut Sts., 1851. NYHS; BD, NYC, 1848; CD.

*Rogers, C. T. Dag'typist, panoramic painter (?). Listed as dag'typist at 39½ 4th St., St. Louis, Mo., 1854. Possibly the same Rogers who painted the Mississippi River panorama for a production of *Uncle Tom's Cabin* at the National Theater, NYC, Mar. 1854. SBD, Ill.; NYHS.

Rogers, E. A. Dag'typist. Mayon (?), Ill., 1854. SBD.

Rogers (Rodgers), H. T. Dag'typist, photographer, author. Gallery at 13th St., New Haven, Conn., 1858–1859. Author of *Twenty-three Years under a Skylight or Life and Adventures of a Photographer* (Hartford, Conn.), 1872.

Root, C. S. Dag'typist. Gallery at S. E. cor. Baltimore and South St., Baltimore, 1849–1850. SBD.

*Root, Marcus A. Dag'typist, artist, teacher. Born 1811, Ohio; died 1888, Philadelphia. Studied painting with Thomas Sully, 1835. Listed as self-employed teacher of penmanship and drawing at 8th and Arch St., Philadelphia, 1840–1846. Learned dag'typing from Robert Cornelius, ca. 1843. Traveled to Mobile, Ala. (partnership with Bennet), 1844; New Orleans, 1844; St. Louis, Mo. (partnership with Samuel P. Miller), 1844. Bought Mayall's gallery, 140 Chestnut St., Philadelphia, 1846–1855; M. A. Root & Co. partnership here with George S. Cook, Dr. G. Langdell, operator, 1856. Gallery at 363 Broadway, NYC (with brother Samuel), 1849–1851; sold to brother, 1851. Made microscopic dag'types—of a flea, a fly's foot, and a fly's wing, 1851. Gallery on Pennsylvania Ave., near 7th St., Washington, D.C. (operator, John Clark), 1853–1857 (?). Exhibited at Franklin Institute, 1844, 1846–1849; American Institute, 1846–1851; Crystal Palace, London, 1851; N.Y. Crystal Palace, 1853, bronze medal. Pioneer in paper photography, beginning in 1850 produced crystallotypes (Whipple's patent). Also famous for his "Crayon" dag'types (Whipple's patented vignette style). Author of *Philosophical Theory and Practice of Penmanship*, 1842; *The Camera and the Pencil*, 1864. SBD; CD; BD; nsp; AI; SA; DJ, 1851, p. 212; PAJ; USC; Missouri Historical Society; MAR; BN; RT.

Root, Samuel. Dag'typist, photographer. Gallery at 363 Broadway, NYC (partnership with brother Marcus A.), 1849– 1851; 363 Broadway (own gallery), 1851–1857. Sold gallery to Thomas Faris, 1857; repossessed gallery, 1859. Moved to Dubuque, Iowa, 1857; continued as photographer, 1867–1878. Exhibited at American Institute, 1850, silver medal; gold medal, 1851; silver medal, 1852, for crayon dag'types. Experimented (with brother) in microphotography, 1850–1851. CD; BD; AI; SA; SV; PAJ; DJ.

Ropes, Joseph. Itinerant dag'typist. Adv., Portland, Me., July 1841, over the store of Vaill & Davis, Exchange St., for a few months. Nsp.

Ropes (Joseph) & Pearson. Itinerant dag'typists. Adv. in Saco, Me., Nov. 6– Dec. 24, 1841. Nsp advs. *Maine Democrat.*

Rose, Myron. Dag'typist. Gallery at cor. Cass and Jefferson Ave., Detroit, Mich., 1853. CD.

Rosenberg, C. Dag'typist. Louisville, Ky., 1855–1856. CD.

Ross & Attenborough. Dag'typists. Gallery at N.W. cor. 6th and W. Row, Cincinnati, Ohio, 1850; Ross & David, 244 W. 6th St., 1851. BD.

Ross, D. A. Dag'typist. Gallery at 244 W. 6th St., Cincinnati, Ohio, 1853. SBD.

Rostron & Bro. Dag'typists. Gallery at 195 Broadway, NYC, 1853. BD.

Roth, John. Dag'typist. Freehold, N.J., 1855. Nsp, *Monmouth Weekly Herald,* Oct. 3.

Rugg., G. S. Dag'typist. Location unknown, ca. 1854. Name imprinted inside miniature case.

Rulofson, William Herman. Dag'typist, photographer. Born 1826, eastern Me.; died 1878, San Francisco. Learned dag'typing from L. H. Hale & Co., Boston, ca. 1843–1844. Itinerant, U.S., Canada, abroad, and Newfoundland, 1845–1848; San Francisco, 1848; Sonora, Calif (partnership with H.S. Cameron), 1850–1851; Sonora, 1852–1862; San Francisco (partnership with Henry W. Bradley), 1863–1878. President of National Photographic Association, 1874. APB, 1874, pp. 357–359; PP, 1875, p. 9; CD; BN; other information courtesy of James de T. Abajian.

Rupp, P. H. Dag'typist. Gallery on 2d St., NYC, date unknown. Imprint on dag'type mat.

Rush, ———. Dag'typist. Gallery at 246 N. 2d St., Philadelphia, 1854–1855. SBD.

Ruth, J. Dag'typist. From Pa. Practiced dag'typing in Marysville, Calif., 1853; Marysville, 1856. Information courtesy of Josephine Cobb for 1853; James de T. Abajian for 1856.

*Ryder, J. F. (J. M.). Portrait painter, dag'typist, photographer. Born 1826; died 1904, Cleveland, Ohio. First listed as itinerant, 1847. Settled Cleveland, 1850; Superior and Bank St., 1855–1858; introduction of ambrotype in Cleveland, 1855. Artist, 1860. Helped introduce negative retouching in America from Germany, 1868. Fontayne in charge of photographic dept. of gallery, 1856. NYHS; BN; CAS; nsp, Cleveland, 1855; *Photographic Times,* 1904, p. 311.

Salem, Peter (T. L.). Dag'typist. Gallery at Howard and Court St., Boston, 1850–(?); Erie, Pa., 1857. BD; CD.

*Salisbury, C. B. Portrait painter, dag'typist. Practiced dag'typing, Albany, N.Y., 1853. NYHS; CD.

Sample, Miss A. Dag'typist. Virginia, Ill., 1854–1855. SBD.

Sampson, J. S. Dag'typist. Augusta, Me., 1849. RBD.

Sargent, Harrison E. Dag'typist. Lowell, Mass., 1855. CD.

Sawyer & Robbins. Dag'typists. Calais, Me., 1855. SBD.

Saxet, ———. Dag'typist. Tex., ca. 1854. SLP.

Saxton, Joseph. Mechanician, inventor, pioneer amateur dag'typist. Born Mar. 22, 1799, Huntingdon, Pa.; died Oct. 26, 1873, Washington, D.C. Curator, U.S. Mint, Philadelphia, 1837. Took view of high school, Philadelphia, Oct. 16, 1839. Made photoengraving plate, exhibited at Franklin Institute, 1840. Exhibited at Crystal Palace, London, 1851, gold medal for precision balance. Member American Philosophical Society; National Academy of Sciences; Franklin Institute. Distinguished member of Franklin Institute and central figure in development of the dag'type in Philadelphia, in the fall of 1839. ACB; BN; RT; MAR.

Sayre & Payne. Dag'typists. From NYC. Adv., Dec. 1843, rooms in Owens Bldg., Savannah, Ga. Nsp.

Scammon, F. Dag'typist. Chicago, 1850. CD.

Schenck, J. H. Dag'typist. Gallery at 460 Grand St., NYC, 1846. Exhibited three frames at American Institute, 1846. AI.

Schoonmaker (C. C.) & Morrison. Dag'typists. Bought out Meade Bros. gallery, Oct. 30, 1850, 2d floor, Exchange Bldg., Albany, N.Y. Partnership, 1850–1852; over post office, 1853–1854 (Schoonmaker); Albany and 283 River St., Troy, N.Y. (Schoonmaker only), 1855–1860; Troy and Albany (Schoonmaker only), 1868. One of the first studios to use Anthony's patented "Magic Background," 1850. CD; HJ; nsp, 1850; PP, 1868.

Schreiber, Franz. Dag'typist, photographer. Died 1893, Philadelphia. Learned art from Langenheim Bros., Philadelphia, 1850–? Philadelphia (Schreiber & Son), 1868–1878. Noted for his photographs of animals. MAR; PP; SV; *Mosaics,* 1893, p. 96.

Scripture, J. C. Dag'typist. Richfield, Ohio, 1850; Erie, Pa., 1857. James F. Ryder, *Voightländer and I in Pursuit of Shadow Catching* (1902), p. 86; CD.

Seager, D. W. Dag'typist. Born Northampton, Eng. Insurance business (Insurance Life & Trust Co.), Wall St., NYC, 1839–1840. Dag'typing self-taught presumably after arrival of *Great Western,* Sept. 10, 1839. First dag'type in America, scene displayed Sept. 27; gave public lectures Oct. 5, Stuyvesant Institute; Oct. 10, Clinton Hall. Pupil of F. Gouraud in NYC, Dec. 5–Jan. 18, 1840. Wrote insulting letter (published in newspaper) to Gouraud, Jan. 18; insulting reply (published in newspaper) by Gouraud, Jan. 22. Seager opened studio room, Tammany Hall, Jan. 21. Published, Mar. 1840, rules for exposure time in the *American Repertory of Arts, Sciences, and Manufactures.* Nsp; CD; RT; BN.

Seaver, C., Jr. Dag'typist, photographer. Gallery at 140 Washington St., Boston, partnership with Butler, 1854–1856; 24 Tremont Row, 1864. Traveled in New England, South, and West, 1868–1878, taking stereo views, BD; SV.

Seeley, Alfred. Dag'typist. Gallery at 156 Fulton St., NYC, 1846; partnership, Apr. 1846, Rogers & Seeley. BD; SA.

*Seibert (Siebert), Selmar Rush. Copper engraver, mapmaker, dag'typist, photographer. Born Sept. 4, 1808, Lehnin, Prussia. To Philadelphia, ca. 1839. Prepared dag'type plates, winter of 1839 and 1840. Left for Washington, D.C., Jan. 1841. Dag'typist during the 1840s, exact dates unknown; photographer, U.S. Corps of Engineers, 1865; took views of war damage in Charleston, S.C. Mapmaker, 1860s; *Stranger's Guide for Washington City.* NYHS; Samuel C. Busey, "Early History of Daguerreotypy in the City of Washington," *Records of the Columbia Historical Society,* vol. 3, pp. 81–95; Josephine Cobb, *Mathew B. Brady's Photographic Gallery in Washington,* 1955.

Seixas, ———. Dag'typist. Gave instructions in dag'typing, Mar. 1840, at American Hotel, Washington, D.C. Nsp.

Selkirk, J. H. & J. Dag'typists. Matagorda, Tex., 1852. HJ.

Senter, E. Price. Dag'typist, photographer. Practiced dag'typing, Auburn, N.Y., 1853–1859. Photographer and ambrotypist, 1859. HHS, p. 57; PAJ, 1854, p. 128; CD, 1859.

Shankland, Mrs. H. Dag'typist. Operator for F. A. Artault at the Lafayette Bazaar, 149 and 151 Broadway, NYC, 1846. *The East.*

Shannon, Mrs. Julia. Dag'typist, midwife. Practiced dag'typing in San Francisco, 1850, cor. Clay and Dupont St. Listed only as midwife, 1852. Information courtesy of Robert A. Weinstein.

Shaw, E. Dag'typist. Gallery at 359 Broadway, NYC, 1849–1850. BD.

Shepherd, N. H. Dag'typist. Springfield, Ill., 1846. Took dag'type of Abraham Lincoln, 1846. Charles Hamilton and Lloyd Ostendorf, *Lincoln in Photographs: An Album of Every Known Pose,* 1963.

Sherrill, H. F. Dag'typist. Columbus, Miss., 1854. HHS.

Shew, F. B. Dag'typist. Bath, Me., 1849. RBD; CD.

Shew, Jacob. Dag'typist, jobber, photographer. Died 1879, San Francisco. Baltimore, 1841; 117 Baltimore St., 1847–1853; bought Van Loan's gallery, Chestnut St., Philadelphia, 1851 (with brother Myron). To San Francisco, 1854–1862; partnership with C. F. Hamilton, 1863–1878. Brother of Myron, Trueman, and William Shew. CD; BN; DJ.

Shew, Myron. Dag'typist, jobber, photographer, inventor. Born 1824, near Watertown, N.Y.; died 1891, San Francisco. Studied dag'typing under Morse, ca. 1840. With brothers Jacob, Trueman, and William built first dag'type gallery in Ogdensburg, N.Y. Associated with brothers in making dag'type cases in Boston. Gallery at 11½ Tremont Row, Boston, 1844–1849; dag'typist, Philadelphia, 1850; 116 Chestnut St., 1850; purchased Van Loan's gallery at 118 Chestnut St., 1851 (with brother Jacob); continued to be

listed at 118 Chestnut through 1855. Invented magnifying dag'type case, 1855. Dealer in dag'type and photographic goods and morocco case manufacturer at same address, 1856–1857. Sold gallery to J. Hill, ca. 1859. Joined brother William, San Francisco, 1856, where he continued as dag'typist and photographer. DJ, 1851, p. 19; BN; USC; CD; BD; HJ, 1859; *California Historical Quarterly*, 1977, pp. 2–19.

Shew, Trueman. Dag'typist. Gallery at 173 Chestnut St., Philadelphia, agent for J. Plumbe, 1841–1844; 116 Chestnut St., agent for J. Plumbe, 1845–1848. Myron Shew (brother) assumed the gallery in 1850 at 116 Chestnut St. MAR; CD; BD; BN.

Shew, William. Dag'typist, casemaker, photographer. Born near Watertown, N.Y.; died Feb. 5, 1903, San Francisco. Studied dag'typing under Morse. Superintendent of Plumbe's gallery, Boston, 1841. Miniature casemaker, 1844–1849. Opened his own gallery, Boston, 1845–1850. Sold gallery to John Sawyer, 1851. Early 1851, left Boston aboard *S. S. Tennessee* for Calif. Sent studio wagon around Cape Horn by boat, while he traveled across country by way of the Isthmus of Panama. Settled in San Francisco and at first used portable wagon about the city. Partnership, Hamilton & Shew, 163 Clay St., 1855–1856; 113 Montgomery St., 1857; gallery continued in San Francisco through 1903, and he continued to work until a few months before his death. CD; BD; BN; PAJ, 1857, p. 112; *California Historical Quarterly*, 1977, pp. 2–19.

Shewell, E. Dag'typist. Gallery at cor. 5th and Western Row, Cincinnati, Ohio, ca. 1848; S.W. cor. Walnut and 5th St., 1853; Portsmouth, Ohio, 1853. SBD; OSU.

Short, J. P. Dag'typist. Winnsboro, S.C., 1851. RBD.

Short, Mrs. S. P. Dag'typist. Gallery in Miller's Block, Cleveland, Ohio, 1853; Superior St., 1854; studied under Cook and Root for ambrotypes; 244 Superior St., Cleveland, 1855–1859. SBD; nsp, Cleveland, 1855; BD.

Shumway, E. G. Dag'typist. Amherst, Mass., 1853. SBD.

Shute, Peter. Dag'typist. Gallery at 130 Grand St., Brooklyn, 1856–1860. CD.

Silsbee, George M. Dag'typist. Died early 1866, Boston. 163 Middle St., Portland, Me., 1850–1851; Ormsbee (Marcus) & Silsbee, 203 Washington St., Boston, 1852; also listing appears as Masury (Samuel) & Silsbee, 299½ Washington St., 1852–1856; Masury, Silsbee, & Case, 1856–?; Silsbee, Case & Co. (G. M. Silsbee, J. C. Case, & Wm. H. Getchell), 1859. Masury & Silsbee exhibited at N.Y. Crystal Palace, 1853. CD; BD; PP, 1866, p. 153.

Silvester, Albert H. Dag'typist. Gallery, Lowell, Mass., 1853. CD.

Simmons & Anno. Dag'typists. Laurel, Ohio, 1853. SBD.

Simmons & Wolcott. Dag'typists. Gallery at 199 W. Baltimore St., Baltimore, 1845. CD.

Simmons, J. F. Dag'typist. Milford, Mass., 1853. CD.

Simons, Montgomery P. Dag'typist, miniature casemaker, author. Born 1817, Pa., died Feb. 28, 1877, Philadelphia. Merchant, Philadelphia, 1841; gas fitter, 173 Chestnut St., 1842. Opened an account for photographic supplies with Scovill Co. (Waterbury, Conn.), 1842. Miniature casemaker, same address, 1843. Assigned U.S. patent (3,085), May 12, 1843, from Warren Thompson, for coloring dag'types. Miniature casemaker, 100 Chestnut St., 1844–1848. Listed as dag'typist only after 1848 at 179 Chestnut St. To Richmond, Va., 1853; 151 Main St., 1855. Returned to Philadelphia, 1856. Continued as photographer until death. Left one of the largest private collections of photographs of distinguished personages in the country. His wife resumed operation of the studio, 1320 Chestnut St. Author of *Plain Instructions for Coloring Photographs*, 1857; *Photography in a Nut Shell*, 1858; *Secrets of Ivorytyping Revealed*, 1860. CD; BN; USC; PAJ, 1853, p. 33, 1856, pp. 217, 285; APB, 1877, p. 93; OSU.

Simons & Morse. Dag'typists. Gallery on Chestnut St., below 10th, Philadelphia, 1857. Montgomery Simons, *Plain Instructions for Coloring Photographs*, 1857.

Simpson, Andrew J. Dag'typist. Gallery at 28 Merrimack St., Lowell, Mass., 1849–1854 (?); Wyman's Exchange, 1855. RBD; CD.

Simpson, C. W. Dag'typist. Gallery at post office, Cleveland, Ohio, 1852–1853. CD.

Simpson, John. Dag'typist. Charleston, Ill., 1854–1855. SBD.

Sissons, N. (Noel) E. Dag'typist. Gallery at 496 Broadway, Albany, N.Y., 1850–1853. DJ; CD.

Skillin, Hiram. Dag'typist. Gardiner, Me., 1855. SBD.

Slack, J. N. Dag'typist. Rossville, Ohio, 1853. SBD.

Sluttery, B. E. Dag'typist. Warsaw, Ill., 1854–1855. SBD.

Sluttery, William. Dag'typist. Warsaw, Ill., 1854–1855. SBD.

Smiley, G. S. Dag'typist. Brunswick, Me., 1854. George A. Wheeler and Henry W. Wheeler, *History of Brunswick, Topsham, and Harpswell, Maine*, 1878.

Smiley, Thomas L. Amateur dag'typist (?). Philadelphia, 1840. Pupil of Morse. Carleton Mabee, *The American Leonardo: A Life of Samuel F. B. Morse*, 1943, p. 243.

Smith & Longman. Dag'typists. Gallery at 233 King St., Charleston, S.C., 1851. Nsp.

Smith & Morrison. Dag'typists. Portland, Me., 1855. SBD.

Smith, A. Dag'typist. Oquawka, Ill., 1854–1855. SBD.

Smith, Mrs. Alice. Dag'typist. Junction, Ill., 1854–1855. SBD.

Smith, Andrew. Dag'typist. Gallery at 337 N. 2d St., Philadelphia, 1854–1856. SBD; PAJ, 1856, p. 126.

*Smith, Benjamin Franklin, Jr. Lithographer, businessman, dag'typist, photographer. Born 1830, South Freedom, Me.; died Mar. 16, 1927. From 1848–1857, print-publishing business, Boston and NYC, with brothers, George Warren, Francis, and David Clifford Smith. The firms issued a large number of views of American cities. Gallery (alone), Portland, Me., 1857. A photographic association was organized in Portland in 1858, and B. F. Smith was chosen president; the Portland Photographic Association included all dag'typists and proprietors of galleries in the city. Smith and his brothers went west, ca. 1858, and invested heavily in real estate; interested in mining operations in Colo. in the 1860s. Organized South Omaha Stock Yards Co., 1882, which became the largest in the world. Returned to Me., 1880s. NYHS; I. N. Stokes and D. C. Haskell, *American Historical Prints*, 1933; OSU (example, dag'type signed with engraver's tool); BD; CD.

Smith, David. Dag'typist. Enfield, Mass., 1853. SBD.

Smith, E. A. Dag'typist. Gallery at State cor. Washington St., Boston, 1842. BD.

Smith, Elias. Dag'typist. Farmington, Ill., 1854–1855. SBD.

Smith, G. S. Dag'typist. Auburn, N.Y., ca. 1848. Imprint on dag'type mat.

Smith, Hamilton Lanphere. Educator, scientist, chemist, inventor, amateur dag'typist, author. Born Nov. 5, 1819, New London, Conn. Experimented with dag'typing, Cleveland, Ohio, 1840. Experimented with glass negatives, 1850–1855. Patented the melainotype (tintype) process (14,300), 1856. While a student at Yale, in 1839, he (and E. P. Mason) made the largest telescope in the U.S. Professor of natural philosophy and astronomy, Kenyon College, Gambier, Ohio, 1853–1868. Published a number of scientific papers, 1844–1887. ACB; BN; *American Journal of Science and Arts*, 1839–1840, p. 139; *Annals of Science*, 1853, p. 174.

Smith, John B. Dag'typist. Gallery at 228 Washington St., Boston, 1847. BD.

Smith, L. C. Dag'typist. Sharon, Vt., 1843. BN.

Smith, Matthew K. Printer, dag'typist. From Canada. Arrived Portland, Oreg., aboard mail steamship *Carolina*, July 15, 1850. Opened dag'type gallery in Dr. Baker's New Bldg., Mar.

21, 1851–May 17, 1851, when adv. notes that he will close "Monday next." Editor of *Weekly Argus*, Honolulu, Hawaii, 1852; editor (briefly) of *The Oregonian*, July 13–Nov. 26 (?), 1853. Member of Eureka Typographical Union No. 21, San Francisco, as late as 1861, although it is not known if he resided in San Francisco at this time. Information courtesy of Allan Miller and James de T. Abajian.

Smith, Michael. Dag'typist. Shelbyville, Ill., 1854–1855. SBD.

Smith, Morris. Dag'typist. Born 1808, Mass. Gallery at 110 Union St., New Bedford, Mass., 1849–1853. RBD; CD; SBD; USC.

Smith, S. R. Dag'typist. Rooms at the court house, Sandersville, Ga., 1855. Nsp, Jan., Feb.

Smith, Washington G. Dag'typist, photographer. Practiced dag'typing, Cooperstown, N.Y., 1850–? Produced stereo views, 1868–1878. *American Heritage*, Dec. 1958; SV.

Snell, William. Dag'typist. Newburyport, Mass., 1848–1851. Left, 1851; Salem, Mass., 1853. CD; SBD.

Somes, A. Dag'typist. Schenectady, N.Y., date unknown. OSU.

Southworth, Albert Sands. Dag'typist, inventor, photographer. Born 1811, Fairlee, Vt.; died 1894, Charleston, Mass. Learned dag'typing from Morse, NYC, with friend Joseph Pennell, 1840. Cabotsville (Chicopee), Mass., partnership with Pennell, 1840–1844; 60½ Court St., Boston (A. S. Southworth & Co.), 1841–1842; 5½ Tremont Row (number changes to 19 Tremont Row in 1845), partnership with J. J. Hawes, Southworth & Hawes, 1845–1861; Boston, A. S. Southworth & Co., 1861–1894. Exhibited at American Institute, 1841, 1846; Mass. Charitable Association, 1842, 1847. U.S. patents: plate-polishing apparatus" (4,573), June 13, 1846; stereoscopic camera apparatus (11,304), July 11, 1854; sliding plate holder (12,700), Apr. 10, 1855; stereoscope (13,106), June 19, 1855. The sliding plate holder (12,700) was declared invalid in 1876 after years of controversy. With the exception of the plate holder, all patents were recorded jointly with Hawes. Began experimenting with stereo dag'types, 1846, and in 1850s extended experiments to include "multiplying" cameras. Made successful dag'type of an eclipse, 1846. Experimented with photoengraving in 1840s. Completed largest parlor stereoscope (twelve whole-plate dag'types), 1853. Experimented with softening prints, 1855. Displayed great variety of photoautographs, 1869. Member National Photographic Association; delivered address, 1871. Made trip to Calif., 1849–1851. SBD; CD; BD; nsp advs.; PP; BN; DJ; AI; APB, 1871, pp. 343–347.

Southworth, B. F. Dag'typist. Defiance,

Ohio, 1853. SBD.

Speer, Alfred. Dag'typist. Newark, N.J., 1842. SA, Oct. 4, 1856.

Spooner, William J. Dag'typist. New Bedford, Mass., 1849. CD.

Stamm & Upman. Dag'typists. Milwaukee, Wis., 1851. DJ.

*Stancliff, J. W. Marine painter, engraver, dag'typist. Born 1814, Chatham, Conn. Trained as carriage painter and copperplate engraver. Studied painting with Alexander H. Emmons and Jared B. Flagg; also watercolor painting with Benjamin H. Coe. Dag'typist, cor. Main & Pearl St., Hartford, Conn., 1849; Lousiville, Ky., 1851. Helped B. Silliman, Jr., in experiments with galvanic light at laboratory of University of Louisville, 1850. President, Conn. School of Design, 1878. CD; NYHS; Jean Lipman, *American Primitive Painting*, 1942; *American Journal of Science and Arts*, May 1851, p. 417.

* Stanley, John Mix. Portrait and landscape painter, dag'typist. Born Jan. 17, 1814, Canandaigua, N.Y.; died Apr. 10, 1872, Detroit, Mich. Orphaned in 1828 and apprenticed to coach maker. Itinerant artist, 1835–1839, Detroit, Ft. Snelling, Galena, and Chicago. Specialized in scenes of Indian life in the West. Pupil of James Bowman (painting). Dag'typist, Fay & Stanley, Washington, D.C., 1842. Indian country with Sumner Dickerman, of Troy, N.Y., Ft. Gibson, Arkansas Territory, fall of 1842; set up studio for taking Indian portraits in both "the pencil and Daguerreotype apparatus," 1842. Cincinnati, Ohio, 1845; exhibited Indian paintings, 1846. Wagon train for Santa Fe, N.Mex., artist of Kearny's military expedition, 1846–1847; Oreg., 1847; Hawaiian Islands, 1848–1849. Exhibited Indian paintings in several cities and deposited paintings at Smithsonian, 1852 (possibly lost in fire, 1865). Expedition with Isaac I. Stevens to explore transcontinental railroad route, as artist and dag'typist, 1853. Resided in Washington, D.C., 1854–1864 (?). NYHS; Robert Taft, *Artists and Illustrators of the Old West*, 1953, pp. 5–21; BN; RT; Peggy Samuels and Harold Samuels, *The Illustrated Geographical Encyclopedia of Artists of the American West*, 1976; nsp, *Maine Democrat* and Washington, D.C., 1842.

Stanley, John T. Dag'typist. NYC, 1844. CD.

Stansburg, B. (Stanberry, J.). Dag'typist. Brooklyn, 1844 or 1845, near Fulton Ferry; 43 Fulton St., 1847; Brooklyn, 1851. CD; *History of Kings Co.*, 1884.

Stanton, John F. Dag'typist, photographer. Gallery at 44½ Dauphin St., Mobile, Ala., 1854–1857; 47 Dauphin St., 1858; 49 Dauphin St., 1869–1870. CD.

Starkweather, J. B. Dag'typist. Gallery on Bacon Block, 79 Washington St., Roxbury, Mass., 1850. Bought out

Lancy & Co., May 1850. 631 Washington St., Boston, 1854–1856; 268 Washington St., 1859. CD; BD.

Starr, Thomas N. Dag'typist. Richmond, Va., Dec. 7, 1841 (partner with J. M. Edwards). Claimed to be pupil of Morse; gallery at cor. Montgomery St. and Calif. St., San Francisco, 1855–1856. Nsp, Richmond, 1841; CD.

Starr, T. N. Dag'typist. Gallery at 233 Broadway, NYC, 1841. Adv., Oct. 26, 1841, "a few seconds necessary." Nsp, *N.Y. Tribune*.

Starrett, A. Itinerant dag'typist. Adv., Greensboro, N.C., Aug. 19–26, 1848. Nsp.

Stearn (Stern), ———. Dag'typist. Partner with McIver, Jonesboro, Tenn., 1846. Nsp adv., *Old Hickory*, June 6.

Steck (S.?), ———. Dag'typist. Gallery at 298 Market St., Philadelphia, 1854–1856. SBD; PAJ, 1856, p. 126.

Steeb, ———. Dag'typist. San Francisco, 1852. Information courtesy of James de T. Abajian.

Steffens, J. Dag'typist. Chicago, 1890s. Built skylight dag'type studio and reused old plates. Had dag'type collection of 22,000 pieces. APB, 1895, p. 369.

Stevens, Ephraim. Dag'typist. Gallery at 3 Potters Block, Manchester, N.H., 1849. RBD.

Stevens, John. Dag'typist. Winslow, Ill., 1854. SBD.

Stevens, J. W. Dag'typist. Craftsbury, Vt., 1849. RBD.

Stevenson, John G. Itinerant dag'typist. Rooms at Mrs. Cummings', Pennsylvania Ave., Washington, D.C., June–Sept. 1840. Baltimore (?), 1840; worked for Wolcott and Johnson, Washington, D.C., 1840. Nsp. *National Intelligencer*, June 29–Sept. 22; RT; Columbia Historical Society.

Stewart, ———. Dag'typist. Mt. Vernon, Ohio, 1853. SBD.

Stewart, Alvin. Dag'typist. Born 1824, Va. Practiced dag'typing, Greenville, Tenn., 1850. USC.

Stewart, William B. Dag'typist. Naperville, Ill., 1854–1855. SBD.

Stiles, E. G. Dag'typist. Gallery at 139 Lake St., Chicago, 1853–1857; partner with Hurlburt, 1857. CHS; SBD.

Stimson, John. Dag'typist. Gallery at 58 Hanover St., Boston, 1852–1853; 131 Hanover St., 1854–1855; 593 Washington St., 1864 (Stimpson). BD.

Stinson, John C. Dag'typist. Gallery at 207 N. 6th St., Philadelphia, 1854–1855. SBD.

*Stock, Joseph W. Portrait and landscape painter, associate dag'typist. Born Jan. 30, 1815, Springfield, Mass.; died June 28, 1855, Springfield. Began painting, ca. 1832; nine hundred portraits, 1842–1845. Associated with dag'typist 1840–1855, Springfield. NYHS; E. P. Richardson, *Painting in America*, 1956, p. 208; Jean Lipman, *American Primitive Painting*, 1942.

Stokes, Edward H. Dag'typist. Gallery at 114 E. State St., Trenton, N.J., and 37 E. State St., ca. 1854; 37 E. State St., 1857. CD.

Stone, G. W. Dag'typist. Gallery at 113 Washington St., Boston, 1850–1851. BD.

Stone, J. Dag'typist. Gallery at 34 Tremont Row, Boston, 1851–1852; 22 Hanover St., 1853; 28 Hanover St., 1854; 94 Hanover St., 1855. BD.

Strafford, ———. Dag'typist. Ca. 1850, location unknown. OSU.

Stroud, William. Dag'typist. Norristown, Pa., 1854–1855. CD; OSU.

Stuber, Daniel. Dag'typist. Gallery at cor. Market & Preston St., Louisville, Ky., 1855–1860. CD.

Sumner, W. A. Dag'typist. Gallery, Grand Detour, Ill., 1854. SBD.

Sutton & Bro. (Moses & N. M.). Dag'typists, photographers. Gallery at 209 (N. side) Jefferson Ave., between Bates & Randolph St., Detroit, Mich., 1853; Fireman's Hall, 1853; Detroit, 1854–1855; listed as Moses Sutton, 1856–1858. Entered photographic business of crystallotypes, 1854. Detroit, 1868–1869. Noted for dag'type views. Took views for the Saut Canal Co., for purpose of displaying them before the legislature to show the progress of the work, 1854. CD; PAJ, 1854, p. 320, 1855, p. 95; HJ, 1854, pp. 265, 266; PP, 1868.

Swasey & Chapin (M. S.). Dag'typists. Gallery at 6 Exchange St., Chicopee, Mass., 1849. RBD.

Swift, Charles. Dag'typist, photographer. Gallery at 247 Washington St., Boston, 1852–1856; Broadway near B St., 1864. BD.

Swift, H. B. Dag'typist. Gallery at 312 Market St., Philadelphia, 1851–1853; Swift & Mahan, 312 Market St., 1854–1855. Exhibited at Franklin Institute, 1852. HJ, 1852, p. 238; SBD.

Swift, Ripley R. Dag'typist. Chicopee, Mass., 1849–1853. RBD; SBD.

Sylla, James. Dag'typist. Galesburg, Ill., 1854–1855. SBD.

Sylvia, Joseph T. Dag'typist. New Bedford, Mass., 1852. CD.

Taber, Isaiah (Isaac) W. Dag'typist, photographer. Born 1830, New Bedford, Mass. New Bedford, 1854; Syracuse, N.Y., 1855 (?); San Francisco, 1864. RT; Ralph W. Andrews, *Picture Gallery Pioneers*, 1964.

Taber, James H. Dag'typist. New Bedford, Mass., 1852. CD.

Taber, Lemuel W. (?). Dag'typist. Born 1824. Practiced dag'typing, Fairhaven (Bristol), Mass., 1850; New Bedford, Mass., 1852. Information courtesy of James de T. Abajian.

Talbot, J. W. Dag'typist. Petersborough, N.H., date unknown. BN.

Tallet, G. R. Dag'typist. Thousand Islands (?). Mat of dag'type scene.

Tanner's Daguerrean Gallery. Gallery at

315 Broadway, NYC, 1853. Bought out Thompson's gallery. *See also* Thompson, Josiah W. *Illustrated News*, Sept. 24.

Taylor, Charles. Dag'typist. From Charleston, S.C., pupil of Morse, 1841. Wrote Morse he could not pay for lessons because he had failed as a professional. Carleton Mabee, *The American Leonardo: A Life of Samuel F. B. Morse*, 1943, p. 243.

Taylor, George F. Dag'typist. Gallery at 98 Broadway, Boston, 1850–1851. BD.

Taylor, J. H. Dag'typist. Springfield, Ill., 1854. Information courtesy of James de T. Abajian.

Teats, John C. Dag'typist. Lyndon, Ill., 1854. SBD.

Terry, ———. Dag'typist. Gallery at 23d and 4th St., Cincinnati, Ohio, 1848–1849. CD.

Terry, Arthur. Dag'typist. From New York. Practiced dag'typing in Lima, Peru, 1848–1852. *History of Photography: An International Quarterly*, Apr. 1979, pp. 112, 119–121.

Terwilliger, Hiram Y. Dag'typist. Gallery at 315 Broadway, NYC, 1853–1854. BD; OSU.

Thacker, L. P. Dag'typist. Middlebough (?), N.H., 1853. CD.

Thayer, Charles. Dag'typist. Gallery at 115 Court St., Boston, 1849–1850; Charlestown, Mass., 1853; 111 Main St., 1856. Sold gallery to Emilus J. Randall, 1856 (?). BD; CD; OSU.

Thayer, J. Dag'typist. Gallery at 1 Chelsea St., Charlestown, Mass., 1849. RBD.

Thayer, N. C. Dag'typist. Gallery at 75 Lake St., Chicago, 1854–1855. SBD.

Thomas, Alexander S. Black dag'typist, photographer. Spent early youth in New Orleans in lucrative trade of "steamboating." Associated with James P. Ball, dag'typist, Cincinnati, Ohio, 1852. Married Elizabeth Ball, sister of J. P. Ball. Listed Ball & Thomas, 120 W. 4th St., Cincinnati, 1854–1858. Sidelight: in black high society in Cincinnati. *See also* Ball, James P. SBD, 1852; *Southern Pictorial Advertiser*, 1858; Wendell P. Dabney, *Cincinnati's Colored Citizens*, 1926; information also furnished by Romare H. Bearden and James de T. Abajian.

Thomas, Mrs. Nancy. Dag'typist. Kenton, Ohio, 1853. SBD.

Thomas, R. Dag'typist. New Boston, Ill., 1854. SBD.

Thomas, William H. Dag'typist. Born 1810, N.C. Practiced dag'typing, Columbia, Tenn., 1848–1850. Nsp; USC.

Thompson & Davis. Dag'typists. Gallery at 164 Fulton St., Brooklyn, 1852. HJ, 1852, p. 202.

Thompson, A. F., & Co. Dag'typist. Gallery at 11 Park Row, NYC, 1844–1845; 285 Broadway, 1846–1847. BD (*The Gem*), 1844.

Thompson, Dana A. Jeweler, dag'typist.

Practiced dag'typing, Roxbury, Mass., 1850. CD.

Thompson, Edwin C. Dag'typist. Gallery at 58 Chatham St., NYC, 1848; 4½ and 6 Pennsylvania Ave., Washington, D.C., 1853–1854. Acquired paper process for use in Washington and planned to photograph heads of honorable gentlemen there assembled. BD; PAJ, 1854, p. 32.

Thompson (Thomson), John. Dag'typist. Gallery at 113 Washington St., Boston, 1854–1856. BD.

Thompson, Josiah W. Dag'typist. Gallery at 281 Broadway, NYC, 1846–1847; 262 Broadway (associated with L. C. Cheney), 1848–1849; 315 Broadway, 1849–1853; 180 Fulton St., Brooklyn, 1856; 182 Fulton St., 1859. BD; HJ; *Gleason's Pictorial Drawing-Room Companion*, 1853; CD.

Thompson, Samuel. Dag'typist. Harrisville, Ohio, 1853. SBD.

Thompson, S. I. (J.?). Dag'typist. Gallery at 57 State St., Albany, N.Y., 1850–1851; partnership with James B. Greene, 1853; Albany, 1859. Nsp, 1850; DJ; CD; HJ.

Thompson, S. N. Dag'typist. Roxbury, Mass., 1853. SBD.

Thompson, Warren. Dag'typist, photographer, inventor. Philadelphia, 1840 (?); invented and patented process of coloring dag'types (3,085), May 12, 1843; assigned to Simons. Paris, France, gallery there, 1849–1860 (listed in directory); pioneer production of photo enlargements of extreme size, 1855. MAR; BN.

Thurlow, Edmond. Dag'typist. Peoria, Ill., 1854. SBD.

Thurston, E. Q. Dag'typist. Waukegan, Ill., 1854–1855. SBD.

Thwaite, ———. Gallery at 206 Chatham Sq., NYC, ca. 1851. Dag'type owned by the New-York Historical Society.

Tilmon, L. Dag'typist. NYC, 1852. Information courtesy of James de T. Abajian.

Tilton, G. W. Dag'typist. Gallery in Melodeon Bldg., Superior St., Cleveland, Ohio, 1850; Watson's Block, 1852–1853. Nsp, 1850; CD.

Tomkins, J. H. Dag'typist. Gallery at 904 Main St., Buffalo, N.Y., ca. 1843. OSU.

*Tomlinson, William Augur. Artist, dag'typist. Born 1819, Conn. Partner with Pardee, gallery in New Haven, Conn., 1845; Poughkeepsie, N.Y., 1846; Troy, N.Y., 1847–1852; 22 Music Bldg., 1852; 447 Broadway, NYC, 1856. Member of N.Y State Daguerreian Association on committee to investigate Hill's color process, 1851. Exhibited at American Institute, 1856, diploma for best ambrotypes. Owned Cutting's patent for NYC, Hudson Co., N.J., and Long Island. Testified at hearings on Cutting's patent disputes, 1868. CD; BN; AI, 1856; PP, 1868, pp. 289, 290.

Tothill, William, Jr. Dag'typist. Gallery at

123 Court St., Boston, 1847. BD.

Townsend, H. Dag'typist. Gallery, Fitchburg, Mass., 1848. CD.

Treat, George. Dag'typist. Morristown, N.J., 1850. SBD.

Troxel, William L. Dag'typist. Gallery on Main St. between 2d and 3d St., Louisville, Ky., 1855–1856. CD.

Trufant, A. F. Dag'typist. Gallery at 103 Court St., Boston, 1855–1856. BD.

Tsing, Charles M. Dag'typist. Gallery at 46 N. 8th St., Philadelphia, 1854–1855. SBD.

Tubbs, Andrew B. Dag'typist, photographer. Born 1801. Employed George W. Collomar, Harrisburg, Pa., 1850; Covert, N.Y., 1867. USC; CD.

Tucker (Isaac) & Perkins (J. W.). *See* individual biographies.

Tucker, Caleb H. Dag'typist. Hillsboro, Ohio, 1853. SBD.

Tucker, Isaac. Dag'typist, photographer. Augusta, Ga. (Leigh, Tucker & Perkins), 1851–1853; Columbia, S.C., 1854; Augusta, Ga., 1855; Augusta and Athens, Ga. (Tucker & Perkins), 1860–1870. HJ; PAJ; also, information courtesy of Dr. W. Robert Nix.

Tucker, J. Dag'typist. Oswego, Ill., 1854–1855. SBD.

Tucker, William A. Dag'typist. Gallery at 101 Baltimore St., Baltimore, 1853. CD.

Tunison, D. C. Dag'typist. Employed by T. Duryea, 140 Grand St., Brooklyn, 1854. CD.

Turner, Austin A. Dag'typist, photographer. Operator for M. Ormsbee, Boston, and employed by Brady, dates unknown. BN.

Turner, G. W. Dag'typist. Gallery on Main St., Springfield, Ohio, 1852. CD.

Turner, Uriah. Dag'typist. Gallery at 183 Broadway, NYC, 1844–1845. BD.

Turpin, Joseph H. Dag'typist. Boston, 1848. Information courtesy of James de T. Abajian.

Tyler & Co. Dag'typists. Gallery at 2 Winter St., Boston, 1855. BD; OSU.

Tyrrel, A. Dag'typist. Gallery at cor. College and Manning St., upper Alton, Ill., 1850. Adv. that he had just arrived from the East. Nsp, *Alton Telegraph & Democrat*, Nov. 18.

Tyson, Thomas H. Dag'typist. Gallery at 272 N. 2d St., Philadelphia, 1854–1856. SBD; PAJ, 1856, p. 126.

Unknown dag'typist. Adv., Dec. 6, 1842, Milledgeville, Ga. Location of rooms, Masonic Hall. "Specimens may be seen at the store of Mr. O. Childs and at the Hall." Nsp, *Southern Recorder*.

Upton, Benjamin Franklin. Dag'typist, inventor, photographer. Born Aug. 3, 1818, Dixmont, Me.; died after 1899. Became settler, remote area, Aroostook Co., Me., ca. 1840, with five hundred acres of forest. His brothers Rufus and William took part but venture unsuccessful. To Brunswick, Me., 1847, as dag'typist. Probably learned the art from Charles E. Blake, Brunswick's earliest dag'typist (1845). Moved

to Bath, Me., 1851, and established gallery. Married Sarah Foster in Topsham, Me., 1851. U.S. patent for "Improvement of Mercury Bath" (9,666), Apr. 12, 1853; apparatus for polishing dag'type plates (11,709), Sept, 19, 1854. Wrote *Photographic Art Journal*, 1854, about copying dag'types and said he had two whole-size cameras. Listed at Bath, 1855. Moved with family to St. Anthony, Minn., 1856, and settled at Big Lake. Pioneer photographer of the West, specializing in landscape scenes and stereographs of Wis. and Minn. Photographed St. Paul, Minn., 1857; Indian tribes, 1862–1866; Miss. shipping, 1867; Minnehaha Falls, 1868; Minneapolis, Minn., ca. 1868–1870. Views identified as "Upton." Removed to Fla., 1875, because of wife's health. Settled in St. Augustine and became a pioneer photographer of Fla. Took scenic views of Fla. for over twenty years. In Sept 1898, he wrote of his work: "I am still actively at work in the landscape part of photography at 80, carting my own rig on the bike when no larger negative than 8 x 10 is wanted. . . . I was the pioneer landscape photographer of Minnesota more than 40 years ago, when I spent much time for 20 years among The Three Nations of Indians who were there at that time, namely, the Sioux, Chippewa and Winnebago." Wife died, Feb. 2, 1886, St. Augustine. Still listed as landscape photographer, 1899. CD; BD, Me., 1855; *News Monger*, 1898; PAJ, 1853, p. 67, 1854, p. 63; RT; St. Augustine Historical Society; William Henry Upton, *Upton Family Records . . .* , 1893; *John Adams Vinton, The Upton Memorial . . .* , 1874; OSU.

U. S. Daguerreo Co. Gallery at 105 Superior St., Cleveland, Ohio, 1855. Operator unknown. Nsp.

Vail, A. Dag'typist. Sandusky City, Ohio, 1853. SBD.

Vail, J. F. Dag'typist. New Brunswick, N.J., 1851. DJ.

Valentine, Frederick. Dag'typist. Athens, Ga., 1857. Dated dag'type owned by Dr. W. Robert Nix.

Van Alstin, Andrew Wemple. Dag'typist, businessman. Born July 26, 1811, Canastota, N.Y.; died 1858. Learned dag'typing from George Adams, Worcester, date unknown. Gallery, Worcester, Mass., 1843–1847; 9 Brinly Hall, 1848–1851; 207 Main St., 1852–1857 (?). Made trip around the world collecting specimens of birds, which were mounted and displayed in gallery. Carried on an express business from Worcester to New York via rail and Norwich boats—Mason & Co. Express business later taken over by Harnden & Co. Took early dag'type views of Worcester. BD; Publications of the Worcester Historical Society, 1928, pp. 433–439; BN; RBD.

Van Bunschoten, Isaac. Dag'typist. Gal-

lery at 337 Broadway, NYC, 1848. BD.

Vance, Robert H. Dag'typist, photographer. Died 1876, NYC. Galleries in San Francisco, Sacramento, and Marysville, Calif. Took three hundred or more scenes of gold-mining camps and views of Calif., etc., in 1850 or 1851; exhibited, NYC, in 1851 and 1852. Sold collection to J. Gurney, 1852 (*see also* Fitzgibbon, John H.). Gallery at Kearny and Commercial St., San Francisco, 1852; cor. Montgomery and Sacramento St., 1855. Operator ca. 1857, S. P. Howes. Held Cutting's patent for ambrotypes. Won all prizes for photographs at State Fair, Stockton, Calif. Opened new gallery with eight reception rooms and twelve operating rooms, 1859. Sold gallery to Charles L. Weed, 1861. Left Calif., 1865. CD; HJ; PAJ; BN; SLP.

Vance, William. Dag'typist, photographer. Brother of Robert H. Vance. San Francisco, 1852–1854; Montgomery St., near Clay St., 1855–1857. CD; PAJ, 1857, p. 112.

Vanderhoven, Elias M. Dag'typist. Gallery at 411 Broadway, NYC, 1850. BD.

Van Loan, Matthew. Dag'typist. Bought Wolcott-Johnson's gallery, Granite Bldg., NYC, in Sept. 1841; 73 Chambers St., 1842; 236 Broadway, 1843; 7½ Bowery St., 1844–1845. Nsp advs.; OSU.

Van Loan, Samuel. Dag'typist. Born Eng. Practiced dag'typing, Philadelphia, 1844–1850; 118 Chestnut St., 1851; sold gallery to M. and J. Shew, 1851; 120 Arch St., 1854–1856. Probably named Van Loan & Ennis Gallery after 1855. BN; SBD; PAJ, 1856, p. 126; HJ.

Vannerson, Julius. Dag'typist. Washington, D.C., 1853–1858. Exhibited at N.Y. Crystal Palace, 1853. BN; PAJ, 1856, p. 317, 1858, p. 98.

Vanwinkle, John. Dag'typist. Gallery at 186 W. 18th St., NYC, 1853. BD.

Venable, Charles H. Dag'typist. 7th and Pennsylvania Ave., Washington, D.C., 1849–1853. CHS; CD; Columbia Historical Society.

Vener, George W. Dag'typist. Charlestown, Mass., 1856; 174½ Main St., 1860. CD.

Villers, M. Doctor, dentist, dag'typist. Rooms at 233 Broadway, NYC, 1841. Nsp, *N.Y. Herald Tribune*, Dec. 1.

Vogel, William. Dag'typist. Gallery at 86 N. 2d St., St. Louis, Mo., 1854–1859; 44 Market St., 1860. SBD; CD.

Von Schneidau, John F. P. Dag'typist, diplomat. Born 1812, Stockholm, Sweden; died 1859, Chicago. Emigrated to U.S. in 1842. Operator for Brady, NYC, 1849; 122 Lake St., Chicago, 1849–1851; 142 Lake St., 1852–1854; 139 Lake St., 1855. Appointed vice-consul for Sweden, Norway, and Denmark after 1855. Exhibited at N.Y. Crystal Palace, 1853. BN; CHS.

Wacksmith, F. Dag'typist. Highland, Ill., 1854. SBD.

Wadhams, David. Dag'typist. Urbana, Ill., 1854–1855. SBD.

Wakefield, L. H. Dag'typist. Portland, Oreg. ca. 1850 (?) to 1853, when he sold gallery to Joseph Buchtel. Ralph W. Andrews, *Picture Gallery Pioneers*, 1964.

Waldo, D. H. Dag'typist. Gallery at 171 E. Water St., Milwaukee, Wis., 1854. CD.

Waldron, W. S. Dag'typist. Middletown, Ohio, 1853. SBD.

Walker & Horton, Dag'typists. Newburgh, N.Y. DJ.

Walker, George G. Dag'typist. Providence, R.I., 1850–1856. CD.

Walker, Samuel L. Dag'typist. Died about May 1874. Practiced dag'typing, Poughkeepsie, N.Y. Said to have been first successful dag'typist in Poughkeepsie. A spiritualist. APB, 1874, p. 185.

Walker, Sheldon H. Dag'typist. Holyoke, Mass., 1853–1854. SBD; PAJ, 1854, p. 160.

Walker, William. Dag'typist. Adv., Sept. 22, 1841, rooms in Brinley Row, Worcester, Mass. Nsp, *Worcester Spy*.

Walling, O. B. Dag'typist. Canal Dover, Ohio, 1853. SBD.

Walsh, Thomas S. Dag'typist. Gallery at 136 Spring St., NYC, 1846–1848; 61 Washington Place, 1849–1853; 241 Gold St., Brooklyn, 1856. BD; CD.

Ward & Whitsal. Dag'typists. Gallery at 6 W. 6th St., Cincinnati, Ohio, 1848–1849. CD.

Ward, C. Dag'typist. Springfield, Mass., 1853. SBD.

*Ward, Charles V. Landscape painter, dag'typist. Born Bloomfield, N.J. Son of Caleb and brother of Jacob Ward. Exhibited at National Academy, 1829, 1830. Itinerant dag'typist, with brother, Latin America, visiting Santiago, Valparaiso, La Paz, Lima, Panama, Jamaica, and Cuba, 1845–1848. NYHS.

Ward, George W. Dag'typist. Brooklyn, 1843. CD.

*Ward, Jacob. Landscape and still-life painter, dag'typist. Born 1809, Bloomfield, N.J.; died 1891, Bloomfield. Artist, NYC, ca. 1829; exhibited at National Academy, American Academy, Apollo Association, and American Art Union, 1829–1852. Took dag'types and sketched scenery in Chile, Bolivia, Peru, and Panama with brother Charles, 1845–1847; Jamaica and Cuba, 1847–1848. Exhibited at National Academy, London, 1852. NYHS.

Wariner, W. Dag'typist. Rooms at residence of John Gage, Chicago, 1845–1846. CHS.

Warner, B. H. Dag'typist. Rooms over Field & King's, Athens, Ga., Apr.–May 1846; Macon, Ga., 1847 (Nov. and before). Athens information courtesy of Dr. W. Robert Nix; nsp, Macon.

Warner, Norton. Dag'typist. Richmond, Ill., 1854. SBD.

Warren, Andrew. Dag'typist. Waltham, Mass., 1853. SBD.

Warren, Gardner. Dag'typist. Woonsocket, R. I., 1843. BN.

Warren, George K. Dag'typist. Lowell, Mass., 1853–1855; 100 Merrimack St., ca. 1855; Lowell, 1859; 100 Merrimack St., 1860. CD; RT; OSU.

Warston, J. H. Dag'typist. Gallery at 276 Arch St., Philadelphia., 1854–1855. SBD.

Wasb, Thomas S. Dag'typist. Gallery at 61 W. Washington Place, NYC, 1848. BD.

Washburn, D. E. Dag'typist. Machias, Me., 1855. SBD.

Washburn, J. H. Dag'typist. Chicopee, Mass., 1853. SBD.

Washburn, Lorenzo S. Dag'typist. Gallery at 252 Broadway, NYC, 1850. BD.

Washburn's Skylight Daguerrean Gallery. 120 Canal St., New Orleans, 1854. RBD.

Washburn, W. W. Dag'typist, photographer. Canal St., New Orleans, 1858 (formerly N.Y. operator); 113 Canal St., 1869. An article in 1869 stated that he had twenty-eight years' experience as a photographer. PAJ, 1858, p. 244; PP, 1869, p. 164.

Washington, Augustus. Black dag'typist. Hartford, Conn., 1851. Said to have been an artist of fine taste and perception and numbered among the most successful dag'typists in Hartford; establishment had female attendant and dressing room for ladies. Martin Robison Delany, *The Condition, Elevation, Emigration, and Destiny of the Colored Peoples of the United States . . .* , 1852, p. 126.

Waterman & Bradley. Dag'typists. Gallery at 88 Cedar St., Philadelphia, 1854–1855. SBD.

Waterman & Johnson. Dag'typists. Gallery, Philadelphia, 1856. PAJ, 1856, p. 126.

Watson, ———. Dag'typist. Springfield, Ill., 1854. SBD.

Watson, G. W. Dag'typist. Bought out J. M. Ford's gallery, Sacramento, Calif., 1854. CD.

*Watson, John Frampton. Lithographer, dag'typist. Born ca. 1805, Pa. Worked in Philadelphia, ca. 1835 until after 1860. Learned dag'typing in 1840. Exhibited at Franklin Institute, Oct. 1840, dag'types; dag'typist, Philadelphia, 1841. Nsp, 1840; CD, 1841; NYHS.

Watson, J. W. Dag'typist. Gallery at 110 Main St., Richmond, Va., 1855; rooms opposite post office, Athens, Ga., Jan.–Mar. 1856, adv. "raised ambrotypes"; 131 Fayetteville St., Raleigh, N.C., 1880s. CD; Athens information courtesy of Dr. W. Robert Nix; *carte de visite*.

Wattles, ———. United States citizen. Claimed to have invented photography before 1839. Nsp, *N.Y. Tribune*, Apr. 29, 30, 1853.

Wear, J. S. Dag'typist. Wytheville, Va., 1857. BD.

Webster (Israel B.) & Bro. (E. H.). Dag'typists. Israel B. Webster: born 1826, Plattsburg, N.Y. Apprenticed in teens as tinsmith, New London, Conn. Learned dag'typing from brother, ca. 1846. Louisville, Ky., 1850–1854; 479 Main St., 1855–1859; 473 Main St., 1859–1866. Partnership dissolved, 1866. Soldier, U.S. Army, as captain of Co. I Volunteers, from 1861–1864. Retired, 1877. Exhibited at N.Y. Crystal Palace, 1853. Pioneered paper process, Louisville, 1854. APB, 1875, pp. 113–114; HHS; CD; MAR; RT; PAJ, 1854, p. 104.

Webster, ———. Dag'typist. Murfreesboro, Tenn., 1842. Miniature case.

Webster, J. L. M. Dag'typist. Hamilton, Ohio, 1853. SBD.

Webster, Myron. Dag'typist. Berlin, Ill., 1854. SBD.

Webster, Thomas, Jr. Dag'typist. Gallery at 15 N. Water St., Philadelphia, 1854–1855. SBD.

Webster, Thomas A. H. Dag'typist. St. Albans, Vt., 1855. SBD.

Weed, Charles L. Dag'typist, photographer. San Francisco, 1850–? 3d & J St., Sacramento, Calif., 1858; San Francisco, 1859. Bought out Vance's San Francisco gallery, 1861. Information courtesy of Robert A. Weinstein; Ralph W. Andrews, *Picture Gallery Pioneers*, 1964.

Weeks, George H. Dag'typist. Gallery at 216 Chestnut St., Philadelphia, 1854–1855. SBD.

Weeks, Dr. G. H. Doctor, dag'typist. Practiced dag'typing, Greenville, Tenn., 1851. Nsp, *Greenville Spy*, Sept. 18, 1851.

Weeks, William. Dag'typist. Born 1824, Ohio. Practiced dag'typing, Cincinnati, Ohio, 1850. USC.

Wehekind, A. Dag'typist. Gallery at 76 S. 3d St., Philadelphia, 1854–1855. SBD.

Weicks, R. E. Dag'typist. Newark, Ohio, 1853. SBD.

Weiser, G. W. Dag'typist, photographist. Practiced dag'typing, Steubenville, Ohio, 1853–1856. SBD; CD.

Welber, William. Dag'typist. Canton, Mass., 1849. RBD.

Welch, J. B. Dag'typist. Gallery at 94 Hanover St., Boston, 1856. BD.

Weld (E. G.?). Dag'typist, photographer. Practiced dag'typing, Cazenovia, N.Y., 1858; Madison Co., N.Y., 1868–1869. Dated dag'type, OSU; BD.

Weldman, Dr. ———. Amateur dag'typist. Practiced dag'typing, Philadelphia, 1839. MAR.

Welles Bros. (J. Horace & Henry M.). Dag'typists. Gallery in Mitchell's Bldg., Chapel St., New Haven, Conn., 1854–1859. CD.

Welling, Peter. Dag'typist. Gallery at 226 Bleecker St., NYC, 1850–1859. BD; CD.

Wellington, R. H. Dag'typist. Employed by T. I. Dobyns, Memphis, Tenn., 1849;

Nashville, Tenn. (formerly with Dobyns & Fitzgibbon), 1853; 219 Main St., Memphis, 1855. HJ; CD.

Wellman, ———. Dag'typist. Charleston, S.C., 1852–1853. HJ.

Wells, Jacob. Dag'typist. Gallery at 252 Broadway, NYC, 1851. BD.

Wells, J. D. Dag'typist. Northampton, Mass., 1850; 6 Kirkland Block, 1851–1853. DJ; SBD.

Welsh, F. G. Dag'typist. Gallery at 117 Hanover St., Boston, 1854–1855. BD.

Welsh, F. G., & O. T. Higgins. Dag'typists. Gallery at 55½ Hanover St., Boston, 1852–1853. BD.

Welsh, T. S. Dag'typist. Gallery at 141 Bowery St., NYC, 1846. Exhibited three frames at American Institute, 1846. AI.

Wentworth, Henry. Dag'typist. Ft. Plain, N.Y., 1851. DJ.

Wertz, George. Dag'typist. Gallery at 413 Pennsylvania St., Pittsburgh, Pa., 1854–1855. SBD; BD.

Wertz & Patterson. Dag'typists. Gallery at 53 5th St., over Klebler's music store, Pittsburgh, Pa., 1855. Nsp.

West, Aaron L. Printer, dag'typist. Gallery at 70 Atlantic St., Brooklyn, 1848; 179 Broadway, NYC, 1849. Listed as printer and artist in Brooklyn directory, 1849. CD; BD.

West, C. E. (Professor). Amateur dag'typist. Experimented with dag'typing, NYC, 1839. RT, pp. 17, 454.

West, C. N. Dag'typist. Gallery at 60, 57 N. 4th St., St. Louis, Mo., 1850. Missouri Historical Society.

*West, George R. Topographical artist, lithographer, dag'typist. Gallery, Washington, D.C., ca. 1842–1850. Assisted William Heine in painting panorama of China and Japan which was exhibited in NYC, 1856. Exhibited paintings, Washington Art Association, 1857. Commissioned by architect of the Capitol to decorate walls of the old rooms of the Senate on Naval Affairs. Obliterated his unfinished paintings when man in charge preferred Italian or French painters to depict American history. NYHS; Josephine Cobb, *Mathew B. Brady's Photographic Gallery in Washington*, 1955.

*West, W. J. Portrait painter, dag'typist. Rooms next door to *Advocate*, Belleville, Ill., 1848. Nsp, *Belleville Weekly Advocate*, July 27; information courtesy of Allan Miller.

Westcott, C. P. Dag'typist. Watertown, N.Y., 1850–1854. PAJ, 1854, p. 128.

*Weston, James P. Artist, dag'typist. 12 Park Place, NYC, 1842–1843 (partner with Franquinet); gallery at 192 Broadway, 1846–1849. Exhibited one specimen, American Institute, 1846; 132 Chatham St., NYC, 1850–1857. *The Artist*, 1843, p. 235; NYHS, AI; CD.

Weston, Robert. Dag'typist. Gallery at 132 Chatham St., NYC, 1851–1853; S. 7th, cor. 1st St., Brooklyn, 1856. BD; CD.

*Wetherby (Wetherbee), Isaac Augustus. Portrait and ornamental painter, dag'typist. Born 1819; died 1904. Trained under itinerant painter, Norway, Me., 1834. Studio, Boston, 1835–1846. Kentucky briefly, 1844; Roxbury and Milton, Mass., 1848. Opened dag'type gallery, Iowa City, Iowa, 1854; Rockford, Ill., 1854–1857; Eureka, Iowa, 1857–1859. Settled in Iowa City, abandoned painting, and was photographer after 1859. Jean Lipman, *American Primitive Painting*, 1942; E. P. Richardson, *Painting in America*, 1956, p. 258; *Image of America* (cat.), Library of Congress, 1957, p. 16; NYHS.

Wheelock, ———. Dag'typist. Chardon, Ohio, 1853. SBD.

Whipple (John A.) & Black (James Wallace). *See* individual biographies.

Whipple, Henry. Dag'typist. Norwich, Conn., 1849. RBD.

Whipple, John A. Dag'typist, inventor, photographer. Born 1822, Grafton, Mass.; died Apr. 11, 1891, Boston. Supplier of photographic chemicals and associate of Elias Howe (later inventor of sewing machine), Boston, 1840–1841. Gallery at 96 Washington St., Litch (A.), Whipple & Co., 1844–1846; 96 Washington St. (alone), 1846–1853; 96 Washington St., Black & Whipple, 1856–1859; Boston, 1860–1872. U.S. patents: "Method for Taking Daguerreotypes" (crayon-style vignette, 6,056), January 23, 1849; negatives on glass (crystallotypes, 7,458), June 25, 1850 (with W. B. Jones). Exhibited at Crystal Palace, London, 1851, bronze (council) medal; N.Y. Crystal Palace, 1853, silver medal. Experimented with glass negatives, 1844–1849; microphotography, 1846–1860 (?); vignetting, 1848–1849. Took dag'types and crystallotypes of moon, sun, etc., 1848 onward. Made fourteen by sixteen in. photograph of more than five hundred Russian sailors, 1864. Photographed solar eclipse, 1867. Installed steam-driven fan for cooling gallery and for photographic purposes, 1846. Specialized in large-size dag'types and groups. Worldwide acclaim for achievements in photographing celestial bodies; complimented by the Royal Academy of Arts and Sciences, London. MAR; BD; RBD; DJ; PAJ; SA; ACB; BJP, 1872; APB, 1888, p. 562, 1891, p. 250; BN; RT; *Photographic News*, Mar. 2, 1866.

Whipple, Randall M. Dag'typist. Charlestown, Mass., 1856. CD.

White, ———. Dag'typist. Atlanta, Ga., 1853. "Shot dead at Atlanta, Georgia, by a lad named Odenna White, formerly of New York." HJ, 1853, p. 239.

White & Andrews. Dag'typists. Gallery at Central Exchange, Worcester, Mass., 1846. Publications of Worcester Historical Society, 1928.

White, Asa. Dag'typist. Age in 1840, twenty to thirty years, manufacture and trades. Practiced dag'typing, Boston, 1843; 20 Washington St., 1844–1847; 36 Washington St., 1848–1851. PWB; CD; BD; USC, 1840.

White, Edward. *See* Manufacturers and wholesale suppliers.

White, F., & Co. Dag'typist. Gallery on Main St., Springfield, Mass., 1849. RBD.

White, Franklin. Amateur dag'typist, stereo photographer. N.H., 1854; Lancaster, N.H., 1855–1868. PAJ, 1854, p. 351; SV.

White, H. S. Dag'typist. Middletown, Conn., 1849. RBD.

White, James. Dag'typist. Rushville, Ill., 1854. SBD.

White, Joseph. Dag'typist. Providence, R.I., 1856. CD.

White, S. M. Dag'typist. Gallery at 112 5th St., Cincinnati, Ohio, 1853; Cincinnati, 1857. SBD; CD.

White, W. W. Dag'typist. Magnolia Hall, Cincinnati, Ohio. 1848–1849. CD.

Whitehead, A. Dag'typist. Geneva, Ill., 1854–1855. SBD.

Whitehurst, Jesse H. Dag'typist, photographer, promoter, West Indian importer. Born ca. 1820, Eastern Shore, Va., died Sept. 8, 1875, Baltimore. Opened gallery (with unknown partner), Norfolk, Va., ca. 1842–1843; Norfolk, Richmond, Va., 1844–1846; Main St., Norfolk; 34 Main St., Richmond, 1847; Norfolk; 77 Main St., Richmond, 1848; Norfolk; 77 Main St., Richmond; 207 Baltimore St., Baltimore; 6 Pennsylvania Ave., Washington, D.C., 1849–1860. Sycamore St., Petersburg, Va., and Main St., Lynchburg, Va., 1850–1856. 349 Broadway, NYC, 1850–1852. Wilmington, N.C. (?), ca. 1853–? Listed at 170½ Main St., Richmond, 1858–? Exhibited at Maryland Fair, 1851; Crystal Palace, London, 1851, twelve double whole plates (about nine by thirteen in. each) of Niagara Falls; N.Y. Crystal Palace, 1853, honorable mention. Put on exhibition of the Vance collection of Calif. views, NYC, 1851–1852. Promoted dag'type lottery, 1854. Whitehurst's entry, a dag'type of Miss Martha Butts, of Norfolk, in P. T. Barnum's collection of beautiful young ladies from America was sold to Lady Morgan, of England, for fifty dollars in Paris, 1855. Whitehurst was one of the foremost pioneer dag'typists and was second only to John Plumbe as a promoter of photography. His assistants, thirty-three in 1851, were said to have been the best anywhere. James A. Cutting, the ambrotype patent holder, taught him the new process in 1855, and the Whitehurst ambrotypes were called the "best in the country, having a delicate beauty." Pioneer in American paper photography and hired John R. Johnson, portrait, historical, and landscape painter and sculptor, to paint many of his famous photographs in oil. His

Washington, D.C., gallery in 1857 had "the greatest collection of distinguished men in the world." Also, he was reported (1855 onward) to have imported excellent artists from Europe to color photographs. In about 1855–1860, he sought to expand his activities by having vessels import guano as fertilizer from the Caribbean, one of many outside speculations which proved unsuccessful. DJ; HJ, 1852, p. 270; PAJ, 1854, p. 32, 1856, p. 217, 1857, pp. 306–307, 331; HHS, p. 41; RT; BN; PP, 1875, p. 300; nsp.

Whitmore, Joseph. Dag'typist. Medina, Ohio, 1853. SBD.

Whitney & Bliss. Dag'typists. Troy and Albany Co., N.Y., 1852. CD.

Whitney & Denny. *See* Whitney, Edward Tompkins.

Whitney, C. L. Dag'typist. Clinton, Mass., 1853. SBD.

Whitney, Edward Tompkins. Dag'typist, photographer, jeweler. Born 1820, NYC; died 1893. Jewelry store, NYC. Learned dag'typing from Martin M. Lawrence, 1844. To Rochester, N.Y., 1845, partnership with Mercer, 1845–1849; Rochester (alone), 1850; partnership with Conrad B. Denny, Rochester, 1851–1854; Rochester (alone), 1855–1858; Norwalk, Conn., 1859–1869 (?). APB, 1880, p. 253; SLP, 1877; PAJ; BN; PP, 1869; *Mosaics*, 1893, p. 96.

Whitney, Ezra A. Dag'typist. Thomaston, Me., 1855. SBD.

Whitney, Joel Emmons. Dag'typist, photographer. Born 1822, Phillips, Me.; died 1886, St. Paul, Minn. Learned dag'typing from Alexander Hesler. Gallery, St. Paul, 1851–1871 (?). Exhibited at N.Y. Crystal Palace, 1853. Noted for his views of St. Paul and his stereo views of Minn., 1861–1878. RT; BN; SV.

Whitney, Thomas R. Dag'typist, jobber. Practiced dag'typing, St. Louis, Mo., 1841; took galvanic battery dag'type, 1841. Gallery at 285 Broadway, NYC, 1844–1845. HHS, pp. 78–80; BD.

Whitney, William S. Dag'typist. Madison, Wis., 1855. CD.

Whittemore, H. Dag'typist. Gallery at 15 Camp St., New Orleans, 1848. Nsp.

Whittemore, H. Itinerant dag'typist. Took views of Apalachicola and Key West, Fla., and Niagara Falls, before 1851. Exhibited, American Institute, forty dag'type views of West Indies, two views of Fla., the Cotton Landing, Apalachicola, and Key West, twelve views of Niagara Falls on double whole-size plates. According to the *Daguerreian Journal*, considered disposal of his collection to a well-known illustrated paper, in London, from which he had an offer. To South America, 1852; Dec., 1852, gallery in NYC, interested in stereoscopes and had curiosities in studio; sold NYC gallery, 1853. DJ, 1851, p. 342; HJ.

Whittemore (Whitmore), S. H. Dag'typist. Lynn, Mass., 1850–1853. SBD.

"Wilde's Cheap Gallery." 147 Congress St., Savannah, Ga., 1855–1856. Nsp.

Wiles, A. D. Dag'typist. Fremont, Ohio, 1853. SBD.

Wilkins & Lufkin. Dag'typist. Gallery at 82 Merrimack St., Lowell, Mass., 1855. CD.

Wilkins, Charles. Dag'typist. Lowell, Mass., 1855. CD.

Willard, A. A. Dag'typist. Buffalo Grove, Ill., 1854. SBD.

Willard, O. H. Dag'typist, photographer. Practiced dag'typing, Philadelphia, 1850s; Oxford Boro, Pa., 1854–1855; 1628 Market St., Philadelphia, 1859; Congress Hall, Cape May, N.J. (seasonal), and Philadelphia, 1868–1878. Exhibited glass transparencies, Boston, May 15, 1861. Member of eclipse expedition, 1869. MAR; BD; RT; PP, 1869, pp. 219, 271; SV.

Willard, W. Dag'typist. Gallery at 120 W. Market St., Philadelphia, 1854–1855. SBD; OSU.

William, J. H. Dag'typist. Skowhegan, Me., 1849. RBD.

Williams & Co. Dag'typist. Gallery on Warren Block, Pearl St., Worcester, Mass., 1849. RBD.

Williams, A. W. Dag'typist. Gallery at 392 Market St., Philadelphia, 1854–1856. SBD; PAJ.

Williams, A., & Co. Dag'typist. Gallery at 7 Bowery St., NYC, 1846–1847. BD.

Williams, D. Dag'typist. Cleveland, Ohio, 1845. CD.

Williams, George. Dag'typist. Gallery at 111 Hanover St., Boston, 1854. BD.

Williams, G. T. Dag'typist. Savannah, Ga., 1849. CD.

Williams, H. V. Dag'typist. 315 Broadway, NYC, 1848. *See also* Cheney, L. C. *Gazette of the Union* (Odd Fellows), 1848.

Williams, H. W. Dag'typist. Gallery at 55 W. Randolph St., Chicago, 1855–1860. CHS.

Williams. J. A. Dag'typist, photographer. Gallery in Washington Sq., Newport, R.I., 1851; Newport, 1861–1878. DJ; SV.

Williams, J. B. Dag'typist. Philadelphia, 1851. DJ.

Williams, J. H. Dag'typist. Skowhegan, Me., 1855. SBD.

Williams, J. T. Dag'typist. Gallery, York, Pa., 1853. OSU; date on book held by subject in dag'type portrait.

Williams, L. Dag'typist. Gallery at 82 Main St., Worcester, Mass., 1849. RBD.

Williams, Robert B. Dag'typist. Gallery at 111 Hanover St., Boston, 1855. BD.

Williams, Seth N. Dag'typist. Rockland, Me., 1855. SBD.

Williams, Simeon. Dag'typist. Worcester, Mass., 1849 or before. Publications of the Worcester Historical Society, 1928.

Williams, William R. Dag'typist. National Daguerreian Gallery, Cincinnati, Ohio,

1846. *See also* Rea, Sampson. Charles Hamilton and Lloyd Ostendorf, *Lincoln in Photographs: An Album of Every Known Pose*, 1963, p. 355.

Williamson, Charles H. Dag'typist, photographer, inventor. Employed by Marcus Root, Philadelphia, 1849–1850; Brooklyn, 1851–1855; 249 Fulton St., partnership with brother Edward M., 1856–1859. Exhibited at N.Y. Crystal Palace, 1853. Invented the cameotype. MAR; CD; BD; BN; RT, p. 136.

Williamson, Edward M. *See* Williamson, Charles H.

Willmarth (P. C.) & Cooke (Beekman). Dag'typists. Gallery at 179 Broadway, NYC, 1850; 233 Greenwich (alone), 1851–1853. BD.

Wilmot, T. T. Dag'typist, jeweler. Died Jan. 21, 1850, Savannah, Ga. Funeral with military honors, member of Chatham Artillery. Gallery, Market Sq. and Bryan St., Savannah; Samuel Broadbent and P. M. Cary were operators there during winter of 1848; gallery opened during summer and managed by D. B. Johnson, 1848. CD; nsp.

Wilson, Allen. Dag'typist. Gallery at 16 Merrimack Block, Manchester, N.H., 1849. RBD.

Winchester, D. D. Dag'typist. Gallery on High St., Columbus, Ohio, 1853–1857. Zanesville, Ohio (?). Adv., in 1856, patented double glass ambrotype. SBD; CD, 1856–1857.

Windmuller & Gompertz. Dag'typists. Gallery at 51 Canal St., NYC, 1851. BD.

Winslow, Abraham. Dag'typist. Gallery at Howard & Court St., Boston, 1848–1850; 39 Hanover St., 1851–1853; 93 Hanover St., 1854–1864. BD; CD.

Winter, W. W. Dag'typist. Springfield, Ohio, 1853. SBD.

*Wisong, William A. Dag'typist, portrait painter, businessman. Born Apr. 1, 1819, Woosborough, Md. To Baltimore with uncle, 1832. Employed in drugstore for few years; partnership, Wisong & Kettlewell, a drug concern, briefly; glass business and artist's supplies and dag'typist's depot. Gallery 2 N. Liberty St., Baltimore, 1851–1858 (?). Firm sold, ca. 1860, to William King & Bros., who continued it as a dag'typist's depot. Entered Internal Revenue Service for about nine years. Became secretary and treasurer of the Safe Deposit and Trust Co., Baltimore. Active in local societies to benefit community. DJ; NYHS; *Southern Pictorial Advertiser*; *Biographical Cyclopedia for Maryland and District of Columbia*.

Witherspoon, James F. Dag'typist. Hillsboro, Ill., 1854. SBD.

Wocester, Samuel. Dag'typist. Portsmouth, Ohio, 1853. SBD.

Wolcott, Alexander Simon. Inventor, pioneer dag'typist, mechanician, dentist. Born 1804, Conn.; died Nov. 10, 1844,

Stamford, Conn. Prior to Sept. 1839, apprenticed in mercantile business; optician (devised adjustment of the speculum of telescopes, eliminated aberration); improvements in the steam engine and horology. Took first successful dag'type portrait, Oct. 6, 1839, with John Johnson, using the speculum camera—later patented, May 8, 1840 (1,582), first patent for photography. Improved the speculum camera, Oct. 1839–Jan. 1840. Opened first commercial dag'type studio in world, cor. (273) Broadway and Chambers St., NYC, Mar. 13, 1840, with John Johnson. Expanded operations (with Johnson) to Washington, D.C., with John G. Stevenson, operator. Contracted with Richard Beard, London, Eng. through William Johnson, spring of 1840. Developed Wolcott-Johnson system of studio lighting, Feb.–June 1840. To England, July 1841, to help Johnson. Sold NYC studio, Sept. 1841. Operated Beard's studio in London, with Johnson, Nov. 1841. Opened English studio or supply depot (?), ca. 1842. John Johnson opened studio in Manchester, Eng. (Wolcott as partner), 1842–1843. Experimented with photographs on glass, Feb. 1843. Patented (English) dag'type-copying apparatus (with Johnson), Mar. 1843. Returned to NYC, 1844. Working on improvement in the manufacture of cotton until his death in Nov. Wolcott and Johnson worked in a close and harmonious partnership and contributed widely to the development of photography in its formative years. CD; BD; RT; BN; Floyd Rinhart and Marion Rinhart, "Wolcott and Johnson: Their Camera and Their Photography," *History of Photography: An International Quarterly*, Apr. 1977, pp. 129–134; nsp.

Wolcott, William K. Dag'typist. Gallery at 217 W. Baltimore St., Baltimore, 1845. CD.

Wolf, Daniel. Dag'typist. Gallery at 7th and Pennsylvania Ave., Washington, D.C., 1846; Washington, D.C., 1849. Columbia Historical Society.

Wood & Knowles (Lucius J.). Dag'typists. Worcester, Mass., Mar. 1842. Publications of the Worcester Historical Society, 1928.

Wood, I. S. Dag'typist, photographer. Practiced dag'typing in 1844, location unknown. Photographer, Hemstead, Long Island, N.Y., 1873. APB, 1873, p. 272.

Wood, R. L. Dag'typist. Athens, Ga., at the Franklin House, Feb.–Mar. 1849; Macon, Ga., 1850–1851. Athens information courtesy of Dr. W. Robert Nix; DJ.

Woodbridge (John S.) & Popkins (Benjamin F.). Dag'typists. Columbus, Ga., 1856–1858. Nsp.

Woodbridge, John J. Dag'typist. Gallery at 90 Chatham St., NYC, 1848–1853. BD.

Woodbridge, John S. (J.?). Dag'typist. Columbus, Ga., 1854–1858. HHS; nsp.

Woods, Gardner. Dag'typist. Gallery at 66½ N. Market St., St. Louis, Mo., 1854. SBD.

Woodward, William. Dag'typist. Gallery on Maverick Sq., E. Boston, 1849–1851. RBD; BD.

Woodward, William. Dag'typist. Kanesville, Ill., 1854–1855. SBD.

Woolen, J. Dag'typist. Exhibited at Franklin Institute, Philadelphia, 1852. HJ, 1852, p. 238.

Wright, L. Dag'typist. Pawtucket, R.I., 1849–1853. RBD; BN.

Wright, Marcus. Dag'typist. Gallery at 104 Market St., St. Louis, Mo., 1854. SBD.

Wykes, J. W. Dag'typist. Wooster, Ohio, 1853. SBD.

Wyman & Co. (E. & H.). Dag'typists. Gallery at 335 Washington St., Boston,

1857–1861; (Henry Wyman) 14 Hanover St., 1864. BD.

*Wyman, John. Dag'typist, ventriloquist, artist. Born 1820, N.Y. state. Ventriloquist, Philadelphia, 1852–1854; dag'typist, 1855; artist, 1856–1861. NYHS.

Wynd, H. J. Dag'typist. Keithsburgh, Ill., 1854. SBD.

Yancey, C. A. Dag'typist. Gallery at 24 W. 4th St., Cincinnati, Ohio, 1848–1849. CD.

Yearwood, Thomas. Dag'typist. Gallery at 90 Chatham St., NYC, 1850. Possibly partner with John J. Woodbridge, same address. BD.

Young, E. Dag'typist. Rooms over Brady's store, Athens, Ga., Aug., 1849. Information courtesy of Dr. W. Robert Nix.

Young, J. M. (J. H.). Dag'typist. Gallery in 1850s, exact date unknown, 145 8th Ave. near 17th St., NYC; 198 and 145 8th Ave. and 418 2d St., NYC, 1858. OSU; CAS.

Zealy, James T. Dag'typist. Gallery at 2 Granite Grange, Columbia, S.C., 1851. Gallery had a piano for lady visitors, a mammoth camera for taking double whole-size dag'types, also for landscapes and military companies. Petersburg, Va., 1856; 2 Granite Grange, Columbia, 1859. PAJ, 1851, pp. 255, 376, 1856, p. 123; nsp, 1859.

Zuky, Anthony K. Dag'typist. Gallery, rear 499 Broadway, NYC, 1853–1854; rooms, Athens, Ga., opposite post office, Jan. 1854. Adv., views, portraits, children one second. Also noted from Saratoga Springs, N.Y., and said he was in Hungarian war. Exhibited at N.Y. Crystal Palace, 1853. BN; Athens information courtesy of Dr. W. Robert Nix.

MANUFACTURERS AND WHOLESALE SUPPLIERS

Allen (W. C.) & Co. Supplier. San Francisco, 1856. CD, adv.

Anson, James P. Supplier. 94 Maiden Lane, NYC, 1852–1853. CD.

Anthony, Edward. Pioneer dag'typist, manufacturer, wholesaler of photographic materials. Born 1818, NYC; died 1888, NYC. Studied civil engineering, Columbia College, NYC; graduated 1838. Listed as merchant, NYC, 1839. Learned dag'typing winter or spring 1840 (probably from Morse or Gouraud). Dag'typist with U.S. Government survey of northeast boundary, 1840–1841 (?). Opened gallery at 11 Park Row, NYC, and Washington, D.C. (probably seasonal or itinerant), 1842. Associated (partnership) with National Miniature Gallery, 247 Broadway, NYC, and Washington, D.C. (seasonal, spring and fall), with J. M. Edwards and H. Chilton (Anthony, Edwards, & Chilton). Chilton withdrew from the firm in late 1844, and name changed to Anthony, Edwards & Co. Established supply house (jobber), Anthony, Edwards, & Clark (J. R.), at 247 Broadway, 1844. Edwards withdrew from the association in 1845 (Anthony, Clark, & Co.), and the National Miniature Gallery continued to take dag'types until late 1847, when Clark withdrew (Clark died in 1848) and the firm's name changed to E. Anthony & Co., dealing only in photographic materials. Relocated to 205 Broadway, 1847–1851. Began manufacturing miniature cases at 142 Fulton St. in 1850. Moved to 308 Broadway, 1851 (sales office). Partnership with brother Henry T., 1852 onward. Expanded operations, 1852–1854, to include the manufacture of a wide variety of photographic materials. Conducted competitive contest for best dag'types, 1853. Leading U.S. dealer in photographic supplies, 1850s. Moved to 501 Broadway, 1860, and name changed to E. & H. T. Anthony & Co. Produced carded paper print stereo views (1859), taken by the company's staff of photographers, and until about 1875 was the country's largest producer of stereo views. Throughout the 1860s Anthony continued to expand and new partners were taken in—Wm. H. Badeau, European representative for E. & H. T. Anthony, and Col. Vincent M. Wilcox as an executive. By 1870, the largest photographic stock establishment in the world. New facilities were acquired—the sales and main office at 591 Broadway; a packing and shipping dept. on Mercer St.; one in Jersey City for manufacturing chemicals; one at 65 Broadway for manufacturing stereoscopes and albums; and the original large quarters over the New Haven Depot were converted in 1870 to cutting and embossing photographic card mounts. Also in 1870 began publishing *Anthony's Photographic Bulletin*, edited by Henry T. Anthony, a publication helpful to the photographic art. Edward Anthony's greatest asset, it was said, was his ability to get along with people. CD, 1839, 1852–1859; BN; AMCA; PWB; BD, 1843, *The Gem*, 1845–1859; nsp adv. *N.Y. Tribune*, 1844; DJ; RT; BJP, Nov. 1872, p. 531; SLP, Feb. 1880, p. 45.

Anthony, Henry T. Civil engineer, inventor, manufacturer of photographic supplies, amateur photographer. Born 1818; died 1884, NYC. Partnership with brother Edward, 1842; in charge of manufacturing division of E. Anthony & Co., NYC, 1852–1860, and E. & H. T. Anthony, 1860 onward. Issued on Jan. 31, 1854, a U.S. patent (10,465) for a press for making miniature cases; issued on Mar. 23, 1854 (with Frank Phoebus), a patent (10,953) for apparatus for the manufacture of dag'type cases; issued on May 28, 1861 (with Frank Phoebus), a patent (32,404) for a photographic album. Member of eclipse expedition, 1869. CD; BD; BN; RT; "History of Ansco" (courtesy of Ansco Co.); PP.

Babbitt, Lewis. Supplier. Worcester, Mass., 1853–1856. SBD.

Bailey & Ketchen. Suppliers: lenses and plates. 136 Chestnut St., Philadelphia, 1842. Nsp, *U.S. Gazette*.

Bardwell, R. D. (Troy Daguerrian Stock Depot). Supplier. 166 River St., Troy, N.Y., 1851–1852. DJ.

Beckers, Alexander. *See* Dag'typists.

Beckers, Louis. Supplier: chemicals. Old York Rd., Philadelphia, 1843; Philadelphia, 1850; 118 Chestnut St., 1858. BD; DJ; Montgomery P. Simons, *Plain Instructions for Coloring Photographs*, 1857.

Benedict, Philander H. Supplier. Syracuse, N.Y., 1854–1859. PAJ; BD.

Binsse, Louis B., & Co. Supplier: general line specializing in dag'type plates. 40 Beech St., NYC, 1839–1841 (no occupation given); NYC, 1843; 83 William St., 1844–1845. CD; BN; BD.

Bishop, Joaquin. Supplier: dag'type cameras. 213 Cherry St., Philadelphia, 1839. Assistant to Robert Hare, University of Pa. FIJ, Sept. 1908.

Bishop, Louis L. Supplier, dag'typist, platemaker. General line specializing in imported plates and chemicals. A native of Paris, France. 285 Broadway, NYC, 1845–1847. BD; CD.

Bishop, Victor. Supplier. Sold Louis L. Bishop plates. 23 Maiden Lane, NYC, 1850–1851. HJ; BD.

Blaisdell, Oliver R. Supplier. 1850–? Died, 1875. Employee, B. F. French, Boston. PP, 1875, p. 378.

Bowers, P. Supplier: apparatus. 164 Essex St., NYC, 1850–1851. BD.

Brassart, August. Silversmith, dag'type platemaker, photographer. Born ca. 1818, France. Silversmith in Paris, 1836. Made first flawless plate for Daguerre at establishment of Mr. Gandois, Paris. Joined French army, 1840–1844. Resumed dag'type platemaking, 1845. Visited by Henry Hayden, of Waterbury, Conn., 1856; to America with Hayden and in employ of Holmes, Booth, & Hayden until 1857, when the tintype began to eclipse the dag'type. Photographer in 1858; gallery 6th Ave., NYC, date unknown. Photographic studio in Naugatuck, Conn., 1890; retired from photography, 1897, and moved to St. Louis, Mo., 1898. *News Monger*, Sept. 1898.

Brown, C. Manufacturer: apparatus. Exhibited at Franklin Institute, "Daguerreotype apparatus by C. Brown, is highly finished and well made," 1842. Nsp, *Public Ledger*, Oct. 29.

Brown, H. S. Supplier, dag'typist. Milwaukee, Wis., 1846; 201 East Water St., 1850–1852. CD; DJ.

Carnes & Haskell. Suppliers and importers of apparatus. 26 Liberty St., NYC, 1844–1845. CD.

Chamberlin, J. & J. Suppliers, agents for Scovill Manufacturing Co. NYC, 1839–1840. PWB.

Chapman, Levi. Supplier, inventor, manufacturer of leather merchandise. 81 William St., NYC, 1840–1846. Dag'type supplies, 102 William St., 1850–1865. George A. Chapman, 63 Duane St., 1866. Issued U.S. patent (14,184) on Feb. 5, 1856, for an improved photographic-plate vise. Chapman manufactured miniature cases, plates, mats, and preservers. Also imported the French Star Brand plate. Employed two traveling agents, George Dobbs and S. R. Crompton, covering U.S., 1850–1851. George A. Chapman sold Chapman's cameras, Chapman's OK tintype plates, and a general line of photographic materials, 1866. BD; CD; DJ; HJ; PP, 1866; AMCA.

Chilton, Dr. James R. Supplier, chemist, manufacturer, dag'typist. Born 1810; died July 24, 1863, Yonkers, N.Y. 263 Broadway, NYC, 1839–1841. A central figure in the development of dag'typing in America, 1839–1840. Reputation worldwide as an analytical chemist. CD; RT; BN; HJ; adv., *American Journal of Science and Arts*, Oct. 1841.

Collins, C. W. Supplier. Urbana, Ohio, 1854. PAJ.

Cook, A. A. & G. L. Suppliers. Milford, Mass., 1853. SBD.

Corduan, Joseph (Corduan, Perkins & Co.). Supplier, plate manufacturer, dag'typist. Listed as platemaker, 1839–May 1840; Corduan, Perkins & Co.,

May 1840–1843; Corduan & Co., 28 and 30 Cherry St., NYC. Dag'typist, 151 4th St., 1844–1845. CD; BD; nsp adv.; BN.

Cremer, James. Supplier, apparatus manufacturer, photographer. Died 1893. 144 Washington St., Boston, 1853; cor. 6th and Chestnut St., Philadelphia, 1857; Philadelphia, 1860–1870. Cremer as a photographer was noted for his stereo views. Member of eclipse expedition, 1869. BD; Montgomery P. Simons, *Plain Instructions for Coloring Photographs*, 1857; PP; *Mosaics*, 1893.

Davis, Ari. Supplier, manufacturer of apparatus, philosophical-instrument maker, machinist. Cambridge, Mass., 1837–1839, as machinist; employed Elias Howe, later inventor of sewing machine, 1837. 11 Cornhill, Boston, 1840, with brother Daniel. Adv. dag'type apparatus for $25 in 1840. ACB; *Boston Almanac*, 1837–1839; adv., *Boston Transcript*, June 9, 1840; BN.

Davis, Daniel, Jr. Inventor, author, magnetical-instrument maker, amateur dag'typist. Born 1813, Princeton, Mass.; died 1887, Princeton. Partnership with brother Ari at 11 Cornhill St., Boston, 1840. Learned dag'typing from Gouraud, 1840. Issued U.S. patent for coloring dag'type pictures (2,826), Oct. 22, 1842; patent assigned to John Plumbe, Jr. Author, *A Manual of Magnetism* (included detail of electroplating dag'type plates), 1842, 2d ed., 1847. *Boston Almanac*; BN; MAR.

Englehard, George. Plate manufacturer. NYC, 1853. Invented a pure zinc dag'type plate, coated with copper and then silver for better pictures. SA.

Foster, Thomas. Supplier. Vessey St., NYC, 1846–1848. BD.

French, Benjamin. Supplier, manufacturer, dag'typist. Born 1819, Lebanon, N.H.; died 1900, Boston. Dag'typist in Boston, 1844–1848; supplier (Hale, L. H., & French), 1848–1850. Supplier and manufacturer, plates and apparatus, 1850–1857. Largest Boston photographic supply house, 1858–1900 (?). Introduced Darlot lens to U.S., 1856. Agency for Voightländer, 1859. Visited Europe searching for improved lenses, 1867. Partnership with stepson, Wilfred A. French, 1884. HJ; BD; RBD; Montgomery P. Simons, *Plain Instructions for Coloring Photographs*, 1857; PP, 1869; *Photo Era*, Feb. 1900.

Gallet, M. A. Supplier, importer of French plates, apparatus, and chemicals. 38 S. 4th St. (or 6th St.), Philadelphia, 1841–1842. U.S. agent for Giroux & Co., Paris, 1841–1842. Nsp adv., *U.S. Gazette*, Apr. 24, 1841; nsp adv., *Public Ledger*, May, Aug. 1842.

Gennert Bros. Suppliers, manufacturers of Eagle plates, mats, and preservers. 106 Center St., NYC, 1858–1860. BD; CD.

Graham, S. S. Manufacturer: camera obscura. Columbia near Pacific, Brooklyn, 1847. CD.

Griesler, John. Manufacturer: bronze metal cameras. 75 Mott St., NYC, 1856. AI.

Harris, D. H. Supplier. Louisville, Ky., 1854. PAJ.

Harrison, Charles C. *See* Dag'typists.

Hen, Edward. Supplier, importer of dag'type apparatus. 18 and 20 Liberty St., NYC, 1844–1845. CD; BD.

Heselwood, R., & Co. Supplier. 372 Washington St., NYC, 1846–1847. BD.

Hidden, George G. Manufacturer: plate holders. 285 Delancy St., NYC, 1846. AI.

Hile, M., & Co. Supplier. Philadelphia, 1853. HJ.

Holmes & Co. Supplier. Attleboro, Mass., 1853–1856. SBD; RBD.

Holmes, Booth, & Hayden (Israel Holmes, John C. Booth, Henry Hayden, all of Waterbury, Conn.). Suppliers, general line, manufacturers of plates, cameras, plastic miniature cases, brass mats, and preservers. 37 Maiden Lane, NYC, 1853–1861; 81 Chambers St., 63 Reade St., 1858–1861. Issued design patent in 1855 for brass mats. HJ; BD; CD; AMCA.

Horsley, Peter N. Supplier, dag'typist. 106 and 130 Broadway, NYC, 1847–1849. BN; BD.

House, L. S. Supplier. Clarkeville, Tenn., 1854. PAJ.

Huddleston, J. S. F. (& Co.). Camera and philosophical-instrument maker, dag'typist. 123 Washington St., Boston, 1840–1841. Built camera for John Plumbe, Jr. Sold dag'type gallery to Henry I. Abel, Sept. 1, 1841. Barometer and thermometer maker at 96 Washington St., 1849. Nsp adv., 1841; BN; SBD.

Humphrey, H. S. Supplier. Ogdenburg, N.Y., 1854. PAJ.

Humphrey, Samuel Dwight. Author, supplier, dag'typist. Canandaigua, N.Y.; took dag'type of moon, 1849; NYC, 1850–1851; editor, *Daguerreian Journal*, 1850–1851; editor, *Humphrey's Journal*, 1852–1859; supplier, 346 Broadway, NYC, and 37 Lespenard St., 1859. Author, *A System of Photography*, 1849; *American Handbook of the Daguerreotype*, 1853, 5th ed., 1858; *Practical Manual of the Collodion Process*, 2d ed., 1856, 3d ed., 1857. BD; RT; BN; DJ; HJ.

Jones & Co. Supplier, plate manufacturer. NYC, 1848–1849. BN; plate in dated case.

Kent, Edward N. Supplier. 116 John St., NYC, 1848–1849. BD.

Ketcham, Charles. Inventor. Penn Yan, N.Y., 1856–1858. Won diploma for best dag'type-cleaning machinery, American Institute, 1856. Issued U.S. patent (20,718), June 29, 1858, for daguerreotype plate cleaner. AI.

King, F. W. & Richard. Suppliers, manufacturers. 33 South St., Baltimore, 1848–1853. Baltimore, manufacturer: dag'type instruments, cameras, plates, cases, chemicals, and galvanic batteries. CD, 1853.

Knowles, Lucius James. *See* Dag'typists.

Kubler, Gaebert. Dag'typist apparatus and telescope maker. 142 Nassau St., NYC, 1850–1851. BD.

Leslie, James Y. Supplier. 14 W. 5th St., Cincinnati, Ohio, 1850–1851. BD; CD.

Lewis, Henry J. Supplier, manufacturer, inventor, dag'typist. 1st St. near S. 4th St., Brooklyn, 1859–1866. Sold patented multiple camera for *cartes de visite* and ferrotypes, 1866. Son of William Lewis. CD; PP, 1866.

Lewis, W. & W. H. Suppliers, manufacturers, inventors. William Lewis: born 1791, London, Eng.; died 1879, Brooklyn. Emigrated to America, 1831, and worked as pattern maker and ship-joiner. Made dag'type apparatus for Wolcott & Johnson, 1839 (?). Worked with son, also inventor, William Henry. Other sons: Richard A. was a noted dag'typist, and Henry J. was a manufacturer of photographic apparatus. 142 Chatham St., NYC, 1844–1850; Daguerreville, N.Y., 1850–1852 (?); 142 Chatham St., 1853–? Invented, with son William Henry, many of the early improvements in photography (see app. 2), including probably the best-known U.S. patent for dag'typing (8,513), Nov. 11, 1851, a bellows-type camera. BD; SA; HJ, 1852, p. 11; *Photographic Times*, 1879, p. 212; AMCA.

Mason, William G. *See* Dag'typists.

Meade, E., & Co. Supplier. St. Louis, Mo., 1854. PAJ.

Meade Bros. *See* Dag'typists.

Moffet, J. G. Supplier: German silver dag'type plates. 121 Prince St., NYC, 1841; Bloomfield, N.J., 1850. Nsp adv., *N.Y. Tribune*, 1841; SBD.

Murtley, A. B. Supplier. Trade name: Central N.Y. Depot. 158 Genesse St., Utica, N.Y., 1851–1852. HJ.

Norton, J. W. Supplier, manufacturer of apparatus and plates. 447 Broom St., NYC, 1856–1857. BD.

Pemberton & Co. Plate manufacturer. Conn., date unknown.

Plumbe, John, Jr. *See* Dag'typists.

Pottinger's (Charles R.). English supply house. Agents for American photographic materials and Scovill's plates. 41 Ludgate Hall, London, Eng., 1854. BJP.

Prosch, Andrew. Supplier, philosophical-instrument maker. Brother of George Prosch. 140 Nassau St., NYC, 1843–1844; 80 Fulton St., 1845. CD; BD.

Prosch, George W. Supplier, manufacturer, inventor, dag'typist. 27 Jones St., NYC, 1838; 140 Nassau St., 1840–1841; Canada, 1842 (?) to 1844 (?); 112 Broadway, NYC, 1845–1846; 45 Bank St., Newark, N.J., 1850; 13 Arch St.,

1851; 244 Broad St., 1852. Dag'typist with brother-in-law Henry Insley at 81 Liberty St., NYC, 1840 (same location as 149 Broadway, 1840). *See also* Prosch, Miss Charlotte. CD; BD; BN; SA, 1846; RT; nsp advs., 1840–1846.

Read, George. Platemaker. Born 1817, Mass. Somerset (Bristol), Mass., 1850. USC.

Reynolds, Thomas. Platemaker. Smith near Dean, Brooklyn, 1847. Partner of James Williams. CD.

Rich, O. Platemaker. Court Ave., Boston, 1840. Nsp adv. *Boston Transcript*, Apr. 14–May 5.

Roach, John. Supplier of apparatus, philosophical-instrument maker. 293 Broadway, NYC, 1837–1841; 72 Nassau St., 1842–1844; 82 Nassau St., 1845–1852. Sold French Star Brand plates, 1850. Reported to have made cameras for Morse and Wolcott. CD; BD; SA; BN.

Rockwell & Kertson. Suppliers, manufacturers, importers of plate glass, dag'type materials, etc. 315 Broadway, NYC, 1858. BD.

Rosengarten & Sons. Suppliers, manufacturers of dag'type chemicals. Philadelphia, 1857. Montgomery P. Simons, *Plain Instructions for Coloring Photographs*, 1857.

Ross, A. M. Supplier of dag'type apparatus. Huron near Franklin, Brooklyn, 1859–1860. CD.

Sawyer, John. Trade name: New England Daguerreotype Stock Depot. Supplier, general line of dag'type materials. Bought out W. Shew, 1851. 125 Washington St., Boston, 1851–1856. HJ; BD; SA; SBD.

Schraeder, Augustus. Supplier: dag'type apparatus. NYC, 1844. CD.

Scott, Charles. Supplier. Ann Arbor, Mich., 1854. PAJ.

Scovill, William H. and J. M. Lamson (Bros.). Trade names: Scovills, Scovill Mfg. Co. Suppliers, manufacturers of metal products, dag'type, photographic apparatus and materials. Located in Waterbury, Conn. Began manufacture of buttons and trade tokens, about 1820. Dag'type platemakers, 1839–1860 (?). Framing mats, miniature cases,

1842–? Established NYC outlet at 101 Williams St., 1846; 57 Maiden Lane, 1850; 36 Park Row and 4 Beekman St., 1859. Continued expansion of Waterbury manufacturing plant, 1850–1870. Subsidiaries: Samuel Peck & Co. (thermoplastic cases and other photographic materials); American Optical Co. (cameras and lenses); Phoenix Plate Co. (ferrotype plates), 1860–1890(?). New York Warehouse, 419–421 Broom St., NYC, and Birmingham, Eng., 1870s. The photographic division separated from the metal division and name was changed to Scovill & Adams, 1889. Merged with E. & H. T. Anthony & Co., 1901. Trade names: Ansco (1907) and Agfa Ansco (1928). PWB; RT; BN; AMCA; BD; SA.

Smith, Frederick H. Supplier, manufacturer, dealer in miniature cases, etc. 97 Chestnut St., Philadelphia, 1846; 52½ Chestnut St., 1848. BD.

Smith, Peter (& Co.). Supplier, general line of dag'type and photographic apparatus, importer of French, English, and German photographic materials. 36 5th St., Cincinnati, Ohio, 1846–1850; Cincinnati, 1851–1869. CD; Cincinnati Almanac, 1850; PP.

Smith, W. H., & Co. Supplier: dag'type materials. 4 Maiden Lane, NYC, 1845–1846. Also carried fancy goods, guns, necklaces, etc. Adv., "late Young & Smith." RBD (*The East*).

Snelling, Henry Hunt. Author, supplier. Born Plattsburg, N.Y.; died June 24, 1897, St. Louis, Mo. Spent boyhood in the West; Ft. Snelling named after father, Josiah. Educated military academy, Georgetown, D.C. Librarian, N.Y. Lyceum. General sales manager for Edward Anthony, 1843 (?) to 1857. Employed at Internal Revenue Dept., 1860. Editor of *Reflector*, Cornwall, N.Y., 1871–1887. Became blind, 1887. Author: *The History and Practice of the Art of Photography*, 1849; *A Dictionary of the Photographic Art*, 1854; *A Guide to the Whole Art of Photography*, 1858. Editor: *The Photographic Art Journal*, 1851–1853; *Photographic and Fine Art Journal*, 1854–1860. Later, contributed a number of articles

about his experiences with early photography. ACB; PAJ; APB, 1888; BN.

Thompson, Josiah W. *See* Dag'typists.

Tilford, W. (William) H., & Co. Supplier, general line. Tilford House, St. Louis, Mo., 1848; 39 N. 4th St., 1857–1863. SLP, 1906; Missouri Historical Society.

Wells & Foster. Philosophical-instrument makers, manufacturers of dag'type apparatus. 2 Baker St., Cincinnati, Ohio, 1840. Nsp, *Cincinnati Daily Gazette*, May 12.

Westcott, C. P. Supplier. Watertown, N.Y., 1854. PAJ.

White, Edward, & Co. Supplier, manufacturer of plates and miniature cases, apparatus importer, dag'typist. Morocco casemaker, NYC, 1840–1841; 175 Broadway, 1842–1847; 247 Broadway, 1848–1850; Southern Dag'type Portrait Gallery and Furnishing Establishment, cor. Camp and Canal St., New Orleans, 1846–1848. Manufactured E. White Maker plates; manufactured jewel, morocco, surgical, dag'type, and dressing cases. Agents for White plates: Langenheim Bros., W. G. Mason, Litch, Whipple & Co., and Meade Bros. Won first premium, American Institute, 1845. Acquired the Anthony-Clark collection of dag'type portraits of eminent men, 1848. White's old establishment was bought (247 Broadway) by Hite, Langenheim, & Fanshaw, 1850. CD; BD; BN; SA; *Gazette of the Union* (Odd Fellows), 1848; PWB.

Williams, James. Platemaker. Smith near Dean, Brooklyn, 1847. Partner of Thomas Reynolds. CD.

Wisong, William A. *See* Dag'typists.

Wolf, J. G. Supplier: optical and dag'type apparatus, lenses. Born Bavaria. 96 Nassau St., NYC, 1839–1840. Imported lenses from Fraunhofer & Co., Munich. Studied under the master optician Fraunhofer, date unknown, Bavaria. Nsp adv., *N.Y. Evening Post*, Feb. 24, 1840; *U.S. Gazette*, Feb. 12, 1840.

Wulfing & Flato. Suppliers: imported materials and glass. 41 Platt St., NYC, 1846–1847. BD.

CASE MANUFACTURERS AND ENGRAVERS

Anthony, Edward. *See* Manufacturers and wholesale suppliers.

Barn & Ranflte. Morocco dag'type case manufacturers. 60 Nassau St., NYC, 1856–1857. BD.

Barnet, Frederick, & Son. Morocco dag'type case manufacturers. 152 Broadway, NYC, 1850–1851. BD.

Barnet, John. Jewel, dag'type, surgical, etc., case manufacturer. 129 William St., NYC, 1856–1858; 91 Fulton St., 1859–1860. BD.

Brady, John. Dag'type casemaker. Died 1851, NYC. Worked with brother Mathew B. Brady, date unknown. DJ, 1851, p. 211.

Brady, Mathew B. Jewel, surgical, dag'type, morocco case manufacturer. 164 Fulton St., NYC, 1843; 162½ Fulton and 189 Broadway, 1844–? *See also* Dag'typists.

Braillard, Francis. Morocco dag'type case manufacturer. 33 Day St., NYC, 1850–1851. BD.

Chemidlin, Nicholas. Dag'type frames. 89 Reade St., NYC, 1846–1847. BD.

Christy, William M. Morocco dag'type case manufacturer. 82 Chestnut St., Philadelphia, 1848. CD.

Clarke, J. Morocco dag'type case manufacturer. 29 Ferry St., NYC, 1853. *The Citizens and Strangers Pictorial and Business Directory*, NYC, 1853.

Coffert, S. M. Maker of dag'type frames. 119 Walker St., NYC, 1848. Won diploma for dag'type frames, American Institute, 1848. AI.

Cole, C. Morocco, jewel, and dag'type case manufacturer. 192 Broadway, NYC, 1841; 187 Broadway, 1844–1845. Nsp adv., *N.Y. Tribune*; CD.

Cooper, George. Morocco dag'type case manufacturer. 180 Fulton St., NYC, 1850–1851. BD.

Critchlow, Alfred P. Horn button maker, diesinker, thermoplastic casemaker, inventor. Born Birmingham, Eng. To America and settled Haydenville, Mass., 1843. Manufactured horn buttons; moved ca. 1846 to Florence, Mass. Experimented (date unknown) with a plastic composition, later known as the Florence Compound. Began manufacturing thermoplastic dag'type cases in 1853. A. P. Critchlow & Co., Northampton, Mass., 1856. Issued U.S. patent (15,915) on Oct. 14, 1856, and reissue on Apr. 21, 1857, for "embracing riveted hinges." Sold business in 1857, and firm became known as Littlefield, Parsons & Co. Information courtesy of J. Harry Du Bois; BD; RBD.

Curtis, Japhet, Jr. Sole manufacturer of Stiles' magnifying dag'type case. Southbury or Southford, Conn., 1850–1851. DJ, 1850, p. 220.

De Forest Brothers & Co. Morocco case manufacturers. Birmingham (Derby), Conn., 1856. RBD.

Downs & Jenkins. Dag'type wood frame manufacturers, NYC, 1848. Sold to southern and western suppliers. Rosewood, walnut, oak, maple, root, etc., frames. *Gazette of the Union* (Odd Fellows), 1848.

Eaton, L. & G. Morocco dag'type case manufacturers. Waterbury, Conn., 1849. RBD.

Eichmeyer, Henry A. Dag'type case manufacturer, dag'typist. All styles of cases except thermoplastic. 46½ Walnut St., Philadelphia, 1848; 62 Walnut St., 1854–1855 (dag'typist). Issued design patent (694) for miniature case, Feb. 27, 1855. BD, 1848; CD, 1854; U.S. patent records; AMCA.

Gaskill & Cooper. Diesinkers (?). Location unknown, ca. 1850. Tiny names embossed on leather case cover.

Goll, Frederick P. Diesinker, engraver, thermoplastic case manufacturer. 112 Fulton St., NYC, 1841–1845; 78 Fulton St., 1846–1860. Worked for Library of American History, Cincinnati, Ohio, 1851. Die-maker for Samuel Peck, 1854–1860. Reproduced in thermoplastic at least six historic designs taken from paintings. CD; BD; NYHS; BN; AMCA.

Gordon & Willis. Morocco case manufacturers. 17 S. 5th St., Philadelphia, 1848. Willis made cases, in partnership with M. P. Simons, until the above date. BD.

Hall, N. C., & Co. Morocco dag'type case manufacturer. 12 Park St., New Haven, Conn., 1856–1858. SBD; CD.

Hall, Ogden. Morocco dag'type case manufacturer. 24 W. Chapel St., New Haven, Conn., 1847–1853. Supplied cases for Scovill Mfg. Co. from May 1847 to 1850. Sold factory to Scovill Co. in 1850. Associate of Samuel Peck. PWB; CD.

Hart & Woodruff. Morocco dag'type casemakers. Southampton, Conn., 1849. RBD.

Hartnett, C. & J. Morocco dag'type case manufacturers. 2 Cortlandt St., NYC, 1841–1851; 13 John St., 1856–1857. BD.

Hayden, Hiram W. Die-maker, embosser, inventor, dag'typist. Worked for Scovill Mfg. Co. before 1854 as die-maker and embosser. Known as "artist of the village," Waterbury, Conn., 1851; exhibited three dag'type scenes on paper, Waterbury, 1851. Connection with Holmes, Booth, & Hayden, Waterbury and NYC, 1854–1858. Issued design patent (733), Oct. 9, 1855, for ornamental mats for dag'type cases. Made dies for thermoplastic dag'type case based on the painting *The Calmady Children*, by Sir Thomas Lawrence. SA, 1851; CD; PWB.

Henning & Eymann. Die-engravers, dag'type case manufacturers (plastic), diesinkers. NYC, 1859–1860.

Homer, Alfred P. Supplier: Morocco cases. 189 Chestnut St., Philadelphia, 1848. CD.

Houston, W. E. Diesinker. Designed dies for Holmes, Booth, & Hayden, ca. 1855–1860. Only die-maker known to have signed his name inside of die. OSU.

Jaiger & Adams. Morocco case manufacturers. 81 Nassau St., NYC, 1856–1857. BD.

Jennings, R. Maker of sliding dag'type case in velvet (?). Listed in Sotheby-Parke-Bernet auction, May 16, 1967.

Key, Frederick C. (& Sons). Engraver, casemaker, diesinker. 27 Beekman St., NYC, 1844–1849; Philadelphia, 1850–1855; 123 Arch St., 1856–1857. Made dies for Samuel Peck & Co., and Scovill Mfg. Co., 1854–1860 (?). Manufacturer of plastic cases, ca. 1860–1865 (?); name on label, "Excelsior Ambrotype Case." BD, NYC; CD, Philadelphia; NYHS; label in thermoplastic case, courtesy of Norman Mintz.

Kolt & Bloomhart. Morocco and velvet dag'type case manufacturers. 8 Harmony Ct., Philadelphia, 1856–1857. BD.

Larwill, Ebenezer. Morocco dag'type case manufacturer. 264 Plane St., Newark, N.J., 1840–1850 (?). One of his cases bears the label: "Original Inventor and Manufacturer of the Improved Daguerreotype Case. Patent applied for Jan 12, 1849." This was probably the double-door case. Information about double-door case courtesy of Les Stricker; trade label on extant case; AMCA, p. 25, fig. 12.

Littlefield, Parsons & Co. Manufacturers of thermoplastic dag'type cases and other articles. Successor to A. P. Critchlow & Co., Northampton, Mass. From 1858 manufactured plastic cases until shortly after the firm changed its name, in 1866, to Florence Manufacturing Co. 36 Warren St., NYC, 1859; Northampton and Florence, Mass., 1860. Largest manufacturers of thermoplastic cases in the late 1850s. BD; RBD; AMCA.

Loekle, Charles. Seal engraver. Philadelphia, 1852–1853 (?); NYC, 1858–1860. Signed leather embossed dag'type case cover "C. Loekle, Phila," date about 1855. NYHS; OSU.

Louis, Denis, & Son. Morocco dag'type case manufacturers. 170 Fulton St., NYC, 1850–1851. BD.

Loyd, W. Inventor of stereoscopic dag'type case. Philadelphia, 1856. Issued U.S. patent (14,670), Apr. 15, 1856, for stereoscopic dag'type case. U.S. patent records.

Martin, S. A. Manufacturer of dag'type case linings. 112 William St., NYC, 1856–1857. BD.

Mascher, John F. Inventor, stereoscopic

dag'type cases; manufacturer and assembler, morocco and thermoplastic stereoscopic cases; dag'typist and experimenter with pinhole dag'typing. Philadelphia, 1852; 508 N. 2d St., 1853–1857. Issued U.S. patent (9,611) for folding stereoscopic dag'type case, Mar. 8, 1853; patent (12,257) for stereoscopic dag'type medallion, Jan. 16, 1855; patent for skeleton book stereoscope, Feb. 18, 1856. Also, other photographic and nonphotographic inventions. Mascher was the first American to experiment with pinhole photography. SA; SBD; FIJ, 1855; AMCA.

Mausoleum Dag'type Case Co. Morocco dag'type case manufacturer. 335 Broadway, NYC, 1856–1857. Cases for portraits of deceased. BD.

Moxon, Alfred S. Morocco dag'type case manufacturer. 259 S. 2d St., Brooklyn 1856. CD.

Paine, R. Engraver, diesinker. Springfield, Mass., 1850s. Possibly designed first successful die for plastic cases. Die was made for Samuel Peck—the only case known to have been signed by him. PWB; OSU; AMCA, pl. 62.

Paquet, Anthony C. Engraver on wood, copper, and steel. Born 1814, Hamburg, Germany; died 1882 Philadelphia. To America, 1848. Philadelphia, 1850–1855. Signed name on embossed silk-covered miniature dag'type case design, Philadelphia, ca. 1852. NYC, 1856–1858. U.S. Mint, Philadelphia, as assistant engraver, 1857–1864; engraved first Congressional Medal of Honor. Exhibited medals, Pa. Academy, during the Civil War. NYHS; OSU.

Peacock & Fickert. Morocco dag'type case manufacturers. 61 Walnut St., Philadelphia, 1856–1857. CD.

Peck, Samuel. Grocer, pioneer dag'typist, inventor, manufacturer of thermoplastic dag'type cases, carver, music hall proprietor, undertaker. Dag'typist associated with Phineas Pardee, Jr., New Haven, Conn., 1844. Own studio, Dec. 1845. Issued patent for dag'type plate holder (7,326) on Apr. 30, 1850. Gave up dag'typing, 1850. Partnership with Scovill Mfg. Co. for manufacturing dag'type cases, New Haven, Conn., Mar. 1851. Associated with Ogden Hall, 1850–1853. Experimented in 1852 with plastic composition and was issued a U.S. patent (11,758) for dag'type case on Oct. 3, 1854. Partnership of Scovill Mfg. Co. and Peck was formalized under the name Samuel Peck & Co., 1855. Issued on Feb. 5, 1856, a U.S. patent for "fastening for the Hinges of Daguerreotype Cases" (14,202). Peck's interests in the company were purchased in 1857, and he left the concern in that year. Samuel Peck & Co. was

listed as dag'type case manufacturer at Day St. and West Chapel, New Haven, 1851–1858; listed as S. Peck & Co., 30 Day St., 1858–1859. Listed as carver, 1858–1859; proprietor of music hall, 1861–1876; proprietor of music hall and undertaker, 1876; undertaker only, 1877–1879. PWB; CD; DJ; information also courtesy of New Haven Free Public Library.

Pretlove, David. Engraver, diesinker, letter cutter. 241 Cherry St., NYC, 1844–1847; Fulton St. (probably partner of F. Goll), 1848–1850. Exhibited engravings, American Institute, Oct. 1846. Signed name to several designs for dag'type cases. CD; BD; AI; OSU.

Ramberry & Ebert. Suppliers of leather for morocco dag'type cases, manufactured cases (?). Georgetown, D.C., 1853–1854. Exhibited at N.Y. Crystal Palace, 1853. Horace Greeley remarked on display: "Very creditable leather-part of a specimen of dag'type leather which presents a remarkable fine-grained and smooth surface." Nsp, *N.Y. Tribune*, 1853.

Robinson, L. Morocco dag'type case manufacturer. Bristol, Conn., 1849. RBD.

Schaefer, Anthony. Engraver, diesinker. 83 Duane St., NYC, 1857–1859. Made dies for Littlefield, Parsons, & Co., 1858–? Themes mostly historical. NYHS; BD.

Schleunes, C. C. Morocco dag'type case manufacturer. 25 S. 2d St., Philadelphia, 1848. CD.

Scott & Woodruff. Morocco dag'type case manufacturers. Oxford, Conn., 1849. RBD.

Seele, John P. Morocco dag'type case manufacturer. 94 Duane St., NYC, 1850–1851. BD.

Seiler, Frederick. Engraver, diesinker. 57 Gold St., NYC, 1849; Seiler & Rupp (Christian), 1850; NYC, 1850–1854. NYHS; Katherine McClinton, *Handbook of Popular Antiques*, 1946.

Serrell, Alfred T. Jewel and dag'type case manufacturer. 30 Cherry St., NYC, 1844–1845. BD.

Shew, Myron. See Dag'typists.

Shew, Jacob. See Dag'typists.

Shew, William. See Dag'typists.

Simons, Montgomery P. *See Dag'typists.*

Simons, Noah A. Morocco dag'type case-maker, jewelry, music cases, etc. 120 S. 4th St., Philadelphia, 1846; 179 Chestnut St., 1847–1848. *See also* Simons, Montgomery P. CD; BD.

Simons & Wight. Manufacturer of morocco products, jewelry, dental surgical, dissecting, and dag'type cases. 20 S. 4th St., Philadelphia, 1846. BD.

Simons & Willis. Dag'type case manufacturers. 172 Chestnut St., Philadelphia, 1843. *See also* Simons, Montgomery P.; Simons, Noah A. BD.

Smith & Hartmann (Frederick B. Smith & Herman Hartmann). Engravers, diesinkers. 122½ Fulton St., NYC, 1850–1859. Made dies for Littlefield, Parsons & Co.; S. Peck & Co. Famous for reproducing Leutze's painting, *Washington Crossing the Delaware*, and Vanderlyn's painting, *The Landing of Columbus*, in whole-size cases. BD; BN; NYHS.

Smith, George. Morocco dag'type cover manufacturer. 249 Navy St., Brooklyn, 1856–1859. CD.

Smith, J. Engraver, diesinker. Worked for Samuel Peck and others, ca., 1855–1860 (?). Usually depicted scenes of nature, portrait, or conventional motifs. Signed name on several dies. OSU.

Smith, J. R. Morocco dag'type case manufacturer. 23 Ferry St., NYC, 1853. BD.

Spaulding Mfg. Co. Dag'type case manufacturer. Hartford, Conn., 1853. Applied for dag'type case patent resembling porte-monnaie. HJ, 1853, p. 239.

Stiles, Ann F. Inventor of magnifying dag'type case. Southbury, Conn., 1850. Issued U.S. patent (7,041) for magnifying dag'type case on Jan. 22, 1850. Japhet Curtis, Jr., sole manufacturer. DJ; AMCA.

Studley, Hiram. Morocco case manufacturer. 16 Haskins Bldg., Boston, 1848–1850. BD.

Studley & Gordon. Trade name: Miniature Case Manufactory. Morocco dag'type case manufacturers. 5 Hanover St., Boston, 1846. OSU; AMCA.

Stull, John. Inventor of stereoscopic dag'type case. Philadelphia, 1855. Issued U.S. patent (12,451) for stereoscopic folding dag'type case on Feb. 27, 1855. U.S. patent records.

Taylor, Edward. Morocco dag'type case manufacturer. 128 Fulton St. and 89 Nassau St., NYC, 1850. BD.

True, Benjamin C. Engraver, diesinker. Albany, N.Y., ca. 1842. Made cases for Meade Bros., Albany. Signed by True. Cincinnati, Ohio, 1850–1860. NYHS; OSU.

Wadham's Mfg. Co. Thermoplastic case manufacturer. Torrington, Conn., 1850s, exact date unknown. Organized 1838 as Wadham, Webster & Co. Began making workboxes, writing desks, dag'type cases, 1850s. Used Kinsley & Parker patented hinges on their plastic cases. Information courtesy of Kenneth Thompson.

Webber, J. Morocco dag'type case manufacturer. 5 N. William St., NYC, 1856–1857. BD.

Webekind, A. Miniature case designer. Philadelphia, ca. 1853. Information courtesy of Eaton Lothrop.

APPENDIX 1

A TABULATION OF HALLMARKS FOUND ON EXTANT DAGUERREOTYPES

The following compilation of die- and press-stamped identifying marks, symbols, initials, and names includes both those used by plate manufacturers and those used by photographic supply houses. A brief sketch accompanies each entry. Additional information may be found under the biographies of the plate manufacturers and daguerreotypists.

Hallmarks found on extant daguerreotypes often provide basic factual evidence toward establishing the approximate dates when each image was daguerreotyped. Information for established dates on hallmarks may be found, for example, under the hallmarks for Scovill Mfg. Co., Extra, Christofle, or H.B.H.; in each case, the plate could not have been in use before an established date.

Additional suggestions for determining the approximate dates of undocumented daguerreotypes have been placed in this section. An examination of the plate for extraneous configurations caused by plate holders or other apparatus may also be helpful —the possibility exists that plate configurations may be reconciled with one or more United States patents, thus providing a not-before date.

Also to be explored are the aperture shape and the finish of the framing mat, presumably the original, if the tarnish imprint does not vary. The protector is also a factor—they were not in general use before 1847. The image itself, by a comparison with documented daguerreotypes, might suggest a date through an analysis of the mode and manner of the pose, the process used (the vignette, for example), and the clothing worn by the subject, particularly if female.

The miniature case must also be taken into consideration. However, any date established by miniature cases needs a cautious analysis, since the photographic unit was not infrequently updated by being placed in a more fashionable or elaborate case (which also happened in later decades). And a miniature case was not necessarily sold immediately to a patron in a daguerreian gallery.

1. Alexander Beckers and Victor Piard, New York City. In business 1849–1856.
A.B.& P.

2. A. Gaudin, French plate, widely used in America ca. 1850–1855; peak year, 1853.

3. Rufus Anson. In business as a daguerreotypist at 589 Broadway, New York City. Anson was not a platemaker but die-stamped his daguerreotype plate to identify his work. First listed at the above address in 1854.
ANSON

4. Edward Anthony (and Company), New York City. Merchant and manufacturer of photographic supplies. In business from 1847. Advertised 1850: crescent, star, phoenix, Scovills, Scovills No. 2, and the new French galvanized plate. Advertised 1854: Scovills, the French plates star and triple star, HB, and Christofle.

4a. Hallmark star, ca. 1847–1848.

4b. Hallmark crescent, ca. 1848–1850.

4c. Ca. 1850. Usually found overlaid, identifying Anthony as an importer or jobber.

4d. Hallmark circle star, ca. 1850–1855. Later plates ca. 1853 omit the weight mark and add a tiny s mark close to the A.

5. Unknown platemaker, ca. 1841.
B

6. Unknown platemaker, ca. 1850.

7. Benjamin French, ca. 1854, Boston. Established in 1848 as a dealer in photographic materials.

8. Unknown platemaker, ca. 1851–1856. Not widely used.

9. Christofle. French platemaker; began manufacturing the scale hallmark plates in 1851.
CHRISTOFLE

10. Joseph Corduan, 1839–1843. Probably the first American daguerreotype platemaker. 28 and 30 Cherry St., New York City. Also (1840) Corduan and Perkins, New York City.
CORDUAN & C⁰

11. French hallmark, ca. 1858. Not widely used.

12. Enslin, Schrieber & Co., 3 Maiden Lane, New York City. Rare. Firm won diploma from the American Institute in 1856 for daguerreotype plates.
E.S. & C⁰

13. Edward White, 1842–1850. Plate-maker and dealer in photographic supplies, New York City and New Orleans.

13a. 1842–1850. Considered the best daguerreotype plate ever manufactured.
E. WHITE MAKER N.Y.
FINEST QUALITY A Nº.1

13b. Ca. 1845. Rare.
E. WHITE N.Y. ✱ 40

14. Unknown platemaker, ca. 1847. Rare. Probably French.
40 M E F° N°

15. Unknown platemaker, ca. 1854.
F S ☆

16. Unknown platemaker, ca. 1850. Probably French.
40 GARANTIE.A.R.

17. Eagle plate, ca. 1853–1858. Not widely used. Probably made by Gennert Bros., 106 Center St., New York City.

18. Grise. French platemaker.

18a. Probably early Grise plate, ca. 1844. Rare.
40

18b. Hallmark diamond, ca. 1845–1847. Not widely used.
DOUBLE GRISE 40

18c. Hallmark eagle and diamond, ca. 1854. Not widely used.
40 DOUBLE GRISE

19. Unknown French platemaker, ca. 1850–1858; peak years, 1852–1855. Probably the most popular French plate.
H.B. 40

20. Holmes, Booth, and Hayden, 37 Maiden Lane, New York City. 1855 and later.

20a. Eagle plate, 1855–1861. Marginally popular.
H.B.H. 40

20b. Wreath plate, 1855–1861. Marginally popular.

21. Unknown platemaker, ca. 1848–1858. Probably French. Hallmark is hexamerous figure.
 40

22. Unknown platemaker, ca. 1853. Probably American.
H.H. 40

23. Unknown platemaker, ca. 1843–1845. Silversmith-style die-marks. Not widely used.
40 H.S

24. Unknown platemaker, ca. 1854. Probably German.
40° IH🐝

25. Unknown French platemaker, ca. 1849. Not widely used. At least two variants exist: one, ca. 1849, has a weight mark on the top left side of the plate and a hallmark on the top right; the other, ca. 1850, substitutes the letter B in the center of a sunburst. Both are rare.
40

26. Unknown French platemaker, ca. 1850. Possibly a J-B brand variant. Rare.
40 DOUBLE

27. Unknown platemaker, ca. 1855–1859. Widely used. Possibly the well-advertised French star brand.
J.F.S. ☆ 40

28. American platemaker, ca. 1848–1849, New York City. Not widely used.
JONES & CO.
N.Y.

29. Unknown French platemaker, ca. 1850–1858; peak years, 1854–1856. Probably the second most widely used French plate.
 4 0

30. Unknown French platemaker, ca. 1855. Hallmark similar to E-R and N-W brands. Rare.
 DOUBLE J W 40

31. Unknown platemaker, ca. 1840–1845. Dated plate, 1841.

31a. Popular early plate. A variant, ca. 1840, is overlaid on an unknown French hallmark.
L.B.B&C° 40

31b. Unknown platemaker, ca. 1842. Same maker as drawing a but a higher-quality plate. Possible early Binsse plate.
 20

32. Louis B. Binsse and Company, New York City, ca. 1844–1848. American platemaker.
L.B.BINSSE & C°N.Y. 40

33. Levi Chapman, American platemaker, ca. 1850–1855 (plates). 102 William St., New York City.
L. CHAPMAN
N.Y.

34. Unknown platemaker, ca. 1855. Rare.
L.G. 40.

35. Unknown platemaker, ca. 1844. Rare. Possibly sold or manufactured by Mc-Clees, Philadelphia; Meade Brothers, Albany; or J. G. Moffet, Bloomfield, N.J.
M 40

36. American platemaker, Philadelphia, ca. 1847–1850. Rare. Also daguerreotypists.
McCLEES & GERMON

37. Unknown platemaker, ca. 1857. Probably American.
MAGIC

38. Unknown platemaker, ca. 1851–1852. Probably American.
M.S.

39. Unknown platemaker, dated plate, 1855. Probably American.
N & W

40. Unknown platemaker, ca. 1856; dated plate, 1856. Rare.
Nº 1

41. American platemaker, ca. 1855–1857. J. W. Norton, 447 Broom St., New York City.
NORTON

42. Unknown platemaker, ca. 1849–1857; peak years, 1850–1852. Very popular brand. Advertised as French plate.
Nº 40

43. American platemaker, date unknown.
PEMBERTON & CO.
CONN.

44. Unknown platemaker, ca. 1848–1856. Not widely used. Probably French.
PHŒNIX

45. Unknown platemaker, ca. 1850–1857. Not widely used. Probably American.
S & F

46. J. M. L. Scovill and W. H. Scovill, Waterbury, Conn., American plate-makers. Began making plates in 1839. Leading plate manufacturer in the 1840s. Declined in popularity ca. 1848. Plate name changed in 1850 to Scovill Mfg. Co.

46a. Die-stamp from an 1849 plate. The die-stamps used by Scovills varied from year to year. It is possible to establish date data by matching die characteristics with plates having documentary dates. The dies used on the 1848–1850 plates do not have the letter V in *Scovills* cast in an off-vertical center manner.
SCOVILLS

46b. A lower-quality plate manufactured ca. 1841–1846.
SCOVILLS Nº 2

46c. Plates manufactured 1850 and later.
SCOVILL MFG.CO. EXTRA.

47. Unknown platemaker, ca. 1850. Light in weight, one-sixtieth part silver.
60

48. Unknown platemaker, ca. 1845. Probably rare French plate. Early daguerreotypes often contained one-twentieth part silver instead of the usual one-fortieth.
20M

49. Unknown platemaker, ca. 1848–1853. Probably American. Die-stamped silversmith-style. Fairly popular.
W.H.H.

50. Unknown platemaker, ca. 1850.
ZOA-GARENTI 40

APPENDIX 2

UNITED STATES PATENT RECORDS

Collectively, the United States patent records for photography are an overview and a measure of the art's development from 1840 to 1860. The graphic representations of the drawings and the precise wording of the specifications provide an intimate insight into photography's efforts toward improvement. Many of the inventions patented were useful for brief periods of time, others lasted longer, while a few were recorded only to fall into immediate discard.

The following table lists all the patents issued under the words "daguerreotype," "daguerreotypes," and "daguerreotyping." Other patents for photography may be found under separate nomenclature in the patent office index, not shown.

THE UNITED STATES PATENT OFFICE
Index of patents issued from the United States Patent Office from *1790* to *1873*, inclusive

Invention.	Inventor.	Residence.	Date.	No.
D.				
Daguerreotype-apparatus	J. Brown	New York, N.Y.	Nov. 15, 1853	10,225
Daguerreotype-apparatus	W., W. H., and H. J. Lewis	New York, N.Y.	Nov. 11, 1851	8,513
Daguerreotype-apparatus for gilding plates	W. and W. H. Lewis	New York, N.Y.	May 8, 1849	6,431
Daguerreotype-apparatus for panoramic views	I. Van Bunschoten, J. G. Woodbridge, and W. Mann	New York, N.Y.	Apr. 17, 1849	6,357
Daguerreotype-case	R. Hill	New York, N.Y.	June 18, 1861	32,562
Daguerreotype-case	I. F. Mascher	Philadelphia, Pa.	Mar. 8, 1853	9,611
Daguerreotype-case hinges, Fastening for	S. Peck	New Haven, Conn.	Feb. 5, 1856	14,202
Daguerreotype-case, Monumental	J. Bergstresser	Berrysburgh, Pa.	Feb. 8, 1859	22,850
Daguerreotype-cases, &c., Apparatus for the manufacture of	H. T. Anthony and F. Phoebus	New York, N.Y.	Mar. 23, 1854	10,953
Daguerreotype-cases, Manufacture of	H. Halvorson	Cambridge, Mass.	Aug. 7, 1855	13,410
Daguerreotype-cases, Manufacture of	S. Peck	New Haven, Conn.	Oct. 3, 1854	11,758
Daguerreotype-cases, Mold for making	J. L. Baldwin	Newark, N.J.	Feb. 11, 1862	34,344
Daguerreotype-cases, &c., Process for ornamenting	J. F. Mascher	Philadelphia, Pa.	Feb. 10, 1857	16,600
Daguerreotype face-plates or mats, Machine for beveling and polishing the inner edges of	E. Brown	Waterbury, Conn.	July 3, 1855	13,196
Daguerreotype-mat	J. Dean	Worcester, Mass.	Dec. 24, 1861	34,035
Daguerreotype-picture	C. J. Anthony	Pittsburgh, Pa.	Jan. 1, 1851	7,865
Daguerreotype-picture	H. E. Insley	New York, N.Y.	Jan. 6, 1852	8,633
Daguerreotype-picture case	A. F. Stiles	Southbury, Conn.	Jan. 22, 1850	7,041
Daguerreotype-pictures, Coloring	D. Davis, Jr.	Boston, Mass.	Oct. 22, 1842	2,826
Daguerreotype-pictures, Coloring	W. Thompson	Philadelphia, Pa.	May 12, 1843	3,085
Daguerreotype-plate buffing apparatus	W. and W. H. Lewis	New York, N.Y.	July 22, 1851	8,235
Daguerreotype-plate holder	P. H. Benedict	Syracuse, N.Y.	Jan. 31, 1854	10,466
Daguerreotype-plate holder	D. N. B. Collin, Jr.	Lynn, Mass.	Feb. 6, 1855	12,344
Daguerreotype-plate holder	M. Finley	Canandaigua, N.Y.	Oct. 4, 1853	10,693
Daguerreotype-plate holder	J. Hill	Skaneateles, N.Y.	Aug. 22, 1854	11,565
Daguerreotype-plate holder	R. Knecht	Easton, Pa.	Feb. 7, 1854	10,508
Daguerreotype-plate holder	G. Mallory	New York, N.Y.	Sept. 17, 1850	7,655
Daguerreotype-plate holder	S. Peck	New Haven, Conn.	Apr. 30, 1850	7,326
Daguerreotype-plate holder	D. Shive	Philadelphia, Pa.	Oct. 9, 1855	13,665
Daguerreotype-plate-polishing machine	D. Shive	Philadelphia, Pa.	Mar. 20, 1855	12,560
Daguerreotype-plate vise	S. S. Day	New York, N.Y.	Oct. 23, 1855	13,701
Daguerreotype-plates, Apparatus for cleaning and buffing	T. Longking	Brooklyn, N.Y.	Jan. 31, 1854	10,475
Daguerreotype-plates, Apparatus for holding	W. and W. H. Lewis	New York, N.Y.	Oct. 23, 1849	6,819
Daguerreotype-plates, Apparatus for polishing	B. F. Upton	Bath, Me.	Sept. 19, 1851	11,709
Daguerreotype-plates, Block for holding	A. Beckers	New York, N.Y.	Oct. 23, 1849	6,812
Daguerreotype-plates, Box for coating	W. and W. H. Lewis	New York, N.Y.	Nov. 15, 1853	10,233
Daguerreotype-plates, Box for coating	J. H. Tompkins	Buffalo, N.Y.	Jan. 15, 1856	14,122
Daguerreotype-plates, Coloring	J. B. Isenring	Canton of St. Gall, Switzerland	Jan. 30, 1846	4,369

THE UNITED STATES PATENT OFFICE

Index of patents issued from the United States Patent Office from *1790* to *1873*, inclusive—Continued

Invention.	Inventor.	Residence.	Date.	No.
Daguerreotype-plates, Coloring	F. Langenheim	Philadelphia, Pa.	Jan. 30, 1846	4,370
Daguerreotype-plates, Machine for cleaning	C. Ketcham	Penn Yan, N.Y.	June 29, 1858	20,718
Daguerreotype-plates, Machine for polishing	T. Duryea	Williamsburgh, N.Y.	June 15, 1852	9,018
Daguerreotypes, Cameras for taking stereo-scopic and other	S. A. Holmes	Brooklyn, N.Y.	May 30, 1854	10,987
Daguerreotypes, Coloring	W. A. Pratt	Alexandria, D.C.	Mar. 14, 1846	4,423
Daguerreotypes, Coloring	B. R. Stevens and L. Morse	Lowell, Mass.	Mar. 28, 1842	2,522
Daguerreotypes for stereoscopes, Taking	A. S. Southworth and J. J. Hawes	Boston, Mass.	July 11, 1854	11,304
Daguerreotypes, Gilding	C. L'Homdieu	Charleston, S.C.	Oct. 26, 1852	9,354
Daguerreotypes in monumental stones, Securing	S. Jenkins	West Cambridge, Mass.	Mar. 11, 1851	7,974
Daguerreotypes, Taking	J. A. Whipple	Boston, Mass.	Jan. 23, 1849	6,056
Daguerreotyping	W. Yarnall	Newark, Ohio	Dec. 28, 1852	9,511
Daguerreotyping, Mercury bath for	B. F. Upton	Bath, Me.	Apr. 12, 1853	9,666

NOTES

1. Events Leading to Photography in America

1. In 1852, Sir David Brewster of the British Museum stated that a small plano-convex rock crystal found near Nineveh was a true optical lens, with a focal length of four and a half inches. See Arthur T. Gill, "When is a Lens not a Lens?" *Photographic Journal* 113 (December 1973): 606.

2. *Encyclopaedia Britannica*, 11th ed., s.v. "Camera Obscura." This excellent account was written by Maj. Gen. James Waterhouse, assistant surveyor general in charge of photographic operations in the surveyor general's office, Calcutta, 1866 through 1897. Waterhouse was also vice-president of the Royal Photographic Society.

3. Robert Hunt, *A Manual of Photography* (London & Glasgow: Richard Griffin & Company, 1854), p. 4.

4. Helmut Gernsheim and Alison Gernsheim, *A Concise History of Photography* (New York: Grosset & Dunlap, 1965), pp. 15, 16.

5. Hunt, *Manual of Photography*, p. 4.

6. Ibid., pp. 4, 5.

7. *Literary Gazette*, February 9, 1839, p. 90.

8. Edward Lind Morse, *Samuel F. B. Morse: His Letters and Journals* (Boston & New York: Houghton Mifflin Company, 1914), p. 421.

9. Ibid., p. 129. Morse's March 9 letter was published in the *New York Observer* of April 20, 1839.

10. Arthur T. Gill, "Call Back Yesterday," *Photographic Journal* 112 (March 1972): 103.

11. *Literary Gazette*, March 2, 1839, pp. 137, 138. Francis Bauer's letter to the *Gazette* was dated February 27, 1839. Also enclosed with Bauer's correspondence was a translated copy of Niepce's communication to the Royal Society, dated December 9, 1827, which was reprinted in the *Gazette*. In his letter to the society, Niepce states that his process "may be applied on copper as well as pewter. I have tried it several times on stone successfully, and I am led to believe that glass would be, perhaps, preferable."

12. Hunt, *Manual of Photography*, pp. 13–17. Niepce's complete process is given, including a diagram.

13. Ibid., p. 34.

14. Levi L. Hill, *A Treatise on Daguerreotype* (1850; reprint ed., New York: Arno Press, 1973), pt. 1, pp. 6, 7.

15. Arthur T. Gill, "Call Back Yesterday," *Photographic Journal* 112 (July 1972): 232, 233.

16. Article reprinted in the *Literary Gazette*, January 12, 1839, p. 28.

17. Gernsheim and Gernsheim, *Concise History of Photography*, pp. 27, 28.

18. Arthur T. Gill, "Call Back Yesterday," *Photographic Journal* 113 (January 1973): 25, 47. An excellent account of Talbot's early attempts with photogenic drawing.

19. "Painting by the Action of Light," *Chambers' Edinburgh Journal*, June 1, 1839, p. 174.

20. A complete report of Talbot's speech may be found in the *London and Edinburgh Philosophical Magazine and Journal of Science* 14 (March 1839): 196–208.

21. Ibid., pp. 209–211. See also letters written by Talbot to the editor of the *Literary Gazette*, reprinted on February 2, 1839, and February 23, 1839.

22. Robert Taft, *Photography and the American Scene* (New York: Macmillan Company, 1938), p. 472. Taft quotes in his note 116 from the Herschel-Talbot letter, reprinted through the courtesy of Miss T. Talbot and Alexander Barclay of the Science Museum, London.

23. Ibid., p. 105.

24. *Literary Gazette*, February 23, 1839, p. 124, mentions Sir David Brewster as pursuing investigations in photography.

25. *Journal of the Franklin Institute* 22 (May 1843): 364.

26. Reprinted from the *Cincinnati Republican* in the *United States Magazine and Democratic Review* 5 (June 1839): 611, 612.

27. *Chambers' Edinburgh Journal*, October 19, 1839, p. 332, printed an account about an early use of photogenic paper:

We have ourselves a somewhat remarkable fact respecting photography to communicate to the public. Since the subject came into notice in Britain, a young Scotch barrister of our acquaintance has brought to us a number of specimens of the art, executed by himself and his young companions, fifteen years ago, *when they were attending the grammar-school of Aberdeen. Photography, which has since become the subject of so much interest and so much discussion among grave men, was then and there practised merely as one of the ordinary amusements of the boys, a sheet of paper covered with nitrate of silver, and then held up to a sun-lit window with a leaf or feather or picture before it, being the whole mys-*tery of the process. Our young friend has no recollection of its being considered as any thing either new or wonderful: it simply ranked amongst the other amusements which boys in a great school hand down from one to another. The specimens exactly resemble those which have been exhibited during the last few months before our scientific societies, but are of course very different from the exquisite productions of M. Daguerre, as described by Sir John Robison.*

How were the prints fixed in about 1824? A simple explanation might be that the idea stemmed from a well-known household hint for the ladies—a solution of common salt in water was long used to retard fading of colors in fabrics. Thus, it would have been logical to apply this principle to sensitized paper. How widespread the use of photogenic paper was in 1839 is unknown. Richards sold sensitized paper in Philadelphia in the summer of 1839.

28. *Cincinnati Daily Gazette*, February 8, 1840.

29. James Wynne, "Samuel F. B. Morse," *Harper's Monthly Magazine* 24 (January 1862): 227. Wynne (1814–1871), physician and author, details the tribulations of Morse's trip to Europe.

30. *Literary Gazette*, March 16, 1839, p. 171.

31. *New York Observer*, April 20, 1839. For the complete letter by Morse to his brothers, see Samuel Irenaeus Prime, *The Life of Samuel F. B. Morse* (New York: D. Appleton & Company, 1875), pp. 400–402.

32. Prime, *Life of Morse*, pp. 406, 407.

33. Morse, *Samuel F. B. Morse*, 1: 141–142.

34. Prime, *Life of Morse*, pp. 405, 406.

35. Morse, *Samuel F. B. Morse*, 1: 142–143.

36. *Journal of the Franklin Institute* 23 (April 1839): 263.

37. *American Journal of Science and Arts* 37 (July 1839): 169–185. This was reprinted from *Foreign Quarterly Review*, no. 81.

38. *Literary Gazette*, July 20, 1839, p. 459.

39. Apparently it had not been Daguerre's intention to give the process to the world. In a letter to the *Athenaeum* of October 18, 1839, Daguerre discusses the English patent for his process obtained by Miles Berry and he writes: "I would add that if you will take the trouble to read attentively the articles of agreement between me and the sold, not

to the civilized world, but to the Government of France for the benefit of my fellow countrymen." From the *Athenaeum*, October 26, 1839, p. 813.

40. *Literary Gazette*, August 24, 1839, p. 538.

41. The exact date when Daguerre's manual was published seems uncertain; several publishers were involved, all printing the same title, *Historique Et Description, Des Procedes Du Daguerreotype, Et Du Diorama*. Some photographic historians believe the manual was for sale a few days after Arago's revelations of August 19; others place the date in the first week of September. See Pierre G. Harmant, "Daguerre's Manual—A Bibliographical Enigma," *History of Photography: An International Quarterly* 1 (January 1977): 79–83.

42. *Literary Gazette*, August 24, 1839, p. 539.

43. *London Globe*, August 23, 1839.

44. *Literary Gazette*, August 24, 1839, p. 539.

45. *Boston Daily Advertiser and Patriot*, October 17, 1839. The date of the Paris letter was September 17. A reprint from the *New York Evening Star*.

2. The Pioneer Days, 1839–1840

1. *New York Commercial-Advertiser*, September 10, 1839. Hall had just completed arrangements for his newspaper to receive French market reports and Far Eastern news directly from France.

2. During this period almost all American editors relied on reprinting European news from English newspapers; consequently, French news was scarce, even in New Orleans.

3. However, photographic historians question whether the booklets detailing Daguerre's process were available to the public at that date.

4. The *Great Western* was the fastest steamship in service between England and New York in the fall of 1839. The *Liverpool* out of Liverpool and the *British Queen*, sailing from London via Portsmouth, each owned by a separate corporation, were the chief competitors for the luxury trade in this era. Their westward passage averaged from fourteen to eighteen days—the *Great Western*'s fastest trip was twelve and a half days—much quicker than the usual four to five weeks required by sailing packets. All three ships ran on a flexible seven-week schedule from their home ports. Fares on the *Liverpool* in May of 1839 were $163.33 and $140 in the foresalon plus $6.66 steward's fees, and no second-class passengers. American newspapers of 1839 would head their European news stories by citing the steamship's name and date of arrival at New York, thus assuring the reader of the latest possible news.

5. National Archives, *Passenger Lists of Vessels Arriving at New York, 1820–97*, Record Group 36 (M237), no. 40 (September 6–December 31). Steamship *Great Western* manifest list of passengers arriving in New York harbor, September 10, 1839. The list contains a number of passengers, besides Francis Hall and the Reverend Edward Kirk, who could possibly have had an interest in the daguerreotype. Most of the seventy-one male passengers aboard the ship were American merchants; also aboard were six French nationals, none of whom are recognizable in the history of photography, nor were the twenty-five Englishmen and the one German. Perhaps future research will connect more names with the history of photography.

6. *New York Evening Post*, September 20, 1839. The *Globe's* reprint appears on the same page.

7. National Archives, *Passenger Lists of Vessels Arriving at New York, Index to Names*, Record Group 36 (M261), no. 87. A search failed to find a D. W. Seager, or any variations of that name, arriving at the port of New York between 1820 and 1846. However, of interest was the arrival of A. (or T.) Segers, a merchant and United States citizen, on the *Great Western* on April 15, 1839. Samuel Morse returned on the same ship, and presumably the men were acquainted.

8. Beaumont Newhall, *The Daguerreotype in America* (New York: Duell, Sloan & Pearce, 1961), p. 22.

9. *American Journal of Science and Arts*, 37 (October 1839): 375. When the editorial comment was printed, the journal had three editors: Benjamin Silliman, Sr., Benjamin Silliman, Jr., and James D. Dana. Dana was absent on this date. It may be assumed that both Sillimans were privy to the information, because it was signed in the plural. While the "professional gentleman" must remain unknown, the chemist was most likely Dr. James R. Chilton, whose reputation was known both at home and abroad.

10. *Niles' National Register*, September 21, 1839. Whether the weekly publication was making excuses for not publishing the article from the *Globe* at an earlier date or whether the individuals in question did not want the information to become public knowledge is a matter for speculation.

11. Prime, *Life of Morse*, pp. 407–408. Morse claimed in his letter to Daguerre, dated November 16, 1839: "The first brochure which was opened at the booksellers' containing your *exposé* of the process, I possess" (ibid.). Morse did not state the date of his acquisition; thus the possibility exists that a shipment of manuals was aboard the *British Queen*.

12. Carleton Mabee, *The American Leonardo: A Life of Samuel F. B. Morse* (New York: Alfred A. Knopf, 1943), pp. 228–229. Sixteen years later, Morse said that he had taken this view from a staircase window on the third floor of the City

of New York University. Exposure time was about fifteen minutes, following the instructions in Daguerre's first booklet exactly.

13. Seager's counterpart had appeared in England on September 13, 1839, to give a first demonstration of Daguerre's process. Its format closely resembled the demonstration given by Seager some three weeks later in New York: "M. D. St. Croix, a French gentleman, performed the operation with great dexterity and complete success. The House in which he exhibited the performance is situated close to the Regent Circus, Piccadilly, and having a view of part of Regent street and the Circus. This view he proposed to represent to the spectators" (*New Yorker*, "The Daguerreotype," November 2, 1839, p. 100); also see the *Literary Gazette*, September 14, 1839, p. 605. The daguerreotype was also introduced in Spain before the year was out: "The Daguerreotype in Spain. At Barcelona a fete was got up, not long since, on the first exhibition of the Daguerreotype. An immense crowd assembled in the square, where the instrument was set up, with banners and music, and so great was the contest for the impression, when taken, that it was disposed of by lottery" (*Boston Evening Transcript*, January 27, 1840).

14. *New York Commercial-Advertiser*, October 5, 1839.

15. Ibid., October 10, 1839.

16. Joseph Dixon claimed that he had taken a portrait in September 1839; see the *Philadelphia Photographer* 5 (1868): 53. However, we do not believe in the validity of Dixon's claim. At a meeting of the American Institute on April 14, 1858, several prominent men in photography were present, including John Johnson, Charles Seeley, Edward Anthony, and Joseph Dixon. Dixon made no effort to dispute Johnson's outline of the Wolcott-Johnson activities of 1839 and 1840. At an earlier meeting on February 10, Dixon read a paper on the history of photography, and again no claim to a September portrait was made. Also see Taft, *Photography and the American Scene*, p. 456, n. 31.

17. *Eureka* 1 (September 1846): 7, 8; reprinted in the *Daguerreian Journal* 2 (June 1851): 57, 73–80. What happened to the first successful portrait? Samuel Humphrey, in *Humphrey's Journal* 7 (1855): 97, states that it was then in his possession; he wrote that he intended to send it across the Atlantic to friends and admirers of the art. What happened to it remains unknown.

18. *American Repertory of Arts, Sciences, and Manufactures* 1 (April 1840): 193. At this time Mapes was a noted chemist as well as editor and publisher of this journal.

19. Julius F. Sachse, "Philadelphia's Share in the Development of Photography," *Journal of the Franklin Institute*

135 (April 1893): 272. For an earlier account of Goddard and bromine, see the *Proceedings of the American Philosophical Society* 3 (1843): 180.

20. *Daguerreian Journal* 2 (1851): 79.

21. *American Repertory of Arts, Sciences and Manufactures* 1 (March 1840): 131.

22. Sachse, "Philadelphia Photography," p. 278; also see the *Philadelphia Photographer* 8 (1871): 225. Sachse implies that the daguerreotype was a portrait, but whether a portrait was shown is not clearly defined. Apparently Marcus Root, the Philadelphia daguerreotypist, gathered together a number of memorials of the early history of the art to be placed in the archives of the Pennsylvania Historical Society. For additional information, see *Photographic and Fine Art Journal* 12 (April 1860): 94.

23. Marcus A. Root, *The Camera and the Pencil* (Philadelphia: M. A. Root, 1864), p. 352.

24. National Archives, *Passenger Lists of Vessels Arriving at New York, 1820–97*, Record Group 36 (M237), no. 40.

25. *Lexington Gazette*, September 26, 1839. Advertisement for Transylvania University.

26. Taft, *Photography and the American Scene*, pp. 20–21.

27. *Appleton's Cyclopaedia of American Biography*, s.v. "Henry Fitz." Apparently Fitz never lost interest in cameras, because just before he died he was about to procure patents for a camera which involved a new form of lens. Also, he had been a practicing daguerreotypist in Baltimore from 1840 to 1842. See Newhall, *Daguerreotype in America*, p. 144.

28. *American Repertory of Arts, Sciences, and Manufactures* 1 (April 1840): 193.

29. Prime, *Life of Morse*, pp. 407–408.

30. John W. Draper, "On the Process of Daguerreotype, and its application to taking Portraits from the Life," *London and Edinburgh Philosophical Magazine and Journal of Science* 17 (July 1840): 217–223. This is the earliest article by Draper detailing his experiments with the portrait. In a letter of July 28, 1840, to Sir John Herschel, he wrote: "I believe I was the first person here who succeeded in obtaining portraits from the life." (Taft, *Photography and the American Scene*, pp. 29–30). Draper's claim can be clarified in his article "Remarks on the Daguerreotype," *American Repertory of Arts, Sciences, and Manufactures* 1 (July 1840): 403, where he specified how he obtained his first portrait: "The first portrait I obtained last December was with a common spectacle glass, only an inch in diameter, arranged at the end of a cigar box."

31. In an invitation to an exhibition, Gouraud mentioned that he had arrived by the *British Queen*, a statement not substantiated by the ship's official passenger list. See National Archives, *Passenger Lists of Vessels Arriving at New York, 1820–97*, Record Group 36 (M237), no. 40; *Index to Passenger Lists of Vessels Arriving at New York, 1820–46*, Record Group 36 (M271), no. 37, Gon-Graw; *Passenger Lists of Vessels Arriving at Baltimore, 1820–91*, Record Group 36 (M255), no. 2 (the year 1839 is missing from the roll); *Passenger Lists of Vessels Arriving at Boston, 1820–91*, Record Group 36 (M277), no. 13; *Passenger Lists of Vessels Arriving at New Orleans, 1820–1902*, Record Group 36 (M259), no. 19.

We made a thorough search to determine when and by what port François Gouraud entered the United States, but no record of his entry was found. The manifest passenger list of the *British Queen*, dated November 25, 1839, showed but a handful of Frenchmen aboard; none of the names resembled Gouraud's. The closest similarity to his name was found on the deluxe French sailing ship *Andelle*, which came into New Orleans on November 19, 1839, carrying Guillamane François Girurd, a guild artist. On the same day a ship left New Orleans for New York and, considering the time involved, it is possible that Gouraud was aboard because he seems to have surfaced in New York about the twenty-ninth of November. Also, it is possible that he came into the United States through Canada, Philadelphia, or a port whose records are not available. Taft, in *Photography and the American Scene*, in a footnote on page 41, states that Gouraud's name was on the passenger list for the *British Queen* on September 21. The name of Guddard, age forty-eight, of France appears on the list, but it is unlikely that this was Gouraud. We also examined numerous passenger lists appearing in various newspapers without finding François Gouraud, and so the mystery remains.

32. *New Yorker*, December 14, 1839.

33. *The Knickerbocker* 14 (December 1839): 560–561.

34. Mabee, *American Leonardo*, p. 233. This notebook was the first written record of photographic experiments in America.

35. Ibid., pp. 234–235.

36. *New York Journal of Commerce*, January 21, 1840.

37. Mabee, *American Leonardo*, p. 407, n. 7. In his letter of November 4, 1839, to Alfred Vail, Morse wrote that George Prosch was making perfect daguerreotype instruments for forty dollars. Undoubtedly, this was the first American camera manufactured in this country. However, J. G. Wolf had not yet developed his lens system.

38. *New York Evening Post*, January 31, 1840. The original spelling of the advertisement has been preserved.

39. Ibid.

40. Gouraud advertised his lecture series widely in newspapers, and even the prestigious publication *The Albion*, on February 8, 1840, carried an advertisement identical to the one in the *New York Evening Post*.

41. *New York Commercial-Advertiser*, February 6, 1840.

42. Mabee, *American Leonardo*, p. 235.

43. Whether François Gouraud was directly responsible for the sale of toilet articles, if indeed they were sold, is not clear. F. Felix Gouraud was a leading New York dealer in cosmetics in this period; although his relationship to François is unknown, we assume that the two may have been related.

44. *Boston Weekly Messenger*, March 11, 1840.

45. *Charleston Courier*, February 20, 1840. The advertisement ran through March 17, although several days were missed.

46. *New York Evening Post*, February 21, 1840. Prosch's advertisement appeared almost daily through May 10. It also appeared in the *New York Observer* from February 29 to March 14.

47. *Cincinnati Daily Gazette*, May 12, 1840.

48. *American Journal of Science and Arts* 40 (1841): 139.

49. *Eureka* 1 (1846): 25.

50. Taft, *Photography and the American Scene*, p. 34. Also see his note 42 (1861), regarding the letter written by "G". If Taft is wrong in his assumption and "G" right, the studio at 52 First Street would have been in operation by February 2. If so, the first photographic studio in the world would have been in operation in January 1840, not in February as often stated. We believe the "G" to represent Jeremiah Gurney.

51. *British Journal of Photography*, June 4, 1886, p. 362.

52. Floyd Rinhart and Marion Rinhart, "Wolcott and Johnson: Their Camera and Their Photography," *History of Photography: An International Quarterly* 1 (April 1977): 132–133. The article gives an account of the first establishment of the Wolcott-Johnson system in England as well as the New York operation.

53. Ibid., p. 132. Albert Southworth was one of the Americans to experiment with the circular room principle. The story of his experiences can be found in the *Philadelphia Photographer* 10 (1873): 277.

54. *Boston Evening Transcript*, March 7, 1840.

55. Ibid., March 11, 1840.

56. Skeptics and photographic historians have repeatedly challenged Gouraud's statement regarding exposure time. We believe that, because of the rapidly moving events, he may have overstated his minimum time but not to the extent hitherto presumed.

57. Josiah B. Millet, *The Life and Works of George Fuller* (Boston & New

York: Houghton Mifflin Company, 1886), pp. 14–15. Fuller bought the apparatus and returned to Deerfield. Apparently, he used the apparatus only once, when he took a daguerreotype of the old homestead.

58. *Boston Evening Transcript*, May 30, 1840.

59. Mabee, *American Leonardo*, pp. 237–240. Reprinted letters of the controversy between Morse and Gouraud. See also *Boston Evening Transcript*, June 26, June 30, June 24, 1840.

60. Mabee, *American Leonardo*, p. 240.

61. Ibid., p. 241.

62. Most historians place Gouraud's death about 1848, but many events before his death remain a mystery. After considerable newspaper research, we are uncertain whether François Gouraud was the same as Francis Fauvel-Gouraud, who began lecturing on astronomy in December of 1842 and, at a later date, lectured on mnemonics in New York City and Boston. Fauvel-Gouraud became involved in a plagiarism controversy in 1844, and none of the prominent men who testified at length mentioned Gouraud the daguerreotypist. For further information on the controversy, see the *New York Daily Tribune*, May 28, May 29, 1844.

63. An item in *Niles' National Register*, February 11, 1843, reported that the "beautiful magical pictures by Daguerre, of Paris, were entirely destroyed by fire on the night of 29th ult." The promoters of the dioramas, artists Maffey and Lonati, had toured all the major cities in the East. The *New Orleans Daily Picayune* stated on January 31, 1843, that "the fire broke out in the back part of the room in which Daguerre's Chemical Pictures were being exhibited, which wholly destroyed the entire set before it was extinguished . . . the fire first commenced under the seats of the exhibition room."

64. Sachse, "Philadelphia Photography," p. 273. Sachse states that Cornelius opened a portrait studio in February 1840 on the northeast corner of Eighth Street and Lodge Alley.

65. *British Journal of Photography*, August 2, 1880, p. 510.

66. *Journal of the Franklin Institute* 25 (May 1840): 300–301. Saxton's experiments in producing a plate for engraving are interesting. Professor Berres of Vienna was following an identical line of inquiry at about the same time. For information on Berres, see the *Literary Gazette*, September 5, 1840, p. 581.

67. *Niles' National Register*, May 30, 1840, p. 208. A reprint from the *Chronicle*.

68. Mabee, *American Leonardo*, p. 243. A limited list of Morse's students includes D. (?) G. Johnson (New Orleans), Thomas Smiley (Philadelphia), a Mr. Dwight, Albert Southworth, Joseph Pennell, Charles Avery (Hamilton College), Eben N. Horsford (Albany Female Acad-

emy), and perhaps F. A. P. Barnard (University of Alabama). Many daguerreotypists later claimed to have been instructed in the art by Morse.

69. *London and Edinburgh Philosophical Magazine and Journal of Science* 17 (July 1840): 217–223.

70. Ibid.

71. National Archives, Record Group RA15, Revolutionary War pension files, under the name Enoch Runes of Canada, N.H. Privateer, R9075, died after July 7, 1838. Widow petition (rejected) 14,144. The post office cancellation stamp reads April 20, Saint Albans, and overlay in ink, "received (in Washington) April 25, 40"; 14,144. The Larrabee broadside was used as an envelope and is part of the U.S. pension records.

72. *American Journal of Photography*, October 1, 1860, p. 142. It may be noted that Wolcott has decided in June to abandon the reflector-type camera and has ordered additional lenses for his American operations.

73. *British Journal of Photography*, June 4, 1886, p. 362.

74. Prime, *Life of Morse*, pp. 408–409.

75. W. H. Goode, "The Daguerreotype and Its Applications," *American Journal of Science and Arts* 40 (December 1840): 137–144.

76. Ibid., pp. 141–142.

77. Ibid., vol. 28 (July 1841): 408. This item tells about the English patent for gilding of February 1837. Fizeau had probably deduced, in his gilding of daguerreotypes, that gold, silver, and mercury had been used to gild metals for a number of years–hence, logically, his successful conclusion.

78. *Journal of the Franklin Institute* 25 (February 1840): 142.

79. Benjamin Silliman, Jr., and William Henry Goode, "A Daguerreotype Experiment by Galvanic Light," *Annals of Electricity, Magnetism and Chemistry; and Guardian of Experimental Science* 9 (July 1842): 354–355. The article gives an interesting insight into early experiments with artificial light. Inadvertently, the two produced some color on their plates, but they did not pursue the matter.

80. *Niles' National Register*, October 10, 1840. A news item announcing the opening of Insley and Prosch's studio at 149 Broadway stated, "If they can keep their countenance for a space of a half minute, they may be daguerreotyped to Perfection."

81. *Philadelphia Public Ledger*, October 20, 1840.

82. *British Journal of Photography*, June 4, 1886, p. 362.

83. *Literary Gazette*, December 12, 1840, p. 803.

84. Helmut Gernsheim and Alison Gernsheim, *L. J. M. Daguerre: The History of the Diorama and the Daguerreotype* (1956); reprint ed., New York: Dover Publications, 1968), pp. 119, 120, 121. Despite the reports, Daguerre wrote an

article titled "New Photographic Discoveries" which appeared in the *Journal of the Franklin Institute* 30 (July 1842): 109, in which he described his methods, his failures, and his success. The article was reprinted from "Bulletin Soc. Indust.," July 1841.

3. The Formative Years, 1841–1846

1. Goode, "The Daguerreotype and Its Applications," pp. 137–138.

2. *Encyclopaedia Britannica*, 11th ed., s.v. "Photography."

3. *Literary Gazette*, July 10, 1841, p. 445. A description of Petzval's lens is also given.

4. American daguerreotypes taken in 1840 and 1841 show a remarkably exact focus of the face, although the hands often appear larger than they should.

5. *Philadelphia Public Ledger*, August 12, September 3, December 6, 1842.

6. *British Journal of Photography*, August 2, 1889, pp. 510–511. It should be noted that the Langenheims were agents for Voigtländer in the United States.

7. *Literary Gazette*, March 20, 1841, p. 188.

8. Hill, *Treatise on Daguerreotype*, pt. 1, pp. 81–85. See information about and prices of American and German cameras.

9. Johnson displayed one of the glass bulbs in the office of the *American Journal of Photography* in 1858, to illustrate how rapid the progress of photography had been.

10. *Niles' National Register*, April 17, 1841. Reprinted from the *New York Journal of Commerce*.

11. Morse's biographers agree that Barnard was one of the men who applied to Morse for instruction, but whether he actually studied under Morse has not been determined. See Mabee, *American Leonardo*, p. 243.

12. *American Journal of Science and Arts* 41 (October 1841): 352, 354.

13. *Photo Era* 4 (January 1900): 12, 13. In the winter of 1839–40, the use of bromine as an accelerator must have been common knowledge. Dr. Charles E. West, president of Rutgers Female College, recalled that at that time they had used iodine and bromine vaporized by pouring the chemicals on a heated plate for increased light sensitivity.

14. *Savannah Republican*, April 28, 1843. During this period of development, we found that in only one advertisement was the time mentioned other than a few seconds. Halsee and Eaton claimed "from 21 to 60 seconds" in their advertisement in the *Republican* on the above date.

15. *Southern Banner*, July 23, 1841.

16. *Richmond Whig and Public Advertiser*, December 7, 1841.

17. *New Orleans Picayune*, February 10, 1842. Separate advertisements for Maguire and Harrington began on the

same date. Harrington's address was 93 Canal Street, Maguire's was 31 Canal Street (upstairs). Canal Street would become a popular center for daguerreotyping at a later date.

18. Ibid.

19. *Anthony's Photographic Bulletin* 2 (November 1871): 343–345. From a lecture given by Southworth to the National Photographic Association at Cleveland, June 1870.

20. Reprinted in the *Publications of the Worcester Historical Society*, n.s. 1 (April 1928): 436.

21. Dr. Philip W. Bishop, "Scovill and Photography." Dr. Bishop compiled notes from the Scovill Company's business correspondence, and he has kindly given us permission to use his material from the unpublished manuscript. The Scovill business correspondence is now located in the Baker Library, Manuscripts and Archives Division, Harvard University.

22. *Boston Advertiser*, March 17, 1841.

23. One of Plumbe's cameras now rests in the George Eastman House. Whether this camera is one which Plumbe offered for sale or one used for his own purpose is not known.

24. Floyd Rinhart and Marion Rinhart, *Summertime* (New York: Clarkson N. Potter, Inc., 1978), pp. 144–155.

25. *Southern Banner*, May 15, 1840.

26. *Savannah Republican*, December 9, 1843; March 9, 1844. On March 9, Broadbent thanked the citizens of Savannah for their liberal patronage and stated that he would remain there only a short time longer.

27. *Georgia Journal and Messenger*, December 10, December 19, 1844.

28. *Southern Banner*, May 15, 1845.

29. *Columbus Times*, December 15, 1846.

30. *Georgia Journal and Messenger*, December 2, 1846. An editorial comment and advertisement. Perry also noted on January 21, 1847, that he would leave on January 23.

31. United States Letters Patent 2,522, March 28, 1842. The English were also interested in color. Richard Beard was issued an English patent for coloring daguerreotypes on March 10, 1842, which was unlike the American patent.

32. *Anglo-American*, October 10, 1846, p. 600.

33. *Journal of the Franklin Institute* 32 (July 1843): 411.

34. Ibid., vol. 34 (July 1844): 397.

35. Ibid., vol. 35 (October 1845): 391.

36. *New Orleans Picayune*, January 19, 1845.

37. *Jeffersonian*, June 19, September 18, 1846. Advertising in small-town newspapers was indicative of Plumbe's promotional abilities. His objective was to make prospective rural patrons welcome on their next trip to the city studio.

38. The only copy of *The Plumbeian* known to exist is in the New York Public Library, bound with Plumbe's publi-

cations under the title *The National Plumbeotype Gallery*.

39. Advertisements of the 1840 to 1845 era seldom mentioned copying daguerreotypes as a service, although it was a widely accepted practice from the very early days. In Larrabee's advertisement the portraits referred to were possibly oil paintings.

40. Reversed original images were seldom used in American daguerreotype portraits. Thus, a quick appraisal can be made of an image to ascertain whether a female has a wedding ring on her right hand (original plate) or on her left hand (copy plate). Men may be examined in the same manner for buttons on the shirt or coat on the left (original plate).

41. Arthur T. Gill, "Patent Specification," *Photographic Journal* 113 (February 1973): 77. English Patent 9,672.

42. Ibid. According to Gill, the Wolcott-Johnson lens arrangement was almost the same as that of John H. Dallmeyer, introduced in 1868.

43. Ibid. Gill states that this type of diaphragm was the same as the Frenchman N. P. Lerebours used in 1845.

44. *Charleston Courier*, March 1, 1847. McIntyre's advertisement is an example of how one daguerreotypist combated the rumor about daguerreotypes fading.

45. *Florida Peninsula*, December 15, 1855.

46. *McClure's Magazine* 9 (1897): 945.

47. *American Journal of Science and Arts* 39 (October 1840): 385–386. Berres' article was reprinted from the London *Athenaeum*, May 23, 1840.

48. *London and Edinburgh Philosophical Magazine and Journal of Science* 20 (January 1842): 18–24.

49. Ibid., vol. 22 (May 1843): 365–368.

50. *Littell's Living Age* 9 (April–June 1846): 551–552. Reprinted from the *Christian Watchman*. The writer had an amazing ability to project things to come. It is incredible, with photography only seven years old, that the photograph was predicted as being a recorder of historical events, by reproductions in newspapers, magazines, and television. Even the use of cameras in stores and banks for crime detection in the future did not pass unnoticed.

4. The Years of Expansion, 1847–1850

1. *Business Directory* (Boston Almanac, 1845); *Business Directory* (Boston Almanac, 1856).

2. *Business Directory* (New York: Doggett, 1844–1845); *Business Directory* (New York: Wilson, 1850–1851).

3. *Photographic Art Journal* 3 (1852): 294.

4. Ibid.

5. Ibid.

6. Josephine Cobb, *Mathew B. Brady's Photographic Gallery in Washington.* Re-

print from the *Records of the Columbia Historical Society*, vols. 53–56 (Washington, D.C., 1955), p. 6. Cobb states that it was unlikely that Brady learned the art from Morse. By the time Brady began daguerreotyping, a number of men in New York City gave instruction—Broadbent, Gurney, Insley, and Prosch, to name a few. Brady, as far as is known, did not reveal his instructor.

7. Ibid., p. 1.

8. *Richmond Whig and Public Advertiser*, June 11, 1847.

9. Ibid.

10. Ibid.

11. Bishop, "Scovill and Photography."

12. *New Orleans Picayune*, December 26, 1846.

13. This assumption of the amount of sales by Plumbe and White is based on the size of their respective operations; no records for either concern have been found to date. Also see an advertisement in the *New York Tribune*, November 2, 1844.

14. *Business Directory* (New York: Doggett, 1844–1845), pp. 93, 147.

15. *The East* (New York, 1846), p. 81.

16. *Business Directory* (New York: Sheldon & Co., 1845).

17. Ibid., p. 42. We have searched for the meaning of the product "galvanopasty" without success.

18. *St. Louis Practical Photographer* 4 (February 1880): 45.

19. *New Orleans Picayune*, January 22, 1848.

20. *City Directory* (Cincinnati: Robinson & Jones, 1846).

21. *City Directory* (Baltimore: Murphy, 1848).

22. *Photo Era* 4 (February 1900): 53.

23. *Richmond Whig and Public Advertiser*, July 25, 1848.

24. *Anthony's Photographic Bulletin* 19 (1888): 559–560. There are different accounts of Whipple's business activities in 1840 and 1841. Just when he began daguerreotyping is uncertain, although most accounts place the date in 1841. There is also the possibility that he began a year or two later. Also see *British Journal of Photography*, October 25, 1872, p. 510. This account places Whipple in partnership with Elias Howe (later inventor of the sewing machine) in the spring of 1841, engaged in manufacturing photographic chemicals.

25. *City Directory* (Boston: Simpson, 1846).

26. *Photographic News*, March 2, 1866, p. 102.

27. Newhall, *Daguerreotype in America*, pp. 93–94.

28. *Photographic News*, March 2, 1866, p. 102.

29. *Proceedings of the American Philosophical Society* (July–December 1851): 208.

30. *Annals of Electricity* 9 (July 1842): 354–356; the same article also appeared in the *American Journal of Science and*

Arts 11 (May 1851): 417–418.

31. *American Journal of Science and Arts* 11 (May 1851): 417–418.

32. Ibid., p. 418.

33. *Journal of the Franklin Institute* 40 (July 1847): 379–380.

34. Ibid., p. 397.

35. Ibid., vol. 42 (October 1848): 424.

36. Ibid., vol. 44 (October 1849): 15.

37. *Charleston Courier*, November 20, 1849.

38. Ibid., December 13, 1849.

39. *Godey's Lady's Book* 38 (1849): 352. Timothy Shay Arthur founded *Arthur's Home Magazine* in 1852. The magazine became, in the later part of the century, a household fixture—it was influential and widely read. Arthur, a prolific writer, is also well known for his book *Ten Nights in a Bar Room* and many others.

40. Taft, *Photography and the American Scene*, p. 61. A chart records the numbers of photographers for each census year from 1840 to 1930.

5. The Affluent Era, 1851–1860

1. Floyd Rinhart and Marion Rinhart, *America's Affluent Age* (South Brunswick & New York: A. S. Barnes & Company, 1971), p. 221.

2. Ibid., p. 191.

3. Ibid., pp. 15–18.

4. Ibid., pp. 183, 186.

5. Ibid., pp. 77–81.

6. *Daguerreian Journal* 2 (1851): 347.

7. William A. Drew, *Glimpses and Gatherings, During a Voyage and Visit to London and the Great Exhibition in the Summer of 1851* (Augusta, Me.: Homan & Manley, 1852), p. 326.

8. Ibid., p. 324.

9. *Harper's Monthly Magazine* 3 (1851): 278.

10. Drew, *Glimpses and Gatherings*, p. 369.

11. *National Intelligencer*, June 7, 1851.

12. Charles T. Rodgers, *American Superiority at the World's Fair* (Philadelphia: John J. Hawkins, 1852), p. 144. The section assigned to jury ten was "Philosophical Instruments and processes depending on their use, musical, horological and surgical instruments . . . There were 34 acting juries, composed equally of British subjects and foreigners. The chairmen of these juries were formed into the council to determine the conditions upon which prizes should be awarded, and to secure, so far as possible, uniformity in the action of the juries. . . . The number of bronze medals awarded was 2918, of the 'council' medals 170." See *Harper's Monthly Magazine* 4 (1852): 126.

13. Taft, *Photography and the American Scene*, p. 70. A quotation by Taft from the official report, *Exhibition of the Works of Industry of All Nations, 1851: Reports by the Juries*, London, 1852.

14. Taft, *Photography and the American Scene*, p. 70.

15. Joseph M. Wilson, *Illustrated Catalogue: The Masterpieces of the International Exhibition, 1876* (Philadelphia: Gebbie & Barrie, 1876). For construction details of the New York Crystal Palace, see his "Historical Introduction," pp. xxvii–xxx.

16. *Art and Industry Exhibition Crystal Palace, N.Y., 1853* (New York: Redfield, 1854). Reprinted from the *New York Tribune*, p. 172; also printed in *Humphrey's Journal* 5 (1853): 139–144; *Photographic Art Journal* 7 (1854): 64.

17. *Art and Industry Exhibition*, p. 172.

18. *Scientific American*, August 20, 1853, p. 386.

19. *Great Metropolis 1849* (New York: H. Wilson, 1848), p. 179. Advertisement.

20. *Humphrey's Journal* 4 (1852): 11, 12.

21. Floyd Rinhart and Marion Rinhart, *American Miniature Case Art* (South Brunswick & New York: A. S. Barnes & Company, 1969), p. 195.

22. *City Directory* (New York: Longworth, 1839, 1840).

23. *City Directory* (New York: Wilson, 1850–1851).

24. Newhall, *Daguerreotype in America*, pp. 62–63.

25. *Richmond Whig and Public Advertiser*, June 23, July 25, 1854.

26. *Citizen*, June 17, 1854.

27. *Scientific American*, January 25, 1851, p. 149.

28. *Humphrey's Journal* 5 (1853): 73, 335.

29. *Photographic News*, April 13, 1866, p. 172.

30. Information courtesy of Romare H. Bearden, who, through correspondence, furnishes much of the biographical information about James P. Ball.

31. In 1855, a lecture commenting on the panorama was printed by Achilles Pugh, publisher and abolitionist, under the title "Ball's Splendid Mamoth Pictorial Tour of the U.S. Comprising Views of the African Slave Trade of Northern and Southern Cities of Cotton and Sugar Plantations of the Mississippi, Ohio, and Susquehana Rivers, Niagara Falls, etc."

32. *Gleason's Pictorial Drawing-Room Companion*, April 1, 1854.

33. Information courtesy of Romare H. Bearden. For information about black life in the United States, consult Martin Robison Delany, *The Condition, Elevation, Emigration, and Destiny of the Colored Peoples of the United States . . .* (Philadelphia, 1852); Wendell P. Dabney, *Cincinnati's Colored Citizens* (Cincinnati: Dabney Publishing Company, 1926); and George W. Williams, *Negro Race in America*, vol. 2 (New York: G. P. Putnam's Sons, 1883).

34. *The Knickerbocker* 42 (August 1853): 137–142.

35. Issued to James A. Cutting of Boston, U.S. Letters Patents 11,213, July 4, 1854; 11,266 and 11,267, July 11, 1854;

English Patent (ambrotypes) 1,638, July 26, 1854.

36. The New-York Historical Society has a number of Prevost's views in their holdings.

37. U.S. Letters Patent 16,700, February 24, 1857, issued to David A. Woodward.

38. *Anthony's Photographic Bulletin* 19 (1888): 296–298.

6. Daguerreotype Plates, Apparatus, and Processes

1. The *St. Louis Post-Dispatch* carried the story, which was reprinted in the *News Monger* 2 (September 1898): 9, 10. Brassart had moved to Saint Louis after retiring from his business as a photographer in Naugatuck, Connecticut.

2. *Photographic and Fine Art Journal* 8 (September 1855): 280.

3. Bishop, "Scovill and Photography."

4. Ibid.

5. Ibid.

6. Ibid.

7. Ibid.

8. Ibid.

9. *Daguerreian Journal* 2 (1851): 76.

10. Ibid., p. 77.

11. Ibid.

12. Ibid.

13. U.S. Letters Patent 2,391.

14. Bishop, "Scovill and Photography."

15. George C. Groce and David H. Wallace, *The New-York Historical Society's Dictionary of Artists in America, 1754–1860* (New Haven: Yale University Press, 1957), p. 51.

16. Hunt, *Manual of Photography*. Advertisements, p. 14, item 112.

17. Bishop, "Scovill and Photography."

18. Ibid. Despite the availability of daguerreotype plates with a well-polished factory finish, many skilled daguerreotypists continued to hand-buff their plates.

19. *Business Directory* (New Jersey, 1850).

20. *Scientific American*, May 14, 1853.

21. A wooden box used for the shipment of daguerreotypes is with the collection of daguerreotypes at the Boston Museum of Fine Arts.

22. *Photographic Art Journal* 1 (1851): 92; vol. 7 (1854): 7.

23. We have made a test using 195 sixth-size plates (the most popular size) dating from the years 1851 to 1854. The test revealed that 98 had platemaker identifications and 97 showed none—an indication, perhaps, of the number of daguerreotypists who employed the cutting method. An even greater number of hand-cut ninth-size (second most popular size) plates showed that plates with hallmarks in this size were the exception rather than the rule.

24. *St. Louis Practical Photographer* 3 (August 1879): 713. Reprinted from *The Western Journal* (1850), from an article

by John Fitzgibbon titled "Daguerreo-typing."

25. Henry Hunt Snelling, *The History and Practice of the Art of Photography* (New York: G. P. Putnam, 1849), p. 20. Also see Newhall, *Daguerreotype in America*, p. 121.

26. Hunt, *Manual of Photography*, p. 235.

27. Hill, *Treatise on Daguerreotype*, pt. 1, p. 44.

28. Hunt, *Manual of Photography*, p. 235.

29. The mark characteristically left by a plate holder can be a potent factor in dating a plate on a not-before basis. This single factor combined with such other factors as miniature cases and hallmarks can date many daguerreotypes with some degree of accuracy.

30. Hill, *Treatise on Daguerreotype*, pt. 1, p. 18.

31. The perimeter indentations left by this type of daguerreotype plate holder have puzzled us for some time. The gripping tool used was probably a vise of some kind suited to an individual daguerreotyper's equipment because, while the marks have an affinity, they range from tiny punch types of about a sixteenth of an inch to those about a quarter of an inch. The pressure on the larger indentations has sometimes caused the edge of the plate metal to rip.

32. Levi Chapman sold Peck's patented holder for $1.00 (one-sixth size), $1.50 (one-quarter size), $2.00 (one-half size), and $2.50 (whole size) in 1850. Advertisement found in the *Daguerreian Journal* 1 (1850).

33. Henry Hunt Snelling, *A Dictionary of the Photographic Art* (New York: H. H. Snelling, 1854), p. 196, has illustrations showing two plate holders. One is particularly adaptable for bending plates for Peck's holder. An advertisement in the *Daguerreian Journal* for November 1, 1850, by Levi Chapman places the price of a plate bender at seventy-five cents. A note in the *Photographic Art Journal* 1 (June 1851): 378, states that Mr. Kingsley invented a plate bender and a plate holder, with Mr. Anthony as the sole agent. Large numbers were sold. Prices quoted were $1.50 for the plate bender and $3.50 for a set of plate holders—ninth to whole size.

34. Hill, *Treatise on Daguerreotype*, pt. 1, pp. 45, 46.

35. Daniel Davis, Jr., *A Manual of Magnetism* (Boston: Daniel Davis, Jr., 1847), p. 62.

36. Hill, *Treatise on Daguerreotype*, pt. 3, p. 82, appendix by W. McCartey, Jr.

37. Samuel D. Humphrey, *American Handbook of the Daguerreotype* (New York: S. D. Humphrey, 1853), pp. 61, 62.

38. Snelling, *Dictionary of the Photographic Art*, p. 4.

39. Hill, *Treatise on Daguerreotype*, pt. 2, p. 48.

40. Ibid.

41. A yellow light was considered the best "safe light" for a daguerreotypist's darkroom.

42. Hill, *Treatise on Daguerreotype*, pt. 1, p. 51.

43. Andrew Ure, *Ure's Dictionary of Arts, Manufactures and Mines*, 2 vols. (New York: D. Appleton & Company, 1853), pp. 564–565.

44. We fail to find a viewing window on Moulson's drawing. Perhaps the "mercurializing" time of a plate was fixed through experience rather than by a constant check from the operator.

45. Humphrey, *American Handbook of the Daguerreotype*, p. 86.

46. Hill, *Treatise on Daguerreotype*, pt. 3, pp. 53–54.

47. We have observed a number of extant daguerreotypes where the brown ashy hue was present, denoting an excess of mercury. Little is known about the finished results obtained by daguerreian artists through the various uses of mercury. Henry Insley used mercury in vignetting to bring out certain color effects; for further information, see his patent for vignetting.

48. Hill, *Treatise on Daguerreotype*, pt. 1, pp. 54–55.

49. *Journal of the Franklin Institute* 26 (July 1840): 343.

50. *Photographic and Fine Art Journal* 12 (January 1860): 28. The date given in Johnson's speech at the American Photographical Society meeting should have been 1841 rather than 1840, as the citation reads.

51. No mention of gilding by electroplating in the 1850s was made by Snelling or Humphrey in their respective books.

52. We were very pleased (and enlightened) when we found the patent record for the Lewis gilding apparatus, as the tiny cone-shaped marks on the corners of some extant daguerreotypes had often puzzled us.

53. *Wilson's Photographic Magazine* 36 (1899): 459.

7. Stereoscopic Daguerreotypes

1. Arthur T. Gill, "Early Stereoscopes," article reprinted by Wilding and Son from the *Photographic Journal* 109 (October–December 1969): 1 (repaged).

2. *Journal of the Franklin Institute* 44 (1849): 159, 160.

3. *Harper's Monthly Magazine* 39 (1869): 481, 482.

4. Gill, "Early Stereoscopes," p. 12.

5. *Journal of the Franklin Institute*, n.s. 25 (1853): 286–287.

6. Ibid., pp. 285–286.

7. *Anthony's Photographic Bulletin* 2 (1871): 346.

8. *Photographic News*, March 2, 1866, p. 103.

9. *Scientific American*, June 26, 1852, p. 313.

10. *Annals of Science* 1 (1852): 4.

11. *Humphrey's Journal* 5 (1853): 44.

12. Ibid., p. 45.

13. *American Journal of Science and Arts* 16 (November 1853): 348.

14. Ibid., p. 350.

15. U.S. Letters Patent 9,611.

16. *Scientific American*, May 28, 1853, p. 292.

17. These case items appear in Anthony's catalog for 1854, found in the back of Snelling's *Dictionary of the Photographic Art*.

18. *Journal of the Franklin Institute*, n.s. 29 (1855): 214.

19. U.S. Letters Patents 12,451 (Stull), 14,670 (Loyd).

20. *Humphrey's Journal* 7 (1855): 12.

21. Rinhart and Rinhart, *American Miniature Case Art*, pp. 40–41.

22. U.S. Letters Patent 10,987.

23. U.S. Letters Patent 11,304.

24. U.S. Letters Patent 13,093.

25. J. F. Mascher, "On taking Daguerreotypes without a camera," *Journal of the Franklin Institute* 59 (May 1855): 344–347.

26. Ibid., p. 345.

27. Ibid.

28. Ibid., p. 347.

29. U.S. Letters Patent 7,784.

8. Color and the Daguerreotype

1. U.S. Letters Patent 2,522.

2. U.S. Letters Patent 2,826. Daniel Davis was a pioneer daguerreotypist and an early experimenter in electricity who wrote the first book in America on the subject. See Newhall, *Daguerreotype in America*, p. 143.

3. Charles G. Page, "Mode of Coloring Daguerreotype Pictures," *Journal of the Franklin Institute* 33 (1844): 312–313. The description of the green color used in landscapes is very interesting. We have viewed a daguerreotype scene which closely resembles this description; it was not done by hand or stencil—the color is unexplained. Also, we have viewed daguerreotypes of the 1840s having the ruby color on the drapery. These are fascinating avenues for future study.

4. With the patent records in the National Archives is a letter written by Simons to the patent office, dated April 11, 1843, in which he describes the process in a slightly different manner. Of particular interest, he states: "I have submitted a picture to Dr. Bird—professor of chemistry in the University of Pennsylvania— I told him it was done by stopping out or by masking the plate—he expressed himself totally unaware of any means by which it could be done effectually from so delicate a picture."

5. We have researched the patent files and have confirmed Simons' patent number and date. Also, no patent by Mayall has been uncovered. Could Van Loan have bought Beard's patent rights, while in England, for use in America? This

would seem likely because of the stencil method used. Newhall, *Daguerreotype in America*, p. 51, mentions that Mayall wrote Albert Southworth for an opinion of the Langenheim patent (1846), a process also using a stencil method for coloring. Mayall also wrote the patent office in Washington and was told that he had no redress in the courts of law. Also see Newhall's n. 7, p. 160.

6. U.S. Letters Patent 4,370.

7. U.S. Letters Patent 4,423.

8. For the complete English patent, see the *Chemical Gazette* 1 (April 1843): 334–335. Specimens of Beard's daguerreotypes are found in the Gernsheim Collection, Humanities Research Center, the University of Texas at Austin. Many of these have blue backgrounds and white clouds. It is likely that the backgrounds were colored by Beard's patented method.

9. *Humphrey's Journal* 4 (1852): 88. For tinting the daguerreotype, also see John H. Croucher, *Plain Directions for Obtaining Photographic Pictures by the Calotype and Energiatype . . . Also, Practical Hints on the Daguerreotype* (Philadelphia: A. Hart, 1853). A reprint of Croucher's chapter on coloring daguerreotypes is found in the *New Daguerreian Journal* 1 (February 1972): 9, 10.

10. For a simple test to see if the coloring process was a chemical one, move the daguerreotype in different directions—if it goes into negative (a refraction of light), a metallic substance has been employed. If the color remains constant, the daguerreotype has been hand-colored.

11. *Photographic Art Journal* 3 (1852): 294.

12. Hunt, *Manual of Photography*, p. 158.

13. Ibid., pp. 158, 159.

14. *Chemical Gazette* 1 (April 1843): 305.

15. We were impressed that von Humboldt was shown the results of Böttger's experiments. The mention of flesh color is significant; it was one of the colors often spoken of by those who viewed Levi Hill's specimens in the 1850s.

16. *Journal of the Franklin Institute* 48 (1851): 211.

17. Levi L. Hill, *A Treatise on Heliochromy* (New York: Robinson & Caswell, 1856), p. 68. Reprinted by the Carnation Press, State College, Pennsylvania, in 1972.

18. *Scientific American*, March 18, 1848.

19. Hill, *Treatise on Daguerreotype*, pt. 4, p. 21.

20. Hill, *Treatise on Heliochromy*, p. 14.

21. *Photographic Art Journal* 1 (1851): 116.

22. Ibid., p. 337.

23. Ibid., p. 338.

24. Ibid., p. 339.

25. Hill, *Treatise on Heliochromy*, pp. 28, 29.

26. *New York Times*, November 21, 1851.

27. *Scientific American*, September 20, 1851. For Niepce de Saint Victor or heliochrome memoir, see *Humphrey's Journal* 4 (1852): 170, 180; also see *Annals of Science* (1853): 101, 102, 118–119.

28. This translation from *Comptes Rendus* may be found in the *Journal of the Franklin Institute* 48 (1851): 212.

29. Morse Manuscripts, Library of Congress. Unpublished letter.

30. Hill, *Treatise on Heliochromy*, p. 81.

31. Ibid., pp. 81–82.

32. *Humphrey's Journal* 4 (1852): 271.

33. Bishop, "Scovill and Photography."

34. *Humphrey's Journal* 4 (1852): 270. Other daguerreotypists who saw Hill's experiments were Charles Harrison, Augustus Morand, C. W. (R.?) Meade, Silas Holmes, Myron Shew, Charles E. Johnson, Charles L'Homdieu, and Remmett E. Churchill. See the *Daguerreian Journal* 2 (1851): 338.

35. *Scientific American*, October 23, 1852. See also *Humphrey's Journal* 4 (1852): 333, 345, 362, 378; vol. 5 (1853): 11, 41, 43, 74, 154, 203, 234, 249, 330.

36. Newhall, *Daguerreotype in America*, p. 102.

37. Snelling, editor of the *Photographic Art Journal*, was the sales manager for Edward Anthony's large daguerreotype supply house who had hoped to secure Hill's process for commercial use.

38. U.S. 32d Cong., 2d sess., *Senate Report* 427, serial 671.

39. *Scientific American*, February 26, 1853, p. 186.

40. Ibid., April 2, 1853. In saying that Hill exhibited a few specimens to a committee in no way suited professionally to give an opinion, the editor missed the fact that the Senate committee on patents had defended Hill's claim to color photography; the statement cited, also, "and the patent office."

41. The daguerreotypists who wrote Hill received, in turn, a circular advertising a reflector and five formulas and another testimony from Morse. See Newhall, *Daguerreotype in America*, p. 103.

42. Floyd Rinhart and Marion Rinhart, *American Daguerreian Art* (New York: Clarkson N. Potter, Inc., 1967), p. 61. For the complete hillotype process, see Hill, *Treatise on Heliochromy*, chap. 14, "The Hillotype," pp. 155–162. Some specimens of Hill's work are in the Smithsonian Institution, cat. no. 3,999, accessioned; no. 125,759, a gift by Dr. John Boggs Garrison, son-in-law of Levi Louis or Lawrence Hill (?). Descriptions from those who have seen the relics do not match the descriptions of hillotypes provided by eyewitnesses and written descriptions of the era. It is likely that these are remnants of Hill's innumerable experiments. He used many different metals and compounds and different procedures of working. Those with dull black backgrounds

are similar in description to the heliochromes described by the Niepce de Saint Victor process. Two of the Hill specimens are described in the accession as being eleven by fourteen inches, two are about seven by nine inches, the smaller ones are of various sizes; one shows a copy of a painting of a bird and much foliage. We have a theory that, after the death of Hill in 1865, some of the better hillotypes were sold to collectors. The Floyd and Marion Rinhart Collection, Department of Photography & Cinema, the Ohio State University at Columbus, has five specimens which are identified on the plates themselves as being the work of Levi L. Hill. Whether or not these are actually hillotypes has yet to be determined—it is hoped that a scientific study may be done to test the validity of these specimens and of the Hill process.

43. *New York Times*, October 26, 1852.

44. Hill, *Treatise on Heliochromy*, p. 160.

45. A major problem in recreating Hill's color process would be the purity factor of today's chemicals. In Hill's time there existed no standardization of chemicals, and each new batch of chemicals would have been different from previous ones, thus making it difficult in Hill's particular process to obtain a standard working formula. With his knowledge of chemistry and the special techniques used only by him, he likely produced results with varying success. Chemistry books of the 1840s and 1850s would have to be consulted for a recreation of the process and today's chemicals somehow made to conform with those used by Hill.

9. Art Influences

1. *Literary Gazette*, January 19, 1839, p. 43.

2. *Daguerreian Journal* 1 (1851): 339.

3. Ibid., vol. 3 (1851): 51.

4. We have been unable to locate any information about Colignon, son-in-law of Daguerre.

5. Samuel C. Busey, "Early History of Daguerreotypy in the City of Washington," *Records of the Columbia Historical Society* 3 (1900): 92. A letter from Seibert to Busey dated October 19, 1896. Also see Cobb, *Brady's Photographic Gallery*, pp. 4, 5. For a brief biography, see Groce and Wallace, *New-York Historical Society's Dictionary of Artists*.

6. For an account of the London diorama and its history, see Arthur T. Gill, "The London Diorama," *History of Photography: An International Quarterly* 1 (January 1977): 31–36.

7. Groce and Wallace, *New-York Historical Society's Dictionary of Artists*, pp. 288, 289.

8. *New Orleans Picayune*, December 28, 1842.

9. Virgil Barker, *American Painting*

(New York: Macmillan Company, 1950), p. 303.

10. For information about the expedition, see John L. Stephens, *Incidents of Travel in Yucatán* (London: John Murray, 1843).

11. Barker, *American Painting*, p. 449.

12. Ibid., p. 450.

13. Newhall, *Daguerreotype in America*, p. 50.

14. *Journal of the Franklin Institute* 42 (1848): 424.

15. Wendy Cunkle Calmenson, "'Likenesses taken in the most approved style': William Shew, Pioneer Daguerreotypist," *California Historical Society Quarterly* 56, no. 1 (Spring 1977): 4.

16. Six panoramas of San Francisco are known; three are complete, while the others have one or more plates missing. The California Historical Society has a seven whole-plate panorama of San Francisco Bay, taken sometime in the spring of 1851 by an unknown photographer. Information courtesy of Robert A. Weinstein.

17. The daguerreotypes were taken on half-size plates with a camera using a Harrison lens. Hesler had found that by electrolyzing the plates by friction he could reduce the exposures to one-fifteenth, and by further keeping the plates prepared a still greater increase in sensitivity was obtained. See the *British Journal of Photography*, October 3, 1884, p. 630.

18. Groce and Wallace, *New-York Historical Society's Dictionary of Artists*, p. 33.

19. Ibid., p. 96.

20. *California Historical Society Quarterly* 6 (1927): 109, 238, gives a transcription of Jones' lecture notes used in the eastern cities. Also, information about Jones is found in John Ross Dix, *Amusing and Thrilling Adventures of a California Artist While Daguerreotyping a Continent* (Boston, 1854).

21. *Philadelphia Photographer* 2 (1865): 120.

22. Rinhart and Rinhart, *America's Affluent Age*, p. 165. The idea for art unions is believed to have originated with a Mr. Hennin, a distinguished amateur of Paris, who organized a society in about 1810 to bring together unsold works of art, exhibit them, and distribute them by lot to subscribers. In 1816 the society merged into the Société des Amis des Arts. See the London *Art Journal* 12 (1850): 79.

23. *Art Journal* 12 (1850): 79.

24. Ibid., p. 295.

25. *Putnam's Monthly Magazine* 1 (1853): 120.

26. Rinhart and Rinhart, *American Daguerreian Art*, p. 2.

27. Newhall, *Daguerreotype in America*, p. 51.

28. Ibid., p. 60.

20. *Photographic Art Journal* 3 (May 1852): 294, 295.

30. Horace Greeley, ed., *Art and Industry, Exhibition Crystal Palace, New York, 1853–4* (New York: Redfield, 1854).

31. *New-Mirror*, August 31, 1844.

32. James D. Horan, *Mathew Brady: Historian with a Camera* (New York: Crown Publishers, 1955), p. 14.

33. *Putnam's Monthly Magazine* 1 (1853): 121–136.

34. Prime, *Life of Morse*, p. 405.

35. Rinhart and Rinhart, *American Daguerreian Art*, p. 3.

36. Mabee, *American Leonardo*, p. 231.

37. Information courtesy of Josephine Cobb.

38. Ibid. In 1866, the building was renumbered from 15 to 51 West 10th Street.

39. *Littell's Living Age* 9 (April–June 1846): 552.

40. *Photographic News*, March 2, 1866, p. 102.

41. Cobb, *Brady's Photographic Gallery*, p. 11.

42. Charles E. Fairman, *Art and Artists of the Capital of the United States of America* (Washington, D.C.: Government Printing Office, 1927), p. 321. Brady's last statement is an interesting one. Does he mean that no daguerreotype materials and supplies were available at this date? The later photographic supplies had undoubtedly made the earlier techniques and materials almost obsolete.

10. Art and the Portrait

1. *Photographic Art Journal* 3 (1852): 230.

2. *Godey's Lady's Book* 38 (1849): 352–355.

3. *Philadelphia Photographer* 10 (September 1873): 277.

4. Ibid.

5. A. S. Heath, E. Heath, and A. H. Heath, *Photography, A New Treatise* (New York: Chemists, A. S. & E. & A. H. Heath, 1855), p. 125.

6. *Daguerreian Journal* 2 (1851): 23.

7. *Photographic Art Journal* 4 (1852): 21.

8. Hill, *Treatise on Daguerreotype*, pt. 1, pp. 19, 20.

9. Snelling, *Dictionary of the Photographic Art*, s.v. "Background."

10. U.S. Letters Patent 6,056.

11. Floyd Rinhart and Marion Rinhart, "Whipple's Crayon-Style Vignette," *New Daguerreian Journal* 1 (June 1973): 4–6.

12. Ibid.

13. Floyd Rinhart and Marion Rinhart, "The Magic Background Process," *New Daguerreian Journal* 1 (December 1971): 4, 5, 12.

14. U.S. Letters Patent 7,865.

15. Rinhart and Rinhart, "The Magic Background Process," p. 5.

16. U.S. Letters Patent 8,633.

17. Floyd Rinhart and Marion Rinhart, "The Illuminated Daguerreotype Process," *New Daguerreian Journal* 1 (April 1972): 4–6.

18. U.S. Letters Patent 8,633. In a December 10, 1851, letter to the patent office in which he enclosed a sample daguerreotype "just as it comes from the bath," Insley recommended gilding the daguerreotype because it brought the colors out more vividly. He also wrote: "Daguerreotypists from almost every part of the country have seen them and pronounced them the prettiest that have yet been got up."

19. *Photographic Art Journal* 3 (1852): 383.

20. U.S. Letters Patent 9,511.

21. Floyd Rinhart and Marion Rinhart, *New Daguerreian Journal* 1 (February 1972): 4–6.

22. U.S. Letters Patent 10,225.

23. Ibid.

24. U.S. Design Patent 360. Design Patents are not to be confused with the regular U.S. Letters Patents—they are handwritten and are listed under a different numerical sequence.

25. U.S. Design Patent 521.

26. *Photographic Art Journal* 3 (1852): 230.

27. *Daguerreian Journal* 2 (1851): 23.

28. Humphrey, *American Handbook of the Daguerreotype*, p. 98.

29. *Lippincott's Magazine* 47 (1891): 579.

30. Humphrey, *American Handbook of the Daguerreotype*, pp. 95–96.

31. Taft, *Photography and the American Scene*, pp. 38, 39.

32. *Business Directory* (New York: Gem, 1844).

33. *Business Directory* (New York: Wilson, 1853).

34. Root, *The Camera and the Pencil*, p. 129.

35. Hill, *Treatise on Daguerreotype*, pt. 1, pp. 18, 19.

36. Rinhart and Rinhart, *America's Affluent Age*, p. 256.

37. *Anthony's Photographic Bulletin* 2 (June 1871): 179.

38. *Daguerreian Journal* 2 (1851): 310.

39. *Photographic and Fine Art Journal* 8 (1855): 76.

40. Humphrey, *American Handbook of the Daguerreotype*, p. 35.

41. *Humphrey's Journal* 5 (1853): 128.

42. Humphrey, *American Handbook of the Daguerreotype*, p. 35.

43. Snelling, *History and Practice of the Art of Photography*, p. 68.

44. Snelling, *Dictionary of the Photographic Art*, p. 10.

45. In an unpublished book manuscript, we have traced the history of American death in the nineteenth century.

46. *Philadelphia Photograher* 10 (1873): 280.

47. Unpublished book manuscript by the authors on death in the nineteenth century.

48. *Photographic and Fine Art Journal* 8 (1855): 80.

49. Floyd Rinhart and Marion Rinhart, "Rediscovery: An American Way of Death," *Art in America* 55 (Septem-

ber–October 1967): 78–81.

50. E. Porter Belden, *Past, Present and Future* (New York: Prall, Lewis & Company, 1850). This book includes the *American Advertiser*, which carries advertisements of mercantile and manufacturing establishments.

51. U.S. Letters Patent 7,974.

52. U.S. Letters Patent 26,370.

11. Miniature Cases

1. *New York Tribune*, October 1, 1841.

2. Rinhart and Rinhart, *American Miniature Case Art*, p. 25.

3. Ibid., p. 26.

4. Ibid., p. 69, pl. 33. The authors later discovered the name E. White embossed on the flying pendant above the sailboat.

5. Ibid., p. 24.

6. Ibid.

7. Bishop, "Scovill and Photography."

8. Ibid.

9. Ibid.

10. Ibid.

11. *Business Directory* (New York: Wilson, 1850).

12. *Photographic Art Journal* 7 (1854): 202.

13. Ibid.

14. *Humphrey's Journal* 5 (1853): 218.

15. U.S. Design Patent 733, October 9, 1855.

16. Rinhart and Rinhart, *American Miniature Case Art*, p. 59, pl. 9.

17. *Humphrey's Journal* 6 (1854): 170.

18. Rinhart and Rinhart, *American Miniature Case Art*, p. 44. For illustration, see p. 43, fig. 41 and 42. U.S. Design Patent 694, February 27, 1855.

19. *Humphrey's Journal* 7 (1855): 160.

20. Bishop, "Scovill and Photography."

21. U.S. Letters Patent 11,758.

22. Bishop, "Scovill and Photography."

23. U.S. Letters Patent 14,202.

24. U.S. Letters Patent 15,915.

25. U.S. Letters Patent 20,436.

26. Bishop, "Scovill and Photography."

27. Ibid.

28. Ibid.

29. Rinhart and Rinhart, *American Miniature Case Art*, p. 37.

12. Reflections of an Age

1. *Putnam's Monthly Magazine* 3 (1854): 92.

2. *Daguerreian Journal* 2 (1851): 180.

3. *Anthony's Photographic Bulletin* 6 (1875): 81, 82.

4. Ibid.

5. *Daguerreian Journal* 2 (1851): 28.

6. Ibid., pp. 231–232.

7. Humphrey, *American Handbook of the Daguerreotype*, p. 58.

8. Ibid., p. 86.

9. Ibid., p. 78.

10. Rinhart and Rinhart, *America's Affluent Age*, pp. 207–220.

11. *Photographic and Fine Art Journal* 8 (1855): 252.

12. Ibid.

13. See Newhall, *Daguerreotype in America*, pp. 71–75, for an excellent account of daguerreotypists traveling in South America.

14. *Anthony's Photographic Bulletin* 6 (1874): 357, 358.

15. *Philadelphia Photographer* 12 (January 1875): 9. Rulofson was president of the National Photographic Association when the article was written.

16. *Charleston Courier*, March 17, 1848. McIntyre advertised the disposal of his apparatus and offered his sensitive mixture at ten dollars a bottle. He also thanked the citizens of Charleston for their patronage over the past three years. Gold was discovered January 19, 1848, and it is possible that he traveled westward shortly after hearing of it.

17. Newhall, *Daguerreotype in America*, p. 153.

18. Rinhart and Rinhart, *American Miniature Case Art*, p. 24.

19. Calmenson, "William Shew, Pioneer Daguerreotypist," p. 5.

20. R. H. Vance, *Catalogue of Daguerreotype Panoramic Views in California* (New York: Baker, Godwin & Company, Printers, 1851). A copy of the 130 entries (a number of views are sometimes under one entry) can be found at the New York Public Library and the California Historical Society. A Xerox copy is with the Floyd and Marion Rinhart Collection, Department of Photography & Cinema, the Ohio State University at Columbus.

21. *New York Times*, October 7, 1851.

22. *Humphrey's Journal* 5 (1853): 105. The great sale of Vance's views took place at Bang Brothers, Park Row, on July 20, and editor Humphrey said they were "displayed at our office" (ibid., p. 89).

23. *British Journal of Photography* 10 (September 1872): 462.

24. Information courtesy of Miss Josephine Cobb.

25. *British Journal of Photography* 10 (September 1872): 462.

26. Rinhart and Rinhart, *America's Affluent Age*, pp. 78, 79.

27. Newhall, *Daguerreotype in America*, p. 88.

28. Rinhart and Rinhart, *America's Affluent Age*, p. 79.

29. *Photographic and Fine Art Journal* 8 (1855): 19.

30. Taft, *Photography and the American Scene*, p. 265.

31. U.S. 36th Cong., 1st sess., 1860, *Executive Document* 56, pp. 37, 103.

32. Information courtesy of Josephine Cobb.

33. Ibid.

34. *The Japan Expedition 1852–1855 of Commodore Matthew Calbraith Perry.* Catalog published by the Smithsonian Institution, 1968, pp. 7–8.

35. Information courtesy of Josephine Cobb.

36. Ibid.

37. *Photographic and Fine Art Journal* 8 (1855): 19.

A DICTIONARY OF DAGUERREOTYPE TERMS

This dictionary has been included to aid institutions, museums, and students of the daguerreotype in their efforts to identify, date, and analyze many of the physical characteristics found on extant daguerreotypes.

Many of the descriptive terms used are innovative, and some miniature case nomenclature has been added for reference convenience.

Bevel: About an eighth-inch bend toward the nonimage side on the perimeter of a plate. Usually about a twenty- to thirty-degree bend or bends were made on factory plates. Standard hand-beveled plates were bent about forty degrees; for an example of a hand-beveling apparatus, see Henry Hunt Snelling's 1854 *A Dictionary of the Photographic Art*. Other bends (sometimes used in patents) ranged up to right angles. See, for example, Samuel Peck's patented plate holder for further information. The early heavy plates did not have a bent perimeter—plate beveling did not become a general procedure with daguerreotypers until about 1844 and 1845. The original purpose for beveling was to prevent the buckskin on hand-buffing tools from ripping or tearing as it crossed the edge of a plate during the polishing process. Additionally, bevels provided strength to the metal and ease of handling.

Bevel reversed: Perimeter bent toward the image side of a plate. Often, this procedure effected a three-dimensional appearance on the finished image. Also used in a gilding apparatus. See U.S. Letters Patent 9,354, October 26, 1852.

Box marks (configurations): Traces left by the box used in the mercury or coating manipulation.

Clipped corners, cut: A simple procedure to facilitate the placing of a plate within the miniature case.

Cloth cases: Wood frame, cloth-covered.

Configurations: Various disfigurements, usually found on the daguerreotype plate's perimeter, caused by the implements or apparatus used in the daguerreotype process.

Cut plate: A plate usually hand-cut from a larger stock plate. For example, six regular-size one-sixth plates were derived from one whole plate. Variations from standard-size plates occur. *See also* Shorted plate.

Factory-finished plate: A finely finished silver plating supplied by the manufacturer, with no discernible buffing marks.

Flat plate: No bevel on the perimeter of the plate.

French plate: Part of a French hallmark visible without any determination of the maker's identity.

Gilding: A daguerreotype procedure to enhance, strengthen, and provide durability to the image.

Hand-buffing: A widely used manipulation thought to improve the receptive qualities of the silvered surface of a daguerreotype plate. The buffing strokes were made opposite to the length of the image.

Indents, indentations (configurations): Small impressed or notch marks left on the perimeter of the daguerreotype plate by an unknown apparatus, probably a plate holder.

Leather cases: Wood frame covered with paper-thin leather.

Lewis-type holder: A commonly used plate holder invented by W. and W. H. Lewis.

Neat plate: A daguerreotype plate, excluding the image, which was produced in a workmanlike manner.

Paper cases: Wood frame covered with paper, an inexpensive counterpart of the leather-covered cases.

Papier-mâché cases: Paper glued together and pressured into a boardlike quality.

Plastic cases: Molded thermoplastic composition.

Plate holder: An apparatus designed to grip and hold a plate; usually used in conjunction with the buffing manipulation. Responsible for many of the configurations found on extant daguerreotypes.

Plate mark: A hallmark, symbol, initial, or name pressure-stamped or incised near an edge of a plate to identify the manufacturer.

Plate sizes, standard:
 Whole plate: 6½ by 8½ inches
 Half plate: 4¼ by 5½ inches
 Quarter plate: 3¼ by 4¼ inches
 Sixth plate: 2¾ by 3¼ inches
 Ninth plate: 2 by 2½ inches
 Sixteenth plate: 1⅜ by 1⅝ inches
The sixth plate was also known as medium.

Plier marks (configurations): Visible traces of a gripping tool used in the daguerreotype manipulation. See Snelling's *Dictionary of the Photographic Art* for various types.

Raised points (configurations): Sharp points on the surface of plates, probably caused by W. and W. H. Lewis' patent gilding apparatus.

Renewed plate, cleaned: A chemical dip process to remove tarnish from a daguerreotype plate.

Resilvered: A thin additional layer of silver applied to a daguerreotype plate by electrolysis.

Scratching on plate: Attempted removal of tarnish from the daguerreotype plate with an abrasive material. For example, using a silver polish.

Shorted plate: Produced by a few daguerreotypists to gain a greater yield when dividing a stock-size plate. Examples: Eight usable sixth plates, 2⅛ by 3¼ inches (narrow in width), could be cut from a standard full-size plate, 6½ by 8½ inches. A quarter plate, 3¼ by 4¼ inches, cut in half would yield two usable sixth-size plates, 2⅛ by 3¼ inches (also narrow in width).

Stitch-type markings (configurations): Traces left on a perimeter of a plate, probably caused by a crude roller beveling machine; these marks may indicate that the daguerreotype was made from about 1845 to 1848.

INDEX

The letter p following a page number indicates the reference is to an illustration.

Accelerators, 43, 48, 58–61, 180; bromine, 28, 37, 54, 432 (n. 13); children, 297; Johnson's display of, 432 (n. 9); for outdoor views, 354–355. *See also* Exposure time, reduction of

Accessories. *See* Art techniques

Actor, portrait of, 375p

Advertising, 37, 38, 90, 258, 287, 432 (nn. 14, 17), 433 (nn. 37, 39, 44)

Albany Daily Knickerbocker, 273

Albany Normal School, faculty of, 360p

Allegorical portraits, 125, 126, 244, 246p, 247p

Allston, Washington, 248

Alta California, quoted, 238, 361

Amateurs, 30, 46, 52, 53, 83, 104, 165 (n. 66). *See also* Goddard, Dr. Paul Beck

Ambrotype, 147, 209p, 224

American Handbook of the Daguerreotype, 272; quoted, 354

American Institute, 64, 73, 107, 176, 212

American Journal of Science and Arts, 19, 25, 58–61; quoted, 82

American Philosophical Society, 29; quoted, 103, 104

Amusing and Thrilling Adventures of a California Artist While Daguerreotyping a Continent, 240

Annual of Scientific Discovery, quoted, 219, 220

Anson, Rufus, 380; portrait by, 156p. *See also* color illustrations, "Man with gray beard"

Anthony, Charles J., vignette patent, 273, 274, 278p, 279p, 380

Anthony, Clark and Company, 96; advertisement, 96p; label, 97p

Anthony, Edward (E. Anthony and Company), 77, 96, 97, 133, 134, 417; cases, 202, 309–312, 316; contest sponsored by, 134; expedition, 367, 369; and Hill, 214, 220; sales receipt, 97p

Anthony, Edwards and Company, 244, 380; advertisement, 83p

Anthony, Henry T., 96, 417

Apparatus. *See* Supply houses

Apparatus, early, 33–37, 50; prices of, 37, 38. *See also* Supply houses

Arago, Dominique François Jean, 9, 10, 12, 16, 18–20, 22, 27, 54, 191, 192; portrait of, 9p

Archer, Frederick Scott, 148

Arkansas Intelligencer, 369

Army uniforms, 151p, 368p, 370p

Art influences, 225–259; art unions, 241–243, 437 (n. 22); of daguerreotype on art, 244–252; dioramas, 232–234; engravers and lithographers, 230, 244–247; illustrations, 244–247; miniature painting, 230, 259; panoramas,

234–241; portrait painting, 244, 249–258, 264, 286. *See also* Vignettes

Art techniques, 259–287; accessories, 280–283; backgrounds, 267–271; lighting, 263–267; posing, 284–288; vignettes, 271–280

Artault, François A., 95, 96, 380; advertisement, 96p

Arthur, Timothy Shay, quote, 113–114, 261–263, 434 (n. 39)

Arthur's Home Magazine, 113, 434 (n. 39)

Artificial light, experiments in, 52, 53, 104

Astronomy. *See* Whipple, John A.

Athenaeum, 215, 288, 429 (n. 39)

Author, portrait of, 374p

Awards, 72, 73, 104–108, 110, 120, 125, 212. *See also* specific institutions

Babbit, Platt D., scene by (attributed), 123p, 380

Bache, Dr. Alexander, 28

Backgrounds. *See* Art techniques

Bailey, John B., 140, 381

Baker, James P., 140–144, 381, 434 (n. 31)

Ball, Thomas C., 144, 381

Barbaro, Daniello, 3

Barnaby, S. B., 381; portrait by, 130p

Barnard and Harrington, 63

Barnard, Frederick Augustus Porter, 26, 53, 63, 381, 432 (n. 11); experiments, 58–61; stereoscopic daguerreotypes, 199, 200. *See also* Harrington, William H.

Barnard, Maj. John G., 200

Barnes, Chauncy, 381; advertisement, 84p; portrait by, 262

Bayard, Hippolyte, 10

Beals, Albert A., 127, 382; advertisement, 300p

Beard, Richard, 40, 57, 187, 211; color patent, 433 (n. 31); 435 (n. 5); 436 (n. 8)

Beckers and Piard, 304, 382; advertisement, 148p

Beckers, Alexander, 46, 287, 304, 382; advertisement, 89p; plate holder, 177

Beckers, Louis, 133, 417

Becquerel, Alexandre Edmond, 192, 213, 215

Belle Sheridan (steamer), 355

Benton, Thomas Hart, 119

Berres (professor), 82, 432 (n. 66), 433 (n. 47)

Binsse, Louis B., 96, 166, 417; advertisement, 96p; plate by, 168p

Biot, Jean Baptiste, 9, 192, 193, 213

Bird (professor), 435 (n. 4)

Bisbee, Albert, 126, 138, 222, 382; panoramic view of Cincinnati, 126

Bishop, Louis L., 96, 167, 417

Bishop, Madam, 95

Black, James Wallace, 138, 359, 382–383

Blacksmith shop, view of, 357p

Bloomville Mirror, quoted, 353

Bogardus, Abraham, 284–286, 383; portrait by, 129p

Bolles, Jesse, 258, 383

Boston, 42–45, 62–68

Boston, view of, 23p

Boston Daily Advertiser and Patriot, 42, 288

Boston Evening Transcript, quoted, 42–45

Böttger, Rudolph, natural color daguerreotype, 213, 436 (n. 15)

Brady, Mathew B., 77, 93, 94, 136, 246, 252, 280, 350, 383, 420; advertisement, 93p; awards, 120, 125; cases, 306; gallery, 93, 94; letterhead, 137p; paintings from daguerreotypes, 257–258; portrait by, 121p, 144p, 370p; portrait of (attributed), 94p

Brassart, August, 155, 417, 434 (n. 1)

Brewster, Sir David, 191, 193, 197–199, 207, 429 (n. 1); stereo viewer, 192p

British Journal of Photography, quoted, 369

British Queen, 24, 25, 30, 157, 430 (n. 11), 431 (n. 31)

Broadbent, Samuel, 70, 110, 164, 180, 310, 383, 384, 433 (n. 26); advertisement, 70p; assistant to Morse, 70, 227; portraits by, 70p, 71p, 72p, 194p, 203p, 226p

Brown, Eliphalet M., Jr., 369, 371, 372, 384

Brown, James Sidney, 125, 384; vignette process, 280

Bryant, Henry, 227, 252, 384

Bull, Ole, 95

Burgess and Fredericks, advertisement, 285p

Burgess, Nathan G., quoted, 376, 384; postmortem, 300–302

Bush, Dr. James M., 30

Butler, Alexander, 128, 384

Butler, William H., 162, 385

Calhoun, John C., 119, 257

California, views of, 357–366, 363p, 364p. *See also* color illustrations, "Miners at work"

Camera and the Pencil, The, 217, 288, 355

Camera obscura, 3, 4p, 5p, 258

Cameras, American, 38, 55; cigar box, 27, 367; Draper, 27; Fitz, 30; Gouraud, 34; Harrison, 58, 128, 355p; pinhole, 206, 207; Plumbe, 68, 433 (n. 23); prices, 431 (n. 8); Prosch, 34, 36, 37p, 95p; solar, 257, 258; Southworth, 64; stereoscopic, 191, 203–207; Wolcott, 20, 30, 37, 38,

Cameras, American (*continued*)
39p, 49, 57. *See also* appendix 2
Cameras, European, Austrian and German, 55–58, 57p, 98, 432 (n. 6); English, 12p, 191; French, 20p, 51, 53, 433 (n. 42)
Campbell, James, 219–222
Cardan, Girolamo, 3
Carleton, Samuel L., 385; case, 309p; portrait by, 275p
Carvalho, Solomon Numes, 227, 369, 385; advertisement, 369p
Case designs (miniature), art and reflections from abroad, 327p–328p; fruits and flowers, 332p–340p; geometric and traditional, 341p–349p; historical scenes and portraits, 317p–321p; pleasant pastimes, 322p–326p; religious, 329p–331p
Case manufacturers and engravers. *See* biographies
Cases, miniature, 114, 133; casemaking, 306, 310, 311; English, 307p; jewelry, 313p; labels, 308p, 309p; magnifying, 313, 314; mats, 309, 311, 311p, 312; novelty, 312–314; patents, 315p, 316p; preservers, 309, 311; thermoplastic, 314–316
Cases, stereoscopic, 192p, 193, 193p, 199, 199p, 201–203
Cass, Lewis, 95, 119
Catherwood, Frederick, 236, 237, 385, 386; engraving by, 237p
Chamberlin (Scovill agent), 158, 162, 417
Chambers' Edinburgh Journal, quoted, 12, 13, 268, 429 (n. 27)
Chapman, Levi, 133, 173, 212, 273, 417, 435 (nn. 32, 33); assigned patent, 283; plate by, 173p
Charleston Courier, 37, 108, 110–111; advertisement, 362p
Chase, Lorenzo G., 227, 386. *See also* color illustrations, "The golden portrait"
Chemical Gazette, quoted, 213
Chess players, portrait of, 374p
Chevalier, Charles, 55
Chevreul, Michel Eugène, 213
Child portraiture, 289–298
Chilton (daguerreotypist), 244
Chilton, B. A. and W. W., 63, 386; advertisement, 63p
Chilton, James R., 28, 33, 36, 40, 41, 417, 430 (n. 9)
Churchill, Remmett E., 386; and Hill, 436 (n. 34)
Cincinnati Republican, quoted, 19
Cincinnati waterfront, view of, 106p, 107p
Clark, James R., 96, 386
Clark, John M., 214, 386
Claudet, Antoine, 93, 144; advertisement, 119p; background of, 268; controversy with Brewster, 197, 198; pioneer mammoth plates, 147; polishing plates, 174; stereoscope by, 199p
Clay, Henry, 80, 81, 95, 119, 257, 258; postmortem portrait of (attributed), 303p
Coating boxes, 180–182; patent drawing, 181p. *See also* appendix 2
Coburn and Cerveau, 387; advertisement, 53p

Cole, C., 306, 387
Collins, David C., 135, 387; portrait by, 128p
Collodion process, 197, 256–257
Color, 208–224, 432 (n. 79); Campbell experiments, 219–223; chemical, 208–210, 436 (n. 10); European experiments, 212, 213; galvanic battery, 208, 210; hand-coloring, 71, 208, 210–212; Hill and, 213–223, 436 (n. 34); natural, 212–223; Page experiments, 208–210; patents, 208, 210–211
Color illustrations. *See* chapter 8 for hand-tinting, chemical coloring, electroplating, unknown
Colt, Judge, 127
Comptes Rendus, quoted, 215–216
Conway Mutual Bank, view of, 358p
Cook, George Smith, 110, 227, 350, 387; advertisement, 228p; portrait by, 227p
Cook, Miss Jane, 227, 387
Coombs, Frederick, 357, 387
Copying apparatus, 79, 79p, 80, 433 (nn. 42, 43)
Copying daguerreotypes, methods of, 76–81, 256–258, 433 (n. 40); copy paintings, 76, 80p, 258; copy portraits, 78p, 79p, 80p, 81p, 82p. *See also* Copying apparatus
Corduan and Company (Joseph Corduan and Corduan, Perkins and Company), 25, 34, 35, 65, 70, 95, 162, 165, 166, 417, 418; advertisement, 163p; plate of, 27p
Cornelius, Robert, 29, 46, 47, 62, 117, 159, 160, 227, 387, 432 (n. 64); portrait by (attributed), 47p
Crayon daguerreotypes, 125, 253, 272. *See also* Vignettes
Critchlow, Alfred P., 316, 316p, 420
Crittenden, John, 95
Crystallotype, 101, 102, 148, 256
Crystal Palace Exhibition, London, 111, 116–121, 434 (n. 12); interior view of, 118p
Crystal Palace Exhibition, New York, 121–129, 244
Cutting, James A., 147

Dabbs, George, and Cremer, James, advertisement, 133p
Daguerre, Louis Jacques Mandé, 7–10, 14–21, 27, 33, 46, 60, 163, 179, 184, 213, 226, 232, 288, 430 (nn. 41, 3, 13), 432 (n. 84); English patent, 429 (n. 39); portraits of, 8p, 91; visit to platemaker, 155–156. *See also* Niepce, Joseph Nicéphore
Daguerreian Journal, The, 98, 115, 228–230, 273, 353
Daguerreotype terms, dictionary of, 439
Daguerreotyping, decline of, 146–150
Daguerreotypist, portrait of, 377p
Daguerreotypists. *See* biographies
"The Daguerreotypists," 113, 114; engraving of, 317p
Daguerreotypist van, view of, 357p
Daguerreville, 131–133
Daily National Intelligencer, quoted, 47, 48
Dallmeyer, John H., 433 (n. 42)
Dark tents, 105, 353
Dated portraits, 87p, 99p

Davie, Daniel T., 214, 215, 388
D'Avignon, Francis D., 246
Davis, Ari, 38, 55, 418
Davis, Daniel, Jr., 71, 179, 208, 418, 435 (n. 2)
Davy, Sir Humphry, 4
Dean, Julia, 127
Delaroche, Paul, quoted, 226
Diorama, 5, 46, 232, 432 (n. 63)
Dixon, Joseph, 388, 430 (n. 16)
Dobyn, Richardson and Company, 126, 388
Dobyns and Company, 202
Dodge, Edward Samuel, 227–230, 284, 388; portrait by, 229p
Dodge, Luther P., 388–389; advertisement, 136p
Dog portraits, and child, 291p, 393p; poodle, 365p; and surveyor, 367p
Douglas, Stephen A., 95
Draper, John William, 26, 27, 47, 48, 51, 163, 389; controversy with Herschel, 83; experiments, 15, 30, 32; and Hill, 214, 218; letter to Herschel, 431 (n. 30); photoengraving, 83, 84
Drew, William, quoted, 117–119
Drummond, Alonzo J., 128, 389. *See also* biography of Brown, James Sidney
Duboscq, Jules, 191, 193
Duncanson, Robert S., 141
Durand, Asher B., quoted, 214

Earle, Austin T., institute of, 116
Early portraits, 27p, 42p, 56p, 59p, 164p, 430 (n. 16), 432 (n. 4)
Edwards, Jonas M., 63, 152, 389
Eichmeyer, Henry A., 313, 420
Elliot and Gunn, 106
England and Gunn (Mlle.), 106, 153, 389
Englehard, George, 169, 418
Enslin, Schreiber and Co.,
Evans, G., 64, 390
Expansion of the art, 62–75, 90–114
Expeditions and explorations, 366–372; Frémont, 369; Japan, 369–372; northeast boundary, 366–368; Stevens, 369
Exposure time, reduction of, 28, 46–52, 297, 302, 355, 432 (n. 14). *See also* Accelerators; Cameras

Factory scene, view of, 361p
Faris, Thomas, 62, 140, 227, 390; advertisement, 114p
Ferrotype, 224
Field, Erastus Salisbury, 227, 258, 390
Fillmore, Millard, 95, 119
Fire engine, Franklin, view of, 376p
First trials, 25–30
Fitz, Henry, 30, 62, 390, 431 (n. 27)
Fitzgibbon, John H., 62, 390; award, 127; gallery, 366; and Hill, 217; Indian warriors, portraits of, 127, 350–351; as itinerant, 351; photoengraving, 128, 129; portrait by, 126p; quoted, 174
Fixing the image, 187
Fizeau, Armon Hippolyte Louis, 52, 84, 187, 208, 432 (n. 77)
Floating galleries, 355
Florence Manufacturing Company, 316
Floridian, 359
Fontayne and Porter, 106, 391; award,

106, 238; views of Cincinnati, 106p, 107p, 120, 238

Fontayne, Charles, 140, 148, 391; advertisement, 143p. *See also* Fontayne and Porter

Forrest, Edwin, 125

Franklin Institute, 46, 53, 73, 104–107, 202, 238; exhibition, 74p

Franklin Institute, Journal of the, 15, 28, 191, 195, 208–210

Fraunhofer and Company, 37

Fraunhofer, Joseph von, 37

Frazer, Professor John Fries, 28, 391

Fredericks, Charles De Forest, 148, 258, 357, 391

Frelinghuysen, Hon. Theodore, 244–246

Frémont, John C., 369

French, Benjamin, 98, 418; advertisement, 98p

French studios, 144–146

Fuller and Company, 391; portrait by, 90p

Fuller, George, letter to father, 43, 391, 431 (n. 57)

Galena Advertiser, 278

Galleries, Broadway, 135–139; cheap, 138–139; European, 144–146; first, 38–42; floating, 355. *See also* individual names

Gallery of Illustrious Americans, 246

Gallet, M. A., 65, 418

Galvanic battery, 178, 179p, 208

Garlick, Theodatus, 38, 63, 227, 391

Gaucheraud, H., article by, 9, 10

Gazette de France, quoted, 9

Georgia Weekly Constitutionalist, quoted, 230

Germon, Washington L., 166, 227, 392. *See also* McClees and Germon

Gilding, 52, 84, 187–190, 208, 432 (n. 77); patent drawing, 190p

Giroux, Alphonse, and Company, 23, 25, 31, 65

Gleason's Pictorial Drawing-Room Companion, quoted, 140–144

Goddard, John F., 54

Goddard, Dr. Paul Beck, 28, 37, 46, 53, 62, 392; equipment used, 29p; view by, 74p

Godey's Lady's Book, quoted, 113, 114, 244

Gold rush, the, 115, 116, 238–241, 357–366; views from, 118p, 363p, 364p. *See also* color illustrations, "Miners at work"

Goll, Frederick P., 327p, 420

Goode, William Henry, report by, 50–52, 55, 104, 432 (n. 79)

Gordon and Willis, 306, 420

Gouraud, François, 30–37, 47, 48, 160, 367, 392; advertisement, 35p; in Boston, 42–45; equipment, using American, 34; and Morse, 31, 33–36, 45; in New York, 31–36, 431 (nn. 40, 43); at Niagara Falls, 45; plagiarism controversy, 432 (n. 62); portrait taking, 44, 45, 288–289; prices and description of Daguerre's specimens, 31; Seager, dispute with, 33

"Governor Boutwell and his Council, 1852," portrait of, 290p

Graduation portrait (Yale), 143p

Great Western, 16, 25, 26, 28, 430 (n. 4); engraving of, 24p

Greeley, Horace, 124, 128, 244

Greenwood, Grace, 95

Greenwood Plantation, view of, 353p

Grove, Sir William R., 83, 178

Gurney, Jeremiah, 135, 136, 366, 392, 393, 431 (n. 50); advertisement, 89p; awards, 125, 134; experiences, early, 53, 54, 75, 102; and Hill, 216; life-size portraits, 258; portrait by, 134p

Haas, Philip, 125, 227, 230, 244, 393; portrait by, 233p

Habersham, Robert, quoted, 5

Hale, Luther Holman, 359, 393

Hall, Francis, 24, 26, 430 (nn. 1, 5)

Hall, Ogden, 310, 420

Hallmarks, 434 (n. 23), 435 (n. 29). *See also* appendix 1

Halsee and Eaton, 393, 432 (n. 14); advertisement, 63p

Halvorson, Halvor, case, 344p; patent drawing, 315p

Harding (artist), 218

Hare, Robert, 15

Harper's Illustrated Guide, 238

Harper's Monthly Magazine, 244

Harrington, William H., 63, 393, 432 (n. 17); advertisement, 64p; experiments, 59–61; stereoscopic daguerreotypes, 199, 200

Harrison and Hill, advertisement, 147p; award, 125; mammoth plates by, 125, 244

Harrison, A. C., 106

Harrison, Charles C., 128, 350, 393; advertisement, 128p; award, 128; camera, 58, 354, 355p; and Hill, 436 (n. 34)

Harrison, Gabriel, 75, 227, 244, 393, 394; article by, 259; on posing, 284

Harrup, Robert, 4

Hartnett, C. and J., 306

Hawes, Josiah Johnson, 77, 227, 230, 394. *See also* Southworth and Hawes

Hawkins, Ezekiel C., 116, 140, 227, 394; exhibits on paper, 128

Hayden, Henry, 155, 156

Hayden, Hiram W., 315, 420

Hayes, Kate, 127

Headrests, 131, 288, 289; Jenny Lind, 288p

Heliochromes, 92, 101, 436 (n. 42)

Henning and Eymann, case, 325p

Henry, Eliza, 53, 394

Henry, G. W., 53, 394

Herschel, Sir John, 13–15; and color, 212; controversy with Draper, 83

Hesler, Alexander, 394, 395; advertisement, 269p; allegorical portraits, 125, 244; award, 126; on lighting, 264, 265; panoramic views, 126, 238, 437 (n. 17); portrait by, 268p; on vignetting, 277, 278

Hidden, George G., 176, 418

Hill, Levi L., 101, 115, 174, 175, 183, 186, 213–224, 395, 436 (nn. 15, 42); Anthony's invoice to, 183p; and backgrounds, 269, 270; and coating plates, 180, 181, 183; extant specimens, 436 (n. 42); and headrests, 289; petroleum and, 223, 224; recreating color process, 436 (n. 45); school, 98, 99, 116; Senate

report, 220, 221, 436 (n. 40). *See also* color illustrations, "Eugenie Bayley," "Country boy," "Girl holding book," "Mary Hill," "Man in blue shirt and sombrero"

Hillotypes, 101, 214–223; exhibited in Albany, 215

History and Practice of the Art of Photography, The, 98, 297

Hite, George Harrison, 218; on lighting, 264; on posing, 284

Holmes, Booth, and Hayden, 133, 155, 156, 166, 169, 312, 316, 418; cases by, 329p, 332p; plates by, 156p, 171p

Holmes, Oliver Wendell, 207

Holmes, Samuel, 316

Holmes, Silas A., 203–205, 395; and Hill, 436 (n. 34); patent drawing, 204p

Horsford, Eben N., 50

Howe, Elias, 396, 433 (n. 24)

Howe, George M., 127, 396; portraits by, 127p, 281p; trade card, 127p

Huddleston, J. S. F., 55, 68, 418

Humboldt, Friedrich Heinrich Alexander, Baron von, 9, 16, 213; portrait of, 9p

Humphrey, Samuel Dwight, 98, 101, 418; coating plates for outdoor views, 354; mercury process, 185; plates, sensitizing of, 180; on proportion, 285, 286; school of photography, 116; vignette backgrounds, 272

Humphrey's Journal, 98, 180, 199, 217

Hunt, Robert, quoted, 54, 174, 212

Hyalotype, 107, 128, 207

Incidents of Travel and Adventure in the Far West, 369

Indian portraits, 351

Innovations, 101–104

Insley and Prosch, 396, 432 (n. 80)

Insley, Henry, 53, 136, 396; illuminated daguerreotypes, 276, 277, 435 (n. 47), 437 (n. 18); patent drawing, 278p; vignette example, 252p, 280p

Instantaneous photography, 61

Instructions in the art, 47, 48, 98–100, 115–116, 432 (n. 68), 433 (n. 6)

Isenring, Johann B., 211

Itinerants, 49, 76, 276, 286, 350–357

Ives, Loyal Moss, 227, 396

Jackson, Andrew, 119

James, Charles, 220

Jameson, Anna Brownell, quoted, 225

Jamestown, California, view of, 363p

Japanese dignitaries, portrait of, 372p

Jaquith, Nathaniel C., 397; portrait by, 283p

Jenkins, Solon, Jr., 304, 397

Jewelry, 312, 313p

Johnson and Wolcott. *See* Wolcott and Johnson

Johnson, Charles E., 397; and Hill, 436 (n. 34)

Johnson, John, 57, 157, 164, 397; portrait of, 27p; quoted, 162. *See also* Wolcott and Johnson

Johnson, William, 40

Jones, J. Wesley, 242, 397, 398; artist sketch (from daguerreotype), 242p; California, pantoscope of, 241, 437 (n. 20); lottery, 135; lottery ticket,

Jones, J. Wesley (*continued*)
242p; portrait of (attributed), 240p;
West, views of, 240–241
Jones, William B., 102, 398
Journal des Débats, 23, 25

Keely, R. N., 398; portrait by, 288p
Kelsey, C. C., 127, 398
Ketcham, Charles, 175, 418
Key, Frederick C., 420; cases, 319p, 320p
Kilburn, William Edward, 119, 144
Kimball, William H., 227, 398
King, F. W. and Richard, 98
Kingston Journal, 98; quoted, 360
Kinsley, Edward G., and Parker, Samuel
A. W., 316
Kirk, Edward N., 25, 430 (n. 5)
Knickerbocker, The, quoted, 31, 32, 37,
145–146, 244
Kossuth, Louis, 127

Langenheim brothers, 56, 57, 73, 107,
165, 194, 211, 399; magic lantern, 241;
Niagara Falls, 237; portrait by, 110p;
Voigtländer camera, 55–58, 432 (n. 6)
Langenheim, Frederick. *See* Langenheim
brothers
Langenheim, William. *See* Langenheim
brothers
Langley, Jones, and Drake, 304
Larrabee (daguerreotypist), 49, 76, 286,
399, 432 (n. 71), 433 (n. 39); broadside,
49p
Larwill, Ebenezer, 420; case (interior) by,
308p
Latent writing, example of, 86p
Law, Thomas, 283
Lawrence, Martin M., 120, 125, 136, 244,
287, 399; advertisement, 124p; award,
120, 244; portraits by, 62p, 120p
Lens, 3, 33–37, 55, 433 (n. 42); aberra-
tion, 52p, 59p; advertisement, 36p. *See
also* Cameras
Lerebours, N. P., 433 (n. 43)
Letillois, M., 216
Lewis, Henry J., 418; quoted, 41, 130–131
Lewis, Richard A., 130, 131, 399
Lewis, William and William Henry, 36,
41, 95, 188, 418; advertisements, 89p,
132p; Daguerreville, 131–133; design
patent, 283; patent drawing, 177p, 181p
L'Homdieu, Charles, 110, 399; gilding,
188; and Hill, 436 (n. 34); patent draw-
ing, 190p
Life-size photographs, 148, 257, 258
Lighting, artificial, 52, 53, 104, 432
(n. 79); portraiture, 263–267; use of
mirrors, 48, 52. *See also* Art tech-
niques; Wolcott and Johnson
Lind, Jenny, 94, 127, 141; headrest, 288p
Litch, Albert, 102, 399
Literary Gazette, 14; quoted, 19, 25, 52,
54, 57
Littell's Living Age, quoted, 83, 254–256
Little Falls (New York), view of, 23p
Littlefield, Parsons and Company, 316,
420; cases by, 318p, 321p, 336p, 342p
Locke, John, 400; advertisement, 15p;
early experiments, 15; lectures, 15p
Lockwood, M. W., 400; lottery, 135, 244
*London and Edinburgh Philosophical
Magazine*, 83

London Globe, 23–25, 29
London Mechanic, quoted, 19
Long, Enoch, 126, 127
Lotteries, 135, 244
Lovering, Reuben F., 70, 400; advertise-
ment, 72p
Loyd, W., 203, 420

McAllister, Matthew Hall, 127
McClees and Germon, 105, 106, 166, 400;
portrait by, 201p
McClees, J. E., 166, 400
McDonnell and Company, 128, 400
McIntyre, Sterling C., 238, 359, 361, 400,
438 (n. 16); advertisement, 362p
Magic Buff, The, 115
Magic lantern, 207, 241
Maguire, James, 63, 401, 432 (n. 17)
Maine Democrat, 369
Mallory, George, 217, 316
Mammoth plates, 75, 125, 173; and
Claudet, 147; Gouraud's display of,
44–45. *See also* Life-size photographs
"Man with twelve fingers," portrait of,
366p
Manufacturers. *See* Supply houses
Manufacturers and wholesale suppliers.
See biographies
Mapes, James Jay, 15, 28, 30, 40, 401;
Wolcott and Johnson, 41, 46
Marston, Joseph H., 206; patent drawing,
205p
Mascher, John F., 193, 194, 199, 201–203,
206, 207, 420, 421; medallion, stereo-
scopic, 203; pinhole photography, 206,
207; stereoscope daguerreotype case
by, 193p, 203p
Mason, William G., 165, 227, 230, 401
Massachusetts Charitable Mechanic Asso-
ciation, 107
Masury and Silsbee, 127, 401
Maury, Matthew Fontaine, 125
Mayall, John, 62, 73, 93, 144, 211, 401; al-
legorical daguerreotypes, 244; color pa-
tent claim, 435 (n. 5); stereoscope by,
192p
Meade brothers, 7, 91–93, 136, 165, 202,
273, 402; advertisement, 93p; allegori-
cal views, 120–121, 125, 244; awards,
125, 212; cases, 306; gallery, 91–92, 92p;
Hill and, 436 (n. 34); portraits by, 8p,
91, 92p
Meade, Charles Richard. *See* Meade
brothers
Meade, George Gordon, portrait of,
369p
Meade, Henry W. *See* Meade brothers
Medallion, stereoscopic, 205
Mercury bath, 183–187, 435 (n. 47); pa-
tent drawing, 184p. *See also* appendix 2
Mifflin, John Houston, 63, 227, 402
Miller, S. S., 402; portrait by, 111p
Mississippi River, 238, 355
Mitchel (daguerreotypist), 70
Moffet, J. G., 169, 418
Moigno, Abbé, 191–193
Moniteur, Le, 23
Montez, Lola, 95
Moon, view of, 103p
Moore, Justus E., 47, 402
Morand, Augustus, 227, 357, 403; and
Hill, 436 (n. 34)

Morning Herald, 25, 26
Morse, Lemuel, 208
Morse, Samuel Finley Breese, 15–18, 26,
40, 58, 66, 115, 134, 403, 430 (n. 7), 431
(n. 37), 433 (n. 6); art influence, 227,
248–250; class portrait, 287; Draper
and, 30, 32, 47, 48, 51, 55; early scene
by, 25; experiments, 5, 25–27, 30, 48,
430 (n. 12); Gouraud and, 31, 33–36, 45;
Hill and, 214–224; letter to Allston,
248–249; letter to Arago, 18; letter to
brother, 16, 45; letter to Daguerre, 18,
19, 30, 33, 430 (n. 11); letter to Hors-
ford, 50; obtaining plates, 157–162; por-
trait of, 17p; pupils of, 63, 70, 361, 432
(nn. 68, 11); visit with Daguerre, 16
Möser, Dr., 83
Moulson, John, 435 (n. 44); patent draw-
ing, 184p
Mourners, the, 299p
Multiple portraits, 80, 81
Musicians, portraits of, 88p, 111p, 193p
Mutant calf, portrait of, 365p

National Intelligencer, quoted, 119, 217
National Plumbeotype Gallery, The, 74,
81
Natt, Thomas J. and Son, 230, 403
Naval officer, copy portrait, 80p
New-Mirror, quoted, 244–246
New Orleans Picayune, quoted, 165
New York City, Broadway galleries, 62,
135–139; Crystal Palace exhibition,
121–129; first daguerreotype in, 26; first
studio in, 38–41. *See also* American
Institute
New York Commercial-Advertiser, 22,
35, 236
New York Evening Post, 24
New York Evening Star, 21, 22, 33, 36
New York Journal of Commerce, 15, 25,
26, 33, 50, 58
New York Morning Herald, 25, 305
New York Observer, 31
New York State Daguerreian Associa-
tion, 214–215
New York Sun, 40
New York Times, 217, 218
New York Tribune, 124, 215, 306
New Yorker, 31
Niagara Falls, 237; view of, 123p
Niepce, Joseph Nicéphore, 6–10, 429
(n. 11); view by, 6p
Niepce de Saint Victor, Claude Félix
Abel, 215, 219, 221, 436 (n. 42)
Niles' National Register, quoted, 25
Nolan, Henry S., 105
North, Walter C., 126, 403–404
Nude baby, portrait of, 260p

Occupational daguerreotypes, actor,
235p, 375p; artist, 209p; author, 375p;
bakers, 364p; bank, 358p; blacksmith
shop, 357p; chess players, 374p; circus
performer, 246p; daguerreotypist,
377p; factory at work, 361p; fire appa-
ratus, 376p; gold mining, 118p, 363p;
military, 368p, 370p; musicians, 89p,
111p, 193p; school building, 139p; school-
teachers, 360p; surveyor, 367p; tin ped-
dler, 351p
Oregon Spectator, quoted, 240

Orr, John William, 247
Outley, John J., 404; portrait by, 137p

Page, Charles Grafton, 404; experiments in color, 208, 209, 210, 212
Page, Cyrus G., 135, 404
Paige, Blanchard P., 94, 404
Panoramas, 106–107, 234–241; views, 106p, 107p, 238p, 239p
Paris, views of, 9, 21, 32, 44; studios of, 144–146
Parker, Joseph E., 53, 165, 404
Parker, Samuel A. W., Jr., 316. *See also* Wadham's Manufacturing Company
Parsons (daguerreotypist), 70
Partridge, A. C., 135, 405
Passe-partouts, 306
Patent drawing (English), copying apparatus (Wolcott and Johnson, Mar. 18, 1843), 79p
Patent drawings (U.S.), battery, galvanic (John Plumbe, Jr., Mar. 4, 1843), 77p; camera attachment (J. H. Marston, June 19, 1855), 205p; coating plates (W. and W. H. Lewis, Nov. 15, 1853), 181p; gilding (C. L'Homdieu, Oct. 26, 1852), 190p; miniature cases (H. Halvorson, Aug. 7, 1855; A. P. Critchlow, Oct. 14, 1856), 315p, 316p; panoramic views (Van Bunschoten, Woodbridge, and Mann, Apr. 17, 1849), 108p; photographic bath (J. Moulson, Sept. 2, 1851), 184p; plate holder (W. and W. H. Lewis, Oct. 23, 1849), 177p; stereoscopic cameras (S. A. Holmes, May 30, 1854; Southworth and Hawes, July 11, 1854), 204p, 205p; vignetting (H. E. Insley, Jan. 6, 1852; W. Yarnall, Dec. 28, 1852), 278p, 281p. *See also* appendix 2
Patents, design, 283, 312, 313
Peck, Samuel, 177–178, 310, 314–316, 421; cases by, 323p, 332p, 344p; plate holder, 178p, 435 (nn. 32, 33)
Pennell, Joseph, 53, 62–64, 405
Perry, Matthew C., 125, 369, 371–372
Perry, William A., 70, 75, 110, 350, 405, 433 (n. 30); portrait by, 73p
Peter, Dr. Robert, 30, 405
Peters, Otis T., 405; advertisement, 196p; award for stereoscopes, 128
Petzval, Josef Max, 37. *See also* Lens
Philadelphia, 28, 29, 46, 47, 53. *See also* Franklin Institute
Philadelphia Chronicle, quoted, 46
Philadelphia Photographer, The, quoted, 359
Photoengraving. *See* Photomechanical processes
Photogenic experiments, American, 5, 15, 429 (n. 27)
"Photogenic War," 33, 35, 45
Photographic Art Journal, The, 115, 135, 170–172, 214, 220, 277, 284
Photographic and Fine Art Journal, The, 115, 300, 355
Photography, early experiments in paper, 5, 10–15; natural color (European), 212–213; prediction for future, 85–87, 433 (n. 50); use for illustrations, 238. *See also* Art influences
Photolithography. *See* Photomechanical processes

Photomechanical processes, 81–84, 128
Pierce, Franklin, 95, 122, 125
Pinhole photography, 206–207
Plant, Henry, 122
Plantation home, view of, 352p
Plate bending, 177, 178. *See also* dictionary of terms
Plate buffing, methods of, American, 174–179; European, 174
Plate holders, 174–178; marks left by, 175p, 176p, 178p, 179p; patent drawing, 177p; prices of, 435 (n. 32)
Plate pliers, 178
Plates, daguerreotype, 155–170; configuration on, 176, 176p, 178p, 179, 435 (nn. 29, 31); criticism of, 170–173; defects in, 157p, 158p; resilvering, 178–179, 176p; shorted, 173, 174p; sizes, 173. *See also* appendix 1; dictionary of terms
Plumbe, John, Jr., 53, 62, 65–68, 70–75, 84, 90, 93, 96, 187, 244, 361, 405, 433 (n. 13); advertisement, 89p; awards, 73; camera, 432 (n. 23); cases, 69p, 307, 309; color patent, 71, 187; galleries, 68, 73–75; galvanic battery, 77p, 208; patent drawing, 77p; photolithography, 74; portraits by, 62p, 65p, 66p, 67p, 68p, 77p; promoter, 67, 68, 81, 433 (n. 37); publisher, 74, 81, 82; pupils of, 75; views by, 75p, 76p
Plumbeian, The, 74, 433 (n. 38)
Poe, Edgar Allan, 26
Politically prominent, 93–95, 119, 120; advertisement, list of, 83p
Pornographic portrait, 138p
Porta, Giovanni Battista della, 3
Porter, William Southgate, 106, 107, 135, 406. *See also* Fontayne and Porter
Portraits, historical, 272–276, 433 (n. 50)
Posing. *See* Art techniques
Postmortem daguerreotypes, 298–302; portraits of, 301p–303p
Pouillet, Claude S. M., 192
Pratt, William A., 101, 406; advertisements, 142p, 294p; color patent, 211
Prentice, W. V., 406; advertisement, 113p
Prevost, Victor, 148
Processes, buffing the plate, 174–178; electrolysis, 178–179; fixing and gilding, 187–190; mercury bath, 183–187; sensitizing, 179–183
Profile portrait, 146p
Prosch, Andrew, 95, 418
Prosch, Charlotte, 95, 406
Prosch, George W., 34, 36–38, 50, 53, 55, 58, 95, 418, 431 (nn. 37, 46); advertisements, 37p, 95p
Public acceptance, 84–88
Putnam's Monthly Magazine, quoted, 243, 247

Quai d'Orsay, demonstrations at, 21
Quicks. *See* Accelerators

Regnault, Henri Victor, 213
Rendu, Abel, 45
Renwick, James, 367, 369
Restored daguerreotype, example of, 123p
Richards, Frederick De Bourg, 194–196, 227, 407

Richardson and Cox, 247
Richmond Whig and Public Advertiser, 200
Riddle, Albert G., quoted, 117–118
Ritter, Johann Wilhelm, 4
Rive, de la (chemist), 187
Roach, John, 36, 55, 95, 419
Robinson, Joseph C., 222, 407
Root and Collins, 73
Root, Marcus A., 80, 81, 105–107, 148, 195, 227, 407, 431 (n. 22); award, 125; and children, 294, 295; crayon daguerreotypes, 253, 272; gallery, 261–263; group posing, 288; Hill and, 216–217; outdoor views, 355; portrait by, 109p
Root, Samuel, 134, 407; Anthony award, 134; crayon daguerreotypes, 272. *See also* Root, Marcus A.
Ross, Andrew, 55
Ruins of Copán, Yucatán, engraving of, 237p
Rulofson, William Herman, 357, 359, 408

Salt Lake City, sketch of, 242p
Sanders, J. Mellon, 116
Sartain, John, 253–254
Sartain's Union Magazine of Literature and Art, 254
Savannah Republican, quoted, 164–165
Savart, Felix, 192
Sawyer, John, 202, 419
Saxton, Joseph, 28, 408; exhibited galvanic copy, 46, 83; experiments, 432 (n. 66)
Scammon and Company, 202
Scenes, outdoor, 304, 353–363, 366–372, 437 (n. 16); allegorical, 52p; amateur, 362p; camera for, 355p; panoramas, 106p, 107p, 234–241, 238p, 239p
Scheele, Karl Wilhelm, quoted, 4
Schley, Governor and Mrs. William, copy portrait of, 82p
Schönbein, Christian Friedrich, 213
Schoonmaker and Morrison, 273, 408
Schulze, Johann Heinrich, 3
Scientific American, quoted, 193, 194, 197, 198, 201, 202, 213, 215, 217, 219–223, 273
Scott, Winfield, 119
Scovill Company (Scovill Manufacturing Company), 419; casemaking, 309–316, 322p; platemaking, 65, 68, 157, 157p, 158p, 159, 160–166; supply house, 95, 96, 133, 134, 202, 217
Scovill, J. M. Lamson, 157–162, 419
Scovill, William H., 157–162, 419
Seager, D. W., 157, 408, 430 (n. 7); dispute with Gouraud, 33–36; early views by, 25, 26
Seamstress, portrait of, 279p
Seibert, Selmar Rush, 230, 408
Seixas (daguerreotypist), 48, 408
Sénébier, Jean, 4
Sensitizing. *See* Accelerators
Shankland, Mrs. H., 96, 408
Shannon, Mrs. Julia, 357, 408
Shew, Jacob, 361, 408
Shew, Myron, 195, 202, 307, 361, 408; and Hill, 436 (n. 34); magnifying case, 313–314
Shew, Trueman, 361, 409

Shew, William, 62, 361, 409; cases, 307, 308p; panorama, 238, 238p, 239p

Silliman, Benjamin, Jr., artificial light, experiments with, 52, 104, 430 (n. 9, 432 (n. 79)

Simons and Collins, 73

Simons and Willis, 306, 421

Simons, Montgomery P., 105, 106, 195, 211, 409; cases, 306; in Charleston, 108–111; daguerreotyping infant, 292; patent, 435 (nn. 4, 5); portraits by, 105p, 113p

Simpson, S. F., floating gallery of, 355

Skylights, 67–68, 264

Smee, Alfred, battery of, 178, 179p

Smith, Hamilton Lanphere, 38, 409

Smith, Peter, 98, 419

Smith, W. H., and Company, 89p, 419

Snelling, Henry Hunt, 97, 98, 115, 149–150, 170–172, 180, 214, 253, 287, 288, 419

Social reflections, 372–376

South. *See* Travel, southern

South Carolina Institute, 110

Southern Literary Messenger, 237

Southworth and Hawes, 194, 197, 199, 230, 410; advertisement, 78p, 198p; lighting, 264; patent drawing, 205p; plate holder, 176; portraits by, 231p, 253p (attributed); postmortems, 299, 300; stereoscopes, 206. *See also* Hawes, Josiah Johnson

Southworth and Pennell, 62–64; exhibited at American Institute, 64; using Wolcott-type camera, 64

Southworth, Albert S., 53, 77, 309, 357, 431 (n. 53). *See also* Southworth and Hawes

Stampfer, S., 37

Stancliff, J. W., 104, 227, 410

Stanley and Dickerman, 369, 410

Stanley, John Mix, 369, 410

Starr, Thomas N., 63, 410

Stephens, John Lloyd, 236–237

Stereographs, 207

Stereoscope cases. *See* Cases, stereoscopic

Stereoscopes, 128, 191–207; prices of, 202

Stereoscopic daguerreotypes, 191–207, 194p, 201p; Barnard and, 200; cameras for, 191, 203–207; Harrington and, 199–200; pinhole, 206–207

Stevens, Benjamin R., 208

Stevens, Isaac I., 369

Stevenson, John G., 50, 53, 66, 410

Studio equipment of 1840, 29p

Studley and Gordon, 307, 421

Studley, H., case interior by, 308p

Stull, John, 203, 421

Supply houses, 36–38, 64–65, 95–98, 130–134

Surveyor, portrait of, 367p

Talbot, William Henry Fox, 10–14, 19; brochure, 13p; photogenic drawing by, 14p; portrait of, 11p

Talbotype, 107, 125, 148, 371

Taylor, Bayard, portrait of, 373p

Taylor, Zachary, 119

Terwilliger, Hiram Y., 411; portrait by, 170p

Theater personalities, 95, 127

Thomas, Alexander S., 144, 411

Thompson, Benjamin (Count Rumford), 4

Thompson, Warren, 210, 411

Tin peddler, portrait of, 351p

Tithonotype, 84

Tombstones, daguerreotypes in, 304

Tomlinson, William Augur, 214, 227, 411

Tompkins, J. H., 182

Trade card, 127p

Transylvania University, 30

Travel, southern, 69, 70, 108, 350

Traveling vans, 351–353, 357p

Treatise on Daguerreotype, A, 213

Treatise on Heliochromy, A, 223

Ulster County Examiner, 219

Union cases, 314–316

"Union mat," 312

United States Capitol, view of, 76p

United States Gazette, quoted, 230

United States Magazine and Democratic Review, 244

United States patent office, Washington, D.C., view of, 75p

United States Senate, report of, 220–221

Upton, Benjamin Franklin, 412; patent, 184, 185; portrait by, 185p

Van Alstin, Andrew Wemple, 284, 412

Van Amburgh, Isaac, portrait of, 246p

Van Loan, Matthew, 41, 50, 412; advertisement, 51p

Van Loan, Samuel, 73, 211, 361, 412, 435 (n. 5); allegorical daguerreotypes, 244

Vance, Robert, 361, 412; sold collection, 363, 438 (n. 22); views of West, 363

Vanderlyn, John, 218

Victoria, Queen, 116, 191

Vignettes, 147, 253, 271–280; examples of, 252p, 253p, 278p, 279p–281p

Voigtländer, Peter Friedrich, 37. *See also* Cameras

Von Prechtl, J. J., 37

Von Schneidau, John Frederick Polycarpus, 125, 412

Wadham's Manufacturing Company, 316, 421; cases by, 318p, 326p, 328p

Washington, D.C., early demonstration in, 48; views of, 75p, 76p

Watson, John Frampton, 53, 227, 413

Waugh, Samuel Bell, 218

Webster and Bro., 125, 413

Webster, Daniel, 95, 119, 257; portrait of, 265p

Wedgwood, Thomas, 4, 5; portrait of, 5p

Wells and Foster, 38, 55, 419

Werge, John, 138, 139, 197, 256

West, Charles E., 414, 432 (n. 13)

Wheatstone, Sir Charles, 191, 192, 197; stereoscope, 192p

Whipple, John A., 62, 148, 165, 414, 433 (n. 24); advertisement, 102p; artificial light, 104; astronomy, 102–104, 138; awards, 120, 128; crystallotype, 101, 128, 256; gallery, 102, 256; and Hill, 216; photomicrography, 104; portrait by, 290p (attributed); view of moon, 103p

White, Edward (E. White and Company), 419, 433 (n. 13); advertisement, 88p,

166p, 167p; case manufacturer, 306–309; plate manufacturer, 165, 166; supply house, 95

Whitehurst, Jesse H., 77, 93, 135, 244, 414; advertisement, 135p; awards, 120, 128; galleries, 94–95, 366; lottery, 62, 104; Niagara Falls, view, 120, 127; portraits by, 122p, 303p; stereoscopic daguerreotypes, 210; vignettes, 271

Whitney, Edward Tompkins, 415; photographing children, 296

Williamson, Edward M., 126, 415

Wilson's Photographic Magazine, 189, 190

Wisong, William, 133, 415

Wofford College (South Carolina), view of, 139p

Wolcott and Johnson, 47, 49, 157, 250; accelerators used, 41, 58; circular railway, 41p; enterprise in England, 40, 50–54, 57; first commercial studio, 38–41; first successful portrait by, 27–28, 430 (n. 17); gilding, 187; lens for copying, 433 (n. 42); lighting system, 38–41, 48; patent for copying apparatus, 79–80; plates, search for, 162–164; photoengraving experiments, 84; polishing apparatus, 164; sold gallery, 41, 50; speculum camera, 27, 30, 38, 39p, 57, 63–64, 432 (n. 72). *See also* individual names

Wolcott, Alexander Simon, 415; to England, 50; letter to Johnson, 50; letter to Mapes, 28, 30; patent for camera, 38; portraits exhibited, 46. *See also* Wolcott and Johnson

Wolf, J. G., 33, 419; advertisement, 36p; lens by, 34–37; pupil of Fraunhofer, 37

Wollaston, William, 4

Woodward, David A., 148

Worcester Spy, 64

Wyeth, P. C., 218

Wyman and Company, 416; portrait by, 141p

Yale class book portrait, 143p

Yarnall, William, patent drawing, 281p; vignettes, 278–279